KANDINSKY

KANDINSKY

Jelena Hahl-Koch

KANDINSKY

RIZZOLI
NEW YORK

First published in the United States of America in 1993 by
RIZZOLI INTERNATIONAL PUBLICATIONS, INC.
300 Park Avenue South, New York, NY 10010

Translated from the German *Kandinsky* by Karin Brown,
Ralph Harratz and Katharine Harrison

ISBN 0-8478-1404-1
LC 91-52769

Production:
Dr. Cantz'sche Druckerei GmbH & Co KG,
Ostfildern-Ruit bei Stuttgart

Printed and bound in Germany

CONTENTS

INTRODUCTION

Many years have passed since fierce controversy broke out over Kandinsky's first abstract pictures. He was accused by the media of being a "madman" and a "bluffer," he was outlawed as a "formalist" in his own Russian homeland, and soon after, during the Nazi regime, his "degenerate" paintings were removed from German museums. Meanwhile his role as the most significant founder of abstract art has been universally acknowledged. And it is not surprising that the power to fascinate art historians, philosophers, psychologists, and ordinary art lovers alike continues to grow. More and more exhibitions with voluminous catalogues and countless research papers demonstrate his importance (while the flourishing sales of posters, calendars, and "popular" editions reflect the growing worldwide interest in him).

Yet no comprehensive monograph has been published on him since 1958! And, what is worse, less than half of the artist's theoretical and literary writings and letters have been published so far, while a considerable proportion of his pictures has until recently remained inaccessible in museum store rooms in the former Soviet Union.[1] While in 1920 the art historian Konstantin Umansky called Kandinsky the "Russian Messiah," Ilya Ehrenburg described his followers in Germany as a "belch in literary painting" (and one suspects this comment was meant to include the master himself). Other Soviet critics tended to echo Ehrenburg's view.

Finally the year 1989 (i.e., even before the cultural opening up of the former Soviet Union) brought the sensation of the first solo exhibition in his homeland, which also featured works from provincial museums and private collections. Pictures that had been thought missing for decades were shown in Moscow and Leningrad (now St. Petersburg), as well as in Frankfurt – the one outpost in the West. This book also covers these hitherto unknown works, discusses the new discoveries, and attempts to find a synthesis between the "Western" Kandinsky and the totally different "Eastern" Kandinsky. It will also feature pictures which are inaccessible in private collections and others which have "emigrated" to Japan. Many new photographs have been taken specially for this monograph, so in addition to the major works there may well be some surprises.

This book also includes the latest information on the life of this extremely private person. My main aim is to pass on the image the great Kandinsky specialist Hans Konrad Roethel and I myself formed of the artist during decades of study: the image of someone full of life, of the most extreme sensitivity and intelligence, a radical yet tolerant seeker after the fundamental principles of art. Kandinsky was also considered fascinating and was much liked as a person, which is the reason we were able to concentrate on him for so long. He will be portrayed objectively rather than idealistically and even some of the darker sides of his character will be brought out into the open.

Since nothing in our long experience has given us the least reason to doubt Kandinsky's own words, and also because he is one of those rare artists whose words can be taken seriously, we will let him speak for himself in many cases. We have selected those parts of his writings where he describes his art, himself, and his colleagues succinctly and often humorously. Unpublished letters and poems, translations of his Russian newspaper articles, and other documents that help us understand his innovations and that have not been discussed before take precedence over, for example, classic art-book descriptions of pictures that recount every detail (as if the reader had no eyes of his own). In this book the reader will be provided with a lot of *new material* which will enable him to form his own judgment. Kandinsky's important statement is also to be respected: imagination needs an "empty space," in other words ambiguity should not be reduced by force, pictures should not be overinterpreted, new discoveries should not be tidied away immediately into drawers.

Remarkably, it is artists rather than art historians who turn out to understand him best (although Kandinsky would not have been surprised, since he never thought very highly of art historians). Even artists as different from him as Alfred Kubin and Diego Rivera characterized him with great accuracy. Kubin wrote him in May 1910 (i.e., before the first completely abstract picture): "You have opened up a completely new opportunity for art, moving in the direction of the abstract, and you are currently immersed in it furthest ... Perhaps in years to come people will see in you the beginning of a new era in art."[2] And Rivera said: "I know of nothing more real than the painting of Kandinsky – nor anything more true and nothing more beautiful. A painting by Kandinsky gives no image of earthly life – it is life itself. If one painter deserves the name 'creator,' it is he. He organizes matter as matter was organized, otherwise the Universe would not exist. He opened a window to look inside the Cosmos. Someday Kandinsky will be the best known and best loved of men."[3]

In addition to quoting the artist's own words, we shall also refer to authentic sources from circles close to him, the comments of colleagues and students, and his friend and biographer Will Grohmann. It is high time to do so, because Kandinsky's enormous quantity of theoretical and poetic writings has given rise to the most disparate interpretations. In fact the contradictions that abound in the secondary literature are almost amusing. Is Kandinsky a product of Munich's Jugendstil, or of Theosophy; or did he fall under the spell of Shamanism? Is he a cold, calculating intellectual, for whom theory is paramount but who deceives us with his spontaneous and vivid pictures? Or is he an irrational dreamer, who does not define his ideas clearly enough and who even helped pave the way for National Socialism in Germany with his idealistic philosophy so remote from the real world? Although I have exaggerated to some extent, one thing is certain: Kandinsky cannot be understood easily or without ambiguity.

And the fact that this true cosmopolitan used to write in Russian, German, and French does not make the task any easier.

This book attempts to "free" the artist from the constraints of excessively narrow interpretations, simplistic explanations, and weak hypotheses. It seeks to restore Kandinsky and his work to the realms of reality. But the spiritual aspect of his personality is a reality, too, and we will be putting forward new information on the subject. A better knowledge of his work and of earlier, useful research will help relate Kandinsky to his time and cultural environment. I have tried not to make the text too complicated (given the complexity of the subject-matter) and some non-experts may be surprised to find themselves understanding his art at last. While his widow was alive, it was mainly his "representative, major" works that were reproduced (and they can be found here too), but nowadays we are also interested in sketches and experimental work. I try to trace his innovations back to their very first seeds, because that is the logical place to begin the attempt to understand them. So we place particular emphasis on Kandinsky's less known early period, the Russian connections and the Munich years when he moved toward the abstract and thereby made his most significant contribution to the history of art.

ACKNOWLEDGMENTS

My warmest personal thanks go to my husband, Marcel Fontaine, to whom this book is dedicated, and then to my parents for unforgettable evenings spent deciphering Kandinsky's handwriting.

I offer my first official expression of gratitude with somewhat mixed feelings: at first I answered the initiators of this monograph, the publisher Marc Vokar and Michel Draguet, that it was more important and urgent to publish Kandinsky's writings. But following Nina Kandinsky's death, a vast number of manuscripts had to be archived in Paris, and this delayed the planned collaboration on the edition of his writings. That is what persuaded me to write this book in the meantime. So I now thank Michel Draguet and Marc Vokar (together with Marie-Hélène Agueros, Francisca Garvie, and Marcus Keller). The Gerd Hatje and Dr. Cantz publishers and printers in Stuttgart are responsible for the overall production of the German, English, French, and Italian editions, which is a guarantee of quality.

I owe thanks to the poet and philosopher Michel Henry for the essay he wrote specially for this book. My thanks, and that of future Kandinsky researchers, also goes to Gabriela Freudenthal, the librarian of the Lenbachhaus, Munich, for compiling and "computerizing" a near-complete bibliography, which is now available for all further publications. Henceforth there will be no need to search, select, write, and compose again and the bibliography (or an abbreviated version) can be printed out directly from the diskette.[4]

The first volume of the *catalogue raisonné* of Kandinsky's oil paintings has been "computerized" on the initiative of Marcel Fontaine, and the second volume on Michel Draguet's initiative. This useful instrument is also available to all researchers.

My warm thanks are offered to the following friends for their help: Maren Altenbach, Patrick Carnegy, Marie-Luce Collart, Annette Evrard, Werner and Noriko Hahl, Manfred Hahl, Alexei Kandinsky, Michel van der Kelen, Vincent Mariani, Astrid Neumann, Nadine Noel, Ingrid Radischat, Julie and Ljubomir Radoyce, Mary Rollins and Brigitta Schierle.

Marc Vokar and I are indebted to the "Societé Kandinsky" and its late administrator Karl Flinker for their assistance. Among my colleagues, I want to thank Vivian Barnett for the archive photos, which enabled us to print the best possible quality black and white reproductions of lost pictures here. I offer warm thanks to my colleagues Natalia Avtonomova, Jelena Basner, Stephanie Barron, Bulat Galeyev, Hideho Nishida, Eberhard Steneberg, Peter Vergo, and Patrizia Veroli, and I would like to thank *all* Kandinsky researchers for understanding that occasional criticism can also serve the common cause. I, too, ask for criticism and corrections: it is through such polemics that we see that Kandinsky's legacy is still very much alive.

I am especially grateful for the permission to print and quote from Kandinsky's unpublished letters, thanks mainly to Maria Jawlensky, Locarno; the Gabriele Münter- und Johannes Eichner-Stiftung, Munich; the Russian Museum, St. Petersburg; Hella Hammid, Los Angeles (and after her death her successor Peg Weiss); the Norton Simon Museum in Pasadena; and the Archives of the Getty Center for the History of Art and the Humanities, Los Angeles. I am most grateful to Ilse Holzinger for her valuable assistance and I want to thank the Director of the Städtische Galerie im Lenbachhaus, Munich, Helmut Friedel, and Annegret Hoberg, Rudolf Wackernagel, and Simone Gänsheimer. The Galerie Maeght in Paris, Galerie Beyeler in Basel, the Leonard Hutton Galleries in New York, Galerie Thomas and Galerie Gunzenhauser in Munich, and Galerie Gmurzynska in Cologne also deserve thanks for their generous assistance, as do Christoph Vitali and his colleagues in the Schirn Kunsthalle in Frankfurt and all the collectors, museums, and galleries that placed their pictorial material at our disposal.

Our collaboration, which on the whole was both fruitful and necessary in the circumstances (for instance when interrelated manuscripts were despersed between Munich, Moscow, Paris, and Los Angeles), had one side-effect: the founding of the international circle "Friends of Kandinsky". It proposes to organize exchanges of information and material, lectures, conferences, and joint research projects, and to publish the findings in *Kandinsky-Forum*. In addition to art historians, the circle warmly invites artists, collectors, galleries, and all art-lovers to take part.

Jelena Hahl-Koch

I.

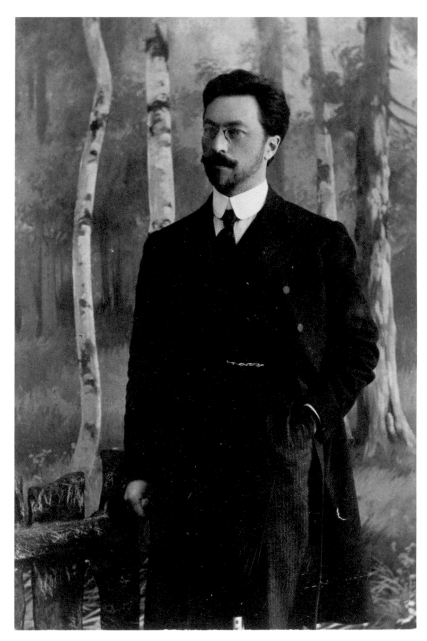

1 *Kandinsky in Odessa, ca 1901*
Gabriele Münter- und Johannes Eichner-Stiftung, Munich

I RUSSIA

CHAPTER ONE
RUSSIAN ART TOWARD THE END OF THE
NINETEENTH CENTURY

To form a picture of Vasily Kandinsky's native Russia in the second half of the nineteenth century, one needs to recall certain historical facts. The artist, for example, was born only five years after the abolition of serfdom. The topic of the first published paper he wrote as a law student was corporal punishment in Moscow province, and this was in 1889! The main reason he gives for what was then a still widely used form of punishment was the extreme poverty of the Russian peasantry: fining offenders who were destitute would have made no sense, and jailing them would have deprived them of the means to earn a living.[1] During a study trip to the northern part of Moscow province, Kandinsky observed that, despite emancipation, the rural population still suffered from extreme poverty. The former serfs had gained rights and dignity, but did not have the concrete means to take advantage of their newly acquired freedom. Thus what characterized the Russia of Kandinsky's childhood and youth was chiefly its "backwardness."

The intelligentsia, the class which supported culture and included not only intellectuals but also merchants, government employees, and families connected with the church (the Orthodox faith requires all but its highest-ranking clergy to be married), wanted to end Russia's widespread illiteracy and sought to act against injustice and inequality before the law. It developed a degree of social commitment unparalleled in any other land: women and men "joined the people" as doctors, teachers, priests. The lack of social institutions left a lot of room for private initiative. Wealthy families vied with each other to found schools, orphanages, hospitals, museums. Patrons of the arts and collectors such as Morozov and Shchukin covered the walls of their villas and townhouses with works by such artists as Matisse, Picasso, Van Gogh, and Gauguin – masterpieces which are now the wealth of St. Petersburg's Hermitage and Moscow's Pushkin Museum (ill. 2). In a letter to his biographer Will Grohmann, Kandinsky recalls that those "strange Muscovite merchants were not only lovingly dedicated to Russian civilization but also to culture." In Moscow, he remembers, "I knew a lady of Siberian origin who moved from her palace to a furnished room after donating everything she owned to cultural institutions."[2] There were idealists in both political camps, the pro-Westerners and the Slavophiles. Each side dedicated itself to serving Russia in its own way; each strove to bring about better living and working conditions; each militated for a more equitable government; each gave priority to the task of alleviating the wretched conditions of the rural population and to combating illiteracy, ignorance, and superstition.

This explains why, as a young man, Kandinsky wrestled with his conscience and hesitated to become an

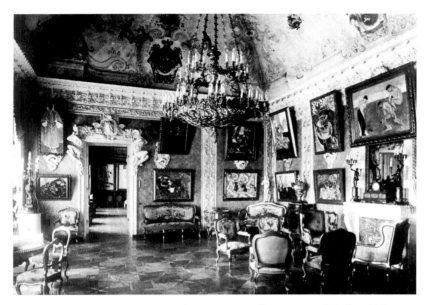

2 *Drawing-room of Moscow Art Collector Sergei Shchukin, 1912*
State Tretiakov Gallery, Moscow
"*Thirty paintings by Matisse are hung in his large drawing-room,*
together with eighteenth-century furniture! And it looks
wonderful." *(Letter to Gabriele Münter, November 9, 1912)*

artist: there seemed far more urgent and useful tasks to be done in Russia. Will Grohmann assumes that his qualms sprang from the fact that an artistic profession was not in his family's tradition (for more about the artistic inclinations of the Kandinsky family, see page 20).[3] Kandinsky himself says: "I longed to be a painter until my thirtieth year, for I loved painting more than anything else, and it was not easy to fight this longing. It seemed to me then that, for a Russian, art was an uncalled-for luxury. That is why I chose the national economy as my field of study at the university."[4] Though he enjoyed studying law and economics, his interest in them began to wane after his first exposure to the arts. Only art had the power to transport him beyond time and space, he recalls in his short memoir,

> Never had scientific work given me such experiences, inner tension, creative moments.
> I was not, however, confident enough to consider myself entitled to renounce my other responsibilities and lead, as it seemed to me then, the boundlessly happy life of an artist. Apart from which, life in Russia was at that time especially bleak, my scientific work was highly thought of, and I decided to become a scientist.[5]

Fortunately he later changed his mind.

Kandinsky's intellectual and artistic growth were so profoundly marked by his rejection of any kind of materialism and utilitarianism and so strongly inclined toward the spiritual that one cannot help wondering to what extent he was reacting to the materialistic and positivistic outlook of the Russian "Enlightenment." After all, he lived in Russia until he was 30; he studied, got married and began his

career there. In all respects except artistically, his personality was shaped there. His vehement criticism of realistic and didactic painting should be viewed in the context of Russia's intellectual history, as should his repeated references to the dichotomy between the material and the spiritual, the outward and the inner, form and content, which run through his writings like a leitmotif. His move toward abstraction may also have been motivated by his aversion for the materialistic view of the world. A number of scholars, notably John Bowlt, have remarked how in his writings Kandinsky distances himself from materialism. But, more than the contents of materialism, it was the ubiquity and lack of sophistication of this ideology from the 1860s through the 1890s that provoked, and indeed justified, Kandinsky's rejection of it. It is worth pausing to take a closer look at the historical situation.

According to Dmitrij Tschižewskij, who has written a useful account of the one-sided, radical, and primitive nature of Russian positivist materialism,[6] the foundations of the spiritual style of the 1860s were laid during the despotic reign of Czar Nicholas I (1825–1855). Nicholas was brought up as a soldier and had no spiritual inclinations whatsoever. Unprepared for the task of ruling his country, he tended to govern Russia the way he had run his regiment: his reign was marked by blind obedience, executions, persecutions of intellectuals, conservative inertia, and police surveillance extending to the most personal areas of private life. Nevertheless, enacting much-needed legal reforms, he passed a series of laws in 1833 which range from the sublimely obvious ("All men must live together in unity, peace, and virtuous love") to the ridiculous ("Persons of the male sex older than seven may not enter women's baths when that sex is bathing there").

After the revolution of 1848 in France, which ended the July monarchy, Nicholas lived in permanent fear of subversive activities. In 1848, Dostoevsky was sentenced to death (the court's decision was later commuted to a stretch of hard labor in Siberia) for belonging to a circle which discussed, among other things, the theories of the French philosopher Charles Fourier. In 1850, Nicholas passed a decree forbidding the teaching of philosophy at Russian universities, declaring that "its usefulness has not been proved and it may even be harmful." Every human being, every action, every idea was judged with regard to its usefulness to the czar and the state.

This extreme utilitarianism continued to predominate throughout the "sixties," the period of the belated but radical Russian Enlightenment which, more precisely, lasted from 1855 to 1885, though its emphasis shifted to a concern for the masses. "In one of the earliest examples of the Russians' tendency to exaggerate the elements of Western culture which they borrowed," writes Tschižewskij, "it was commonly held – not without a strong admixture of Western European materialism and positivism – that matter was a basic state of existence whose role was to serve as a stepping stone to a higher state."

Whatever seemed difficult to grasp or to deduce from observable facts was rejected out of hand, and sometimes even its very existence was denied. The influential critic D. I. Pisarev condemned Pasteur on the grounds that "his discoveries [in the field of bacteriology] contradicted the materialistic belief that life was born from inert matter. Another writer, V. Zaicev, upheld racial inequality 'from a materialistic viewpoint' and defended slavery (provided that the slaves were black and not Russian serfs)." To Tschižewskij the Russian Enlightenment was distinguished by its extreme primitiveness and by the poverty of its spiritual content; it was characterized, he says, by such maxims as "a pair of boots is more useful than Shakespeare" and "a real apple is more beautiful than a painted one."[7]

Even Tolstoy in his essay "What Is Art?," written just before the turn of the century, remarks that one expects art first of all to be intelligible. Kandinsky says that he preferred Schumann's definition of the painter as someone whose role is to "send light into the depth of the human heart" to Tolstoy's artist as "someone who can draw and paint everything."[8] The views expressed by Tolstoy, Pisarev, Zaicev, and in particular Nikolai Chernyshevsky may have been popular because, in a time of great social need, they seemed simple and self-evident. It is easier to justify teaching the masses, healing the sick, and painting didactic pictures than creating a "pure art" whose significance to the population at large and perhaps even to humanity may only emerge in the future and even then may never be universally accepted.

Let us now look at the 1860s through the eyes of Kandinsky's generation. The politically active Symbolist writer Georgi Chulkov explains that,

> Even before the end of the 1840s, Russia's intelligentsia [...] was already so deeply immersed in one or the other political currents that it altogether lost the faculty to see the arts as independent pursuits. Fiction, philosophy, painting – everything was viewed and judged from the standpoint of social utility. Yet the way "utility" was understood verged on the scurrilous and the naive.[9]

The Symbolist poet and theorist Valeri Briusov speaks of the "deadly influence of materialism, positivism, and naturalism" and of the "great stagnation of ideas" in the second half of the nineteenth century.[10] The poet and theorist L. Ellis looked forward to "a great era and new culture" which would be "in every way opposed to our contemporary materialistic and positivistic-utilitarian culture."[11] Dmitri Merezhkovsky, in his important essay of 1892 introducing Russian Symbolism, describes the "sixties" as follows: because of the "specificity of the Russian national temperament," this period was marked by a utilitarian, positivistic sobriety and a busy, practical matter-of-factness. Beauty and poetry were set aside; it was

fashionable to express disdain for religion and Christian morality. "Basically the entire fin-de-siècle generation harbors in its soul the same indignation at the stifling, stultifying influence of positivism."[12]

Such was Kandinsky's generation. It is not surprising then that the artist's writings express almost exactly the same sentiments as those voiced by the Russian Symbolists. In the introduction to his main theoretical work, *On the Spiritual in Art and Painting in Particular*, he writes:

> Our souls, which are only now beginning to awaken after the long reign of materialism, harbor seeds of desperation, unbelief, lack of purpose. The whole nightmare of the materialistic attitude, which has turned the life of the universe into an evil, purposeless game, is not yet over.[13]

This repeats almost word for word a passage in an early article by Valeri Briusov which appeared in 1901 in *Mir iskusstva* (The World of Art), in which Kandinsky published his "Letters from Munich" that same year. Briusov argues that the natural sciences were never a threat to literary fiction, whose "magic crystal" is far too resistant to be affected by the positivism of the second half of the nineteenth century. Is there anyone, he asks, who can still be seduced by the "childish theories" which reduce nature to the dance of meaningless atoms and the mystery of the universe to brain functions? He goes on to quote the great Symbolist precursor, the philosopher Vladimir Soloviev, who had foreseen the demise of theoretical materialism, declaring that it was merely a childish stage of philosophy and would soon pass.[14] Kandinsky returns to this subject in Chapter Two of *On the Spiritual in Art:*

> At such blind, dumb times men place exclusive value upon outward success, concern themselves with material goods, and hail technical progress, which serves and can only serve the body, as a great achievement. Purely spiritual values are at best underestimated, or go generally unnoticed.[15]

And, again, in Chapter Three:

> Scientifically these people are positivists, recognizing only what can be weighed and measured. They regard anything else as potentially harmful nonsense, the same nonsense they yesterday called today's "proven" theories. In art they are naturalists...[16]

Marianne Werefkin, his compatriot and fellow-painter during the Munich years, expresses these views even more sharply:

> The child loves, the genius creates, both have faith. The others are all mired in materialism, scepticism, the mendacious and obtuse worldly intelligence which

holds that the truth can be grasped, that that which is desirable is what the eye absorbs, the hand grasps, the stomach digests, and reason analyses. And since they are determined to be clear-sighted and penetrating, they don't discern life's true beauties which a loving heart, a firm belief, and a tremendous genius are capable of intuiting without being the poorer for it.[17]

Kandinsky commences his essay "Whither the 'New' Art" with the famous remark by the German pathologist Rudolf Virchow: "I have opened up thousands of corpses, but I never managed to see a soul." These glib and superficial words, says Kandinsky, are typical of the era of deified matter, when only the physical, the materially visible, was recognized. "The soul has been abolished as a matter of course. The heavens have been devastated."[18]

What kind of painting (except, of course, naturalist art, as Kandinsky says), can survive in times like those when a leading ideologist like D. I. Pisarev could declare: "To gaze at a marble column is an altogether stupid, useless, and unrewarding occupation ..."[19] The socially useful art of the "Wandering" artists (peredvizhniki) was born in complete contrast to this attitude toward art and aesthetics. As early as the 1870s their declared aim – to bring art to the people, to organize exhibitions in the provinces, and to choose subjects that were related to daily experience – gave significance to their movement as the basis of a truly autonomous Russian art. But it is true too that, in keeping with the materialist-positivist ideas of the sixties, the "Wanderers" wanted to educate and improve the masses by means of easily understandable, realistic representations. It was this predominantly social, extra-artistic aspect of their commitment that gained acceptance for their art in an era when the aesthetic was deemed "useless." The rehabilitation of this realist current by Soviet critics is gaining increasing acceptance in the West, but the fact remains that the art of the "Wanderers" does not stand up to comparison with that of their contemporaries in Western Europe. This is one of the reasons why Kandinsky, like countless other Russian artists before and after him, left his country to study painting in the West.

Typically, the 1860s witnessed a "rebellion" at the St. Petersburg Academy (founded in 1757; the only one in Russia till the twentieth century) against imported French and German art and against the classical teaching that seemed utterly removed from real life. In 1863, fourteen academy examination candidates, led by Ivan Kramskoy, rejected the subject assigned to them – a traditional theme of Scandinavian mythology – and withdrew their work in protest. So grave was this incident considered that the press was ordered not to report it. This was in fact the beginning of that vital alternative to academic orthodoxy, the first "Secession." Influenced by Nikolai Chernyshevsky, an ideologist who drew on the ideas of Fourier and Feuerbach, the author of the much acclaimed novel *What Is to Be Done?* they founded a popular socialist study group. The wealthy

industrialist Pavel Tretiakov (remembered for the museum he endowed in Moscow) became their patron. It was with his support that, in 1870, they established the "Society of Wandering Exhibitions," which gained increasingly widespread acceptance and even ended up influencing the St. Petersburg Academy, notably in the field of genre painting. Yet even the narrow realism of the "Wanderers" was a belated response to Western imports. Russia had not experienced the manifold, conflicting intellectual currents of the West where in the field of philosophy positivism, and in the field of art realism, followed romanticism, and its art consequently tended to be radical, absolutist, socially and politically engaged; as a rule it was less responsive than Western art to purely artistic demands. The message and moral content of a painting were considered more important than its strictly artistic merits. Chernyshevsky's program, formulated in his 1855 treatise *The Aesthetic Relations of Art to Reality*, was thus completely realized: "Let the arts content themselves with their elevated and admirable task: to compensate somehow for a lack of reality and to provide mankind with a guide to life."[20]

Very different were the views held by Kandinsky:

Art, which at such times leads a degraded life, is used exclusively for material ends. It seeks in hard material the stuff of which it is made, for it knows no finer. Thus, objects whose portrayal it regards as its only purpose, remain the same, unchanged. The question

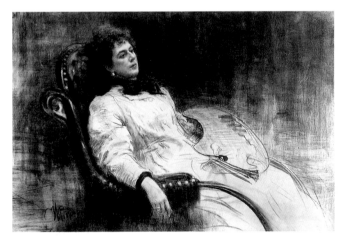

3 *Ilya Repin,* Portrait of Maria Tenisheva, *ca 1885*
Charcoal
State Tretiakov Gallery, Moscow

"What?" in art disappears *eo ipso.* Only the question "How?" – How will the artist succeed in recapturing the same material object? – remains. This question becomes the artist's "credo." Art is without a soul.[21]

The "Wanderers" claimed to depict life as it is apprehended in daily experience. But later generations saw in their paintings only those aspects of life that had been avoided by academism. The work of many "Wanderers" is weakened by a tendency to overstate the subject and by an excessive,

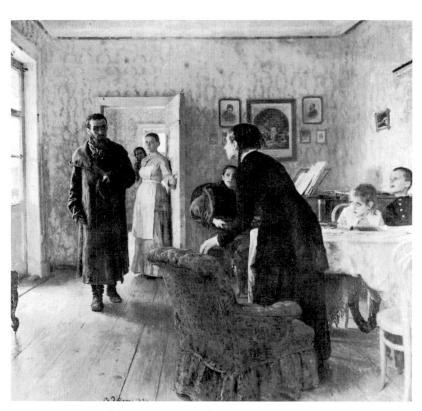

4 *Ilya Repin*, Unexpected, *1884*
Oil on canvas, 63 x 65 ¾ in
State Tretiakov Gallery, Moscow

almost caricatural effect. This is the case notably with the pictures of their leading exponent, Ilya Repin (1844–1930). Repin, who played an important role in Kandinsky's life, was also the master of his companions Alexei von Jawlensky and Marianne Werefkin. In *Reminiscences*, Kandinsky recalls the years before 1896 (in more detail in the Russian than in the German edition):

> Previously I had known only realistic art, in fact only the Russians. As a child I was already deeply impressed with Repin's *Ne zhdali (Unexpected*, ill. 4), and as a young man had often remained standing for a long time before the hand of Franz Liszt in the portrait by Repin...(ill. 5).[22]

Repin's famous painting, *Unexpected*, which the artist himself thought highly of, now hangs in Moscow's Tretiakov Gallery. It depicts the dramatically unexpected homecoming of a young revolutionary, presumably after long years of Siberian exile. The artist, as was his custom, first made numerous studies of the figures in the painting, so as to be able convincingly and effectively to portray their individual reactions to the event depicted. The portrait of Liszt, now at the Moscow Conservatory, is less well known. Repin painted it in 1886, shortly before the composer died. The aged musician's visionary, deeply expressive head and strongly veined left hand opening a small volume seem to be illuminated by a spotlight and stand out strikingly in the otherwise dark painting.

Yet, as early as 1901 Kandinsky criticized Repin in a letter to his friend Dmitri Kardovsky. "Yes, I also saw Repin in Odessa, during last year's Wandering Exhibition. Hastily and poorly executed. The charcoal portrait of Tenisheva in particular is poorly drawn, somewhat unnatural" (ill. 3).[23] Jawlensky and Werefkin had already turned their backs on Repin in 1896 and had left Russia to study art in Munich.

Kandinsky, in his first article concerning art, the "Critique of Critics" published in 1901 (see *Documents*, pp. 47 f.), is strongly critical of Russian art in general, which he again attacks, even more harshly, in an essay from 1911. (He published only a few essays between 1901 and 1911.) Its violent tone, which is atypical of the even-tempered artist, suggests the depth of his alienation from the prevailing artistic climate in Russia.

> At such dark moments nobody needs art. All people need is its auxiliary role, its service as a lackey. Artists, themselves permeated through and through by materialism, forget their vocation and slavishly ask the public, "What can I do for you?" Serving sacred art becomes a gesture of amusement. "I've ordered a portrait, so get on with it – what do I care about your 'painting'?" says the complacent client to the meritorious artist. "Give me a bit of nature in a landscape," says the all-powerful customer. "Make the bush like a real one! What do I care about your painting!" And the artist does his best to give gratification. From being a prophet and a leader, he turns into a parrot and a slave. Ladies fainted and men felt sick in front of Repin's picture *Ivan the Terrible and his*

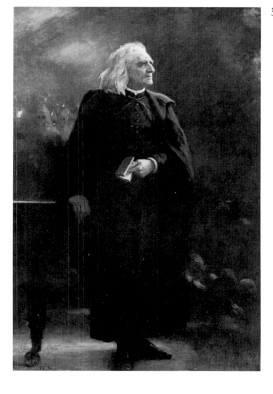

5 *Ilya Repin,*
Portrait of Franz Liszt,
1886
Oil on canvas,
State Conservatory,
Moscow

Son (ill. 6) – the blood flowing and clotting in lumps was so well done, so realistic. "What do I care about painting?" – it was as if Repin himself was speaking – "I want the bloood to flow, I want the smell of bloood."[24]

Kandinsky is hardly exaggerating. Repin himself once said: "My first rule in painting is: matter as such. I am not concerned with color, the layering of colors or virtuoso brushwork. I have always striven for the essential, the body as body."[25]

Kandinsky's remarks, written in 1911, express his frustration as a young artist in Russia, his sense of a spiritual claustrophobia which was strong enough to drive him from his homeland. In *On the Spiritual in Art*, which he worked on between 1904 and 1911, he refers to "the oppressive discomfort of the materialist philosophy,"[26] and more than once he opposes the materialist-positivist present to a more spiritual future. But here, as in later writings such as "On the Question of Form" (1912) and *Reminiscences* (1913), he expresses himself more temperately. Thus, in a matter of a few years, he acquired the tolerance and equanimity that were to remain the hallmarks of his character.

Repin continued to paint well into the twentieth century and the Society of Wandering Exhibitions actually survived up until 1922. But as early as the 1880s, after it had become clear that the champions of "Enlightenment" had failed to solve Russia's pressing social and political problems, a number of critically-minded young people had begun to turn away from the predominant positivist ethos. Concurrently with the already well-established "Wandering" movement, increasing numbers of painters devoted themselves exclusively to landscapes, a genre relatively free of social philosophy and moral commitment. Isaac Levitan (1860–1900) was, with his melancholy pictures, the most representative of these artists. He was acquainted with Anton Chekhov, whose plays share the brooding quality of Levitan's pictures. Kandinsky remarks that

> More refined painting was merely "mood," the incantation of melancholy and inconsolable grief. It was precisely this kind of painting (like great Russian literature) that reflected the despair before the locked doors. Both in Chekhov's works and in Levitan's landscapes a perpetual atmosphere of terror existed and was conveyed by them as a cold, clammy, slippery, stifling fog. In works such as these art fulfills only half its mission.[27]

Such resignation and lack of moral purpose were characteristic of the 1880s and were chiefly due to the repressive climate ushered in by the powerful reactionary politician Constantine Pobedonostsev, whose name is often associated with this period. Pobedonostsev, one of the czar's councillors and the chief representative of the Holy Synod,

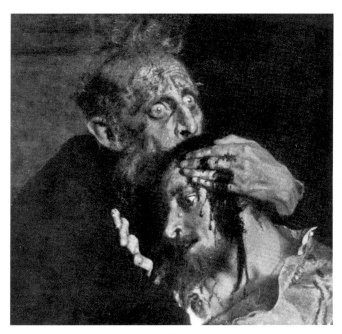

6 *Ilya Repin*, Ivan the Terrible and His Son, *1885*
Oil on canvas, 77 x 99 in (Detail)
State Tretiakov Gallery, Moscow

believed that culture was unnecessary and that it posed a threat to the authority of Church and State. At his instigation intellectuals were again subjected to police surveillance and censorship.[28] In his account of the political activities during his student years, Kandinsky recalls:

> It was the time of the creation of a pan-student organization that was to embrace the student body not simply of one university, but of all the Russian and [as its ultimate goal] Western European universities as well. The students' struggle against the cunning and undisguised universities bill of 1885 was still going on. "Disturbances," assaults on the old Muscovite traditions of freedom, the abolition by the authorities of organizations already established, our new societies, the subterranean rumblings of political movements...[29]

Alexander II had not only abolished serfdom and instituted legal reforms, but, in a gesture of unprecedented liberalism, in 1863 granted Russia's universities an independent status. Notwithstanding, terrorist activity increased, climaxing in the czar's assassination in 1881. As a result, Alexander III issued in 1884 (and not in 1885 as Kandinsky recalls) new university regulations inspired by Pobedonostsev's distrust of intellectuals. Student clubs were outlawed and "suspicious persons" both inside and outside the universities were placed under surveillance. These measures provoked widespread unrest among students in 1887 and again in 1890, particularly at the University of Moscow, where Kandinsky was then studying law.

DOCUMENT

A number of surprising facts concerning the Siberian origins of Kandinsky's family have recently come to light. In the course of extensive research on the Decembrists exiled in Siberia, the Buriat journalist Vladimir Baraev came across several references to Kandinskys who generously gave hospitality to some of these political outcasts.* He also unearthed some rather startling things about the genealogy of the widespread Kandinsky clan. So far nothing suggests that the artist was even aware of them – the family's origins were sufficiently disreputable to be kept a secret.

The first ancestor on record, Alexei Kandinsky, lived by the river Konda in the Tabolsk district, in the early eighteenth century. His son Peter (1735–1796) was jailed in 1752 in Yakutsk for robbing a church, and Peter's son, Chrisanf (1774–185?), was a notorious highwayman who was sentenced to hard labor in Nerchinsk. A portrait of Chrisanf (ill. 8), painted when he was already well on in years, does indeed suggest a rather adventurous youth. Baraev sees both Buriat and Tunguz blood in the sitter's features, and explains this by the fact that Russia's "Wild East" was colonized peacefully and the Russians who often married native Asiatic women.

Yakutsk is mentioned only in connection with the first Kandinskys on record. The family's roots lay, as the artist himself says, in Nerchinsk and Kyakhta. There is documentary evidence that banished Decembrists on their way to exile stayed with one of Chrisanf's brothers or sons. Chrisanf had five brothers and a sister, eight children and eighteen grandchildren. The clan ended up controlling the fur trade around Lake Baikal, and prospered. Trade meetings in a Kandinsky manor are mentioned in the travel diaries of the writer M. Bestuzhev, who says that on one occasion he and the other guests spent an entire week playing chess and listening to music before getting down to business.

Kandinsky's cousin M. I. Vodovozova was the first Marxist publisher and editor of Lenin's works. Viktor Chrisanofovich Kandinsky (1849–1889) was the founder of Russian psychiatry. He is remembered for his research into hallucinations and pseudo-hallucinatory phenomena. He wrote a distinguished philosophical treatise on "empirio-criticism" – from a positivist standpoint, of course. The family also included a singer and two painters. It was connected with the Tokmakov, Sabashnikov, and Shemiakin families (Anna Shemiakina was Vasily Kandinsky's first wife), as well as with the Lushnikovs and Mamontovs (who became rich and famous thanks to the construction of the Trans-Siberian railroad).

The first Kandinsky to leave Siberia and move to Moscow was the artist's uncle Nikolai, followed by his father, the "Honorable Merchant of the First Guild"

Vasily Silvestrovich (1832–1926). A contemporary document tells us that the latter met the radical socialist leader Alexander Herzen in London in 1862. His son Vasily surely knew about this meeting, but mentions it nowhere in his writings. The little we know regarding Kandinsky's ancestors and university friends (the sociologist Sergei Bulgakov, for example, a Marxist in his youth) suggests strongly that during his student years the artist was at least close to Marxist circles.

* Vladimir Baraev, *Drevo, Dekabristy i semeistvo Kandinskikh* (Family Tree. The Decembrists and the Kandinsky Family), Moscow, 1991.

7 *Kandinsky's Relatives
in Kyakhta,
Siberia, ca 1890
Courtesy V. Baraev, Moscow*

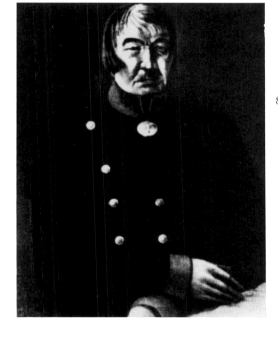

8 *Unknown Artist,*
Chrisanf Petrovich Kandinsky,
*ca 1850
Oil on canvas,
Courtesy V. Baraev, Moscow*

CHAPTER TWO
A CULTIVATED FAMILY:
KANDINSKY'S CHILDHOOD

"My father comes from Eastern Siberia, to which his forbears were exiled...for political reasons." This laconic statement in *Reminiscences* is all that Kandinsky has to say about his paternal origins. The Russian edition of his memoir gives the town of Nerchinsk as his father's birthplace.[30] Vasily senior was evidently one of the many Siberian exiles who were granted permission to return to Russia under the reign of Czar Alexander II. Unfortunately, we know practically nothing about why his ancestors were banished.[31] There is an oral tradition that Kandinsky's great-grandmother on his father's side was a Mongolian princess.[32] Such family legends are seldom pure invention, and, as Kandinsky's nephew Alexei once observed, there is indeed something Mongolian (or rather Buriat) about the features of the artist and other members of his family.[33]

Kandinsky's maternal grandmother was of Baltic origin. She spoke German with her grandson and recited German fairy tales to him. French too was spoken in the Kandinsky household, as was the case generally among cultivated middle- and upper-class families in pre-Revolutionary Russia.

A questionnaire sent to members of the Beethoven Society in February 1914, requesting information about their family's artistic inclinations, turned up in 1984 among the papers in the estate of the artist's widow, Nina.[34] Kandinsky states that his mother played the piano, his father the sitar. He adds that his father drew, was a frequent exhibition-goer and was something of an art collector. He had uncles both on his father's and his mother's side who were gifted painters.

In the Russian edition of *Reminiscences*, Kandinsky makes frequent reference to his father. He tells us, for example, that as a young man Vasily senior was a prolific draftsman.

> I still remember the fine, delicate, and expressive lines which seemed perfectly suited to his delicate body structure and amazingly beautiful hands. One of his favorite pastimes had always been to go to exhibitions. He would look at the paintings attentively and at great length. He never condemned pictures that baffled him, but tried to understand them and questioned anyone who might explain them to him.[35]

The younger Vasily goes on to say that his father

> was educated in Moscow, and had come to love this town as much as his birthplace. His profoundly human and affectionate spirit understood the "Moscow soul," and he knew the external visage of Moscow equally well. It is always a pleasure for me to hear

him, for example, listing in reverential tones the innumerable churches, with their wonderful names. Without a doubt, that is the echo of an artistic spirit.[36]

He remarks in a footnote that his father never attempted to discourage him from trying to realize his dreams:

> When I was ten years old, he tried to educate me into choosing between grammar school and secondary school: by explaining the differences between these two schools, he helped me, to the best of his ability, to make the choice for myself. With great generosity, he supported me financially for many long years. At the turning points in my life he would talk to me like an older friend, and in important matters never exerted a trace of pressure on me. His principles of upbringing were complete trust and a friendly relationship with me.[37]

Such are Kandinsky's memories of his father in *Reminiscences*. They are entirely affectionate throughout. Nina Kandinsky states that she never heard her husband speak a disparaging word about his father, not even in his later years, and that he had an unreserved admiration for the older man's courage and faith in reason and life.[38] Rather than speculate about whether Kandinsky's father was a hypochondriac who lacked his wife's vitality and whether this may have been the reason why their marriage broke up – there is a good deal of such theorizing in Kandinsky criticism – I offer the reader a sample of Vasily senior's handwriting. The comparison with the artist's script is revealing. Even without knowing Russian one cannot help being struck by the difference between the two (which contrast markedly in their very different ways with that of Kandinsky's mother, a representative example of the conventional script taught in Russian schools at the end of the nineteenth century; see ills. 11, 12, 13).

I know of only one document in which Kandinsky voices any criticism of his father, an early letter to his companion Gabriele Münter. However he does not dwell on details or explanations, and immediately adds: "I myself don't quite know what I truly feel and what comes from my imagination. Sometimes I would like to be all alone in this world, alienated from the whole world, perhaps at odds with it. And not have a soul who wishes me well. Banish me from society! Absolute solitude!"[39] Other examples of such extreme reactions will be given in the course of this book. Evidently Kandinsky never rebelled against his father, a fact that some critics seem to hold against him.[40] However, the elder Vasily was evidently not an authoritarian figure; he was friendly and generous, according to his son, who makes a point of insisting on his graceful good looks and artistic soul. In other words, he was simply not the kind of father it is necessary to rebel against. So instead of defying the authority of his father, he broke with his father's generation.

Kandinsky's feelings about his mother, Lidia Tikheeva, were even more enthusiastic. Linking her with his native Moscow, he observes:

My mother is a Muscovite by birth, and combines qualities that for me are the embodiment of Moscow: external, striking, serious, and severe beauty through and through, well-bred simplicity, inexhaustible energy, and a unique fusion of [a sense of] tradition and genuine freedom of thought, in which pronounced nervousness, impressive, majestic tranquility, and heroic self-control are interwoven. In short: the human incarnation of "white-stone," "golden-crowned" "Mother Moscow."[41]

Vasily junior was born in Moscow on 4 or 5 December 1866. (His birthday was celebrated on the 5th up until 1918, when the old Russian Julian calendar was replaced by the Gregorian calendar.) He was an only child.[42] His family was prosperous and well-educated, and as a result he must have started life under the best possible conditions. Until at least his fifth year – when his parents divorced – he evidently enjoyed the full measure of love and security that

was to form the basis of his trusting and optimistic view of life as a mature artist.

Vasily senior's health seems to have been poor and in 1871 the family moved to the milder climate of Odessa, on the Black Sea, where he was offered the directorship of a tea trading company. Shortly thereafter he and his wife divorced. Lidia Tikheeva soon remarried and eventually had four children – a girl and three boys – with her second husband. In later years she wrote that her first son Vasily was like an "angel" with his half-siblings. This sounds like a fond mother's way of putting a gloss on a potentially difficult situation, but from all the documentary evidence we possess, especially the hundreds of letters the artist wrote to Gabriele Münter, it is clear that Kandinsky loved his younger siblings. Remarkably, he never once refers to them as half-brothers and -sister.

Since little is known about Kandinsky's relationship with his family, a relationship which undoubtedly played a decisive role in his development as an artist, one naturally would like to have more glimpses of it. Thus it is interesting to note that his visits to his family were always more extended than planned, and that in almost every one of his letters to Gabriele Münter he speaks warmly of his numer-

9 *Kandinsky's Father, ca 1886*
 Gabriele Münter- und Johannes Eichner-Stiftung, Munich

10 *Kandinsky's Mother, ca 1886*
 Gabriele Münter- und Johannes Eichner-Stiftung, Munich

11 *Page Written by Kandinsky's Father, 1911*
 Gabriele Münter- und Johannes Eichner-Stiftung, Munich

12 *Page Written by Kandinsky's Mother, 1913*
 Gabriele Münter- und Johannes Eichner-Stiftung, Munich

13 *Manuscript Page of* On the Spiritual in Art,
 Murnau/Moscow 1910
 Gabriele Münter- und Johannes Eichner-Stiftung, Munich

ous Russian relatives. Here is just one example: "My heart feels good and warm here and is resting from all its struggles."[43] One does not expect to see a somewhat unsociable artist describe the intimacy of family life in such glowing terms. The Kandinskys were constantly sitting together talking, like the characters in Chekhov's plays, having tea with the artist's sister-in-law and dining in gatherings which included his father and stepfather, his siblings and their children – Kandinsky was always very fond of children – as well as assorted relatives and friends.

During his visit to Odessa in 1903, Kandinsky wrote to Gabriele Münter that his father, mother, and three half-brothers (though not his half-sister, who had just given birth to her second child) had come to greet him at the station.[44] Not long after this, one of his half-brothers died of tuberculosis, and in 1905 the eldest was killed in the Russo-Japanese war. In 1906 Lidia Tikheeva wrote a troubled, sorrowful letter about the physical and moral state of health of her youngest son – who was also Kandinsky's godson. She had asked Vasily to keep an eye on him in Paris, hoping that his influence would be beneficial. But evidently the boy did not contact his elder brother and seemed to have more interesting things to do than visit him.[45] This problem child later became a well-known psychiatrist, Alexei Kozhevnikov. Kandinsky's eldest half-brother's son, who was to call himself Alexander Kojève, studied philosophy in Heidelberg and became a Hegel scholar. He was interested in Kandinsky's painting and eventually wrote about it.[46]

After his parents' divorce, Kandinsky lived with his father. His mother seems to have visited him daily and her sister, Elizaveta Tikheeva, took care of him.[47] (It is to the latter that *On the Spiritual in Art* is dedicated.) In a footnote in *Reminiscences* (the Russian version) he recalls this truly exceptional woman as follows:

> My mother's eldest sister, Elizaveta Ivanovna Tikheeva, had a great and ineradicable influence over my entire development. No one who had any contact with her during her deeply altruistic life can forget her radiant nature. To her I owe the awakening of my love for music, fairy tales and, later, Russian literature and the deeply spiritual nature of the Russian people.[48]

In 1989 a new source of information came to light in a series of letters Kandinsky wrote to his friend Dmitri Kardovsky. Kardovsky studied at Anton Ažbè's atelier in Munich and returned to Russia in 1900. Kandinsky wrote to him on March 13, 1901: "You ask why I'm not well? My uncle, whom I was deeply fond of, has died and I am very sad. My nerves have suffered. All is emptiness and ugliness. My uncle left me an inheritance which is sufficient for me to live on."[49] Thus, in addition to the financial help he received from his father for several years, Kandinsky also seems to have gotten some income from this bequest. But what strikes one about these lines is the deep grief Kan-

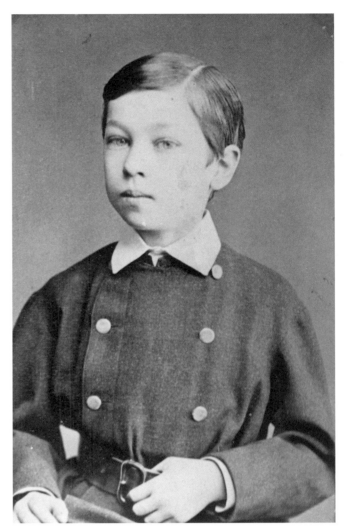

14 *Kandinsky (aged nine)*
 Gabriele Münter- und Johannes Eichner-Stiftung, Munich

dinsky expressed at the death of this uncle who – unlike his aunt Elizaveta Tikheeva – is mentioned nowhere in his writings.

The Kandinsky family ties seem to have been strong and affectionate. The family nicknames are an amusing indication of this. In her letters to her son Vasily, the artist's mother calls him Vasyutochka instead of the usual diminutive Vasya. Such nicknames are of course quite common in Russia, but their appearance in the family correspondence is nonetheless revealing, as is the fact that Kandinsky complained repeatedly to Gabriele Münter that she was too reserved about expressing her feelings, reminding her pointedly on one occasion that as a child he had been idolized by his family.[50]

Kandinsky's earliest memories, going back to his third year, were mainly connected with color impressions. *Reminiscences* begins with the statement that "The first colors to make a powerful impression on me were light juicy green, white, carmine red, black, and yellow ochre." Though these colors are linked with objects, the objects

themselves stand out much less vividly in his memory. In the Russian edition of his autobiography the white of barkless tree trunks is associated with a taste memory: he recalls they were "incredibly perfumed when fresh!! They tempted one to lick them, but were bitter to the taste."[51]

When Kandinsky was three years old, his parents took him on a trip to Italy. For a Russian family which could afford a private nanny and a chauffeur, this was not an unusual thing. A French, English, or German governess to see to the child's good manners and mastery of a foreign language would have been in order too in that society, but there is no mention of one in the records. Perhaps Vasily's aunt and his German-speaking grandmother filled that rôle.

Italy to Kandinsky was "two black impressions": the black coach which drove him to kindergarten in Florence,

> and black again – steps leading down into black water, on which floats a frightening, long, black boat with a black box in the middle: we are boarding a gondola at night. It was here that I developed a gift that made me famous "throughout the whole of Italy," and bawled my head off.[52]

Black is associated too with his first artistic disappointment. Trying to color a white horse's hooves black without the help of his aunt who usually guided his childhood artistic efforts, he remembers: "I was in despair and felt cruelly punished! Later I could well understand the Impressionists' fear of black and later the very prospect of applying pure black to the canvas would still put the fear of God into me. This kind of childhood disaster throws a long, long shadow over many years of later life." The Russian edition of *Reminiscences*, written in 1918, contains another illuminating sentence: "Up until a short time ago I still used pure black with quite a different feeling than [when using] pure white."[53] Another color Kandinsky remembers from his infancy is the yellow ocher of a toy horse. After he moved to Munich he saw a horse of the same color in the street, and this filled him with joy: "...I suddenly felt at home..."

Kandinsky wrote his short autobiography because he wanted to recount the history of his artistic development and explain its context. Here, as in his other writings, he avoids mentioning private matters and anything unconnected with his art. The same could be said of his paintings: "I have no inclination to paint my own states of mind, for I am firmly convinced that they do not concern others, that they are uninteresting to them."[54] Granted that his memory may have been selective and that some of his descriptions of childhood experiences may be somewhat exaggerated, there is no doubt that his first color impressions were unusually powerful. Interestingly, Carl Einstein was one of the first critics to notice Kandinsky's almost "hallucinatory" fascination with color.[55]

Already as a child Kandinsky experienced pigment as a living substance squeezed from the tube.

As a thirteen- or fourteen-year-old boy, I gradually saved up enough money to buy myself a paintbox containing oil paints. I can still feel today the sensation I experienced then – or, to put it better, the experience I underwent then – of the paints emerging from the tube. One squeeze of the fingers, and out came these strange beings, one after the other, which one calls colors – exultant, solemn, brooding, dreamy, self-absorbed, deeply serious, with roguish exuberance, with a sigh of release...

Having learned to value those "strange beings" which taught him more than any teacher or master ever could, and which his memory almost personalizes, he displays his remarkable powers of synesthesia by observing:

> It sometimes seemed to me as if the brush, as it tore pieces with inexorable will from this living being that is color, conjured up in the process a musical sound. Sometimes I could hear the hiss of the colors as they mingled. It was an experience such as one might hear in the secret kitchens of the arcane alchemists.[56]

These lively, poetic memories show (as do some of Kandinsky's theoretical writings) a genuine gift for literary expression.

The manuscript of *Reminiscences* contains a description of a childhood dream which Kandinsky deleted from the published version. It is worth quoting in full because it gives us a rare glimpse into the inner recesses of his psyche.

> What is a dream? Neither the positive nor the metaphysical sciences offer a clear answer to this question. I know from my own experience that a dream can cast light on one's whole life and that it therefore represents a determinant force in life. There are two dreams I shall never forget. When I was four or five years old [later amended to five to seven] I had a dream about heaven, and the memory of it still grips me with undiminished force. It seems to me that as time goes by this dream enables me to distinguish the spiritual from the physical, to feel their difference (i.e. the autonomous existence of both elements), to test it with my feelings and finally to experience spirit as the nucleus within the shell-like body which in part is alien to it, in part determines it, and in part is hampered by it.[57]

Almost nothing is known about Kandinsky's school years. His biographer Will Grohmann may have been told by the artist himself that he had not been drawn to any particular area of studies. In *Reminiscences*, Kandinsky passes directly from mathematics to his eidetic skills – which of course played a vitally important role in his art. He claims that he never had what is called a "good memory" and that he always had trouble remembering figures, names, and poetry.

My multiplication tables always presented me with insuperable difficulties, which I have not overcome to this day and which drove my teacher to despair. From the first, I had to summon my visual memory to my aid, and then I was alright. In my final examination in statistics I recited a whole page of figures, simply because in my excitement I could see this page *in my mind*. Thus, even as a child I was able, as far as my technical knowledge allowed, to paint pictures from memory at home that had intrigued me at exhibitions. Later, I was sometimes able to paint a landscape better "by heart" than from nature. In this way I painted *The Old Town*, and later many colored Dutch and Arabian drawings [ill. 73]. In the same way, I could recite by heart the names of all the shops in a long street, without mistakes, because I saw them in front of me. Quite unconsciously, I was continually absorbing impressions, sometimes so intensively and continuously that I felt as if my chest would burst, and breathing became difficult. I became so overtired and sated that I often thought with envy of civil servants who, after work, may and can relax completely. I longed for dull-witted repose, for what Böcklin called porters' eyes. I had, however, to see continuously.[58]

Elsewhere in *Reminiscences*, Kandinsky writes that very early his father became aware of his love for drawing and arranged for him to have private drawing lessons in addition to piano and cello lessons.[59]

Concerning Odessa, where Kandinsky spent his school years, we are told that neither he nor his parents ever felt at home there. Odessa was a thriving city in those days, with a lively local cultural scene, a cosmopolitan openness to Western Europe and the Mediterranean, a port, and large Jewish and foreign colonies. I shall return to the question of anti-Semitism in the chapter on Schönberg; suffice it to say, for the time being, that Odessa's mixed population fostered an atmosphere of tolerance, but it also bred ethnic rivalries and animosities which could and often did take the form of anti-Semitism, instances of which Kandinsky may well have witnessed as a child.

Revisiting Odessa in 1903, Kandinsky was reminded of his secondary-school years; writing to Gabriele Münter, he particularly recalled the "solitary nights" when he vowed he would always be "noble and honest."[60] His strong, perhaps overwrought response to his surroundings, especially chromatic impressions, and his almost obsessional need to "see everything," were evidently responsible for times of extreme nervous tension.

> Even as a child, I had been tortured by joyous hours of inward tension that promised embodiment. Such hours filled me with inward tremors, indistinct longings that demanded something incomprehensible of me, stifling my heart by day and filling my soul with turmoil by night, giving me fantastic dreams full of

terror and joy. Like many children and youths, I tried writing poetry, which I sooner or later tore up. I can remember that drawing alleviated this condition, i.e., it allowed me to exist outside of time and space, so that I was no longer conscious of my self.[61]

One of Kandinsky's letters to Gabriele Münter gives us an even more revealing insight into his deepest motivations. As he seldom opens himself up to such an extent, it offers a particularly valuable clue to his real nature:

> You barely seem to know joy, that most beautiful, purest of joys which does not come from people, nor is caused by people. It's a godlike feeling, which suddenly brings clarity to the eternally unclear. Though you have no knowledge of it, however, surely you sense that something like it exists. In my early youth I was frequently sad. I was groping toward something, missing something, all of me was yearning for something. And it seemed impossible that I would ever find that missing thing. In those days I called this state of being "the feeling of Paradise Lost." Only later did I acquire eyes to see through the keyhole in the gate to that paradise. But I'm too weak and too wicked, and I'm not always able to keep these eyes open. I'm still searching for so much on this earth. And, of course, he who searches for something down here can't be looking for something up there.[62]

All this makes one wonder about Kandinsky's religious background. Unfortunately he himself says nothing about it, perhaps because he regarded it as a strictly private matter and felt that it had no relevance to his art. All we know for a fact is that, like virtually all Russians of his day, he was a member of the Orthodox community and remained so to the end of his life. But he does not even credit his altruistic aunt with any particular religious piety. Like many other cultivated, enlightened families of the Russian bourgeoisie, the Kandinskys were probably quite liberal in their religious views even though they were attached to traditional church observances. Christenings are mentioned in their correspondence, and it is not unlikely that young Vasily regularly attended Sunday services. He certainly visited churches with his father, though perhaps less for religious than for artistic reasons.[63] There is no doubt, in any case, that he was familiar with the art of icons from his earliest childhood, a fact that might have a bearing on his discovery of abstraction. In this connection, it is interesting to note that, as late as 1937, he confided to a museum director in Paris: "In truth, the origin of my abstract painting essentially ought to be looked for in the Russian icon painters of the tenth to fourteenth centuries and in Russian folk painting, which I saw for the first time on my trip to northern Russia."[64]

In *Reminiscences*, Kandinsky mentions having had passing crises of "disbelief":

15 *Icon: Head of Christ*
Mid 12th century
School of Vladimir-Suzdal
State Tretiakov Gallery, Moscow

16 *Icon: Madonna*
Early 18th century,
School of Yaroslavl
State Tretiakov Gallery, Moscow

Man often resembles a beetle kept lying on its back: it moves its legs in mute yearning, clutches at every stalk held before it, and constantly believes it will find salvation in this stalk. During my periods of "disbelief" I used to ask myself: Who is it that is keeping me on my back? Whose hand holds the stalk in front of me and takes it away again? Or am I simply lying on my back on the dusty indifferent ground, clutching at stalks that grow around me "of their own accord"? And yet, how often I felt this hand at my back, and another that covered my eyes, so that I found myself plunged in deepest night while the sun shone.[65]

It was not long before young Kandinsky found his way to free religious sentiments which were bound neither to his homeland nor to the church of his early years. During a stay in Venice in 1903 he evidently attended services at the "rival" Catholic church,[66] and he usually referred to

Christianity and the Christian tradition in general rather than Orthodoxy in particular. It is worth bearing in mind that his childhood friend Benia Bogaevskaya, his biographer Will Grohmann, and his first English collector, Michael Sadler, all considered him religious.[67] Moreover, his second wife, Nina, who has always reported his views loyally and literally, observes that

He was a believer, but did not attend church regularly [...]. He told me that in his youth he would often react [to things] very spontaneously, very impulsively, and sometimes quite uncontrollably. He told me he had always found it difficult to discipline himself. As an adult he exuded self-control, independence, and self-discipline [...]. He respected truth and admitted his mistakes and errors, even to his friends."[68]

CHAPTER THREE
STUDENT DAYS

Moscow

"Our desire to be able to go back to Moscow never left us, and this town unfolded in my heart a longing similar to that described by Chekhov in his *Three Sisters*. From my thirteenth year on, my father used to take me with him to Moscow every summer, and at the age of eighteen, I finally moved there, with the feeling of being home again at last."[69] Kandinsky interweaves memories of his native Moscow with hymns to his mother. This reveals something about his inner picture of that city. Anyone familiar with his treatment of this topic in his poems and theater pieces knows how strikingly he emphasizes freedom and the almost irreconcilable qualities of effervescence and majestic calm, tradition and genuine freethinking, thereby creating tensions which nevertheless mesh together to form a complex harmony. Electrical contrasts of opposites occur throughout his pictorial oeuvre, often breaking out into open conflict – a central theme.[70] Few of his pictures can be said to have a simple, quiet harmony.

Not only clashing opposites (a leitmotif which we shall have occasion to return to) are connected to his birthplace:

> I regard this entire city of Moscow, both its internal and external aspect, as the origin of my artistic ambitions. It is the tuning fork for my paintings. I have a feeling that it was always so, and that in time, thanks to my external, formal progress, I have simply painted, and am still painting, the same "model" with ever greater expressiveness, in more perfect form, more in its essentials.[71]

Kandinsky's strong feelings about his native city are of such a profoundly aesthetic nature that the question of whether or not they were colored by Slavophile influences is pretty much irrelevant. The following lyrical description is of the highest significance to anyone interested in his pictorial oeuvre:

> The sun is already getting low and has attained its full intensity which it has been seeking all day, for which it has striven all day. This image does not last long: a few minutes, and the sunlight grows red with effort, redder and redder, cold at first, and then increasing in warmth. The sun dissolves the whole of Moscow into a single spot, which, like a wild tuba, sets all one's soul vibrating. No, this red fusion is not the most beautiful hour! It is only the final chord of the symphony, which brings every color vividly to life, which allows and forces the whole of Moscow to resound like the *fff* of a giant orchestra. Pink, lilac, yellow, white, blue, pistachio green, flame red houses, churches, each an independent song – the garish green of the grass, the deeper tremolo of the trees, the singing snow with its thousand voices, or the *allegretto* of the bare branches, the red, stiff, silent ring of the Kremlin walls, and above, towering over everything, like a shout of triumph, like a self-oblivious hallelujah, the long, white, graceful, serious line of the Bell Tower of Ivan the Great. And upon its tall, tense neck, stretched up toward heaven in eternal yearning, the golden head of the cupola, which among the golden and colored stars of the other cupolas, is Moscow's sun.

> To paint this hour, I thought, must be for an artist the most impossible, the greatest joy. These impressions were repeated on each sunny day. They were a delight that shook me to the depth of my soul, that raised me to ecstasy. And at the same time, they were a torment, since I was conscious of the weakness of art in general, and of my own abilities in particular, in the face of nature.
> [...]
> At that time, however, in my student days, when I could devote only my leisure hours to painting, I sought – impossible though it might seem – to capture on the canvas the "chorus of colors" (as I called it) that nature, with staggering force, impressed upon my entire soul. I made desperate attempts to express the whole power of its resonance, but in vain.[72]

17 *Kandinsky, ca 1886*
 (as a young university student in Moscow)
 Gabriele Münter- und
 Johannes Eichner-Stiftung, Munich

These last lines tell us something about what Kandinsky required art to be. Not only must it rival nature's deeply felt beauty, but it must find an adequate expression for the spectacle in front of the artist's eyes. Did Kandinsky recognize elements of "his" Moscow in the works of other, past or present artists, elements he was as yet unable to render? Presumably not, for nowhere does he mention anything of the kind. Oddly enough, in this connection he mentions having attended a performance of a Wagner opera and says that it was one of the "two events that stamped my whole life and shook me to the depths of my being."

> *Lohengrin*, on the other hand, seemed to me the complete realization of that Moscow. The violins, the deep tones of the basses, and especially the wind instruments at that time embodied for me all the power of the pre-nocturnal hour. I saw all my colors in my mind; they stood before my eyes. Wild, almost crazy lines were sketched in front of me. I did not dare use the expression that Wagner had painted "my hour" musically. It became, however, quite clear to me that art in general was far more powerful than I had thought, and on the other hand, that painting could develop just such powers as music possesses. And the impossibility of seeking out these powers, let alone discovering them, made my renunciation all the more bitter.[73]

Typically, Kandinsky finds in music the expression of something he has been searching for in the visual arts and which he himself at this time feels incapable of creating. It is not surprising then that musical references should abound in his description of Moscow: "...the final chord of the symphony...the *fff* of a giant orchestra...the deeper

tremolo of the trees, the singing snow with its thousand voices...the *allegretto* of the bare branches...," and so on. Music, as we shall see, played a vastly important role throughout his life and, owing no doubt to his remarkable powers of synesthesia and his eye for the overlapping elements in the different arts, the idea of a grand synthesis of all the arts was to be one of his central preoccupations.

But to come back to Kandinsky's private Moscow, one of his favorite figures was St. George, who is often represented in icons and happens to be the patron saint of Russia's capital. There are many effigies and depictions of him in that city, notably on the façade of the Tretiakov Gallery where Kandinsky was a frequent visitor (ill. 19).[74]

For obvious reasons, Soviet scholars have not concerned themselves with the part Moscow, Russia, and the Orthodox church played in Kandinsky's life and oeuvre. By 1921 when the artist emigrated from his homeland for the

19 *Façade of the Tretiakov Gallery, Moscow, 1905*
Pencil sketch by the architect Viktor Vasnetsov
State Tretiakov Gallery, Moscow

second time, the "Old Russia" tradition was already becoming suspect. In other countries this aspect of Kandinsky scholarship has been hampered by a paucity of materials. The Norwegian art historian Marit Werenskiold published her study of "Kandinsky's Moscow" in 1989. Correcting Sixten Ringbom's findings, she shows that the influence of Moscow and the Orthodox faith was far more important than Kandinsky's later and, in time, very limited fascination with Madame Blavatsky's Theosophy and Rudolph Steiner's Anthroposophy.[75]

In the Orthodox tradition, Byzantium was viewed as the second Rome. After it fell to the Turks in 1453, it was succeeded by Moscow, which was then often regarded as the spiritual center of Eastern Christianity. If, by analogy with the Holy Trinity, ancient Rome was regarded as the Father and Byzantium as the Son, Moscow, the city of the "third era," was connected with the Holy Ghost. Kandin-

18 *Kandinsky Playing the Cello, ca 1888*
Gabriele Münter- und Johannes Eichner-Stiftung, Munich

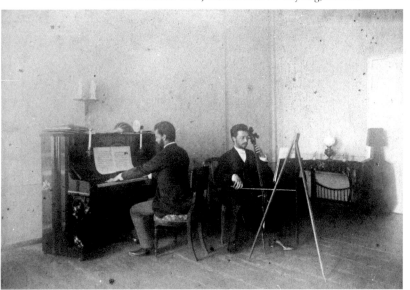

sky's "epoch of great spirituality" is clearly related to this notion. As Ringbom and Werenskiold show from the historical and literary sources they examined, the "third Rome" tradition was widespread in nineteenth-century Slavophile circles. Dostoevsky was one of its most ardent prophets. Young Kandinsky's contemporary, the deeply religious writer Dmitri Merezhkovsky, belonged to this tradition as well, or rather to that strand of it which goes back to the medieval mystic Joachim of Flora (1131–1202), who held that history comprises three spiritual ages, the third being that of the Holy Ghost. In a contribution to an international symposium on religion published in 1907 in the French literary review, *Le Mercure de France*, Merezhkovsky announced that the third age was not just around the corner – it had already begun.[76]

But Ringbom and Werenskiold were unaware of what is by now an established fact: Kandinsky was personally acquainted with Merezhkovsky and his ideas at least as early as 1897, through their mutual friend Marianne Werefkin.[77] In 1892 Merezhkovsky, in his treatise *On the Cause of Decadence and the New Currents in Contemporary Russian Literature*, expressed ideas that were in the air in turn of the century Russia, in particular the notion that an epoch of "divine idealism" was on the way.[78] Viacheslav Ivanov, another influential writer and theorist, prophesied that a major upheaval would occur in the year 1900 and would usher in a new epoch in history. The poet Andrei Bely, for his part, cites Nietzsche, Soloviev, and Merezhkovsky as the heralds of a major historical convulsion. In the spiritual domain, the religious philosopher and mystic Vladimir Soloviev, with his apocalyptic visions of St. Sophia, was an important precursor of the Russian Symbolists.

If these names are seldom remembered today, it is because the literary and intellectual scene in Russia at the turn of the century (like the avant-garde art of the 1920s) has until recently been studiously ignored by Soviet historians and critics, who considered its output both elitist and too hermetic for the masses. Even in the West, the Russian Symbolists – apart from Blok and Merezhkovsky – are still little known, for their poetry and complex theoretical writings are difficult to translate and the originals are all but unavailable. In the late 1800s and early 1900s, though, they were popular among the Russian intelligentsia and even beyond, despite – or perhaps because of – several censorship scandals. As a student, Kandinsky was therefore bound to be familiar with at least the gist of their ideas. He cannot have helped being in some way affected by the millenary pessimism and apocalyptic forebodings of the "decadents," as the first generation of Symbolists was called, and, after the turn of the century, by the growing mystical faith in the redemptive role of the arts.

Unlike Merezhkovsky and his canonical vision of Moscow as the third Rome, the other Symbolists inclined toward a more secular mysticism. Their outlook was unquestionably more congenial to Kandinsky than

Merezhkovsky's (a fact to which, I believe, Werenskiold does not attach sufficient weight). The Kandinskys were a cultivated, indeed rather cosmopolitan family; their trip to Rome was not a pilgrimage but a visit to a city that was a cultural "must." Of course, Werenskiold's research is valuable, even indispensable, as a corrective to the abundance of material on Kandinsky's French, German, and Theosophical influences. Apropos the artist's numerous depictions of the Kremlin, Werenskiold points out that Muscovite icons and popular prints traditionally represent Moscow on the same plane as the Celestial City of the Apocalypse.[79] That Kandinsky was familiar with this art from childhood on is certain; this fact should not, however, be given more weight than it merits. Kandinsky borrowed motifs from popular religious imagery in the same way, for example, that he used the various historical costumes he studied and copied. Appropriating only those elements he considered necessary, he did not hesitate to combine them with elements from other costumes, even when the latter were anachronistic. Likewise, he interpreted religious themes with great freedom, often combining them in unusual and surprising ways.

20 *Kandinsky, ca 1889*
 Gabriele Münter- und Johannes Eichner-Stiftung, Munich

From peasant law to art

Kandinsky's hymn to Moscow in *Reminiscences* is followed by more prosaic, though equally vibrant, memories of his student activities:

> At the same time, my soul was kept in a state of constant vibration by other, purely human disturbances, to the extent that I never had an hour's peace. [...] The developments of student autonomy continually brought new experiences in their train and thus made the strings of one's soul sensitive, receptive, exceptionally ready to vibrate.

Kandinsky's political activities as a student are particularly interesting in the light of the fact that he later became increasingly apolitical, a fact confirmed by his second wife, Nina, whom he met in 1916 when he was fifty.

As a student, Kandinsky lived with relatives in Moscow. In his second cousin, Anna Federovna Shemiakina (Ania), whom he married in 1892, he found a cultivated mate.

Oddly enough, Kandinsky descerned a connection between art and the subjects he studied at Moscow University: law and economics. In *Reminiscences* he observes:

> My various studies trained me to acquire the necessary gift of immersing myself in the finer realms of the material, otherwise known as the "abstract." Apart from my chosen specialization (economics, which I studied under the tutelage of a highly gifted intellectual and one of the most unusual people I have ever met, Prof. A. I. Chuprov),[80] I was strongly attracted, sometimes by turns, sometimes simultaneously, by various other disciplines. Roman law (which enchanted me on account of its intricate, conscious, refined "construction," but which could ultimately never satisfy me as a Slav because of its far too cold, far too rational, inflexible logic); criminal law (which affected me, perhaps too much to the exclusion of all else, by way of what was then the new theory of Lombroso);[81] the history of Russian law and peasant law (which, by contrast to Roman law, commanded my deepest respect and sincere affection for its freedom and happy resolution of the fundamental [problems of] law; ethnography, which also touched upon this same discipline (and which, I promised myself initially, would reveal to me the soul of the people); all these occupied my time and helped me acquire the capacity for abstract thought.[82]

In a note concerning peasant law Kandinsky explains further that, after emancipating the serfs in 1860, the czarist régime allowed them to control their own economy and, as a result, the Russian peasantry rapidly attained political maturity. The ex-serfs had their own courts and their own judges, who were empowered to settle rural disputes and even, in some instances, criminal cases.

Here, in particular, the people have devised the most humane principle, punishing lesser guilt severely and greater offenses leniently or not at all. The peasants have their own expression for this: "according to the man." Thus, it was not a stiff code of law that was established (as, e. g., in Roman law – expecially the jus strictum!), but an extremely free and flexible form, determined not by the external, but exclusively by the internal.

This is followed by a revealing afterthought, which Kandinsky later deleted:

> It gives me great satisfaction to think that I based the principle of art on "spiritual necessity": After the publication of my *On the Spiritual [in Art]*, I remembered this legal principle and saw that my whole concept of art had sprung from the bedrock of the people's soul.

Finally, a footnote in the Russian edition of *Reminiscences* concludes with the words:

> This principle of judgment is concerned less with the outward facts of the crime than with its spiritual origin – the soul of the criminal. How close this brings us to the basis of art![83]

Kandinsky also studied Russia's national economy, and wrote a dissertation "On the Legality of Laborer's Wages." His comments concerning these studies are particularly interesting:

> In my chosen field of economics, however, my only love apart from the question of wages was purely abstract calculation. Banking, the practical side of monetary affairs, I found utterly repellent. I had, however, no choice other than to accept these aspects along with the rest.[84]

This is virtually all that Kandinsky has to say about his academic studies. According to the University of Moscow archives, Kandinsky interrupted his studies for three years in 1889 "for health reasons," a fact to emerge only one century later.[85] It seems unlikely that he was too ill to attend classes, for it was around this time that he visited Paris, traveled extensively to gather research, and studied for his examinations. He completed his academic work and was awarded a "first degree" diploma in November 1893 (a date confirmed by the University archives). Will Grohmann states that Kandinsky married Ania and passed his law examination in 1892, and that he was appointed teaching assistant at the Law Faculty in 1893 on the strength of his paper on wages.[86]

Kandinsky spent the summer of 1889 traveling through the northern portions of Moscow and Vologda

provinces and the territory of the Syryenian communities, in what is now the Autonomous Republic of Komi. The purpose of this journey, which was approved by the Imperial Society for Science, Anthropology, and Ethnography, was to investigate surviving pagan beliefs and to study the principles of primitive law underlying peasant law. Kandinsky presented his findings in two papers published the same year in Moscow, in the *Ethnographic Review*, and in the *Publications* of the Imperial Society.[87]

Both essays are articulate, well-structured, and scientifically sound. Kandinsky outlines the results of his researches in a manner both lively and earnest, though his style, especially in the paper on criminal law, differs little form the usual jargon-studded scientific idiom. (The language of his later writings in German, on the other hand, is original and spirited – but then he was never exposed to the German academic establishment.)

The esssay "On Sentences Pronounced By Peasant Courts in the Moscow District" begins with a clear and logical presentation and delimitation of the subject. The future artist goes on to stress two factors determining the types of sentence handed down by peasant courts: the concept of crime as a personal offense (an inheritance from the old Russian prescriptive law) and the still vital distinction between peasant (district) court sentences and sentences "prescribed by law," especially penal law as it was taught in universities. Characteristically, Kandinsky favors the human principle in determining sentences. He notes approvingly that the peasant judge will often consider "whether the criminal is a first offender or has had previous brushes with the law, *what kind of a person he is in general* [Kandinsky's italics], and whether he admits or denies his guilt." In another passage, he goes so far as to express his personal opinion. Reporting on a woman who was sentenced to two days of imprisonment for resisting her husband when he beat her, and observing that the penalty for wife-beating was relatively mild, he takes issue with the legal discrimination against women – a subject that was to crop up again when he established his art school, the "Phalanx."

Kandinsky's tolerant attitude toward corporal punishment has already been mentioned. He asks, "How is one to account for the innumerable blows on peasant's backs meted out week after week – in the Pechorsky district fifty persons or more at a time are condemned to be caned – if not by invoking the extreme indigence of the rural population?" He is forced to admit that there are many arguments in favor of this type of punishment: physical blows make a lasting impression and are thus more effective than other types of punishment; moreover the peasants themselves seem to prefer them to being jailed, which deprives them of their work and hence their ability to earn a living. But the most important consideration is that caning and whipping do not inflict lasting damage on either the offenders or the community at large. "The reason is very simple and shows that inhumane corporal punishment is meted out for humane reasons," Kandinsky concludes.[89]

He mentions another custom, one that is only indirectly connected with his subject: the practice of out-of-court settlements. The courts, he says, view such settlements with favor and even recognize them officially. "The district court usually enforces the settlement upon the parties."[90] But appearances are often deceptive, and Kandinsky concludes that the negative aspects of this practice outweigh its positive ones, for the main reason for most such settlements seems to be the plaintiff's fear – and often the judge's – that the defendant will take matters into his own hands and seek revenge. The future artist equates peaceful settlements with

the decline of morals and legal principles. It [this practice] futher reduces moral responsibility to a mere economic advantage, especially in criminal cases, which often end with a glass of vodka or the payment of a ruble. And, ultimately, the sentence is subordinated to the will and desires, or the capriciousness, of the plaintiff.[91]

This would seem to contradict Kandinsky's favorable view of the "human principle" in peasant law. But since the above was written for publication in a law journal, one can hardly expect the author to come out unequivocally on the side of informal (if not anarchistic) justice, as opposed to Russia's formal legal system. Twenty-three years later, coming back to this issue in *Reminiscences*, Kandinsky reaffirmed the human principle "which is determined by the spiritual" as a foremost influence on his artistic development.

Toward the end of his memoir, Kandinsky, reverting to the subject of art, declares that

[I have] always been put out by assertions that I intended to overthrow the old [tradition of] painting. I could never see any such intention in my works: in them I could feel only the inwardly logical, outwardly organic, inevitable further growth of art. In the end, I came to experience consciously my earlier feelings of freedom, and thus the merely incidental demands I made of art gradually disappeared. They vanished in favor of one single demand: the demand for inner life in the work of art. Here, I noticed to my astonishment that this demand grew from the same basis as that which Christ had established as a qualitative criterion. I observed that this conception of art was Christian, and that, at the same time, it concealed within itself the elements necessary for receiving the "third" revelation, the revelation of the spirit.

This is followed by a long and, in the context, luminous footnote: "In this sense, Russian peasant law [...] is likewise Christian and should be contrasted with the heathen Roman law." Contrary to traditional legal thinking based on Roman law, Kandinsky adds, the *absolute*

crime does not exist. Good and evil are abstracts and reality is always a blend of the two.

> Every deed is ambivalent. It is balanced on a knife edge. It is the will that gives it a push – it falls to right or left. Outward flexibility and inward precision is, in this instance, highly developed in the Russian people, and I do not think I am exaggerating when I say I recognize a marked capacity for this development in Russians generally. Thus, it is no wonder that peoples who have developed according to the formal, outwardly most precise, Roman mind [. . .] either shake their heads over the Russian way of life, or else reject it with contempt.[92]

To the superficial observer, the quality of mercy in the native Russian penal system may look like laxity, but that is to miss the underlying precision beneath the surface. It is for this reason, Kandinsky concludes, that free-thinking Russians show more tolerance of other peoples than is shown them. Interestingly enough, this appears in the German edition of *Reminiscences* (upon which the American translation is based), while the Russian edition contains the following:

> The gradual freeing of the mind – which is the joy of our times – is, for me, the cause of that genuine interest for, and growing "belief" in, Russia increasingly evinced by free-thinking Germans. I received more and more calls during the pre-war years in Munich from representatives of the young, unofficial Germany; people to whom I had never paid attention before. [. . .] Somehow I was strangely pleased to find among them Swiss, Dutch, and English people who had the same attitude. When I was living in Sweden during the war years, I had the good fortune to meet Swedes of the same spiritual type. The divisions between peoples are disappearing as slowly and inexorably as mountains are leveled. And soon the word "humanity" shall no longer be a mere word.[93]

This statement reveals yet a new side of Kandinsky: his commitment to peace and mutual understanding between peoples. The material concerning this deep ideal belongs mostly to a later period in his life. We will have occasion to return to it.

Journey to the center of the picture

Kandinsky's second purpose in going to northern Russia was to trace surviving pre-Christian beliefs and practices among the Russified Syryenian tribes, who had originated in eastern Finland. He approached this task with a truly scientific conscientiousness. He set the limits of his topic clearly, researched it meticulously, and pointed out the innaccuracies and debatable assertions of other scholars in the field. He discovered only a few traces of pagan worship

among the communities he visited, and attributes the fact that the Syryenians' primitive beliefs seemed to have been forgotten to their rapid Christianization. In this connection he mentions Bishop Stephen of Perm whose *Life*, written around 1400, an early landmark in Russian literature, he was evidently familiar with.[94] Reading between the lines of his paper, one senses reservations about the rapid Christianization of the Syryenians, though nothing in his scholarly essay supports Peg Weiss' contention that his interest in Shamanism was more than scientific.[95] Unfortunately, Weiss does not give the English-speaking public the opportunity to become acquainted with Kandinsky's actual words in translation. Instead she merely summarizes and paraphrases in her thirty-five page essay his five- to six-page article, unduly stressing some points and glossing over others. She attributes a huge significance to Kandinsky's ethnographic work, seeks to show that he was enthusiastic about pagan beliefs, and attaches too much importance to his criticism of Christianity. She quotes from an impressive range of material, though intrinsically it neither proves nor disproves her claims. By skillfully manipulating this material and constantly repeating certain loaded statements, she brings the reader (who has neither the time nor the opportunity to check for himself) to the absurd conclusion that Kandinsky was a Shaman!

Since its Russian publication in 1889, Kandinsky's paper has appeared only in German translation.[96] No one who reads it can fail to be struck by its thoroughly impartial and scientific tone. Nor does the fact that it has been quoted from time to time – usually in ethnographic literature – mean that it is a major contribution to anthropology. Perhaps the best assessment of the future artist's contribution in this field is his own laconic statement: "My scientific work was highly thought of."[97]

The archives in the Kandinsky estate contain a notebook of over 500 pages with a map and a calendar for the year 1889. The map shows Kandinsky's route through northern Russia (ill. 21). The Syryenians had settled in the Province of Vologda, the capital of which (Vologda) lies about 500 km. north of Moscow. Kandinsky notes that this territory is about as big as France and extends as far as the Urals (which he visited too).[98] The first section of the notebook, which shows that the expedition was meticulously prepared, contains quotations from, and references to, literature about the country he intended to explore and the legal issue he meant to research. These are interspersed with notes concerning daily occurrences between late May and early July and observations concerning local customs and practices. Kandinsky remarks for example that the Syryenians had no songs of their own; their songs were all adapted from Russian traditions. He describes a religious celebration at the end of Lent, when the village he was visiting brewed rye beer and proceeded to drink it with much singing and dancing. The Syryenians' cheerful and open ways won his heart. He expresses astonishment that this primitive tribe had no concept of the soul.

But it is Kandinsky the artist who interests us here, and so we will not linger on his ethnographic research, which was anyway not the only purpose of his journey. For him, the expedition was a lonely adventure to far northern reaches and a series of impressive encounters with nature, primitive peoples, and folk art. As such, it had a major influence on his later artistic development. This is how he describes it:

My tendency toward the "hidden," the concealed, saved me from the harmful side of folk art, which I saw for the first time on its own ground and in its original form on my journey through the Province of Vologda. I traveled initially by train, with the feeling that I was journeying to another planet, then for several days by boat along the tranquil and intro-verted Sukhona river, then by primitive coach through endless forests, between brightly colored hills, over swamps and deserts.

The Russian edition adds that Kandinsky sometimes also traveled in a telega, "which, for those who are unused to it, rattles to make your insides ache." He notes in his travel diary on June 22–23 that he covered 45 versts – almost 50 km. – in one day on horseback:

21 *Map of Russia,*
 with pencil marks by Kandinsky of his trip
 north of Moscow to the Ural Mountains, 1889
 Musée national d'art moderne
 Centre Georges Pompidou, Paris

22 *A Room in a Farmer's House,*
 Northern Russia, 1850
 Photo State Russian Museum, St. Petersburg

Lord, I wouldn't wish this on my worst enemy! [...]. I traveled completely alone, which was of incalculable benefit as regards absorbing myself in my surroundings and in my own self. It was often scorching hot during the day and frosty at night [...]. I would arrive in villages where suddenly the entire population was clad in gray from head to toe, with yellowish-green faces and hair, or suddenly displayed variegated costumes, running about like brightly colored, living pictures on two legs.

These sights appear to have made a lasting impression on him: his description of the Vologda villagers is repeated almost word for word in the stage directions of the theater compositions he wrote between 1909 and 1912 (see p. 150). But unquestionably his most important experience in northern Russia was his encounter with folk art in peasant houses, where every item of furniture was lavishly decorated with colorful motifs and designs.

Folk pictures on the walls;[99] a symbolic representation of a hero, a battle, a painted folk song. The "red" corner (red is the same as beautiful in old Russian) thickly, completely covered with painted and printed pictures of the saints, burning in front of it the red flame of a small pendant lamp, glowing and blowing like a knowing, discretely murmuring, modest, and triumphant star, existing in and for itself. When I

finally entered the room, I felt surrounded on all sides by painting, into which I had thus penetrated.

In the more detailed Russian version of this passage, Kandinsky describes his experience as follows: "In these magical houses I experienced for the first time the miracle that was later to become an element of my art. I learned not to look at a picture from outside, but to move *within the picture*, to live in the picture." He had experienced the same thing before, though had not then been aware of it, he says, when visiting Moscow's churches, especially the main Kremlin cathedral, the Assumption of the Virgin, and St. Basil's on Red Square. So it is perhaps no coincidence that, when he was twenty, he did a delicate and precise ink drawing of the Cathedral of the Assumption – his very first work to come down to us (it is dated 1886 on the back. See ill. 24).[100] Grohmann states that, in the Russian edition of *Reminiscences*, Kandinsky remarks that as a student, he "painted many church interiors in Moscow, in strong colors copying the ornaments on the church walls."[101] Grohmann is mistaken about the source, but as he knew the artist well he may have gotten this item directly from his mouth.

When I next visited these churches after returning from my journey, the same feeling sprang to life inside me with total clarity. Later, I often had the same experience in Bavarian and Tyrolean chapels. [...]

23 *Architectural Sketches, 1889*
Pencil
Travel notebook
Musée national d'art moderne
Centre Georges Pompidou, Paris

24 *Cathedral of The Assumption of the Blessed Virgin*
(in the Kremlin), Moscow, 1886
India ink, 7⅞ x 5¹⁵⁄₁₆ in
Musée national d'art moderne
Centre Georges Pompidou, Paris

I made many sketches – these tables and various ornaments [ill. 27]. They were never petty and so strongly painted that the object within them became dissolved. This impression, too, impinged on my consciousness only much later.[102]

These impressions, adds Kandinsky, probably helped to shape his artistic goal of letting the viewer "stroll" around within the picture.

Thus Kandinsky's response to Russian folk art differed fundamentally from that of contemporary Russian Symbolist and Art Nouveau artists, especially the Mamontov circle at Abramtsevo, who had begun to comb the countryside for folk art (see pp. 53 ff.) It differed also from the more directly artistic interest of younger painters like Larionov, Goncharova, and Malevich who modelled pictures on rustic shop signs and *lubki* (ills. 28, 29, 172, 174). Unlike these painters in their "primitive," pre-Cubist phase, Kandinsky never consciously painted in a naif manner that sought to emulate primitive folk art. The one thing he shares with them is a profound interest in an unspoiled art, an interest which later drew him to Henri Rousseau's pictures and to the childrens' drawings which he was fond of collecting (see the photograph of his apartment, ill. 30). For him, the decisive factor was the experience of being surrounded by brightly colored

25 *Landscape* *Pencil*
26 *Sketch of* Saint Feodosia *Travel notebook, 1889*
27 *Sketch of a Table* *Musée national d'art moderne*
 with Color Notes *Centre Georges Pompidou, Paris*

images: it was the enveloping sense of color that mattered, rather than the folk motifs or themes; the all-encompassing, global impression he received inside farm houses and churches. (Russian churches are lavishly ornamented; the Orthodox iconostasis, in particular, is covered with icons from top to bottom.) He felt much the same thing in the ornate Baroque – or rather Rococo – churches he later visited in Bavaria and the Tyrol. His experience of space, of "moving within the picture," can easily be relived in both types of church.

Still, there is no sign of any of this in his early work. Memories of folk and religious painting seem to have awakened in Kandinsky only after he began to move toward abstraction. And it was only in 1913, in *Reminiscences*, that he was able to articulate the key experience of being surrounded by folk art's bright colors – an experience he sets beside three other major artistic encounters: his discovery of Rembrandt (which we shall come back to in the next chapter), his first view of Monet's *Haystack* (ill. 32), and a performance of Wagner's *Lohengrin*. The last two events occurred around the same time, according to Kandinsky, and, since we know that the Monet was shown at the French Industrial and Art Exhibition in Moscow in the summer of 1896,[103] we can safely assume that this was shortly before Kandinsky made up his mind to leave Russia and become a painter. His memoir devotes a good deal of space to both encounters which, he says, "shook me to the depths of my being." It is significant that this passage follows hard upon a sentence about Ilya Repin and the Russian Realists. Kandinsky's knowledge of art had hitherto been limited to the latter; with the discovery of Monet, he writes,

suddenly, for the first time, I saw a *picture*. That it was a haystack, the catalogue informed me. I didn't recognize it. I found this nonrecognition painful, and thought that the painter had no right to paint so indistinctly. I had a dull feeling that the object was lacking in the picture. And I noticed with surprise and confusion that the picture not only gripped me, but impressed itself ineradicably upon my memory, always hovering quite unexpectedly before my eyes, down to the last detail. It was all unclear to me, and I was not able to draw the simple conclusions from this experience. What was, however, quite clear to me was the unsuspected power of the palette, previously concealed from me, which exceeded all my dreams. Painting took on a fairy-tale power and splendor. And, albeit unconsciously, objects were discredited as an essential element within the picture. I had the overall impression that a tiny fragment of my fairy-tale Moscow already existed on canvas.[104]

28 *Russian Lubok (folk print)*
Alkonost', Paradise Bird
Taken from: D. Rovinski, Russkie narodnye kartinki,
5 vol., St. Petersburg 1881

29 *Russian Lubok*
The Apocalyptic Riders
Taken from: D. Rovinski

30 *Kandinsky in Munich, July 1911*
 Photo: Gabriele Münter
 Gabriele Münter- und Johannes Eichner-Stiftung, Munich

31 *Dmitri Kardovsky,*
Portrait of Marya Anastasievna Chroustchova, *1900*
Oil on canvas,
59 1/4 x 37 3/8 in
The Solomon R. Guggenheim Museum, New York

32 *Claude Monet,* Haystack, *1891*
Oil on canvas,
Kunsthaus, Zürich

CHAPTER FOUR
THE FIRST OIL PAINTING

Surprisingly little is known about Kandinsky's artistic beginnings. New facts keep turning up all the time to alter or flesh out our scant knowledge of the young artist. Will Grohmann, in his excellent monograph, describes a very large classical female portrait dated 1900 as "Kandinsky's first large oil painting" and supplies the reader with a full page reproduction of it (ill. 31).[105] This picture was sold as such to a renowned museum, and is mentioned repeatedly in the scholarly literature devoted to Kandinsky. The most detailed analysis of it is the one by Klaus Brisch, who reads the signature as a K surrounded by "Jugendstil ornamentation."[106] In point of fact, the signature consists of a joined D and K and is identical with that of Kandinsky's Russian student colleague Dmitri Kardovsky. Through a stylistic comparison of the two artists, I was able to demonstrate, in 1974, that the portrait is actually Kardovsky's work.[107] This attribution has since been accepted by the museum in question and by the Kandinsky Society.

The careers of the two artists show some striking biographical parallels. Both were born in Russia in 1866; both studied law at the University of Moscow and passed their examinations around the same time. Later, both decided to become painters. Both left Russia in 1896, both settled in Munich. They met at Anton Ažbè's school – though they may have already been acquainted with each other in Moscow. Then, however, their paths diverged. Kardovsky, a Neo-Classical artist who remained true to the

Realist tradition, gained a reputation as a book illustrator. His attitude toward Kandinsky's work became increasingly critical. In the twenties, when both artists were back in Moscow and both teaching art, he complained:

> [...] no matter how highly esteemed he [Kandinsky] may be as a cultivated man with a firm character, even he (alongside Tatlin, Malevich, *et al.*) should never have been admitted to the Art Faculty, especially not as a teacher; as concerns his true artistic knowledge, he is a total washout, and as an abstract painter he is a downright dangerous individual.[108]

The confusion over the portrait is amusing, for the two artists were actually worlds apart. Grohmann surely sensed this, for he was clearly uneasy about making his attribution; indeed, he seemed to have concluded the picture was a Kandinsky largely because he was unsure about how much academic training Kandinsky actually did acquire in Russia. The literature of art history up to and including Dora Vallier's widely read paperback, *L'Art abstrait*,[109] perpetuates Grohmann's error, which was not corrected in the revised edition of 1980. So let it be said once and for all: the portrait is not a Kandinsky!

Does this mean, then, that the small, energetic landscapes of 1901 are certifiably Kandinsky's first works, apart from the few drawings he made from 1886 on (ills. 24–27, 58, 59)? Was Kandinsky the only artist of his generation not to have possessed a body of traditional early work? This seemed indeed to be the case until 1989, when a "pre-Kandinsky Kandinsky" turned up in the first Soviet retrospective devoted to the Moscow-born artist. This picture, called *Odessa – Port I* had been shown in 1898 as Kandinsky's first work; it had then vanished from view for the better part of a century.[110]

Now 1898 is precisely the year when Kandinsky failed the entrance examination at the Munich Academy (as he himself candidly admits). We know that he had started to study painting about a year and a half earlier. Until very recently, all that was known about his beginnings as an artist is what he himself says in his "private catalogue," where he states that he first exhibited in Odessa and St. Petersburg in 1902, then in Odessa and Moscow in 1903, and again Moscow and St. Petersburg in 1904. But in a letter to Kardovsky, he seems to change these dates. Thus, in a letter dated November 14, 1900, he mentions the possibility that the Moscow Artists' Association will set aside a separate room for new artists, where they would both be able to exhibit along with Jawlensky, Golovin, and others. On March 13, 1901, he states: "My show in Odessa and Moscow was quite successful." He does not even hint that this was his first exhibition.[111]

A strong, sensitive feeling for color suffuses *Odessa – Port I*. It is a softer, lighter, more monochromatic picture than any of Kandinsky's certified early landscapes. (Our illustration 33 is, incidentally, the first reproduction of this painting since it was cleaned. When it was exhibited at the Moscow retrospective in 1989, its yellow patina gave it the appearance of a Turner. It was reproduced in this state not only in the Moscow catalogue, but also – despite the fact that it had been cleaned before leaving the Soviet Union – in the catalogue of the later Frankfurt retrospective.) The light blue to yellowish-white sky is saturated with light; against it stand out fine yellowish-brown masts and a lantern, so delicately outlined that the mast on the left appears as a broken line. One is reminded of Isaac Levitan's work, an impression strengthened by the seemingly infinite variations of the basic yellow ocher tones on the right. The dark hulls and their shadows in the water are rendered in solid colors and look more substantial. The light areas of the water are opaque, thickly painted and traversed by dark brown spiralling reflections of shadows.

There is more of Rembrandt than Turner in this handling of light and dark tones. In *Reminiscences*, Kandinsky writes that Rembrandt was the first painter to move him deeply. He specifically mentions the "gigantic double sound" of the Dutch master's tonal contrasts, which seem to flow onto the canvas as if through a time filter. The manuscript contains a revealing phrase that was later deleted from the published version: "[...] my task is either to discover my own strength or to renounce art altogether." Referring to the period around 1900 to 1902, Kandinsky writes:

> I painted only three or four such pictures, trying to infuse into every part an "endless" series of initially concealed color-tones. They had to lie in such a way that they were completely hidden at first (especially in the darker parts), revealing themselves only in the course of time to the engrossed, attentive viewer, indistinct and at the same time tentative, quizzical at first, and then sounding forth more and more, with increasing, "uncanny" power. To my great astonishment, I noticed that I was working according to the Rembrandt principle.[112]

The question of which early paintings Kandinsky is referring to here has still not been answered satisfactorily. Almost none of his very first works survive, and none of those that do is as strikingly divided into a large light and small dark area as *Odessa – Port I*. It is interesting to note that, in that work, the rich scale of colors in the dark zone is not immediately visible; the spectator's eye is drawn to the light surfaces, and only gradually does it move on to the shadows, slowly registering the gradations within them.

33 Odessa – Port I, *ca 1896–1898*
Oil on canvas,
25⅝ x 18 in
State Tretiakov Gallery, Moscow

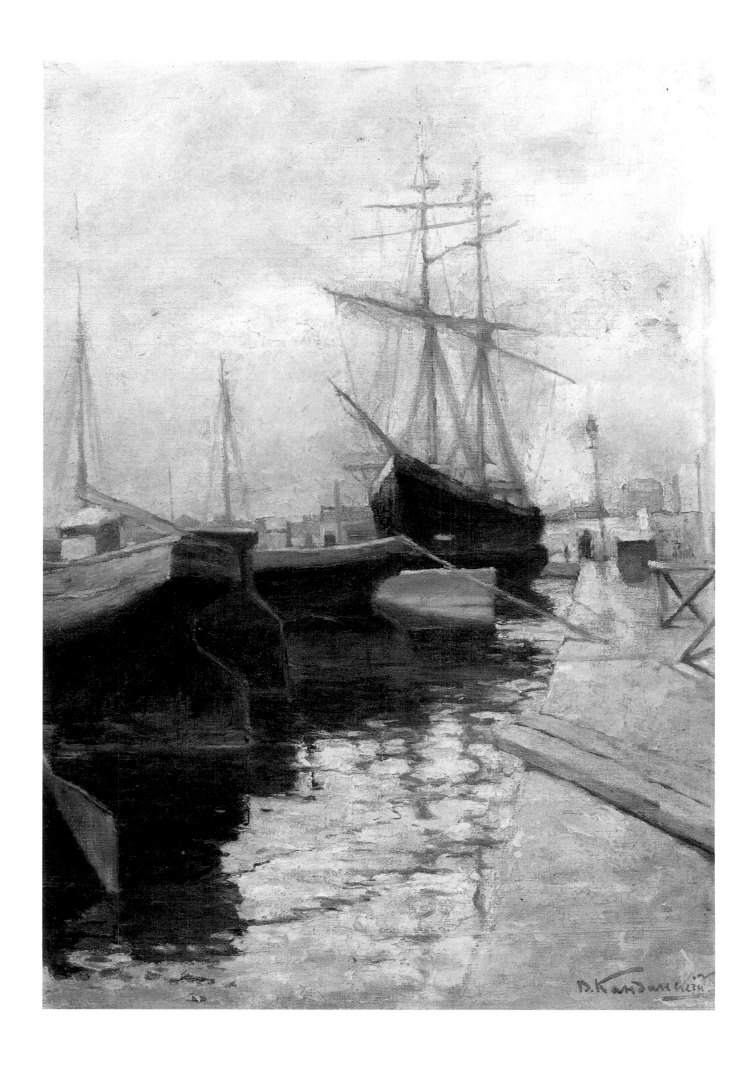

41

34 The Sluice, *1902*
 Oil on canvas,
 30¹¹/₁₆ x 20¹/₁₆ in
 Miyagi Museum, Sendai, Japan

35 *Study for* The Sluice, *1901*
 Oil on cardboard,
 12⅝ x 9⁷/₁₆ in
 Städtische Galerie im Lenbachhaus, Munich

The composition is based on a delicate balance of diagonals. The main movement is a resolute sweep from the lower left to the upper right. The shadowy part of the painting projects in a sharp triangle past the center of the picture, though minor obstacles impede this thrust: the plank and slat on the right, the bow and boom in the middle, the diverse grooves above the keel, the light keel in the far lower left, up to the pure diagonal shape of the table and the rigging in the center right. Characteristically, the artist has taken pains to avoid horizontal lines (contrast, for example, *Old Town II*, ill. 73).

Compared with the artist's treatment of the water in the oil studies of 1901–1902 onward – particularly *The Sluice* (ills. 34, 35), *Achtyrka – Autumn* (ill. 72), and *Munich – The Isar* (ill. 75), *Odessa – Port I* seems a more traditional, less temperamental, less decisive picture. More attention is given to the naturalistic reflections of the ships in the water. Only the dark areas share something with the later paintings. The rendering of the water and the huts in the background reveals a considerable mastery of the oil technique. Presumably Kandinsky acquired experience in this medium prior to attending Anton Ažbè's school in Munich. We know that he acquired his first oil paints when he was around thirteen or fourteen, and surely he didn't wait until he was thirty – the age when he suddenly decided to become a painter – to try them out?

In all but a few points, then, *Odessa – Port I* differs markedly from Kandinsky's other known early works. As for the landscapes painted in Munich (which were no doubt a sort of compensation for the academic discipline of nude and portrait drawing at Ažbè's school), Kandinsky doubtless waited, as was his habit, for the new vision which they express to mature within him. Possibly he did not move on to strongly colored spatular landscapes until 1901? Moreover, as he himself stated on several occasions, he destroyed a substantial number of "unsatisfactory" works.[113] This may explain why no proven early Kandinsky comparable to *Odessa – Port I* has come down to us. Though it clearly precedes the Munich landscapes, it is virtually impossible to date precisely. 1896, just before Kandinsky's departure for Munich, would seem to be a logical choice.

Odessa – Port I belongs to the tradition of Russian realism that emerged as a "Secession" from the narrowly conservative St. Petersburg Academy. The Society for Wandering Exhibitions was founded for the purpose of disseminating a socially critical and "rural" art throughout the Russian provinces. This had led to the growth of the national Russian art movement after 1870. Vasily Polenov (1844–1927), who owed his fame to his landscapes and pastoral scenes rather than his traditional, "academic" historical paintings, was a leading "Wanderer." And it so happens that the only painting known to have been copied by Kandinsky is Polenov's *Christ*: "...many is the time I copied the *Christ*...from memory and I admired Levitan's rowboat and monastery painted with a force that mirrors itself in the river..."[114]

36 *Vasily Polenov*, Christ, *1888*
Oil on canvas,
31⅛ x 42¾ in
State Tretiakov Gallery, Moscow

Polenov's *Christ* is a pure landscape with a lake and a single figure – Christ – on the shore (ill. 36). When Kandinsky speaks of having "copied" it, he presumably means that he copied it in oils. Now, what distinguishes Polenov from the other "Wanderers" is his preference for the harmonious, rather than conflict-laden themes of social criticism. He baffled the public of the mid-seventies (which was used to gray and brown tones) with the clear colors of his landscapes. He did not hesitate, for example, to paint the sky's reflection on a wall or in water light blue. He was the first Russian *plein air* artist to study the interaction of light, air, and color; the first to render shadows with transparent colors rather than uniformly dark tones; the first to dissolve contours in an atmosphere saturated with light. The colored shadows and somewhat "dissolved" masts in *Odessa – Port I* may well have been inspired by Polenov.

Another Russian artist Kandinsky mentions is Isaac Levitan (1860–1900), who was his senior by a mere six years. In all likelihood Kandinsky was acquainted with Levitan's art before leaving Russia: Tretiakov, whose private gallery was open to the public, had acquired his first Levitan as early as the 1880s. Levitan had studied with Polenov, among others, and had contributed to the vogue for landscape painting at a time when the mood in Russia – as exemplified by the plays of Levitan's friend, Anton Chekhov – was particularly receptive to this kind of art (ill. 37). His often melancholy pictures show his mastery of delicate color shadings and gradations of a single basic tone. And this was precisely what seems to have appealed to Kandinsky: the imaginative, almost musical variation of a single shade of blue across the great expanse of sky and the ocher tones on the right side of *Odessa – Port I*.

When it was recently shown in Moscow *Odessa – Port I* was positively identified as a Kandinsky. However, on the recommendation of the Kandinsky Society, it was presented at the Frankfurt retrospective as "attributed to

Kandinsky," thus indicating that there was still some doubt as to its authorship due to the fact that there is simply no painting comparable to it in the artist's oeuvre. It is included in the Grohmann and Roethel *Catalogues Raisonnés*, both of which reproduce an archive photograph of a canvas that is clearly the recently rediscovered painting. Thus everything would seem to indicate that *Odessa – Port I* can legitimately be considered Kandinsky's first known oil painting and that it can be dated 1898, or earlier. There is an entry to support this under the same title in the artist's "private catalogue" (I, n° 1a); the line with the entry 1a is clearly added above the original first entry n° 1, and the year "1900" seems to indicate the limit date to the next picture, painted in 1901, rather than to apply to *Odessa – Port I*. The same "private catalogue I" lists, in the section devoted to "small oil studies," four undated works identified as *Odessa – Port II–V* and numbered 31–34 (ill. 38), presumably studies for the painting, which were exhibited in Moscow in 1901.[115] The artist didn't have a scholar's compulsion to be exact and was repeatedly wrong by a year or two when remembering the publication dates of even his own books. Be that as it may, the re-emergence of his earliest success casts a new light on his astonishingly self-assured state of mind when, as early as 1901, he founded his own exhibition society and painting school, the "Phalanx."

We know for a fact that by 1901 Kandinsky was already contributing to exhibitions of the Odessa Association of Southern Russian artists. Why should he not have begun to do so as early as 1898? Does it make sense that, as some experts conjecture, a namesake of Kandinsky's – an obscure painter in the Impressionist vein – would have exhibited in Odessa precisely then? Nowhere in Kandinsky's notes, letters, or other writings is the existence of such an artist mentioned, as surely it was bound to be, had an artist having the same name exhibited a picture with the same title in the same place three years earlier. Or are we to assume that this hypothetical other Kandinsky was none other than the artist's father – after all, his father's profession is listed as "painter" in the Munich police form mentioned above (see note 35)? But this theory quickly collapses if we compare the signature on the painting to the sample of Vasily senior's handwriting (ill. 11)!

Why should Kandinsky the law student and amateur painter be denied the right of every beginning artist to experiment with sundry techniques and procedures and gradually develop a personal style? Is it really that unlikely that he should have started out (when copying Polenov) painting traditional pictures, and that at least one of these early works should have survived? Kandinsky was a notoriously meticulous artist, and surely he did not, without first engaging in a certain amount of preparation and practice, start out right away painting original oil sketches, rapidly executed with a spatula. We know that his critical turn toward abstraction, too, was preceded by years of painstaking research and experimentation.

Regarding the issue of Kandinsky's signature, why shouldn't it too have changed over the years? The authenticated paintings from 1901 are signed with unusually delicate capital letters. The signature in *Odessa – Port I*, on the other hand, is executed with a broad brush: the "K" of Kandinsky makes a sweeping arc, which may well be an artistic stylization. This peculiarity does not appear in the artist's later signatures; however, the handwriting of the *Odessa – Port I* signature clearly matches the handwriting in Kandinsky's early diaries after 1889; and, besides, there are in the artist's oeuvre other examples of the signature with a sweeping K (ills. 56, 65). The V of Vasily is clearly that of his usual signature, and the double I ending (in Russian) is identical with that of the word *sinii*, which crops up frequently in Kandinsky's manuscripts of this period; there are two ways of writing the d̲ in Russian, and it is noteworthy that Kandinsky always wrote it as he does here. Small differences in the brushstrokes of Kandinsky's signatures are probably due to the different implements he used: brush, pencil, and fine-nibbed pen.

X-Rays and photographs of the surface structure of *Odessa – Port I* have been useful in helping experts to compare this picture with the certified 1901 landscapes. (Recent Kandinsky research in Russia relies heavily on such objective techniques which focus exclusively on pictorial materials.)[116] M. P. Vikturina has thus been able to establish parallels between the brush and knife movement in *Odessa* and that in Kandinsky's other early works. Unfortunately, such optical analyses do not help much in

37 *Isaac Levitan,* Evening Bells, *1892*
 Oil on canvas,
 36 1/4 x 42 3/8 in
 State Tretiakov Gallery, Moscow

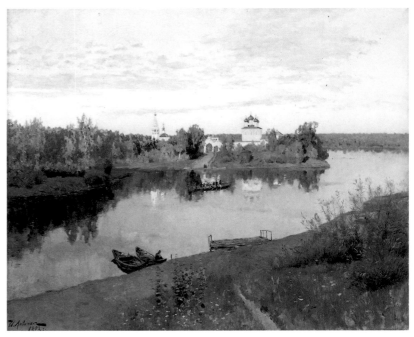

38 *Study for* Odessa – Port I, *ca 1903*
 Oil on canvas,
 3⅞ x 6⁷⁄₁₆ in
 Städtische Galerie im Lenbachhaus, Munich

39 *Kandinsky's Signature*
 (*on* Mountain Lake, *1899*)
 Collection M. G. Maluchina, Moscow)

establishing the picture's date, since, as Vikturina points out, we simply do not know when the artist began using the spatula technique. In a letter to Kardovsky, written in the spring of 1901, Kandinsky states that he finds the spatula technique "irreplaceable" when painting with oils. Presumably, as a beginner he started with the most common artist's tool, the brush, before increasingly using a palette knife as well. The fact that both implements were used for *Odessa – Port I* would seem to indicate that this picture was painted around 1896/1898.

What precisely do we know about Kandinsky and Odessa? The future artist lived there from his fifth year until he attended the University of Moscow (though he apparently regarded himself as a Muscovite – and, in due course, a cosmopolitan – rather than a provincial). He may have chosen the theme of *Odessa – Port I* specially for one of the Odessa exhibitions; indeed, it may have been after one such provincial show that someone – a critic or perhaps even his companion Gabriele Münter – referred to him as a "son of Odessa." Writing to the latter from Odessa on October 31, 1904, he expresses satisfaction with his success in Paris: "You can really achieve things in Paris!" he exclaims, adding, "It isn't like those dull (hum! pardon) Germans who take years to get accustomed to anything new. But I definitely will not be called a son of Odessa!!!" (In another letter, written on the day before, he remarks, "I have quite a swollen head about my success here! Just so! Take that! And the fact that I'm Dr. Kandinsky means

nothing here. And nobody has eeeever abused me here!")[117] The artist's next letter, dated November 2, mentions the Odessa art association for the first time. "Yesterday I spoke with one of the most interesting of the local painters about a secession from the old association to which we both belong." And, again, on November 8:

There was a small secret meeting yesterday. The very well-known portrait painter who helped me a good deal during those first difficult times said to me: "Why don't you stay on for a few months and take things in hand. One needs a lot of energy and indifference to insults from the press. You have plenty of both."[118]

This must have amused Kandinsky, who was used to being called a "wild Russian" in Germany and a "German" in Russia and to receiving abuse from ignoramuses in both countries. In 1901, he had been so angered by inaccurate and unprofessional criticism that he had published in a Moscow daily his caustic "Critique of Critics" (see Document, p. 47).

The phrase about "those first difficult times" suggests that he is looking back from a distance of more than three years: had he only exhibited in Odessa for the first time in 1901, Münter would already have been aware of that fact, since she and Kandinsky became acquainted with each other very soon after the exhibition took place.

40 Russian Knight, *1901–02*
 Gouache on gray cardboard
 6⅛ x 14⅜ in
 Städtische Galerie im Lenbachhaus, Munich

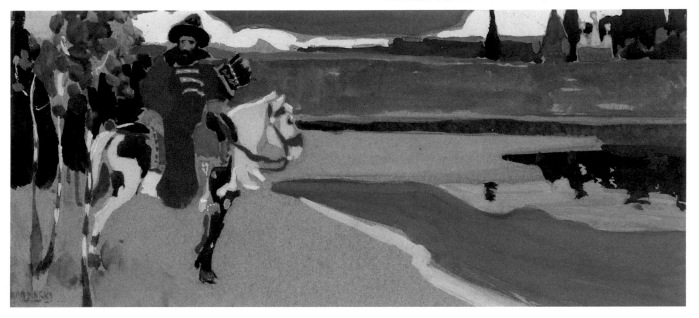

41 The King Arrives, 1902–03
 Watercolor, opaque white, crayon, and pencil,
 9¼ x 11⅝ in
 Städtische Galerie im Lenbachhaus, Munich
 "Red trumpeters as in Seeshaupt and copper-green trumpets.
 Birch tree with yellow-white trunk as in Sch[l]ehdorf; in the
 shadow a crowd of people: cold knights, warm clothes (small
 contrast). Sweet background (mountains as in Bad Kochel, blue
 forest and colorful boats with sails). White city with red roofs."

DOCUMENTS

Two letters to Dmitri Kardovsky

Munich, November 14, 1900

There is some hope that the Association of Moscow
Artists will give a separate room to the new group of
artists I have already mentioned to you. The members of
this group are to be – from Munich: Jawlensky, Salz-
mann, Seddeler, and myself; from Paris: Kruglikova
and approximately two other candidates; from Moscow:
Tatevosyanc,[119] Mamontov, Maliutin, Golovin, and
perhaps Vrubel; from St. Petersburg: Kardovsky, if he
doesn't refuse. [...]
I have a second suggestion to make. Due to propitious
circumstances last summer, I decided to discuss with
various people the project I have long been nourishing,
namely founding a new association in Munich which
will permanently exhibit works from all artistic fields.

Munich, March 13, 1901

I'm alone in my work. My knights are faring well,
they're alive and enjoying the company of Byzantine
emperors. I've exhibited quite successfully in Odessa and
Moscow. There was a rather strange article about me in
Odessa which conjured up the ghost of Puvis de Chavan-
nes, among a lot of others, and called him an Impres-
sionist. Goloushev had kind words to say about me in
Moscow, despite the fact that, for various reasons, my
weakest paintings were shown there. [...]
But somehow everything I do is "temporary." I simply
can't get down to what I really want to do; I'm besieged
and plagued by all manner of ideas, but I don't even have
the time to sketch them. A kind of restlessness and
uneasiness and a desire to work only "provisionally"
prevent me from tackling anything with depth. I too lack
knowledge, which is why I go to [Franz von] Stuck; and
though I enjoy doing studies, at home they only turn
into snippets. But there is so much I need and want to
achieve! My health hinders me a little too, i.e. nerves +
stomach. Not excessively, but considering that one never
hears a single fresh word from anyone, one gets dejected.
– I seem to have discovered a very good bond based on
varnish. But one has to try it out, read, learn... If only I
were 20! But I always have the feeling that it's too late
for anything and then I get downright feverish. [...]

(Kandinsky catalogue: *The First Soviet Retrospective*, Frank-
furt am Main, 1989, pp. 48 ff.)

Critique of Critics

[...] The serious and effective critic cannot limit himself
to mere evaluation of certain phenomena, since he is
obliged to make such phenomena accessible to less
sensitive persons, to explain them to others. Any sensi-
tive person can appreciate what is good, can evaluate
half-consciously that which is beautiful. But it is a more
difficult task to introduce the elements of consciousness
and comprehension into this sensitivity. To achieve this,
knowledge is essential. Only one who possesses both
these human qualities in due measure – acute sensitivity
and knowledge – can be a critic.
[...] I have found all kinds of abuse being used by a whole
succession of critics ("daubing," "barbarism," "dirty
dauber," "smeared it on hastily, to no purpose," etc.),
but there's not one line that, albeit primitively, refutes
the principles fundamental to the new school of art!
These are the critics who know absolutely nothing about
art, whom I have called naked.
Their colleagues of the pen, the half-naked ones, do
manifest some symptoms of being serious. Here, in fact,
you will find art terms, in addition to all manner of dicta,
and also names of foreign artists, who sometimes really

suffer at the hands of our Russian reviewers. For example, Mr. Si-v (Russian Gazette), in order to show off his erudition and give authority to his articles, likes now and then to flaunt two or three names that he juxtaposes purely by caprice. In his review of the same exhibition of the Association of Moscow Artists, he says: "While pursuing (why not "while creating"?) new trends, artists in the West do not cease to respect form, perspective, and in general, (!) drawing. Suffice it to mention, for example, the names of Roll, Cottet, de Gas, et al." Why did he choose precisely these three names and why is Degas, that great and famous artist, transformed into de Gas? Is it not because Mr. Si-v has never seen Degas's signature on his paintings, i.e., has never seen Degas's paintings? Indeed, only such ignorance of Degas can explain the critic's statement that this artist has not ceased to "respect" drawing. How could Degas not "respect" drawing when this celebrated master is among the "foremost" draftsmen of our time? [...]

I think that I have introduced enough excerpts to demonstrate the illiteracy of many Russian critics in art, their matchless audacity and complacency. [...]

In conclusion, I would point out that in the irresponsible and ignorant hands of Max Nordau,[120] "art" reviews are being engulfed by references to the sickness of the modern school in art, to the psychological derangement of contemporary artists, whom our critics cleverly propose placing in Kunstkammern [curio cabinets], panopticons, and lunatic asylums. A particularly large number of such flattering good wishes greeted the last exhibition of the Association of Moscow Artists, for which the exhibitors have to thank mainly G.I. Rossolimo and his lecture "Art, Bad Nerves, and Education." Not having had the pleasure of hearing this erudite lecturer, I found out only from a short newspaper report that in his presentation Dr. Rossolimo "outlined all kinds of art, elucidated the diversity of creative processes...and came to the conclusion that modern art is no more or less than a product of a sick mind...of degeneracy." I must thank Dr. Rossolimo, who "coming to the end of his most interesting paper, said that it was, of course, impossible to cure art."

(Vasily Kandinsky, "Critique of Critics" [Kritika kritikov], in *Novosti dnia*, Moscow, April 17 & 19, 1901. Translation in CW pp. 37ff.)

Excerpts from two reviews of the Exhibition of Southern Russian Artists in 1901

...What everyone was looking for, the kind of social content found ten or fifteen years ago in the work of the Peredvizhniki [the Wandering artists] – Repin's Unexpected, for example [ill. 4] – no longer exists. One must view the exhibition only from the standpoint of artistic

42 *Kandinsky's Armor, ca 1900*
Archive photo
Gabriele Münter- und
Johannes Eichner-Stiftung,
Munich

emotion. [...] Mr Kandinsky's paintings are such peculiar emotions that at the sight of them one feels at a loss and shrugs. This is the latest cry in art [...]. I am convinced that this latest cry is a useless, stupid, and inartistic affair, which the jury should not have accepted. The jury made concessions to fashion, to the Secession, which every normal person abroad laughs at.

Loengrin (pseud.), "The Picture Exhibition of Southern Russian Artists," in *Iuzhnoe obozrenie* (Southern Review), N° 1612, October 3, 1901.

...Unfortunately landscape painting has slipped into sordid, empty triviality. This goes for Kandinsky's notorious Sun Spot, *despite its incidentally rather elementary Impressionism.*

Altalena (pseud.), from a review of the same exhibition, in *Odesskie novosti* (Odessa News), N° 5432, October 9, 1901.

II.

43 Portrait of Gabriele Münter, *1905*
Oil on canvas,
17¾ x 17¾ in
Städtische Galerie im Lenbachhaus, Munich

II MUNICH

CHAPTER ONE
"NOW OR NEVER!"

Upon completing his studies Kandinsky took a job in Moscow. As a student, his interest in wages had been largely theoretical, but now

> I wanted to approach this same problem from the practical side, and I took up the position of manager in one of the largest printing firms in Moscow. My new speciality was heliographic reproduction, which to some extent brought me into contact with art. My environment was one of working people.
> I stayed in this job, however, for only one year. At the age of thirty, the thought overcame me: now or never. My gradual inner development, of which until now I had been unconscious, had progressed so far that I could sense my artistic powers with complete clarity, while inwardly I was sufficiently mature to realize with equal clarity that I had every right to be a painter.[121]

This is all that Kandinsky has to say about these years. We know that he was not obliged to work for a living. The property his uncle had bequeathed to him brought in a steady income and allowed him to live much as he pleased – a fortunate thing for him, considering his aversion to any obligation that might hamper his freedom of action. Presumably he painted during his free time, and no doubt this gave him more satisfaction than his first professional tasks. There is no evidence that he attended any drawing or painting classes at this time. Seemingly, then, Kandinsky received no academic training in art prior to leaving Russia. As for *Odessa – Port I*, it is his only known oil dating from before 1900.

Thus, at the age of thirty, Kandinsky was faced with a crucial decision. As an "assistant" at the University of Moscow, he was well on the way to an academic career. Indeed, in 1896, the University of Dorpat (now Tallinn in Estonia) offered him a teaching job. He turned it down. His disapproval of the enforced Russification of Dorpat may have played a part in this decision, but the main factor was undoubtedly a radical change of heart concerning his intended profession.

> I began to notice that my earlier belief in the beneficial value of the social sciences, and, ultimately, in the absolute rightness of positivistic methods, had seriously diminished. Finally I decided to throw overboard the results of many years work... And it seemed to me then that all that time had been wasted. Today, I know just how much I accumulated during those years, and I am grateful.[122]

There may have been another reason for Kandinsky's momentous decision. An event unconnected with art

seems to have made a profound impression on him around this time: the discovery of radioactivity. This occurrence, he recalls in *Reminiscences*, "removed one of the most important obstacles from my path."

> The collapse of the atom was equated, in my soul, with the collapse of the whole world. Suddenly, the stoutest walls crumbled. Everything became uncertain, precarious and insubstantial. I would not have been surprised had a stone dissolved into thin air before my eyes and become invisible. Science seemed destroyed: its most important basis was only an illusion, an error of the learned, who were not building their divine edifice stone by stone with steady hands, by transfigured light, but were groping at random for truth in the darkness and blindly mistaking one object for another.[123]

Kandinsky may not have grasped all the details of Becquerel's experiment of 1896 (just as, later, he may not have been able to understand the finer points of the Curies' and Einstein's work), but he was deeply impressed by it all the same.[124] For an artist, he seems to have had an unusual sensitivity for science; moreover Becquerel's discovery clearly satisfied his increasing distrust of the simplistic certitudes of positivism. As early as in *On the Spiritual in Art*, he approvingly mentions those scientists who questioned the concept of matter which had seemed, up until then, to be the bedrock of all knowledge, and strove to replace it with what he calls the "electron theory." Clearly, the spiritual revolution he longed for could not be far off if the very foundations of positivist thinking were crumbling.[125]

Kandinsky was evidently both fascinated and disturbed by atomic physics. That the new science had an impact on his subconscious is clear from the following account of a dream he had in 1906–07. This passage from the manuscript of *Reminiscences* was deleted from the published version.

> I went into the dining room and realized that the china cabinet was missing! Its place was vacant. I saw the empty floor and the uncovered wallpaper, but sensed that this spot was not *completely empty*. And then the air gradually got thicker and the cabinet rebuilt itself, rematerialized, at first indistinctly and then increasingly clearly, until it was as solid and hard as before. This seemed perfectly natural in my dream, but nevertheless I felt shaken as by a revelation. It cast a definitive light on the theoretical questions that preoccupied me at that time. Ever since then I have ceased to "believe" in the solidity of matter, and I would not be surprised to see an object "dissolve" before my eyes even when I was awake.[126]

Kandinsky does not connect this dream with any particular recent discovery in physics, but relates it instead to what he feels is the coming *spiritual revolution* – a theme he was especially interested in during these years, a time when he was personally experiencing the prevailing shift toward spiritual matters with an increasing intensity.

Feeling that Russian painting did not provide a good basis for studying art, Kandinsky took the momentous decision of leaving his homeland. There is nothing so far to indicate that any political motives or reasons of a more personal nature prompted this decision. His attachment to Moscow was less a matter of patriotic or Slavophile sentiment than of aesthetic and artistic feeling. He was fascinated by the intensity of the light and the vivid sunsets over his native city; he felt that its somewhat contradictory appeal corresponded in some way to both his and his mother's character; above all, he felt that Moscow was the "origin" of his artistic ambitions and "tuning fork" of his painting. It is ironic that he should have felt obliged to leave Moscow in order to study art.

He hesitated between Paris and Munich. Grohmann mentions two short visits to Paris in 1889 and 1892, but Kandinsky himself makes no mention of them, so they were presumably of little artistic consequence, merely the excursions of a young man more involved with new sights than with new directions in art. (The Eiffel Tower was being built in 1889, and Van Gogh was having his first one-man show – an event Kandinsky would doubtless have mentioned had he attended it.) At any rate, he finally opted for Munich. He was more familiar with Germany and German culture, after all, than with France. Then too he may have associated Munich, the then famous "city of the arts," with the German fairy tales his Baltic grandmother told him as a child. In his letters to Gabriele Münter, whom he loved and hoped to marry, he insisted on his ties with Germany: "I am no patriot, Ella. I'm only ½ Russian [. . .]. I grew up ½ German. My first language, my first books were German; as a painter *I have a feeling* for Germany and all things German, German antiquities mean more to me than to many Germans."[127]

Turn of the century Munich was a stimulating art center. Perhaps less stimulating than Paris, but more so than Berlin, in comparison to which it also seemed more provincial, more *gemütlich* – and its inhabitants more given to drinking beer. Its geographical situation gave it a somewhat "southern" charm, and, as it was a much smaller city than either capital, its artistic colony was quite conspicuous. Moreover, Kandinsky had little sympathy for Berlin, where he was repelled by "all those soldiers, that stupid parading" (a remark that tells us something about his views on military matters at this time). Later he visited that city again and came to like it better. Nevertheless he declared to Gabriele Münter: "I really prefer our old Munich by far. I definitely would not like to live here."[128]

The Munich Secession had been founded in 1892, before even the Berlin and Vienna Secessions. It had put

the Munich public in touch with the international art scene – although, as Kandinsky legitimately complains, this was true only in its very first years (see Documents, p. 58). Its founders included Max Liebermann, Lovis Corinth, Paul Besnard, Eugène Carrière, Giovanni Segantini (whom Kandinsky mentions with profound respect in *On the Spiritual in Art*), as well as Franz Stuck who was later to become Kandinsky's teacher.

1896, the year Kandinsky arrived in Munich, was an *annus mirabilis*. It saw the birth of two influential periodicals: the popular Socialist-leaning political and satirical *Simplicissimus*, and the *Münchner Illustrierte Wochenschrift für Kunst und Leben* (Munich Illustrated Weekly for Art and Life): the celebrated *Jugend* (Youth) – a name that recalls not only German Art Nouveau (Jugendstil), but also the whole movement of rejuvenation and renewal that swept through art around the turn of the century.

Hermann Obrist was active in Munich, where he had founded the *Vereinigte Werkstätten für Kunst und Handwerk* (United Workshops for Arts and Crafts) in 1897. He was mainly involved with the movement to elevate the applied and industrial arts, in particular applied graphics, to the rank of true arts. Obrist and Kandinsky were to meet later (though Peg Weiss' thesis that Obrist influenced Kandinsky does not stand up to scrutiny).[129]

It was in 1896, too, that Obrist's student August Endell shocked the citizens of Munich with his unconventional design for the Elvira photography studio (ill. 45). Declaring that literal realism was not art, Endell spoke out instead for shapes that represent nothing, but move the soul like music.[130] Thus Kandinsky was not the only artist to express such ideas. However, if one looks closely at the

45 *August Endell*
Façade of the Elvira Studio, Munich, 1896–97

work of Endell, Obrist, and others, one cannot help noticing a certain discrepancy between theory and practice. Kandinsky, on the other hand, quickly distanced himself from Jugendstil decorative strivings toward free forms, and recast the ideas they expressed in an entirely novel and wholly satisfactory manner. What is the true heritage of the great Munich Jugendstil experiment? It sought to raise crafts to the realm of pure art; and, indeed, the Jugendstil masters succeeded in doing so inasmuch as they directed all their energies to this task. But beyond this, most contemporary art historians would say that they created nothing genuinely great. To be sure, some scholars have been led to think otherwise by the sheer volume of documentary material accumulated with genuine German thoroughness in the course of the recent Jugendstil vogue.[131] Thus Peg Weiss, in her abundantly documented *Kandinsky in Munich*, tries to demonstrate that Munich Jugendstil gave a vital impetus to Kandinsky's art.[132] But Kandinsky was simply not shaped by Art Nouveau, whether in its German, Russian, or any other form.

It was definitely not Jugendstil that attracted Kandinsky to Munich. Peg Weiss overlooks the fact that, as an extension of the English Arts and Crafts movement, Art Nouveau came to Russia early. Had Kandinsky been strongly drawn toward it, he would not have felt the need to leave his beloved Moscow and the neighboring arts and crafts colony at Abramtsevo. Abramtsevo had been bought in 1870 by the wealthy patron of the arts Savva Mamontov, who had made it a center for folk art, "new style" architecture, the applied arts, and revolutionary theatrical productions of Russian folk tales and operatic works (the

44 *Franz Stuck*
Poster for the 7th International
Art Exhibition in Munich, 1897
Lithograph, 13⅛ x 18⅞ in
Munich Stadtmuseum

46 Viktor Vasnetsov
Menu for the Coronation of Czar
Nicholas II, 1896
Color lithograph, 34 7/16 x 9 11/16 in
(Detail)
State Russian Museum, St. Petersburg

47 Mikhail Vrubel,
Majolica Fireplace, 1899–1900
Museum, Abramtsevo

48 Viktor Gartmann
[Hartmann],
Studio in Abramtsevo, 1883

49 Maria Tenisheva,
Door in Talashkino, before 1906

50 Mikhail Vrubel,
Panel for the "Gothic
Cabinet" in the House
of the Art Collector
A. Morozov
in Moscow, 1896

first of which was given at Mamontov's Moscow town house in 1878).[133] As early as 1881, Viktor Vasnetsov's setting for Ostrovsky's *Snegurochka* had put Abramtsevo on the cultural map and had paved the way for a renaissance of the Russian theater. It had been based on the then novel concept of a stage production as an organic whole, a stylistic unit, if not a "total" work of art. (This was the tradition that Sergei Diaghilev was to perpetuate. Savva Mamontov had been the first to commission stage settings from artists like Vasily Polenov and Isaac Levitan, rather than from professional stage decorators. Mikhail Vrubel had collaborated on some of his productions, and had early on established a majolica studio (see his first Art Nouveau style works, ills. 47, 50). In a letter dated 1900, Kandinsky cites him as a potential participant in an art exhibition. Yet another Abramtsevo figure was the founder of the Moscow Artists' Theater, Konstantin Stanislavsky, to whom Kandinsky was later to submit his stage composition *Yellow Sound*.[134]

The importance of the Abramtsevo colony's contribution to the fine arts – as distinguished from the applied arts – is debatable. Nevertheless, the Abramtsevo style was characterized by a two-fold tendency which is not unrelated to Kandinsky's early researches in Munich. Firstly, it inclined toward a decorative stylization based on motifs drawn from Russian folklore. This was particularly true of the work of Viktor Vasnetsov, who sought to develop a standard modern style from old Russian themes. Clearly Kandinsky's "colored drawings" (ills. 89–105) are comparable to such experiments. Secondly, the Abramtsevo artists practiced a *plein air* painting that avoided "beautiful" views and effects, much as Kandinsky was to do in the small landscape studies he painted in Munich after the turn of the century.

These comparisons do not mean that Kandinsky was influenced by the Abramtsevo artists, but merely that he may initially have been stimulated by them. He cannot have failed to be aware of their activity before the end of 1896, when he left Russia – he was always on the lookout for artistic innovations. Even if he had missed the birth of Russian Art Nouveau, he would have discovered its existence when he visited Russia later. If Art Nouveau had genuinely interested him as an artist, he would have been content with what Moscow had to offer. But the new decorative art coming out of Abramtsevo, Talashkino, and other artists' colonies in Russia offered him no more of an incentive to stay than did the realism of the Wanderers.

Kandinsky's Phalanx poster of 1901 (ill. 83) is invariably cited as an example of his "Jugendstil art." But there exists a very little-known earlier poster, which he designed for a relative's chocolate factory and had printed in Munich in 1897 (ill. 56). The surface treatment, the stylized forms (areas left uncolored to represent clouds), and the decorative lines of the plants in the foreground, echoing the poster's calligraphy, are clearly Art Nouveau or, as it was called in Russia, "*Stil Modern.*" One is reminded of works

51 *Sergei Malyutin,*
 House in Talashkino, before 1906
 Museum, Talashkino

52 Russian Village, on a River with Boats, *1902*
 Watercolor, colored pencil, and crayon and metallic powder,
 1¹⁵⁄₁₆ x 5³⁄₁₆ in
 Russian text: "This thing is almost the same as the long one,
 only shorter of course. Here, an ornament at the top and at the
 bottom are still necessary."
 Städtische Galerie im Lenbachhaus, Munich

by such contemporary Russian artists as Bilibin, Rerich, and others (ills. 53, 54) or, for that matter, any number of German, Belgian, or English painters of the late 1890s.

Since Kandinsky did not settle in Munich until December 1896, he probably discussed the poster – and showed sketches of it – with his family before leaving Moscow. It seems unlikely that he would have absorbed Jugendstil within a few months, let alone weeks, of arriving in Germany and applied its decorative principles to a work of his own. It simply was not his way of going about things.

It is surely significant that only a small portion of Kandinsky's early posters, woodcuts, and "colored drawings" display any trace of Russian or German Art Nouveau. Interestingly, his fellow Russian painter Alexei Jawlensky, who moved to Munich around the same time he did – and who may have been exposed to Art Nouveau already before leaving St. Petersburg – was never inspired to adopt that decorative style. In any case, Kandinsky's Art Nouveau "phase" hardly lasted and it involved only a fraction of his output. As he himself has said, it was of little consequence to his later artistic development. The best *a contrario* demonstration of this is, precisely, the reproductions in Peg Weiss' *Kandinsky in Munich* and, more eloquently still, the "Munich and Kandinsky" exhibition she organized in New York and Munich in 1984. Kandinsky's early experiments clearly have some superficial things in common with Jugendstil. Within a few years he left Art Nouveau behind without retaining a single trace of its influence.

From the very first, Kandinsky's ambitions lay in an entirely different direction – one that did not as yet exist. Hence his curiosity about everything that was new in art. Now it was precisely the appeal of novelty that drew him to the West. Russian art was just not progressive enough. This was a view he shared with a number of his countrymen who went to study in the West. Many of them came back and settled in Russia after satisfying their curiosity and acquiring technique. Not Kandinsky, who felt, even after several years of living and studying in Munich, that he had still to reach his goal.

53 *Nikolai Rerich [Röhrich],*
 Old Times, *1904*
 State Russian Museum, St. Petersburg

54 *Elena Polenova,*
 Ornament, *ca 1900*
 Museum, Abramtsevo

55 *Elena Polenova,*
 Fairy Tale, *1880–85*

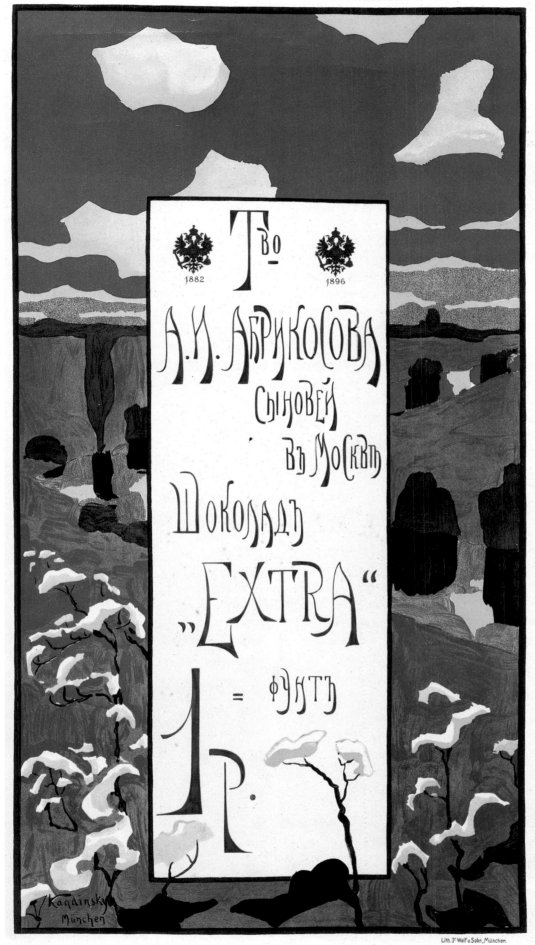

56 *Poster for the Abrikosov Company,*
 1896/97
 Color lithograph
 after a design by Kandinsky,
 27½ x 14⅛ in
 Städtische Galerie im Lenbachhaus,
 Munich

DOCUMENTS

Letter to Dmitri Kardovsky

Munich, March 13, 1901.

The Spring Secession [in Munich] has opened, so stifling, cheap, complacent, and routine that one is disgusted. This arrogant, "brilliant" manner reeks of the swamp. Everyone seems to be clinging to the little he has achieved, and hangs back from taking the smallest step for fear of losing something. Even the "youngest" artists, who get by with the achievements of others, are intent on using this same "brilliant" facture. No new ideas anywhere, no fresh feelings. You write "glum, glum." And what can I answer if not the same?

(Kandinsky catalogue: *The First Soviet Retrospective*, Frankfurt, 1984, p. 47.

I. International Exhibition of the Secession

After a degree of internal confusion and confrontation between the younger members of the Secession and the "old guard" (among whom even Franz Stuck is numbered), perhaps mainly as a consequence of the incipient rivalry with Berlin for the title of "Kunststadt" [city of art], the leaders and organizers of the Munich Secession have evidently decided to put on a special effort this year. After their brilliant debut and comparatively rapid success with the more artistically minded members of the public, the exhibitions of the Secession suddenly appeared to wane. The catalogues contain, for the most part, the names of the same local artists who aroused lively interest in the past. But hanging on the walls, it seems, are the "same old things" we saw long ago, only somewhat faded – pictures that repeat themselves and thus forfeit the luster of the artist's intentions; temperament has been replaced by "method." [...] At the same time, the Secession has stopped trying to attract foreigners to take part in its exhibitions (and it was, remember, the Secession to which, in its day, Munich owed the "discovery" of Scottish, Russian, and Scandinavian artists). Instead, little by little, year by year, the purely local, secessionistic air has begun to stagnate – the air of the "new academy."
[...] Uhde, Habermann, Samberger, Kaiser, Becker, Keller, Reutlingen and, of the younger artists, Schramm, Jank, and Winternitz have altered not a whit; one might well think that they could paint blindfold.

II. Annual Exhibition of the Glaspalast

[...] Dull and muddy in his portraits, this still-youthful artist [Fritz Erler] is both excessively spectacular and forcedly original in his other paintings. It cannot of course be otherwise, an artist who interprets nature so weakly and limply (in his portraits) must invent his subject-matter. [...] Boecklin once said that the true picture "must appear like a great improvisation." May I be allowed to add that it is therefore a matter of complete indifference whether the actual picture was painted in eight days or eight years. I feel obliged to linger upon this point because in Munich of late one finds increasing value being placed on "speed of execution." To comply with this fashion, artists pile up heaps of colors and apply them with quite extraordinary flourish – supposedly to express their personalities. There can be nothing more distasteful and harmful than this kind of artificial technical fad. Real personality does not submit to this kind of approach, but expresses itself in its own terms, eventually demanding attention in its own right. [...].

Vasily Kandinsky, "Correspondence from Munich," in *Mir iskusstva* [The World of Art], St Petersburg, 1902, N° 5/6, pp. 96–98. Translated in CW, pp. 46–51.

CHAPTER TWO
BRIEF STUDIES WITH AŽBÈ AND STUCK

Kandinsky and his first wife Ania arrived in Munich in December 1896 and rented an apartment on Friedrichstrasse, in the artists' quarter of Schwabing. Early in 1897 the artist registered at Munich's most renowned private art school, the academy of Anton Ažbè, which was located close by. There he encountered several of his countrymen, among them his fellow Muscovite and ex-law student Dmitri Kardovsky, who had studied with Repin in St. Petersburg. There too he met Alexei Jawlensky and Igor Grabar; all three men had come to Bavaria a few months earlier, accompanied by Marianne Werefkin. The works of Ažbè's students had seemed to them far superior to those of Repin's pupils and consequently the trio had registered at his atelier. "We were forced to admit that we knew nothing. Ažbè started to teach us something. He was a good teacher," Kardovsky recalls in his autobiography. He and the others seem to have been particularly happy with Ažbè's lessons on "greater form and line."[135]

However, Kandinsky was disappointed. Perhaps, not having been exposed, like them, to academic teaching in Russia, he started out with illusions which they had already lost. His reaction to life studies of heads and anatomies is interesting insofar as he felt that the principles of academic pedagogy did not seem to have much to do with art. Nevertheless he attended Ažbè's classes, albeit irregularly, for about two years. As he notes in *Reminiscences*, he felt conscience-bound to go to the anatomy classes, and even attended two courses; he was particularly impressed with the teacher of the second course, Siegfried Mollier (ill. 57).[136]

Only a few of Kandinsky's student works have survived. A *Male Nude* (ill. 58) in an undated sketchbook was probably done at Ažbè's school. It is the work of a gifted student. The play of fine dark contours – which, like the shadings, are sparing – and the light, stylized crosshatchings are interesting; so is the obvious attempt to find an overall treatment for the feet and hands. Several female nudes (ill. 59), also undated, show greater maturity in their deliberate abstraction of details. They were evidently drawn later.

Anton Ažbè (1855–1905) came from Ljubljana in Slovenia. He had studied at the Vienna Academy for two years before moving on to the Munich Academy, where he spent six years, from 1884 to 1890, and had been a student of Löfftz. In 1891 he had founded his own drawing and painting school. He must have been a remarkably gifted teacher. All of his students have paid tribute to his pedagogic skill. Ažbè not only respected their individual talents, but guided them with gentle and thoughtful criticism. The fact that his atelier produced such radically different artists as Kandinsky, Jawlensky, the Neo-Classicist Kardovsky, Grabar (who later developed a "luminous Impressionism" of his own), the delicate decorative painter

57 *Anatomical Studies, before 1900*
Pencil, colored crayon,
6 13/16 x 10 3/16 in
Städtische Galerie
im Lenbachhaus, Munich

58 *Male Nude, 1897–98*
Charcoal (Sketchbook, 5 1/4 x 8 7/16 in)
Städtische Galerie im Lenbachhaus, Munich

Ivan Bilibin, the illustrator and scene painter Mstislav Dobuzhinsky, the Slovene Impressionists Jama, Grohar, Jakopich, Sternen, and the "wild" Cubo-Futurist David Burliuk, speaks both for his broad-mindedness and his ability to bring out the individual gifts of his students.

Ažbè was a familiar and original figure in Schwabing. Numerous contemporary caricatures depict him as a hunchback or cripple, a regular frequenter of beer and wine taverns, a perennial Virginia cigar jammed between his lips. He taught the art of drawing heads according to the principle of "spherical lines" – which was not particularly new – a method Kandinsky's fellow students seem to have thought of highly.[137] But even here Kandinsky was not wholly satisfied with Ažbè's instruction and sought the advice of more experienced classmates like Jawlensky. "I learned a lot from you then," he wrote to the latter in 1934, "and I shall always be deeply grateful. It wasn't so much a matter of the head itself as of the organic relationships, the unity of the shape which exists only in the 'summary.'"[138] Ažbè's "principle," Grabar reports, was: "Skip the details! Generalize broadly and with expression!" And Kardovsky remembers that he liked to repeat, "Feel your way from the general to the particular."[139].

The method of "color crystallization" derived from the French Neo-Impressionists constituted the more progressive aspect of Ažbè's curriculum. The idea was to place dots of pure colors on the canvas, instead of mixing pigments on the palette, in such a way that they combine in the viewer's eye. But, to judge from Ažbè's own paintings, his approach to this method seems to have been more conservative than that of the French Divisionists (ill. 60). Kandinsky is clearly being generous when he calls Ažbè a "gifted artist and an uncommonly good person."[140]

Indeed, I find it difficult to subscribe to Peg Weiss' thesis that Ažbè was an important teacher and model for Kandinsky, and that the latter's treatment of pure colors, his use of the spatula (Ažbè recommended employing wide brushes), his scepticism about academic rules, and even his subsequent discovery of abstraction, all owe something to Ažbè.[141] Ažbè may have been more progressive than the Munich Academy teachers; but elsewhere, especially in France, even more progressive things were being done; and surely they did not escape the notice of an artist as open to innovations, as searching as Kandinsky. Moreover, if Ažbè's instruction had been all that Weiss claims it was, why did Kandinsky choose to leave his school after only two years? "I too lack knowledge, that's why I'm going to Stuck," he wrote to Kardovsky on March 13, 1901. We know that he had already applied to the Munich Academy, where Stuck was teaching, well before this date.

> He thought everything rather distorted and advised me to work for a year in the drawing class at the Academy. I failed the examination, which only annoyed, but by no means discouraged me [...]. After a year working at home, I approached Franz Stuck a second time – on this occasion solely with sketches for pictures I had not yet been able to complete, and a few landscape studies. He accepted me into his painting class, and in reply to my question about my drawing, he answered that it was expressive.

Today Stuck is esteemed, or rather smiled at, as a Symbolist painter, but at the turn of the century he was regarded as "Germany's foremost draftsman."[142] (The young Paul Klee, who was initially a graphic artist, also studied under

61 *Franz Stuck*, Lost Paradise, *1897*
Oil on canvas,
78¾ x 114¼ in
Gemäldegalerie Neue Meister, Dresden

Stuck.) Stuck's criticism could be harsh, but Kandinsky evidently found it more bracing than Ažbè's gentle advice: "Stuck opposed my 'extravagant' use of color, even in the first studies I made at the Academy, and advised me to paint initially in black and white, so as to study form by itself."[143]

Franz Stuck (1863–1928) was influenced by Böcklin, studied at the Munich Kunstgewerbeschule (arts and crafts school) and stood, very much in the spirit of the times, at the intersection of the fine arts, the applied arts, and even architecture (he designed his own home – now Munich's "Stuck Villa" – down to the smallest detail). Peg Weiss discusses him at length in her book *Kandinsky in Munich*[144] and tries to establish a close affinity between him and Kandinsky, but the result is unconvincing. Concerning Stuck, Kandinsky himself declares: "I wanted to study only drawing with him, since I had observed at once that he possessed little sensitivity to color..."[145] (ill. 61). Moreover, the latter's mythological themes and his pervasive and always explicit eroticism (ill. 62) are quite alien to Kandinsky's artistic personality. There is not even a hint of anything like Stuck's frank, sensuous eroticism anywhere in Kandinsky's oeuvre.[146]

In his tribute to Stuck in *Reminiscences*, Kandinsky mainly remembers one suggestion that had little to do specifically with art, though it is obviously a good rule for any kind of protracted work: that is simply the advice to resist the temptation of putting off doing the dull parts

62 *Franz Stuck*, Salomé, *1906*
Oil on canvas,
45¼ x 24⅝ in
Städtische Galerie im Lenbachhaus, Munich

until later. "He told me I worked too nervously, that I singled out the interesting bit straightaway, and that I spoiled this interesting bit by leaving the routine part of the work until too late."[147] Beyond this item of practical wisdom, Kandinsky's year of study under Stuck does not seem to have provided much of an artistic revelation.

In short, Kandinsky's academic training was both of short duration and, whether under Ažbè and Stuck, of limited value. Apart from the sundry impressions and experiences he received during these years (the old masters at the Pinakothek and the more or less innovative contemporary painters he discovered), and his own experiments and reflections on art, his Munich studies contributed only moderately to his development as an artist. His stunningly rapid progress as a painter owed less to those studies than to what had preceded them: the "Sunday" painting, copying, and absorbing impressions related in Part I. A late starter, Kandinsky had the advantage of beginning as a mature person.

Even so, he felt that he was not making rapid enough progress: "If only I were 20! But I always have the feeling that it's too late for anything," writes the 35 year-old "beginner" (see Documents p. 47).

Perhaps the most valuable thing he got from his brief academic studies was the ambition to do better. This and his experience of the large Munich exhibitions, where young artists were clearly disadvantaged and where the different arts were still strictly segregated, spurred him to found his own artists' association. As early as 1900 he mentions in a letter "the project I have long been nourishing" to create a new association in Munich combined with a permanent exhibition of works from all the realms of arts (see Documents p. 47). The conditions were right and, in 1901, Kandinsky founded the Phalanx.

DOCUMENTS

I arrived in Munich with the sense of being born anew, toil behind me, recreation in front of me: but I quickly encountered a constraint upon my freedom that turned me into a slave, even if only temporarily and in a new guise – studying from the model.
Anton Ažbè's then extremely famous school was, as I could see, heavily frequented. Two or three models "sat for heads" or "posed nude." Students of both sexes and from various countries thronged around these smelly, apathetic, expressionless, characterless natural phenomena, who were paid fifty to seventy pfennigs an hour. They drew carefully on paper or canvas with a soft, sibilant sound, trying to represent exactly the anatomy, structure, and character of these people who were of no concern to them. They used crosshatchings to denote the coordination of the muscles, particular treatments of surface or line to model a nostril or lip, or to construct the whole head "on spherical lines;" and they spent, as it seemed to me, not one second thinking about art.

Vasily Kandinsky, *Reminiscences*, in CW, pp. 373–374.

[…] Kandinsky was not particularly successful at Ažbè's, and he did not exactly distinguish himself through his talent.

Igor Grabar, *Moia zhizn* [My Life], Moscow & Leningrad, 1937, p.141.

[Concerning the "soulless 'Munich school of painting.'"]
Composition is neither striven for, nor demanded by any kind of inner impulse. Naked bodies in the open air, without any attempt at painting. Women lying on the ground with their heels toward the spectator, sometimes with disheveled hair. Geese flapping their wings. Pale women set against rose-colored backgrounds (silver mixed with pink!). And year after year, red-coated huntsmen on dappled steeds jumping over hurdles. The cheerless call of a great fat trumpet: Stuck, Stuck, Stuck! And latterly, the dull thump of the already tiresome drum: Putz, Putz, Putz! This kind of art, or what passes for art, is like a well-made, brightly painted, dead, utterly dead doll – see what the Munich exhibitions have substituted for the live, striking, vibrant, stirring spirit.

Vasily Kandinsky, "Letter from Munich II," *Apollon*, N° 4, January 4, 1910, p. 28. Translated in CW, p. 62.

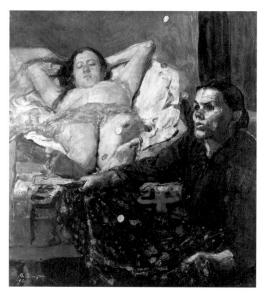

63　Max Slevogt, Danaë, 1895
　　Oil on canvas,
　　Städtische Galerie im Lenbachhaus, Munich

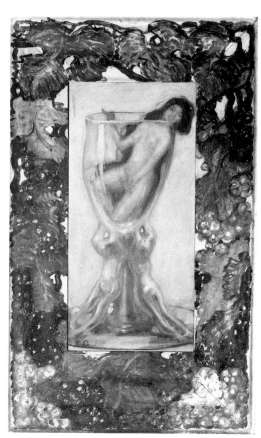

64　Leo Putz, Girl in a Glass, ca 1902
　　Oil on wood,
　　21⅝ x 10¼ in
　　Städtische Galerie im Lenbachhaus, Munich

[…] *For every glowing fire there waits a cooling. For every early bud, the menacing frost. For every young talent, an academy. These are not merely tragic words, but a sorry fact. The academy is the surest means of putting an end to that power of children just described. In this respect the academy puts more or less of a brake on even the greatest and strongest talent. The less-gifted perish by the hundreds. An academically trained man of average gifts is distinguished by the fact that he has learned to recognize the practical-purposive and has lost the ability to hear the inner sound. This kind of person will provide a "correct" drawing that is nonetheless dead.*

Vasily Kandinsky, "On the Question of Form," in the *Blaue Reiter Almanac*, 1912. Translated in CW, I, pp. 251–252.

CHAPTER THREE
LESSONS FROM NATURE: THE EARLY LANDSCAPES

Recalling the drudgery of doing heads and nudes at Ažbè's school, Kandinsky admits that he was at times obliged to force himself to render lines that he found repulsive; he was, he says, in almost continual conflict with himself.

> Only out on the street could I breathe freely again, and I not infrequently succumbed to the temptation to "skip" classes and go off with my paintbox to capture Schwabing, the English Garden, or the banks of the Isar after my own fashion. Or else I woud stay at home and try to paint a picture from memory, from studies, or as an improvisation – a picture that had not a great deal to do with the laws of nature. On this account, my colleagues regarded me as lazy and often as untalented, which sometimes hurt me deeply, for I could clearly feel within me my own joy in working, my own industry and talent. In the end, I began to feel isolated and alienated in this environment, and became all the more absorbed in my own wishes.[148]

It is significant that painting out of doors is the first of Kandinsky's alternatives to academic exercises. Obviously he preferred this unsupervised *plein-air* painting to doing studies. The number of surviving small landscape sketches painted between 1901 and 1907 is a clear indication of this. Kandinsky states that he painted every day, weather permitting, in the outskirts of Munich or the surrounding countryside, and adds that he usually came home with one or two finished studies. He was seldom satisfied with these sketches, however, and says that he "worked" very few of them into pictures. His "compositional" requirements, which were still only half conscious, were exacting almost from the beginning. On the other hand, wandering around with a paintbox, "feeling at heart like a hunter," seemed less of a responsibility to him.

> When sketching, I would let myself go. Giving little thought to houses and trees, I drew colored lines and blobs on the canvas with my palette knife and made them sing as powerfully as I knew how. Within me sounded Moscow's evening hour, but before my eyes was the highly colored atmosphere of Munich, saturated with light, its scale of values sounding thunderous depths in the shadows. Later, especially at home, always profound disappointment. My colors looked weak and dull, the whole study – a vain effort to capture the power of nature.

Did this constant dissatisfaction drive Kandinsky to make more and more sketches? Did he paint them, as Klaus Brisch suggests, to accumulate a stock of optically apprehensible realities to sustain his increasingly abstract-

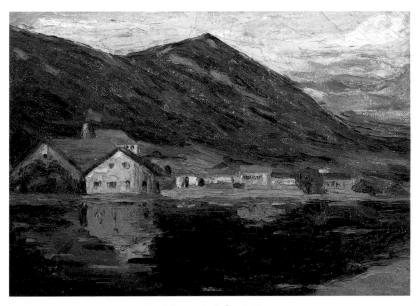

65 Mountain Lake, *1899*
Oil on canvas,
19⅝ x 27½ in
Collection M. G. Maluchina, Moscow

ed pictorial environment?[149] Did he paint them simply because he enjoyed nature – or did he paint them for all three reasons? Whatever the answer, Kandinsky himself goes on to say: "How strange it was to hear that I exaggerated the colors of nature, that this exaggeration made my pictures incomprehensible, and that my own salvation would be to learn to 'break the hold' of color."[150]

He paid no attention to this advice. On the contrary, he searched for a style of his own, one with increasingly vigorous brushstrokes, bold colors, and indefinite color forms. He continued to regard nature as a kind of rival, endeavouring to match the splendor of her colors with his own. It was a contest that must often have driven him to despair, for he loved nature profoundly – unlike Mondrian, who could not abide the opulent green meadows of his native Holland – and he possessed an unusually strong feeling for its beauties. "I would get drunk on nature," he recalled in 1925, speaking of his youth.[151] In his frustration with his own work he not only destroyed many of his paintings, but worked feverishly, making oil sketches, experimenting with the techniques of watercolors, gouaches, tempera, and woodblocks.

As early as *Odessa – Port I*, Kandinsky used a palette knife, though not exclusively, instead of a brush. His next surviving early painting, *Mountain Lake*, signed and dated 1899, was entirely executed with a knife (ill. 65). Its treatment of shadowy water and the as yet relatively realistic handling of reflections is similar to that in *Odessa –*

66 Kochel Waterfall I, *1900*
Oil on canvas,
12¾ x 9¼ in
Städtısche Galerie im Lenbachhaus, Munich

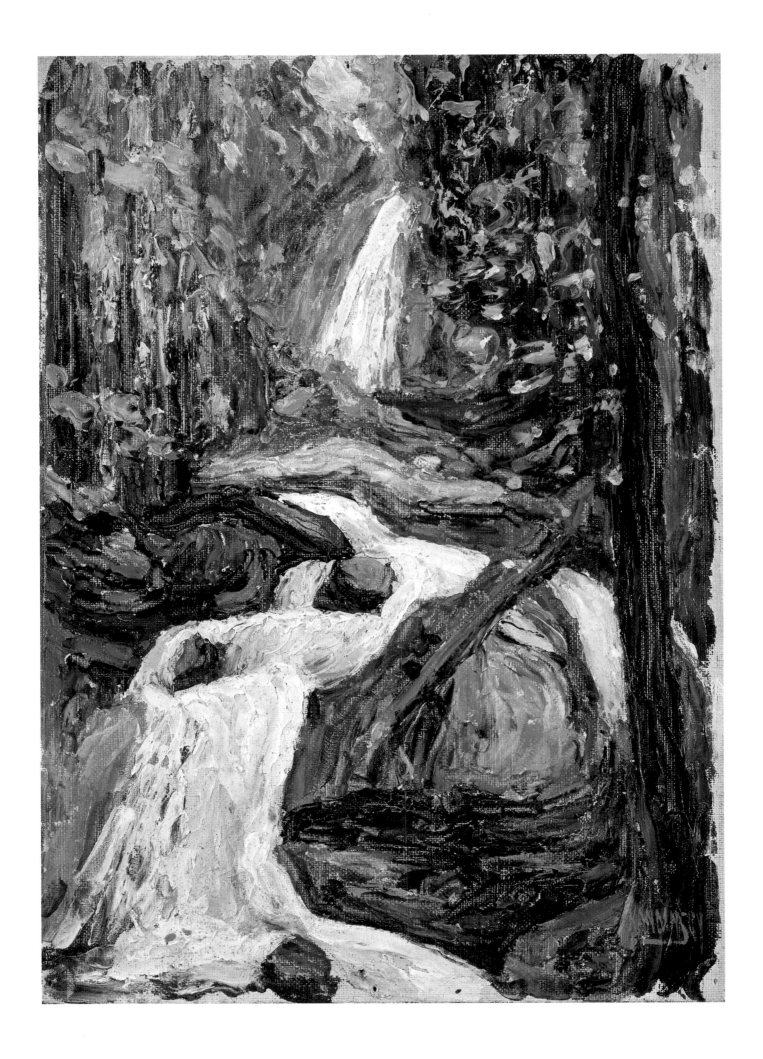

Port I. However, notwithstanding its format, which is that of a full-scale painting rather than a study, it is a sketchier and more rapidly executed picture. Then, too, it is a fairly simple and unassuming painting; the sweep of the palette knife espouses the shapes of the objects: diagonal for mountains, horizontal for clouds, meadows, and the water. The style is uniform and does not yet reveal much of Kandinsky's personality. Owned by a private collector in Moscow, *Mountain Lake* was unknown in the West before 1989. The X-rays and photographs of the surface structure taken at the Tretiakov Gallery show the same layering and color distribution as in authenticated early landscapes like *Kochel – Lake with Grauer Bär Hotel*, dated 1902 (ill. 67), where, however, several patches of water revealed under ultra-violet testing a bluish, fluorescent luminosity that was thought to be a trace of varnish used as thinner. Such additions of varnish give dark colors a luminosity and a particular sheen: recipes found in Kandinsky's notebooks and in a letter dated March 1901, in which he reports "to have discovered a fairly good bond based on varnish," make it clear that he did use this type of additive.[152] Indeed his

earliest studies, like *Kochel Waterfall I* (1900, ill. 66), have a brilliant, varnish-like coloring.

Tests such as these, which are now being conducted in Russia, are giving us, for the first time, a clear picture of young Kandinsky's working methods. In *Kochel – Lake*, the foreground was painted first; next came the water, the lake shore, and the mountains; and last of all, the sky. Kandinsky used the same procedure in most of the pictures he painted around this time.[153] These are not the only technical considerations to interest Kandinsky scholars. Kandinsky, it turns out, primed his smaller canvases himself, as shown by the undulating deformations of the threads on the edges of some of his paintings. Will Grohmann confirms this, declaring that the artist made his own grounds and experimented with such materials as plaster, casein, clay, and ground egg shells.[154] He applied such thin primings that the texture of the canvases he used remained visible even after they were covered by an equally thin first layer of pigment. When painting on unprimed cardboard, he occasionally left areas unpainted and used the natural tones of the support as part of his composition. He would

67 Kochel – Lake with Grauer Bär Hotel, *1902*
 Oil on canvas,
 9⅜ x 13 in
 State Tretiakov Gallery, Moscow

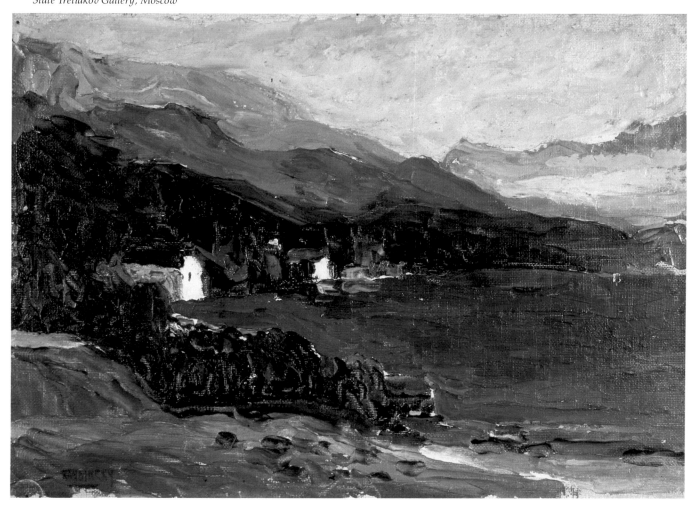

usually first sketch in the primary shapes of his compositions with a pencil, then outline them with dark blue oil paint; only then would he lay down a more substantial layer of color over the first thin coat, structuring and shaping the pigment with a palette knife. He would complete the picture with a few dot-like touches applied with a brush.

Kandinsky employed this technique for some two decades, using it both in his later non-figurative pictures and in his earlier works. And why not, after all? Only in the Soviet Union, where abstract painting has received little attention up until now, is this fact viewed with astonishment.[155] Soviet historians were no less surprised to discover that a dynamic, spontaneous, and obviously fast-working painter like Kandinsky could have painted in such a methodical and even meticulous fashion. They saw something almost dishonest about the fact that the artist created an impression of spontaneity through a series of carefully calculated artifices.

Inspite of their evident "clear logic and thorough elaboration," his compositions were not engendered spontaneously or instantaneously, but were the result of "a painstaking process – and what is more, they were quite often subject to changes during the creative process." Kandinsky was never the anarchist he would have liked to have been.[156]

Still, wasn't his technique an aspect of his pictorial mastery rather than a matter of calculation? After all, one encounters the same sort of approach among figurative painters and other artists, such as musicians, who, in their striving toward great and original achievements, are able to reconquer their spontaneity on a higher plane, so to speak, after an initial phase of meticulous studies and scrupulous craftsmanship. In fact, it seems to me that Kandinsky worked more spontaneously, more rapidly, and with fewer *pentimenti* than many other painters.

Let us now turn to a fresh discovery that recently found its way into a Western European private collection: a canvas entitled *Winter (Schwabing – Nicolaistrasse I)*. It is listed in the artist's private catalogue for the year 1901 under N° 4. It was exhibited that same year at the Phalanx, the following year in Odessa and St. Petersburg, and still a year later in Moscow. The entry is followed by the word "gift." This painting was long considered to have been lost and does not appear in the Grohmann and Roethel *Catalogues raisonnés*, though it will figure in the supplement to that work. The signature is clearly visible and the handwriting on the back of the stretcher is definitely Kandinsky's. It is listed as a tempera painting in the artist's catalogue, but in fact it is a mixed media work, as became evident when it was cleaned. An initial coat of water-soluble tempera is painted on a chalk ground that emphasizes the rough texture of the burlap support. This is covered with an oil or varnish-base paint applied with a brush rather than a knife in thick layers of impasto.[157]

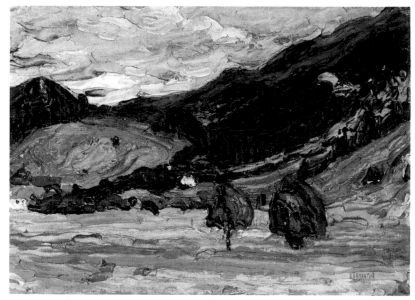

68 Landscape, *1901–02*
Oil on cardboard
9 ¼ x 12 ¾ in
State Museum of Art,
Tbilisi, Republic of Georgia

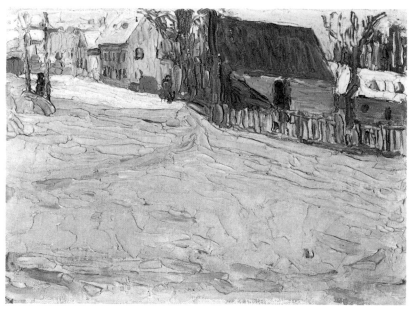

69 Cityscape, *1902–03*
Oil on canvas board,
9 ¹/₁₆ x 12 ⁹/₁₆ in
Museum of Art, Odessa

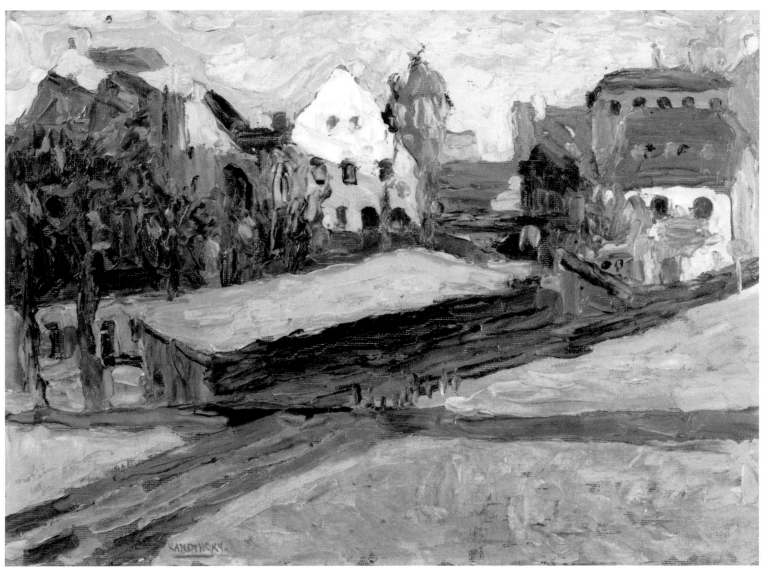

70 Schwabing – Nikolaistrasse in Winter II, *1901*
Oil on cardboard,
9 7/16 x 13 in
Collection Gustav Schürfeld, Hamburg

This painting is a little jewel. There is a sprightly contrast between warm and cold tones; the colors in the sun-drenched upper portion of the canvas have a wonderful radiance characteristic of cold, clear winter days in Munich. Even though the facts and the appearance of this work establish Kandinsky's authorship, it has a few peculiarities which attest to his versatility. An authenticated pendant to this painting, *Schwabing – Nicolaistrasse in Winter II,* produces a more lively impression and displays the typical palette knife strokes of Kandinsky's early work. There is less emphasis on horizontality here than in the newly rediscovered picture with its wide, almost clumsy, quite uncharacteristic fence running parallel to the base of the frame. Even the figures seem unfamiliar (there are no figures in its pendant work): they are less stiff and stylized, more "normal," than the figures in other Kandinskys of

this period. Even the dog looks normal: it is Daisy, Ania Kandinsky's pet.[158]

In *Kochel – Lake* (ill. 67) the artist's knife technique is already considerably bolder, more sweeping, and varied than it was in 1899. Its range includes very short strokes and dots; the colors are brighter and less naturalistic; there are more gradations within the large, circumscribed planes – meadows, lake, mountains, sky.

One can only hope that other oils from the so-called "pictureless years" prior to 1900 will turn up and will tell us more about Kandinsky's early development and the changes in his technique. In the West, the Kandinsky Society is reluctant to authenticate even *Mountain Lake* because there are simply too few other surviving Kandinskys from this period with which to compare it. On the other hand, Moscow's Tretiakov Gallery has unreservedly

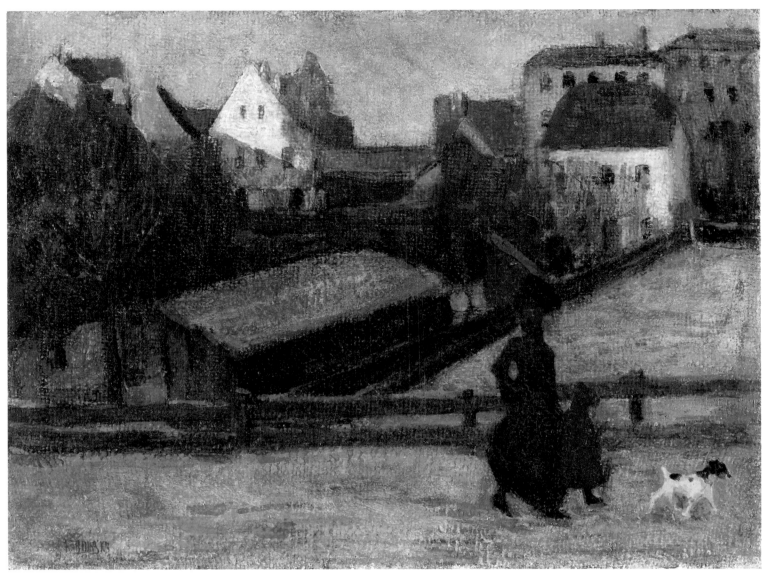

71 Winter (Schwabing – Nikolaistrasse I), *1901*
Oil (?) and tempera on burlap,
12 ¹¹⁄₁₆ x 9 ⅜ in
Private Collection, Germany

accepted the genuineness of both this picture and *Odessa – Port I*. It will be interesting to see how this particular East-West debate evolves and to know if the authorship of these and perhaps other controversial works can definitely be established. Considering what we know about Kandinsky's working habits, it seems unlikely that he would have painted such daring, brightly colored studies as *Kochel Waterfall I* without building up to them with more cautious and traditional oil sketches.

In the small masterpiece *Sketch for Achtyrka, Autumn* (1901, ill. 72) the artist's increasing grasp of technique is evident, particularly in the use of the palette knife. Kandinsky often painted in the neighborhood of this forest lake near Moscow, his sister-in-law's property. The lake is rendered through an interplay of horizontal strokes and short vertical lines running counter to the orientation of

72 Sketch for Achtyrka – Autumn, *1901*
Oil on canvas board,
9 ³⁄₈ x 12 ⁷⁄₈ in
Städtische Galerie im Lenbachhaus, Munich

the color forms. Wildly irregular strokes in a variety of directions suggest trees, while the lone tree by the house is barely indicated at all. Klaus Brisch was the first to give a competent account of the pictorial characteristics of this study, and since his dissertation has often been referred to but seldom quoted, it is worth citing:

> A characteristic feature is the contraction of the firmly delimited color aggregates within which there predominates a single hue varying little in density, tone and luminosity. [. . .] The pictorial effect created by the distinctive surface treatment – i.e. the hatching produced by very short, irregular, curved strokes – is quite different from that of a color surface obtained by means of long straight strokes. It makes for an abundance of contrasts of every conceivable kind,

which are independent of the color surface's objective meaning. Here in the early works, of course, they are largely conditioned by the artist's rendering of optically experienced differences.[159]

Brisch observes interestingly that Kandinsky avoids having structural lines meet the edges and corners of his picture. He interprets this as evidence of the artist's intention to keep the picture plane as flat as possible. Moreover Kandinsky raises the horizon, to offset any sensation of spatial depth. Thus, even in these early sketches, Brisch sees indications of a will to hold the viewer's eye to the two dimensions of the picture plane; and that is why here, as in his later work, Kandinsky pays attention to the pictorial surface and the elements of his composition.[160]

These remarks apply as well, Brisch thinks, to Kan-

73 Old Town II, 1902
 Oil on canvas,
 20 7/16 x 30 7/8 in
 Musée national d'Art moderne
 Centre Georges Pompidou, Paris
 Nina Kandinsky Bequest

dinsky's major early work, *The Old Town* (Rothenburg) of
1902, which Kandinsky himself valued highly and often
exhibited. Its dimensions and the fact that it is a "com-
posed" picture place it among his large compositions. The
first version was painted some time in late 1901, though the
artist dates it 1902 – clearly a mistake since it was exhibited
as early as January 1902 in the Phalanx show. It now exists
only as a reproduction in old catalogues. However, an
almost identical version (ill. 73), painted in 1902 or later, is
still extant.

> I do not know where these studies may be hiding;
> they have vanished. Only one picture has survived
> from this trip, and that is *The Old Town*, which I
> painted from memory only after my return to
> Munich. It is sunny, and I made the roofs just as
> bright a red as I then knew how.[161]

Here too, as in Moscow, Kandinsky sought to capture the "most beautiful hour" when every color is brought "vividly to life." But the artist tells us that the finished composition wasn't executed until after his return from Rothenburg. And indeed his studies (ills. 74–81) have a freshness and vitality that is missing from this painting. Characteristically, the latter is based on a "conscious" compositional scheme: several major parallel lines lead toward the right, whereas the expressive dark shadows point toward the left. As in *Odessa – Port I*, with its remarkable diagonal composition, he carefully avoids horizontal lines – not even for the roofs of the houses. If one compares the ocher area in the foreground with the ocher area on the right side of that picture, one immediately notices a difference in the way the pigment is laid down: in the earlier painting it is applied uniformly over a partly visible dark ground; in *The Old Town* it is painted with distinct separate strokes – a technique that Kandinsky was to resort to increasingly and even more drastically in his oils of the pre-abstract period.

Only a fraction of Kandinsky's oil studies was known in the fifties when Brisch was working on his dissertation. He was not aware of the sketchier, more experimental studies that have come to light since then. These are interesting precisely because they are rough: they reveal Kandinsky "in the raw."

In *Munich – The Isar* 1901, (ill. 75), the bridge's reflections on the water are far less realistic than the water reflections in the two earlier pictures, and the color spots in the foreground correspond only vaguely to natural shapes. The composition recalls that of *Odessa – Port I*, with the difference that instead of a counter-diagonal leaning toward the left we now have several horizontal lines. One major line reaches almost to the lower left corner – an exception to the generally valid rule formulated by Brisch.

Another recent find, so far not listed in any catalogue but undoubtedly authentic, is the charming, utterly spontaneous sketch *Nymphenburg* (ill. 76) with its supremely well-aimed knife strokes. The rendering of the yellowish, shimmering atmosphere and the sparse treatment of the pictorial details make one see why rapidly executed sketches like this were called "Impressionistic." The little sketch *Kochel, Lady Seated by the Lakeside* (1902, ill. 77) is equally rapid and dynamic in its execution. The water is rendered with large clear impasto color bands which animate the lower left foreground and are applied in longer, more serene strokes around the female figure's head. The row of houses on the shore is a masterpiece of simplification; however, the posture of the seated figure is not entirely convincing. The play of warm and cool red tones is particularly audacious. One can see clearly from the treatment of the foreground, especially the little dots of color, how the artist applied pigment with a palette knife in such a way as to produce his characteristic "row-boat" shaped strokes with their thick edges and relatively transparent center revealing the texture of the canvas. The thick impasto and lively, plastic treatment of the surface are characteristic of Kandinsky's palette knife technique.

The Russian tests mentioned above confirm Brisch's observations with respect to many of Kandinsky's early works. Grohmann mentions in passing that Kandinsky sometimes applied colors onto the canvas straight from the tube.[162] This is frequently apparent to the naked eye.

All of the sketches mentioned here were painted on, and make use of, a medium coarse canvas: in spots the canvas is entirely free of pigment, elsewhere it shows through, and gives transparency to an extremely thin coat of paint. This is an intended effect: Kandinsky uses the texture of the support as an additional compositional means.

74 *Study for* Figures on the Beach, *1901–02*
Oil on wood,
4 x 6½ in
Gabriele Münter- und Johannes Eichner-Stiftung, Munich
This tiny sketch was only found in 1992 in the Kandinsky archives in Munich. With its quick brushstrokes it is a first attempt at expressing an idea for a painting. The small red figures seem to be mirrored in water in the foreground, and the green round forms on the edge evoke trees.

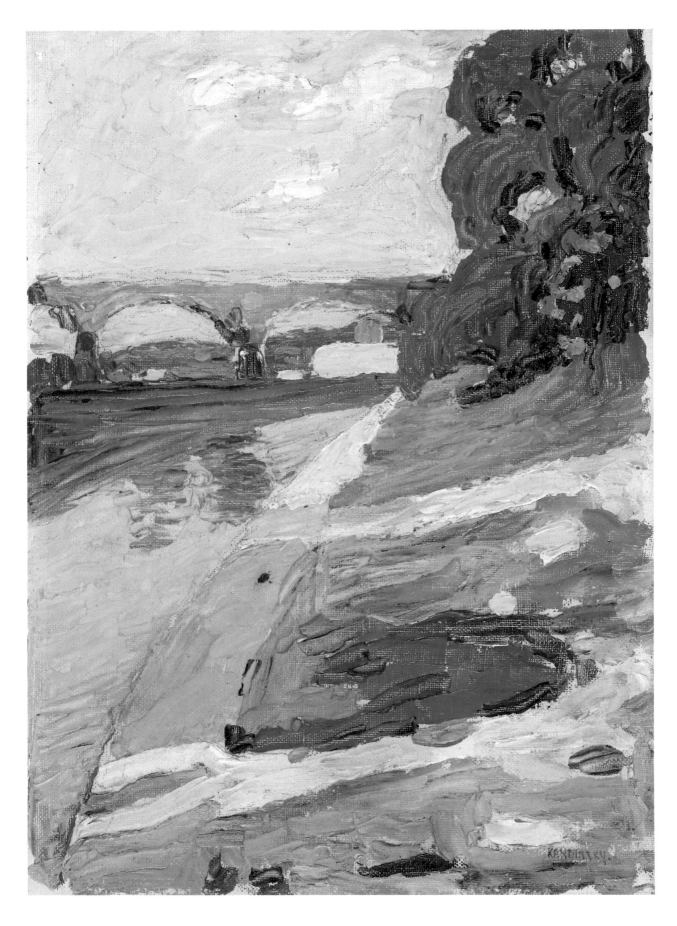

75　Munich – The Isar, *1901*
Oil cn canvas board,
12¹³⁄₁₆ x 9⁵⁄₁₆ in
Städtische Galerie im Lenbachhaus, Munich

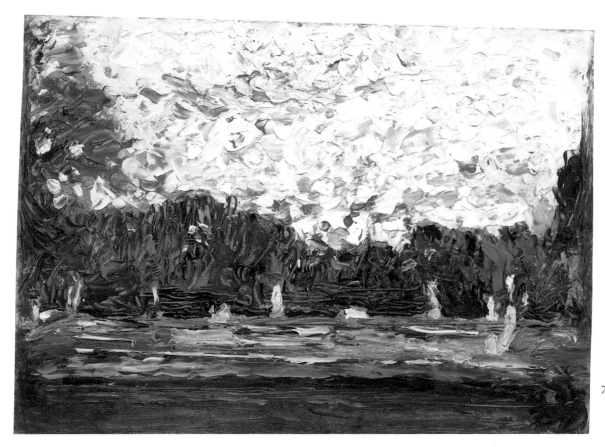

76 Nymphenburg, *1902–05*
 Oil on cardboard,
 5⅛ x 7⅛ in
 Galerie Gunzenhauser, Munich

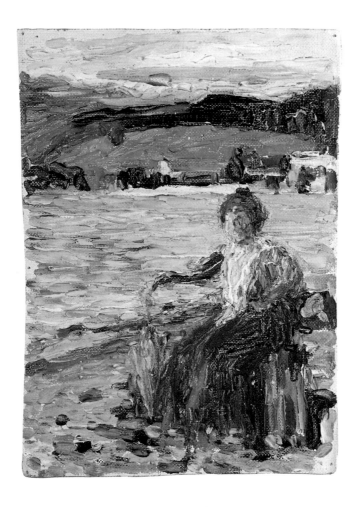

77 Kochel – Lady Seated by the Lakeside, *1902*
 Oil on canvas,
 12⁹⁄₁₆ x 8¹³⁄₁₆ in
 Cortesy Leonard Hutton Galleries, New York

Obviously, Kandinsky employed a broad range of palette knife strokes in this period, but we get no sense of any development or slow change from picture to picture.[163] Consequently we are obliged to establish the date of the studies from evidence in Kandinsky's travel notes, rather than from strictly technical criteria. We find especially short strokes, for example, in the foreground of *Kallmünz – Vilsgasse II* (ill. 78). In this study, red dots stand out against darker areas which just barely qualify as local coloring. The figure in the foreground seems stiff and awkward – as are all the figures in the early oils – as if it were posing for a photograph. Christian Derouet's observation that in his oil studies Kandinsky used mythological references and symbols with Jugendstil motifs, to the exclusion of figures and even, if possible, houses, is clearly erroneous.[164] But figures were always more of a problem for Kandinsky than landscapes, as he himself, as usual openly and objectively recognizing his own shortcomings, readily admitted:

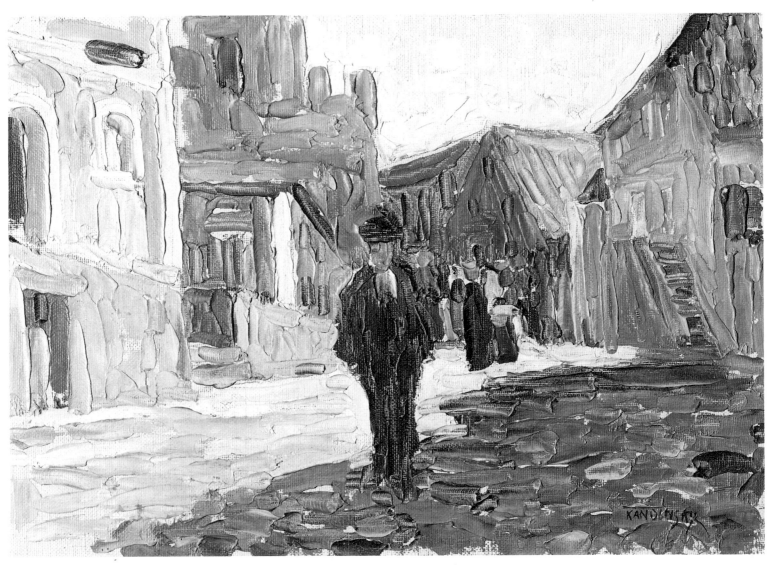

78 Kallmünz – Vilsgasse II, *1903*
Oil on canvas board,
9½ x 13 in
Courtesy Leonard Hutton Galleries, New York

I always found it unpleasant, however, and often distasteful, to allow the figures to remain within the bounds of physiological laws and at the same time indulge in compositional distortions. It seemed to me that if one physical realm is destroyed for the sake of pictorial necessity, then the artist has the artistic right and the artistic duty to negate the other physical realms as well. I saw with displeasure in other people's pictures elongations that contradicted the structure of the body, or anatomical distortions, and knew well that this would not and could not be for me the solution to the question of representation.[165]

Indeed, contrary to the German Expressionists of *Die Brücke* and to many contemporary French painters, Kandinsky never resorted to figure distortion as a stylistic device. Properly speaking, from about 1909 on, the practice of simplifying or reducing the human figure cannot really be said to constitute distortion in this sense (see also p. 325).

79 *Kandinsky 1903 in Kallmünz,*
Photo: Gabriele Münter
Gabriele Münter- und
Johannes Eichner-Stiftung, Munich

As early as 1902, pure landscapes, especially such non-anecdotal themes as a large lake or open sea, inspired Kandinsky to paint strangely "empty" canvases. These works are almost pure color studies and seem very contemporary to our eyes (ills. 80, 81). A trip to Tunisia in 1905 produced several particularly lovely pictures of beaches; their lack of anything resembling a concrete subject places them almost beyond the realm of figuration. They recall August Strindberg's seascapes, especially *Beach View* and *Seascape*, both painted in Passy in 1894; in both, that inspired albeit perfectly professional artist approaches the threshold of abstraction, and would perhaps have crossed it had his pictorial concept not been so deeply rooted in reality. He too, like Kandinsky, was obsessed with color, and he treated it virtually as an independent value. He applied pigments rapidly and energetically in broad, thick strokes with a palette knife (he once declared that he did not own any brushes), yet he clung to such strange remnants of reality as a toadstool. In his 1894 manifesto he makes a statement that resembles an idea Kandinsky was later to formulate: "The art to come (and go, like all the rest!): imitate nature approximately, mainly imitate *its way of creating!*"[166] (We do not know whether Kandinsky saw any of Strindberg's paintings before the turn of the century.)

From year to year Kandinsky's colors become stronger, purer, the constrasts more daring, but in all other respects there is little stylistic development in the landscape studies he painted between 1900 and 1907. One wonders in this connection how good was his knowledge of the French Impressionists and Neo-Impressionists. His early oil studies are often referred to as "Impressionist," but this should surely be taken in the broadest sense of that term. Apart from the choice of subject – often a "fortuitous" fragmentary view – even the smallest oil studies seem to show little awareness of the Impressionists' achievements. Moreover Kandinsky himself writes that the Impressionists' concern with light and air did not particularly interest him; and in general his statements apropos the Impressionist movement, which he considered excessively preoccupied with appearances and physical shapes, are always very succinct.[167]

Neo-Impressionism is another matter. In *On the Spiritual in Art* and other writings prior to 1928 Kandinsky quotes from Paul Signac's *D'Eugène Delacroix au néo-impressionisme* several times.[168] We now have documentary proof that Kandinsky was well acquainted with that seminal work: a notebook in his estate contains eighty-one manuscript pages of a Russian translation of it by a friend from his university days (for more about this hitherto unknown woman see pp. 107 f.). Five early pencil sketches are inserted in this notebook.

Signac's simple and eloquent defense of the Divisionist principle – he rejected the term "Pointillist" – presents the Neo-Impressionists as legitimate heirs to Delacroix. The French artist declares that, in freeing color from the pervasive brown and gray shades of academic art, the

80 *Sailboat, ca 1904*
Oil on wood,
6 9/16 x 3 15/16 in
Städtische Galerie im
Lenbachhaus, Munich

Impressionists went a step beyond that master, but adds that their approach was less scientific. In this context, he also mentions Chevreul.[169] The Neo-Impressionists, who derived their scientific principles from Delacroix, were able to obtain colors having an unparalleled luminosity. They employed the colors of the spectrum exclusively, never mixing them on the palette; instead they juxtaposed pure color dots on the canvas so that they would interact upon the retina of the viewer standing at a certain distance from the canvas. Now Kandinsky, even though his main preoccupation in this early period was precisely with color luminosity, never had recourse to this technique. Nevertheless his knowledge of Signac's treatise may well have helped him develop the characteristic palette knife strokes of his oil sketches, as well as the color dotting in his tempera paintings.

D'Eugène Delacroix au néo-impressionisme is one of the few treatises we are certain Kandinsky read closely (a title jotted down in his notebooks may simply mean that he intended to read the book; as for the volumes in his personal library, a number of them were probably gifts and may never have been read). Kandinsky doubtless sympathized with Signac's statement that he was initially influenced by Monet. And no doubt Signac's, or rather Delacroix's, ideas on art struck him particularly, since they were very close to his own: Nature was, as Delacroix had stated earlier, the artist's "dictionary," but at the same time it was not the artist's task to represent objects as such.[170]

81 Starnberg Lake, *1902*
Oil on canvas board,
9 7/16 x 13 in
Private Collection

Then, too, Kandinsky cannot have failed to sympathize with Signac's critical view of academic art, his anger at the ignorant criticism and vilification of "modern" artists like Corot, Monet and, finally, those "lunatics," the Neo-Impressionists themselves. "The public requires fifty years to get used to something new," wrote Signac.[171] Kandinsky, who received more than his share of abuse from critics, makes similar statements. He may have drawn some comfort from the fact that Signac pointed out that Delacroix esteemed "thinking" artists. Signac's comparison of colors to musical sounds and his remarks about the "moral" uses of color – in other words, its impact upon the subconscious – may have confirmed some of his own beliefs.[172] It was probably in Signac's book that he discovered the pictorial concept of "mini-intervals" between light and dark tones-within-tones, as well as between contiguous warm and cool tones. Later, he would come across this idea again, formulated with greater precision, in music theory, and would see in it a particularly useful means to act directly on the subconscious. It is significant that he would choose to translate and publish Nikolai Kulbin's essay, "Free Music," in the *Blaue Reiter Almanac*.

It is vital to know just when Kandinsky first read Signac's essay if we want to understand his art and ideas. He was studying art in Munich the year *D'Eugène Delacroix au néo-impressionisme* was published in Paris (1899). Excerpts of the treatise appeared almost immediately in the Berlin avant-garde periodical *Pan*, and its then revolutio-

nary concepts were surely discussed by young artists thirsting for new ideas. Kandinsky's fellow student at Anton Ažbè's atelier, Alexei Jawlensky, was by this time already painting in a sort of "Neo-Impressionist" manner which may well have been influenced by Signac (ill. 82). Thus he may well have became interested in Signac's ideas as early as 1899/1900, and may have wanted to communicate them to other Russian artists and perhaps even to the backward Russian public. His mordant "Critique of Critics" (1901) is clearly written by someone well-versed in professional terminology. As for the Russian translation of Signac's treatise in the Kandinsky estate, the handwriting of the manuscript suggests that it was written not long after the publication of the original edition. It is clearly an immature hand, very different from the more "adult" writing of the translator's letters also found in the estate. (These letters are summarily dated with the day and month, but not the year, so one cannot tell when they were written, except for a postcard addressed to the artist at Sèvres, which is postmarked 1906.)

If one compares Kandinsky's early studies with the work of his contemporaries in Munich – Lenbach, for example, and other artists who were still turning out portraits and traditional landscapes – one begins to understand the shock value that the young Russian artist's oils must have had in an artistic environment where browns and grays still predominated. Even Corinth's temperamental landscapes and some of the paintings of the "Scholle"

group with their broad, thickly-painted, but essentially decorative intention are fundamentally alien to Kandinsky's art.

In his "private catalogue" Kandinsky listed 108 small landscape studies in addition to his full-scale "paintings" and "colored drawings." (Quite a few unlisted studies are known to be extant.) He rarely signed or dated these visual "keyboard" exercises. He showed them much less willingly than his "colored drawings," and only one of them, *The Lock*, figures in his 1913 *Sturm-Album*, among twenty-seven paintings done in a different manner. Kandinsky's own opinion of these studies, in his undelivered 1914 Cologne lecture, is remarkably detached. He begins by explaining that "the amateurish period of my childhood and youth, with its uncertain, mostly distressing stirrings, its nostalgia which I was unable to grasp," was the first phase of his artistic development. It was characterized by the simultaneous action of two totally different impulses:

1. Love of nature.
2. Indefinite stirrings of the urge to create.

This love of nature consisted principally of pure joy in and enthusiasm for the element of color. I was often so strongly possessed by a strongly sounding, perfumed patch of blue in the shadow of a bush that I would paint a whole landscape merely in order to fix this patch. Of course, such studies turned out badly, and I used to search after the kind of "motifs" of which each constituent part would affect me equally strongly. Of course, I never found any. Then I would try to make more effective those parts of the canvas which produced a lesser effect. It was out of these exercises that my later ability developed, as well as my way of painting sounding landscapes.[173]

82 *Alexei Jawlensky*, Hyacinth, 1902
Oil on canvas, 29⅞ x 14 1/16 in
Courtesy Jawlensky-Archives, Locarno

This search for "effectiveness" is what Kandinsky's early critics and even many of his fellow artists failed to understand, regarding it merely as chromatic exaggeration; and it is precisely in this that we now recognize the artist's increasingly asserted personality. And yet most art historians regard the early landscape studies as juvenilia having little intrinsic artistic value. The exceptions are Wilhelm Hausenstein who, as far back as 1913, recognized in them a depth and metaphysical dimension that go beyond their figurative subject matter,[174] and Hans Roethel who commented on their remarkable sensitivity and extraordinarily variegated palette. Thus it is perfectly absurd to speculate that Kandinsky embraced abstraction because he had little talent for figurative painting.[175]

The sensitivity and delicacy of Kandinsky's early works was in fact the main revelation of the large exhibition held in 1984 at the Centre Pompidou in Paris; less because of the quantity of smaller works that were being publicly shown for the first time, than because of the shocking contrast between these pictures and their new frames! Someone had had the idea of painting each frame the dominant color of the painting it surrounded. The result was disastrous: not even the most muted, neutral gray-green or faded pink frame harmonized with the artist's delicate, refined, yet sometimes powerful tones.

*He painted landscape studies in a small format, not with
a brush but with a palette knife, massing loud colors onto
small, limited areas. The result was multicolored little
pictures, discordant from the chromatic standpoint. Our
attitude toward them remained reserved and we some-
times even gently poked fun at those "pure color
exercises."*

(Igor Grabar on Kandinsky, in *Moia zhizn.* Moscow &
Leningrad, 1937, p. 141.)

*Everything showed me its face, its innermost being, its
secret soul, inclined more often to silence than to speech –
not only the stars, moon, woods, flowers of which poets
sing, but even a cigar butt lying in the ashtray, a patient
white trouser-button looking up at you from a puddle on
the street, a submissive piece of bark carried through the
long grass in the ant's strong jaws to some uncertain and
vital end, the page of a calendar, torn forcibly by one's
consciously outstretched hand from the warm compan-
ionship of the block of remaining pages. Likewise, every
still and every moving point (=line) became for me just
as alive and revealed to me its soul. This was enough for
me to "comprehend," with my entire being and with all
my senses, the possibility and existence of that art which
today is called "abstract," as opposed to "objective."*

(Vasily Kandinsky, *Reminiscences*, in CW, p. 361.)

83 *Poster for the First Phalanx Exhibition, 1901*
 Color lithograph, 18⅝ x 23¾ in
 (Detail)
 Städtische Galerie im Lenbachhaus, Munich

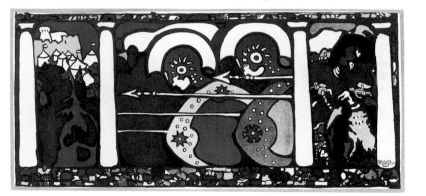

Shortly after interrupting his brief art studies, toward the
end of 1900, Kandinsky began to talk about his long-
nourished project of founding a new association in Munich
that would exhibit works from all the arts on a permanent
basis. Twelve months later this project had come into
existence. Recently available Soviet documents as well as
material in the Kandinsky Archives in Munich show
clearly that Kandinsky did not establish the Phalanx
singlehandedly and that he obtained solid financial back-
ing. To Kardovsky he mentioned having succeeded in
interesting several "benefactors" in his plan; he hoped
consequently to hold the society's first exhibition in the
spring.[176] A manuscript by Gustav Freytag, the son of the
renowned German author, gives details about how the
association was set up and who its patrons were.[177] Freytag,
who was in Munich at this time studying medecine, was the
only non-artist in the association and became its treasurer.
From another unpublished source, a manuscript by the
daughter of the sculptor Wilhelm Hüsgen, we learn more
about the society's membership.[178] Hüsgen and Waldemar
Hecker, who were both active in *Die Elf Scharfrichter* (The
Eleven Executioners), a satirical political puppet theater,
had founded a sculpture atelier some time earlier: the
Phalanx eventually fused with it to make a full-fledged art
school. The painter and illustrator Rudolf Niczky became
the new society's first president.

Freytag reports that the Phalanx did not reflect an
identity of views among its members so much as a protest

> against the [official] jury system and the state of
> affairs within the Artists' Association and the Seces-
> sion. The Secession in particular was accused of being
> elitist and intolerant toward new artistic currents. The
> new society was founded not only with the aim of
> giving disadvantaged artists an opportunity to show
> their works, but also of organizing group exhibitions
> of out-of-town and foreign artists whose work had up
> until then rarely been seen in Munich.[179]

The periodical *Kunst für Alle* commented in its September
19, 1901, issue that the more equitable but "very compli-
cated" jury rules of the Phalanx, as detailed in that society's
statutes, were designed to set up a strictly impartial
selection process for its exhibitions. Artists submitting
works to the Phalanx shows were asked to do so anonym-
ously. Reviewing the first Phalanx exhibition, which had
opened its doors a month earlier, the journal remarked that
"the gentlemen of the jury had indeed made their choices
from a strictly artistic standpoint."

Freytag claims that it was he who came up with the
name "Phalanx," but it was Kandinsky who created the
association's visual identity in a poster (ill. 83) that can be
viewed both as a criticism and a "correction" of Franz von

Stuck (ill. 84, see also ill. 44). In the same way, the organization of the Phalanx exhibition society and art school was Kandinsky's answer to the Academy and, in general, to the official art establishment. While it is true that both artists share the Jugendstil elements of flatness and linear dynamics, their concept of art lay at opposite poles. Stuck's posters, which were highly thought of in Munich, embody the murky atmosphere of the 1890s; Kandinsky's works, on the other hand, express the dawning twentieth century. This would appear to be so obvious that it is hard to understand how anyone can credit Peg Weiss' thesis that Kandinsky was artistically dependent on his celebrated master at the Munich Academy.[180]

In addition to occasional visits by Hermann Obrist and von Debschitz (the founders of the Vereinigte Werkstätten für Kunst und Handwerk), the Phalanx meetings were attended by Herman Schlittgen (the graphic artist of *Fliegende Blätter*), the sculptor Eugen Meier, Franz Hoch, the Bulgarian landscape painter Leon Kojen, and the Russian artist Alexander von Salzmann, the most original of the lot. Salzmann, who "incidentally came from a good family,"[181] was a total bohemian. Freytag relates the following anecdote, which he got from Kandinsky himself: When Salzmann arrived in Munich a few years after Kandinsky, the latter went to meet him at the station, but Salzmann's appearance was so disreputable – even by Schwabing standards – that Kandinsky asked to follow him at a discrete distance on the opposite sidewalk!

Kandinsky always dressed as a gentleman, despite his sympathy for rebels and his own fundamental nonconformity. Tremendous changes have taken place in society over the last hundred years; the upbringing and culture of the turn of the century generation – the strict segregation of classes and castes, the generally conservative bourgeoisie and its rigid code of behaviour – are very foreign to us today; and it is difficult for us to understand how Kandinsky could have been at once so broadminded and such a stickler for respectabilty. Freytag, who admits to having reservations about Kandinsky's paintings and concept of art, always mentions him with deep respect. Kandinsky, he says, rapidly became the Phalanx's spiritual leader and eventually – and deservedly – its president. Freytag and he were long on friendly terms; and their ties within the Phalanx became even warmer when Freytag moved to the Friedrichstrasse where Kandinsky was living with his "uncommonly petite but very likeable" wife Ania. The wealthy Freytag and Kandinsky, who was "by no means destitute," were the pillars of the association; and, in the end, they paid its outstanding debts from their own pockets.[182]

No catalogue was printed for the first Phalanx show. Thus perhaps the most valuable portion of Freytag's manuscript is the following unpublished excerpt:

Kandinsky's were among the most remarkable paintings [at the show]. At this time he was still painting

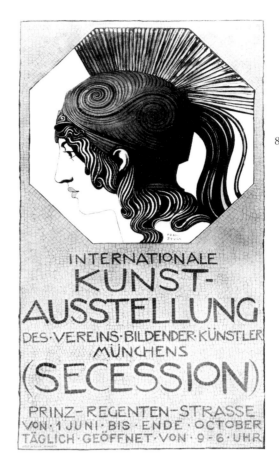

84 *Franz Stuck, Poster for the Secession, 1893 Lithograph, 24³/₁₆ x 14³/₈ in Stadtmuseum, Munich*

altogether figuratively, producing veritable orgies of color; and he then began to study technique in earnest in order to give his paintings ever more luminosity and longevity. But what my as yet untutored eyes saw was a certain carelessness in the drawing and contours. Colors and their contrasts dominated the painting; anatomy and movement played a secondary role [...]. On many occasions Kandinsky offered to give me paintings of his! I steadfastly refused to accept his offers then, and was content to own two very small works of his: a miniature park landscape in a broad white frame and a colored woodcut, *At the Beach*, which depicted a woman sitting somewhat stiffly next to a potted plant, with a band of blue sea shining in the background (see ill. 120).

This is interesting, not only because it is the reaction of a contemporary who was not an artist, but also because of the "broad white frame" which was presumably chosen by Kandinsky himself.

The second Phalanx exhibition included applied art works representing the most progressive movements of the turn of the century, in particular items by the renowned Ludwig von Hofmann (1861–945) and the Russian textile artist Natalia Davydova, who worked with Elena Polenova at Abramtsevo (see p. 56) and had successfully shown at the Paris Universal Exhibition of 1900. Kandinsky's contributions to the show consisted mainly of temperas and

watercolors, among others *Dusk* (ill. 86). The artist also mentions two oils in connection with this event.

Kandinsky's greatest success as an organizer (and surely also the fulfilment of an old dream) was the first Munich show (late 1903) of Claude Monet, the painter whose *Haystack* had made such a deep impression on him seven years earlier in Moscow. In addition to woodcuts and lithographs by other leading French artists – Bonnard, Renoir, Degas, Denis, Toulouse-Lautrec, Vuillard, and Vallotton – as well as the Flemish painters Van Gogh and Van Rysselberghe, the exhibition catalogue lists thirty-one works by Carl Strathmann, thirty-two by the graphic artist Heinrich Wolff, and fourteen by Arthur Stremel.

Early in 1904 Kandinsky showed twenty-four works of the young and extremely gifted draftsman Alfred Kubin, who had become famous overnight the previous year with a portfolio of dark and decadent drawings whose eerie atmosphere shocked yet fascinated many viewers (ill. 85).

The tastes of Munich art lovers were basically conservative and as a result none of the Phalanx shows attracted as much notice as they deserved. The single exception was one of the society's last exhibitions, which caused a considerable stir. Among works by Vallotton, Toulouse-Lautrec, Jules Léon Flandrin, Charles Guérin, Pierre Laprade, Jacqueline Marval, Theo van Rysselberghe, Georges Lemmen, and several young graphic artists who showed their work simultaneously in a parallel exhibition, Kandinsky showed several works by the French painter whose theories had begun to interest him: Paul Signac. *Kunst für Alle* reviewed Vallotton relatively favorably in its May 19, 1904, issue, but criticized Signac's Pointillism sharply: "One step further and the same thing could be obtained with a machine."

Kandinsky had succeeded in breathing a little life into the Munich art scene, but organizing the Phalanx shows had been an expensive and time-consuming business, and he had received no thanks for his efforts.

The Phalanx painting school was opened in the sculpture atelier of Hüsgen and Hecker in the winter of 1901–1902. It did not succeed in attracting a sufficient number of students to make it viable and it closed its doors by the end of 1903. Interestingly, though, Gustav Freytag

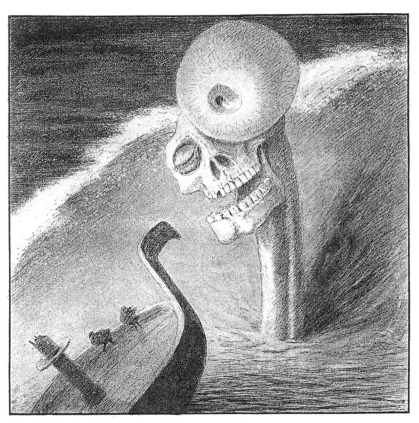

85 *Alfred Kubin, Horror, 1901*
India ink, 10¾ x 10¾ in
Collection Leopold, Vienna

(who evidently taught the anatomy class) states that Kandinsky's "artistic seriousness, pedagogic skill, humanity and maturity [...] attracted growing numbers of studious art lovers." His classes were always lively, remembers Freytag.[183]

Kandinsky taught painting, nude drawing and, once a week, still life. Though he by no means abandoned the classical principles of art instruction, he nevertheless took liberties with them, notably with modelling. Carl Palme, a Swedish student, recalls that Kandinsky recommended getting away from outlines.[184] He goes on to say that

86 *Dusk, 1901*
Gouache, crayon and metallic powder
on gray cardboard, 6⅛ x 18⅜ in
Städtische Galerie im Lenbachhaus, Munich

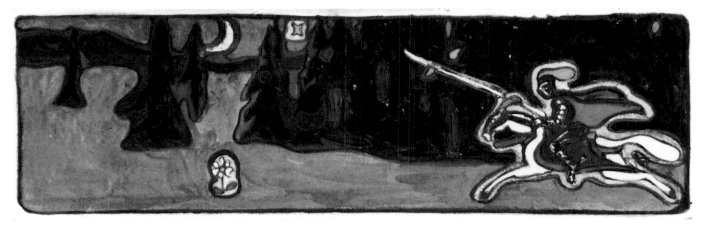

nature studies in Kandinsky's classes were done in the Divisionist manner of Seurat and Signac:

> Kandinsky found his own way to this technique long before he discovered the Neo-Impressionists. Consequently, he practiced Divisionism on a black instead of a white background. He painted beautiful, romantic compositions – often after old Russian themes (legends of saints and such) – with varnish and luminous colors. It then occurred to him to work in the Divisionist manner on black cardboard – like doing mosaics with clear, flat yet luminous tempera pigments.[185]

Kandinsky scholars disagree about whether Palme's reminiscences (which were written long after the events they describe) are reliable and whether Kandinsky did indeed teach the Divisionist technique. The fact is that his own works, and those of his students like Gabriele Münter, show no trace of this. In a letter to Münter he goes as far as to express disapproval of the Pointillist method:

> Frankly I don't think that the dot painting at Jawlensky's is quite right [ill. 82]. Anyone can use this manner, but it is hardly to be recommended as a teaching principle. In any case, I would absolutely not dissuade you from working there for a while, even with dots: as I said, you can pick up something from Jawlensky and later give up his method if it doesn't suit you.[186]

To Kandinsky, the painting classes and exhibition society were not primarily a means of making a living, but a commitment, an opportunity to put his ideas to work and to act rather than merely criticize an unsatisfactory state of affairs in writing. One of the changes he wrought was to admit women. As early as 1889, in his article on peasant law, he had shown sensitivity for the issue of women's rights; in *Reminiscences* he would assail art academies for excluding women and, in 1909 and 1910, he would sharply criticize the *Deutscher Künstler Verband* in Munich for discriminating against foreigners and women:

> In the small print at the bottom of the posters (red, of course) – recently put up by the same society that has invited all artists to collaborate in making preparations for the May exhibition – appears the remark: "Since ladies cannot be members of the society, this invitation does not extend to them." Short and unambiguous.[187]

Not surprisingly, then, the Phalanx's prospectus begins with the words: "Gentlemen and ladies of all ages admitted." As a result of this broadminded policy there were in fact more women than men in the atelier, as is clear from surviving photographs and repeated references to female students in Kandinsky's correspondence. The artist's encounter with the talented, twenty-five year old Gabriele Münter, with whom he promptly fell in love, was a turning point in his life.

Kandinsky was fond of sketching from nature, and during the summer months he organized bicycle excursions with his students (ill. 87), mostly to the picturesque pre-Alpine country south of Munich. During one visit to the Kochelsee in the summer of 1902, he painted small oil studies of at least five different women against the lake landscape, including Gabriele Münter and his wife Ania (with her dog).

The demise of the Phalanx painting school and, in 1904, of its Phalanx exhibition society coincided with a crisis in Kandinsky's personal life, caused by difficulties in his relationship with Gabriele Münter and by the fact that he felt he was not spending enough time on his own work. "Treumann and Obrist keep talking about my nervousness and lay all the blame on the poor Phalanx [...]. Schlittgen too: why don't you let it die? [...] It's a good thing people have this explanation for my state: I hate it when they see what I really feel."[188]

The Phalanx was Kandinsky's first experience of teaching and organizing. Thereafter his life would often oscillate between phases of predominantly creative work and phases of organizing and teaching when he would yearn for tranquility and more time for his own art. The pattern was set as early as October 2, 1903, when he complained to Münter that the Phalanx school was interfering with his creative dreaming, that life was too short, that once again he was unable to see things simply: "My previous calm was of course to a high degree selfishness. But an artist needs to be that way in order to work undisturbed. Perhaps! Perhaps his feelings need to be manysided. What I know for sure is that I mustn't dwell on this."[189]

87 *Kandinsky with his Students, Kochel 1902*
 Gabriele Münter- und Johannes Eichner-Stiftung, Munich

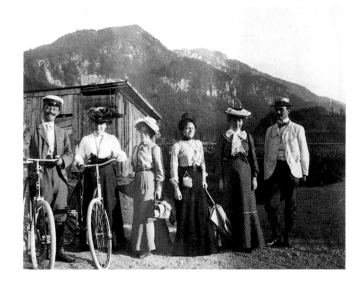

DOCUMENTS

During the carnival of 1902 or 1903 we too had a party in the vast rooms of our house, a "criminal's ball." [Kandinsky] wearing a large colored feather behind his ear, came as a "gangster," meaning a journalist and critic! [...]

We often talked about art when we met with Kandinsky. But the ideas of that rather taciturn man had not yet matured. It was easy to see that his concept of art revolved around color, though he insisted emphatically on the trinity of drawing, color, and composition as the sole basis for any work of art. He was fiercely opposed to all historical painting [...].

I already knew that his political stand was quite on the left. [...] Clearly, he was generally dissatisfied with the conditions in imperial Germany at the beginning of the century. [...] It is not impossible that, after the war, he went to Russia, not as a convinced communist, but simply in the hopes of finding healthy, liberal views and conditions after the collapse of the czarist regime. [...] Kandinsky was always a lively storyteller and enjoyed laughter; he had a sense of humor and what I would like to stress particularly, since there have been speculations to the contrary, he was never depressive or reclusive, at least not when I knew him. He appeared to be a rather positive, self-assured man with serious views and law-abiding thoughts. His manners were impeccable; though his looks were somewhat Asiatic, his behaviour was European, particularly insofar as he had mastered the German language and spoke with only a very faint

88 *Carnival in Munich, ca 1899*
Kandinsky (right) with Nikolai Seddeler
and Dmitri Kardovsky (center, with wig)
Gabriele Münter- und Johannes Eichner-Stiftung, Munich

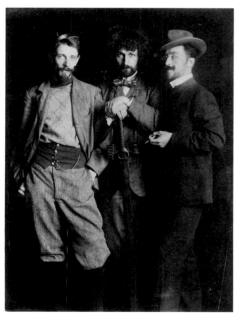

Eastern accent. He was of average height, rather stocky, and wore a dark Henry-Quatre, which he kept trim, dapper and worldly as was his entire appearance, and quite unlike many Schwabing characters.

(Gustav Freytag, memories of the "Phalanx", MS, Städtische Galerie archives, Munich.)

Letters to Gabriele Münter (GM/JE St.)

November 8, 1902

[...] I now have time to dwell a bit on my own thoughts. Up until now, I've felt only something disquieting in me, but I didn't know what it actually was. I seem to do nothing but stupid things; I've forgotten my old ideals; my dreams have become hopelessly confused; the artist in me is dead. No, not dead! But so deeply slumbering that its sleep is like death, could slip into death. Life gives me no rest, it forces its way into me and turns me into a merchant instead of an artist. That is the personal thing weighing on me. But there's something else too: of late, all I've been seeing in people is a lust for murder. And that alters my whole image of nature, the old image I cherished. It makes my thoughts even more confused. I have terrible dreams and scream every night like a lunatic. And I feel lonely in my life. It seems to me I have to get away, far away from mankind. Stupid, isn't it? It would be just as well. After all, I'm unable to give happiness to anyone in this world. I only bring suffering to those I love. Damn, [...] I'm seldom capable of being joyful. But there is joy in my heart, I enjoy life and nature very much, and from time to time I give heartfelt thanks to the unknown power that brings me this joy. One can read this joy in my paintings. But what use is it to others? I don't know how to express everything in me.

January 30, 1903

If I wanted to characterize myself, I would say: constantly, chronically restless. Yes, that is the possibly surprising but strict truth. [...] Not a moment's rest, you understand. Am always excited, my heart always feels different things simultaneously [...]. There's plenty of joy in my heart. I love life so very much.

May 7, 1903

[...] In most of my works: deeply hidden in the joy, sorrow shows its face. And that's as it should be: to me the world, the entire, vast, eternal world is an eternal joy. It will all become clear one day. The suggestions nature communicates to me take shape in a clear large answer. The sorrow hidden in this joy is the reflection of my poor little soul. I want to probe deep into myself again. This open life and public activity have made me petty and vain. Away with all that!

Letters to Dmitri Kardovsky

April 8, 1904

Last week I resigned the presidency, to which Treumann was elected. I am acting provisionally as vice-president in order to help Treumann in the beginning. He will do well, he has been vice-president since January, which has been helpful. In May I will travel through Germany to get a rest, visit shows and look for interesting things on the German art scene, which will be the theme of our Fall line, form, and color exhibition. At our next meeting we will admit Jawlensky as a member. I smile with pleasure at the thought that I will soon be rid of these constant worries about the Phalanx, these never-ending petty details. I have projects, plans and ideas. My hands itch and my heart races. I did only 5 small paintings last winter, 3 are now at the "Berlin Secession," two at home. A few woodcuts, quite a number of color drawings, that's all. Many a seed has ripened in my soul. I am almost ready for a definite picture. I look forward to it eagerly. Perhaps I will succeed in saying with it what so far (except for a small picture which is still at home) I have merely suggested.

March 24, 1901

Lately, I have become strongly attached to tempera, which means that my palette knives are resting and waiting for better times; they are irreplaceable for oils.

(In Kandinsky catalogue. *The First Soviet Retrospective*, Frankfurt, 1989, pp. 51 ff.)

CHAPTER FIVE
THE PAST AS ARTISTIC INSPIRATION
COLORED DRAWINGS AND RELATED OIL
PAINTINGS

An uninformed viewer would probably find it hard to believe that the meticulous "colored drawings" illustrated in this chapter were executed by the same artist, and at the same time, as the spontaneous oil studies that Kandinsky tossed off in his reaction to academic painting. The difference is too great to be explained simply as the result of a beginner experimenting with style. For the first time Kandinsky's artistic versatility, which would characterize his entire output hereafter, becomes evident. It can be viewed as an expression of his rich personality, with its many tensions between such antinomic traits as hypersensitive spontaneity and rational calculation.

Kandinsky himself placed less value on his nature studies in oils than on his so-called "colored drawings," which are in fact tempera paintings. He composed the latter with more thought and greater care; their subjects, decorative elements, and message meant more to him. As it happens, it was mainly their decorative aspect which appealed to his contemporaries, and indeed these romantic paintings, which are infused with the atmosphere of legends, are still favorites. But even though they (and the woodcuts) brought Kandinsky his first measure of public success, he soon understood that this manner of painting would become a dead end for him and he abandoned it suddenly and definitely in 1907. Later he virtually dismissed them as juvenile mistakes. Yet their significance in terms of his subsequent development is by no means negligible. At the time, though, he defended these relatively unimportant and, on the surface, purely decorative works when his new companion, Gabriele Münter, criticized them. Characteristically, he connected them with an insipid little poem which he composed in 1903 (when his grasp of German was too uncertain to allow him to avoid hackneyed rhymes) and entitled: "Song, or Perhaps It Will Be a Drawing on Black Paper." Unruffled by Münter's criticism, he wrote another poem in rhyming verse two months later. The title "Song" suggests that the poem – indeed both poems – were written to be set to music and sung by Gabriele Münter (who studied voice; Kandinsky seems to have helped her in her attempts to compose).[190]

Kandinsky's first dated gouache is *The Comet (Night Rider)* of 1900 (ills. 89, 90). The paint is applied irregularly, and barely covers the dark cardboard support. The result is not very satisfying. The comet is rendered in gold-bronze pigment, in an attempt to enhance the interest of this nocturnal scene by adding a brilliantly contrasting color. But compared to the tempera paintings of the following year, this is obviously the work of an artist who is still groping.

The gouache *Summer Day* (which was rediscovered in 1989 in a Russian private collection) depicts a scene of

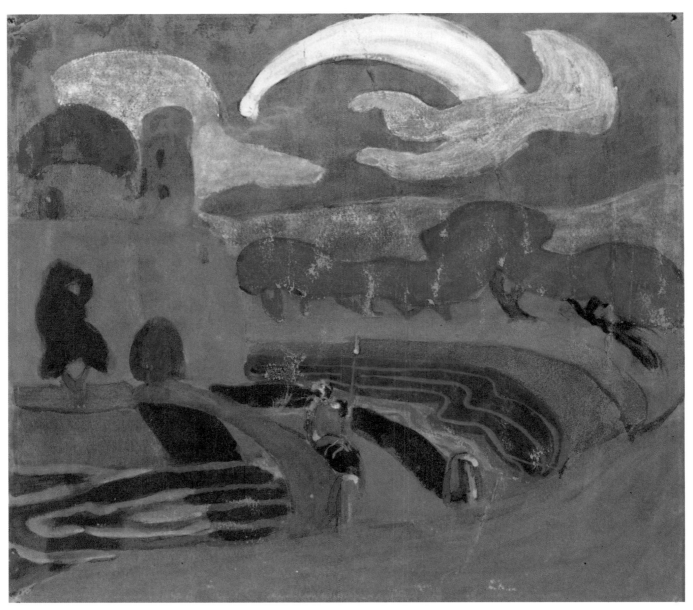

89 The Comet (Night Rider), *1900*
 Gouache on red paper,
 mounted on black cardboard
 7¾ x 9 in
 Städtische Galerie im Lenbachhaus, Munich

90 Night Rider, *1900*
 Sketch, 13⅝ x 8½ in
 Städtische Galerie im Lenbachhaus, Munich

91 Summer Day, *1901–04*
 Gouache on tan cardboard,
 19¼ x 27⅛ in
 Private Collection, St. Petersburg

92 Saturday Night (Holland), *1904*
 (detail),
 Gouache on black cardboard,
 13⅞ x 19¾ in
 Musée national d'art moderne
 Centre Georges Pompidou, Paris
 Nina Kandinsky Bequest

tranquil elegance (ill. 91). The signature is unquestionably Kandinsky's. Under the section devoted to "colored drawings" in the private catalogue he began keeping in 1901, Kandinsky made two entries, either of which might be for this picture: "N° 8, *Promenade*" (which was exhibited from 1902 on and was sold for 300 marks, a price that corresponds to other large colored drawings) and "N° 40, *Summer Day*, aqu./gouache," which was shown for the first time in 1904. From a stylistic viewpoint, the earlier date seems more plausible. The figures and miniature horses in the background are too "true to nature," too delicately and precisely executed to have many equivalents in Kandinsky's oeuvre. The two women with their lively, individual movements and facial expressions are very different from the artist's usual treatment of figures. If they can be compared to any other Kandinsky figures, it is to the two girls on the right in the 1904 gouache *Saturday Night* (see detail, ill. 92). The color dots on the meadow can be read as flowers. The painting accurately renders Munich's English Garden as viewed from the south looking toward the northeast; the brook, monopteron, and woods in the background are unchanged to this day. The tan cardboard support shows at the top and bottom of the picture and in gaps between the colors. The monochrome tones are a calculated effect that serves to emphasize the flatness of this relatively large painting. Alexander von Salzmann, Kandinsky's fellow Russian at Stuck's atelier and the Phalanx, painted in this style, though more decoratively and with a greater wealth of details, up until at least 1910 (by which time Kandinsky had long since developed a very different pictorial manner).

The romance of medieval chivalry was a favorite turn of the century theme which Kandinsky was fond of treating after his own fashion, both in tempera and in large-scale oils. The motif of what he called the "decorative sketch" *Dusk* (ill. 86) he varied many times. The following description corresponds to the subject of *Crusaders* (dated 1903), though the contrast between the colors of a lost tempera or gouache and the two knights (ills. 93, 94) shows that Kandinsky continued to toy with the difficult idea of painting the charging knight in peaceful green and the waiting knight in aggressive red:

> My painting *Kämpfe in Roth und Grün* (Battle in Red and Green) continues to evolve. I might bring the sketch with me. It must be serious, strong and solemn. One knight (green) rushes full of rage at the other (red), who is calm and self-possessed. Background – old, white, prosperous Russian town, stormy sky; in the foreground, a brown-gray path and green lawn with many nicely executed flowers and flowerlets. I am looking forward to this painting and expect a great deal from it. Perhaps the language of the colors is too clear and narrative. No matter! Saw much beauty today in color values – deeply resounding tranquil organ tones.[191]

93 Battle in Red and Green, *1904*
The Rivals?, Tempera (?)
Location unknown.
Photo Gabriele Münter- und
Johannes Eichner-Stiftung, Munich

94 Crusaders, *1903*
Gouache on brown cardboard,
11⅜ x 16½ in
Fridart Foundation, New York

Once again Kandinsky connects colors with sounds! Gabriele Münter relates that Kandinsky associated the theme of jousting knights with music: "Once while listening to Beethoven he saw medieval knights in armor rushing at each other."[192]

Another walled town – a kremlin – appears in the background of *Sunday (Old Russia)* (ill. 97), which depicts several soldiers on horseback advancing from the right, while the left side of the painting is filled with groups of people. The variations on this theme include a nearly identical but larger oil. The "oil study" illustrated here shows a less spotty treatment of color than the final version. Finally, a black-and-white woodcut (ill. 95) of the same subject combines several sharply delimited areas each possessing its own flecked inner structure. One of Kandinsky's letters to Gabriele Münter contains the following informal description of *Sunday (Old Russia)*:

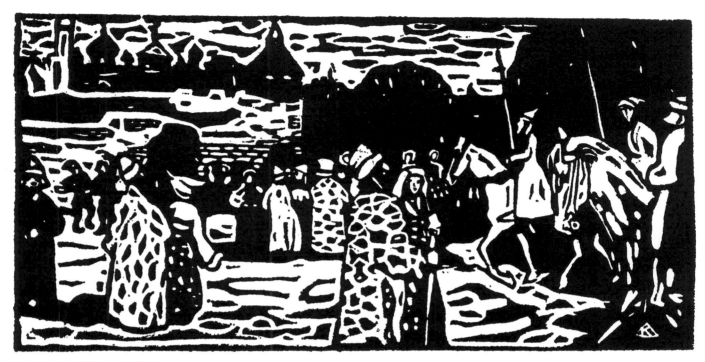

95 Sunday (Old Russia), *1904*
Woodcut, 3⅛ x 6⁹⁄₁₆ in
Städtische Galerie im Lenbachhaus, Munich

96 *Tiny Sketch in Letter to*
Gabriele Münter, February 10, 1904
Gabriele Münter- und
Johannes Eichner-Stiftung, Munich

97 *Study for* Sunday (Old Russia), *1904*
Oil on canvas,
15⅛ x 35 in
Städtische Galerie im Lenbachhaus, Munich

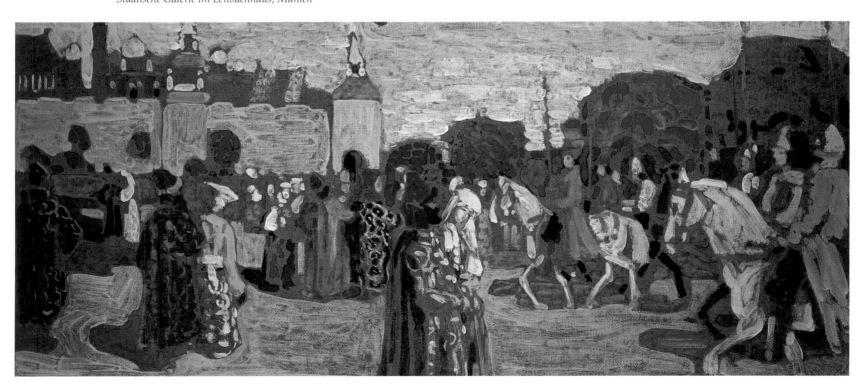

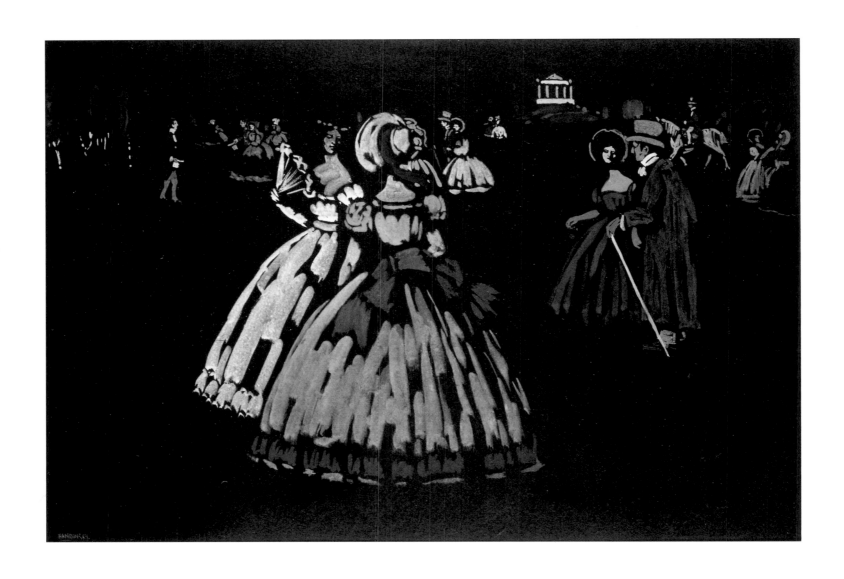

98 Nightfall, *1905*
 Gouache on black paper, mounted on cardboard
 12½ x 18½ in
 Miyagi Museum, Sendai, Japan

99 *Embroidery Design with Sun and Small Apple Trees, ca 1904*
Gouache and white crayon on black paper, 3¼ x 5⅞ in
Städtische Galerie im Lenbachhaus, Munich

100 *Four Designs, ca 1905*
Pencil, 8³⁄₁₆ x 10⅝ in
Städtische Galerie im Lenbachhaus, Munich

Then I looked at my unfinished sun-color composition. I brought the colors back from my brief outing yesterday (I had to go to the Schwabing post office by bicycle and pushed on a ways toward Neu-Freimann) and I incorporated them into an invented old Russian piece.

Passionate, deep, solemn colors which must sound like a ff in an orchestra. Bold, passionate treatment. Good beginning. But it's drying too fast. A pity this technique is impossible in tempera. Perhaps I'll find a solution (February 11, 1904).

Kandinsky did in fact eventually find a solution, as is clear from the large tempera pictures he painted in 1906–1907.

From 1904 on, the treatment of some of Kandinsky's tempera paintings became increasingly "spotty," verging on Pointillism. Eventually the artist adapted this technique to his mixed media and oil paintings, notably his masterpiece *Riding Couple* (ill. 101), a picture he refers to in a letter to Gabriele Münter, dated December 4, 1906:

> In it I have given shape to many of my dreams: it is really like an organ, there is music in it [...] and already twice I have felt that strange quickening of my heart which I used to get so often in the days when I was more of a painter-poet.[193]

After doing several pencil (ill. 102) and tempera studies Kandinsky painted this picture in oils. Yet the dark background and the Pointillism have more in common with his tempera paintings than with his other oils. To be sure, there are elements in the picture that justify the use of dots: the birch trees with their small, round leaves taking on the whole range of autumn tones from yellow to brown and filling the foreground with larger, darker spots as they lie scattered on the earth; a city in the distance, its cupolas appearing as dots on the right and, where they are reflected in the water, trailing off in short, horizontal rows of diminishing points. Even the couple's clothes and the saddle cloth on the horse are broken down into large, different-sized dots.

Color separation into micro-elements of different sizes was nothing new: after all, it is the principle of the very ancient technique of mosaics, where brightly colored stones and a gold background create the characteristic luminosity we associate with that art. Then, too, there is Russian pearl embroidery, a folk art going back many centuries and originally used for decorating church vestments. We know that Kandinsky had several items of pearl embroidery done for him around this time: Gabriele Münter made silk embroideries after designs by the artist, which were exhibited in Paris in 1906 (ills. 99, 100). But obviously the main technical inspiration for such paintings as the *Riding Couple* was the art of the Neo-Impressionists, especially Signac, whose treatise Kandinsky read carefully (see pp. 76 f.). Signac's ideas about increasing luminosity

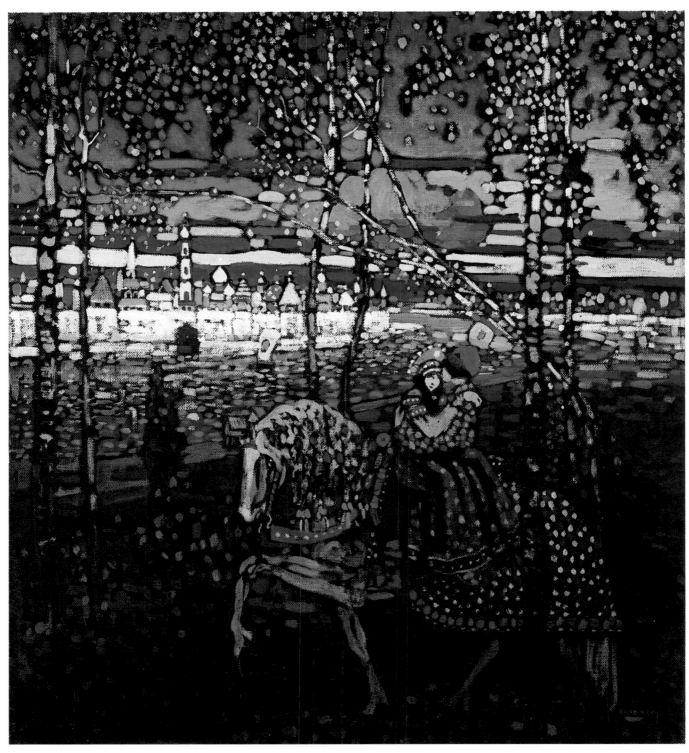

101 Riding Couple, *1906–07*
 Oil on canvas,
 21⅝ x 19⅞ in
 Städtische Galerie im Lenbachhaus, Munich

102 *Sketch for* Riding Couple, *1906*
 Pencil, 7¹³⁄₁₆ x 5 in (sheet)
 Städtische Galerie im Lenbachhaus, Munich

by means of the Divisionist technique are stated very persuasively, and no doubt they found receptive ground in Kandinsky, who was, as we have seen, particularly interested in luminosity. However Kandinsky never actually employed the Divisionist technique on a white background, as did the Neo-Impressionists, at any rate not the way he utilized it in the *Riding Couple* on a dark background. And even in that painting, his most Divisionist work, he varied the size and shape of the dots to a far greater extent than did Seurat, Signac, and their circle. Still, it would be a mistake to underestimate the stimulation that he got from the Neo-Impressionists, as Jonathan Fineberg shows in his excellent dissertation.[194]

How is one to explain Kandinsky's fondness for dark or even black backgrounds? Gabriele Münter recalls that he painted his tempera pictures on the same dark photographic cardboard he employed in his photographic and color experiments.[195] He painted the background a dark color in canvases like the *Riding Couple* and the large tempera *Motley Life*. Not only did he prefer dark backgrounds at this time, but he often left large areas unpainted and gave them a decisive role in his compositions. Why? Kandinsky himself has said that black makes a good background because it "is externally the most toneless color, against which all other colors, even the weakest, sound stronger and more precise."[196] But another possible reason comes to mind, one that Kandinsky himself never mentions. Even non-Russians are familiar with the bright laquered paintings on a black background, for instance the popular works from Palech: decorated broaches, boxes, spoons, and so forth, with their delicate miniature renderings of troikas and other traditional Russian motifs. The pure, bright colors stand out against the black with a particular luminosity and the dark background seems to increase the flatness of the image. Possibly Kandinsky transposed this typically Russian art to his own work. Finally, his black backgrounds are in a sense the equivalent of the gold backgrounds in Russian icons: black and gold both seem more "immaterial" backgrounds than white.

We have Carl Palme's testimony (see p. 82) that Kandinsky began to use black backgrounds even before he adopted – and adapted – the Divisionist technique. It was around this time too that the Russian artist began to experiment with woodcuts, and surely this was no accident: black can be the natural background in a woodcut printed in black and white.

What inspired Kandinsky's pictorial ideas? One valuable clue to this mystery is found in the Russian edition of *Reminiscences*, in a passage where the artist describes certain particularly intense pictorial dreams that frightened him, though they sometimes also gave him tantalizing glimpses of harmonious compositions.

> Once, when I was ill with typhoid fever, I had a very clear vision of a finished picture, but as I got better it somehow began to disintegrate. Some years later I

painted the *Arrival of the Merchants* [tempera 1905], followed by *Motley Life* [ill. 104] and finally, after many years had gone by, I was able to express the essence of that fever vision in *Composition II* [ill. 203].[197]

The *Arrival of the Merchants* and *Motley Life* resemble each other in several ways, though they seem to have nothing in common with *Composition II. Motley Life* was painted in Sèvres in 1907, and Kandinsky says that he chose a bird's eye view so as to be able to superimpose all the elements in the picture. This very large canvas seems unusually flat even though the color contours in the foreground, and thus the figures, appear relatively enlarged. Painted mostly in tempera, it seems to encompass all of life. It is a definitive statement; nothing can be added to it; it brings the series of "colored drawings" permanently to a close.

> It is strange that people see only the "decorative" side of my drawings and take no notice of the content. But I do not want to stress it [i.e. the content] further. The content, what is inside, should be *sensed* only. I find too obvious a content unbeautiful, unsound, unsubtle. It should almost always be a homogeneously beautiful form (artistically "beautiful" of course, thus perhaps "unbeautiful" to the uninitiated). One should not constantly be obliged to see the beauty of the thing right off. Some things should seem incomprehensible at first. So that the beauty then shines through. And only then will what is inside become apparent to those who possess a fine sensitivity. The thing must "ring." Through its ringing one comes by and by to the content. But the content should never be too clear or too one-sided. The more one leaves to be guessed at and interpreted, the better. Various contrasts of form-feeling can best be combined when one has a deep, serious content. The deaf and the blind will quietly walk past without noticing anything. It is bad

103 Gomon (Arrival of the Merchants), *1903*
Woodcut, 2¾ x 6¼ in
Städtische Galerie im Lenbachhaus, Munich

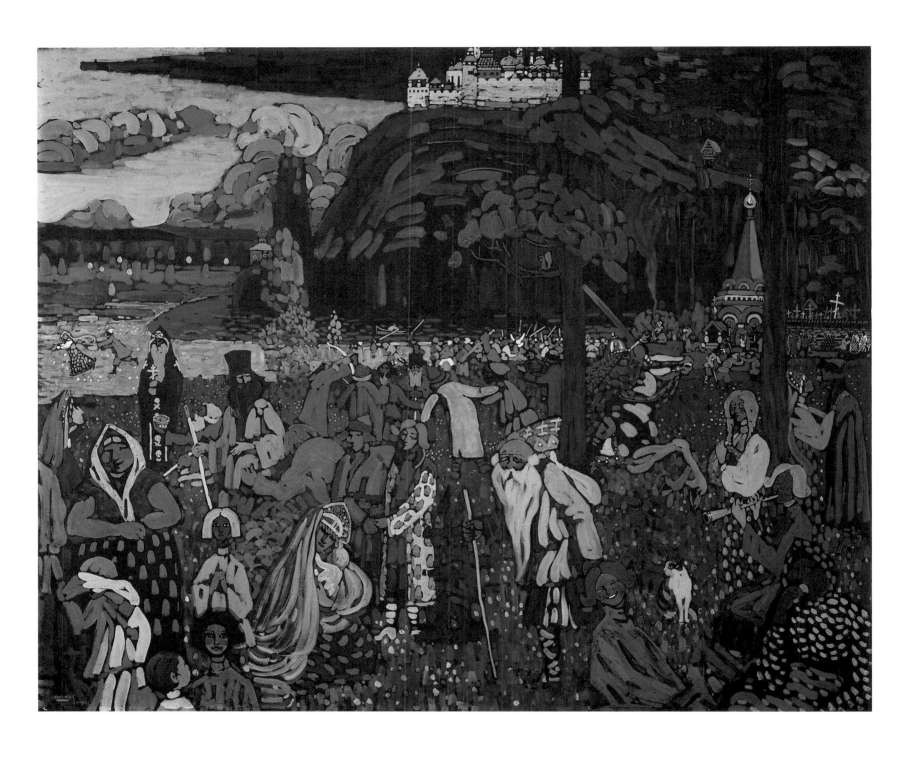

104 Motley Life, *1907*
Tempera on canvas, 51⅛ x 64 in
Städtische Galerie im Lenbachhaus, Munich

when they notice something: for then the content is surely base, cheap. There you have my philosophy of art, which as a rule I am averse to talking about.[198]

Kandinsky's elitism, his refusal to see the folk and fairy tale themes of his "colored drawings" as mere motifs or illustrations, is evident here. Clearly the abstruseness and ambiguity of his pictures is a deliberate choice, a calculated stategy in an ongoing revolt against the ultimately explicable. Hereafter his entire oeuvre will reflect this choice.

Apropos his experiments with mixed media, he thus once remarked (but anyone who expects a clear explanation from the artist will be disappointed):

> What I call a "watercolor" is not really a watercolor, for I combine different techniques; for example, several [of my] watercolors are painted exclusively with oils or gouaches or distemper or pigments I myself mix, or else they are painted using several media simultaneously on a single sheet. (Similarly, what I call an "oil" is not always painted with oils, but with the same combinations.)[199]

Even here Kandinsky shows himself to be an anarchist or, at least, an antipurist.

Nor is this unconventional technique really at odds with the medieval, Rococo and romantic-chivalric inspiration of the "colored drawings" and woodcuts. That the future inventor of abstraction painted pictures of knights is no contradiction. Chivalric themes were fashionable not just among the Pre-Raphaelites, but generally in late nineteenth and turn of the century art. The French Symbolists were enthusiastic readers of German romantic poetry and philosophy and made a cult of Richard Wagner. Kandinsky presumably read the German romantics too, and was certainly familiar with Wagner's operas and the dramas of the Belgian poet and playwright Maurice Maeterlinck. The paintings of Böcklin and Stuck must have presented a challenge to him, and it is not surprising that he should have been drawn to the same type of historical and legendary themes they unfolded, though he treated them in an entirely independent manner. In Russia ballets based on folk tales were an established genre. Russian painters, particularly those of the Westernized St. Petersburg school, tended to paint large decorative canvases based on chivalric and folk themes.

The leading Russian art journal, *Mir iskusstva* (The World of Art), to which Kandinsky contributed reviews from Munich in 1902, published work by Mikhail Vrubel (whom Kandinsky thought of highly) and such younger artists as Alexander Benois, Konstantin Somov, Ivan Bilibin and others (ill. 108–112). Thus Kandinsky had a substantial "historical excuse" for employing themes and subjects that seem retrograde and nostalgic to us. Still, one wonders why he who as a rule was so independent swam with the current in this instance?

105 Madonna, *1905*
Sketch for mural painting,
Tempera, 35 7/16 x 39 3/8 in
Location unknown.
Photo Gabriele Münter- und
Johannes Eichner-Stiftung,
Munich

106 *Design for* Madonna,
Letter to Münter of
September 19, 1905
Gabriele Münter- und
Johannes Eichner-Stiftung,
Munich

The arts, we read in *On the Spiritual in Art*, "turn away from the soulless content of modern life, toward materials and environments that give a free hand to the nonmaterialist strivings and searchings of the thirsty soul." Thus, says Kandinsky, "the past, inasmuch as it is something that no longer exists in reality, gives me the freedom to use the colors I feel within myself."[200] Color, again! No mention of lines and contours: they belong to the prosaic realm of the "recognizable." It is the artist's way of ducking the troublesome issue of verisimilitude, for what resemblance can there be between a fairy tale and reality? What are a legend's "real" colors? Maeterlinck had answers to these questions – by no means the answers of a positivist – and we know that Kandinsky particularly admired him: he owned first editions of the Belgian writer's books and quoted him several times with deep respect in his own writings. A few lines beyond the passage just cited, he describes Maeterlinck's method thus: "He builds up this [spiritual] atmosphere by purely artistic means, whereby material means (dark castles, moonlit nights, swamps, the wind, owls, etc.) play a more symbolic role and are used more as inner sounds." A statement which could apply as well to Kandinsky's tempera paintings whose evocative motifs and colors create a dreamy atmosphere, a climate of mystery and uncertainty inviting introspection. One cannot do justice to Kandinsky if one tries to identify specific legends or historical events behind these pictures. He deliberately combines invented elements with motifs borrowed from books or museums. His main purpose was to distance himself from the present, from the experience of

107 *Details of Horse (Bridles) and Female Costumes, ca 1900*
Pencil, 5⁹/₁₆ x 9⁵/₁₆ in
Städtische Galerie im Lenbachhaus, Munich

108 *Konstantin Somov,*
Untitled
Color autotype, before 1913
in: Mir iskusstva
(World of Art)

109 *Cover of the St. Petersburg Art Journal* Mir iskusstva *(World of Art)*

111 *Ivan Bilibin,*
Illustration of the Fairy Tale
Beautiful Vassilissa,
1899–1900

110 *Konstantin Somov,*
Lady with Dog, *before 1910*
in: Apollon *Nº 3, 1910*

112 *Ivan Bilibin,*
Princess in the Tower
Illustration for
The White Duck, *1902*

the quotidian, in order to avoid reproducing a definite moment, as the majority of his contemporaries were still doing.

The leading Kandinsky scholar Hans Roethel speaks of a Raphaelesque *certa idea*, a precise though as yet indefinable artistic vision,[201] tending very early in Kandinsky's oeuvre toward abstraction. The "colored drawings" were a first step in this direction, even though in some ways they seem to constitute an isolated step. An artist's imagination ought to reach further than reproducing reality, no matter how subjective the reproduction. A painter ought to be as free as a musician or poet.

Kandinsky's treatment of the human figure in the tempera paintings is less problematic than in the early landscapes. There is an increasing stylization, a "typing" that goes far beyond the personal element. Considering the subjects he chose and his own artistic evolution it would be a mistake to expect him to be still concerned with verisimilitude. Yet this is precisely what seems to have bothered Dmitri Kardovsky, who wrote to him in 1907 to congratulate him on the progress he was making in his new works (several photographs of which he had seen), but to complain also about the absence of any "personal trait" in his Russian figures. Kardovsky clearly considers "the expression of the personal" in these paintings as "too weak." Kandinsky commented on this in a letter to Gabriele Münter (June 23, 1907). We would expect him to say that this is precisely what he wanted to avoid, that his own intentions had nothing to do with the manner in which Kardovsky and other contemporary Russian artists were working. Strangely enough, though, Kandinsky, who had obviously made more progress in practice than in theory, wrote instead: "Well, he's right there. I still feel like an idiot when confronted with this problem." It was only a year or two later that he began to see where his own path was leading. As late as 1909 he complained, in a remark that incidentally tells us how he viewed the figures in his own pictures, "I want something, but what? I have a longing – but for what? I myself don't know. I feel like the figures in my paintings."[202]

CHAPTER SIX
GRAPHIC WORK

Surely it will come as no surprise to the reader to learn that Kandinsky applied the principle of a "disorder of techniques" to the graphic arts as well. What he termed a "woodcut" is in fact often a lino cut. (I will continue to use his term for both.) The woodcut technique limits artistic expression in almost every way. The format is reduced; cutting the block is a laborious process, one that makes it difficult for the artist to render small details; the colors are basically limited to two (usually black and white); and the medium itself is ill-adapted to expressing depth through perspective. In woodcuts of landscapes, space is usually indicated by horizontal bands which partition the picture plane. Lines and colors are entirely subordinated to the plane. In *Point and Line to Plane* Kandinsky observes that interest in woodcuts began in the late nineteenth century with the "sudden awakening" of interest in the art of the plane.

Yet it was through these limitations that Kandinsky achieved his first masterpieces. Like his "colored drawings," his woodcuts include many lovely and original, somewhat romantic or folkloric minor works, as well as pictures of a supreme pictorial and technical quality.

Perhaps the year he spent working with the Kushnerev printing firm in Moscow paved the way for his own graphic work. In any case, from 1902 on, he wrote several times to Gabriele Münter (who evidently did not share his enthusiasm for this medium) to tell her about the joys of woodcutting.

> More about woodcutting. You see, leaving aside the issue of success and sales (which can never come first with me), [...] there are artistic purposes involved here which you do not understand because they probably are not as yet expressed with sufficient energy. But do not attempt to hold me back. I am incorrigible as far as this goes, pigheaded and particular about even the smallest detail. It is utterly impossible to influence me in any way in this matter. And do not question me either about the usefulness of this or that type of work: they all have the same usefulness – I must do them, for I cannot rid myself of my thoughts (or possibly dreams) any other way. I do not envisage any practical use. I simply MUST do the thing. Later you will understand better. You say this is playing! Yes indeed! Everything an artist does is also merely play. He wracks himself, tries to express his feelings and thoughts, speaks with colors, shapes, drawing, sounds, words, etc. Why? A big question! [...]. This is why I do all the things I MUST do: it is ripe inside me and it MUST find its expression. When I play like this, every one of my nerves trembles, music rings through my whole body, and God is in my heart. I don't care a bit about whether it's difficult or

114 *Kandinsky in Dresden, 1905*
with his Woodcut Promenade
Photo: Gabriele Münter
Gabriele Münter- und
Johannes Eichner-Stiftung, Munich

113 Night, *1903*
Woodcut, 11⁹⁄₁₆ x 9⁷⁄₁₆ in
Städtische Galerie im Lenbachhaus, Munich

115 Promenade, *1904*
Woodblock with watercolor,
8¹⁵⁄₁₆ x 23³⁄₁₆ in
Thomas Gallery, Munich

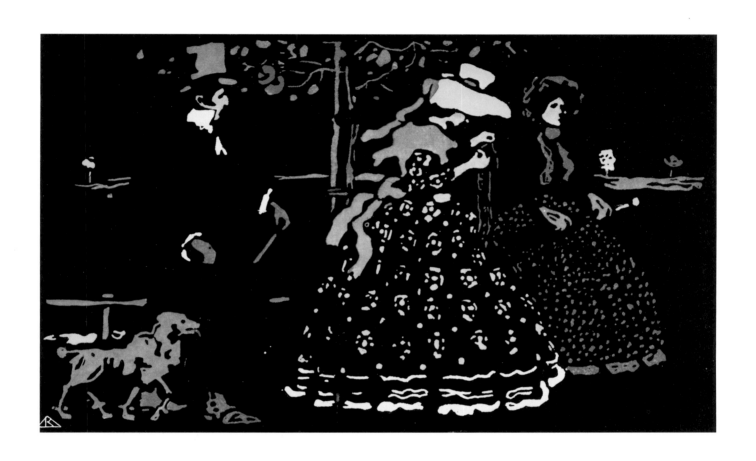

116 Promenade, *1902,*
 Color woodcut,
 5⁷⁄₁₆ x 9⁷⁄₁₆ in
 Städtische Galerie im Lenbachhaus, Munich

easy, useful or not, or how long it will take. And from time to time I even meet people who are grateful for my things, who get something out of them. A well-known Russian painter came to see me yesterday and told me that my long lady with child [ill. 117] put him in a good mood for a whole day; he kept seeing it in front of his eyes, and he finally went back to Litauer [a Munich art dealer] and bought it so as to be able to continue to enjoy it. And this makes me glad too. [...] That you should be especially demanding pleases me a great deal, really a great deal, but do not expect everything from every work I do for, first of all, that would simply not be feasible, and even if it were, it would be detrimental and bad for the work. The best example of this is Munich art.[203]

Thanks to Hans K. Roethel's monumental study of Kandinsky's graphic work,[204] this aspect of his oeuvre is extremely well documented. By carefully examining the woodblocks, one can see that when doing woodcuts in a small format the artist used end-grain wood and, up until 1908, special water colors (for example, the Japanaqua pigments manufactured by the firm of Günter Wagner in Hanover). He was apparently familiar with Japanese woodcuts. The Munich painter Toni Stadler owned a large collection of the latter, including color prints. Emil Orlik, an artist Kandinsky exhibited with at the 1903 Berlin Secession exhibition, had visited Japan a year earlier in order to study Japanese colored prints, particularly the technique of shading and bleeding one color into another using the same woodblock. We learn from Roethel that Kandinsky was also acquainted with the graphic work of Felix Vallotton. He exhibited that artist at the 1904 Phalanx show, and may have been influenced by him. It is clear from his own woodcuts that he was interested in experimenting with different techniques. Thus he sometimes used a separate contour block to produce striking contrasts between saturated black outlines and his favorite soft watercolor tones.

Even his very small vignettes reveal his mastery: in fact, the more reduced they are, the more masterful they seem. The black lines and areas in the black and white prints may represent outlines, shadows, surfaces, or areas of darkness; the white ones suggest either space, surfaces, contours, or light. When executing larger size prints, Kandinsky sometimes combined several blocks.[205]

What did Kandinsky mean when he wrote (in 1906) that he recalled having once been more of a "painter/poet"? Perhaps he was referring to his wonderfully poetic woodcuts published in Moscow in 1903 in a slim, precious volume entitled *Poems Without Words* (ill. 118), which contains sixteen handmade and hand-glued prints (suggesting a very small print-run). This book combines several motifs from the "colored drawings" Kandinsky had painted earlier, was painting around this time, or was soon to paint. It also contains examples of the kind of Pointillism

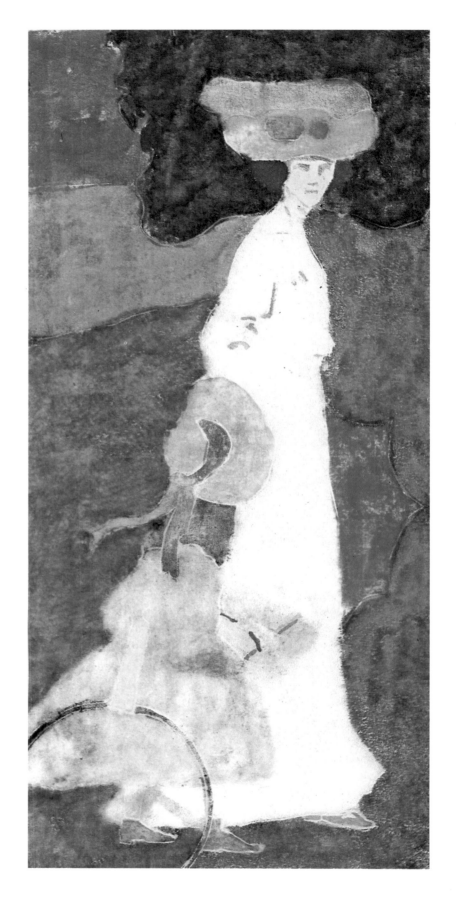

117 A Summer Day, *1904*
Color woodcut,
12¼ x 5⅞ in
Städtische Galerie im Lenbachhaus, Munich

118　*Cover for* Poems Without Words, *1903*
Woodcut 9 1/16 x 6 5/16 in
Städtische Galerie im Lenbachhaus, Munich

119　Eternity, *1903*
Woodcut,
2 5/16 x 3 1/8 in
Städtische Galerie im Lenbachhaus, Munich

120　At the Beach, *1903*
Color woodcut,
12 3/16 x 12 1/8 in
Städtische Galerie im Lenbachhaus, Munich

he practiced from 1902 on (ill. 116), as well as prints based on abbreviated, closed forms like those in the masterful *Eternity* (ill. 119), which concludes the volume. A single print dating from the same year repeats the theme of the "colored drawing" the artist presented to Gustav Freytag (ill. 120, see p. 80).

Chivalric motifs appear in a number of woodcuts. The *Farewell* (ill. 121) from 1903 is a stylized scene showing a charger, its silhouette barely indicated, led by a knight in armor taking leave of his mistress. The youth's profile is the type favored in German and Russian fairy-tale illustrations: a straight aristocratic nose, large, beautiful eyes and a dauntless virile chin. It has been said that this is a portrait of the poet Stefan George, but that is doubtful. Portrait painting was something utterly alien to Kandinsky (see p. 107) and his striving toward the type or the generalization (before becoming a search for abstraction) precluded any concern with rendering an individual resemblance. Surely this should be obvious to anyone knowledgeable about Kandinsky's art and ideas, yet the theory of the Stefan George "portrait" is repeated in a major monograph, a catalogue, and a scholarly paper.[206] Kandinsky painted only one portrait during his life, that of his companion Gabriele Münter. We do not know of a single self-portrait by him. His depictions of Münter or other figures in a landscape are never "personal." Their faces are always deliberately rendered in such a summary way that

121 Farewell *1903*
Color woodcut,
11⅝ x 12¼ in
Städtische Galerie im Lenbachhaus, Munich

122 Green Women, *1907*
Color linoleum cut,
4 11/16 x 9 1/4 in
Private Collection

the question of whether they may or may not be likenesses is irrelevant. The faces in his woodcuts and "colored drawings" tend to be conventional and stylized: they are types, like his stage figures or the "super-puppet" Edward Gordon Craig speaks of (p. 143). This lack of interest in, verging on an aversion for, verisimilitude is a coherent and fundamental aspect of Kandinsky's concept of art: "I do not require a fairy tale like 'The Seven League Boots' or 'Sleeping Beauty'; I do not require an 'objective fantasy,' but merely the strictly pictorial fairy tale, which only and exclusively unfolds painting through its own reality."[207] Besides, neither the knight's hair nor his type of beauty correspond in any way to Stefan George's. And why George of all people? No matter how spiritual and transcendent, George's pathos seems totally foreign to Kandinsky's clear, modern, at times almost insolent idiom. It belongs to Stuck's world, the twilight of the nineteenth century, whereas Kandinsky is inherently a twentieth-century artist. If Kandinsky had had any interest in George, he could easily have asked their common acquaintance Karl Wolfskehl to introduce him to the poet – after all, he introduced himself to Kulbin and Arnold Schönberg – but in his own writings he never mentions George.[208] It was also not his style to indulge in vague hero worship or to render homage from afar to someone he admired.

Kandinsky had connections in Paris as early as 1904. In October of that year he wrote to Gabriele Münter from Odessa:

123 Russian Knight, *1904–05*
Woodcut,
3 1/2 x 3 1/2 in
Städtische Galerie im
Lenbachhaus, Munich

124 Birds, *1907*
Woodcut,
5 3/8 x 5 11/16 in
Städtische Galerie im
Lenbachhaus, Munich

125 *Monk, 1907*
Color woodcut,
9½ x 2⁹/₁₆ in
Städtische Galerie im Lenbachhaus, Munich

126 *Poster "New Artist's Association" (Neue Künstler*
Vereinigung) First Exhibition, 1909
Städtische Galerie im Lenbachhaus, Munich

I've received requests for reproductions of my things from two [French] publications [...]. Paris really offers opportunities! Not like those insipid (Hm! Sorry!) Germans whom it takes years to get used to anything new. [209]

Toward the end of 1906 eight woodcuts of his appeared in *Tendances Nouvelles*, a modest art review published in Paris. Twenty-five others followed between that date and 1909, and in 1908 the *Tendances Nouvelles* publishing firm issued a thousand copies of Kandinsky's *Xylographies* (Woodcuts) with an enthusiastic preface by the critic Gérôme-Maësse. Relations between the artist and the periodical were cordial and productive. The editor, Alexis Mérodack-Jeaneau, was an artist himself and shared many of Kandinsky's ideals; he wanted, notably, to supply a direct link between artists and the public, in order to circumvent the often perverting and self-interested intercession of dealers, critics, and art historians. He sold moderately priced woodcuts – including some by Kandinsky – on a subscription basis (but was not entirely successful in this venture). Among other activities, he ran a "People's Museum" in his native Angers, where, in May 1907, he invited Kandinsky to take part in an exhibition, alongside such artists as Cézanne and Henri Rousseau. (Kandinsky sent in a representative sampling of 109 works!) On this occasion, the knowledgeable and sensitive Gérôme-Maësse (probably a pseudonym of Mérodack-Jeaneau) wrote in *Tendances Nouvelles* that Kandinsky possessed a rare two-fold gift: "An unquestionably talented engraver on wood, he is also a true painter of values."

Kandinsky's graphic output between 1903 and 1911 is both qualitatively and quantitatively impressive. From 1909 on his woodcuts begin to display the same level of abstraction as his paintings – an abstraction based on simplifying forms rather than dissolving them. His poster for the *New Artists' Association* (ill. 126) shows that the artist nearly crossed the frontier between figurative and autonomous "concrete" forms as early as 1909 – for surely it is rather pointless to try and identify the summary chromatic shapes of this work as mountains, outcrops, or isolated rocks?

127 *Woodcut for* Der Sturm, *1910*
4⅛ x 7¾ in
The Hilla von Rebay Fondation,
The Solomon R. Guggenheim Museum, New York

There she stands, like a fairy-tale city, incomparable and proud and solemn. Nothing can make her look kitschy! These tall, svelte, slender, swarthy girls of the common people, with their long black shawl wrapped tightly round their body, their dark skirts and the fans in their hands, project something calmly solemn that no painter (poor black souls that we are!) has yet taken away from them. Color, color! Noble, darkly luminous, crudely harsh and deeply harmonious colors revealing as clearly as can be how poor, weak, and dirty our palette is! Damn!

The very rapidly executed, but wonderfully self-assured sketch (ill. 130), which is published here for the first time, shows Kandinsky's exceptional gift for line and contour and his ability to render a subject's essential – though not necessarily individual – traits.

The main problem in Kandinsky's twelve-year relationship with Gabriele – one that eventually left its mark on the art of both partners – emerges from the start as a leitmotif in Kandinsky's letters:

I too feel sorry for you. It seems to me that you haven't the slightest idea of what joy is, JOY, the most beautiful, purest joy, which does not spring from man, is not made by man. The divine feeling that suddenly almost makes the everlastingly unclear seem quite clear. If you don't know it, surely you have an inkling that something like it must exist.[214]

Kandinsky could not imagine that a person who was unable to experience that divine feeling was simply unreceptive to it, even when it was communicated with deep love. Clearly religious in the sense that it connects one with the

131 Lady *(Gabriele Münter), 1910*
Oil on canvas,
43¼ x 42⅞ in
Städtische Galerie im Lenbachhaus, Munich

132 *Gabriele Münter,*
Sketch for Kandinsky and Erma Bossi, *1910*
Pencil, 6¼ x 8¼ in
Städtische Galerie im Lenbachhaus, Munich

origin of being, this feeling develops from the sense of security of early childhood, and becomes a source of strength throughout one's life. Kandinsky certainly possessed it; it shielded him from his exceptional intellect and his overwrought sensitivity, and those who knew him felt its influence. He badly wanted Gabriele to share this creative joy and faith (call it God or what you will, he was never dogmatic about such matters). He said: "One can discern this joy in my paintings."[215]

He saw Gabriele as a rather unhappy woman, which is in fact how she appears in her self-portraits and in most photographs of her from her childhood on; it is the impression she gave to acquaintances[216] and is indeed the impression we get from her and Kandinsky's correspondence. "I will make you my wife only after I'm convinced that you will be unhappy otherwise too. I love you ever more seriously and better. That is why, at present, I'm not only thinking of my happiness but of yours as well." Such was the state of their relationship on December 24, 1903. Kandinsky seems to be wondering whether he is capable of giving her the kind of love she needs. In his portrait of her (ill. 43), she has the same melancholy expression as in most of her photographs. He calls it a "lousy painting" (September 18, 1905), and as usual his self-criticism is justified: it is one of his most conventional and derivative works. Portraiture was essentially as foreign to him as was historical painting. It is an art of resemblance, which is precisely what he wanted to get away from. His talents did not lie chiefly in that direction. Five years later he again painted a picture of Münter, but as the anonymous title, *Lady*, indicates, it does not claim to be a likeness, but merely an impression of the sitter's brooding, melancholy personality (ill. 131).

In her large joint biography of Münter and Kandinsky (1990) Gisela Kleine shows clearly and explicitly that Gabriele grew up in an uncaring environment, unlike Kandinsky who as an infant was coddled by all the members of his family. But her conclusions do not really fit the facts (or the wording of Kandinsky's letters), and they ignore the most elementary notions of psychology. Kleine, who has a strong feminist commitment, is determined to prove that Kandinsky, the creative male, preyed on Münter like a parasite. She rightly points out that Münter too was a creative person, but seemingly draws no conclusions from this. Her thesis is that Münter lost her initial love of life and creativity in her relationship with Kandinsky. Yet there is nothing in the correspondence or the couple's other writings – or paintings – to support this view.[217] Indeed later events seem to contradict it. For decades after their break-up in 1916, Münter sought psychological help to overcome her despair and hatred; her paintings were never again to have the quality they had in 1909–1910. Her uncomplicated nature, her love of dancing, her openness to the outside world: none of these traits countradicts the basic fact that her personality, which was not rooted in faith like Kandinsky's, was less stable than his. She once wrote, "as regards my inner substance, I have already told you that you overestimate me." And even more poignantly: "I am diminished without you, you belong to me and enrich me, and without you, this place is empty."[218]

Another recurring theme in Kandinsky's letters to Münter is the characteristic lament: "To those I love I bring only suffering." Didn't I already tell you in K[ochel] that I make all those who are close to me unhappy. It's my fate. I suffer from it myself. [...] This is NOT pessimism. I hate it."[219] It seems unlikely that he brought real unhappiness to many women. His failed marriage with Ania undoubtedly gave him concrete reasons for feeling guilty, and possibly there were similar reasons in his relationship with the Russian woman who translated Signac's treatise for him: Benia Bogaevskaya. Unfortunately Bogaevskaya burned Kandinsky's letters to her, though her letters to him have come down to us.

Who was Bogaevskaya? So far Kandinsky scholarship has turned up next to nothing about her. Kleine speculates on rather shaky grounds that she and Kandinsky had a daughter born out of wedlock, and she proposes a very "private" interpretation of the *Lady in Moscow* (ill. 133). Let us look at what little we do know. Bogaevskaya once declared that she remained close to Kandinsky all her adult life, even though their paths seldom crossed. (Their lives ran along parallel courses, she says.) The tone is that of a family friend rather than lover (though the latter cannot be completely ruled out). Writing to Gabriele Münter from Moscow in 1910, Kandinsky frequently mentioned seeing Bogaevskaya, who was able to decipher his handwriting and dictate his "brochure" (as he calls *On the Spiritual in Art*) to a typist. Bogaevskaya's letters to him are those of an intelligent, independent, and modern young woman who

was deeply religious, often sick, and manifestly depressive. She limits herself to reporting such events as the fact that her husband Piotr Mikhailovich was to go to Moscow to present his dissertation. (He was a friend from Kandinsky's student days and had published an ethnographic paper a year before the artist's own anthropological article).[220] In this same letter dated August 22 she mentions being pregnant. At first she felt very upset about this, she writes, but then she came to accept it as fate and now with each passing day she is feeling happier and calmer. "You are religious, I prefer to ask you rather than anyone else to be the godfather. [...] I am writing this well ahead of time because I know it always takes you 3 months to answer, so *juste le moment*." Several years later she remarked how her

daughter Ksenia loved books and knew whole passages of them by heart. "Galunov thinks that Ksenia looks like you (judging from a photograph). Naive, therefore innocent. It seems to me too there's something in it. Goodby. I press your hand. Write. – Benia."[221]

Are we to infer from this that Kandinsky was Ksenia's father? Bogaevskaya's phrases may simply be an ironical dig at a former – or almost – lover. Her daughter Ksenia assured the present author that Kandinsky was indeed her godfather, but certainly not her father. She described her mother's relationship with the artist as a "long, close friendship," and speculated that they might have been lovers when Kandinsky was still a student at Moscow University.[222]

133 Lady in Moscow, *1912*
Oil on canvas,
42 ¹³⁄₁₆ x 42 ¹³⁄₁₆ in
Städtische Galerie im Lenbachhaus, Munich

DOCUMENTS

Letters to Gabriele Münter (GM/JE St.)

October 31, 1903

You're suffering from a typical neurasthenia: tired and pessimistic in the morning, cheerful and full of hope in the evening... I know it all so well: I was once exactly like that. And even now I sometimes feel remnants of it in me. Those damned dark morning-glasses! The way to fight it: water and water and more water – hydrotherapy.

134 Cow in Moscow, *1912*
Painting on glass, 11 x 12 ⅝ in
Städtische Galerie im Lenbachhaus, Munich

February 18, 1904

Read Turgeniev and had several not exactly amusing ideas. Has man himself made such a terrible mess of life? Or, no matter what he does, does life itself (or that incomprehensible power we always want to understand and cannot) make man's destiny complicated, entangled, tragic? An old question, old thoughts which suddenly awaken and beg for an answer! Why is it that everything that gives one joy almost always hurts someone else? [...] Why can't one build a tower in which one hears nothing of the world, of life? Why does life seep into everything, like dust into a cracked shoe? [...] Again I saw life from above – it's been a long time since I've done this. Appalling, wretched, luckless. Curse the minutes when one sees "life" from above!

[Undated, late March 1904]

When our souls are even more closely united, understand and penetrate each other even more deeply, I will again be calm and full of life, as that is my true nature. Remember how I used to torture myself almost constantly. One cannot take that without it leaving traces. But my nature does resist and reemerges as it truly is. Just believe me and help me in my weak moments. Let us be more united and let us both think more of each other. The result will be a harmonious and free life for both of us, after these troubled times. We live together as one being. We understand each other, feel together; together we enjoy life, nature, God. I wish I could communicate my faith to you. I would like us to feel together already now. And things are going well. Look at the progress we've made since last summer. We belong together. A great power has united us. And I'm grateful to this power with all my heart, whatever its name.

December 8, 1910

[Kandinsky reflects on the contrast between his family ties and his relationship with Gabriele Münter:] I wonder then how I could stand it, I who was not used to pain. I had nobody aside from you with whom I could talk about it. Do you remember what you said about this once? That was in Sèvres and I asked you to move to Paris so that I wouldn't constantly have to keep a hold of myself [...]. Don't forget that this was me, a man who as a child had been spoiled and adulated (I may use that word here). This stay in Moscow has taken me back to that old atmosphere. But now I've reached the point where I see this undeserved love (that too is a word I may use), and the unfairness of it, which hurts me. I've reached this far... Hopefully I'll perhaps get much further. And that may be your mission. [...] If I could only get the better of my pride and be totally satisfied with this much: that you love me so much less than I love you.

CHAPTER EIGHT
MURNAU

By the end of his year in Sèvres (1906–1907), Kandinsky was in such a poor state of health that he felt he must go alone to a health resort to "get a rest." The difficulties in his relationship with Gabriele Münter, his uncertainties about where to settle permanently – Ania was still in Munich – the fast pace of life in Paris, and the fact that the experiments of the Fauves painters reached far ahead of his own: all this was too much for Kandinsky. He complained of heart palpitations, dizzy spells and nervousness. Writing to Gabriele Münter in July 1907, he described himself as feeling "apathetic" and hypersensitive to "impressions." "I cannot live on deaf and blind after having had eyes and ears. [...] Only music can save me now. [...] I must have good music, it stimulates me so much."[223]

To recuperate, he went to Bad Reichenhall, a spa famous for its salubrious climate, its relaxed atmosphere, and its medical staff's principle of healing through physical therapy rather than medication. Kandinsky's physician pronounced his heart organically sound and it was not long before the artist began to feel better. After cycling with Gabriele Münter through Switzerland – a demanding tour for a convalescent – to visit his mother and sister who were vacationing there, he moved to Berlin, where he had been invited to participate in the Berlin Secession exhibition of September 1907. There he spent the winter with Gabriele, enjoying the German capital's rich cultural offerings.

In the fall of 1908 came the next important stay, in picturesque pre-Alpine Murnau, south of Munich, where Kandinsky and Münter had been invited by their friends Marianne Werefkin and Alexei Jawlensky. The foursome spent the summer painting together and discussing art in the surrounding countryside in the radiant light of that pre-Alpine region. (On days when the Föhn blew, the warm southern wind made even the most distant peaks seem close enough to touch.) This landscape was almost certainly an important source of inspiration to Kandinsky. Kandinsky experts in Germany tend to credit his artistic renewal at this time to the splendid views around Murnau; other experts usually cite the influence of the Fauves. But as stated earlier, Kandinsky was not the kind of painter who spontaneously absorbs the achievements of other artists. His practice was to let new influences ripen slowly inside him and to appropriate only those elements that seemed useful to his own art, modifying and adapting them to his own needs.

The studies he painted in 1908 make it clear that Kandinsky used landscapes to experiment with what was for him a new way of seeing and painting (ills. 136–157). Evidently he did not attribute a great deal of importance to these studies. The fact that he did not include them in his private catalogue is not particularly significant. But the fact that one of them was found by the artist's widow only in

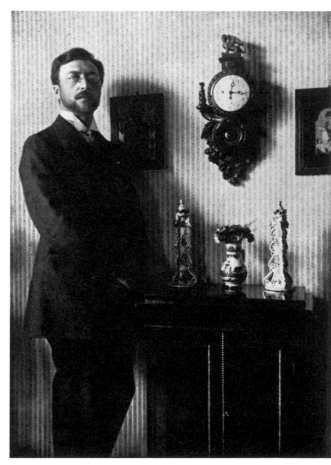

135 *Kandinsky in Munich, ca 1910–11*
Gabriele Münter- und Johannes Eichner-Stiftung, Munich

the 1970s, wrapped in a Munich newspaper dated 1908, is more eloquent.

There is a striking contrast between shadow and sunlight in a lovely small view, *Murnau – Street* (ill. 136). The large wall of the house on the left is summarily indicated by streaks of pigment, much like the treatment of the wall in the view of the marketplace, but here it is nearly monochrome. The contrast between the deep tones of the shadows in the foreground and the luminous pastel-like, zinc-white based colors of the street is particularly powerful. The colored row of houses creates a happy synthesis.

The *Lake of Starnberg* (ill. 138) strikes one as an attempt to create a synthesis between the early landscape sketches which are often summarily constructed with broad bands of color and the tempera paintings' small dots on a dark background. Its tones are considerably brighter and more luminous than those of the early studies, its color-combinations (especially yellow and pink) more daring. The thin, pastel-like, almost uniform treatment of the yellow cloud is a new and seldom repeated occurrence in Kandinsky's oeuvre.

Kandinsky's work of this period is experimental and quite obviously expresses a change in his way of viewing

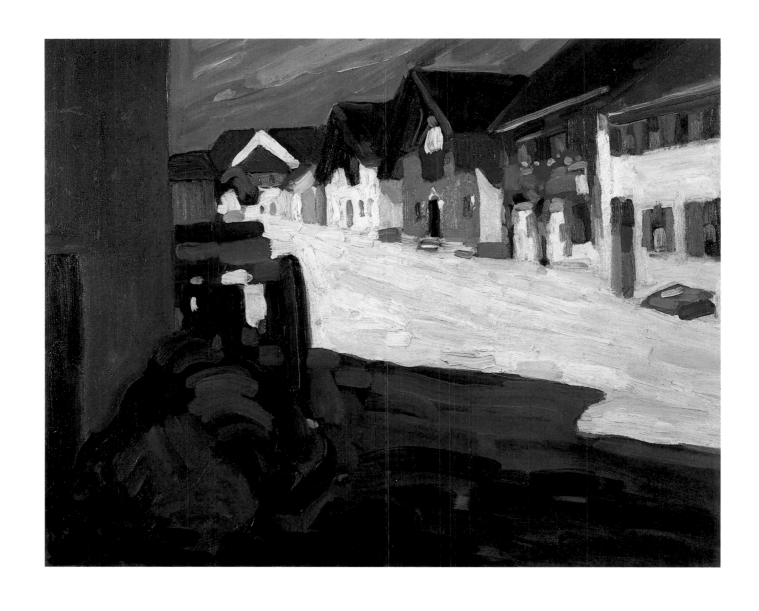

136　Murnau – Street, *1908*
Oil on canvas board, 13 x 16⅛ in
Courtesy Leonard Hutton Galleries, New York

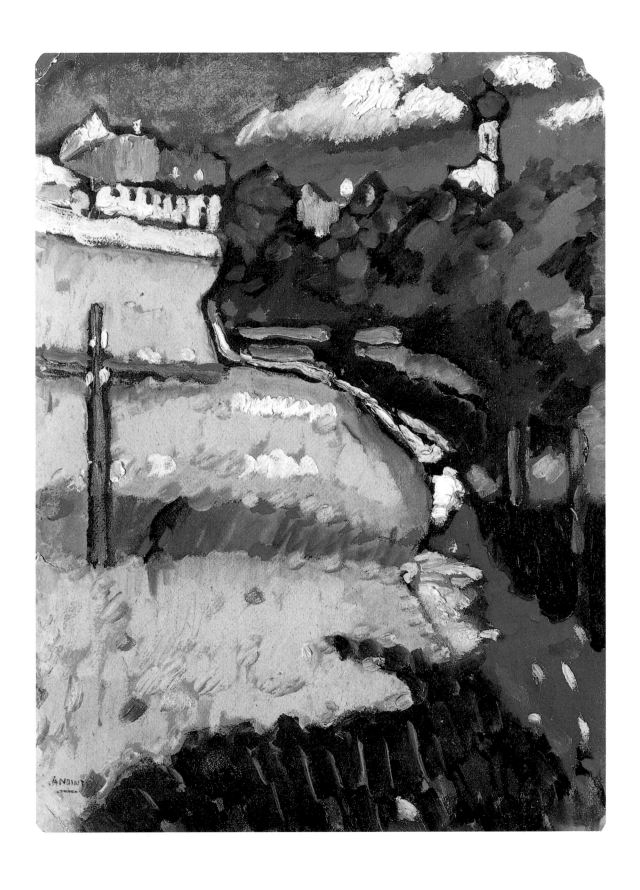

137　*Study for* Church at Murnau, *1908/09*
Oil and tempera (?) on cardboard, 17½ x 12⅞ in
State Art Museum, Omsk

nature. Gabriele Münter has stated that Kandinsky once told her that his right hand was too smooth, too deft, too quick to finish what it was painting, and that, in order to avoid routine, he sometimes held his brush in his left hand. He advised her on the same occasion to concentrate on a small, seemingly insignificant object, saying that it provided a more favorable ground for large forms and broad strokes than a panoramic view of nature with all its details.[224] Significantly, it was during this period that Kandinsky resolutely abandoned his knife technique, which he had by then thoroughly mastered.

Kandinsky's so-called studies are of special interest, because the artist himself valued them as highly as his final paintings (ills. 139, 140). They are often more figuratively detailed than the finished painting they precede. In the study reproduced in ill. 142, the woman and child are clearly recognizable, as are the shapes of the pine trees projecting from right and left toward the center. These shapes are in a sense the point of departure for the no longer recognizable forms in the final painting.

This sketch displays a remarkably diverse treatment of color. The green surface on the upper left is rendered with rapid, curved, anarchic strokes laid down in a thin coat of pigment which does not quite cover the cardboard support. In contrast, the brushstrokes in the middle are thickly charged with pigment. The bottom right of the picture is rendered with a multitude of superimposed transparent layers of color executed with a variety of brush movements. The large, central tree-shape with its almost confused welter of colors contradicts the emphatic symmetry and almost sculptural frontality of the composition (which could almost serve as a stage décor).

Kandinsky, with his usual grain of irreverence, privately gave the most significant of his 1909 paintings, *Improvisation 8* (ills. 144, 145), the title *Tall Fellow With Sword*.[225] The outsize figure with his outsize sword stands very erect at the foot of a somewhat unstable yellow town fortification behind which rises a multitude of cupolas. The contrast between the figure – the gate keeper of the Celestial City? – and the background is extreme. Both

138 Lake of Starnberg, *1908*
Oil on cardboard, 24¾ x 37¹³⁄₁₆ in
Courtesy Leonard Hutton Galleries, New York

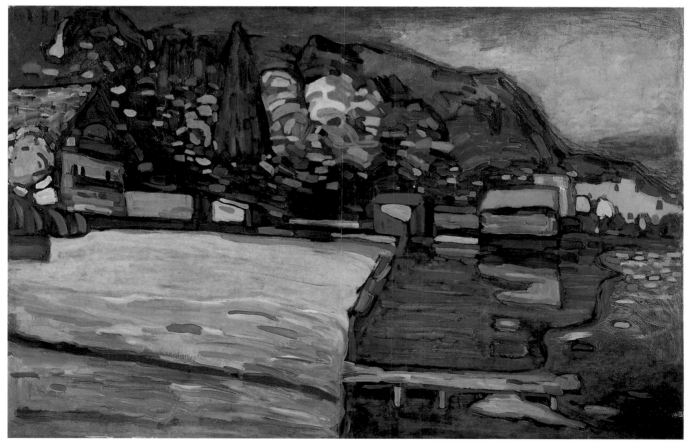

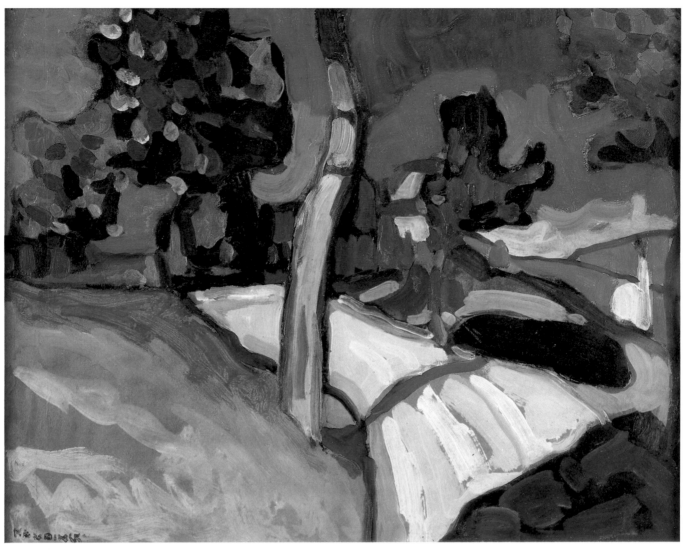

139 Murnau – Kohlgruberstrasse, *1908*
 Oil on cardboard, 28 ⅛ x 38 ⅜ in
 Olix Collection – On loan to the
 Setagaya Art Museum, Tokyo

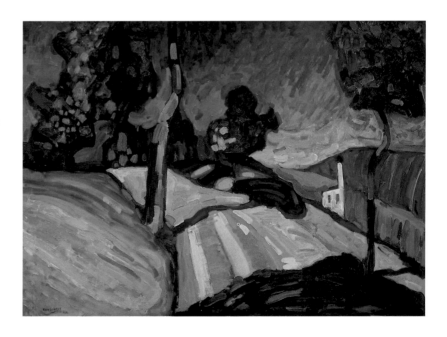

140 *Study for* Murnau – Kohlgruberstrasse, *1908*
 Oil on cardboard, 13 x 16 ⅛ in
 Private Collection, Switzerland

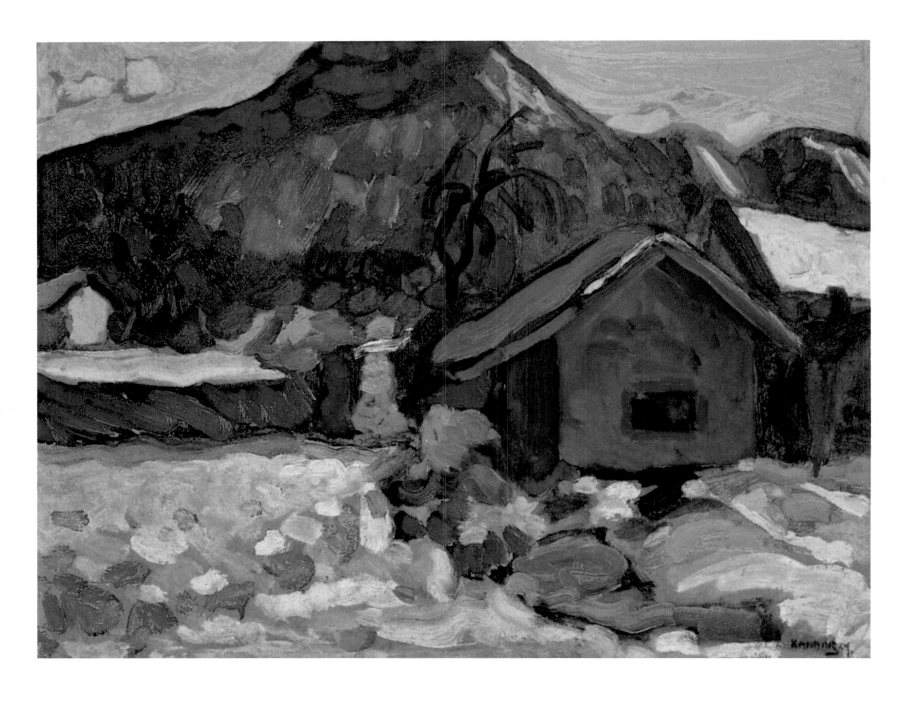

141 Winter Study with Mountain, *1908*
Oil on cardboard,
13 x 17¾ in
Private Collection, New York

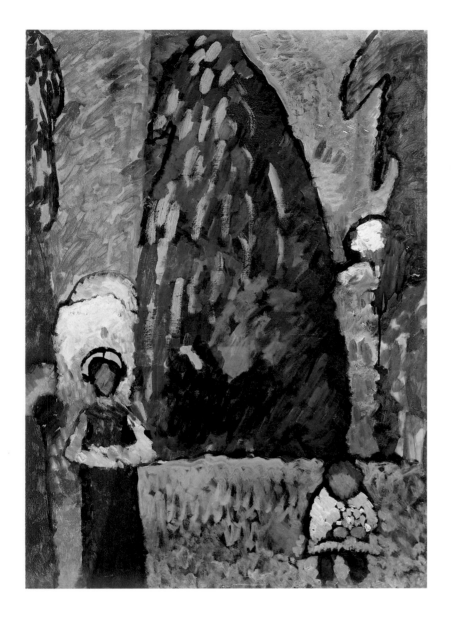

sword and figure are monumental and rendered in relatively muted colors. The secondary figures at the bottom almost dissolve into color dots and are far less recognizable as human figures than in the preliminary study (ill. 143). The pair on the left recalls traditional Russian depictions of the brothers Boris and Gleb, as well as Kandinsky's own, later versions of the pair. In the finished painting, Kandinsky drops this association with the two brothers and emphasizes the sword-bearing figure. But the essential difference between the two versions resides in the disappearance of the vertical division which extends to the upper part of the sketch, and the more succinct treatment of the right side, which gives greater vigor to the movement toward the upper right via the well-defined, pale yellowish-green shape pointing in the same direction as the yellow wall.

142 *Detail of* Improvisation 2 (Funeral March), *1909*
 Oil on cardboard,
 38⅝ x 27¾ in
 Courtesy Leonard Hutton Galleries, New York

143 *Study for* Improvisation 8, *1909*
 Oil on cardboard,
 38⅝ x 27½ in
 Kunsthaus, Winterthur

144 *Sketch of* Improvisation 8 *in Kandinsky's*
 letter from Moscow to Gabriele Münter
 of November 3, 1910
 Gabriele Münter- und Johannes Eichner-
 Stiftung, Munich

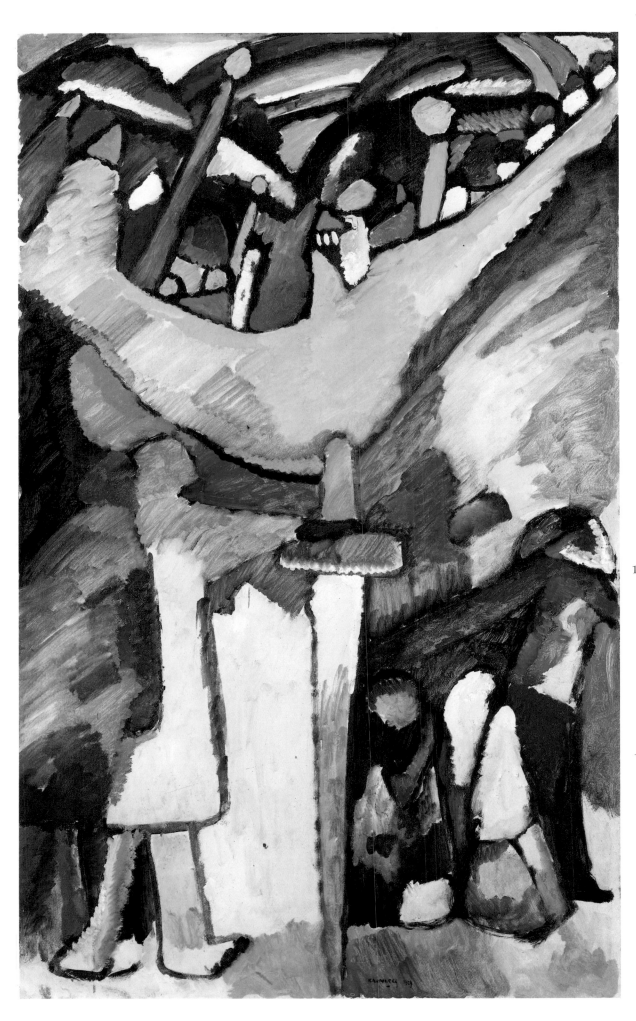

145 Improvisation 8
(The Sword), *1909*
Oil on canvas,
49-3/16 x 28 3/4 in
Private Collection

Mountain (ill. 146) – a masterpiece of simplicity – has a similarly symmetrical composition, though almost reversed. Kandinsky has taken the suspended triangle in the upper half of *Improvisation 8* and has turned it upside down to render the shape of the mountain. The fortress on the mountain-top can barely be discerned; a viewer unfamiliar with Kandinsky's recurring themes during this period will perhaps miss it entirely, as he may miss the rider and the standing figure. The other shapes are even more drastically simplified and create an effect merely with their liberally spread colors and outlines. This simplification clearly enhances the effect of the colors and the dynamics of the composition, which radiates such strength that it cancels out the static symmetry of the equilateral triangle resting on the base of the picture and reaching its top. In *Mountain*, Kandinsky went a step further than the Fauves in dissolving shapes and giving colors their own individuality. More clearly than any of his other works of 1909, it points the way toward his future involvement with abstraction. This is probably much more obvious to us now than it was to the artist himself at the time he painted it, otherwise he would not have made so many detours before breaking through to abstraction two years later. *Mountain* is now generally considered one of his major works, but there are indications that he himself had doubts about it. He signed and dated it, but did not list it in his private catalogue and did not exhibit it. (However, as the painting remained in Gabriele Münter's possession after they separated and Kandinsky never saw it again, he could not have shown it after 1916 even if he had wanted to.)

Even though landscapes predominate in Kandinsky's early Murnau period, the artist did not quite forget his old subjects. *Crinolines* (ill. 147) is remarkable for its apparently classical composition, its unusual symmetry, and the way it dissolves contours.

After its determined, fresh start inspired by nature,

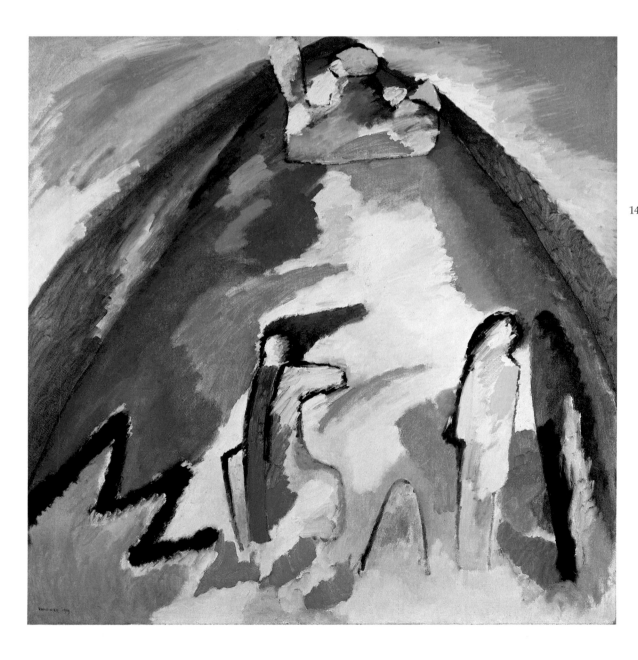

146 Mountain, *1909*
 Oil on canvas,
 42 15/$_{16}$ x 42 15/$_{16}$ in
 Städtische Galerie im
 Lenbachhaus, Munich

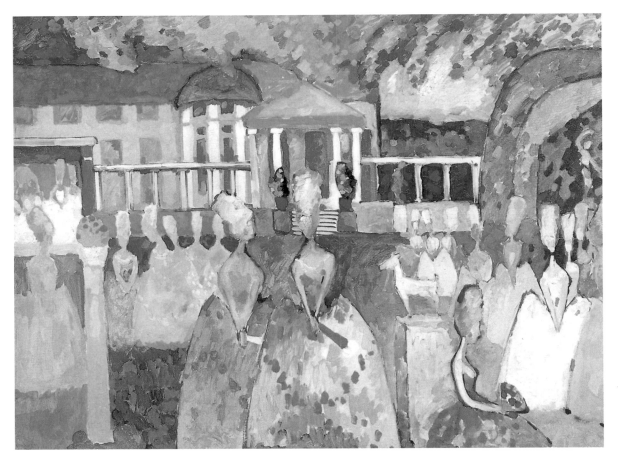

147 Crinolines *1909*
Oil on canvas,
37⅜ x 50⁹⁄₁₆ in
State Tretiakov Gallery,
Moscow

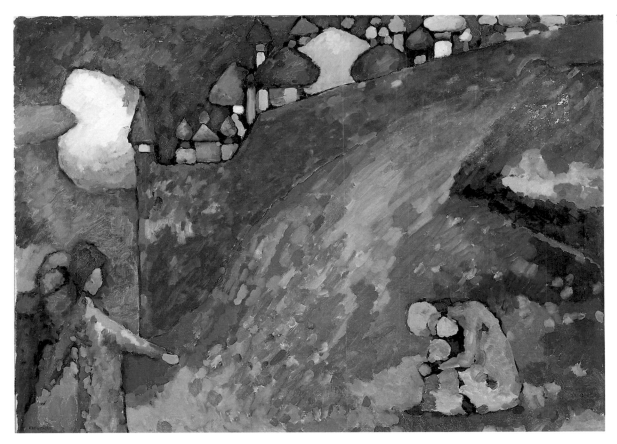

148 Cupolas *1909*
Oil on cardboard,
33½ x 45¹¹⁄₁₆ in
State Art Museum,
Astrakhan

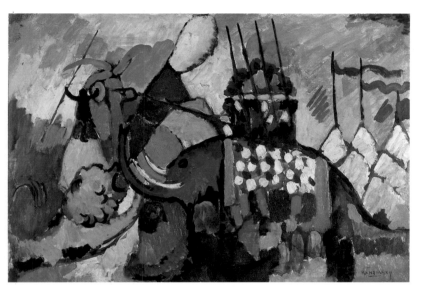

149 The Elephant, *1908*
Oil on cardboard,
18⅛ x 27 in
Private Collection

150 *Sketch for* The Elephant, *1909*
Pencil, Notebook 1909, p. 37,
1¼ x 3⅛ in
Städtische Galerie im Lenbachhaus, Munich

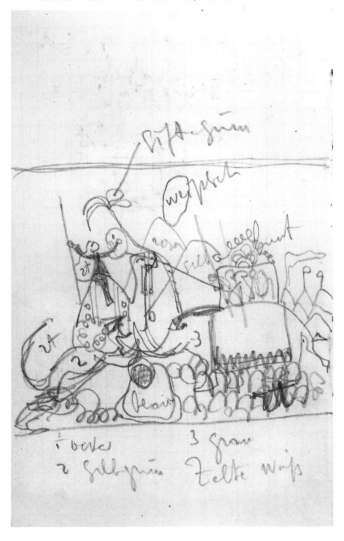

Kandinsky's painting of 1908–1909 seems to strike out in several directions at once. It reverts to earlier discoveries, annexes a few of the Fauves' stylistic procedures – particularly their glowing palette – before experiencing a liberation and suddenly surging forward. Compared to the far smaller landscape sketches done after the turn of the century, the new paintings are bolder, brighter, still more temperamental. They are filled with greater tension and tend further toward abstraction and simplified forms and colors. At last, Kandinsky becomes Kandinsky! But though everyone agrees that he made a breakthrough at this time, few scholars agree about the origins of that breakthrough. For Grohmann, Kandinsky's "expressive, painterly style," which would stimulate both Jawlensky and Münter in their own ways, was as original as that of the Fauves and the Brücke artists. Similar trends and discoveries were occurring independently of each other all over Europe during these years. "Whereas in the Fauves expression almost coincides with harmony, and in the Brücke group with drama, a naive inwardness is preponderant in Kandinsky." He has, he adds, "a rural quality, just as the Brücke painters have an urban quality and the Fauves sophistication."[226] Eichner too says that Kandinsky developed his style independently. "It was a satisfaction for us to see that Kandinsky fell back neither on Jawlensky's example nor on his Paris memories. He blazed his own trail."[227] But this is not the opinion of another art historian, who states that Kandinsky, on the contrary, owed his great leap forward in 1908–1909 to Jawlensky and, mainly, Werefkin, who introduced him to the Fauves.[228] Jawlensky had been aware of the latest developments in French art for several years, and had even worked in Matisse's studio. Jonathan Fineberg, on the other hand, argues in his excellent, very thorough dissertation that it was Kandinsky's personal acquaintance with the Fauves during his year in Paris that made the breakthrough possible.[229] Peg Weiss objects that there is "not much evidence to substantiate this theory, except perhaps the fact that Kandinsky's palette became brighter after his return." She believes that Kandinsky owes his breakthrough solely to the influence of the natural scenery near Murnau.[230] There is an element of truth in each of these theories. What Kandinsky himself has to say about the Fauves is surely more to the point than any of the above scholars' assertions. Published in an obscure journal in 1910, his observations concerning them are both precise and revealing. They complete the scholarly statements just cited, all of which were probably made without the knowledge of the artist's own comments.[231]

Reviewing an exhibition of Fauvist paintings, Kandinsky observed:

> Among the works by these artists, there is not one that is mediocre. All are interesting, beautiful, serious. Much of the work consists of miraculous painting (*peinture*). But among them, only Matisse has gone beyond the "accidental forms of nature" – or, better

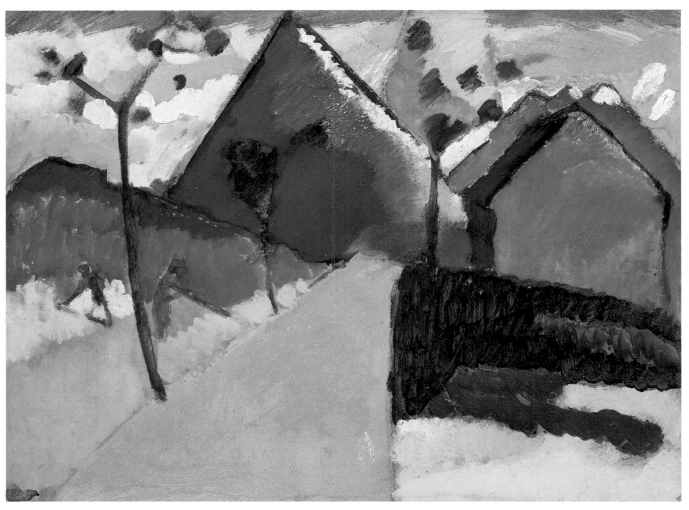

151 Kochel – Straight Road, *1909*
Oil on cardboard,
12 ¹⁵/₁₆ x 18 ⅛ in
Städtische Galerie im Lenbachhaus, Munich

152 *Kandinsky with Bicycle,*
Photo: Gabriele Münter, 1902
Gabriele Münter- und Johannes Eichner-Stiftung,
Munich

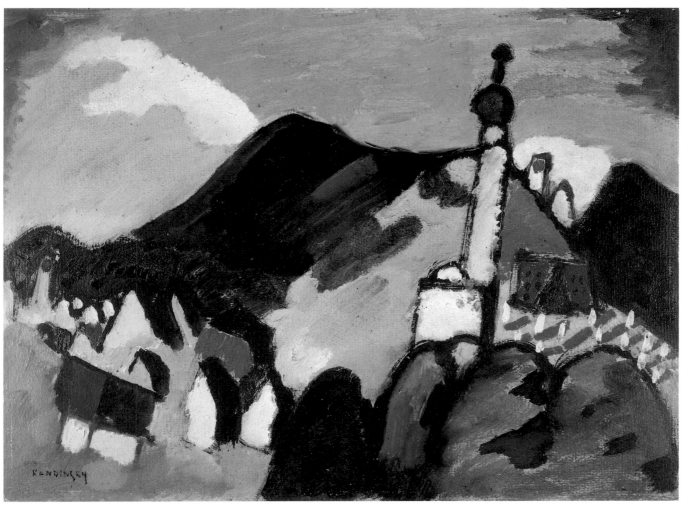

153 *Study for* Murnau with Church II, *1910*
Oil on cardboard,
12 9/16 x 17 5/16 in
Private Collection

154 Improvisation 4, *1909*
Oil on canvas,
42 1/8 x 62 5/8 in
State Art Museum, Nizhni Novgorod

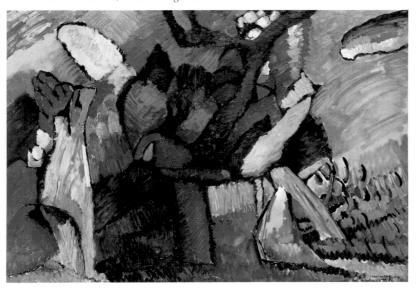

expressed, only he has succeeded in entirely discarding the inessential (negative) aspect of these forms, replacing it with, so to speak, his own forms (positive element).

All the other artists here represented (least of all, perhaps, Girieud) display almost to the extent of complete inviolability that contingent attitude toward line, the same accidental delimitation of form that they have discovered in nature. It is curious to observe how their whole creative energies are directed solely toward color. Why? Why is it only color that undergoes these modifications, violations, substitutions? What prevents the artist from likewise submitting the linear and planar aspects of nature to the same artistically necessary transformation? Why does the creative urge direct itself solely toward *"peinture,"*

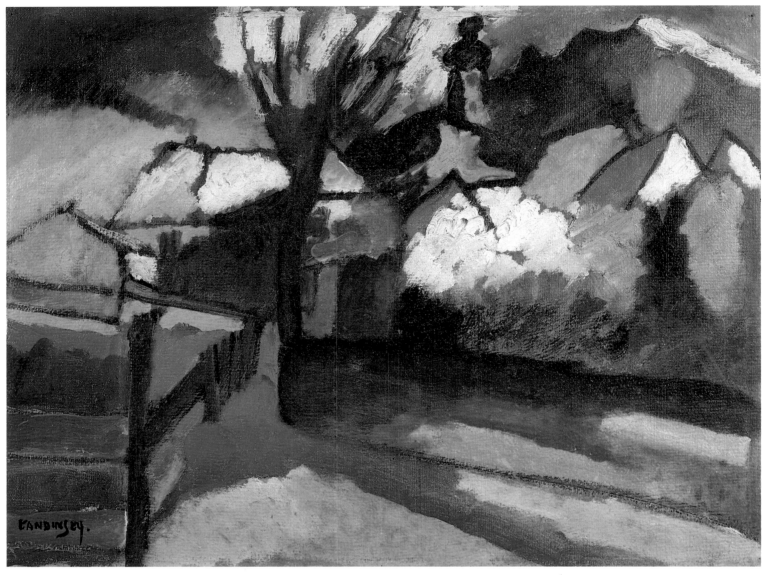

155 Autumn Landscape with Tree, *1910*
Oil on cardboard,
12 ⅞ x 15 ¾ in
Courtesy Leonard Hutton Galleries, New York

and why does the other, uniquely powerful, essential aspect of painting – what we rather vaguely refer to as "drawing" – remain untouchable? Going from one canvas to another, one ends up with the impression of nature simply decked out in various colors, just as one might paint one's cupboard. These different objects may, depending upon their colors (ornamental juxtaposition of color-tones), produce different effects upon the spectator, but they remain, for all that, objects, and not the transformations wrought by "pure art," i.e., not art understood in terms of concrete forms, not (in the accepted use of the term) abstract. These were the thoughts going through my head as I looked at these really beautiful, richly painted pictures. I could not free myself from the question: Why is it necessary to "paint" nature in

different colors? If it is to derive pictorial composition, the inner sound of the picture, then why does this "composition," this "sound," extend only as far as the transformation of color? And why is drawing, that is to say, the nonpainterly, incidental aspect of art, so carefully avoided, thus, as it were, clipping the wings of the artist's creative imagination and power?

Strange, how it appears necessary to find, discover, resurrect anew that principle of subordinating drawing, too, to internal aims that was so clearly, so definitely resurrected from the dead by Cézanne! In fact, if it were not for the presence of Matisse at this exhibition, one would suspect that this spirit had already departed again. That only one of the "younger" French artists exhibiting here has kept it alive may be explained by the fact that the others have

not as yet impressed upon themselves the imperative necessity of creating pictorial composition, or indeed, developing the necessary language.[232]

It was Kandinsky who forged that language. The Fauves' way of taking liberties with colors must have struck him as a revelation in Paris: it corresponded perfectly to his own, increasingly clear pictorial intentions. By absorbing their example, he was making headway both on their path and his own. But it was only after a long process of maturation that he was able to discern the element he thought was lacking in the Fauves' painting, and, by integrating it into his own art, to move beyond them. Kandinsky's own, very great, wholly independent contribution to the history of art was to condense and dissolve shapes, to free painting increasingly from the object. A direct line of filiation leads from Cézanne to Kandinsky via Matisse.[233]

Kandinsky had been familiar with Germany's pre-Alpine landscapes since 1897 and with Murnau since at least 1904. But his decisive, intense experience of nature began only in 1909 when Gabriele Münter bought a house they had instantly liked outside the village. Living in the country was a novel experience for both of them. It was a secluded, rural, electricity-less existence, with a garden they tended together, and it doubtless made a deep impression on Kandinsky and influenced his art. Moreover, having a place of their own after five years of traveling and living abroad semi-clandestinely, with frequent separations, ushered in a relatively happy and hopeful phase in their troubled life together.

The following summer, after they settled in Murnau, Kandinsky painted the view from his studio window (ill. 157). Apart from the sunflowers, little is recognizable in this picture. (It is reproduced upside down, as illustration 340, in Roethel's *Catalogue raisonné*.) Only on second glance does one identify the red-roofed houses on the slope, their angles contrasting vividly with the rounded shapes of the garden. The sky is rendered with wild blue diagonal stripes. The large, dark shapes at the bottom are the only link between this "view" and traditional nature painting. In the course of his further development, Kandinsky would tend to place heavy pictorial elements in the upper portion of his pictures where, in seeming defiance of the laws of gravity, they would appear to float in midair (especially the shapes in his later paintings).

Kandinsky decorated the banister and several items of rustic furniture in his house in the manner of local folk artists (ill. 160). Gabriele Münter writes in her diary that they had both been captivated, during their stay in the Tyrol in the spring of 1907, by the "beautifully painted martyred saints" and, later, by naïf glass paintings in Murnau.[234] Münter studied the latter technique with one of the last local artists still practicing it, and went on to copy a number of authentic folk paintings on glass, before eventually doing glass paintings of her own in the tradi-

157 Murnau – The Garden II, *1910*
Oil on cardboard,
26⅜ x 20 1⁄16 in
Private Collection

158 *Music Room in Murnau*
 with Saint George above the harmonium.
 Photo: Gabriele Münter
 Gabriele Münter- und Johannes Eichner-
 Stiftung, Munich

159 Saint George
 Votive Picture, South German,
 turn of the 19th century
 (Kandinsky's collection)
 Gabriele Münter- und Johannes Eichner-
 Stiftung, Munich

161 *Gabriele Münter,*
 Painting on Glass, *1908–09*
 7¹⁄₁₂ x 6⁷⁄₁₆ in
 Gabriele Münter- und Johannes Eichner-
 Stiftung, Munich

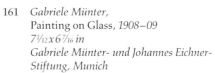

160 *Dresser, Pine*
 Painted by Kandinsky, ca 1910
 39³⁄₈ x 22 x 12³⁄₁₆ in
 Städtische Galerie im Lenbachaus, Munich

162 All Saints I, *1911*
Painting on glass, 13⅝ x 15 ¹⁵⁄₁₆ in
Städtische Galerie im Lenbachhaus, Munich

tional manner (ill. 161). But copying existing works was not Kandinsky's style, and, as always, the stimulating influence of folk art – particularly naïf religious art – did not declare itself in his painting till some years later, and then only in a very modified form.

He and Gabriele Münter began by acquainting themselves with the Murnau collection of glass paintings now at the Oberammergau museum. They bought several small paintings, which were not yet considered valuable, and one large work, a votive image of St. George which hung above Kandinsky's harmonium (ills. 158, 159). Another version of this saint – the patron saint of Moscow – greeted the artist in the ancient church of Ramsach near Murnau. In one way or another, St. George would accompany Kandinsky through his Blaue Reiter years, if not till the end of his life.

Kandinsky's first glass painting, *With a Yellow Horse* (see ill. 158), shows how he attempted to adapt his new pictorial style to what was for him a hitherto unfamiliar technique. Glass painting was long practiced by amateurs in southern Germany and Austria; a farmer, with the intention of offering thanks to a particular saint for interceding for him, would paint a clumsy, heartfelt little picture in bright colors. The authentic, sincere, naïf expression of these images must have appealed to Kandinsky in much the same way that the canvases of the Douanier Rousseau attracted him. Surely he was not only, or even mainly, drawn by their religious iconography, as Rosel Gollek thinks – after all, he had been familiar with those themes since the icons of his Russian childhood.[235] Obviously, the other attraction of these paintings was the simplified forms required by the technique of reverse

163 All Saints I, *ca 1911*
Oil on cardboard, 13 ⅝ x 15 ¹⁵⁄₁₆ in
Städtische Galerie im Lenbachhaus, Munich

painting on glass. The German term for this art is *Hinter-glasmalerei* (under-glass painting). Since only the underside of the pane is painted, the artist must begin by rendering the contours of the foreground, then filling them in with colors, and only then adding the background in the remaining empty spaces. In short, this technique is exactly the opposite of the way an oil painting on canvas or cardboard is executed. Moreover, as anyone who has ever done any printing knows, or as any painter will tell you who has ever examined a picture of his in a mirror to check its composition, it is a far from simple thing to work in reverse, inverting left and right.

Nearly two years after his first attempt at glass painting, Kandinsky used this technique to paint his *Saint Vladimir* of 1911 (ill. 164). This representation, which fully applies the principles of folk art, is flat, frontal, and has the bold contours of authentic naif painting. Even the treatment of the religious theme – for example, the symbolically reduced attributes – is genuinely popular. But the setting is Russian rather than German, as is clear from the Orthodox cross and the inscription "The Holy Prince Vladimir". It represents the evangelization of Russia after Vladimir decided to adopt the Byzantine faith; the little church in his hand is like a model of one of the first Russian churches built with crossbeams.

Vladimir figures again in a secondary role in *All Saints I* (ill. 162), on the left side of the painting under the arm of the large angel blowing the trumpet of the Last Judgment. Several other Russian motifs occur in this picture: the Kremlin-like fortress above the angel, the brothers Gleb and Boris in the center right (see also p. 116), and the black monk on the lower left side. Other Christian symbols are

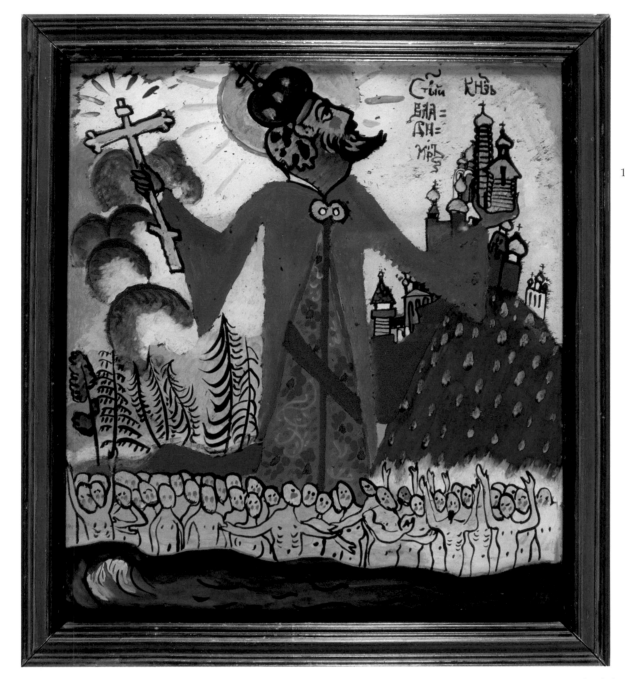

164 Saint Vladimir, *1911*
Painting on glass,
11⁷⁄₁₆ x 10¹⁄₁₆ in
Städtische Galerie im
Lenbachhaus, Munich

165 *Sketch for* With Sun, *Painting on glass, 1910*
Colored pencil, 11½ x 15⅜ in
Städtische Galerie im Lenbachhaus, Munich

the tiny crucifix, the outsized flower, the bird and the butterfly, the sun and the moon, St. George on a horse, and the other saints. Here too, as in the painting just mentioned, Kandinsky scales figures and objects according to their symbolic importance and mainly to the requirements of the composition, rather than to nature. The construction of the figures reminds one of the artist's early tempera and related oil paintings like *Motley Life* (ill. 104). However the treatment of *All Saints* is flatter, and, because of its subject matter and the frame painted by the artist himself, this picture clearly belongs to the category of "glass paintings." Kandinsky repeated its theme, with modifications, in a watercolor, a woodcut, and two large oils (ill. 163). The glass painting, which is based on a drawing, came first, and its naif details help one to decipher the later works having the same theme (ills. 165–167).

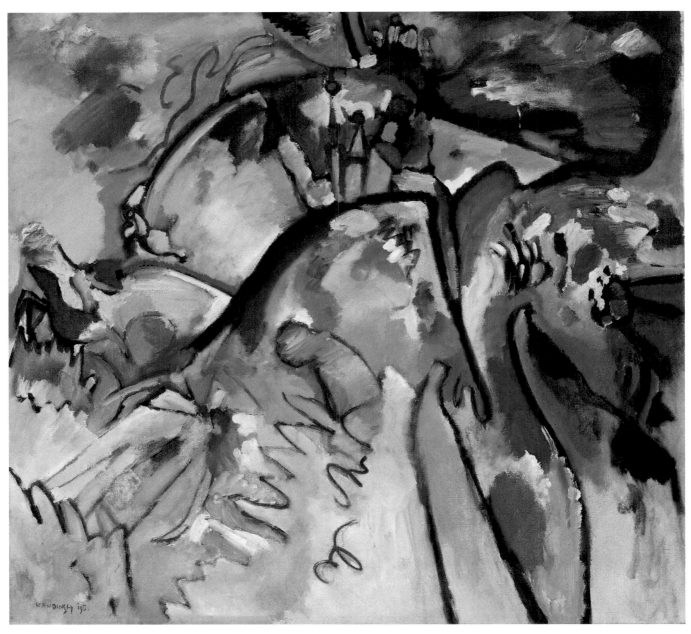

166 Improvisation 21a, *1911*
 Oil on canvas, 37¹³/₁₆ x 41¹⁵/₁₆ in
 Städtische Galerie im Lenbachhaus, Munich

167 With Sun, *1910*
 Painting on glass, 12 x 10¹/₁₆ in
 Städtische Galerie im Lenbachhaus, Munich

CHAPTER NINE
THE NEW ARTISTS' ASSOCIATION

During their stay in Murnau, Kandinsky and Gabriele Münter renewed contact with their friends the Giselists, as Marianne Werefkin and Alexei Jawlensky were called (because of their apartment on Giselastrasse in Munich). Their reinvigorated friendship had an important result – the birth in January 1909 of the New Munich Artists' Association *(Neue Künstlervereinigung München)*. Kandinsky had taken part in discussion groups of German and Russian artists and intellectuals in Werefkin's house ever since 1897. From time to time, the presence of Sergei Diaghilev (who had organized an exhibition of Russian artists at the Munich Secession in 1898), Victor Borisov-Musatov (who made a point of passing through Munich whenever he traveled between Paris and his native Russia, in order to see the much-respected Werefkin), and other visitors from abroad helped to keep the group informed about the latest art trends in both the West and the East. Gustav Pauli, the director of the Bremen museum, who sometimes joined these discussions, remembers that,

> In the shadow of famous artists basking in their success, the dissent of the younger members flowered somewhat like a communist conspiracy in the heart of bourgeois society. There were jokes about the heroes of the day, exhausting discussions about the basic issues of creativity. [...] Werefkin's salon was one of the poles of this world [...]. She was the daughter of a

168 *Sketch for Membership Card, 1908–9*
Woodcut, 4¹³⁄₁₆ x 5¹¹⁄₁₆ in
Städtische Galerie im Lenbachhaus, Munich

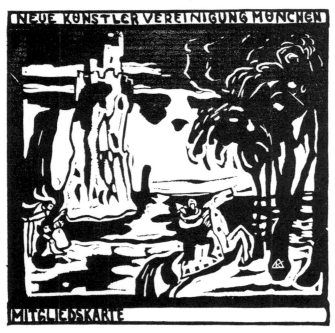

Russian general, had been brought up abroad, was cosmopolitan, intelligent, voluble, and critical. A little group of faithful followers, mostly Russian artists, gathered daily round her tea table, among them the dancer Sakharov and his Munich friends. It was a very heterogeneous crowd, with Bavarian aristocrats rubbing shoulders with footloose representatives of the international bohème. [...] I was introduced to it by a new friend from Odessa, the German-Russian painter Alexander Salzmann. [...] I have never again encountered a group of people so charged with tension. Its center, the transmitter, so to speak, of those almost physically perceptible energy waves was the baroness [Werefkin]. She dominated not only the conversation but also all her surroundings. There was little talk about politics. Everyone took it for granted that the state of imperial Russia was gloomy, and no one felt there was any point in discussing it further. But everything concerning art and literature was discussed with an incredible passion and wit.[236]

In a painting that Kandinsky later traded with Paul Klee, the artist depicts – though without rendering their features – Münter sitting to the left of a rather bizarre and tense-looking Werefkin (ill. 169). In a self-portrait, the latter characterizes herself as a fiery woman with penetrating red eyes (ill. 170).

It is not easy to decide which of the foursome – Kandinsky, Münter, Werefkin, and Jawlensky – contributed what to the New Artists' Association project. The preface to the Association's first catalogue seems to reflect Kandinsky's ideas and words (inner world, necessity), though the emphasis on "synthesis" reminds one more of Jawlensky.[237] As an artist, the latter had the most experience, and one would have expected him to take the lead. But he was not interested in organizing, and Kandinsky, who was experienced in this area, was appointed the Association's president. The main purpose of the Association was to breathe new life into Munich's somewhat sleepy art scene. Hugo von Tschudi, the progressive museum director from Berlin, was asked to support the Association, and he did so with conviction.

Kandinsky contributed some of his well-known ideas to the preface of the Association's catalogue:

> Our point of departure is the belief that the artist, apart from those impressions that he receives from the world of appearances, continually accumulates experiences within his own inner world. We seek artistic forms that should express the reciprocal permeation of all these experiences – forms that must be freed from everything incidental, in order powerfully to pronounce only that which is necessary – in short, artistic synthesis. This seems to us a solution that once more today unites in spirit increasing numbers of artists...

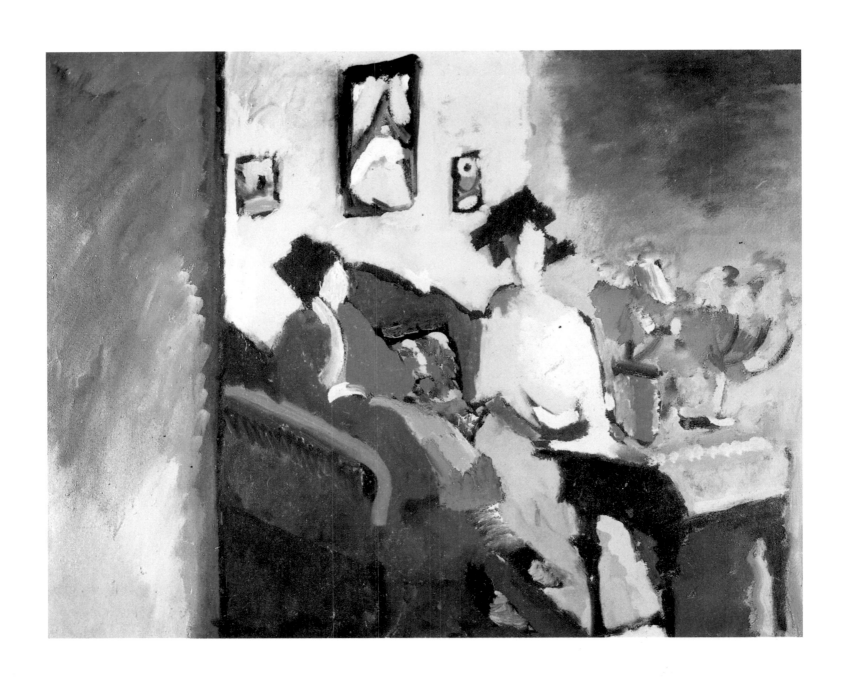

169 Interior (with Two Ladies), *1910*
Oil on cardboard, 19⅞ x 25⁹⁄₁₆ in
Private Collection

Reviewing the Association's first exhibition for the St. Petersburg review *Apollon*, Kandinsky wrote:

> The whole strength, the whole energy of this small exhibition resides in the fact that every member understands not only *how* to express himself, but also *what* he has to express. Different spirits produce different spiritual sounds and, as a consequence, employ different forms: different scales of color, different "clefs" of construction, different kinds of drawing. And, nonetheless, everything here is the product of one shared aim: to speak from soul to soul. It is this that produces the great, joyful unity of this exhibition.[238]

This is why the four founders of the Association respected each other even though, as painters, they did not have much in common. Before long they were joined by Alfred Kubin, Adolf Erbslöh, and Alexander Kanoldt, though the

170 *Marianne Werefkin*, Self-Portrait I, *ca 1910*
Tempera, 20 1/16 x 13 3/8 in
Städtische Galerie im Lenbachhaus, Munich

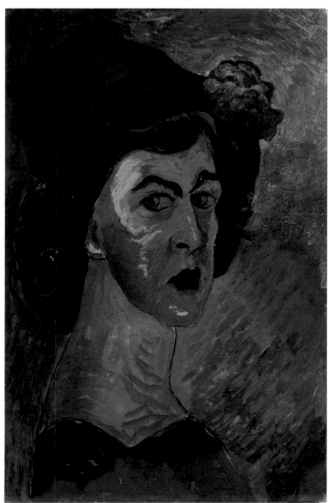

last two were far more conservative than the others, a fact that would eventually lead to a rift in the Association. But for the time being Kandinsky was optimistic:

> An association like this is a useful thing and we indeed have the most interesting German painters in our midst. Can it be helped if there aren't any better ones? I continue to hope that our people will become more serious and will recognize their great duty. Then the paintings will improve too. An association is a spiritual force. It is isolated forces (as always, only a few artists) that are creating, in Paris as well as here, a more substantial atmosphere operating in a natural way.[239]

The Association gained new members as early as 1909. They included Karl Hofer (who soon left), Erma Bossi, the Neo-Impressionist Paul Baum, the former Russian officer (like Jawlensky) Vladimir von Bechtejeff, the Russian Jews Moishe Kogan and Alexander Sakharov (at that time still a painter, though he later became world-famous as a dancer), and, in 1910, the French artists Pierre Girieud (ill. 171) and Henri Le Fauconnier. The society's ranks also contained a number of art patrons.

Its first exhibition opened in Munich, in December 1909, then toured other German cities and even traveled to Brno in Czechoslovakia. Everywhere it provoked outrage. The public took artistic happenings very seriously in those days and, when shocked, would go as far as to spit physically on works it considered unworthy; it had no understanding for avant-garde artists and reacted angrily to them. The Fauves in France, the Futurists in Italy, and the Cubo-Futurists in Russia all got pretty much the same treatment: they were subjected to scorn, ridicule, and the venom of public and press alike.

The Association's second exhibition, in September 1910, fared no better than the first. The *Münchener Neueste Nachrichten*'s critic called the participating artists imposters and lunatics. The only favorable review to appear was written by a young Munich painter, Franz Marc. Marc later joined the Association, a fact that was to have far-reaching consequences not only for Kandinsky but for German art as a whole. Marc began by declaring that Gauguin had been the first artist to call for a true spiritualization of the reality to which the Impressionists were still desperately clinging. He praised Kandinsky's paintings, seeing in them a

> totally spiritualized and dematerialized intensity of feeling. What is the cause of our stunned admiration for this oriental art? Does it not remind us mockingly of the one-sidedness of our European concepts of painting? This thousandfold deeper art of color and composition puts our conventional theories to shame. [...] Such are the artistic insights of this rare painter![240]

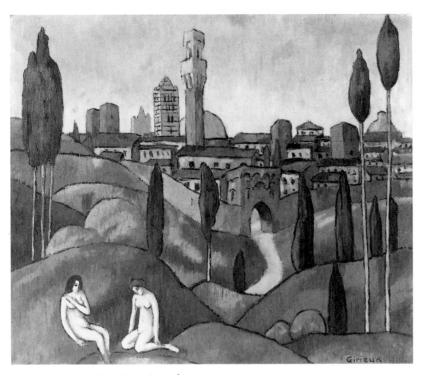

171 *Pierre Girieud*
Untitled, 1911
Musée national d'art moderne
Centre Georges Pompidou, Paris

October 13/26, 1910 [Kandinsky always gives the old style Russian date first, followed by the Western one].
Yesterday, we (Tomik [Thomas von Hartmann] and I) went to see Goncharova. She was rather cool (it is she who wrote that rude letter). I chewed her out in a thoroughly amiable way (she is very young), which impressed her, as she had hoped to show many paintings which I allowed myself to criticize (very gently). Very talented things, with much feeling, in other words very interesting, even though they're too theoretical on the one hand, and, on the other, not really thoroughly finished (ill. 172). She invited me to come Sunday to meet Larionov and to go and visit the new modern art dealer (Kurland) with him. I accepted very gladly. [...]

October 15/28, 1910.
Yesterday I went to the Stroganov arts and crafts institute where their efforts and aspirations made a good impression on me.

October 16/29, 1910.
Just came back from seeing Lentulov (the painter I turned down). [...] Then lots of painters arrived: Konchalovsky (friend of Le Fauconnier) whom I will see again the day after tomorrow at Mashkov's, Goncharova, Larionov, some others... I spoke about Marianne [Werefkin] [...]. Le Fauconnier read lots of my things to Konchalovsky in Paris and told him he absolutely had to look me up in Moscow. [...]

Marc was deeply impressed by Kandinsky's elegance and sensitivity when he met him. He declared that the new ideas on the Munich art scene were being generated by two long-obscure Russian artists: Jawlensky and Kandinsky.

For its second exhibition, the Association published a large catalogue which included contributions by the young Russian avant-garde painter David Burliuk,[241] as well as Le Fauconnier, Odilon Redon, and Rouault. Vladimir Burliuk (David's brother) (ill. 173), Braque, Derain, Van Dongen, Picasso, and Vlaminck were some of the artists whose works hung in the show and consequently both the exhibition and the catalogue attracted attention in Paris, as Kandinsky reports in one of his letters to Gabriele Münter: "It is particularly gratifying that there is so much talk about us in Paris, a fact which we owe of course to Le Fauconnier. Bernheim-Jeune sent me a catalogue of the Cross collection." This gallery knew and liked Kandinsky's work and offered to schedule an exhibition for him, an offer he turned down because he disagreed with the financial terms he was proposed (they included contributing toward the gallery's expenses).[242]

As the organizer of the Association, Kandinsky contacted a number of Russian artists. This is a little-known side of his activities, and so we will quote relevant passages from some of the artist's letters to Gabriele Münter. After all, there is no better source of information than his own words.[243]

172 *Natalia Goncharova*
Cover for the Catalogue of
"Knave of Diamonds", 1910–11
Musée national d'art moderne
Centre Georges Pompidou, Paris

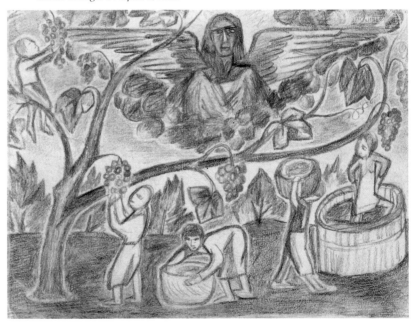

173 *Vladimir Burliuk*
Dancer, ca 1910
Oil on canvas, 39⅜ x 64 in
Städtische Galerie im Lenbachhaus, Munich

Gauguin collection, a few good Van Goghs, fine Cézannes, and finally lots of Matisses, including recent ones. I said a few words, and well. Convinced Shchukin, by the way, that he must buy some of the very latest Picassos, which frighten him. He pondered this and said very kindly: "You are right." I also spoke well of Matisse, who had baffled a few ladies and a musician, and I ended with the words: "Well, actually Matisse is already passé." This impressed them, and even Sh. listened carefully. [...] Saturday at Lentulov's was very nice. At 3.30 in the night he still did not want to let me go home: "No, no, you are leaving soon, you must stay here till 8 in the morning. Everyone is staying for you. [...] I was dead. He finally let me go, but I had to promise solemnly that I would come back Wednesday [...]. I accompanied Larionov and Sologub (architect) a short way. Both shook my hand when we took leave, and said that we (you and I) must move to Moscow. And it came from the heart, it wasn't just politeness. Everyone, by the way, wants us to live here and only one person said: "No, Kandinsky must live part time in Munich, he is very much needed there." Larionov is the theoretician here, the thinker, and he does not want to be upstaged. A bit like Marianne (Werefkin), but more interesting and brighter.

174 *Mikhail Larionov,* Soldier's Head, *1909–11*
Gouache, 11⅛ x 8⅞ in
(exhibited in the Blaue Reiter, 1912)
Musée national d'art moderne
Centre Georges Pompidou, Paris

October 19/November 1 [1910].
Spoke [with Mashkov and Konchalovsky] from 5 to 9 unobserved and passionately: first alone with M. who made a whole speech against philosophy in the arts, later with both, and K. affirmed the opposite. But we ended up getting along fine. It pleases me that they are all striving and not clinging to what has already been achieved.

October 24/November 4, 1910.
Spent yesterday from 8.30 to 1 at Lentulov's (Hartmann, Larionov, Goncharova, Mashkov). Much discussion and arguments about monumental art [...]. Our 8 Munich artists have now been invited to participate as non-competitors with 2 works each in the Bubnovy valet (Knave of Diamonds) exhibition in December [...]. Larionov seems to be the most sensitive, and he thinks.

October 31/November 13, 1910.
Turned down the painter Petrov-Vodkin (who had invited me to lunch at the "Apollo") by telegram.

November 8/21, 1910.
Spent not quite two hours at the Shchukin gallery. [...] Monet, Pissaro, Raphael, Degas etc., large

November 9/22, 1910.
[Kandinsky begins by saying that the Giselists – Jawlensky and Werefkin – are "drum sounds: dumm, dumm."] Let them have their moods, darling. Let us do our duty toward others as well as we can, and not concern ourselves with the results. Right? [...] The distance between us and Gisela [i.e. the Giselists] may widen steadily. But there may be a turn about which we do not expect. It saddens me to have to use "politics" so often. If only it was possible to approach people with the heart alone!

November 25/December 8, 1910.
They [the Giselists] can take a jump in the lake. I want to live in solitude and be free of life's adversities. Alright! I know this is despondency. I know it well. But I'm tired, tired of being generous [a play on the words "Kleinmut," which means despondency, and „Grossmut," which means generosity]. As a matter of fact, I'm tired of a lot of things. I want to live solely for art. Ah, to pull up trees by the roots! I want to uproot trees. Just as long as it's not weeds.

August 10, 1911 [from Kandinsky in Murnau to Münter in Bonn]. A committee meeting [for the New Artists' Association] two days ago. We laughed ourselves silly, and dropped things, when Marc told us about it! [...] It was again very nice at the Marcs. I feel very much at ease there, almost as much as at the Hartmanns. [It was probably on this occasion that Kandinsky wrote a witty nonsense sketch, *Lokal*, poking fun at the misunderstandings and human weaknesses of the comittee members.][244]

By the end of 1910, the divisions within the Association had become so open that Kandinsky contemplated resigning. "But I do not know whether my conscience will allow it," he confessed to Gabriele Münter.[245] The final break with the New Artists' Association occurred a year later. The pretext was the format of Kandinsky's *Komposition V*, which was judged to be too large to be admitted to the exhibition. But the real issue was of course not the size of the painting, but its degree of its abstraction, which seemed too extreme to the Association's other members. This was, in a sense, the first step toward the founding of the "Blaue Reiter".

DOCUMENTS

Unpublished correspondence between Kandinsky and Nikolai Kulbin[246]

Dear Mr. Kulbin! 6/24, 1910

I have been told that you are the chairman of the "Triangle," and I therefore take the liberty of putting a request to you. It seems that our young organization is very close, in its goals and undertakings, to yours. But our information about the "Triangle" is very scant and spotty. We would therefore be grateful to you for sending us your statutes, catalogues, etc... I in turn am sending you our statutes, the catalogue of our first exhibition which will tour Germany, starting in November, and an announcement. I would be very grateful for any information you send us.

Sincerely yours,
Vasily Vasilievich Kandinsky
President New Artists' Association
Munich

[Following a series of letters, Kulbin writes on May 19, 1911]:

As you may know, the Congress of Pan-Russian Artists is scheduled in December and you will play an active part in it with your text.
There are plans for exhibitions in connection with this congress [...]. If the Russian members of your association wish to participate in one of these shows, their works will not be submitted to a jury [...]. We will endeavour to keep the new art well away from the academic [...]. It is almost certain that the ARS [Society for the Synthesis of the Arts] will also be represented. This society was just founded last spring. It has the following principles: 1) be progressive, 2) unify the different arts, work toward a general synthesis of the arts. [Kulbin names eight sections that have expressed the intention of working together: Music under Anatoli Drozdov, Drama under Nikolai Evreinov, Dance under Mikhail Fokine, Literature under Sergei Gorodetsky and Alexander Blok, etc.]

[After a further series of letters, Kandinsky writes to Kulbin on July 19, 1911]:

Dear Nikolai Nikolaevich,
I thank you very much for your kind and detailed letter. I cannot say anything definite at this point concerning the participation of our members in the section you are organizing, for they are almost all away. I, however,

gladly accept the invitation. I believe that my wife [Gabriele Münter] would also gladly participate, if she is eligible as a German. You have probably seen her works at Izdebsky's "Salon" which she took part in this year, also at the Knave of Diamonds show in Moscow. I am almost sure too that M[arianne] Werefkin and A[lexei] Jawlensky would like to show their paintings. I will write to you concerning this later. They are all members of our association. I also think that Franz Marc (also a member) might join us [...]. Marc is a very talented and serious artist. This circle inclines as a whole toward Russia and feels very close to Russian art [...]. I would also like to recommend the composer Foma Gartmann [Thomas von Hartmann]. [...]. He is a man of exceptional talent and depth. [...].

Do you know how the Muscovites, such as Goncharova, Mashkov, Larionov, Lentulov, Konchalovsky, etc. will react to this participation? I am delighted to learn that the Burliuks [David and Vladimir] will also exhibit with you. Did you invite Izdebsky too? [...].

Do you know the Viennese composer Prof. Arnold Schönberg (see his article translated by me in the catalogue of the 2nd exhibition of Izdebsky's "Salon")? Two of his very interesting and radical quartets and three piano pieces were published by "Universal Edition" in Vienna. Use my name, if you want to get in touch with him.

[On April 10, 1911, Kandinsky writes to Kulbin]:

I am sending you the prospectus of the first Blaue Reiter Almanac, which I have just finished putting together and which is being printed so as to be published probably right after Christmas. In order to stir up some musical ideas, I have taken the liberty of reprinting your "Free Music" [...]. Would you be so kind and let me know about the current situation of the ARS? I would like to publish a comment about them in the almanac.

Vasily Kandinsky, "Content and Form", (in V. A. Izdebsky, *Salon 2.* Odessa, 1910; translated in CW, pp. 87f.):

The work of art is the inseparable, indispensable, unavoidable combination of the internal and the external element, i.e., of content and form.

In art, form is invariably determined by content. And only that form is correct which expresses, materializes its corresponding content. All other considerations, in particular, whether the chosen form corresponds to what is called "nature," i.e. external nature, are inessential and damaging, in that they detract from the sole purpose of form – the embodiment of its content. Form is the material expression of abstract content. Thus, only its author can fully assess the caliber of a work of art; only

he is capable of seeing whether and to what extent the form he has devised corresponds to the content which imperiously demands embodiment. The greater or lesser degree of this correspondence is the criterion by which the "beauty" of the work of art may be judged. The most beautiful work is that whose external form corresponds entirely to its internal content (which is, so to speak, an eternally unrealizable ideal). Thus in essence, the form of a work of art is determined according to internal necessity.

The principle of internal necessity is in essence the one, invariable law of art.

III.

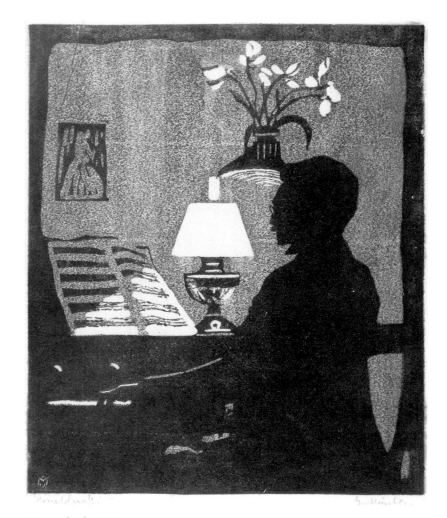

175 *Gabriele Münter,*
Kandinsky at the Harmonium, *ca 1909*
Color linoleum cut,
Gabriele Münter- und Johannes Eichner-
Stiftung, Munich

III CHANGE OF INSTRUMENTS

CHAPTER ONE
THE POEMS

"I sometimes (but seldom) like to put down the brush in order to take up the pen (typewriter). I can do neither on command, only when I feel compelled to," Kandinsky wrote in 1935 in a hitherto unpublished letter to the New York gallery owner J. B. Neumann.[247] At the time, the word "seldom" corresponded to the truth, but between the years 1908 and 1911, when it was by no means clear to the artist which direction his painting would take in the future, he was active in several related creative fields. It is no accident that his intense experiments with other art forms, his frequent "change of instruments," occurred in the transitional period preceding his "conversion" to abstraction. It was in these years that Kandinsky wrote five stage plays, composed most of his prose poems, and devoted himself earnestly to music. He shared this interest in neighboring arts with other contemporary artists – Oskar Kokoschka, Alfred Kubin, Ernst Barlach, Kasimir Malevich, and most of the Russian Cubo-Futurists – as well as with the composer Arnold Schönberg. Dedicated artists often seem to find an outlet in neighboring fields for the tension that builds up during difficult phases of radical change, fields where they are able to experiment without the pressure that comes with success and where they feel unhampered by tradition. In Kandinsky's words, "It is also always easier to have an unfettered mind in other fields."[248]

Kandinsky had already begun to write poems in school, "which I sooner or later tore up" (see p. 25). Nevertheless, some of his unpretentious songs for Gabriele Münter, who composed music, and a few undatable Russian fragments, have come down to us. Furthermore, a small number of manifestly early poems were integrated into the stage compositions Kandinsky worked on from 1908. However, in a letter to Gabriele Münter, dated 1910, he dismisses them: "For me these things are already quite antiquated, particularly some poems contained in them."[249] This refers, for example, to the chorus's speech about contrasts in *Yellow Sound*. (The original Russian version of this text was written in rhyme. Kandinsky later translated it into German himself.)

> Stone-hard dreams... And speaking rocks...
> Clods of earth pregnant with puzzling questions...
> The heaven turns... The stones... melt...
> Growing up more invisible... rampart...
> Tears and laughter... Praying and cursing...
> Joy of reconciliation and blackest slaughter.
> Murky light on the ... sunniest...day
> Brilliant shadows in darkest night!![250]

The first prose poems in the volume *Klänge* (*Sounds, Zvuki* in Russian) were originally written in Russian. Kandinsky collected them for several years before deciding to publish

176 *Woodcut for the* Edition Salon Izdebsky, *1911*
11⅛x11 in
Städtische Galerie im Lenbachhaus, Munich

177 *Study for the Russian Edition of* Sounds, *ca 1910*
Gouache and pencil on thin cardboard, 12⅝ x 12¾ in
Städtische Galerie im Lenbachhaus, Munich

them in Russia. He designed the volume's cover, the dummy of which is now preserved in the artist's estate in Munich (ills. 176, 177). He organized everything: the woodcuts were to be printed by the firm of F. Bruckmann in Munich, the text was to be typeset in Moscow under Mamontov's supervision, and Izdebsky was to publish the book in Odessa. Kandinsky wrote to Gabriele Münter on December 9, 1910 that "Izdebsky and David Burliuk will come to see me tomorrow. Izd. owes 4000 rubles for the first 'salon' [international exhibition] and is now living more than modestly."[251] Not surprisingly in these circumstances, the project never got off the ground. It was only in 1912 (with an imprint of 1913) that the volume was published – in Munich and in German. By then Kandinsky had translated the poems into German and added some considerably more recent and "modern" pieces. Two apparently early poems were not translated, perhaps because the author felt that they were too obvious. The following unpublished poem, from a Kandinsky manuscript, is printed here for the first time:

Landscape
Is the lake, in your opinion, silvery? It is not silvery! It is wet. Look, a lamb is drinking its wet water. It would do better not to drink. There's no point in it. The butcher is already approaching with his big, oh so big knife. He's looking for it, already. He will find it. It cannot be that he will not find it. So why is it still drinking?
Or is it maybe totally inevitable that it will drink once

again? That is your opinion, but then, in your view, the lake is silvery too!
The other. The lake is silvery and the long stretched out clouds making their way across the sky are purple paths. And the big mountains in the distance are sleeping monsters covered with old, rotten, worn pelts. And the great silence is loud talk.
Might tears be precious pearls you're afraid of losing?

Compared to the above and other early poems, the new pieces with their alogical tendencies prefigure the sound poems of the Russian Futurists and German Dadaists. Thus it is not surprising that David Burliuk chose four of these poems for inclusion in the manifesto of Russian Cubo-Futurism, "A Slap in the Face of Public Taste."

Still, it would be a mistake to regard the prose poems in *Klänge* as sound poetry, simply because their sense is obscure. Kandinsky's literal German translation shows that he was exclusively concerned with the poems' contents and images, not their sound. The notion of "sound" meant much more to him than the word's dictionary definition, as did the notion of content as opposed to form, even when the content was incomprehensible from a conventional standpoint, because it was ambiguous. It is striking how, in the years up to 1912 – parallel with the development of his painting – Kandinsky moved further and further away from the traditional description of reality, from conventional grammar, syntax, and existing words.[252]

Gaze and Thunderbolt
That while he (the man) wanted to feed himself, the thick white comb cast off the rosebird. Now she rubs the windows wet in wooden towels! – Not to the distant, but to the bent. – Discharged itself the chapel – hey! hey! Semicircular pure – circles press almost upon chess boards and! iron books! Kneeling beside the jagged ox wants Nuremberg wants to lie – horrifying weight of the eyebrows. Heaven, heaven, imprinted ribbons you can bear... Even from my head the leg of the short-tailed horse with the pointed mouth might grow. But the red prong, the yellow heel at the north polack like a rocket at midday!

Kandinsky's colloquial use of language has an emphatic simplicity, in striking contrast to the poetic language that dominated German and Russian literature of the early twentieth century (with Stefan George and Rainer Maria Rilke in Munich, the Symbolists Konstantin Balmont, Alexander Blok, Valeri Briusov, Viacheslav Ivanov, and others in Russia). This was Kandinsky's answer to their pathos. It was an attempt to see and to speak in a new way, a return to the simplest, most basic things (concurrent with the discovery of "primitive" art by European painters around this time). The poem's sharp, minute observation of ordinary details should be understood along the same lines:

Early Spring
A gentleman took his hat off in the street. I saw black and white hair, stuck down with brilliantine to right and left of the parting. Another gentleman took his hat off. I saw a large pink, rather greasy pate, with a bluish reflection. The two gentlemen looked at each other, and each showed the other crooked, grayish yellow teeth with fillings.

Kandinsky's predilection for synesthesia and bizarre, penetrating, totally illogical images and metaphors expressed itself in many of the poems:

Oboe
Nepomuk had his beautiful new outdoor coat on as he sat down on the small round flat hill. Below, the small blue green lake pricked the eyes. Nepomuk leaned against the trunk of the small white green birch tree, pulled out his big long black oboe and played many well-known songs. He played for a very long time with a great deal of feeling. Getting on for two hours. As he started on "*Es kam ein Vogel geflogen*," and had just got to "*geflo…*," Meinrad, hot and out of breath, came running up the hill and, with his crooked, pointed, sharp, curved, gleaming sabre, cut a large chunk off the oboe.

Cage
It was torn. I took it in both hands and held the two ends together. Round about, something grew. Close about me. And yet there was nothing to be seen. Indeed, I thought there was nothing there. And yet I could not move forward. I was like a fly under a cheese cover. I.e., nothing visible, and yet insuperable. It was even empty. All alone in front of me stood a tree, in fact a sapling. Its leaves as green as verdigris. Thick as iron and just as hard. Small red apples hung with a blood-colored glow from the branches. That was all.

KREIDE UND RUSS

Oh, wie langsam er geht.
Wenn nur **einer** da wäre, der dem Menschen sagen könnte:
Schneller, geh doch schneller, schneller, schneller, schneller,
schneller.
Er ist aber nicht da. Oder doch?

178 *Woodcut in* Sounds, *1913*
 Städtische Galerie im Lenbachhaus, Munich

179 *Woodcut in* Sounds, *1913*
 Städtische Galerie im Lenbachhaus, Munich

LENZ

1.

Im Westen der neue Mond.
Vor des neuen Mondes Horn ein Stern.
Ein schmales hohes schwarzes Haus.
Drei beleuchtete Fenster.
Drei Fenster.

DOCUMENTS

I simply wanted to shape sounds. But they shape themselves. That is the description of the content, of what is inside. It is the ground, the earth in which a profusion of things grew, partly by themselves, partly thanks to the hand of the calculating gardner. But this hand was never cold; it never summoned by force the "propitious" hour: in spite of all calculations, even this hour comes by itself and determines the moment. All the "prose poems" were written within the last three years. The woodcuts go back to 1907. Time adapted the form to the "content" which was refining itself.

(Vasily Kandinsky, from the circular announcing the publication of *Klänge*.)

Coming from Kandinsky the pioneer, the old-fashioned, almost wraithlike aspect of this poetry can be explained by the fact that he forced himself to adopt a manner of expression that does not correspond to his nature, and that his sharp mind, which here endeavors to back up a theory with an invented practice, could not produce anything other than a cold, intellectual armchair poetry, a still-born product.

If one looks closely at these pages, one will see that they establish associations of content – for they have precise pictorial contents. It makes little difference with regard to their impact whether they are deliberately and artificially obscure or whether – as a doctor might say – they are unearthed from the subconscious in a way that corresponds to a specific pathological perversion. [...] Kandinsky the artist is not equal to Kandinsky the thinker; driven to create by the former, the latter accomplishes its achievements with an intellect and taste that flicker crudely and bizarrely in the ambiguous light of new theories, but are no more modern than Kandinsky's poetry. [... His art] remains far behind the theories it is meant to illustrate. Thought and creation are separated by a deep gulf, and an artist caught up in his past clings to the thinker who – with greater precision and clarity than others – shows us paths to the future.

(Hans Tietze: "Kandinsky, Klänge," in *Die graphischen Künste*, 1913, pp. 15 f.)

Kandinsky was also the first poet to illustrate purely mental phenomena. In Klänge, *he shapes movements, growth, color and sound through the simplest means (as in "Oboe"). The negation of illusion is still achieved through contrasting elements of illusion drawn from conventional language, so that they cancel each other out. Such a daring purification of language has never previously been attempted, not even by the Futurists. And Kandinsky even went one step further. In* Yellow Sound, *he was the first to discover and use a totally abstract idiom consisting purely of vowels and consonants in harmony.*

(Hugo Ball, Lecture on Kandinsky, Zurich, 1916–1917. MS at the Städtische Galerie im Lenbachhaus, Munich.)

The book of poems Klänge *is one of the outstandingly great books. [...] With these poems Kandinsky has attempted the rarest of intellectual experiments. Out of the "pure" mind he has conjured up hitherto unheard of beauties into this world [...]. The steady flux and shaping of all things is brought to the reader's mind through sequences of words and sentences often colored with gallows humor. [...They] reveal the vacuousness of appearances and reason.*

(Hans [Jean] Arp – who, like Hugo Ball, was strongly influenced by Kandinsky –: "Der Dichter Kandinsky," in Max Bill, ed., *Wassily Kandinsky*, Paris, 1951, p. 147.)

CHAPTER TWO
KANDINSKY AND THE THEATER

The stage compositions Kandinsky wrote immediately after his sojourn in Berlin during the winter of 1908–1909 were a significant part of his creative activity.

Ernst Stern, an artist Kandinsky had known earlier in Munich, had became a scenographer for Max Reinhardt's theater in Berlin, and it was probably thanks to him that Kandinsky saw plays produced by that celebrated innovator of the stage. Reinhardt was not only the moving spirit behind the Regie-Theater – which may have interested Kandinsky only moderately – but, like the Russian dramatist Nikolai Evreinov in his "monodramas," he also experimented with lighting and the psychological application of colors on stage. Reinhardt came to Munich in the summer of 1910 and produced a play in pantomime called *Sumurun* at the Künstlertheater. (Alexander Sakharov's partner, Clotilde von Derp, danced in this work in 1911, as well as in a production of *Midsummer Night's Dream* the previous year.) From the very first, Kandinsky's stage compositions seem to reflect a familiarity with the ideas of Edward Gordon Craig, especially the latter's concept of the "super-puppet," and the fact is that Gabriele Münter's sister in Berlin knew Craig's German translator, who had presented her in 1905 with a copy of *The Art of the Theatre* now listed in the Kandinsky-Münter library.[253]

But let us first glance at the little-known Russian theater of Kandinsky's youth. From his thirteenth year on – 1879 – he spent all his summers in his native Moscow where, studying and working between 1887 and his departure for Munich, he had ample opportunity to familiarize himself with the Russian cultural scene.

As an art form, the level of the theater had sunk even lower in Russia than it had in Western countries at this time. But in 1898 there came a change, ushered in by the founder of the Moscow Art Theater, Konstantin Stanislavsky. Stanislavsky's great achievement was to get rid of the empty pathos of nineteenth-century drama and to bring historical truth and realism to the stage. He went further in this direction than his models, the Saxonian Meininger troupe and the Théâtre Antoine in Paris. His actors wore costumes that were replicas of actual historical garb. But what impressed contemporary critics and theater-goers most were his realistic décors and "true-to-life" crowd scenes. Only later did they learn to appreciate the subtlety of his acting method based on the actor's total identification with his role. When Gorky's *Na Dne (The Lower Depths)* was produced, Stanislavsky required his players to live in lower class districts in order to pick up the speech pattterns and behaviour of the masses. The Moscow Art Theater's repertory included historical dramas, plays by Maxim Gorky, Gerhart Hauptmann and, from 1903 on, Anton Chekhov. In the early years of the twentieth century the naturalism of its productions was colored by a subtler psychological realism that played on significant pauses and typically Chekhovian shadings in delivery. As a result of this increasing sophistication, the theater again became fashionable among Russia's intelligentsia (to which Kandinsky's family and their circle belonged).

Kandinsky's relationship with the Moscow Art Theater probably began around the time when he was becoming seriously interested in drama as an art form. Perhaps, reacting on the one hand to his memories of the vapid theater of his youth and, on the other, to Stanislavsky's extreme naturalism, he had already begun to dream of writing a play of his own that would be something radically new. For the Russian theater provided an ideal terrain for carrying on his ongoing feud against materialism. Two generations – the Symbolists and the Futurists – had been, and were still, battling for the same cause.

In 1902 the St. Petersburg magazine *Mir iskusstva* published the luminous Symbolist theorist Valeri Briusov's fundamental critique of the Russian realist stage in general and the Moscow Art Theater in particular, *"Nenuzhnaia pravda"* (The Meaningless Truth), an essay that paved the way for the new "stylized theater."[254] (Coincidentally, Kandinsky's "Correspondence from Munich" appeared in the same periodical that very same year.) Like Kandinsky, Briusov believes that the artist's soul must be one with the content of his work. Seeking to imitate external appearances, he says, should never be the goal of art, but merely a pretext for creation, the artist's true aim being to express the soul. Briusov criticizes Stanislavsky's meticulous realism and declares that the essence of drama lies instead in what he calls *uslovno*, the "qualified" or "stylized," as exemplified by the stage conventions in Shakespeare's day, when a board inscribed "forest" stood for a forest. Like Vsevolod Meyerhold and Viacheslav Ivanov, he argues that classical Greek drama too was characterized by *uslovno*, whereas in his opinion the realism of the Moscow Art Theater seeks to delude the audience with three-dimensional tree trunks and accurately depicted foliage. There is no point in this, he remarks: after all, is there anyone foolish enough to mourn for an actor who "dies" on stage? In drama as in painting, naturalistic illusionism merely undermines artistic quality; conscious stylization betrays art less than does meticulous realism, and indeed, he proclaims, it is time to put an end to the superfluous, meaningless, forever unsuccessful imitation of reality on the stage. A battle can be rendered more effectively by the orchestra playing a few bars of discordant music than by twenty or even 200 extras on stage wielding wooden swords. Like Kandinsky, Briusov discerns in Maeterlinck's plays the first glimmerings of a theater based on spiritual values.

Some years later Briusov, in his capacity as a literary adviser, reported on Meyerhold's experiments at Stanislavsky's Theater Workshop. He responded with fervor to the staging of Maeterlinck's *La Mort de Tintagiles* in 1905: "There was more plasticity than realism in the movements; some groups resembled living Pompeian frescoes.

Sudeikin and Sapunov's brilliantly executed décors were not in the least concerned with natural phenomena."[255]

Vsevolod Meyerhold began to sever his ties with his teacher Stanislavsky around 1903–1904. His 1907 essay "K istorii i tekhnike teatra" (On the History and Technique of the Theater)[256] reflects the slow growth of the theory of the so-called *Stilbühne* or "stylized theater," the key to which Meyerhold had found in Maeterlinck's extreme simplicity and his inclination to regard the actor as a sort of puppet. His own productions of Maeterlinck's dramas drew on the following principles: A cold, chopped style of delivery; a unity of form and content. Everything, from the actors' movements on stage to the lines they speak, the colors of the décor and the costumes, must be harmonized in a musical-rhythmical manner. For example, the seamstresses in Act III of Hauptmann's *Schluck und Jau* are seen embroidering a long sash to the rhythm of the music. The actors' gestures stand out against a simple, flat background. The audience must never be allowed to forget that it is in a theater. In his journal for 1908, Meyerhold mentions another important aspect of the "stylized theater": "The renovators of the contemporary theater have elevated the *picturesque* to a central aspect of staging. The role of color dots, the play of lines and the expressive potential of groupings are crucially important."[257]

Maeterlinck's plays were frequently produced in Russia around this time: their uncannily still atmosphere seemed made to order for the "stylized theater." Their stylization, the impersonal gestures and delivery the author wished the actors to have, seemed just right. Kandinsky, who considered Maeterlinck a leading pioneer of the modern theater, was particularly struck by his favorite device of repeating certain words so as to focus the audience's attention on their sound. His personal library contains a copy of the first Russian edition of Maeterlinck's plays (St. Petersburg, 1896), and his own theater compositions are clearly related to Maeterlinck's dramas, less in their approach than in the spirit in which they were conceived. Like the latter, they synthesize a work of art from a dramatic situation that has been pared down to the essential. But with a difference: Maeterlinck is primarily interested in the soul, whereas Kandinsky's subject is really the whole cosmos, of which man is just one part.

The early fragmentary drafts of Kandinsky's stage compositions *The Garden of Paradise* and *Daphnis and Chloe* come closest to the "stylized theater." In 1908, working either alone or with his young friend the composer Thomas von Hartmann,[258] the artist began work on a play based on Hans Christian Andersen's fairy tale, "The Garden of Paradise." In a hitherto unpublished lecture, Hartmann relates the early stages of their collaboration in some detail:

The first thing we wanted to stage was a fairy tale by Andersen. In no time at all, Kandinsky drew a marvellous sketch of a medieval town. The houses seemed to be taken from his *Painting with Houses*, but

viewed from the front [ill. 181]. First we considered the different scenes and how they could be adapted to a ballet, then we realized that none of the existing forms of ballet could give us what we were looking for. We wanted something entirely different.[259]

As early as 1908–1909, then, the two men hoped to invent a new style of dancing. Possibly they were inspired by Isadora Duncan, whom Kandinsky had seen performing in Munich. (He mentions her in several letters to Gabriele Münter, notably in one dated November 30, 1902.) Some of their ideas are reflected in fragmentary outlines in *The Garden of Paradise*[260] and another composition having the same protagonists, *The Magic Wings*. The manuscript of *The Magic Wings* (ill. 180) contains small sketches of the sorcerer and the harlequin (both characters are named in the fifth line). There is also a note concerning a muscular woman with fat pink legs in ballet tights and an old woman wearing a bright green dress and red kerchief. The latter reappears as the "entirely green female figure" in *Green Sound*. A cryptic remark about an "Arab with very big snake – straight line with wavy [line]," shows that, far from being distracted by this colorful fairy-tale atmosphere, Kandinsky had already worked out the composition's basic constructive components: straight and undulating lines.

180 *Manuscript: First Page of* The Magic Wings, *ca 1908*
Gabriele Münter- und
Johannes Eichner-Stiftung, Munich

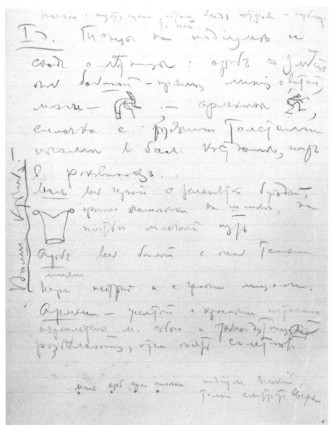

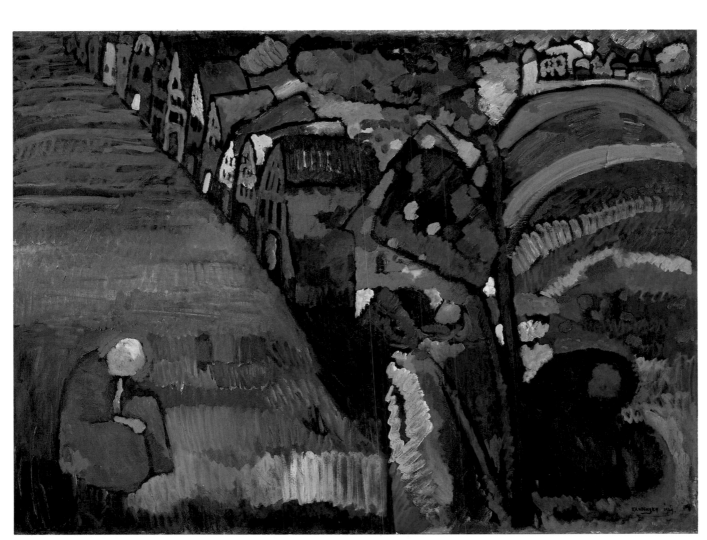

181 Painting with Houses, 1909
Oil on canvas, 38³⁄₁₆ x 51⁹⁄₁₆ in
Stedelijk Museum, Amsterdam

182 *Sketch for* Painting with Houses, *1909*
Brush and pencil, 4¹⁄₈ x 7⅜ in
Städtische Galerie im Lenbachhaus, Munich

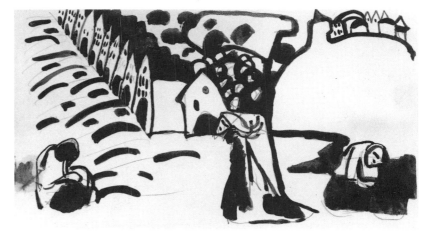

Over the years, increasingly stripping away merely decorative elements, he crystallized the drama's essential content and structure. He manifestly wanted to reduce the human figure to a vehicle for color, movement and, occasionally, sound. Thus, two trumpeters appear on stage in the following guise:

> The loud clacking sound of their wooden heels is audible. Ff of the trumpets and the yellow light. Pause. Clattering hoofs. The yellow light weakens. Combines with red, which intensifies as the herald approaches. As he reads out loud the light gradually turns completely red, and all colors vanish at the word "death," everything becomes motionless and dull gray. [...] The previously white flowers become colored.

All of these devices which here still give emphasis to symbolic meanings turn up again in later compositions: e.g. the clattering hoofs in *Black and White*, the coloring flowers in *Yellow Sound*. What is more, demonstrable though infrequent parallels occur between Kandinsky's stage compositions and his pictorial works of the same period. *The Garden of Paradise* contains a figure described as "the prince from the light blue sketch for a woodcut." "The fruit light up from within." Painting did not offer such theatrical effects. Nor did it provide much in the way of strictly musical effects (which may have appealed to Kandinsky precisely for that reason).

Gabriele Münter's store of private memories has yielded up one item of particular interest in this connection: she recalls Kandinsky constructing a small model of a marionette or hand-puppet theater (ill. 184).[261] However the most detailed memories are those of Thomas von Hartmann. After dismissing classical ballet as unsuitable to his and Kandinsky's purpose, Hartmann mentions a dancer who had studied painting, rather than ballet, before inventing his own style of expressive dancing:

> Precisely at this moment we were joined by a gifted young man who understood what we were after. This was Alexander Sakharov, later to become a well-known dancer. We began by looking into ancient Greek dancing, which Sakharov studied in museums. That is how we went from Andersen to *Daphnis and Chloe*.[262]

In the Kandinsky archives in Munich there is a manuscript that sticks rather closely to the well-known Greek pastoral novel by Longus. Though several Russian translations of *Daphnis and Chloe* were available at the time, the most recent being Dmitri Merezhkovsky's, Kandinsky himself apparently translated substantial portions of the novella from the original Greek (as suggested by his corrections on the manuscript).

In *The Garden of Paradise* Kandinsky jettisons verisimilitude and pares down the décor to a strict minimum –

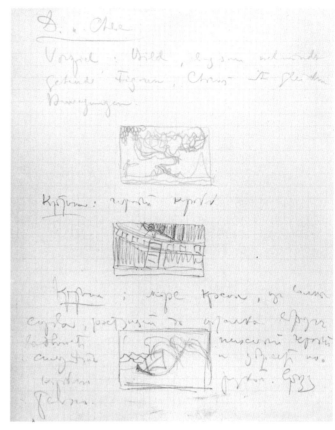

183 *Manuscript Page of* Daphnis and Chloe, *ca 1908–09 Gabriele Münter- und Johannes Eichner-Stiftung, Munich*

184 *Manuscript Page of* Garden of Paradise, *ca 1908 Gabriele Münter- und Johannes Eichner-Stiftung, Munich*

basic bright ungraduated tones – thus revealing his affinity for the "stylized theater." This tendency is even more marked in the "uniform movements" of the chorus and the homogenous stance of the warriors in *Daphnis and Chloe*, as well as in the grape-harvest baskets grouped according to their colors in the stage composition's final scene. Kandinsky's note concerning "wooden" acting and "toy figures" calls to mind both Maeterlinck's ideal of puppet-like acting and Craig's "super-puppet."

Like the manuscript of *The Garden of Paradise*, the draft of *Daphnis and Chloe* is adorned with small sketches (ill. 183). The Russian text in the space between the first two sketches specifies: "Scene: black ship," and indeed the

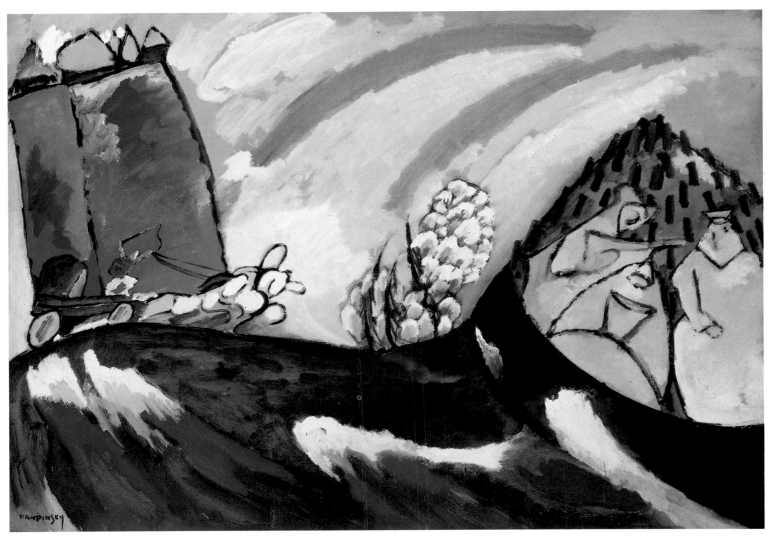

185 Painting with Troika, *1911*
 Oil on cardboard, 27⁹⁄₁₆ x 39⅜ in
 The Art Institute of Chicago,
 Arthur Jerome Eddy Memorial Collection

186 Act IV, "Storm"
 Pencil, 1⁵⁄₁₆ x 2³⁄₁₆ in
 Städtische Galerie im Lenbachhaus, Munich

second sketch shows a ship with its boarding ladder. This is followed by a new "scene": "red sea, suddenly a black silhouette emerging from a wave on the right, building all the way up to the ceiling, its hand slapping the ship. Sudden darkness." A loose leaf belonging to this series (ill. 186) contains the note: "Act IV. Storm."[263]

Here we have the first statement of a theme central to Kandinsky's only published stage composition, *Yellow Sound*. In *Daphnis and Chloe*, a black ship looms up on a red sea and disgorges sword-wielding warriors who abduct Chloe. In *Riesen* (Giants) – as *Yellow Sound* was still called in 1909 – a bright green ship with bright yellow giants appears on stage. In the succeeding version five yellow giants "appear from left to right (as if hovering above the ground)." They do not carry swords, and do not need to: they express an uncanny threat merely through their inordinate size and violent yellow coloring (see Kandinsky's definition of colors in *On the Spiritual*).

Kandinsky's *Painting with Troïka* (ill. 185) contains some of the rare pictorial echoes of Kandinsky's theatrical themes. It is not a very homogeneous painting: for a picture executed as late as 1911, it is still curiously steeped in a fairy-tale atmosphere; and to a viewer unfamiliar with its context it must seem a strangely isolated work indeed. It depicts a horse-drawn chariot racing toward the shore and a large black vessel carrying misshapen yellow giants. The team of horses is still quite recognizable, but the giants, the ship and even the sea are not so easily identified. To a viewer unacquainted with the themes and treatment of *Daphnis and Chloe* and the successive versions of *Yellow Sound*, these details might seem baffling.

A note in the draft of *Daphnis and Chloe* and the model stage Münter mentions in connection with *The Garden of Paradise* both make it clear that Kandinsky intended these compositions to be staged: "The scenery to be changed during the musical interludes, as in *Peleas*, in order to create the illusion of a dream and not to break the spell." *Peleas* is of course Maeterlinck's *Pelleas et Mélisande*. Kandinsky may have seen it produced in Russia or, possibly, Germany (it was staged at the Munich Hoftheater in the winter of 1908–1909).[264]

Ironically, the artist never attended a production of his own plays. Hartmann reports that he and Kandinsky were unaware at the time that Mikhail Fokine had chosen the same theme. "We did not want to continue our work on it after we learned of his [Fokine's] plans, even though his subsequent production differed considerably from our concept."[265] Diaghilev's production of the ballet, choreographed by Fokine, opened at the Théâtre du Châtelet in Paris on June 8, 1912. The music was by Maurice Ravel, the décors by Leon Bakst, and the cast of dancers included Nijinsky and Karsavina. It was a classical ballet and probably far more conventional than what Kandinsky had intended.

This was the concrete reason for abandoning the project. Another reason may have been the fact that, well

before June 1912, Kandinsky's artistic development had progressed far beyond the point where *Daphnis and Chloe* could still interest him in its traditional form (as he wrote in 1909 to Gabriele Münter). Were Diaghilev's plans formed as early as 1909 and were they known about then? Kandinsky's other stage compositions in Russian, developing several themes from *The Garden of Paradise* and *Daphnis and Chloe* on a definitely "more abstract" level, are dated March 1909. His notebook containing the prologue from *Daphnis* and inscribed simply "Daphnis and suchlike" contains a German version as well, but nothing indicates that this is the beginning of a true revolution in the theater:

"Stage Composition I," later called "Green Sound" *(Der grüne Klang)*, "II, *Riesen*", later renamed "Yellow Sound" *(Der gelbe Klang)* and "Stage Composition III, Black and White" *(Schwarz und Weiss)* are clearly related to each other. The only one to be developed further was *Yellow Sound*, which was published in 1912.

Gabriele Münter recalls that in February 1909 she and Kandinsky "visited the Hartmanns in Kochel ... Hartmann (very interesting – very talented) and Kandinsky were creating the music for *Riesen* together."[266] One of Kandinsky's letters from Moscow (Oct. 3, 1910) shows that he was then still working on this project with Hartmann and that he had not yet renamed the composition. He had barely arrived in Moscow when Hartmann invited the "counterpoint-musician, best student of Taneev, leftest composition revolutionary," Boleslav Javorsky. Kandinsky reacted enthusiastically: "His music theory is an immediate sister of my theory of painting: based directly on sensitivity and on the physiological/psychological effect." When Hartmann performed *Riesen* for him, he promptly decided it should be staged. Javorsky had plans of his own along the same lines and Kandinsky considered asking him to compose part of the score while Hartmann wrote the other.[267] "In any case," Hartmann remembers,

> these activities led Kandinsky to write his stage play *Der gelbe Klang*, a work that must be regarded as one of the greatest experiments in this field. The text was published in *Der Blaue Reiter*. I wrote the music for it, though it was only a rough draft since the music's definitive form and orchestration were to depend on the type of theater that accepted the play. Kandinsky made stage sketches which I took to the Moscow Artists' Theater, but they turned the play down. Not even there was it understood.

Hartmann is of course referring to Konstantin Stanislavsky's theater – clearly the wrong address! Meyerhold on the other hand would probably have been delighted to produce *Yellow Sound*. Unfortunately he was not contacted and none of Kandinsky's early plays was ever staged during his lifetime. The First World War put an end to Hugo Ball's project of staging *Yellow Sound* and portions of *Violet* in Munich. It also interfered with his plans to publish a

187 *Photo of the Dancer Alexander Sakharov,*
 ca 1910
 Scene from Lamento
 Photo: H. H. Hoffmann, Munich

had initially wanted to publish in the *Blaue Reiter Almanac*, wrote about Martynec, and Oskar Bie published a piece on "Illusion and Style on the Stage."

Kandinsky was thus acquainted with the "stylized theater" thanks to the writings of the Symbolists and of Meyerhold, not to mention performances he may have attended in Russia, well before he discovered the Reliefbühne in Munich. a new theater venture by Georg Fuchs in the spirit of the stylized theater. He advised the dancer Alexander Sakharov to study Greek vases and frescoes as a way of perfecting the highly stylized expressive dances he performed at the Reliefbühne (his never staged role as Daphnis in Kandinsky's composition was transformed into the "Greek Dances" of his first stage appearance in 1910, ill. 187).

Peg Weiss' criticism that the role of Munich's Künstlertheater (Artists' Theater) founded in 1908 by Georg Fuchs and its direct influence on Kandinsky's *Yellow Sound* has up until now been neglected, is groundless. Compared to Briusov, Ivanov, and other Russian Symbolists, not to mention Meyerhold, Fuchs was not much of an innovator. The theory that the nearly forty-year-old Kandinsky was so impressed by Fuchs' ideas that he promptly adopted them simply does not stand up to scrutiny. What grounds does Weiss have for suggesting that Kandinsky is thinking less of the Russian stage than of the "much closer Munich Artists' Theater" when he discusses the new trends in the Russian theater in *On the Spiritual in Art?*[270] Kandinsky and Hartmann never even mention Fuchs, which is not surprising since the latter was mainly concerned with a theater of "spoken drama" as opposed to the "musical theater" they were interested in. Kandinsky uses a number of devices in his stage compositions, but the word is the least of them. And though it is true that, like him, Fuchs was apt to speak about "vibrations," this was pretty much true of everyone involved with the creative arts at the time. Finally, while Kandinsky's early stage efforts are indeed related to the

volume on the new theater to which he wanted Kandinsky and others to contribute. Then Hartmann was no longer free to work with Kandinsky. None of the subsequent projects to stage the play in Russia, at the Berlin Volksbühne in 1922, or later still at the Bauhaus in a performance that was to be directed by Oskar Schlemmer, ever came to anything.[268]

Oddly enough this streak of bad luck continues today. The few attempts to stage *Yellow Sound* in the last three decades either fell short of the mark or else expressed their producer's personal ideas rather than the author's original intention. Nor have Kandinsky's stage compositions all been published so far, though there are now plans for a complete edition of his theater.[269]

Kandinsky was able to learn a good deal about the Russian theater just by leafing through copies of the periodical *Apollon* where some of his own articles appeared. This magazine published accounts of performances in St. Petersburg (by Sergei Auslender), Riga (by Johannes von Günther, especially in issue n° 7, April 1910), and Viacheslav Ivanov's small "Tower" theater (by the competent critic Znosko Borovsky, in issue n° 8, 1910). In issue n° 10 (1910) the famous dramatist Nikolai Evreinov, whom Kandinsky

188 *Marianne Werefkin*, Alexander Sakharov,
 in Lamento, *ca 1911*
 Pencil drawing
 Museo Comunale d'Arte Moderna, Ascona

stylized theater, in *Yellow Sound*, which is the stage composition Weiss is referring to, he is already well on the road toward a theater of abstraction (like Meyerhold, who was later to turn his back on the stylized theater and create a "bio-mechanical" theater, and like Malevich, Mayakovsky, and Oskar Kokoschka who, each in his own way, were to give the theater a radically new direction).

Hartmann, in a still unpublished essay from 1913 characteristically entitled "The Indecipherable Kandinsky," gives us a valuable insight into the artist's creative process and his involvement with other, though related forms of art. It was probably written for the Kandinsky "Album" which Herwarth Walden published that same year. The original essay has been lost, but there is a handwritten translation into German by Kandinsky, accompanied by a letter addressed to Walden, dated August 1, 1913. The translation may have been completed too late to be included in the volume, for evidently Kandinsky did not mail either it or the letter. Both documents were found in his archives. The fact that Kandinsky personally translated Hartmann's essay gives it a kind of seal of approval. Hartmann, incidentally, was the only friend whom Kandinsky spoke to using the informal German *Du*.[271]

Hartmann begins by recalling the period when Kandinsky had already painted *Motley Life* (1907, ill. 104) but not yet *Composition I* (1909).

This period was marked by his steadily increasing interest in music, his ideas about bringing painting in a kind of relationship to musical theory, and his increasing dissatisfaction with the contemporary theater (particularly opera). He was dissatisfied with the Wagnerian personification of the three arts united in musical drama, and he often declared that the possibilities of such a path were limited to the lowest stage of evolution. His most interesting "Stage Composition" *[Der Gelbe Klang]*, which will probably only be produced at some future date, was one result of these ideas of his [...]. I can only emphasize that the artist's idea is unique in that he sees each of the three components as a totally independent element possessing its own life and destiny in the shaping of the total art work [ills. 189, 190]. The future will tell us whether this idea can actually be carried out. As one of its originators, I leave to the public the wide realm of scepticism.[272]

Kandinsky's gropings toward abstraction are noticeable in his stage compositions, from the early drafts of 1909 to the last additions in 1912. Thus "glaring, multicolored human processions with banners and wreaths" becomes "people in diversely colored knitted garments, ressembling articulated puppets, their hair concealed by hairless, close-fitting wigs" [sic]. In the final version of this stage direction the actors' wigs and faces are the same color as their costumes: i.e. man is reduced to a mere vehicle for color. In

189 *Analytical Sketch with Musical Notes, ca 1909
Handwriting: Thomas von Hartmann
and Kandinsky.
Städtische Galerie im Lenbachhaus, Munich*

190 *Analytical Sketch with Musical Notes, ca 1909
Handwriting: Thomas von Hartmann.
Städtische Galerie im Lenbachhaus, Munich*

the 1909 composition *Schwarz und Weiss* (Black and White), a high-pitched, guttural voice utters inarticulate sounds. This is developed further in *Yellow Sound* (1912) where, on two tension-filled occasions, a tenor voice shrills completely incomprehensible words containing the vowel "a" (for example "Kalasimunafokala").

Kandinsky's stage compositions tend toward a kind of purposeless playing with colors, movement, and sounds. Less and less room is left for "action" in the conventional sense of that term. Kandinsky may even have entertained the notion of supplementing pictorial elements like color and form with temporal elements such as music, motion, and lighting, which modify both form and color. In other words, he dreamt of setting his paintings in motion. Hartmann's remark about the historical significance of Kandinsky's innovations is astute: Kandinsky was the first in the era of the post-Naturalist theater to achieve a successful synthesis of different but equal components which are causally and logically unrelated to each other. In contrast to the nineteenth-century dramatists (including Wagner, Kandinsky would say) who merely accumulated theatrical effects to enhance scenic artifices, Kandinsky elevates the artifice itself to the status of having independent significance.

Consider the apparently Christian ending of Kandinsky's best-known stage composition, *Yellow Sound*: the last remaining yellow giant slowly lifts his arms sideways and grows upward. "At the moment he reaches the full height of the stage, and his figure resembles a cross, it becomes suddenly dark." In the upper left corner of the large oil study for *Composition II* (1910, ill. 203) there is a similar yellow figure with outstretched arms. *Yellow Sound* was the only one of Kandinsky's stage compositions to be published, but it must not be forgotten that it was written as a bridge between *Green Sound* and *Black and White*. *Green Sound* ends with a wholly green female figure slowly advancing across the stage, while *Black and White* concludes with a bird – perhaps a phoenix – rising into the air. "A blueish-green bird of undefined contours lifts off from the ground, becoming completely blue as it rises, and vanishes aloft."[273]

The following passages from an undated, hitherto unpublished manuscript by Kandinsky clearly establish the cosmic foundation of his dramatic themes:

A stage where no boundary seems conceivable. [...] Movement. Sounds. Collision. Loud report. Explosion. Disappearance. Appearance. No beginning. No end. – Dust flies – planets whirl. On one planet – human beings. One act of the plot, which consists of three scenes:
1). Genesis of the body – world genesis. Revelation of the purpose of God the Father.
2). Shaping – connection – harmonic principle – revelation of love – God the Son.
3). Infusion of the spirit – Motion – Revelation of

freedom. Preceded by a question mark. Followed by a question mark. At both ends – immense silence. [...] An invisible hand tears open the curtain. One sees the first ray of the infinite sun.

This looks like a rough idea for a stage composition and makes one think immediately of *Yellow Sound* and its two side pieces, *Green Sound* and *Black and White*, but it leads Kandinsky to further propositions which illustrate his general philosophy of art:

What is freedom? Freedom is not the possibility of going left and right simultaneously, but the unlimited possibility of going left or right...with joy.
What is joy? The path of joy is the path to knowledge;
What is knowledge? Knowledge is: experience of the soul.
What is the path to the experience of the soul? Art.
Thus art mirrors and foretells the path to knowledge.
Thus contemporary art mirrors motion, foretells freedom.
What is the indispensable means for art to mirror and foretell? Unlimited freedom.
Thus today already art shows the first ray of the infinite sun – freedom.
Art is the prophet of what is to come. This prophet comes from the land of the whole first act. And reflects in itself the first two scenes: the genesis of bodies – Construction – Shaping of the harmonic principle – art's means.
Thus art is a prophetic being which continues to grow as an independent body and serves the spirit through freedom.[274]

These fragments shed more light on Kandinsky's stage compositions than any attempts at exegesis, beginning with those of his colleague Lothar Schreyer who interprets *Yellow Sound* from the standpoint of his own, deeply Christian plays as a "crucifixion of light," and ending with the most recent efforts at elucidation.[275]

CHAPTER THREE
THE SYNTHESIS OF THE ARTS

For Kandinsky the first prompting – or at least an early encouragement – for his interest in the synthesis of the arts came from Wagner (see p. 28), whose music he knew well. It is difficult, however, to establish the precise extent of his knowledge of such Wagnerian concepts as "inner necessity." Wagner's concept is basically derived from early Hegel, it combines recolutionary criticism with a world historical outlook typical of the 1840s. Thus in his *Art and Revolution* of 1849, Wagner links materialism with ancient Rome, the Christian contempt for the world with a rejection of Roman materialism, and the modern state and industrial system with a degraded, hypocritical Christianity. World history appears as a barbarian battle of systems from which general freedom will eventually emerge victorious. The ideal for the modern age is Greece's classical period. Kandinsky of course did not take anything from these bombastic early works.

Yet, though he did not get it from Wagner, we find in Kandinsky's writings the same criticism of materialism (see Part I, Chapter One). But with a difference: around 1850, Wagner was a materialist in the sense given to that term by Ludwig Feuerbach, who made "the nature of mankind" the measure of all things. Wagner's idea of a "total art work" was originally a critique of the division of labor and the modern class society. Like the Russian Symbolists, he dreamt of a nation like ancient Athens that would be capable of participating in the universal experience of the total art work.[276]

The substantial difference between Wagner's and Kandinsky's notions of the total art work resides in the fact that the former places the free, beautiful, strong human being – in a revolutionary, classicist transformation of Feuerbach's philosophy – at the center of the work, whereas Kandinsky views art as a pure spiritual medium and therefore increasingly turns away from representing the human figure and human actions in order to center his work around cosmic phenomena.

Like Wagner and, later, the French and Russian Symbolists, Kandinsky regarded music as the foremost art. He had a particular reason for doing so: he valued music as the art with the most abstract content. He wrote enviously to his new friend Arnold Schönberg:

> How infinitely lucky [...] musicians are with their so far advanced art. Real ART that already has the privilege of dispensing totally with strictly practical means. How long will painting have to wait for this? And it is entitled to it (= responsibility): color and line, in and of themselves – what unlimited beauty and power there is in the medium of painting![277]

Painting can thus learn from music the principle of using its means of expression in a non-utilitarian und ultimately

191–192 *Sketches for* Impression III (Concert), *1911*
Musée national d'Art moderne
Centre Georges Pompidou, Paris

abstract manner, as music does with sounds. That is why Kandinsky, who was not very knowledgeable about music theory (as he confesses to Schönberg in the letter just quoted), was particularly interested in meeting progressive composers. He was so enthusiastic about Schönberg's first atonal compositions, which he felt were very close in spirit to his own experiments, that he promptly wrote to the composer after attending a performance of his music in early 1911. This was the beginning of a fruitful correspondence. The same concert also seems to have inspired one of Kandinsky's most beautiful *Impressions* (ill. 193). This painting is listed in Kandinsky's private catalogue for the year 1911 as the third of a series of thirty-three works. It was painted shortly after the concert, and is a good example of this sequence of clear, simple pictures: "Direct impressions of 'external nature' expressed in a drawing/painting form. I call these paintings 'Impressions'." Pictures inspired by "events of the spiritual type," Kandinsky named "Improvisations." What he termed "Compositions" were works shaped and elaborated over many successive studies – a slower procedure. The constant presence of music in Kandinsky's thought and feelings comes to the fore in *Impression III*, as it does in many of his

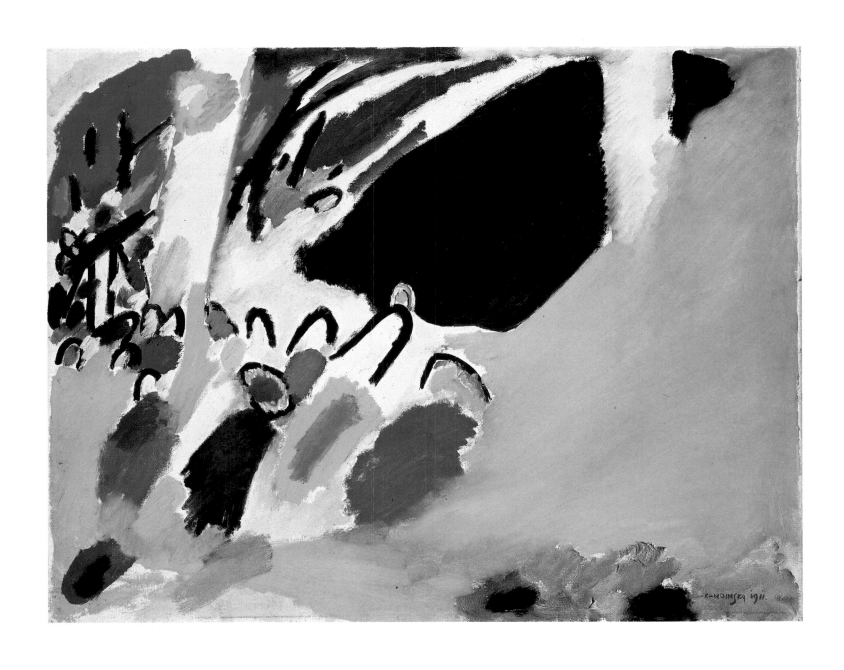

193 Impression III (Concert), *1911*
Oil on canvas, 30¼ x 39⅛ in
Städtische Galerie im Lenbachhaus, Munich

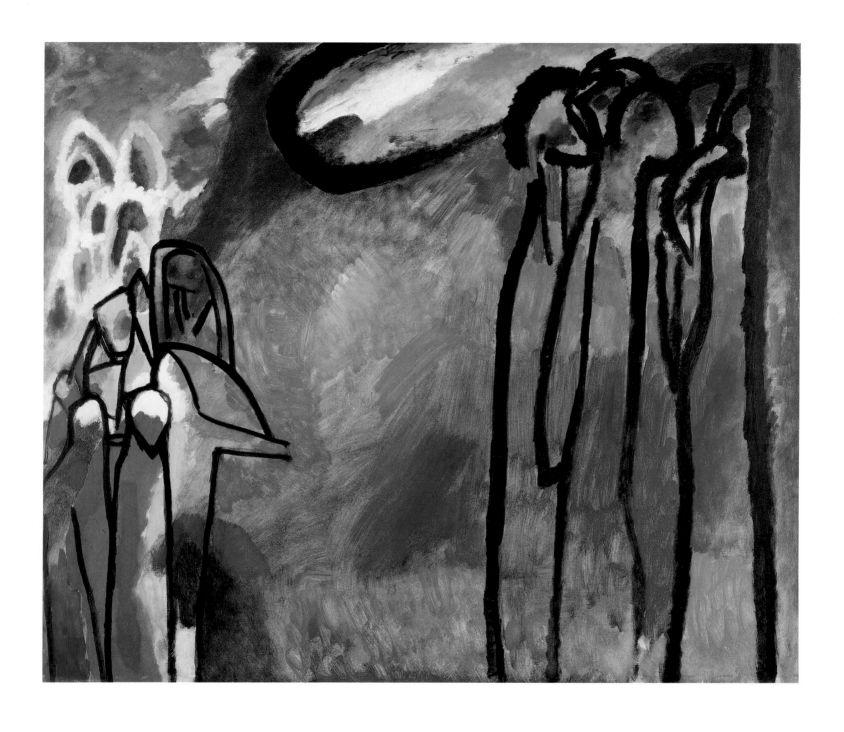

194 Improvisation 19, *1911*
 Oil on canvas, 47¼ x 55 ¹¹⁄₁₆ in
 Städtischen Galerie im Lenbachhaus, Munich

195　*Woodcut of* Improvisation 19, *1911*
5 ¹⁵/₁₆ x 7 ⁵/₁₆ *in*
Städtische Galerie im Lenbachhaus, Munich

196　*Later Sketch of* Improvisation 19, *1911*
Musée national d'art moderne
Centre Georges Pompidou, Paris

works. The black dot-like grand piano and the audience are clearly identifiable, but the two white columns cannot be recognized unless one has seen the preliminary sketches (ills. 191, 192). The most daring feature of this painting, however, is its large yellow area. In *On the Spiritual in Art*, Kandinsky describes the effect produced by the color yellow as follows: "A painting done in yellow always exudes spiritual warmth." Discerning two movements in yellow, he sees on the one hand a "striving toward the spectator" and on the other a tendency to "leap over its boundaries, dissipating its strength upon its surroundings." When directly observed, he adds, yellow is "disquieting to the spectator, pricking him, stimulating him, revealing the nature of the power expressed in this color."[278]

In addition to Thomas von Hartmann and Schönberg (whom he rightly recognized as the greatest musical innovator of his times), Kandinsky was also in touch with the progressive composer Boleslav Javorsky, whom he met in Moscow in 1910 (see p. 148). Kandinsky may not have realized when he wrote that same year to Nikolai Kulbin in St. Petersburg to inquire about the latter's art society, the

Triangle, to what degree their friendship would be colored by music and the notion of the synthesis of the arts. But he guessed rightly that the New Artists' Association and the Triangle had similar aims (see Documents, p. 135). A few months later, Kandinsky informed Kulbin, "I may travel to Kaluga to speak with A. V. Unkovskaya (i. e., to meet her."[279] He is referring to Alexandra Vasilievna Zakharina-Unkovskaya, a violinist, music teacher, and Theosophist who is mentioned in *On the Spiritual in Art* as practicing a method of teaching music to unmusical children based on sound/color/number equivalences. It was through Maria Giesler, who wrote to Kandinsky to tell him that she had heard Unkovskaya give a lecture in Budapest, that the artist was able to get in touch with this unusual woman. Giesler may have met her on the occasion of the Theosophical Society's congress in 1909. Unkovskaya had designed a chart of equivalent tones in color and music, which Giesler gave to Kandinsky that same year. In October 1910, Kandinsky reported that the table had been forwarded to him in Russia. Somewhat later, he entertained the notion of reproducing it in the *Blaue Reiter Almanac* (see p. 200). In *On the Spiritual in Art*, he writes warmly about Unkovskaya, comparing her method to that of Scriabin, "who has constructed empirically a parallel table of equivalent tones in color and music, which very closely resembles the more physical table of Mrs. Unkovsky. Scriabin has made convincing use of his method in his *Prometheus*." But in a letter to Gabriele Münter dated October 23, 1910, Kandinsky is more critical of the famous composer: "We (the Hartmanns and I) heard Scriabin's music a short while ago. It is certainly interesting, but it is too beautiful for me. He too has given a lot of thought to the correspondence of musical and color tones, but, as far as I know, not enough. I may go to see him, for he is now in town."[280] Still, Kandinsky was sufficiently interested in Scriabin to later publish an esssay on him in the *Blaue Reiter Almanac.*

In May 1911, Kulbin wrote to Kandinsky that the Triangle's goals were "to unify the different arts, work toward a general synthesis of the arts. It would be splendid if all the members of your group who are interested would join us." Kandinsky promptly suggested the following candidates: Gabriele Münter, Franz Marc, Alexei Jawlensky, Marianne Werefkin, the "very original and talented Elisabeth Epstein," and a man of "enormous talent and depth" – Thomas von Hartmann. He inquired whether Kulbin knew the revolutionary Javorsky,[281] and warmly recommended Arnold Schönberg (who was in fact invited to conduct a concert in St. Petersburg in 1912).

Kandinsky thanked Kulbin for the latter's seven-page pamphlet entitled "Free Music, Musical Applications of the New Theory of Art," and translated an excerpt from it for the *Blaue Reiter Almanac*. (As published, this excerpt is so brief as to be barely comprehensible.) Kulbin was primarily interested in "small intervals" – not only quarter and eighth tones, but ¹/₁₃th tones and indeed "everything that

exists in nature!" He claimed that such micro-tones acted directly upon the soul without detouring through the brain. He seems to have been one of the first to express such ideas – ideas that were in the air at the time – and to experiment with them.

That same year – 1911 – Vladimir Izdebsky printed a long essay illustrated with graphs by Henri Rovel in the catalogue for his second international "Salon." Rovel, an expert on synesthesia, had already published an essay in *Tendances Nouvelles* which Kandinsky mentions in *On the Spiritual in Art*.[282] His idea was basically that, man being an organic "entity," his senses cannot be separated from each other: thus the eye, he claims, reacts to strong acoustic influences by seeing colors where none in fact exist, even though the eye as a rule is excited by short waves (vibrations) and the ear by long ones. Rovel cites such authorities as Helmholtz, Rood, and Boll, and gives precise graphs of the wavelengths of the seven colors of the spectrum and the seven basic tones. Kandinsky, who had long been looking for a precise, demonstrable common denominator for the arts – as well as a Goethean "figured bass" for painting – was understandably interested in these lucubrations.

In the fall of 1910, while pursuing their joint work on the stage compositions, Kandinsky and Hartmann had an opportunity to become acquainted with the invention of a certain Smirnov at the Conservatory: a non-tempered harmonium. They were given a demonstration of the difference between it and a tempered instrument. "What is considered unharmonic and impossible becomes fabulously delicate and harmonious on these natural keys," Kandinsky wrote to Gabriele Münter. "For example, even the sequence of si-do-re is ... harmonious! [...] This could be the beginning of a great revolution in harmony and counterpoint."[283]

In Smirnov's harmonium, as in Zakharina-Unkovskaya's chart of equivalences, Kandinsky saw a return to "natural" laws. He observed approvingly in October 1910 that Javorsky had constructed a complete music theory and formulated new principles based on the most ancient ones.[284] He made a similar comment about Schönberg when presenting his translation of excerpts from the latter's as yet unpublished *Harmonielehre* in the catalogue for Izdebsky's second international "Salon" in 1910–1911. He urged the readers to notice particularly the

> strong sensitivity with which this revolutionary composer feels the unchangeable *organic* relationship, the unchangeable natural development of the new music in relation to the older music springing from the depths of its remotest and earliest sources. "Art... goes the way of human nature." The developing human mind eternally fertilized art, and art, with its new means of expression, fertilized the mind in return. But in each period there are limits to what can be attained [...]. This is Schönberg's opinion too:

every combination of sounds, every step forward, is legitimate, "but I also feel, even today, that there are certain conditions which determine whether I use this or that dissonance." Schönberg's thought combines a great freedom with a great faith in the principle of the mind's development.[285]

It is hardly necessary to add that Kandinsky is also speaking for himself.

DOCUMENT

I myself experimented abroad with a young musician and a dance artist. The musician selected from a number of my paintings the one that seemed to him to have the clearest musical content. He improvised this painting in the dancer's absence. Then the dancer joined us. The music was played for him, he translated it into dance and then guessed which painting he had been dancing. [Kandinsky is clearly referring here to Thomas von Hartmann and Alexander Sakharov and to the years when they were collaborating on the stage compositions in Munich, i.e., from about 1908 to 1912.]

(Vasily Kandinsky, Lecture published in *Vestnik rabotnikov iskusstv*, N° 4–5, Moscow, 1921, pp. 74 f.)

IV.

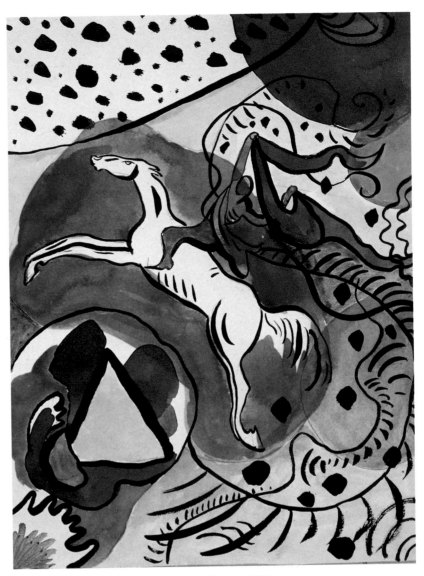

197 *Study for Cover of the* Blaue Reiter Almanac, *1911*
Watercolor, India ink, and pencil,
10⅞ x 8⅝ in
Städtische Galerie im Lenbachhaus, Munich

IV PERIOD OF CREATIVE GENIUS

CHAPTER ONE
NATURE AND ART ARE TWO DISCRETE REALMS

There will always be a degree of uncertainty over exactly when Kandinsky had the following key experience that was to give him further insight into the role of the object in his painting.

> It was the hour when dusk draws in. I returned home with my painting box having finished a study, still dreamy and absorbed in the work I had completed, and suddenly saw an indescribably beautiful picture, pervaded by an inner glow. At first, I stopped short and then quickly approached this mysterious picture, on which I could discern only forms and colors and whose content was incomprehensible. At once, I discovered the key to the puzzle: it was a picture I had painted, standing on its side against the wall. The next day, I tried to re-create my impression of the picture from the previous evening by daylight. I only half succeeded, however; even on its side, I constantly recognized objects and the fine bloom of dusk was missing. Now I could see clearly that objects harmed my pictures.[286]

He immediately asked himself what could replace the missing object in his pictures; embellishment, the "dead semblance of stylized forms," he found merely repugnant. At the end of 1909 Alfred Kubin had made him aware of the danger of rigid stylization; in May 1910 he expressed his views as only a fellow-painter could, with a degree of perception and an accurate sense of what was to come: "Your method is crazy and ecstatic and tempting. You clear the hurdle of embellishment. [...] Perhaps in years to come people will see in you the beginning of a new era of art."[287]

But Kandinsky remembers that he needed many years of patient application; he could never bring himself to use a shape that had developed from logical processes. Both facts, including the priority of painting over theory, are confirmed in writings and letters. Also no one since Kubin seems to have noticed that in Kandinsky's paintings sensuality and Eros strike the onlooker in a surprising variety of ways.[288]

The pictures categorized as "Impressions," "Improvisations," and "Compositions," have already been discussed in the previous chapter. From 1909 onward Kandinsky uses "Improvisation" particularly often as a title for his pictures, but "Impression" on the other hand only from 1911 onward, even though this is the simplest term for impressions of nature. After the Murnau landscape sketches, his interest probably turned to the next, more conscious level.

Like many other oil paintings of 1910–11, *The Last Judgment* (ill. 198) still contains some echoes of the religious subject matter and extreme rigor of the Murnau

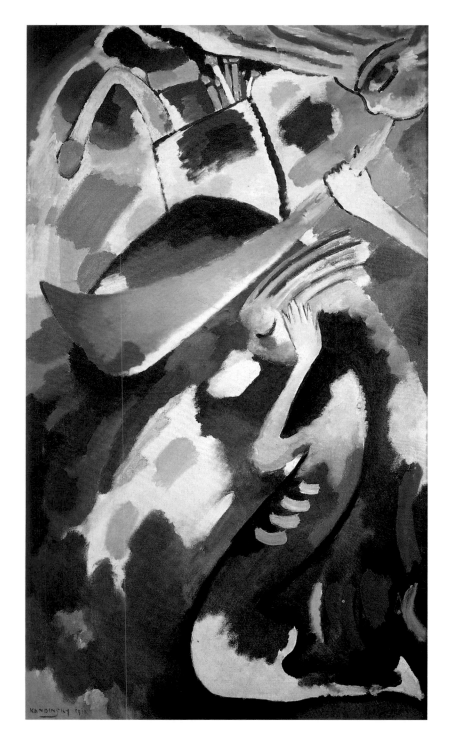

198 The Last Judgment, *1910*
 Oil on canvas, 49 ¼ x 28 ¾ in
 Joseph H. Hazen, New York

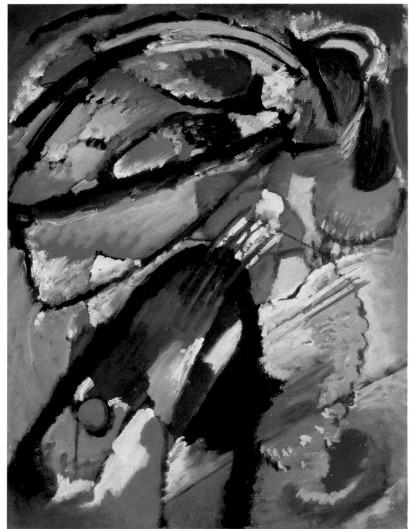

199 Angel of The Last Judgment, *1911*
 Oil on cardboard, 33 ½ x 29 ⅛ in
 Private Collection

200 *Sketch for* Improvisation 5, *1910*
Oil on cardboard, 27¹⁵/₁₆ x 27¹⁵/₁₆ in
Minneapolis Institute of Arts
Gift of Mr. and Mrs. Bruce B. Dayton

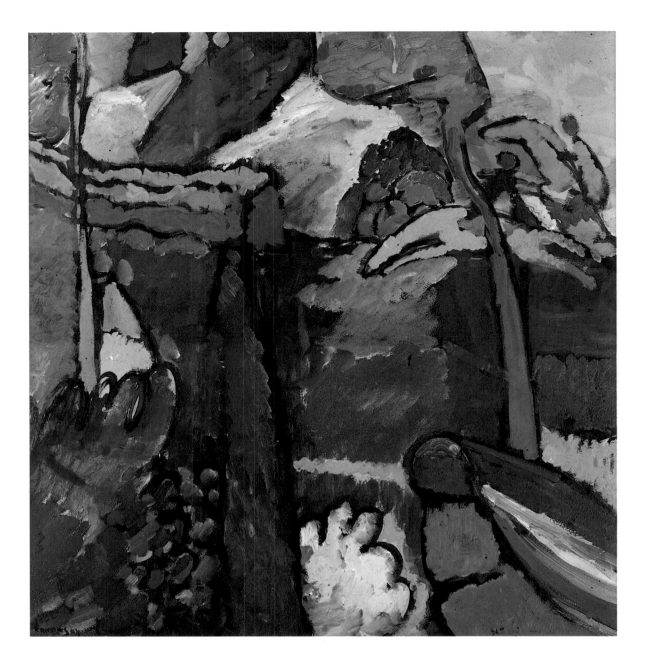

201 *Sketch for* Improvisation 5, *1909*
Pencil, 5³/₁₆ x 3⅛ in
Städtische Galerie im Lenbachhaus, Munich

202 *Sketch for the* Archer, *ca 1909*
India ink and pencil, 12½ x 12½ in (Detail)
Städtische Galerie im Lenbachhaus, Munich

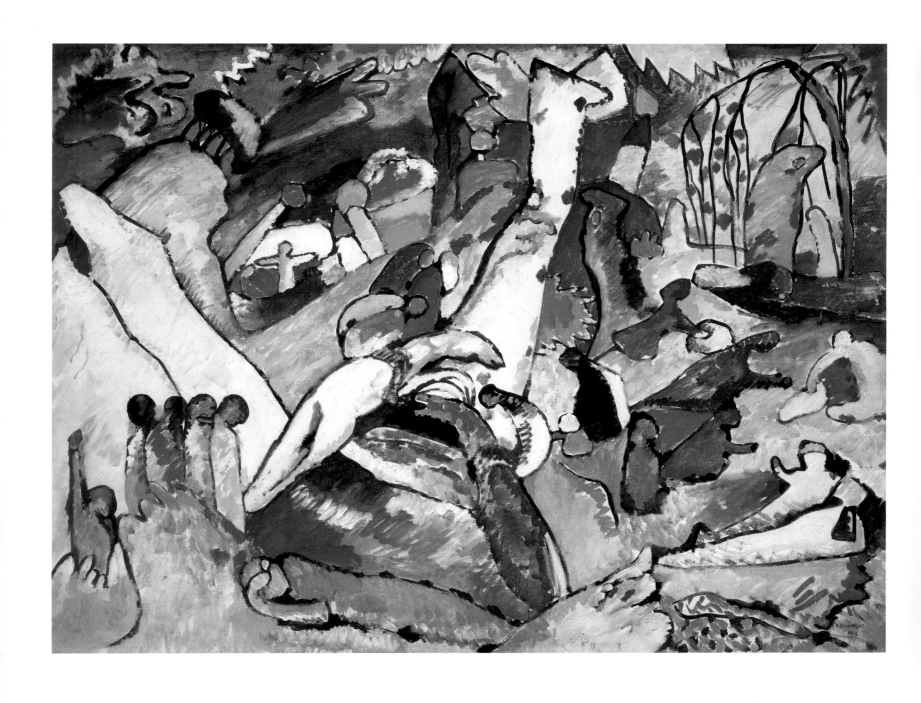

203　*Sketch for* Composition II, *1910*
Oil on canvas, 38⅜ x 51⅝ in
The Solomon R. Guggenheim Museum,
New York

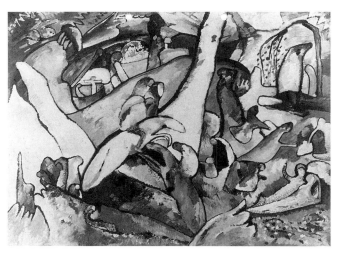

204 Composition II
(destroyed, archive photo)

205 *Woodcut for* Composition II
 Städtische Galerie im Lenbachhaus, Munich

The large oil painting *Sketch for Composition II* (ill. 203) has two horsemen in combat leaping toward each other, surrounded by many already familiar motifs; on the left next to the form of the "pointer" is a row of figures which brings to mind the giants of *Yellow Sound*, as in *Improvisation 19* (ill. 194). The same is true of the small yellow cross-shaped figure in the background. Kandinsky himself called *Composition II*, which bears a close resemblance to the large oil painting, quite simply *Paysage* (Landscape). He said it was painted "without a theme"; the viewer was meant to see the free use of color without regard for the demands of perspective. He claimed to have mitigated the tragic element in the composition and drawing by using more indifferent colors.[289]

But let us consider the connection with other paintings as stated so expressly by the artist (p. 92). Amidst this wealth of forms one can recognize the already famous reclining couple on the right and a weeping willow with trailing branches in the background. This right-hand side is also the main theme of the smaller *Fragment of Composition II* (ill. 206), so called by the artist himself. This painting too is a masterpiece in its own right, despite its title; it has even got the handpainted, fitted frame that Kandinsky occasionally produced since his days as a glass painter. Although the two-dimensional silhouettes of the reclining and crouching figures are still perceptible, the artist has completely obscured the willow's outline with blobs of color. Do the silhouettes on the right-hand side of *Improvisation 10* (ill. 208) perhaps recall these willow branches? But once again the quest for a motif is unimportant in comparison with the composition of the picture. In the wake of many compositions based more on color, Kandinsky stresses contour lines here, surrounding the colored shapes with thick lines, which also give the impression of being independent elements, like the bowed willow branches on the right in front of the mountains and the kremlin up above.

Is this a final trace of the fortress or kremlin in *Improvisation 9* (ill. 209) of the previous year? It is paradoxical that it was this particular masterpiece that was used as the cover illustration for Robert Harbison's 1980 polemic against *Deliberate Regression. The Disastrous History of Romantic Individualism in Thought and Art, from J. J. Rousseau to Twentieth-Century Fascism.*

Other than the kremlin on the mountain, nothing is apparent at first sight in the earlier *Improvisation 7* (ill. 212, see also the study, ill. 210). Nor can any continuous, consistent development toward the dissolution of forms be detected within the "Improvisation" series. Instead, Kandinsky continually makes leaps forward and backward. This picture from Moscow, as yet relatively unknown, once again bears witness to his immense dynamism. The title Kandinsky himself gave this work in the catalogue for his one-man exhibition in 1912 at the Berlin gallery of the same name, *Sturm* (Storm), speaks for itself. The brushstrokes visible in the color shapes at the top and bottom make just as much of a contribution to the whole as does the

glass paintings. There is in fact a glass painting of a similar composition. However it has already undergone a considerable transformation in the oil painting; it is not only reversed, but has large splashes of color which are unconnected, lack an outline, and are juxtaposed as beautifully and as daringly as in some Fauvist painting, though in a manner unique to Kandinsky.

The artist uses a further well-known motif in the sketch for *Improvisation 5*, which he gave to Jawlensky (ill. 200): the archer, a horseman turning round in the saddle, almost overtaken by the pursuer. Here too allusions to shapes and landscapes are still to be found, but the leading role is played by the inimitable splotches of color. The large-size *Improvisation 5* has been lost, but there are several variations, including the more famous picture of 1909 in the Museum of Modern Art in New York.

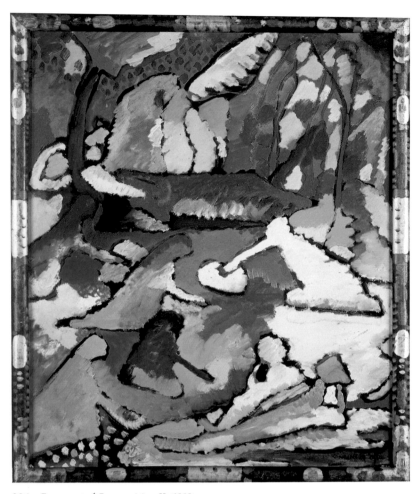

206 *Fragment of* Composition II, *1910*
Oil on cardboard, 22⅞ x 18⅞ in
Private Collection

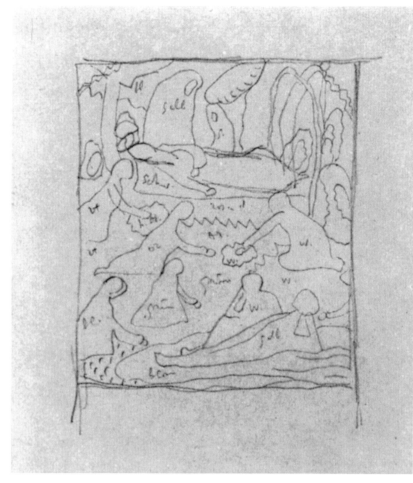

207 *Sketch for* Fragment of Composition II, *1910*
Pencil
Musée national d'art moderne,
Centre Georges Pompidou, Paris

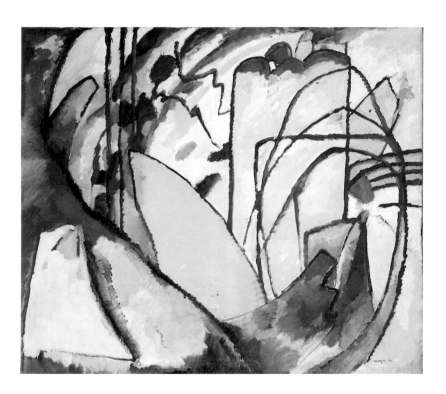

208 Improvisation 10, *1910*
Oil on canvas, 47¼ x 55⅛ in
Courtesy Beyeler Gallery, Basel

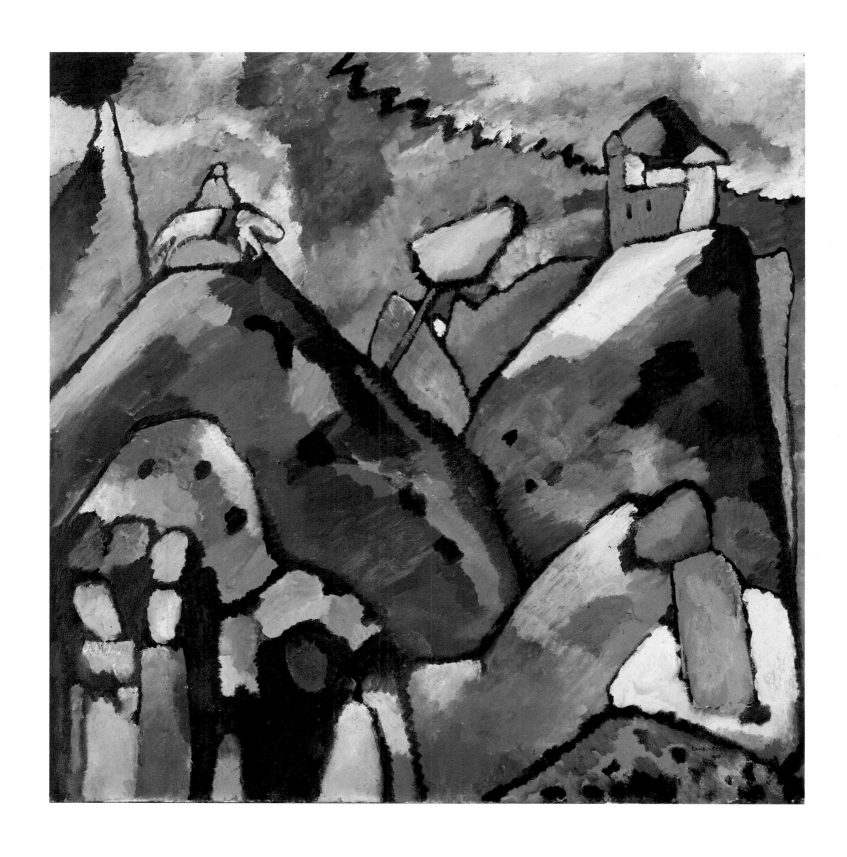

209 Improvisation 9, *1910*
Oil on canvas, 43⁵⁄₁₆ x 43⁵⁄₁₆ in
Staatsgalerie, Stuttgart

strongly emphasized movement of the color shapes from bottom to top, then accelerating toward the right.

The first three "Compositions" were destroyed in World War II. But as the large sketches and other clues bear out, the "Compositions" have been worked out in detail after a very great number of sketches and preparatory studies. This is something to which the artist attached great importance, as he did to the outsize format of these works, in keeping with their significance and the variety of their subject matter. The contemporary public was at a loss; even Franz Marc, enthusiastic as he was, could only think of Persian carpets as a point of comparison. Viewers today, who are neither experts nor well-acquainted with Kandinsky's work, likewise have more trouble with the "Compositions" than with the "Impressions," which are clearer and often limited to a single motif. Having said that, this distinction has of course never been strongly upheld with regard to many comparable pictures not included in any of these three categories. In the case of the "Compositions" it is debatable whether their large format in conjunction with their frequently small forms and variety of subject matter does not come across as "overloaded." Schönberg put forward a very well-constructed critique, mentioning proportions and concluding that "this equation could be grasped more easily if it were 'cancelled out'." Kandinsky countered with just as legitimate a question: "Are you against doubling the strength of an orchestra? [...] By using dimension my aim is (sometimes) to prevent a person from immediately grasping the picture in its entirety."[290] This is in fact what he managed to do.

Among some of the most valuable of the theoretical works bequeathed to us by Kandinsky are the "Supplementary definitions," as he called them. He wrote the first one to accompany his *Composition IV* (ill. 213) in 1911, the same year as the painting. It is a precise, substantial, and exemplary account, and it shows the extent to which he was inclined to pay attention to representational allusions.

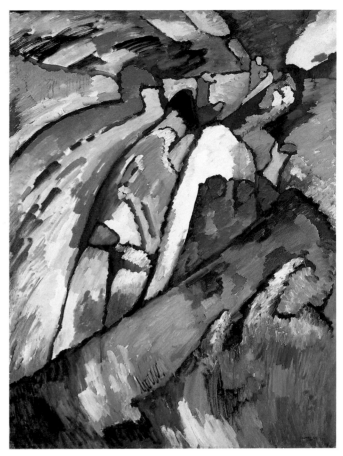

210 *Study for* Improvisation 7, *1910*
Oil on cardboard,
27 3/16 x 18 7/8 in
Yale University Art Gallery, New Haven
Collection Société Anonyme, New Haven

211 *Sketch for* Study for Improvisation 7, *1910*
Pencil, 5 13/16 x 3 15/16 in
Städtische Galerie im Lenbachhaus, Munich

212 Improvisation 7, *1910*
Oil on canvas, 51 1/2 x 38 3/16 in
State Tretiakov Gallery, Moscow

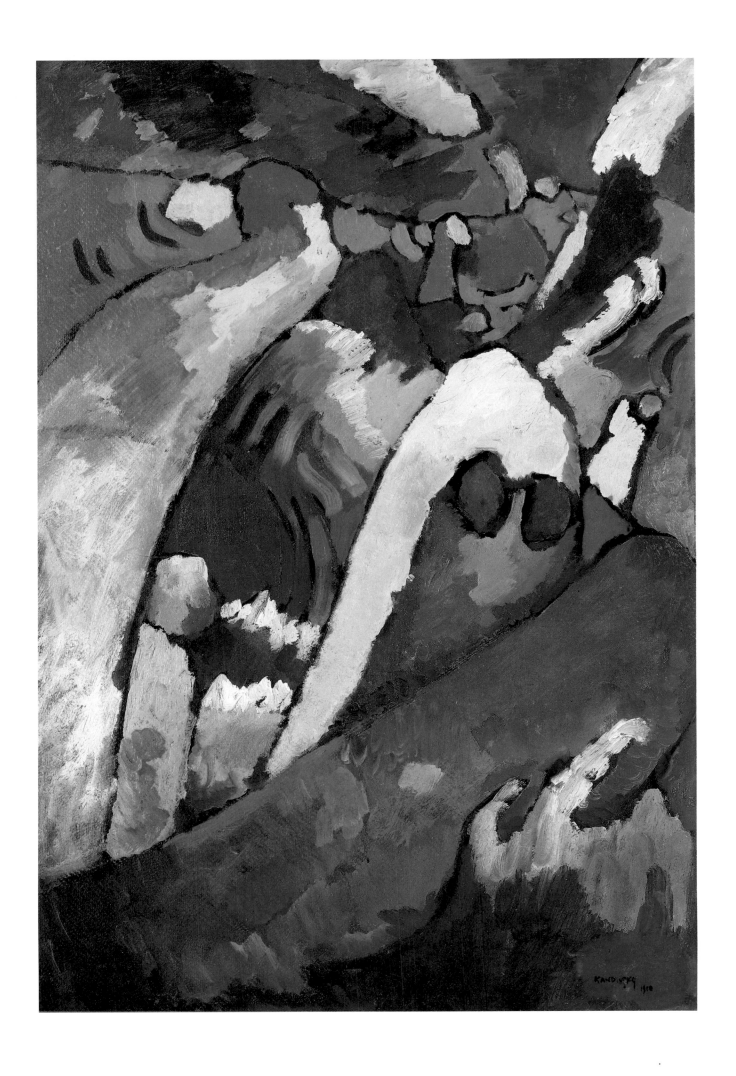

Composition 4

Supplementary definition

1. *Masses* (Weights)

Color
- lower center – blue (gives the whole picture a cold tone)
- upper right – divided blue, red, yellow

Line
- upper left – black lines of the entangled horses
- lower right – extended lines of reclining figures

2. *Contrasts*

between mass and line

between precise and blurred

between entangled line and entangled color, and *principal* contrast: between angular, sharp movement (battle) and light-cold-sweet colors

3. *Running-over*

of color beyond the outlines

Only the complete contour of the *castle* is diminished by the way in which the sky flows in over its outline

4. *Two centers*

1. Entangled lines
2. Acute form modeled in blue

separated from one another by the vertical black lines (lances).

The whole composition is intended to produce a very bright effect, with many sweet colors, which often run into one another (resolution), while the yellow, too, is cold. The juxtaposition of this bright-sweet-cold tone with angular movement (battle) is the principal contrast in the picture. It seems to me that this contrast is here, by comparison with *Composition 2*, more powerful, but at the same time harder (inwardly), clearer, the *advantage* of which is that it produces a more precise effect, the *disadvantage* being that this precision has too great a clarity.

The following are the basic elements of the composition:
1. Concord of *passive* masses.
2. *Passive* movement principally to the right and upward.
3. Mainly *acute* movement to the left and upward.
4. *Counter-movements* in both directions (the movement to the right is contradicted by smaller forms that move toward the left, and so on).
5. *Concord* between masses and lines that simply recline.
6. *Contrast* between blurred and contoured forms (i.e., line as itself (5), but also as contour, which itself has in addition the effect of pure line).
7. The *running-over* of color beyond the boundaries

of form.
8. The *predominance* of color over form.
9. *Resolutions.*

The road to abstraction was long and there were many incidental discoveries and backward steps en route; it cannot therefore be seen as a straightforward progression toward a single goal. It is more difficult to reduce Kandinsky's progress to a concise formula than that of his fellow-artists. Mikhail Larionov and his wife, Natalia Goncharova (who won Kandinsky's admiration), were both inspired by rays of light falling through trees and founded their "Rayonnism" on the experience. Anybody can observe this phenomenon in the forest and draw their own conclusions. But could this have happened before 1910, as some claim? Kandinsky makes no mention of such sensational news in his daily reports to Gabriele Münter, when Larionov presented his work to him at the end of 1910. In any case Kandinsky received "primitive" pictures from them for his exhibitions and for the *Blaue Reiter Almanac* (ills. 172, 174). Piet Mondrian's method led very single-mindedly from Cubism, especially from the tree shapes portrayed in the simplified Cubist manner, to his amazingly profound, yet nonetheless limited, abstractions. Frantishek Kupka was the first to produce pictures entirely devoid of subject much earlier. Like Mondrian and Kasimir Malevich, he also shared Kandinsky's spiritual interest, in fact he was probably the most spiritual of all in the literal sense. As an artist, however, he was in an inferior league. Mikaloius Chiurlionis studied music and was a composer before he became a painter. His lyrical, far-reaching, yet somehow never completely abstract pictures have a quite different root: his subjective visualization of music. So to compare his paintings with Kandinsky's work is just as meaningless as to compare the latter with those of the artists mentioned above. From our modern viewpoint, that earlier period appears to be compressed; we can see its trends quite clearly. At the time, however, individual painters felt themselves to be isolated and worked toward their goal alone.

Kandinsky's development is more complex than that of the artists already cited and of the French Fauves. His reduction of representational forms was a continual process that reached far beyond the bounds of the recognizable. This resulted in a constant acquisition of new, purely artistic shapes and new content. In a nutshell, his innovations are: first, his decisive abandonment of detail, something he had done already, albeit differently, in his woodcuts and glass paintings; second, the way he makes the contour independent of color (see ill. 194) and reduces motifs to "shorthand symbols," for example, a few lines for the reclining couple or the willow or especially the horse and rider; and finally, the dissolution of forms into a blur.

This last point suggests a logical but ingenuous question: would the fact that Kandinsky was short-sighted and wore glasses have been a contributing factor? What can

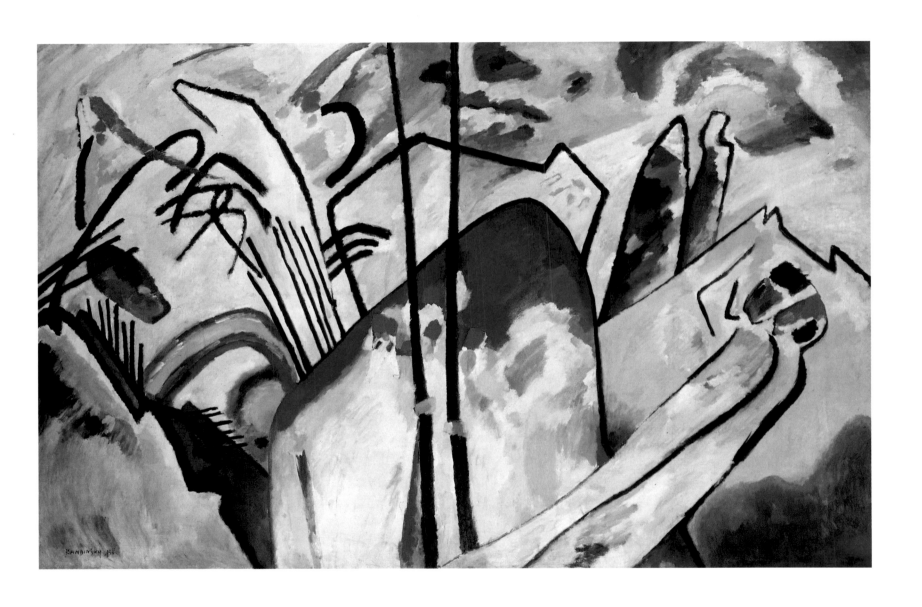

213 Composition IV, *1911*
Oil on canvas, 62 13/16 x 98 5/8 in
Kunstsammlung Nordrhein-Westfalen, Düsseldorf

any short-sighted person do that no one else can imitate? If he removes his glasses, all outlines become blurred, objects become hazy beyond recognition, and only colors remain unchanged. The more blurred the object, the more vivid seems the glow of the colors shapelessly spreading outward. But this conclusion is of course false. Kandinsky's myopia is certainly not the explanation for his dissolution of forms; after all, he was short-sighted before and after 1909–14. Since his writings, poems, and stage scripts show how carefully he observed optical phenomena (see p. 216), it is a point of some interest that he may from time to time have been able to derive some advantage from his myopia. Paul Overy makes a comparison with some other painters who had defective vision, but one would have liked to have more solid empirical evidence on this subject.[291]

After establishing that his method could not develop through anatomical distortions, the artist made the following comment on his dissolution of objects in his own work:

Thus, objects began gradually to dissolve more and more in my pictures. This can be seen in nearly all the pictures of 1910. As yet, objects did not want to, and were not to, disappear altogether from my pictures. First, it is impossible to conjure up maturity artificially at any particular time. And nothing is more damaging and more sinful than to seek one's forms by force. One's inner impulse, i.e., the creating spirit, will inexorably create at the right moment the form it finds necessary. One can philosophize about form; it can be analyzed, even calculated. It must, however, enter into the work of its own accord, and moreover, at that level of completeness which corresponds to the development of the creative spirit.

Every object has a definite spiritual sound that he wanted to include from time to time. So he would sometimes keep some objects in his picture, breaking others up.

"In general, however, I already knew quite definitely at that time that I would conquer absolute painting."[292]

This text is not dated. Kandinsky made another conclusive remark that can however be dated between the end of 1912 and 1913, thus before the publication of *Reminiscences*. In it he says that inner necessity is the only thing that can overturn every known rule and limit at every moment. This is followed by an insight that must originally have opened up the way for his individual style of painting:

For me, the province of art and the province of nature thus became more and more widely separated, until I was able to experience both as completely independent realms. This occurred to the full extent only this year.[293]

DOCUMENTS

May 6, 1910

You can be as convinced as you like that you have taken the right path, but one word of recognition from someone whom you really value has enormous worth. Even if this word of recognition strikes you as exaggerated to the extent that yours does.

June 26, 1912, on the philosophy of art of Meier-Graefe

What stupid and harmful thinking that is. It really makes you wonder that such narrow-minded and heartless people can devote themselves to the theory of art. No, really! Is he supposed to be a cut above the rest as a theorist of art?

(Vasily Kandinsky, letters to Alfred Kubin, Kubin Archive, Städtische Galerie im Lenbachhaus, Munich.)

Nuremberg, January 19, 1912

Yesterday had a proper look at the wood carvings in the "Germanic." I realized quite clearly that you can see a definite striving to depict reality as early as the fifteenth century. And the more real a thing becomes, the more lifeless. Rococo looks like a spasm of despair in the face of approaching mindless Realism.

October 9/22, 1912 (Russian and Western dates)

It's incredibly boring reading the idiocies of these "professional theorists of art;" they are narrow-minded, and devoid of both imagination and energy. Mind you, I'm pleased by the "lack of understanding," as you know. If these boneheads understood me today, my concerns wouldn't actually be worth much.

October 15, 1912

My parents are very happy at my success. I told them all about it so they could have their thrill. As always in such situations, I've got mixed feelings about it. They're even more mixed when people buy my pictures. I sat on a tall, lonely tower for a long time. Now I'm no longer alone. Is the tower still tall, even?

(Vasily Kandinsky, letters to Gabriele Münter, GM/JE St.)

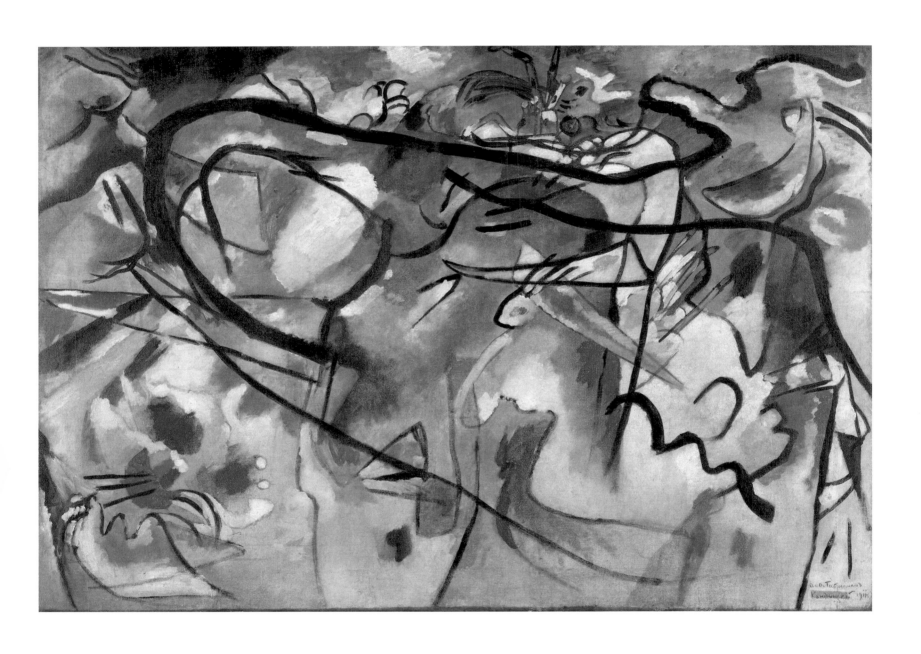

214 *Sketch for* Composition V, *1911*
Oil on canvas, 37¼ x 54¾ in
The Hermitage, St. Petersburg

CHAPTER TWO
ON THE "SPIRITUAL"

Nobody studying Kandinsky should forgo the pleasure of reading the whole of his brief but epoch-making treatise *On the Spiritual in Art*. After all the well-known quotations and paraphrases, it is always refreshing and enlightening to hear the artist "speak for himself." This chapter contains new information, firstly on Kandinsky's book, then more broadly on the topic of the "spiritual," since this has a central importance in Kandinsky's world of thought. So central that, for example, no one noticed at the last manuscript stage before printing that the word for "yesterday's" (*gestrig*) had been distorted during dictation into "spiritual" (*geistig*) with the result that the sentence concerned is unintelligible. Only in the latest (English) edition has this error been noticed and corrected.[294]

There are in all nine (!) manuscripts for this seminal work, all dating from the period 1904–11, including some in Russian and German as well as a version written out by Münter under dictation (her handwriting was the more legible). Like all of Kandinsky's manuscripts, these pages show that he wrote down his thoughts hastily, generally in one sitting, and that even in German he made surprisingly few corrections. The earlier manuscripts concern *The Language of Colors* and are dated 1904. Thus Kandinsky collected his notes over many years. He wrote first in German, translating into Russian in 1910, and adding new material. Substantial further additions were made shortly before printing in 1911.

On April 14, 1904, he informed Münter, "I've been working all evening on the Theory of Color and I'm tired." Eleven days later he predicted:

> I have to look into the depths of my own being to judge how colors affect my soul. [...] I've made quite significant inroads into the subject and can see my way ahead pretty clearly. I think I can say without exaggerating that if I accomplish this project, I shall be pointing the way to a beautiful, new method of painting with infinite possibilities for development. I am breaking new ground only dreamed of periodically by some masters. Sooner or later people will recognize it.[295]

Kandinsky's premonition has clearly realized itself, and *On the Spiritual in Art* has become one of the most influential foundation courses for modern art history.

Having completed the German manuscript, on October 18, 1910 shortly after arriving in Moscow, Kandinsky writes that he must give a lecture four days later to an educated public of about twenty people, mainly "musicians, painters, philosophers, etc." The composer Javorsky organized this event. Kandinsky found time to write on October 22, "Am giving my lecture in three hours. Working like a dog. Nearly ready. Excited, but not over-

215 *Cover and Vignettes for* On the Spiritual in Art, *before 1912*

172

much." The next day (he wrote to Münter every day, not only after important events) he summed up as follows:

It went well yesterday. I was excited at first, then I quickly calmed down. I read to an enormously attentive audience for nearly two hours with two breaks. I showed illustrations of Primitives and Persians (the Hartmanns got hold of the reproductions for me). That really interesting lady, Briusova, was there (author of that booklet mentioned before). She and Javorsky, a famous musician (conductor), had answers for me. They were clever and interesting. [...] I'm not quite free of my booklet yet [this is the modest way in which he habitually referred to *On the Spiritual in Art*.] 1) I've not yet translated everything (I skimmed through it yesterday). 2) Everything's still got to be organized and written out. Benia will do that for me; she's very good at reading my hieroglyphics and will dictate to the typist. Now I'm off to make a few visits; artists, churches, museums, etc.[296]

On October 26 he wrote in more detail:

As it happens, my lecture was quite a success. Javorsky said it made a powerful impression. [...] Lots of people said it was so new and there were so many profound and interesting ideas in it. [...] Very probably I'll be asked to speak again on the subject by another musical association that also has elderly musicians (like Taneieff) as members. I know that would be a wider-ranging group of people. I don't really fancy it, but PERHAPS I'll do it anyway. However I shall certainly not do it in front of the general Association of Artists with people of any old kind, in spite of being urged to do so by Benia and Hartmann.

Finally on November 5 he wrote, "I've managed to complete everything for my Russian booklet (translation with some small alterations). I'm really delighted. Slipped something into the German version as well, so here's the final copy. [...]"

On November 13 Kandinsky was in St. Petersburg and visited Sergei Makovsky, the editor of *Apollon*, which had already published his five "Letters from Munich":

Spent three hours at the *Apollon* offices. Got to know Makovsky and several others. Talked a lot. Makovsky said,"Write about them, then" (my opinions). I said, "I already have." He said, "I'd like to print it." I said on condition that it appeared as a book as well as in *Apollon*, and he agreed. [Makovsky seemed to find the treatise too difficult to understand. Once Kandinsky had explained, he understood and said:] "You have Asiatic roots. You look and think as if you do." So one *word* was enough to make him understand. Now he's

very keen to publish the thing, but ... the language! The language! These words! And the never-ending sentences! I write like an artist, but I should write like a man of letters (like Tschudi, etc.). I said quite bluntly, "I won't change a thing." [...] So then he gave me the whole spiel that I got from the Germans. He regretted very much that I was sacrificing such important subject matter to the wrong style. I insisted, "but the style is appropriate." Then it got to the stage that he'd accept it if I were prepared to countenance *small* alterations. I sensed that at any rate, but I just didn't want to do it. Oh, these writers who give themselves airs. Oh well, painters do too.

Kandinsky was too Russian for the Germans and (it seems from this new information) too Asiatic for the Russians! While the Germans invoked Kandinsky's "Slavic soul" to explain his incomprehensibility, the Russian Makovsky put this down to his "Asian-ness" (while to other Russians he seemed to have fallen prey to evil German influences). *On the Spiritual* was very nearly not brought to press. It was not so much Kandinsky's language that was responsible for this, since he wrote better Russian than German, as the content, which was at that time new and hard to understand. However, everyone criticized his language. Even Alfred Kubin did so in 1909, although he was captivated by the content.[297] The fact remains that today the text strikes us as totally clear and comprehensible, in spite of the occasional awkward turn of phrase.

Another accusation is now being leveled from the art historians' camp: Kandinsky is said to be difficult to understand because his concepts are vague. What is "spirit," or "soul," or "inner necessity"? But Kandinsky never intended to be a philosopher, still less a dictionary. In contrast to art historians (of whom Kandinsky is known to have thought very little, see p. 170), artists from Europe to America and Japan do not have the slightest problem understanding him, even in the absence of exact definitions of "spirit," "soul," "inner necessity," and "art." But how are we to interpret the seemingly unsystematic, at times interchangeable, use of the words "spirit" and "soul" (see Documents, p. 179)? I would suggest, exactly as Kandinsky himself uses them. He may even mean that he does not always wish to make a sharp distinction between the two concepts. This distinguishes him from the Munich "Cosmic Circle" of Stefan George, Ludwig Klages, and Alfred Schuler, who considered "spirit" and "soul" to be opposites. An additional aid to understanding might be furnished by comparing the two languages used by the artist. The Russian word *dukh* seems to me to encompass the realm of the soul and religion slightly more than the German word *Geist*. Russian does not make the same distinction as modern German between "spiritual/intellectual" (*geistig*) and "spiritual/religious" (*geistlich*), but instead *dukhovnoe* (the spiritual) has the same root as *dukhovenstvo* (priesthood) and similar derivations.[298]

216 Improvisation 16, *1910*
 (lost, it was shown at the "Knave of Diamonds" exhibition, 1910)
 Photo Courtesy Mrs. Vivian Barnett

Kandinsky's assumption that all revolutionary innovations would finally be understood in one or two generations once again proved correct. At the time, however, his reaction to the book's critics in Russia, following similar experiences with publishers and colleagues in Munich, was as follows: "You end up getting cross, when you encounter nothing but resistance to such things, such as my writing. And I find it so difficult to run around offering it all over the place."[299]

This was in fact the last time he offered his book; thereafter Franz Marc saw to its publication. Kandinsky's whole correspondence confirms clearly that "mediation and marketing art," as well as "cultivating contacts," were foreign to him. The fact that from time to time he did make an effort to push an exhibition, a potential publishing venture, or to make contact with colleagues cannot be attributed to personal ambition. He wanted to make an impact because he *had something to say.*

If it had not been for Franz Marc, he would have given up! *On the Spiritual in Art* was finally published by Piper in Munich at the end of 1911 (with the imprint 1912) and reprinted twice within a year. It had already caused an uproar in St. Petersburg, when Nikolai Kulbin gave it a public reading at the Pan-Russian Congress of Artists. Friend and foe alike from those days state that it was this book that made Kandinsky famous overnight, rather than his pictures.[300]

In *On the Spiritual in Art* Kandinsky develops one of his leitmotifs in particular: *inner necessity.* By this he means the artistic conscience that leads every conscientious artist to search for the mode of expression best suited to him. Obviously this inner voice is more important the further removed from the imitation of reality the artist is and the fewer opportunities he has for comparing his work with external models. This involves more than just personal conscience, however. Great artistic achievement is only possible if, besides forming natural bonds with his own time and cultural environment, the artist remains closely in touch with cosmic unity and the laws of nature, so that his art is necessary not only to himself but to the world.

Kandinsky's well-developed sense of mission and his elitist ambitions are also plain to see in this book. It is possible for an artist who creates as a result of an inner necessity, who is constantly refining his sensibilities and further developing his ethos, to transgress aestheticism and become a pioneer and a leader of mankind. This is an honor, but also a burdensome duty. It makes one think of Plato's "Artists' State."

Kandinsky made an additional remark in private to Gabriele Münter at the end of 1910 on another central theme of his book:

I gave a really good, concise definition of form in my booklet. Externally – delimitation; internally – external expression of the internal. If you can really imagine what I mean by that (don't philosophize about it, just simply understand and imagine it!), then you will discover form as well. You have to let form affect you and forget about all those Picassos and Picassore. [...] Form is very important, but only as a means, so it is at the same time not important at all. Form can be faultless, dazzling, and yet worthless, because it is empty. So, long live form, and down with form! You personally have nothing to fear; you have to say something, because you have been given something to say. Just put your ear to your heart and listen! [...] The world rings with sound, nothing is silent. The ear has to capture what is necessary to it. This necessity comprises beauty and truth. For that reason there is neither a single beauty nor a single truth. There are as many of each as there are souls in the world.[301]

Kandinsky's idealistic and dualistic standpoint, suggested by his criticism of materialism, is also plain to see in the

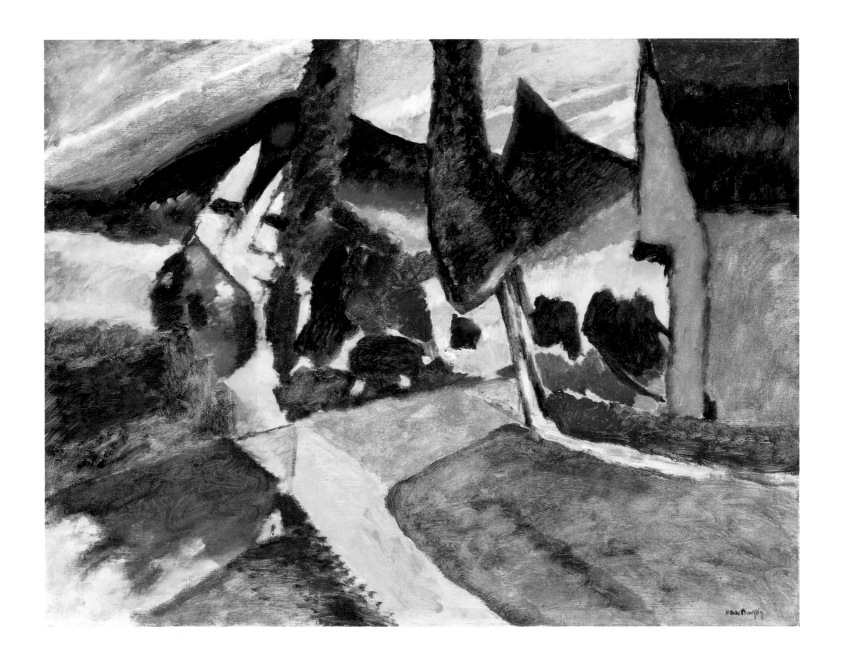

217 Landscape with Two Poplars, *1912*
Oil on canvas, 30⅝ x 39⅜ in
The Art Institute of Chicago.
Arthur Jerome Eddy Memorial Collection

218 Nude, *1910–11*
Watercolor on light gray cardboard, 13 x 13 in
Städtische Galerie im Lenbachhaus, Munich

constant comparison of form and content, corresponding to matter and spirit, where he appears to give priority to content as he does to spirit. However we find that the dualistic world view, on which principally Christianity had a formative influence, is also qualified from time to time, as it is in a Russian essay from 1910 (see p. 136). The two poles belong together; they are interdependent; Kandinsky even perceives them to be inseparable at times. It is not possible to identify him with the idealist camp without further qualification. Like countless other people then and now, Kandinsky must have welcomed the teachings of Oriental religions concerning the limitations of dualism. This was perhaps one of the reasons for his interest in Theosophy.

His connection with Theosophy, and with the Anthroposophy of Rudolf Steiner that emerged from it, has already been written on in great detail (one might almost say too much detail). Here are a few new facts. As early as 1901, as teacher at the Phalanx School of Art, Kandinsky was attracting not only artistically but also spiritually inclined students (for the most part, predictably, impressionable young girls), such as Olga Meerson, Emy Dresler, Maria Giesler, and Lisa Epstein. Perhaps someone will one day publish a study rediscovering these forgotten students and showing that Kandinsky would not have come to Theosophy had it not been for their influence. What seems more likely, anyway, is that there was a mutual exchange of ideas. Kandinsky once wrote to Münter about Epstein that she was "hoping and learning more and more to think and act in accordance with the will of God. You can imagine how pleased I am about this. I must write to her right away. She has been asking for a letter."[302]

Maria Giesler remembers how disappointed she was with standard painting classes, when she heard about Kandinsky and enrolled at the Phalanx:

In any case he was the most striking and personally independent person there at that time, among those who carried in themselves the conviction that, as it were, a transformation and rearrangement was inevitable in the field of art, as it was also in the fields of science and religion.[303]

Giesler was responsible for two other interesting contacts, one with Alexandra Zakharina-Unkovskaya, the Russian musician and Theosopher (see Part III, Chapter 3, The Synthesis of the Arts), the other with Rudolf Steiner. Giesler joined the Anthroposophic Society in 1908, and her husband, the engineer Alexander Strakosch, became Steiner's personal secretary. During the winter of 1907–8, when Kandinsky and Münter were staying in Berlin, the couple took them to Steiner's lectures. We learn from Alexander Strakosch that they bought Steiner's *Theosophie* of 1904 and all the issues of the journal *Luzifer-Gnosis*.[304] In one of these journals, which can be found in Münter's library, Kandinsky made various handwritten comments,

and illustrated particularly difficult questions for himself with his own notes.

Naturally Kandinsky welcomed this new spiritual movement, which spread rapidly through the West and Russia. There was an enormous need for it. However, in Kandinsky's case there is no reason to suppose that he questioned the fundamental doctrine of Christianity. As illustrated earlier in Chapter Two, he subscribed to it, admittedly in the broadest, "abstract" sense. In Orthodox Russia a timid discussion of fundamentals did not begin until it was perhaps already too late. For instance many people, including several renowned Symbolists, converted to Roman Catholicism, others turned to Theosophy or to Sufism, which although originating in the Near East had been introduced to Russia in a roundabout way.

At the end of 1910 Kandinsky writes about his cousin, Elena Tokmakova, with whom:

I share pleasant memories of our youth. Her husband is the professor (National Economics) who was my colleague. He's the one I wrote to from Berlin about the *spiritual movement* in Russia who sent me such a kind, lengthy reply. I've been invited there the week after next and am looking forward to it.

Kandinsky had already mentioned this family several times before.[305] His cousin was married to Sergei Bulgakov, according to Kandinsky one of the people most profoundly acquainted with Russian religious life. Bulgakov, like the more famous Nikolai Berdiaev and many others, "converted" from Marxism to Idealism and devoted himself to studying fundamental questions about Russian religious culture. For example, in 1905 at the end of the journal *Novy put* (The New Way), dedicated to such questions, he attempted to establish a new religious forum with *Voprosy zhizni* (Questions of Life). But this undertaking soon failed. He reached a wider public with his essay "Christianity and Mythology" of 1911 in the popular journal *Russkaia mysl*.[306]

The influence of Theosophy and Anthroposophy on Kandinsky's painting has been studied in greatest detail by Sixten Ringbom and Rose-Carol Washton Long.[307] However, it is questionable whether a painter such as Kandinsky, who was striving to get away from reproduction, would have found it necessary to include in his painting "spiritual photographs" or auras or other apparitions, which were figments of other people's imaginations instead of what he could see with his own eyes. It may be that he was fascinated by such things; but they obviously went beyond what appealed to his sensibility. Perhaps a trace of them did make its way into his pictures here and there. He may have drawn on them as raw material, just as he did on the natural world, his own dreams, and his own observations of optical phenomena. On the whole it seems that Ringbom and his followers exaggerate this influence on his painting. It is certain that Kandinsky never joined any

spiritualist society in spite of any interest he may have had in it initially. Having fully acknowledged Theosophy in *On the Spiritual in Art*, he intended to limit himself to a brief, if possible statistical résumé in the *Blaue Reiter Almanac*, but even that was never accomplished.

Since art historians were duplicating each other's efforts, Ringbom's approach was accepted everywhere, until a large exhibition was held under Kandinsky's title *On the Spiritual in Art*.[308] In the meantime there was talk of séances and "table-turning." It is a short step from the "spiritual" to "spiritualism" and even to Shamanism, on the subject of which a picture will be discussed at the end of this book. About 2000 letters and notes give information on this subject, in particular the open, detailed correspondence with Münter. Not once does Kandinsky mention anything of the sort; he did not engage in meditation or similar practices, as Johannes Eichner thinks he did,[309] and as his friend Alfred Kubin undoubtedly did from time to time. Kandinsky says nothing on this subject, though he otherwise reports everything, including cold baths, muscle exercises with a chair, nervous stomach complaints, and unaccustomed drinking sessions with colleagues.

There seems to be no end to the discussions on the subject of Kandinsky and Theosophy, but there has never been a word said about another spiritual influence that might have been important to him. The acquaintanceship he struck up in 1908 with the composer Thomas von Hartmann (see pp. 133, 148 f.) led to a very close, life-long friendship. As far as Nina remembers, Hartmann was the only friend with whom Kandinsky used the less formal word for "you," "*Du*."[310] Kandinsky was on less intimate terms with Marc, Klee, Schönberg, and indeed any of his Russian friends. Both Hartmann and his wife Olga, the singer, were interested in Sufism even before joining Gurdjieff's esoteric group in 1917.

Sufism, or the mystic, heretic branch of Islam, was still an esoteric doctrine at that time. Its members were not supposed to reveal anything to the uninitiated in order to avoid abuse and harm. On the other hand, it is difficult to keep a secret when working closely with a personal friend. Moreover, a steadfast character like Kandinsky (who was in any case seventeen years older than Hartmann) could surely be trusted. Thus it is highly probable that the Hartmanns at least hinted to their friend how important for example the so-called "Wazifas" were to them (as they had been to numerous Sufis for centuries). These are sequences of sounds, which embody some primeval significance, used to name those capacities of God which are shared in some measure by every human being. These sounds, when used as prayer and spiritual exercise, affect a person's various so-called "Chakras" (centres of energy). For instance, the sound "i" stimulates the ocellus (the "third eye"), the seat of loving insight. The sound "a" (stressed by Kandinsky in the incomprehensible words of a scream of fear in *Yellow Sound*) affects the heart-"Chakra." On initiation into many Sufi communities, the disciple is given one or more

"Wazifas" to practice daily by a teacher who senses what this particular disciple needs to strengthen, or even discover and develop in himself. In Sufism sounds and in particular overtones were generally studied in some depth and used in prayer and healing.

How was Hartmann supposed to maintain a strict silence in front of a friend, who had been studying similar phenomena related to colors since 1904, and who wanted to include these as well as noises and music in his stage compositions? Like Goethe, Chevreul, Delacroix, and many others before him, Kandinsky examined which colors were soothing, which were arousing or aggressive, and what counterparts might be discovered for them in sounds.

Sufis attach great importance to dances and ritual movements, not only to the whirling dances of dervishes symbolizing the human equivalent of the movements of the stars. There is no clear indication whether Kandinsky knew of this aspect of Sufism, although Olga von Hartmann insisted that the movement of the last giant in *Yellow Sound*, where he lifts his arms slowly sideways till his figure resembles a cross, was based on a Sufi movement (she and the author argued about this for a whole week, since this struck the author as being quite plainly a Christian symbol).[311]

As far as Sufi ideas are concerned, there is no question of influence, as they are in remarkably close accord with Kandinsky's opinions. Russia was penetrated to a greater extent by the tolerant branches of Sufism from Afghanistan and India, and these did not insist on a conversion to Islam. Typical Kandinsky spiritual themes, such as "die and be born" (*Solve et coagula*) and "the reconciliation of opposites," can be related to Sufi ideas, as well as his practical ethos of fulfilling one's "duty to fellow men" by feeling love toward them during private differences of opinion.[312]

In the final analysis, the moral concepts of Sufism converge with those of Christianity and other religions. However the following, previously unknown comments by the artist illustrate a more special relationship with its ideas:

Yes, I agree that essentially or *eventually* everything is one unity. There is simultaneously a double movement 1) from the complicated to the simple and 2) vice versa. For this reason I was constantly but unconsciously looking to unite these two currents in my pictures. I was always trying to connect these two seemingly unconnectable principles. All revelations are like rays of light that in the end merge into *one* "sun," truth.[313]

Consider too the following from his letter to Münter cited above: "The world rings with sound, nothing is silent. The ear has to capture what is necessary to it. This necessity comprises beauty and truth. For that reason there is neither a single beauty nor a single truth. There are as many of each as there are souls in the world."

The non-denominational and esoteric school of Sufism does not seek to replace or compete with other religions. It claims that every spiritual movement or religion has the same goal regardless of one's point of departure. A central point is also its remarkable tolerance, and so too the eclecticism rooted in it. Sufism integrated valuable ideological components from many faiths: Zoroastrian, Christian, the particularly Islamic awareness of being included in the great unity as part of the cosmos and God (rather than the belief that one should seek God and evil only outside oneself). In contrast to many Christian beliefs, Sufism does not condemn joy of life or joy of the senses. Love, harmony, and beauty are its cardinal principles. Kandinsky's description of the deep love he feels toward even the lowliest inanimate object (see Documents, p. 79) could have been written by one of the great Sufist poets. Such a view, which amounts almost to attributing a soul to inanimate matter (animism would be too strong a term in this context), may have been strengthened by contact with Hinduism. As the Sufi doctrine spread through India, it naturally picked up elements of religions there and later affected Europe with these in its turn. An example of this is seen in the ideas of Gurdjieff, Hartmann's future master.

One may reasonably assume that the discussions between Kandinsky and the Hartmanns were not without consequences for both parties. Their correspondence and the artist's numerous letters to Gabriele Münter (see pp. 133, 178) bear witness to the extent to which Kandinsky valued these friends and how very close they were. On one occasion the first thing he did on arriving in Moscow was to visit Hartmann: "We spent 13 hours together. What a real pleasure that was! The dear little lady kept saying, 'You! You here! Oh how wonderful.' Tomik kissed me again and again. Could it be that this friendship will last forever? And they spoke about you so warmly."[314]

On reading Hartmann's essay in the *Blaue Reiter* or his manuscript on "The Indecipherable Kandinsky," or even the lecture he later wrote on the death of his friend, one encounters not a single thought that is not also a thought of Kandinsky's. Is this conclusive evidence of the older Kandinsky's strong influence? Maybe it is, but only their very close spiritual affinity can be proven, most probably embracing many *mutual* ideas. Hartmann must have possessed a particularly interesting and appealing personality, or Kandinsky would not have had time for him.

It is not the present author's intention to claim that Kandinsky was introduced to the philosophy of Sufism by the Hartmanns. In fact, all the written and pictorial material suggests that there was never any necessity for such an introduction. From the very outset, there was a fundamental closeness of ethos, joy of life, and world outlook. It is for this reason that such a deep, lifelong friendship with the Hartmanns could develop. Like Kandinsky they were seekers on a spiritual level. But unlike Kandinsky, they were more closely identified with a particular group.

DOCUMENTS

In a mysterious, puzzling and mystical way, the true work of art arises from out of the artist. Once released from him, it assumes its own independent life, takes on a personality, and becomes a self-sufficient, spiritually breathing subject that also leads a real material life: it is a being. [...] It lives, and acts and plays a part in the creation of the spiritual atmosphere that we have discussed.

(Vasily Kandinsky, *On the Spiritual in Art*, CW, p. 211)

The book ends with these words:

In conclusion, I would remark that in my opinion we are approaching the time when a conscious, reasoned system of composition will be possible, when the painter will be proud to be able to explain his works in constructional terms (as opposed to the Impressionists, who were proud that they were unable to explain anything). We see already before us an age of purposeful creation, and this spirit in painting stands in a direct, organic relationship to the creation of a new, spiritual realm that is already beginning, for this spirit is the soul of the epoch of the great spiritual.

(Vasily Kandinsky, *op. cit.*, pp. 218 f.)

219 Mountain, *1911–12*
Watercolor, India ink, and pencil, 6⁵⁄₁₆ x 8⅞ in
Private Collection

CHAPTER THREE
THE FIRST ABSTRACT OIL PAINTING

While scholars are still arguing over whether the "*First Abstract Watercolor*" (ill. 220) dates from 1910 or 1913, Kandinsky himself almost never mentioned the watercolor, but attributed historical significance to his first abstract oil painting, *Picture with a Circle*, of 1911 (ill. 224). There are at least nine written comments by him that bear this out.[315]

The watercolor of 1910 owes its fame mainly to his widow Nina Kandinsky. It has been exhibited many times and, presented as the artist's first abstract work (since the oil painting was "lost" until 1989 in the Soviet Union), it attracted more and more discussion. One reason for this is that the painter did not enter this work in his private catalogue until later. Furthermore the signature and date on the picture could be associated with a later date, as he was often wont to do. For instance, his first American buyer and contact A. J. Eddy wrote to Gabriele Münter, "Don't forget to remind Kandinsky to sign every picture."[316] As far as Nina Kandinsky remembers, however, it was already signed and dated when it was returned to him by Münter in 1926.[317]

The watercolor is completely abstract and unlike any other work of 1910. On the other hand it does contain elements of the sketches and studies for *Composition VII* of 1913 (ill. 256). The center is most easily recognizable, and in its other motifs it is most closely related to the earliest, large oil painting (ill. 254). So there is an indisputable connection with *Composition VII*, and it seems logical to assume that it was produced in 1913. In contrast to other sketches, the effect of this watercolor lies in its playful, very hurried composition, which seems to have been done with very few preliminary pencil marks. It seems like the very first, hastily begun idea for a picture, which can emerge long before the actual elaboration of the subject. The eminent researcher on Kandinsky, Hans Konrad Roethel, judged the watercolor to have been painted in 1910, even though he too acknowledged that it does have links with *Composition VII* (since Roethel did not have a chance to publish anything on this subject before his death, his idea is mentioned here). Hideho Nishida on the other hand placed the picture firmly in eighth place of a series of 11 studies, thus indicating 1913. The catalogue of the Centre Pompidou leaves the question of the date open.[318]

The source of the problem is that Kandinsky's ethical position, as is emphasized by all who knew him, virtually excludes any possibility of deliberate antedating. Facts confirm that every comment Kandinsky made proved right sooner or later. So, if he did sign and date the work later on, was he out by three years? There is a watercolor dated 1911, which is not well known, that contains the same motifs, thus similarly anticipating the idea of *Composition VII* (ill. 221). If one compares the two watercolors, the *First Abstract Watercolor* is quite clearly earlier than that of 1911, so either 1910 or 1911 is possible. A further complication arises from the discovery that Kandinsky may have antedated this work too, by as much as two years.[319]

From what is known about Kandinsky's working methods, he usually thought through and executed an idea for a picture relatively quickly. But there were instances where he hesitated for some time. For example he himself introduces his *Supplementary definition* of *Composition VI* with the sentence, "I carried this picture around in my mind for a year and a half [. . .]."[320] In the case of the major work *Composition VII* for which he made significantly more sketches and studies than for *Composition VI* or any other painting (about thirty drawings and watercolors and six large oil paintings), it does not seem out of the question that the complexity of the subject should require an extremely long preparation. Some of the preparatory work may have been done before 1913, but little is dated. If Kandinsky had conceived the watercolor as the first on the subject of *Composition VII* in 1911 or 1912, then it is understandable that when faced with the huge number of sketches fifteen years later, he might have remembered the period between the first sketch and the finished work as longer than it was in fact and dated the watercolor 1910 as a result.

Even if the year of origin of the watercolor is to remain forever indeterminable, this is not absolutely essential, since his first abstract oil painting, *Picture with a Circle*, was rediscovered in 1989. Roethel spent years looking for it for his *Catalogue raisonné* and finally gave it up as lost. He rightly considered it to be such a milestone in Kandinsky's development that he devoted a short essay to its history, without ever having seen more than an old black and white photograph of it.[321] The collector Georges Costakis had received the photograph in Moscow from Vasily Bobrov, Kandinsky's secretary in the period around 1920. On the back of the photograph someone, probably Bobrov, has written in Russian "Picture with Circle – first abstract one, 1911, Kandinsky Collection."

The significance Kandinsky himself attached to this work is revealed in a letter of August 4, 1935 to his new gallery agent in New York, J. B. Neumann, to whom he explained some fundamentals:

When I left Moscow [in December 1921], some of my pictures, including some large formats, remained in the keeping of the Museum of Western European Art. Among these was my very first abstract picture of 1911 (this is the first ever abstract picture to have been painted). Unfortunately I do not have a photograph of it. At the time I was dissatisfied with the picture and so did not number it or write on the back as I normally do. I did not even include it in my private catalogue. It is a very large picture, almost square, with very vivid shapes, and a large, circular shape top right. When I took German citizenship, all these pictures were declared the property of the Russian state, and I

220 "First Abstract Watercolor", *ca 1911*
 Watercolor, India ink, and pencil,
 19 ½ x 25 ½ in
 Musée national d'art moderne,
 Centre Georges Pompidou, Paris,
 Nina Kandinsky Bequest

221 Watercolor with Red Spot, *1911–12*
 Watercolor, 19 x 24⅞ in
 Deutsche Bank AG

couldn't get them back. If it were possible to get a good photograph of the first abstract picture, I would be very pleased.[322]

In a further letter to Neumann on December 28, 1935 Kandinsky explained more precisely, "Since it is neither numbered nor signed, I would very much like photographic evidence that the picture was painted by me in 1911. It is actually the first abstract picture in the world, because no other painter was painting in the abstract at that time. So it is a 'historic picture'."[323]

Kandinsky was right; the picture is neither numbered on the back nor included in the private catalogue. However it is signed and dated, as shown by the old photograph, which was taken at his request. Since he had often not signed his work, his memory may have played tricks on him. Roethel suspects it is very likely that Kandinsky wanted to exhibit the picture in Russia and so brought it to Moscow in 1912. On returning after the outbreak of war in 1914 he found it again. In the following year he showed it in the important exhibition "The Year 1915" in Moscow (he entered it as number 43 in the catalogue). It was perhaps then, once he decided he liked it after all, that he signed and dated it, but then forgot this by 1935.

Picture with a Circle (ill. 224) was at last exhibited in 1989 in Moscow, Frankfurt, and St. Petersburg and was the sensation of the "First Soviet Retrospective." Nobody had guessed that it had been hidden for all those years in the store rooms of the Tbilisi museum.

The initial visual impression is one of a certain incompleteness or at least imbalance. One can sympathize with the artist's initial dislike of the picture. Only the upper part is really structured and has for this reason a heavy effect, producing an upward-moving vortex. In contrast at the bottom left there is a large area consisting only of delicate, overlapping grains of color. Kandinsky called comparable areas in his *Painting with White Border* (ill. 246) "smudges."[324] The same is certainly true of the bottom right corner of *Improvisation 26 (Rowing)* (ill. 229). It is however more common to find a rather "empty" bottom left corner in Kandinsky's works. *Picture with a Circle* is the most extreme example of this kind, and this is what contributes to the initial sense of imbalance in the picture's composition. On further examination of the picture any doubt that it is incomplete is dispelled, even though it is obviously a courageous first attempt to manage without the support of a subject. It is perhaps not yet a masterpiece.

The principally light, hazy (in the artist's terminology "sweet") colors make the picture a happy one. There are a variety of nuances from pink to red, white to gray, and green to blue via turquoise. Mixed with plenty of white, large parts of the picture come across as "pastel" and subdued, particularly when stood beside other pictures from the same period, almost all of which contain a richer, brighter palette. Consider his description of *Composition VI*

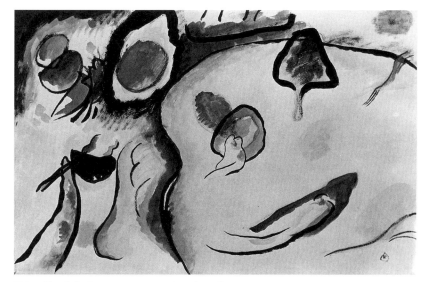

222 *Sketch for* Improvisation 25 (Garden of Love I), *1912*
Watercolor and India ink, 12⅜ x 18¾ in
The Solomon R. Guggenheim Museum, New York

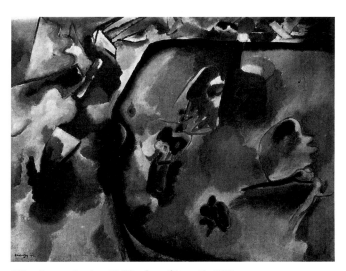

223 Improvisation 25 (Garden of Love I), *1912*
Oil on canvas, 18⅞ x 26⅝ in
Lost, formerly Museum of Art, Smolensk,

(ill. 242) and similar pictures: "I deprived my colors of their clarity of tone, dampening them on the surface and allowing their purity and true nature to glow forth, as if through frosted glass."[325] Outlines missing from the splashes of color and the uncertain delimitation between them, especially in the bottom left, also give the impression of indistinctness. The element Water is present.

The forms are vivid and turbulent, as the artist himself puts it. They show centrifugal and centripetal movement, spinning the multiple circular shape center top, pulsating and swimming from bottom to top. Contrary to the natural laws of gravity, the large masses are at the top of the picture. The shapes "breathe;" they are surrounded by an unreal space, at times seemingly near, at others an

184

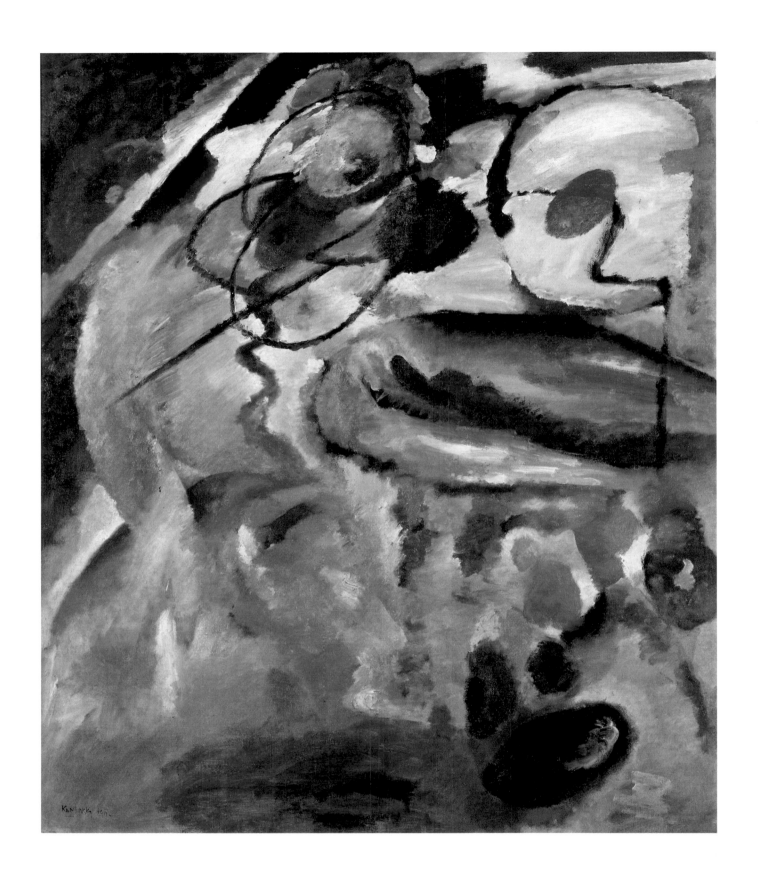

224 Picture with a Circle, *1911*
Oil on canvas, 54¾ x 43¾ in
State Museum of Art, Tbilisi, Republic of Georgia

infinity away, as for example the large, horizontal, blue-green oval shape to the right of the center, which interrupts the ascent of shapes which seem to be nearer. This unconventional treatment of space was to become a distinguishing feature of all of Kandinsky's abstract works (a sign of great mastery so difficult to imitate that Roethel was able to use it to recognize fake pictures; in fakes the space, the atmosphere surrounding the shapes would be missing, however skilfully the individual motifs had been copied).

But what is unreal space? Every illusion of space on canvas is unreal, even classical perspective. The distinguishing feature of Kandinsky's abstract oil paintings is that they never give the impression of being flat, in spite of the numerous graphic elements they contain, such as individual lines that are not there as outlines, for example in the top part of *Picture with a Circle*. On the other hand one cannot claim that Kandinsky consistently surrounds arbitrary, three-dimensional shapes, just like known objects, with illusionistic space. Instead he plays to greater or lesser degrees with long-distance effect, perspective, corporeality and atmosphere in an ambiguous manner that makes it almost impossible to fix a bearing on the shapes or see how they relate to one another. The shapes perceived as physical are admittedly surrounded by space, but never in a consistent or totally regular way, with the result that this type of space is even more unreal than other illusions of space on the two-dimensional surface of canvas. Independent dark lines add to the complexity, even confusion. Take as an example yellow, a color that Kandinsky's investigations and indeed the general consensus consider to be a color that comes towards us, whereas blue appears to retreat. The large circle top right that seems to be heading for the onlooker is cut through by a black line which is therefore in front of it. However the blue circle inside is not intersected by the line, so it is nearer to us despite being distanced from us by its color.

The picture contains a lot of space, in which single particles are immaterial and of a depth that cannot be ascertained. Some seem clearly to be near, or far, while the seeming nearness or farness of other shapes turns out to be erroneous. One publication in which one might have expected to find something on the subject of space in Kandinsky's art is the exhibition catalogue *Space in European Art*, Tokyo, 1987, where Kandinsky is represented and discussed in an article on the twentieth century, "The Fourth Dimension."[326] But there is nothing. Carl Einstein (see p. 294), one of the first interpreters of the art of this century, did not acknowledge any space in Kandinsky's abstract pictures. This is the main reason he is so disparaging about the artist, because for Einstein space is the most important measure of quality, perhaps even an obsession. As a friend and admirer of Picasso and Braque he takes as a yardstick the Cubist treatment of space and mass. His criticism is negative wherever he does not find these, from the Impressionists to the Russian Constructivists, and especially Kandinsky.[327] His fixation with space aside, the

highly educated man of letters and authority on art gives a sharply focussed, accurate judgment of the art of the early twentieth century. So in the case of Kandinsky Einstein's negative criticism should be taken seriously, since he picks up those points which have repeatedly provoked criticism or misunderstanding.[328]

Kandinsky's own comment on "space" in his painting of 1910–11 is entirely true of *Picture with a Circle*:

> The colors, which I employed later, never lie as if upon one and the same plane, while their inner weights are different. Thus, the collaboration of different spheres entered into my pictures of its own accord. By this means I also avoided the element of flatness in painting, which can easily lead and has already so often led to the ornamental. This difference between the inner planes gave my pictures a depth that more than compensated for the earlier, perspective depth. I distributed my weights so that they revealed no architectonic center. Often, heavy was at the top and light at the bottom.[329]

In contrast to most of the other works of 1911, *Picture with a Circle* is in fact completely abstract. There are none of the many "traces" of material objects that are so often in evidence in other works. Kandinsky himself was very conscious of this and so would never have described *Improvisation 20 (Two Horses)* (ill. 225) from the same year as his first abstract picture, because some outlines of the horses still define the composition quite distinctly. For this

225 Improvisation 20, *1911*
 Oil on canvas, 37 3/16 x 42 1/2 in
 Pushkin Museum, Moscow

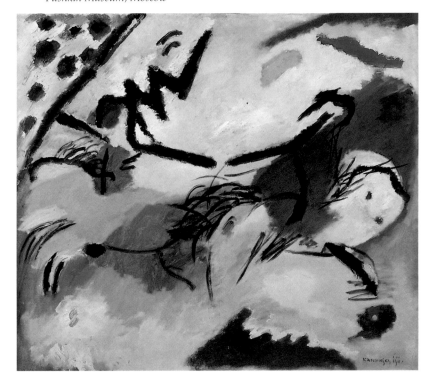

226 Improvisation Deluge, *1913*
Oil on canvas, 34⅜x59½ in
Stäätische Galerie im Lenbachhaus, Munich

reason the claim in the 1984 catalogue of the Centre Pompidou and the note based on it in the Frankfurt catalogue of 1989 that the artist could also have been referring to *Improvisation 20* as his "first abstract painting" are dubious.[330] He never made a secret of the figurative remnants in his art, as his subtitles suggest, for example here "Two Horses;" for *Impression III* from the same year "Concert;" for *Improvisation 26* "Rowing" among many others. He never called such pictures "abstract."

At first *Picture with a Circle* seems similar to another large, completely abstract picture with mainly round shapes, *Improvisation Deluge* of 1913 (ill. 226), although this later work has darker colors, generally stronger contrasts, and a denser richness of form. But the impression of water and movement is the same. Roethel associated *Picture with a Circle* with *Garden in Murnau* of 1910 (see the variant, ill. 157). It is more illuminating to compare it with *Improvisation 25 (Garden of Love I)* of 1912 in Smolensk, which is lost and of which only a poor-quality photograph now remains (ill. 223), as well as with the accompanying large watercolor (ill. 222), the left side of which bears the closest resemblance to *Picture with a Circle*. Will Grohmann

writes of this watercolor: "at the right we see a garden with couples under the trees; at the left, water with a rowboat reduced to a few formal indications."[331] This clearly separate left side seems to take up *Picture with a Circle*; the same void below and a vortex moving up toward a heavy upper part of the picture in darker colors. The spiral or multiple circular shape in the center of the top left corner and the outlined circle top right can all be seen again here. The dark oval shape (a trace of a boat) has been moved up slightly toward the centre of the picture. The initial impression of water and movement, so like *Improvisation Deluge*, comes across more clearly in the watercolor. Since it is not dated, it is not out of the question that the watercolor was painted before, not after, *Picture with a Circle*. It is also closely related to a woodcut of 1911, *Pattern from Improvisation 25* (ill. 227), in which the top of the picture once more contains the outlined circle on the right and the double circle shape on the left. The dark left corner and the shapes lying between the circles echo exactly those in the watercolor. In the bottom part of the picture there are *two* boat shapes, however. In connection with the outlined circle, if one were really looking hard for a representational model, one might

227 *Pattern from* Improvisation 25, *1911*
 Woodcut, 8⅝ x 8¹¹⁄₁₆ in
 Städtische Galerie im Lenbachhaus, Munich

228 *Sketch for the Etching* Trees and Rowing Boat, *ca 1911*
 India ink and pencil, 13 x 12¹⁵⁄₁₆ in
 Städtische Galerie im Lenbachhaus, Munich

think of an ink drawing of around 1910 (ill. 228); the large tree shape (which is more like an enormous flower) seems to form the foundation of the more highly abstracted outline shapes of circle and oval.[332]

However, this tracing back of the history of motifs goes too far where *Picture with a Circle* is concerned. The outline of the circle is less pronounced here, the inner circle is smaller; the link with the sketches mentioned above is weak and restricted to a few formal distinguishing features, and perhaps the composition. The comparisons do not suggest more than this, and it is the author's view that such investigation into the history of motifs is only a limited aid to understanding and is legitimate only as long as the onlooker keeps the habit of seeing "representationally." The question whether forms can be traced back to earlier, still recognizable motifs will soon be irrelevant to an understanding of Kandinsky's wholly abstract pictures. If this search is exaggerated, understanding may even be impeded. The artist himself gives the best support regarding this. His diverse subtitles and names "for private use," such as the simple "Jockey" for *Lyrical* (ill. 237), do not exclude such associations completely. On the other hand he excluded representational comparisons to a large extent in his *Supplementary definitions* (see pp. 168, 202 ff.).

One year later *Improvisation 26 (Rowing)* appeared (ill. 229). With its rather "empty" bottom right corner, the dark top left corner, the bold black stripes in the top quadrant of the picture, several red outlines and individual lines and, on the whole, round splashes of color, it might be compared with *Picture with a Circle*. It is less comparable with its brighter, more definite color and a representational echo of the still recognizable motif of a rowing boat. Although the bottom right corner is hardly more structured than the left-hand one in *Picture with a Circle*, and the composition is just as "unbalanced," the effect of *Improvisation 26* with its even more dynamic, more suspense-laden overall composition is artistically more satisfying.

In conclusion it must be emphasized (since this chapter has until now concerned itself more with exact dates and detailed comparisons) that a connection with other works – not to mention a difference of one or two years – does not of course carry any weight with an art work. In speaking of Kandinsky's "*First Abstract Water-color*," the author's intention was to restore the artist's

229 Improvisation 26 (Rowing), *1912*
Oil on canvas, 38 3/16 x 42 5/16 in
Städtische Galerie im Lenbachhaus, Munich

230 *Vignette for* Sounds, *1912*
Woodcut, 2 15/16 x 3 1/16 in
Städtische Galerie im Lenbachhaus, Munich

credibility to its rightful place; to show that he did not antedate with dishonest intent, but was possibly mistaken by one or two years, as he often was over the dates of publication of his own books. He was no pedant when it came to the question of time.

His almost aggressive, for him untypical insistence on the fact that he had created in *Picture with a Circle* the world's first abstract painting might be due to the pedantic "calculations" of the art historians. Had not Delaunay, or Larionov, Chiurlionis, Kupka, or Katharina Scheffler already painted in the abstract before Kandinsky? What if they had? Does that alter the quality of his pictures? In which year, which month did this or that picture appear? Which picture may be classified "abstract" and which not quite?

Kandinsky's point of view is clear; *Picture with a Circle* is abstract, but many other works from 1911 are not, even if contemporary viewers were able to recognize far fewer "traces of objects" than we can today (as Kandinsky remembered later in a letter to Hans Hildebrandt in 1927, in which he added that the habit of seeing is acquired gradually. In his youth he himself had not recognized the subject of Monet's painting *Haystack*).

Just how significant for Kandinsky was the degree of abstractness of a picture? Not at all, as far as its quality was concerned. While he was aware of the tremendous importance and impact of his discovery, he repeatedly emphasized in his theoretical writings, especially after 1912, that realistic and abstract art were equal in quality. The important thing was that the artist should choose what was "internally necessary" for him from the arsenal of possibilities, which included most recently abstract shapes, colors, and lines as well.

CHAPTER FOUR
INFLUENCES, STIMULI, MOOD OF THE TIMES

Kandinsky felt himself to be isolated and his spiritual interests to be misunderstood during his progress toward abstraction, a path which he was convinced no one else except Schönberg was taking. Yet there is a wealth of books concerning all the parallels and imaginable influences of numerous precursors and contemporaries.[333]

If one were to calculate how much time would have been needed to read only the fraction of these books that Kandinsky *ought* to have been familiar with, he would not have been able to paint more than three pictures in what would have remained of his life. His work in fact left him little time for reading. He refers to Mirbeau's *Le Jardin des Supplices* and "modern philosophers" at one point. He also wrote to Münter: "Am reading Anatole France's *Histoire Comique*. Should I send you Huysmans? It's difficult to read and nothing more than a talented, naturalistic book."

He misinterpreted Maxim Gorky's realistic portraits from the life of the lower classes as glorification of "hooliganism."[334] Apart from Turgenev, Dickens, and a "suffragette novel," as well as occasional "light reading" when he was too tired for anything else, there is little mention of his reading in his letters.

Kandinsky was certainly better acquainted with the Russian classics (principally nineteenth-century authors) than with other countries' literature. Not only does his library contain many of these, but he must have had plenty of opportunities to read Russian authors during his school and university years. In Russia reading was and is still a more widespread habit than elsewhere; people read the novels of Gogol, Dostoevsky, and Tolstoy with great enthusiasm. The Russians' thirst for books is also shown clearly by the numbers of copies of Western European literary works in translation around the turn of the century. At that time no member of the Russian "intelligentsia" would not have been thoroughly familiar with the Russian classics. Kandinsky's detailed knowledge of, for example, Dostoevsky's *Brothers Karamazov* is revealed in his response to a lecture given by the renowned German art historian Dr Julius Meier-Graefe:

> [...] There was literally not a single idea in it. He spoke on Dostoevsky's Karamasovs for about 20 minutes and showed beyond a shadow of doubt that he literally did not understand a single word. He made a dime novel out of it, without meaning to. He thought he was praising Dostoevsky to the skies.[335]

For a glimpse of Kandinsky's cultural background, it is interesting to study in detail his personal library. *His* library, including the books returned by Münter in 1926, is now in Paris (in the Centre Pompidou), his last place of residence before his death. Münter's library is in Munich, where some of their jointly-owned books are also to be found (Gabriele Münter- and Johannes Eichner-Stiftung).[336] The Paris collection contains almost *all* of the Russian classics, some in multi-volume editions, beginning with Zhukovsky, Pushkin, Goncharov, Saltykov-Shchedrin, Lev and Alexei Tolstoy, and including Ostrovsky, Chekhov, Nekrasov, Bunin, Gorky, Ilya Ehrenburg, and Konstantin Stanislavsky's reminiscences on the theatre. The Symbolists will be discussed later. Kandinsky also owned a large number of manifestos and illustrated pamphlets by the Russian Cubo-Futurist painters, most of whom he knew, such as *A Slap in the Face of Public Taste*.[337] Also among his books is a twelve-volume *Lives of the Saints*, a work about old Novgorod and its churches, various history books, nine volumes of Pisemsky and eight of essays by the critic Belinsky, who led Russian "Westernism" in a radical direction and took up his position immediately behind Marx and Engels as a pillar of Communism. There is also *Byloe i dumy*, the memoirs of the leader of the Russian intellectual movement of the forties, fifties, and sixties, Alexander Herzen, who was concerned with French Socialism, a champion of democracy and publisher of the London-based exiles' journal *Kolokol* (The Bell). This is perhaps a legacy from Kandinsky's father, who sought out Herzen in London in 1862 (a fact which has only recently come to light).[338]

French literature is nearly as well represented, mainly in Russian translation. There are works by Racine, Voltaire, Balzac, Stendhal, Hugo, Zola, Musset, Maupassant, Flaubert, Baudelaire, Valéry's *Monsieur Teste*, Camus, Gide, Aragon, a critical study of Verlaine. In short, they are works one would expect to see in the library of any Russian family of average education (French literature would be in the original for a higher-than-average education).

English literature is less well represented. There are works by Shakespeare, seven volumes of Dickens, three of Shelley translated by the Symbolist poet Konstantin Balmont, Thackeray, Poe, Kipling. The German volumes include Goethe, Schiller, Hermann Hesse, Theodor Däubler, Hegel, the little-known Bernus, and writings by "The Eleven Executioners" (Munich, 1901), some of whom Kandinsky knew well (see p. 79). Other books include Cervantes, four volumes of Ibsen, D'Annunzio, Marinetti's *The Futurist Manifesto* of 1910, Chinese fairy stories, Lao Tse, the Indian drama *Sakuntula* by Kalidasa (which was often performed in turn-of-the-century Russia), Hans Künkel, Friedrich Schwieckert, Robert Henseling, and a few other astrological writers of the twenties. Titles such as these, together with every conceivable esoteric treatise and mystical essay, still predominate in the Munich library from which Münter did actually return all of Kandinsky's own books in 1926. Some of the books in Münter's collection belonged to her parents. It is doubtful whether some of the others were either bought or ever read by Kandinsky.

On the subject of German philosophy, Hegel, we know, questioned the imitation of nature in art.

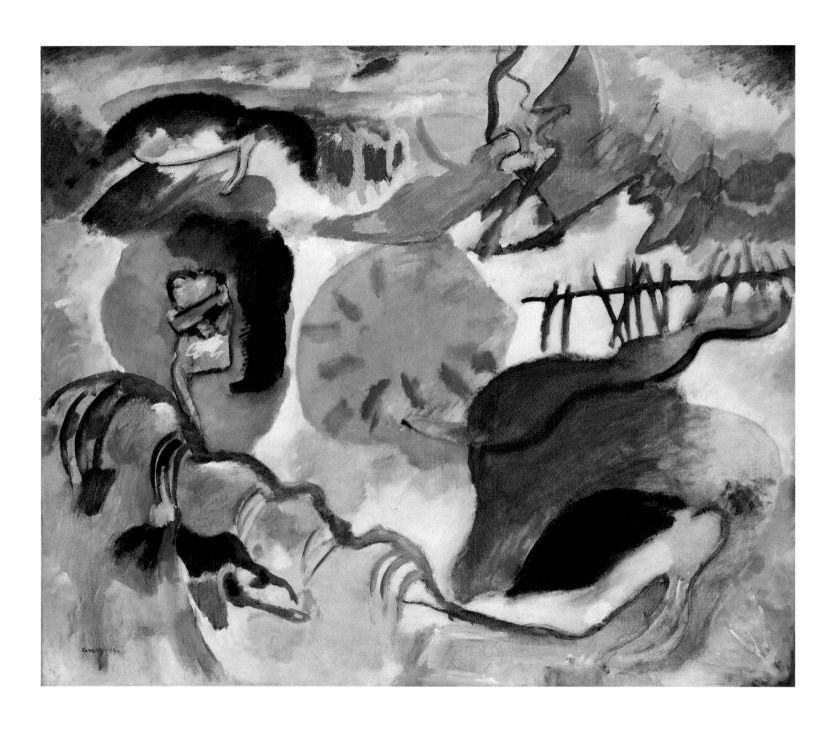

231 Improvisation 27 (Garden of Love II), *1912*
Oil on canvas, 47⅜ x 55¼ in
The Metropolitan Museum of Art, New York
The Alfred Stieglitz Collection.

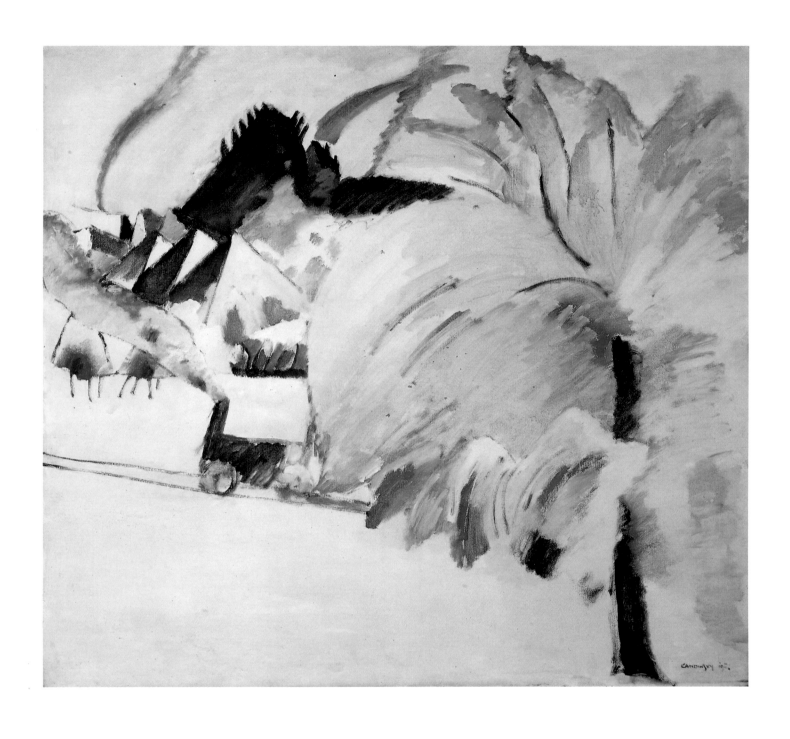

232 Winter Landscape, *1911*
 Oil on canvas, 37⅝ x 41⅛ in
 The Saint Louis Art Museum.
 Bequest of Morton D. May

Schopenhauer linked "abstraction" above all with music, but paid more attention to art and its "essence" or inner qualities than other philosophers. Kandinsky could have discovered these and many related ideas in his writings, more than in Nietzsche's. He speaks of Nietzsche's "transvaluation of values" in *On the Spiritual in Art* (this was the terminology of the day). Peter Vergo has illustrated the close link between Kandinsky's and Schopenhauer's ideas.[339] In support of this thesis, it is worth adding that there was always one of this philosopher's works in Kandinsky's possession, the *Theory of Colors*; and Kandinsky's friend Alfred Kubin was definitely influenced by Schopenhauer.

Closest to Kandinsky however was Henri Bergson, whose ideas on intuition were influential even outside his native France. His *Introduction to Metaphysics*, in a German translation (Jena, 1912), is still in the Munich collection. Konrad Fiedler's writing was also attracting attention in the early years of the twentieth century. Like Richard Wagner and many others, he had already formulated what was to become Kandinsky's central idea of "inner necessity." The concept of a "Philosophy of Life" gained much ground at the turn of the century. Ludwig Klages and Alfred Schuler were working on this in Munich, and Kandinsky would have heard of them through Kubin and Karl Wolfskehl.[340] All these ideas were "in the air;" everyone knew something about them, even if they had not read the increasingly popular philosophers' works themselves.

Kandinsky would have learned a great deal at Marianne Werefkin's salon, for she spent almost all her time reading new publications in French, German, and Russian literature.[341] She knew "everything" and everyone. For example she was responsible for Kandinsky meeting the Russian Symbolist writer Dmitri Merezhkovsky. There are many of the latter's writings, including *Griadushkhy kham* of 1900, as well as his essays on Symbolism, Chekhov, and Gorky, in the Paris library. There is also a copy of *Daphnis and Chloë*, the ancient Greek pastoral novel, in a translation into Russian made by Merezhkovsky in 1903. Finally, the Paris collection contains works by the following Russian Symbolists: Alexander Blok, Valeri Briusov (*Urbi et Orbi*), Leonid Andreev, Konstantin Balmont (*Pod severnym nebom*, poems, 1894), Georgi Chulkov, Fedor Sologub, Alexander Kuprin. Many of the French and Russian Symbolists were known to the Munich circle thanks mainly to Werefkin, who also promoted the achievements of the French "Nabis." Moreover, Gauguin's legacy of theoretical ideas was made available to the Munich circle thanks to Jawlensky's friend, the Dutchman Father Willibrord (Jan Verkade).[342]

William Worringer's doctoral thesis *Abstraktion und Einfühlung* was published by Piper in Munich in 1909. It is not certain exactly when Kandinsky became acquainted with his ideas, which diverged from his own quite significantly. Worringer takes as his point of departure Schopenhauer, Theodor Vischer, and Theodor Lipps and reaches conclusions of great interest to philosophers and theoreticians, but of less interest to painters like Kandinsky. The correspondence between Kandinsky and Marc contains mention of at least one epistolary contact with Worringer in April 1911. The three of them seem to have had projects in common. Many hypotheses have been put forward on how much Kandinsky may have learned from the 26-year-old doctor of philosophy. There is one concrete piece of information though. Klaus Brisch had an opportunity to question Worringer himself and included the response in his thesis: the two men's acquaintance did "not have the characteristics of a conscious and as it were logically ordered merging of thoughts that would signify a common direction."[343]

Maeterlinck seems to be the only philosophical mind with which Kandinsky was certainly well-acquainted and which he admired. His Paris library contains the first edition of Maeterlinck's anthology *Le Trésor des Pauvres* (Riches of the Poor) of 1898 (January 25, 1899, the date he was given the book, is written inside it), as well as the Brussels 1903 edition of *Théâtre*. *Von der inneren Schönheit* (On Inner Beauty) is in the Munich library. Although Kandinsky and Maeterlinck may have had closely related ideas on the spiritual, "inner beauty," and aesthetics, this did not extend to Kandinsky's ideas on abstraction.

Back in Russia, Tyuchev's famous adage "Every thought expressed out loud is a lie" had been rediscovered by the Symbolists and was being used as the basis of some of their theories, which are surprisingly similar to Hugo von Hoffmannsthal's inspired, typically *fin de siècle Lord Chandos Brief*. As we have seen, Kandinsky had more than just a passing acquaintance with the Symbolist authors, who wrote widely on the subject of music, art, and aesthetics (see pp. 15 ff). The musician Leonid Sabaneev, whose essay on Scriabin Kandinsky published in the *Blaue Reiter*, remembers the poet and theoretician Viacheslav Ivanov:

> Like all Symbolists, Ivanov believed that he was living in an "age of catastrophe," waiting for a specific "EVENT" that would manifest itself not so much as a war or a revolution, but as an eschatological act more in line with the Last Judgment.[344]

Agrippa of Nettesheim had predicted in the Middle Ages that there would be a historic upheaval in 1900 which would usher in a new era. Ivanov cited besides this example more recent prophets such as Dostoevsky, Soloviev, Nietzsche, and Merezhkovsky who had also predicted apocalyptic events for 1900 as prophets of the new age.[345] Andrei Bely also frequently named Nietzsche, Soloviev, and Merezhkovsky. The titles of his anthologies, such as *On the Mountain Pass* or *At the Turning Point of the Ages*, reflect his preoccupation with this topic. His essay on "The Apocalypse in Russian Poetry" has less to say about poetry than about culture in general. Kandinsky shared this

intellectual heritage with the Russian Symbolists. Their great precursor was the religious philosopher and mystic Vladimir Soloviev with his apocalyptic vision of Sophia, divine wisdom. The new era would be marked with the sign of the spirit (see p. 15). This is of course restating Maeterlinck's "awakening of the soul" described in *Le Trésor des Pauvres*. Kandinsky speaks in the final sentence of his *On the Spiritual in Art* of "a conscious, reasoned system of composition: ... and this spirit in painting stands in a direct, organic relationship to the creation of a new spiritual realm that is already beginning, for this spirit is the soul of the epoch of the great spiritual."[346]

Abstract art seemed to fit more logically into a nascent age of the spirit such as this, than did the former, more materialistic, principally representational type of art.

Besides external influences, psychological points of view have also been advanced in the literature on Kandinsky. Mention should at least be made of a theory that can no longer be put forward at the end of the twentieth century, but that was given as the fundamental "explanation" of the emergence of abstract art only a few decades ago. This is the theory, based on Kretschmer's doctrine of types, that abstract art could be categorized principally as the art form of introverted (or "leptosomic") people. This applies to the viewer as well as the artist. Walter Winkler classified several artists including Kandinsky in these terms.[347]

When Kubin refers to "us mystics," to what extent is he justified in including Kandinsky? Mysticism and art have a deep connection, especially where Kandinsky is concerned. His work as a whole (if not each individual picture) approaches mysticism. But it was *art* in particular to which he devoted himself and which had an answering effect on its creator. Since his turbulent youth, a period fraught with excessive sensitivity, perhaps egocentricity, religious doubts, and escapist dreams, Kandinsky had developed himself positively on all levels through his artistic creativity (see pp. 25f.). The "artist-prophet" and "leader of mankind" mentioned in his *On the Spiritual in Art* have their root in his own experience. He understands, even when he knows himself still to be far from his goal. He is characterized by the modesty which marks all truly great people. He sees his art as something relative, as a step from which others will continue. In no sense did he intend to force "laws of art" onto the world (see "What Kandinsky's contemporaries have to say").

But let us return to Kandinsky's own words after all this discussion. He referred several times, even in his later, "sober" periods, to the "icon painters of the tenth to fourteenth centuries" as the source of his art (see p. 25). How is one to interpret this? There is not the slightest overt resemblance to this art in his painting, unlike the later work of his friend Jawlensky, who actually created a contemporary sort of icon (ill. 233). Kandinsky employed religious themes for a few years only. His comment has been mentioned but never discussed in critical literature. This author would like to suggest *one* possibility, the better to understand the artist's striving toward abstraction. The icon painting with which he was familiar is characterized not only by its subject matter but also by a fundamental attitude far removed from any Western view of art. It remained the most popular artistic form in Russia until the eighteenth century. While in the West not only secular, but also religious art in its diverse guises as sculpture, wood-carving, painting, and stained-glass windows, were subject to an incessantly changing style, icon painting had undergone little change since the ninth century. As decreed by Abbot Feodosi, "As the shadow is to the body, so the reproduction is to the 'original'." Originals were those icons reputedly "not painted by human hand," that only selected artist-monks were allowed to reproduce, chanting prayers all the time they worked. There was obviously no room for either individual style or pictorial fashion (and this is evident in icon painting up until Rublev). This explains Western art historians' criticism that icons have no artistic character. The goal was not "art" in the Western sense, but a devotional image as close as possible in appearance to the "original."

233 *Alexei Jawlensky,* Love, *1925*
Oil on cardboard, 23¼ x 19³⁄₁₆ in
Städtische Galerie im Lenbachhaus, Munich

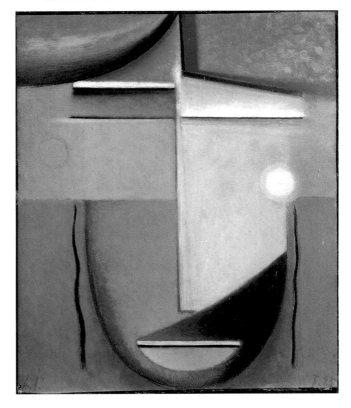

There is an even more important difference, however. The protestant theologian Rainer Volp (admittedly referring to the Reformation, Luther, and Zwingli) regarded as the root of the relationship between art and religion none other than the Old Testament commandment about not making graven images. The impossibility of ever fully grasping the idea of God prevents us from viewing any one image of God as a true image. We invoke art only when an artist manages to *resist* the temptation to fix an image in the usual way. "Art encompasses pictures, even if this undermines its own position" (in other words, it protects them).[348]

It must not be forgotten that the ban on images was more extensive in the Orthodox Church, if not as complete as in Islam. The iconoclasm under Emperor Leo III in 726 and the ban on icons under his son Constantine were partially lifted at the Council of Nicaea in 787. Icon worship was distinguished from idolatry on the grounds that an image was not an embodiment. Empress Theodora was even more tolerant in 843 and gave official permission once more for icons and frescoes to be painted. But there has always been this difference from Western Christianity, which has tolerated wide variety and a highly diverse and realistic church art.

Surely the resistance to realistic representation in Byzantine art led at least to a renunciation of the more "material," tangible media such as sculpture and carving, and to the unrealistic manner of painting in the icons? Could this *idea*, so central to Byzantine art in particular and to the Orthodox faith in general, explain Kandinsky's strong attraction to abstract art? It is perhaps not pure chance that Russian artists founded a variety of new artistic movements, all tending diversely toward abstraction. To name but a few: Kandinsky, Jawlensky, Larionov, Goncharova, Malevich, Rodchenko, Stepanova, Popova, Rozanova, Chashnik, and Redko. This list excludes pure Constructivists (without good reason). Despite the diversity of these artists, there is perhaps a common factor, learned from the *principle* of icon painting, that underlies both their unconscious reluctance not to get too close to the "original," and their longing to render the intangible in a form that does not resemble anything in this world...

Has there ever been a comparable situation in human history when the artist felt himself to be a demiurge and, instead of reproducing reality, so clearly (high-handedly?) created his own world? Kandinsky was not only motivated from within; his desire was not to paint "states of mind" (see p. 202), but actually to participate in the cosmos through his work. There is a fundamental difference between the reproduction of objects, however personal the palette, and the creation of hitherto unseen objects. Could it not be that an essentially religious person like Kandinsky perceived the former to be at least a *form* of blasphemy? There is no evidence for this. He considered absolutely everything that was inspired by "inner necessity" to be justified. His occasional criticism of friends was directed at decorative and "benevolent" painting, which he did not so much despise, as regard as separate from the realm of art (see Munich Jugendstil, pp. 56–58, 62 f.).[349] His criticism is also directed at "intellectual art" and above all against any art he considered "superficial" – that is to say, produced by artists, however talented and sincerely creative, who had made little spiritual progress and were merely concerned with being easily understood and accepted.

234 *Photograph Taken on the Balcony of Kandinsky's Flat in Munich, Ainmillerstrasse, 1911*
From left: Maria and Franz Marc, Bernhard Koehler, Heinrich Campendonk, Thomas v. Hartmann, seated: Kandinsky.
Gabriele Münter- und Johannes Eichner-Stiftung, Munich

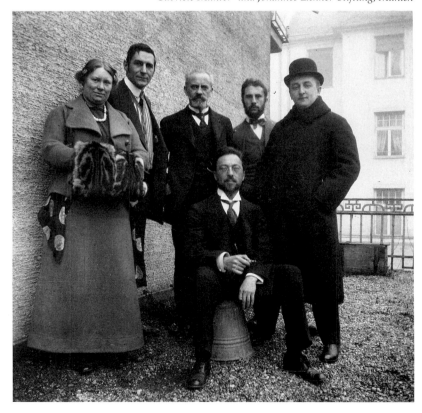

Kahnweiler sent me some Picasso photos; he splits the subject up and scatters bits of it all over the picture; the picture consists of the confusion of the parts. Really interesting! Picasso is pursuing his course. Hopefully, he'll master the external aspect of nature too. [Picasso was supposed to be seeking the ratio of the individual parts…] No, this is not the solution! But it is pleasing nonetheless. Some of Picasso's stuff is like intellectual reflections of decay; that's the consequence of an incomplete renunciation of naturalism. A former student of mine was at Matisse's just now when he got my letter. He found it interesting. […] I'll write to Picasso as well. [on October 4, 1911 again:] This decomposition is very interesting. But frankly "false" as I see it. I'm really pleased with it as a sign of the enormous struggle toward the immaterial though!

(Vasily Kandinsky on Picasso, letter of October 2, 1911 to Franz Marc, when the two were preparing the *Blaue Reiter*; *Kandinsky/Marc Briefwechsel*, 1983, pp. 61 ff.)

[On the "Brücke" artists admired by Marc:] Have received the crowds of Berliners, and I'm especially grateful. You know how much all that kind of thing interests me. I understand you too; last year (1910!) I formed a similar strong impression of the Muscovites, who impressed me with the mountains of their canvasses. But I must say this, even if it annoys you, I think … I prefer our Munich crowd. I mean, I value more our slow (maybe, but only on the outside), careful work done with respect and consideration. And we're more personal too. That's evident maybe not only from our "great inner significance," but also from the solitude in which we work.

(Vasily Kandinsky, letter of January 14, 1912 to Franz Marc, *Briefwechsel*, 1983, pp. 112 f.)

CHAPTER FIVE
THE "BLAUE REITER"

This "Secession" spearheaded by the New Artists' Association of Munich has come to be universally regarded as the most significant German art forum of the twentieth century, even though it was limited to a single almanac and two exhibitions, organized by Kandinsky and his younger friend Franz Marc. Its aim, in complete contrast to the other vital center of German Expressionism, the "Brücke" ("Bridge"), was to illustrate *the European avant-garde in all its variety*. In this it reflected Kandinsky's characteristic dislike of cliques.

The story of how its name was found is typical of Kandinsky's inclination, also apparent in the titles of many of his pictures, to play down important concerns. It is probably true that he and Franz Marc dreamed it up over a cup of coffee. But this does not explain the rider motif or the significance of the color blue, which is presented in *On the Spiritual* as the color of heaven and transcendence.

The rider motif has already been encountered many times; as Saint George, who is always called "the victorious" in Russian, at times as Saint Martin, as a jockey in full gallop, as an archer and a fighting warrior, as a delicate horsewoman. There is seldom a horse without a rider in Kandinsky's oeuvre. Why was this motif so important for him? First of all the horse is generally considered to be beautiful, a creature of harmony and nobility. Kandinsky was an aesthete. He enjoyed riding himself, and although this should not be attributed too much importance, it is not without consequence. As fencing lessons during his student days drew his imagination toward chivalry, so too his contact with horses opened up this rich imaginative field to him.

According to Greek mythology, the first horse was a gift to mankind from the sea-god Poseidon. It was a strong creature, dashing out of the sea, that is, out of a not very "material" element. Water represents the unconscious as well as the transcendental element, and the color blue is connected with it. In Indian mythology, the horse knows the way to the kingdom of heaven. This brings to mind one of Kandinsky's favorite motifs: Elijah's ascension to heaven in a horse-drawn chariot (see pp. 208 ff., 236, ill. 276). In many other cultures the horse symbolizes the religious or philosophical quest.

In *On the Spiritual in Art* Kandinsky explains that the horse represents strength and speed, held in check and guided by man. He was perhaps drawn to this idea, since he felt himself swept along by a compelling life force which was nevertheless united within him with his rational intellect (not always without difficulty).

With the *Blaue Reiter Almanac* Kandinsky realized a dream that he had first spoken of as early as 1900, and had striven to realize at the Phalanx school, in the New Artists' Association, and in the exhibition catalogue of Izdebsky's second "International Salon" in Odessa: achieving a syn-

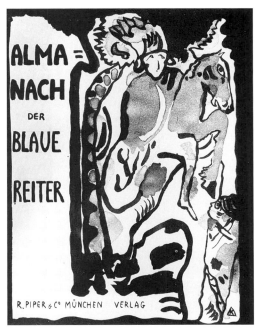

235 *Final Study for the Cover of*
the Blaue Reiter Almanac, *1911*
India ink, watercolor, and pencil
10⅞ x 8⅝ in
Städtische Galerie im Lenbachhaus, Munich

236 *Vignette for the* Blaue Reiter, *1911*
(taken from the prospectus)
Städtische Galerie im Lenbachhaus, Munich

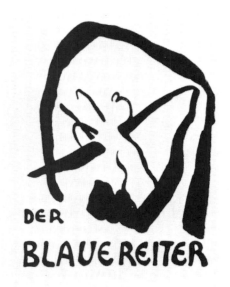

thesis of the various arts and an international forum for the avant garde. He shared his elation with Alfred Kubin, who had left the New Artists' Association out of solidarity with him, along with Marc, Hartmann, Epstein, and Münter:

> I don't know how I should begin?! You see me at the gateway of happiness. You have before you a man who was thrown out of every decent community for real (the best!!!) art because of his stupid (unartistic!!!) dreams. A man who did not want to wake up because he believed in the reality of his dreams. The dreams were weak, emaciated, and anaemic. A man who ... well, anyway! We have established ... a new, really new society? No indeed! A really liberated, international (ha ha!) journal, free of cliques, which will be published as irregularly as only truly good things appear. See for details in the circular. Colleagues are: in Paris, Le Fauconnier, Girieud; in Vienna, Arnold Schönberg (musician); in Moscow, Th. v. Hartmann (musician), two Burliuk brothers [David and Vladimir]. Everyone's raring to go. Le Fauc. wants to mobilize the whole of Paris. Now the only thing missing (it is missed!) is the final word of Alfred Kubin's undertaking, and particularly his contribution. [...] My book *On the Spiritual in Art* is being published by Piper. After two years! I am indebted for all this happiness to Franz Marc. He is an absolute magician and also a true friend.[350]

Kandinsky had already mentioned his idea for an almanac to Marc just before the rift in the New Artists' Association in June 1911. So it was not primarily a demonstration against those of his colleagues who had remained in the association. No Kandinsky expert would be surprised to hear that the motto the new group adopted was Delacroix' comment, "Most writing about art is by people who are not artists; that is where all the false concepts and judgments come from."

Matisse was asked to contribute an essay but instead generously gave some illustrations. Initially there were plans for eight musical contributions, including *Color-Tone-Number* by Unkovskaya and a long, theoretical article by Briusova (see pp. 155, 173, 200); also six items on painting and three on theatre, including one by Evreinov on "monodrama," which was just starting to attract attention in Russia, but had nothing to do with Kandinsky's stage compositions. The almanac's scope was to be exceptionally broad: "We are doing something on the Russian religious movement in which all classes participate. For that reason I've involved my former colleague Professor Bulgakov (national economist and one of the greatest experts on religious life). Reference to Theosophists must be short and sharp, if possible statistical."[351]

As head of the "New Secession" in Berlin, Max Pechstein was also part of the group. There were plans for illustrations by Jawlensky and Werefkin, but these were scrapped after the rift between them and Kandinsky. The dispute was not settled until a year later.

What remained of the project was still a rich, enthusiastic, pioneering program for the new art. Kandinsky's essay "On the Question of Form" is a fundamental and masterly achievement; his stage composition *Yellow Sound* was the most revolutionary of its day. Burliuk's and von Hartmann's essays give support to Kandinsky's endorsement (emphasized more clearly in other writings) of anarchy, used of course in the original sense of the word, which has nothing to do with terrorism and bombs, but with the highest level of freedom. Marc's essays are filled with the starkest emotion; he describes the goal of the German "savages" as follows: "To work to create *symbols* of their age, which belong on the altars of the spiritual religion to come and behind which the technical manufacturer will disappear."[352]

The almanac's unusual illustration section containing a wide variety of art and "non-art" attracted considerable attention. While the "recognized" masterpieces of Western art were hardly represented, there were primitive masks from Borneo, African and Mexican sculpture, Egyptian shadow puppets, naïve painting such as Russian *lubki*, Bavarian glass paintings, even children's drawings and amateur art. Schönberg and Rousseau, who until then had been ridiculed as artists, were also represented. All of the above was combined colorfully with work by Matisse and Picasso, illustrations from the Bible and fairy tales, Cézanne, Gauguin, Van Gogh, a fourteenth-century tombstone, El Greco, Delaunay, Klee, Kubin, Macke, Münter, Arp, Old German masters, Japanese art, and much more. This was done with the aim of showing the unity of "inner necessity" characterizing all true art, through the variety of its modes of expression.

The pictures are scattered as if at random throughout the volume. The editors envisaged only an occasional comparison between two pictures or shock effects. Of course it is possible, on close examination, to find a correlation between a given text in the almanac and the reproductions accompanying it,[353] but that is exactly what was *not* intended! On the contrary, every item in the book was supposed to speak for itself, freely and independently. The principle of illustration was ill-founded as far as the two editors were concerned.

A sign of Kandinsky's tolerance for, if not love of, realistic art is given by his selection of three of Arnold Schönberg's naïve-realistic pictures, which he valued more highly than the latter's abstract ones. More importantly still, he accepted seven examples of Henri Rousseau's work for the almanac, as well as buying some for his own private collection, and this precisely at the time he was trying to promote abstract painting! Rousseau is in fact the most represented painter in the *Blaue Reiter*. Kandinsky played a greater role in selecting the pictures than his younger co-editor, Franz Marc, as their correspondence shows. This statement from a letter written toward the end of 1911

237 Lyrical
Color woodcut, 5¾ x 8⁹⁄₁₆ in
Städtische Galerie im Lenbachhaus, Munich

is characteristic: "I think that Rousseau belongs to the group. Kahler, Kubin, Epstein, Schönberg, Münter. My opposites! Maybe that's why I love them and value them so much?"[354]

The first Blaue Reiter exhibition took place in Munich in December 1911 and went on to the Gereon club in Cologne, whose president was Emmy Worringer (the sister of the author of *Abstraktion und Einfühlung*), and to many other German cities. Kandinsky's *Composition V* (ill. 214), rejected by the New Artists' Association, and three of Delaunay's major works, *Saint Séverin*, *The Tower*, and *The Town*, attracted most attention. This is how Delaunay's "Orphism" became famous in Germany and exerted an influence on Marc, Klee, and especially August Macke, one of the youngest members of the Munich circle.

The second exhibition opened in March 1912. Though limited to watercolors, drawings, and graphic works, it proved to be even more international than either the first exhibition or the almanac. It brought together over 300 pictures by the best, most advanced artists in Europe: Picasso, Braque, Vlaminck, Larionov, Goncharova,

Malevich. The other German avant-garde movement, the Brücke ("Bridge") Expressionists, was represented with pictures by Kirchner, Heckel, Nolde, Mueller, and Pechstein. This was due mostly to the initiative of Franz Marc, who had a higher regard than Kandinsky for these artists. The two artists' correspondence from this period when Marc was reporting from Berlin is particularly revealing. Despite objective goodwill, Kandinsky cannot refrain from making the following comment: "Out of 24 photos, there are 9½ nudes with or without pubic hair, 5 bathers, and 2 circus pictures." Although he was not condemning any artist for his choice of subject, he still preferred the slower, more careful development of the Munich group: "Not for us the lashings of the competitive whip, nor the steps which others have built and on which we are generously allowed to set our foot."[355]

His objectivity and his artistic ethos are reflected in his decision to reject certain pictures by artists from his own ranks, such as Heinrich Campendonk: "There is nothing in art I hate more than a translation into trivial kindliness. That's money-lending in the temple."[356]

DOCUMENTS

Might I ask you to excuse the disturbance I caused in your house earlier today due to a panic attack I suffered.

(W. S. Ghuttmann, letter to Gabriele Münter, undated [end April 1912], after he had looked at Kandinsky's pictures, GM/JE St.)

Letters to Gabriele Münter

October 3/16, 1910 [Russian and German dates].

I am currently reading a booklet about the science of music by a student of Jaworsky (the lady in question is Briusova). It is very interesting, but of course rather complicated for my unmusical mind.
[Kandinsky is referring here to Nadezhda Briusova, whose long article he almost included in the Blaue Reiter – it even figured in the first list of contents. See Lankheit, 1963, p. 310. The manuscript is in the Munich collection.]

September 29, 1910.

Delaunay is planning a French edition of the Blaue Reiter, Frau Epstein would like to translate it.

November 3/16, 1912.

"Knave of Diamonds" [artists' group] and his almanac (session yesterday from seven till half one at night), visits from artists with a lot of talking, I must write a manifesto for the "K.D." ["Knave of Diamonds"] (I've done that already) and I'm translating my Question of Form for a lecture in St. Petersburg. Well! Besides that I'm visiting relatives, friends, churches, museums, writing letters. [...] This time I'm finding Moscow quieter (I'm not crazy), but I'm soaking it all up and ... quivering almost continuously. I feel very at home here, and the contrasts seem very close to me. I long for work though, my work, painting, and want to have complete peace for it. The seed must ripen and start to sprout in silence [...].
My task was to sow as much freedom as possible among artists here, and to strengthen the bond between Russia and Germany.
It is also necessary that I meet an important publisher tomorrow, through that nice painter Yakulov. I don't want to visit only the "K.D.," but also other painters ("Symbolists") and get to know some of those that have come here for a St. Petersburg exhibition. Among these I'm still interested in Rerich. I get on well with Yakulov, maybe better than any of the others, and he wants to help me a lot. I've accomplished quite a lot with the "K.D." and am very pleased.
[However, instead of his manifesto, the "K.D." printed

four of his quasi "alogical" prose poems, without his direct consent. He thought it necessary to protest against this publicly, because he did not like the coarse, intolerant tone of their almanac A Slap in the Face of Public Taste.][357]

November 9, 1912 from Moscow.

[Kandinsky is referring to the famous art collector Sergei Shchukin.]

Shchukin was very nice and invited me round next week to see his gallery under electric lighting. The 30 Matisses are hanging in his large salon with furniture from the ... eighteenth century! It's an amazing effect. That man has feeling. He considers the best contemporary painters to be Matisse and Picasso, and he doesn't think too highly of my few little efforts! In fact, my Compositions 2–5 would come across all right at his place. I imagined it vividly...If I lived here, I'd soon get him... Many want to make me do it... live here, I mean. There isn't a single theorist here, especially not for the new art. I'd be set up as a cannon against the Petersburg Benois.

July 19/August 1, 1913.

I do what I can against the leading power from Paris. This is greeted enthusiastically on all sides. But it's high time we stopped all this bowing and scraping to the French.

August 8/21, 1913.

Beffie definitely bought some of my stuff for 3000 Marks. A Mr Eddy from Chicago came round to my place in Munich. Fanny [the housekeeper] showed him my work. He wants to buy some small things straightaway for 1000 Marks, and then put together a small collection of my work "from all periods." Wonderful!

(Vasily Kandinsky, letters from Russia to Gabriele Münter, GM/JE St.)

238 Small Pleasures, *1913*
Oil on canvas, 43¼ x 47⅛ in
The Solomon R. Guggenheim Museum, New York

239 *Kandinsky in Front of* Small Pleasures, *1913*
Photo: Gabriele Münter
Gabriele Münter- und
Johannes Eichner-Stiftung, Munich

CHAPTER SIX
SELF-IMAGES

With the publication of *On the Spiritual in Art* and the *Blaue Reiter*, not to mention the exhibitions wreathed in scandal as early as his first one-man show in Herwarth Walden's avant-garde gallery, "Der Sturm," in Berlin in 1912, Kandinsky achieved a certain degree of fame. This, combined with numerous misunderstandings and misjudgments[358] by critics and art scholars, provoked him to describe his artistic development and road toward abstract painting in *Reminiscences*. This short autobiography and the artist's three picture interpretations appeared in the album *Kandinsky 1902–12* published by Walden. The open manner in which Kandinsky discusses his problems and weaknesses is striking. An even more candid response to critical misinterpretations are his lecture notes for an exhibition in Cologne in 1914. They are extremely interesting, but are so sloppily written and have such an irritating tone that they struck the exhibition organizers as unsuitable and were never read (the prose poems from *Sounds* read instead were greeted with laughter). In the Cologne Lecture notes, also known as "My Development," Kandinsky declares that art criticism:

> has, alas, until now often been rebarbative and has shouted falsehoods into the ears of many who were inclined to hear.
> I do not want to paint music.
> I do not want to paint states of mind [*Seelenzustände*].
> I do not want to paint coloristically or uncoloristically.
> I do not want to alter, contest, or overthrow any single point in the harmony of the masterpieces of the past.
> I do not want to show the future its true path.

Kandinsky went on to say that the main error of art historians was to assume that an artist works for praise or admiration or seeks to avoid criticism. On the contrary, the artist obeys the categorical commands of a voice which is none other than God's. This was how he summarized his idea of "inner necessity."[359]

The brief picture interpretation of 1911 (see p. 168) was followed by the more detailed one for *Composition VI* in May 1913 (ill. 242, compare also the glass painting, ill. 240):

> I carried this picture around in my mind for a year and a half, and often thought I would not be able to finish it. My starting point was the Deluge. My point of departure was a glass painting that I had made more for my own satisfaction. Here are to be found various objective forms, which are in part amusing (I enjoyed mingling serious forms with amusing external expressions): nudes, the Ark, animals, palm trees, lightning, rain, etc. When the glass painting was finished, there arose in me the desire to treat this

240　Deluge, *1911*
Painting on glass,
(Lost. Archive photograph)

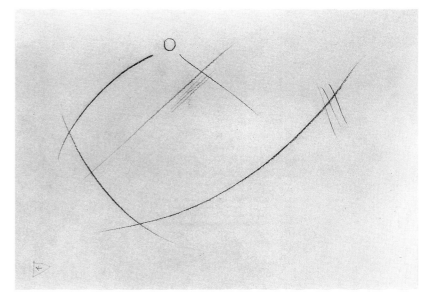

241　*Main Structure of* Composition VI, *1913*
Charcoal
Musée national d'art moderne
Centre Georges Pompidou, Paris

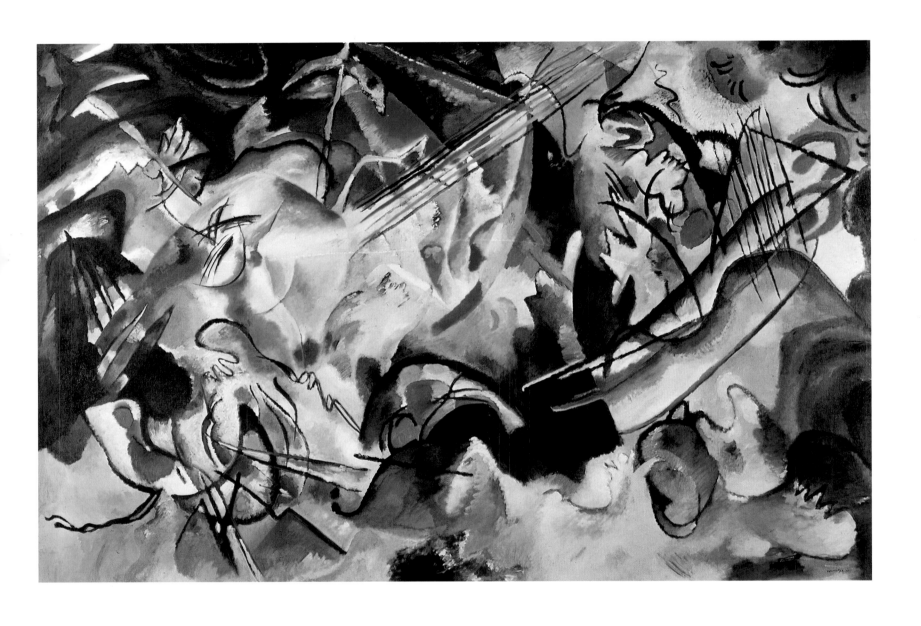

242 Composition VI, *1913*
Oil on canvas, 76¾ x 118⅛ in
The Hermitage, St. Petersburg

theme as the subject of a Composition, and I saw at that time fairly clearly how I should do it. But this feeling quickly vanished, and I lost myself amidst corporeal forms, which I had painted merely in order to heighten and clarify my image of the picture. I gained in confusion rather than clarity. In a number of sketches I dissolved the corporeal forms; in others I sought to achieve the impression by purely abstract means. But it didn't work. This happened because I was still obedient to the expression of the Deluge, instead of heeding the expression of the *word* "Deluge." I was ruled not by the inner sound, but by the external impression. Weeks passed and I tried again, but still without success. I tried the tested method of putting the task aside for a time, waiting to look at the better sketches again all at once, with new eyes. Then I saw that they contained much that was correct, but still could not separate the kernel from the shell. I thought of a snake not quite able to slough its skin. The skin itself looked perfectly dead – but it still stuck.

In the same way, for a year and a half, that element which was foreign to my inner picture of that catastrophe called the Deluge still stuck to me.

My glass painting was at that time away on exhibition. When it came back and I saw it again, I at once received the same inner jolt I had experienced on creating the glass painting. But I was mistrustful, and did not now believe I would be able to create the big picture. Still, I looked from time to time at the glass painting that hung in my studio. Every time I was struck, first by the colors, then by the compositional element, and then by the linear form itself, without reference to the object. This glass painting had become detached from me. It appeared to me strange that I had painted it. And it affected me just like many real objects or concepts that have the power of awakening within me, by means of a vibration of the soul, purely pictorial images, and that finally lead me to create a picture. Finally, the day came, and a well-known, tranquil, inner tension made me fully certain. I at once made, almost without corrections, the final design, which in general pleased me very much. Now I knew that under normal circumstances I would be able to paint the picture. No sooner had I received the canvas I had ordered than I began the laying-in. It advanced quickly, and nearly everything was right the first time. In two or three days the main body of the picture was complete. The great battle, the conquest of the canvas, was accomplished. If for some reason I had been prevented from continuing work on the picture, it would still have existed – the main part was done. Then came the subtle, enjoyable, and yet exhausting task of balancing the individual elements one against the other. How I used to torture myself previously when some detail seemed to me wrong and

I tried to improve it! Years of experience have taught me that the mistake is rarely to be found where one looks for it. It is often the case that to improve the bottom left-hand corner, one needs to change something in the upper right. If the left-hand scale goes down too far, then you have to put a heavier weight on the right – and the left will come up of its own accord. The exhausting search for the right scale, for the *exact* missing weight, the way in which the left scale trembles at the merest touch on the right, the tiniest alterations of drawing and color in such a place that the whole picture is made to vibrate – this permanently living, immeasurably sensitive quality of a successful picture – this is the third, beautiful and tormenting moment in painting. These tiniest weights, which one here employs, and which exert so powerful an effect upon the whole picture – the indescribable accuracy of the operation of a hidden law, which leaves room for the intervention of the trained hand and to which that same hand is subservient – is just as delightful as the initial piling-up of masses upon the canvas. Each of these moments has its own tension. How many unsuccessful or uncompleted pictures owe their sickly state simply to the fact that the wrong tension was applied.

In this picture one can see two centers:

1. on the left the delicate, rosy, somewhat blurred center, with weak, indefinite lines in the middle;
2. on the right (somewhat higher than the left) the crude, red-blue, rather discordant area, with sharp, rather evil, strong, very precise lines.

Between these two centers is a *third* (nearer to the left), which one only recognizes subsequently as being a center, but is, in the end, the *principal* center. Here the pink and white seethe in such a way that they seem to lie neither upon the surface of the canvas nor upon any ideal surface. Rather, they appear as if hovering in the air, as if surrounded by steam. This apparent absence of surface, the same uncertainty as to distance can, e.g., be observed in Russian steam baths. A man standing in the steam is neither close nor far away; he is just *somewhere*. This feeling of "somewhere" about the principal center determines the inner sound of the whole picture. I toiled over this part until I succeeded in creating what I had at first only dimly desired and subsequently became ever clearer within me.

The smaller forms within the picture demanded an effect at the same time very simple and very broad (*largo*). To this end, I employed the same long, solemn lines I had already used in *Composition 4*. I was very pleased to see how this same device here produced such a different effect. These lines are linked with the thicker lines running obliquely toward them in the upper part of the picture, with which they come into direct conflict.

To mitigate the dramatic effect of the lines, i.e., to distort the excessively importunate voice of the dramatic element (put a muzzle on it), I created a whole fugue out of flecks of different shades of pink, which plays itself out on the canvas. Thus, the greatest disturbance becomes clothed in the greatest tranquility, the whole action becomes objectified. This solemn, tranquil character is, on the other hand, interrupted by the various patches of blue, which produce an internally warm effect. The warm effect produced by this (in itself) cold color thus heightens once more the dramatic element in a noble and objective manner. The very deep brown forms (particularly in the upper left) introduce a blunted, extremely abstract-sounding tone, which brings to mind an element of hopelessness. Green and yellow animate this state of mind, giving it the missing activity.

The alternation of rough and smooth, and other tricks in the treatment of the canvas itself, have here been exploited to a high degree. Thus, the spectator will experience a different response again on approaching the canvas more closely.

So it is that all these elements, even those that contradict one another, inwardly attain total equilibrium, in such a way that no single element gains the upper hand, while the original motif out of which the picture came into being (the Deluge) is dissolved and transformed into an internal, purely pictorial, independent, and objective existence. Nothing could be more misleading than to dub this picture the representation of an event.

What thus appears a mighty collapse in objective terms is, when one isolates its sound, a living paean of praise, the hymn of that new creation that follows upon the destruction of the world.

Likewise in May 1913 Kandinsky wrote the comprehensive "supplementary definition" of his major work *Painting with White Border* (ills. 246, 243–245):

For this picture I made numerous designs, sketches, and drawings. I made the first design immediately after my return from Moscow in December 1912. It was the outcome of those recent, as always extremely powerful impressions I had experienced in Moscow – or more correctly, of *Moscow* itself. This first design was very concise and restricted. But already in the second design, I succeeded in "dissolving" the colors and forms of the actions taking place in the lower, right-hand corner. In the upper left remained the troika motif (troika = three-horse sled. This is what I call the three lines, curved at the top, which, with different variations, run parallel to one another. The lines of the backs of the three horses in a Russian troika led me to adopt this form.), which I had long

since harbored within me and which I had already employed in various drawings. This left-hand corner had to be extremely simple, i.e., its impression had to be directly conveyed, untrammeled by the form. Right in the corner are white zig-zag forms, expressing a feeling I am unable to convey in words. It awakens the feeling, perhaps, of an obstacle, which is, however, ultimately unable to deter the progress of the troika. Described in this way, this combination of forms takes on a wooden quality that I find distasteful. For instance, the color green often (or sometimes) awakens in the soul (unconsciously) overtones of summer. And this dimly perceived vibration, combined with a cool purity and clarity, can in this case be exactly right. But how distasteful it would be if these overtones were so clear and pronounced that they made one think of the "joys" of summer: e.g., how nice it is in summer to be able to leave off one's coat without danger of catching cold.

Thus, *clarity* and *simplicity* in the upper left-hand corner, blurred *dissolution*, with smaller dissolved forms vaguely seen in the lower right. And as often with me, *two centers* (which are, however, less independent than in, e.g., *Composition 6*, where one could make two pictures out of the one, pictures with their own independent life, but which have grown together).

The one *center*, to the left: combination of standing forms, which approach the second center, with pure, powerfully sounding touches of color; the red somewhat runny, the blue self-absorbed (pronounced concentric movement). The means employed are thus also extremely simple, and quite undisguised and clear.

The other *center*, on the right: broad, curving brushstrokes (which cost me a great deal of effort). This second center has, both toward the outside and on the inside, incandescent (almost white) zigzag forms, which bestow upon the rather melancholy character of this curved shape the overtones of an energetic "inner boiling." Which is extinguished (in a sense, putting it over-explicitly) by the dull blue tones, which only occasionally attain a more strident pitch and which, taken together, enclose the upper part of the picture with a more or less egg-shaped background. It is like a small, autonomous realm – not a foreign body that has merely been tacked onto the whole, but more like a flower springing out of the soil. At its edges, I have treated this more or less egg-shaped form so that it lies clearly revealed, but does not produce too conspicuous or strident an effect: I have, for example, made the edges clearer toward the top, less distinct at the bottom. Following this edge with one's eye, one experiences an inner sensation like a succession of waves.

These two centers are separated, and at the same time

linked, by numerous more or less distinct forms, which are in part simple patches and areas of green. It was quite unconsciously – and, as I see now, purposefully – that I used so much green: I had no desire to introduce into this admittedly stormy picture too great an unrest. Rather, I wanted, as I noticed later, to use turmoil to express repose. I even used too much green, and especially too much Paris blue (a dully sonorous, cold color), with the result that it was only with exertion and difficulty that I was later able to balance and correct the excess of these colors. [...] At the bottom left, there is a *battle* in black and white, which is divorced from the dramatic clarity of the upper left-hand corner by Naples yellow. The way in which black smudges rotate within the white I call *"inner boiling within a diffuse form."*

The opposite corner, upper right, is also similar, but that is itself part of the white edge.

I made slow progress with the white edge. My sketches did little to help, that is, the individual forms became clear within me – and yet, I could still not bring myself to paint the picture. It tormented me. After several weeks, I would bring out the sketches again, and still I felt unprepared. It is only over the years that I have learned to exercise patience in such moments and not smash the picture over my knee.

Thus, it was not until after nearly five months that I was sitting looking in the twilight at the second large-scale study, when it suddenly dawned on me what was missing – the white edge. [...]

I treated this white edge itself in the same capricious way it had treated me: in the lower left a chasm, out of which rises a white wave that suddenly subsides, only to flow around the right-hand side of the picture in lazy coils, forming in the upper right a lake (where the black bubbling comes about), disappearing toward the upper left-hand corner, where it makes its last, definitive appearance in the picture in the form of a white zig-zag.

Since this white edge proved the solution to the picture, I named the whole picture after it.[360]

The most significant point in Kandinsky's analysis is when he warns against over-interpretation. He was unwilling to convey the meaning of the white zig-zag forms in words. Even the expression "obstacle" was too concrete for him. For him such restricting terms were "distasteful," since they make living things wooden. All he wanted was the merest overtones of meanings and objects.

Kandinsky mentions only one recognizable shape: the troika-motif. He describes the pursuing horseman with a long, white lance simply as "broad brushstrokes" and says it cost him much effort. Was this a more conscious nickname for the knight at arms (St. George) with the many-headed dragon, described by him as "left center?" Possibly, although he showed great surprise to Grohmann

243, 244, 245 *Sketch, Details, and Analytical Sketch for* Painting with White Border (Moscow), *1913* *Städtische Galerie im Lenbachhaus, Munich*

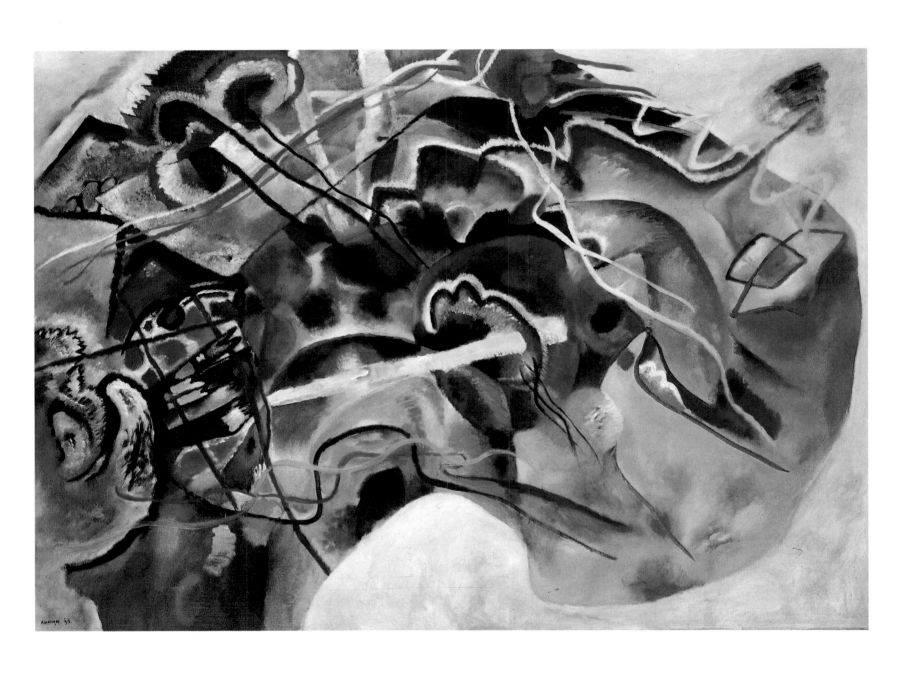

246 Painting with White Border (Moscow), *1913*
Oil on canvas, 55 ¼ x 78 ⅞ in
The Solomon R. Guggenheim.Museum, New York

that some observers appeared to "recognize" more in his pictures than he himself did. Perhaps he saw this shape as an intangible memory that he did not want to enforce upon the observer.

Kandinsky uses the troika-motif principally for the image of the *Ascension of Elijah* (ill. 247). A coach and horses also occurs frequently in the imagery of the Eastern church. The troika was no ordinary cart or sleigh, but a luxurious plaything for the aristocracy. Slight, temperamental horses were hitched to it in such a way that only the middle one was actually pulling it. The pace for this lead horse was a trot, since a gallop would have made the ride uncomfortable. But as a gallop looks so much more graceful, the two side horses were made to gallop. Partly for decorative reasons, and partly to help them settle into their natural rhythm, these two horses were reined in so that they had to hold their heads out to the side. The "essence" of the troika is represented even in Kandinsky's late works as scarcely more than a barely decipherable hieroglyph of three exuberantly flowing lines. But it would be wrong to read too much into this hint of a troika. The fact that the troika has become a typically Russian symbol may have had a nostalgic effect on the emigrant artist, but should not be seen as a Slavophile tribute, or as a reference to "salvation from the East," or any such thing.[361] It is significant that Kandinsky never once used this symbol in a nonsensical way, pointing straight up or down for example. Its origin was probably never far from his mind. This is true also of his other "hieroglyphs."

247 Ascension of Elijah
(Russian folk print)
taken from: D. Rovinski, Russkie narodnye kartinki, 5 vol.,
St. Petersburg 1881

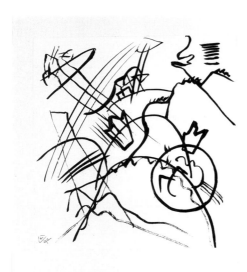

248 *Patterns of Troika and Rider, 1912*
India ink
Musée national d'art moderne
Centre Georges Pompidou, Paris

249 *Main Structure of* Picture with Black Spot I,
India ink and red pencil, 4⅛ x 6 1/16 in
Städtische Galerie im Lenbachhaus, Munich

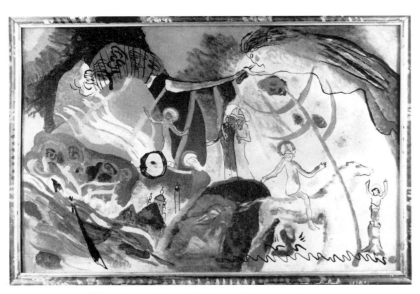

250 Composition with Saints, *1911*
Painting on glass, 12⁵⁄₁₆ x 18⁷⁄₈ in
Städtische Galerie im Lenbachhaus, Munich

Noteworthy too is the fact that he usually adds a further feature to the troika: the tall, semi-circular, almost triangular, yoke over the withers of the middle horse (see ills. 248, 249). If this is greatly magnified, it may resemble a porch or eaves, a shelter (ill. 252). Again one must be wary of overinterpretation. Is the arch supposed to limit the otherwise "impetuous" movement of the three lines? Or is it supposed to separate it from the rest of the picture's action? Whatever Kandinsky's intention, the arch became an *increasingly independent* aspect of his painting, up until the geometrical pictures, where it plays a major role. The troika yoke as origin of some of the arch-shapes is an interesting point for discussion, since to the author's knowledge there has not yet been a plausible argument put forward concerning this aspect of Kandinsky's imagery. The Russian word *"duga"* means both "yoke" and "arch" and is used by Kandinsky for all his pictures "with arch." As far as he was concerned, every form speaks for itself.

Kandinsky scholars have already proposed five (different!) derivations for the simple element of the circle alone. The artist himself admittedly does mention certain motifs and their derivation in detail. Like the troika motif, motifs that became shadows of their former selves, such as the rider, are never used in a completely absurd way. For instance, the position of the yoke on the shoulders of the middle horse remains basically the same. We really owe it to Kandinsky to notice such things, since he took time and effort to reach abstraction. Otherwise, had he deformed and reduced forms "any old how," depending on his mood, he might have found his way to abstract art as early as 1905, producing pictures that would have been correspondingly "any old how," soon to be forgotten.

Even Felix Thürlemann in his extremely interesting and forward-looking attempt to dissect and analyze in detail Kandinsky's pictorial language ultimately gives names and derivations to his motifs. To derive the small triangular or arch shape above the three lines of the horses (see his diagram, ill. 253) from the "trumpet" of one of the "angels in The Last Judgment"[362] seems questionable, since the trumpet is not a component of the troika, like the yoke, and since Kandinsky seldom links two different motifs as closely as this. Furthermore, he usually depicts trumpets pointing into his pictures. If there is no linear yoke-shape, as in *Painting with White Border*, then the set of lines or horses racing out of the picture is broken to some extent by different forms – here the very much larger, extensive "color" form, cutting through the whole center portion of the lines. To describe this as a hint of a trumpet seems exaggerated, even if it might be applicable to a preliminary watercolor in which such a form was brass colored.

The major work of the Munich period is *Composition VII* (ill. 256), thoroughly prepared by over thirty drawings, watercolors, and oil sketches. As with earlier compositions and other complex works, Kandinsky clarified the "energy lines" and the main emphases through analytical sketches (ill. 255). Whereas earlier annotations referred mainly to

251 *Vignette in* Sounds, *1911*
Woodcut, 2¼ x 2¹¹⁄₁₆ in
Städtische Galerie im Lenbachhaus, Munich

252 *Vignette in* Sounds, *1911*
Woodcut, 2⁵⁄₁₆ x 2¹¹⁄₁₆ in
Städtische Galerie im Lenbachhaus, Munich

253 *Diagram of the Troika with "Arch"*
by Felix Thürlemann,
in: Kandinsky über Kandinsky, *Bern 1986, p.184*

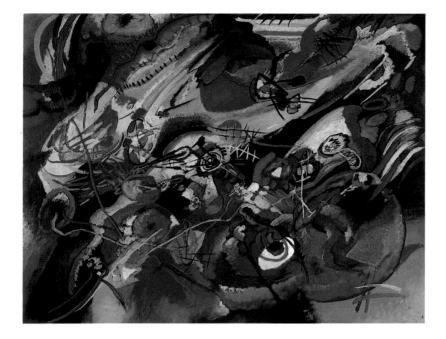

254 *Sketch I for* Composition VII, *1913*
 Oil on canvas, 30⅝ x 39⅜ in
 Private Collection

the colors, here it is abstract concepts that abound: "Solutions," "Collision," "Suddenness." It is difficult to decode these radically abbreviated Russian expressions written for his own use. Uncertainties are flagged by a question mark.

Gabriele Münter's four photographs (ill. 257) provide an invaluable record of the genesis of this major work. There is one photograph per day: after all his preparations, Kandinsky painted this enormous work in only three and a half days!

If one is familiar with the large-format oil sketches, considered as works in their own right (ill. 254), with their chaotic, complex effect, full of wild movement, rich color contrasts and many forms, the final composition comes as a surprise. It is admittedly larger, but also much calmer and more balanced. Regardless of the art historians' exhaustive interpretations of its underlying themes of the end and the creation of the world, its compelling violence appears spontaneous and speaks for itself. Interestingly, Kandinsky later removed one of the more direct suggestions of creation and conception from the oil study (ill. 254): the blue and red lines of the reclining couple at the bottom left, labeled *zarozhdenie* (genesis) in the analytical drawing.

After Kandinsky's own interpretations of his pictures as well as all the additional discussion about the origin of "traces of objects" and motifs, it is interesting to discover them for oneself in this work.

Kandinsky's artistic range broadened further, as shown by the contrast between his more delicate pictures and the heavier, more powerful paintings (ills. 258, 259). He also refined his transformation of the combined technique of watercolor and woodcutting into oil painting. Oil painting is the most versatile of all techniques. It can be made to encompass many features of watercolor. One of Kandinsky's most delicate, lyrical oil paintings is *Light Picture*, which has the effect of a watercolor. On comparing it with the much smaller watercolor study (ill. 258), one might ask which of the two is the more significant work of art? Had Kandinsky, in keeping with the accepted practice of the day (and even of today), merely "enlarged" a small masterpiece? The charming glass painting *Lady in Moscow* comes to mind. In the author's view it is superior to the large oil painting it preceded (ill. 133). It is hard to imagine that an artist as idiosyncratic as Kandinsky subscribed to

255 *Outline for* Composition VII, *1913*
 India ink and red crayon, 8¼ x 10¹³⁄₁₆ in
 Analysis of the above sketch, November 1913
 (with translation by J. Hahl)
 Städtische Galerie im Lenbachhaus, Munich

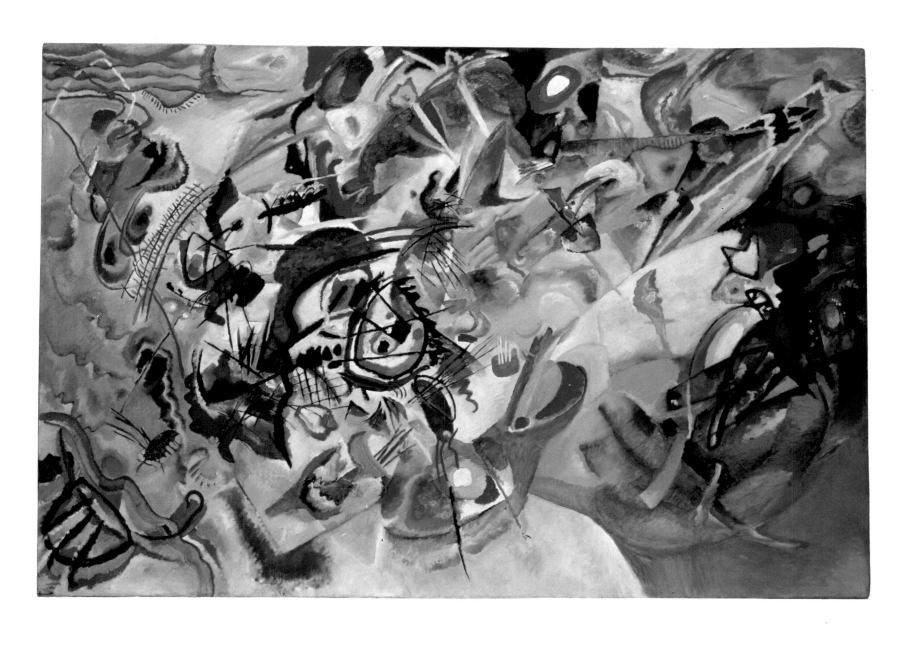

256 Composition VII, *1913*
Oil on canvas, 78 ¾ x 118 ⅛ in
State Tretiakov Gallery, Moscow

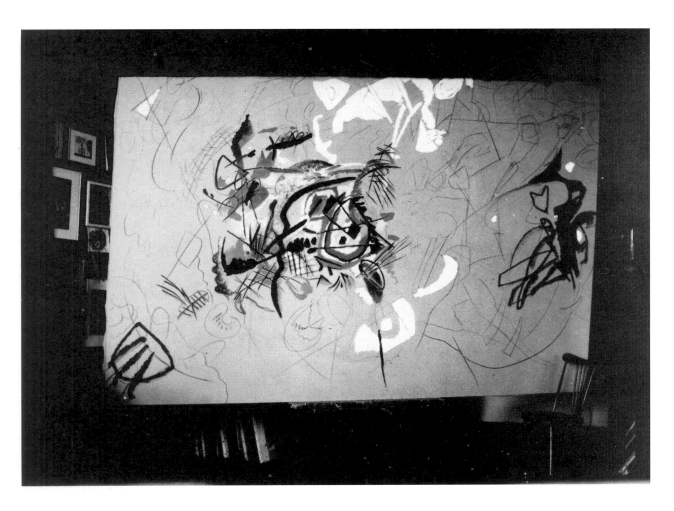

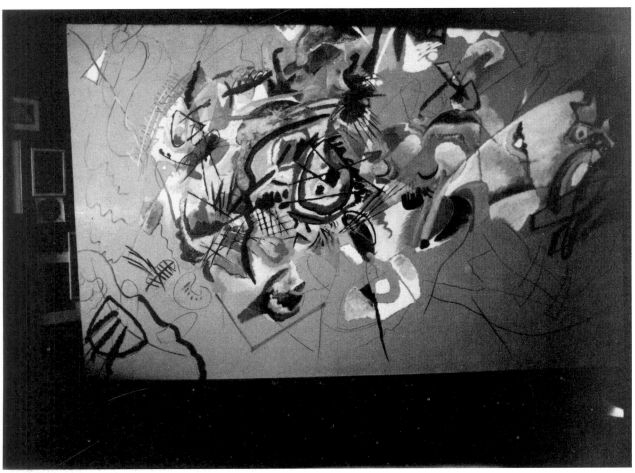

257 *Four Photographs, Taken by
Gabriele Münter in the Span of 3½ Days,
Showing* Composition VII *in Progress.
Gabriele Münter- und
Johannes Eichner-Stiftung, Munich*

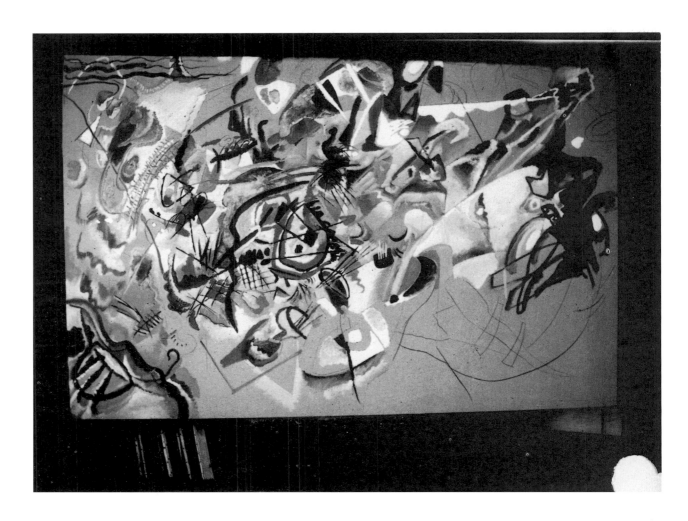

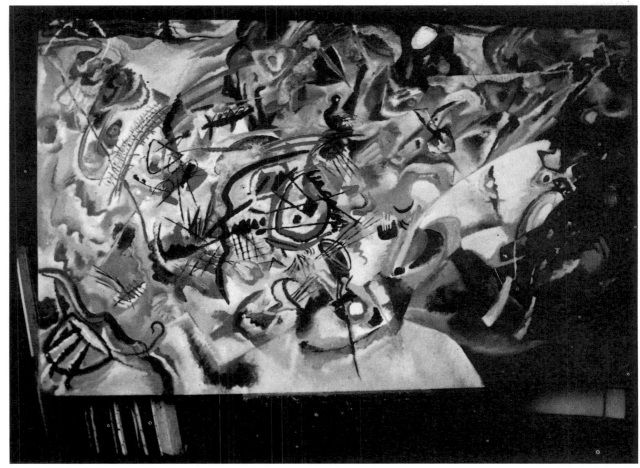

258 *Study for* Light Picture, *1913*
Watercolor and India ink, 10⅛ x 13⅝ in
Germanisches Nationalmuseum, Nuremberg

common practice purely out of the practical consideration that only large oil paintings were noticed at exhibitions and purchased by museums.

The period between 1912 and 1914 was the most active of Kandinsky's life. It was then that he made his American breakthrough. Arthur Jerome Eddy (1859–1920), who had studied law like Kandinsky, put together a small collection of the artist's work from different periods (see p. 200). *Improvisation 27*, bought by the Stieglitz Gallery in New York for $ 500, was exhibited at the Armory Show of 1913 alongside works by Cézanne, Van Gogh, Gauguin, Matisse, Picasso, and others. Eddy negotiated a contract for Kandinsky for four panels in the oval entrance hall to the apartment of his friend Campbell, co-founder of the Chevrolet Motor Company. As always these were preceded by preparatory studies and projects, which were rejected due to misunderstandings about the required size (ill. 261). Common to all four panels is the complete "nonobjectivity," and even lack of a particular

theme. The first "commissioned work" for so foreign a culture could not of course take as its theme the apocalypse, or a Russian troika, or the Garden of Love. Even the commonly used sequence of the four seasons had to be ruled out, as it was not in keeping with Kandinsky's line of thought. We are told that the paintings were put on the market after Campbell's death, and the two smaller ones were eventually sold (unrecognized) in 1953 for $ 25 and $ 15.[363]

How Kandinsky found time to write his stage play *Violet* while all this was going on remains a mystery. The most remarkable thing about this stage composition is its clear anticipation of Dadaist, absurd components. Hugo Ball wanted to perform excerpts from it in 1914 at the Munich Artists' Theater. The appearance of a red-painted, crudely cut-out cow in the "main role" (ill. 263), mooing with the chorus, brings to mind Kandinsky's intention in the second part of the *Blaue Reiter Almanac*, "to go to the very limits of kitsch – or as many might think, beyond the

259 *Study for* Painting with White Lines, *1913*
Watercolor, opaque white, and pencil,
15⅞ x 14⅛ in
Germanisches Nationalmuseum, Nuremberg

260 Improvisation 34 (Orient II), *1913*
Oil on canvas, 47¼x55⅛ in
State Art Museum, Kazan

limits."[364] This was the approach he was to take in Russia and Sweden a year later.

The fine detail in which Kandinsky observed natural phenomena becomes clear in the stage composition *Violet*, as indeed it had already in his prose poems and other writings. In the play, for example, he describes how the sun sends out its rays and then "draws them back into itself" again. This might sound puzzling, until one has once been in a dark forest and seen the delicate shafts of sunlight momentarily transpierce the foliage. The optical illusion changes constantly, in accordance with our ever-changing visual perceptions: one moment the sun's rays appear to be shining down through the trees, the next the beams seem to have been "reversed." Such an experience immediately brings to mind Kandinsky's precise observation, which pictorially he was unable to represent other than by an evocative suggestion, and perhaps for that reason he resorted to verbal description.

261 *Study for* Panel for
Edwin R. Campbell, *Nº 4, 1914*
Oil on cardboard,
25 ⁹/₁₆ x 19 ¹¹/₁₆ in
Miyagi Art Museum, Sendai, Japan

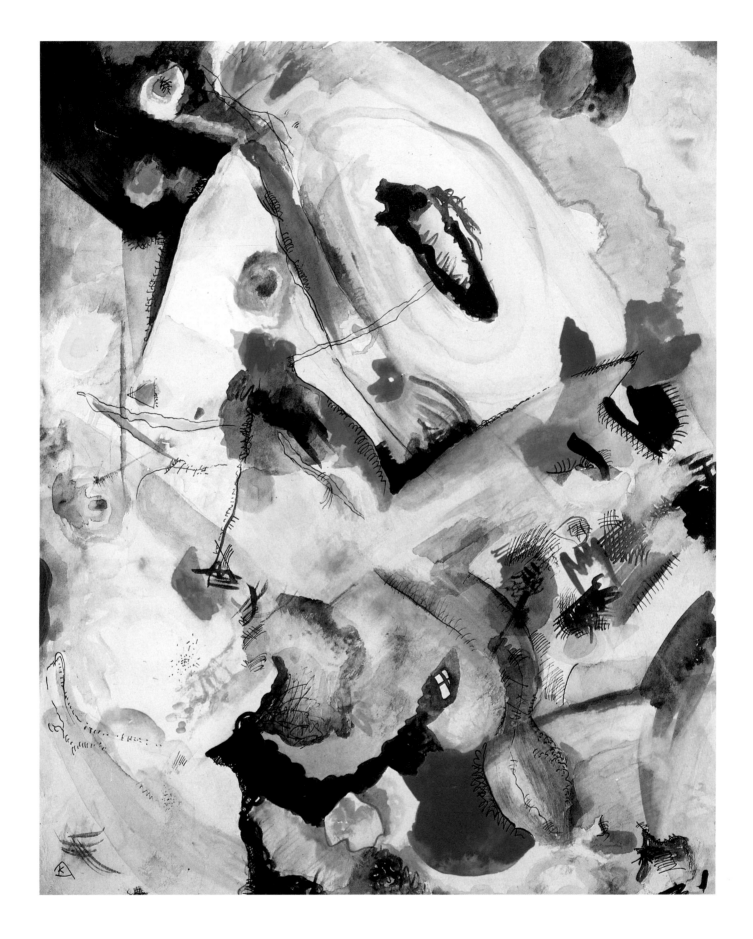

262 Untitled, *1913*
Watercolor, India ink, and pencil,
17 ⅗ x 14 in
Stephen Hahn Collection, New York

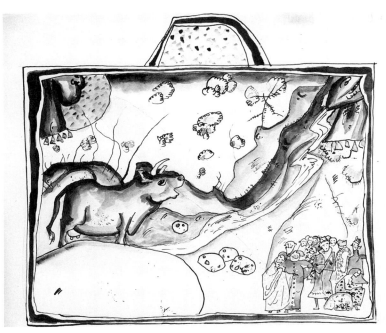

263 *Stage Design for* Violet *(Scene III), 1914*
 India ink and watercolor, 9 ¹⁵/₁₆ x 13 ³/₁₆ in
 Musée national d'art moderne
 Centre Georges Pompidou, Paris
 Nina Kandinsky Bequest

DOCUMENTS

Painting is like a thundering collision of different worlds that are destined in and through conflict to create that new world called the work. Technically, every work of art comes into being in the same way as the cosmos – by means of catastrophes, which ultimately create out of the cacophony of the various intruments that symphony we call the music of the spheres. The creation of the work of art is the creation of the world.

(Vasily Kandinsky, *Reminiscences*, 1913, CW, p. 373.)

Yet another of those unfortunate monomaniacs claiming to be the herald of a new form of painting has just been exhibiting at Louis Bock & Son. We have already crusaded against the nonsensical theories of these people as well as their botched daubs with good aesthetic reason, so we can certainly put paid to this Kandinsky chap from Russia without too much fuss.
Standing in front of this hideous hotch-potch of colored splodges and lines [...] it's difficult to tell what you should be more amazed by: Mr Kandinsky's inordinate arrogance in assuming these daubs will be taken seriously, or the hostile cheek with which the comrades of "Sturm" are propagating this savage painting as the revelation of a new art for the future [...]. In the end, one pities this crazy, irresponsible painter, who was capable of beautiful, elegant compositions before this shadow fell on him. There is also a certain satisfaction in knowing that this sort of art has finally reached the point where it reveals itself as the "-ism" upon whose shores it must run aground, that is to say cretinism.

(Kurt Küchler, in *Hamburger Fremdenblatt*, 15 February 1913.)

CHAPTER SEVEN
KANDINSKY AND POLITICS

It would not be entirely mistaken to view Kandinsky as utterly unpolitical, after all – in the wake of two world wars, two revolutions, and two dictatorships – he increasingly stressed his political disinterest toward the end of his life. Even his 1914 initiative for international peace and understanding, discussed below, does not fall strictly within the bounds of politics.

The liberal attitude of Kandinsky's family, which was hardly supportive of the czarist government, as well as Kandinsky's own affinity with the largely Socialist Russian students' movement have been observed in earlier chapters. However, a brief examination of his private, hitherto unknown, almost daily reports on the Russo-Japanese war and the revolution of 1905 shed new light on his attitudes.

At the end of 1904 he voiced an opinion on the war with Japan, upholding the Russian cause: "I surprised myself to discover how much I love Russia, in spite of all the things here that I hate." He went on to say, with reference to the war damage: "I certainly believe in eternal life and eternal beauty. However, I'm too shortsighted, weak, small, and stupid to understand the necessary suffering."[365] On November 12, 1904, he commented on the discrepancies in his attitude, for example, his claim to believe in God while nonetheless supporting a war. He reduced this rather crudely to the formula "world harmony and diarrhea..."

On September 8, 1905 he reported that the dispute between the government and intellectuals in Russia continued unabated. The following day he saved three newspaper cuttings, including one from the *Münchner Neueste Nachrichten*, to refute the "unbiassed reporting" of the German press, opposed to Russia: "One of the greatest evils of our time is the Press, which is allowed to spit in anyone's face without ever being wrong." He wrote to *Simplicissimus* about the contradictory articles in the *Münchner Neueste Nachrichten* and sought to bring the paper's "biassed stupidity" to its own attention on September 21. "I take no part in the Revolution in Russia, Ella. You know what I think about that. I want to paint something great first, I want to express what has been weighing down my soul for so long. And I still hope to blaze a new trail in painting," he wrote to Gabriele Münter on September 17, and then complained three days later that she did not understand his suffering on account of his homeland: "You might try to sympathize in your heart, if not in your head..."

Fortunately for us, he persisted in trying to involve Gabriele Münter by writing regular, comprehensive reports on the situation to her. On September 24 he wrote: "The government in the Caucasus has been involved in some really dirty tricks. Damn the government to hell!" The peasants had formed a confederation. Kandinsky was pleased with the Zemstvo congress and the developments at the universities. The Russians had behaved liberally and independently: "I predicted as much a long, long time ago. Government – People! Hell and Heaven." Such was his opinion on September 28. Two days later he wrote about his father and himself: "We both cursed the government and hoped for its rapid demise." Finally, on October 25, he wrote: "If you only knew how proud I am that my prophecies on true Russian liberalism are becoming more of a reality every day. 'Cheers, Russia!' a thousand times over, for spitting on Roman law and formality!" On October 30 he broke the good news in a way that certainly cannot be described as politically disinterested:

> Ella, Ella, congratulate me! It has happened, at last, at long last. We have a proper constitution and are no longer serfs, but citizens, real citizens with all the fundamental rights. After 25 years of waiting I'm experiencing this day, it brings tears to my eyes. Great processions with red flags, thunderous 'hoorays'. – Congratulations, joy. Finally, freedom at last. There are some who are already asking for more. What's the point, if the people now have the power to make laws? Happiness, Ella, happiness! Beloved one, my dear, I know you will rejoice with me.

But disappointment was soon to follow – on November 3! He was unwilling to describe the days of horror; there had been deaths: "The most beautiful moment of Russian history has been completely ruined. [...] The hostility between Russians (here in the south) and Jews was no secret to me, and I have never been keen on southerners. But recent events have gone beyond the pale, and I now find myself hating the whole of the south. Now you will understand why I don't like people to think of me as coming from Odessa." More details on the nightmare that he missed by a hair's breadth were to follow three days later: "Our house was to come under fire, so father and I spent the night elsewhere. Father wants to move away, he finds Odessa so repulsive; he never liked the place either." There were over three thousand dead and wounded. Hooligans, representing the basest section of the people ("whom Gorky saw as the hero"), were responsible, besides the police and to some extent the clergy, who supported the old regime. The Cossacks also remained loyal to absolutism. The plan in Moscow was to disarm the Cossacks and transform them into simple peasants ("always a dream of mine").

Thus Kandinsky found himself in Odessa not only at the heart of the action in 1905, when mounted Cossack troops bloodily beat down the uprising of the people, but in actual danger himself. Need one enquire about the origins of the countless pictures he painted of warring horsemen?

Kandinsky's attitude toward the German Reich becomes apparent when he writes on December 15, 1910, about Thomas von Hartmann, of Russo-German extraction, and about the Baronesses Maindorf, "of German

origin, but essentially very Russian" that "in *every war*, in every hour of need they have been of help [which shows that] it is not *the Germans* but the idiotic history of the last century which is to blame for the faults of that country."

In *On the Spiritual in Art*, Kandinsky declares his position more forcefully than usual, surprisingly enough in strong opposition to the Socialists, using the same arguments that were found in conservative circles at the time: the Socialists had never borne responsibility, they were inexperienced. Where is the Revolutionary and the Anarchist here, one might ask? He is still around, but firmly refusing to subscribe to any one party, or artistic-"ism," or the Eastern Orthodox Church, or the Theosophists, or whatever. Even Yule Heibel's interesting and informative study tries to define Kandinsky too narrowly.[366] Complex and inconclusive links such as the above and the question whether he is referring more to the Russian or to the German situation deserve further investigation in the light of a book published in Russia and the facts given here.[367]

Kandinsky was aware of the threat of world war as early as November 25, 1912, and declared that the Russians were categorically opposed to any war "except for the dear 'patriots.'" But a remarkable thing happened before war broke out. Following the documents in Kandinsky's Munich estate, we find that he informed Gabriele Münter on April 17, "I've received a very interesting text from Volker. A new foundation for liberated people. I have been asked to win over Merezhkovsky too. Some of it is really quite good." Leaving "Volker" for the moment, let us first take a look at letters from the Serb, Dimitri Mitrinovich; the first from June 1914 illustrates that he already knew Kandinsky, he had given a lecture on his painting in the spring of 1914, and before that Kandinsky had written to Franz Marc, "I would like you to get to know Mitrinovich. He could be *very useful* to the BR [Blaue Reiter]."[368]

Mitrinovich asked to discuss the important plans face to face, especially the almanac "of our movement" and colleagues' queries. He had apparently already written to the cultural philosopher, Otto Braun, sending him Kandinsky's regards and at the same time recommending "our philosophers Fritz Mauthner and Erich Gutkind [Volker]" to him. He intended to write to Przybishevsky immediately and visit him the following week to canvas his support for the almanac. On July 19 he is able to report that Przybishevsky replied in the warmest of terms, promising to devote all his energies to it, "a resounding success." He would have to present a detailed project outline to the publishers, in particular of the German participants [the publisher in question was the Delphin-Verlag in Munich]. Further suggestions he made on the structure and the collaborators included: "The *Peace Movement* with Alfred H. Fried [Austrian Nobel Peace Prizewinner] and Norman Ansell, *Cultural Politics* with David Kerfen? (a Russian Jew) and *Society* with Franz Oppenheimer and Eduard Bernstein [Swiss publisher of the journal *Der Sozialdemokrat*]." He

264 *Kandinsky, 1913*
Photo: Gabriele Münter- und
Johannes Eichner-Stiftung, Munich

221

undertook to write for *Religious Culture* himself: "Dostoevsky's Religion," "On Soloviev's Notion of God as Man," and "The Russian Philosopher Spiz." He planned "for the *Kritische Rundschau* a column on 'The Seekers of the Future' about our colleagues, as I understand them pragmatically for *Das Arische Europa*."[369] There would be "Essays on the work of Mauthner, Papini, Chamberlain, Merezhkovsky ... on Gutkind, Schönberg, the great work of Kropotkin and on your own work" in due course.[370] He apologized as he explained that he would be forced to ask for some small participation on Kandinsky's part (Kandinsky had obviously made it clear from the outset that while he was able to invest a little money in the project, to fund the enthusiastic young Mitrinovich's travel and other activities, he was unable to invest much of his time). Mitrinovich asked Kandinsky to write to Merezhkovsky in St. Petersburg, since he was personally acquainted with him, and to the art historians Dr. Burger and Dr. Hausenstein (both were defenders of the new art; Dr. Fritz Burger was a lecturer at Munich University); he was also to write to Erich Gutkind, whose book *Die Siderische Geburt* (The Sidereal Birth) Mitrinovich held to be true religion "worthy of a united Europe" and whom he hoped soon to visit in Berlin.

Gutkind had sent his book to the *Blaue Reiter* in 1912 and visited Kandinsky and Münter in Murnau in the fall of 1913. Kandinsky was instrumental in setting up the relationship between Mitrinovich and Gutkind. "An alliance, a deep understanding with Gutkind will breathe depth and life into the movement." Mitrinovich was already aware of this before their initial meeting on July 19, 1914, and confirmed it three days later. He reported that things had also gone far better than he had hoped with Professor Rudolph Eucken, whom he had originally intended to visit with Kandinsky. Hausenstein had in the meantime also sent a positive response, promising active collaboration and expressing his desire to seek out Socialist and Anarchist groups.

After Mitrinovich had again requested that he at least send letters to Merezhkovsky and Gutkind, Kandinsky drafted the following to Fritz Burger on July 7, 1914, setting out the objectives of the peace initiative:

Dear Doctor,
As I believe I once mentioned briefly to you, Mitrinovich is planning a widespread international association – not in any officially recognized sense of course – with the aim of putting important people in touch with each other; those who live in the present but are concerned about the future, whose souls and minds are fixed on "tomorrow." [...] Mitrinovich's plan is exhaustive in its conception, based on firm foundations and extremely comprehensive in its scope. All aspects of the human mind are to be cultivated simultaneously and following a similar direction: art, politics, religion, education (pedagogics), science and philosophy. All the forces which have achieved something significant (*really* significant) in a competent way, *and* retain a hold on the idea of "tomorrow" should be involved in this great and organically founded effort.
Initially the plan is to bring out an almanac, a set of guidelines you might say, summarizing the ideas above. This is due to appear in early 1915. M. is expending quite phenomenal energy on bringing together the necessary resources. He will travel to France, Russia, England, and Italy, to win over the necessary support at any price, giving lectures, holding conferences, etc. The other participants will also have to make such journeys, if they have the necessary abilities and desire so to do.
M. asked me to write to you to request your collaboration. He writes that your "opinion of the work of art as part of a general outlook on life" is "the most valuable idea in the modern German history of art." He is well aware that you took a fairly critical interest in his lecture, and told me two months ago now that "we absolutely must have Dr. Burger!"
Later on there will be a substantial journal (besides lectures etc.), if possible in three languages: French (for the Latins), German (for the German-speakers) and Russian (for the Slavs). I have unfortunately left my list of collaborators in Munich, but can nonetheless give you some names: Chamberlain, Otto Braun (philosopher), Christiansen, Deussen [Paul – philosopher], Merezhkovsky, Fritz Mauthner, Przybishevsky, Maeterlinck, Papini, Däubler, etc.[371]

One word which stands out in both Kandinsky's and Mitrinovich's correspondence is "Aryan." Even Erich Gutkind, himself a Jew, who after his emigration to America devoted himself entirely to Zionist issues, uses this term frequently. Of course, they were all using "Aryan" in its original sense, that is "Indo-European", rather than in the narrow-minded one later adopted by the Nazis ("northern European, non-Jewish"). Kandinsky went on to say in his letter that he hoped other peoples would not hang back. The idea of Pan-Europeanism was to be merely a point of departure for the ultimate goal of global human peace and understanding.

Who was Mitrinovich? His name appears in connection with Marc, Klee, and Münter as well, and the group made several earnest enquiries as to his whereabouts after the war. They often abbreviated his name to "Mitrin.," and many research notes are reduced to "Mitriz." with a question mark.[372] Those who have read the 1920–21 series of articles on "World Affairs" in *The New Age* by a certain M. M. Cosmoi would not necessarily suspect that this is one and the same person.

The Serb Dimitri Mitrinovich (1887–1953) came from an educated family of teachers in Herzogovina. He was the oldest of ten children. Like the majority of young

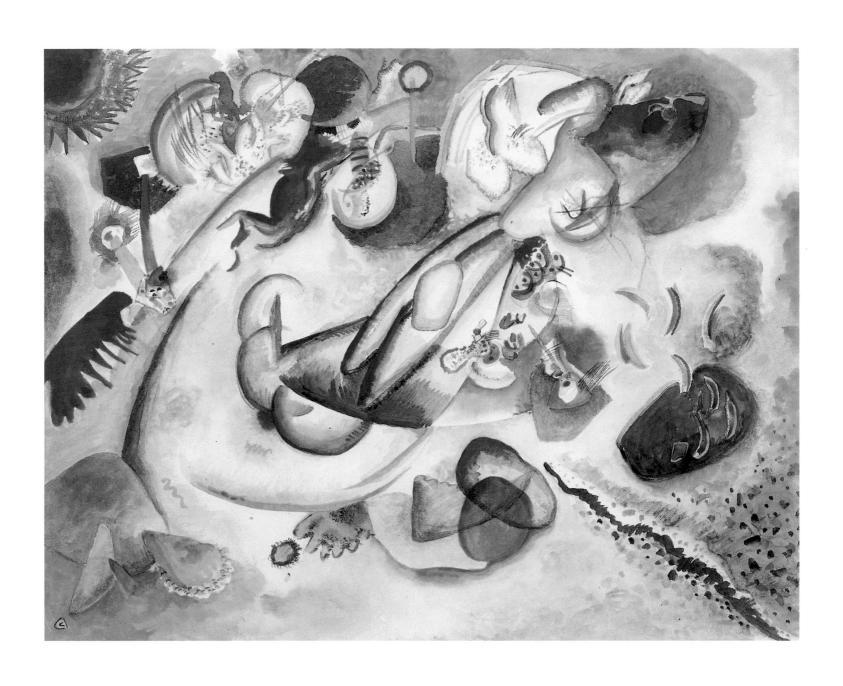

265 Improvisation, *ca 1914*
 Watercolor and gouache, 14¼ x 18¼ in
 Mrs. Bertram Smith Collection

Serbs, he rejected the foreign Habsburg rule and while still a student became a spokesman for the modern concept of "Yugoslavia," that is the unification of the individual southern Slav peoples, beginning with those arch-enemies the Orthodox Serbs and the Roman Catholic Croats, with the aim of creating an independent federal state (an aim which was realized, only for the state to collapse in the early nineties). Mitrinovich studied philosophy, psychology, and logic in Zagreb, and then later in Belgrade and Vienna. From 1907–13 he wrote for the literary journal *Bosanska Vila*, leading it away from its previously narrow-minded nationalist viewpoint. He was opposed to any form of violence, the clergy, and any harmful foreign influences, and he was in favour of the dispossession of the aristocracy. Small wonder then that he was arrested in 1910. His 1913 series of articles, "Aesthetic Reflections," in *Bosanska Vila* echo many of Kandinsky's ideas, for example that of "inner necessity," which Mitrinovich calls "the morality of the soul through intuitive expression." The supremacy of intuition over reason is another idea he shares with Kandinsky, as are the ideas of a synthesis of all art forms and the task of leadership to be shouldered by an artistic elite. His opinion on the "beauty of the soul" reflects that of Maeterlinck, as indeed does Kandinsky's. So it is no surprise to find this name appearing in connection with Mitrinovich as well: the Belgian poet was also to be included in the peace movement.[373] Mitrinovich had come to Germany in 1913 with the aim of completing his art history studies in Tübingen under Heinrich Wölfflin; however he met Kandinsky's circle of friends in Munich and decided to devote himself to the cause of the peace initiative.

The third central figure in this affair was Erich Gutkind (1877–1965). He was the son of a wealthy Jewish industrialist in Berlin; his mother came from the family of Heinrich Heine, the German poet.[374] In 1910 he published his first book, *Die Siderische Geburt* (The Sidereal Birth), under the pseudonym "Volker" and sent it to the Blaue Reiter to make contact with the group. Franz Marc found it outrageous and unreadable. Gabriele Münter struggled through it, as shown by her letter of August 20, 1912, to Arnold Schönberg:

> I would like to draw your attention to a book which I think would give you a lot of pleasure. [...] I myself am ploughing through it rather slowly, unfortunately with a lot of breaks. I get as much out of it as I can stand. I cannot follow it all the way, and I think by the end of it it will have become too much for me. But it is like a heavy gold chain slipping link by link, phrase by phrase, through my fingers.

In the meantime Schönberg's long letter arrived, in which he went into raptures over Kandinsky's *Yellow Sound* and pronounced himself firmly in favour of intuition and opposed to construction. Further to this, Münter added:

Now I am quite certain that Volker is your man! On page 31 below he describes the elements of Kandinsky's Compositions II, IV, and V, etc. Not in connection with Kandinsky of course, since he was probably not at all acquainted with either him or his work at the time. I believe it is important that such people get to know each other (remember I found your address that time?).[375]

Münter's notes in the margin of the copy that belonged to her and Kandinsky reveal her efforts to understand the book. The book is made difficult to read by its heavy, flowery style; it is such an exaggerated combination of Nietzsche and Stefan George as to be almost a parody! There are a few parallels with Mitrinovich's style in evidence, which also uses a richly embellished and metaphorically overloaded pathos, possibly derived from the tradition in his home country of handing down heroic epics by word of mouth. Both authors are worlds apart from Kandinsky's own clear and precise style. Admittedly, *On the Spiritual in Art* and other works do contain the odd flash of prophetic pathos, but more in subject-matter than in style. Kandinsky must have read Gutkind's book, but probably not in quite so much depth as Münter; all the marginal notes are in her handwriting. If the book was difficult for her, and for Marc and others, it must have been even more so for Kandinsky, who was not as competent in the German language. As much as he may have sympathized with Gutkind's ideas, it is not possible to establish how well acquainted with this difficult book Kandinsky was. Most importantly, it is hard to prove any claim that he was particularly influenced by The Sidereal Birth.[376]

Having worked one's way through Gutkind's stylistic idiosyncrasies and the chaotic organization of his exposition, one has to admit nonetheless that his ideas testify to a certain prophetic energy and vision. They were probably the author's most preciously guarded treasure, which he felt he could display to the reader only in the most elaborate, ornate setting. The following points echo Kandinsky: anti-materialism, scepticism about the positive sciences, and, more strongly, the idea of self-fulfillment in an ethical-religious sense, victory over the personal ego, not as un-individualization, but as full realization of human potential. Only in such a way could man, having "died" in today's incomplete world, be resurrected through a "sidereal birth" as a more god-like being. In other words, this is Kandinsky's leitmotif of "death and rebirth," a theme which had been developed in a variety of ways in the works Münter called "Compositions." On this fundamental level, Gutkind's ideas correspond with those of the Russian Symbolists, especially with those of Viacheslav Ivanov, who, like Mitrinovich, had been particularly keenly influenced by Vladimir Soloviev (see p. 15). Kandinsky was sympathetic to all these ideas, without ever having gone to quite such extremes in his own writings.

The concrete result of the friendship that sprang up

between Gutkind and Mitrinovich was the initiative described above. Gutkind had also been making preparations for such a movement: together with the Dutch writer, doctor, and psychologist Frederik van Eeden, he had been planning since 1912 to create a "blood brotherhood." an elite community which would lead mankind to peace and harmony by setting a good example of its own. This would be a kind of elaboration of the Socialist-oriented colony "Walden," set up in 1898 near Amsterdam by Van Eeden, which had survived until 1907.

To what extent was Kandinsky actually involved in these projects previously conceived by Gutkind and Mitrinovich? From what he said about political initiatives during his student years, as well as from what we know about his thoughts on synthesis and the role of the elite, and above all from the "prophetic" sections of *On the Spiritual*, we must presume he was overjoyed to rediscover his theories being put into practice to some extent and to be able to help implement them yet further.

The fact that Kandinsky's ideas had at least some effect on Gutkind is clear from the latter's letter cited below.

Kandinsky was not present at a meeting at Gutkind's residence in Potsdam near Berlin (large garden, lake etc., a nice place for a meeting) in June 1914; Van Eeden and another Dutchman were there, also the orientalist Henri Borel, who had lived for many years in China and India, the Swedish psychologist Poul Bjerre, the anarchist Gustav Landauer, the poet Theodor Däubler, the Jewish philosopher Martin Buber, and the historian and theologian Florenz Christian Rang (Kandinsky in any case did not entirely subscribe to the ideas of the latter). Gutkind reported to Kandinsky on this meeting on July 5, 1914, saying that something wonderful had happened, "which swept us all off our feet and made everyone smile, each one of us seeing reflected in the other the roots of his being; it was clear to us that we could not carry on living without this. At the same time we felt that we held a power in our hands, an almost magical power, which could give the whole world a sharp electrical shock." Theodor Däubler had "the most comprehensive understanding of your new ideas that I've ever come across. [...] In any case, it is clear that *you* must not be absent from this circle. We expect great things of you. I ask you, my dear Kandinsky, to agree to join our ranks. Integrity, valued by us all, compels me to tell you nonetheless that the circle cannot of course espouse any particular attitudes or artistic trends. [...] We want to study metaphysical things together and accomplish something really worthwhile. This is an opportunity that *you* simply *cannot* refuse."[377]

Actual events subsequent to this were as follows: a meeting was planned for the fall of 1914 in Forte dei Marmi in Italy (hence the group is known also as the "Forte" group). Later they hoped to acquire a well-situated property, where casual meetings could be held at any time, and where discussion would give rise to further projects on

peace and international understanding – Plato's beautiful concept of an artistic elite? Gutkind wrote to Mitrinovich on July 12, 1914 about "Kandinsky, whom I value most highly as a central element in what is to come." He did not agree with Mitrinovich's suggestion that Chamberlain be included, saying that the latter rejected Jewish and Southern (Latin) Europe. He also questioned the integrity of Maeterlinck. However he was in complete agreement with the proposal to include Hamsun and Hodler.

Kandinsky joined the society, but expressed one or two reservations (see his not *entirely* enthusiastic reaction cited above "some... quite good"), and mentioned his lack of time in particular. Gutkind continued to urge him on, arguing: "This concerns the homo metaphysicus, who aspires to the Absolute and does in his time the one thing that it requires. All we need is the person, his existence – that is all. You cannot fail to participate. That is not intended as a compliment..." Kandinsky answered by return on July 11, 1914, saying that since the whole of Europe was under the imminent threat of war, Mitrinovich was in a great hurry to take concrete action and was on his way to Berlin to get to know Gutkind and start a lecture tour through Germany as soon as possible. Kandinsky planned to meet him in two or three months' time in Russia; from there Mitrinovich intended to travel on to London, Paris, Italy, and America, where he hoped to find some financial assistance as well. Kandinsky wrote some very illuminating words about himself:

I would very much like to come to Forte. But it so happens (rather importantly for me) that I have to be in Moscow at this time. Admittedly this "have to be" contains an element of "want to be." I have been feeling a profound and almost unremitting yearning for Moscow since the winter. I am going through a phase in my work which absolutely compels me to spend a few months of my life in Moscow. I regret that I cannot explain this profound love of mine to you. The ultimate goal of my life is to paint. I have allowed a great deal (a terribly great deal) of time to "slip through my fingers." Now I see quite clearly that I will only attain my goal, in part at least, if I sacrifice everything to its end. For that reason I am withdrawing from every other activity, I am giving up a lot that I love – things that I hold worthy, necessary, beautiful, and good. [...] Moscow is the ground from which I draw my strength and where I can live the inner life my work demands. Earlier I was able (perhaps I was forced) to be in direct contact with the outside world, I could play an active part in it (which gave rise to various undertakings, such as the Blaue Reiter). It was probably necessary for me then. But now it has become harmful to me, threatening my existence. A few things have now become clear to me. This "becoming clear" about being an artist has little to do with reason. It belongs in the domain of the

spiritual life, which needs the most favourable environment so that what has "become clear" can become corporeal. Otherwise it is a waste of time and reduces the artist to a criminal. The strongest of flames must first burn on the quiet so that it can develop the strength later to withstand any storms. I hope that I will hear news of you again in Potsdam. My inner voice will then let me know what I have to do.[378]

It is not clear whether or not this letter closed this chapter for Kandinsky. A fortnight after he wrote it, Austria and Hungary declared war on Serbia – the spark that set off the First World War. As a result, not only did the planned meeting in Forte have to be canceled, but the whole ambitious plan was developed too late ever to be put into action. Kandinsky seems to have kept up with only a few of the acquaintances; with the Swede Poul Bjerre, the Swedish writer and pacifist Ernst Norlind, and the wealthy Hjalmar Wijk, who had been a patron of Van Eeden's "Walden" community. These people were useful contacts for Gabriele Münter when she went to Stockholm in 1915 after the outbreak of the war.[379] Münter travelled first to Berlin, where she met Gutkind and Herwarth Walden, whose wife Nell, the Swedish musician and painter, gave her an address in Stockholm from where she would be able to correspond with Kandinsky in Russia. Nell and Herwarth Walden were probably also behind the contact with Carl Gummeson's Stockholm Gallery, where Münter and Kandinsky were granted exhibitions.

Kandinsky stayed in touch with Bjerre longer than with any other member of the peace group. During the twenties Kandinsky was still trying to involve him in new plans from Russia (see letter p. 262). Although Bjerre was a professional psychologist and had won a reputation for introducing Freud's theories into Sweden, he and Kandinsky shared many other things besides simply their commitment to peace and international understanding: Bjerre also wrote for the theater and had many diverse interests, for example in parapsychological issues and the origins of creativity (he had written on Nietzsche and his "inspired madness"). He had also published a work on Kandinsky's pioneering achievements as an abstract artist.[380]

V.

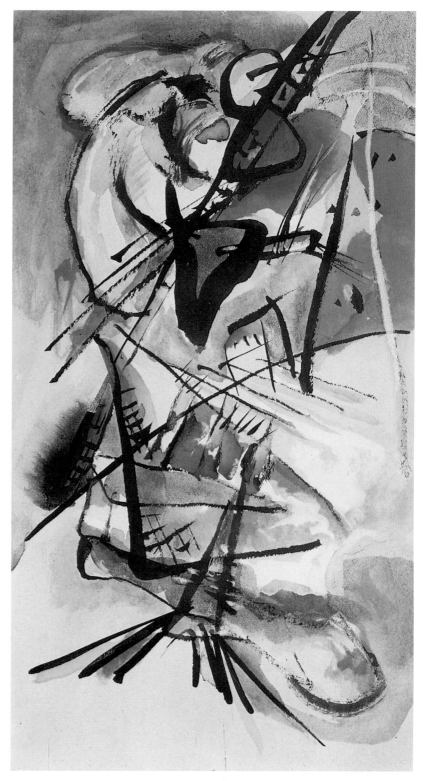

266 Untitled, *ca 1915*
 Watercolor and India ink on tan paper,
 8⅞ x 4½ in
 Private Collection

V MOSCOW 1915–1921

CHAPTER ONE
A DIFFICULT FRESH START

In the letter to Gutkind cited earlier, Kandinsky refers to Moscow as the particular source of his artistic inspiration and says that he longs for it. Similarly, his letters to Gabriele Münter in 1912 and 1913, during prolonged visits in Moscow and Odessa, show his increasing devotion not only to his homeland but also to his large family. There is an increasingly evident distancing from his companion of many years. He had not once taken her with him to Russia, although until 1910 he had mentioned his intention of doing so. Nor should there have been any impediment to their planned marriage after his official separation from his first wife in 1911. In 1905, when the separation proceedings had begun, he had been very keen to marry Gabriele without delay.

In 1914, Kandinsky was able to return to Moscow for a long period, but in circumstances other than those he might have wished. As a Russian citizen, he was obliged to leave "hostile" Germany at the outbreak of the world war. After a stay of several months at Goldach by Lake Constance with Gabriele Münter he traveled back to Moscow (with relatives), while she later moved to neutral Sweden and kept in touch with him from Stockholm. Even his first letter from Russia contains indications that he wanted to loosen their bond a little. He tells Münter to help herself to as much of his money as she needs. "Each of us should have complete freedom. Without this I am increasingly aware that I am worthless." He said he hoped that she would soon be happier and that her bitterness would eventually fade.[381] (He was not to meet his future wife Nina until a year and a half later.)

During his exhibition at the Gummeson Gallery in Stockholm early in 1916, he lived with Münter for three months. It was their last time together. Soon after his return from Sweden he began an intense love affair with the beautiful, 24-year-old Nina Andreevskaia, a general's daughter who was studying literature and philosophy. In addition to wartime worries (such as imminent conscription into the army medical corps),[382] emotional complications distracted him from his creative work. He wanted to remain friends with Münter as he had succeeded in doing with his first wife, Ania. But Münter insisted on her "rights" and remained bitter for years to come. All this has already been described in detail elsewhere.[383] The break was of course painful for both. Even before Nina entered his life, Kandinsky confided to Münter: "It's a constant source of anguish to me that people are so good to me and yet I seem incapable of reciprocation. The excuse that I'm made like this and can't change is no excuse. Even if it were, it's no comfort to me. Right now I crave a life of solitude, which I have not yet experienced and which I suspect is still a long way off."[384] His letters reveal his honest attempts to make his point of view as clear as possible to his partner of so many years and to hurt her as little as possible. This

might explain why he later spared her the news that he had made a young girl pregnant and was going to marry her.

Nina herself recalls that she was immediately captivated by Kandinsky's paintings, which she first saw at an exhibition in Moscow. When she got to know the artist personally, it was as much love at first sight for her as it was for him. The early loss of her father may well have increased the attraction for her of the 50-year-old artist who had nevertheless remained young at heart. Kandinsky had perhaps never experienced such unconditional love and respect from a beautiful young girl before.

His love for Nina gave his artistic impulse a much-needed boost, after the very difficult fresh start in Russia, when he could scarcely bring himself to pick up a paint brush, let alone reflect on the new artistic direction which he admits he was unable to pluck up the necessary "courage" to take. Toward the beginning of 1915 he wrote to Münter: "You know me. Nothing external can have an effect on me indefinitely. I constantly turn my gaze inwards. My task in art is so great, and I have achieved so little, that it is no easy demand to 'be patient.'"[385]

Besides the discrepancy between his exacting personal standards and unfavourable circumstances, such as lack of space and materials, he had trouble finding an atmosphere that was conducive to work. Was he suffering from "depression," as some critics speculate? Why did he produce so few large paintings at this time?[386] War was raging, a revolution was soon to break out. Even if from time to time Kandinsky did manage to lay his hands on the art materials he required, it is hardly to be wondered at that the "courage" for painting large pictures may have failed him under such circumstances. The results (ills. 266–278) also suggest that he was unsure in which direction to go. His letters indicate a desire for greater precision (see p. 242), yet at this very time he was producing bleakly retrospective, romantic or idyllic drawings and glass paintings. Their consciously naïve but refined imagery reflects a very different kind of precision than that which one might have expected (ills. 272, 275, 276, 279–281). He worked in this style for his exhibition in Stockholm, and Münter rather appropriately called these pictures *Bagatelles*.

Once again, Kandinsky began with small canvases, simple "finger exercizes." In the same spirit he turned his mind back to absolute basics. In 1914 by Lake Constance he had reflected about "more precise forms" and had later been inspired to write his essays on *Point and Line* (see p. 258). In Moscow, using what he saw from his window on the fifth floor, he once again attempted apparently "realistic" city-scapes, with more natural colors (ills. 273, 274). These are so untypical of his work that one would hardly guess that he had painted them. Admirers of Kandinsky's unique style cannot but be disappointed by this collection of about twenty city- and landscapes from 1916 and 1917.

At this time he mainly took up drawing and painting in watercolor again: "I must prepare myself internally even for small, clear-cut subjects. So I'm practicing a lot

267 *Kandinsky and Münter, 1916*
Gabriele Münter- und Johannes Eichner-Stiftung, Munich

with watercolors and with ink pen. I may finish a few engravings. I can sense a proper frame of mind gradually coming back to me."[387]

In November 1915 he reported:

It's minutely detailed work, you might say I'm learning the jeweler's craft. This helps me with the large pictures which are taking shape increasingly in my mind's eye. I'd like to create a huge picture with immense depths and suggest the effect of distance by using subtle effects, which might only be seen from up close. This is the idea I've already had in the pictures that you've seen. Now I can envisage this on a larger, more practical scale, thanks to the many watercolors I've done recently.[388]

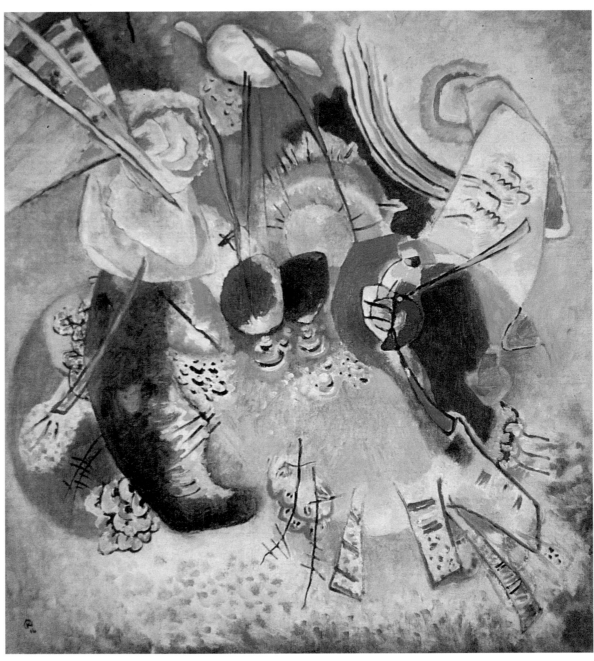

268 Untitled, *1916*
Oil on canvas, 26 ⅜ x 23 ⅝ in
Museum of Tiumen, Russia

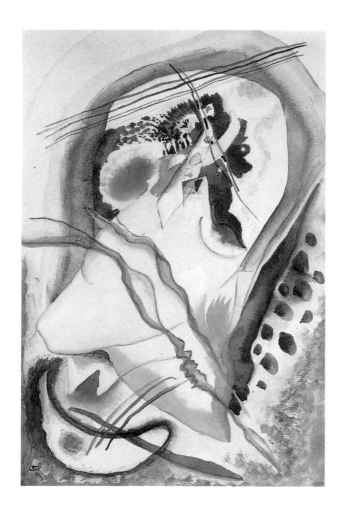

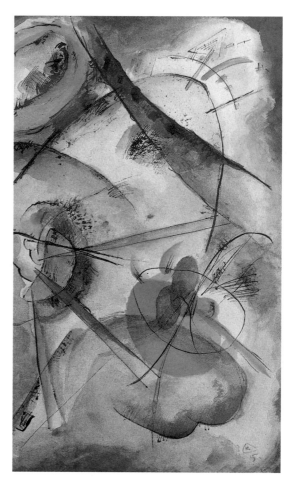

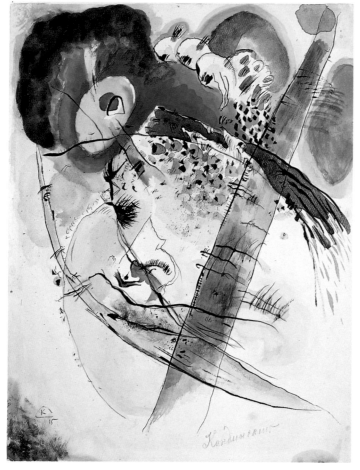

269 Untitled, *1915*
 Watercolor, 13 x 8⅞ in
 State Art Museum, Ryazan

270 Composition Z, *1915*
 Watercolor and India ink,
 13⅛ x 8⅝ in
 Pushkin Museum, Moscow

271 Exotic Birds, *1915*
 Watercolor and India ink,
 13⅛ x 9⅞ in
 State Tretiakov Gallery, Moscow

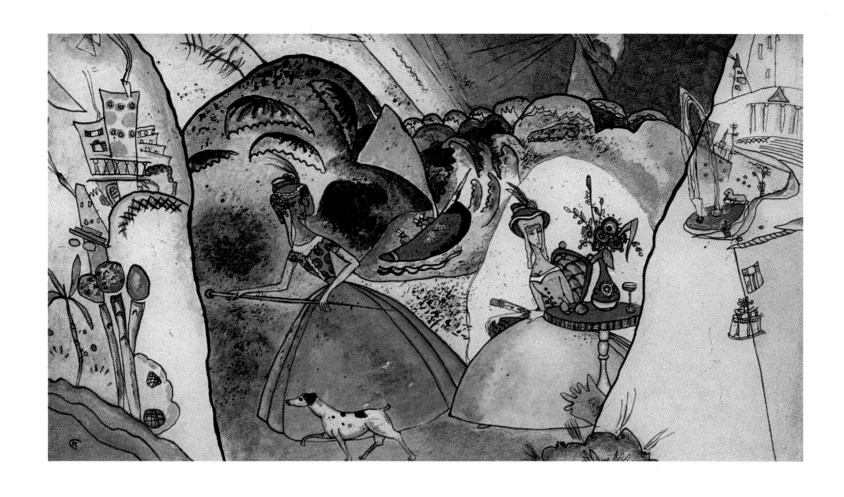

272 Ladies in Crinolines, *1918*
Painting on glass, 9⅞ x 16¹/₁₆ in
State Tretiakov Gallery, Moscow
(Gift of George Kostakis)

273 Moscow – View from Apartment Window, *ca 1916*
Oil on canvas, 13 ⁹⁄₁₆ x 14 ¾ in
Private Collection
Courtesy A. Kostakis, Athens

274 Zubovsky Square, *ca 1916*
Oil on cardboard,
16½ x 18⅛ in
Private Collection, Moscow
(not in Catalogue raisonné)

275 Engraving No. III, *1916*
Drypoint 3⅝ x 3⁵⁄₁₆ in
Städtische Galerie im Lenbachhaus, Munich

276 Ascension of Saint Elijah, *1916*
India ink and pencil, 6¹¹⁄₁₆ x 8³⁄₁₆ in
Städtische Galerie im Lenbachhaus, Munich

277–278 Untitled, *1917*
Drawings in India ink
10¹⁄₁₆ x 13³⁄₈ in
Sketchbook 1915/17
Private Collection

Of all the techniques Kandinsky had used until then, watercolor was the one he had mastered the least. He had concentrated far more on gouache and tempera, which produce matt, opaque colors that preclude working in the hasty, spontaneous fashion of more transparent watercolors, which can be mixed while still wet on the paper. After all his experience with tempera, oil, woodcut, and glass painting, the almost 50-year-old painter now immersed himself in the most delicate of all mediums. If he wanted to emphasize linear elements instead of colorful ones, he would draw or work in a mixture of watercolor and fine ink pen drawing. He also devoted himself intensively for the first time to drypoint (ill. 275). Hans Konrad Roethel particularly admired the detail and finesse of this period's engravings. It was not long before Kandinsky began to produce high-quality works of art in these new media.

Those who are unfamiliar with Kandinsky's individuality will be surprised at the ease with which he worked simultaneously in completely abstract and representational modes. To label his work of this period as "lacking homogeneity" is to understate matters. The artistic quality of many pictures from these years (including oil paintings) is certainly not up to that of his earlier Munich period. Russian scholars, such as Dmitri Sarabianov and Natalia Avtonomova, see things differently, however, and it is really only now that any discussion of any interest on this point can begin.

Why did Kandinsky backslide to the themes of Rococo, Biedermeier, and high society genre scenes? Was it because such material was easier to sell in Russia? This is the assumption made by almost every art historian since Grohmann.[389] For the first time in his life, Kandinsky was in financial straits. He had been forced to sell his house in Moscow even earlier than the general dispossession of

279 Untitled, *1917*
 Watercolor, India ink, and pencil
 10 x 18⅛ in
 Private Collection

280 Untitled, *1918*
Watercolor and India ink
12½ x 9¾ in
Private Collection

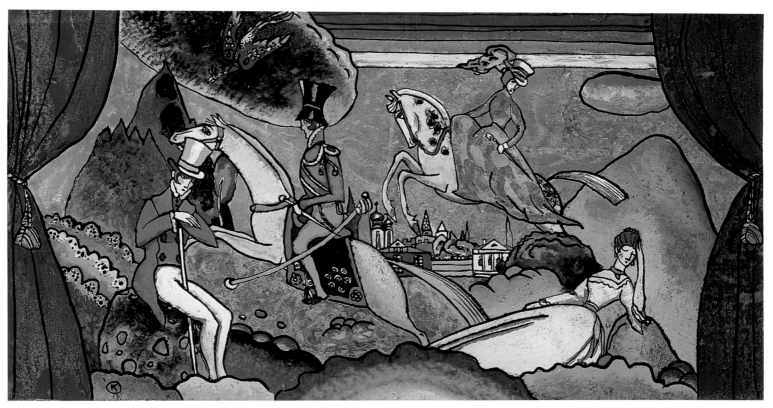

281 With Officer, *1917*
Painting on glass with silver foil
8½ x 15⁹⁄₁₆ in
Collection S. L. Sobinova, Moscow

1917, in which he lost everything he owned. He was not able to live off selling his pictures during this time of severe restrictions; not even his little "idylls" would sell in poverty-stricken Russia. However the Swedish gallery-owner Gummeson did buy all the small pictures in his exhibition, both abstract and figurative. Sweden, neutral and not suffering from shortages, eventually set up relief action to help Kandinsky.[390]

Rather than interpret his retrospective style of painting as a kind of marketability, however, why not investigate the obvious *irony* of these scenes? Is this merely mild playfulness? If Kandinsky welcomed radical social change, the downfall of the czar and aristocracy, and the rise of democracy, is it not probable that he might have had a joke at the expense of the former feudal régime, even in a gently nostalgic way? Such themes were unfashionable as early as 1905; on closer examination it is possible to detect a faintly ironical tone in these temperas and woodcuts, especially from the vantage point of the Bolshevik revolution of 1917. Irony is more noticeable in the representational watercolors and drawings of the later period, which differ also from the work Kandinsky did between 1902 and 1907 in their more conscious affectation, formality, and stylization.

Kandinsky said himself that his watercolors should be seen as preparations for larger works. In his desire for more *precision* he was in line with the trend then current. All around him, artists were adopting geometric forms, almost always derived from Cubism. In contrast to all his younger Russian and German friends, from Franz Marc and August Macke to David and Vladimir Burliuk and even Malevich, Kandinsky was never involved with Cubism.[391] Rather than haggling over dates, let us admit that other, younger Russians beat him as well as all Western artists to it; he could observe their innovations from 1915 onward. Was he speechless with admiration? Or dumb with envy? Was he at least surprised?

> I went to an exhibition recently. Good stuff, tasteful for the most part. But nothing outstanding. All kinds of styles including would-be Picassos. Large pictures from the Knave of Diamonds group. Talented, as ever, but superficial. [He had expressed himself in this way since 1912.] As usual, I was overwhelmed by the sight of all those pictures. My word! There's so much painting going on. Think of the effort, the sacrifice, the painting materials, the money! And almost all of it unnecessary. Some had already been sold. These pictures are hung in apartments for a couple of generations, before being put in the attic, where they become dark and full of holes and gradually disintegrate. [. . .] I've seen two exhibitions here already, but left both disappointed. Lots of skill, elegance, and finish, but no sense of a powerful underlying spirit.[392]

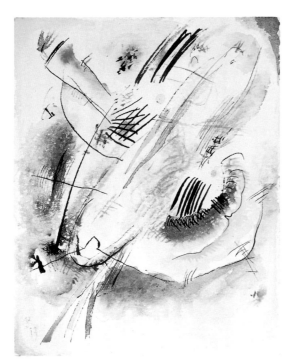

282 Untitled, *1917*
Watercolor and India ink,
6⅛ x 4¾ in
Private Collection

CHAPTER TWO
CHANGE OF STYLE

Research opinions differ widely over the exact time and circumstances of Kandinsky's change of style to that of geometric forms. Lindsay, Grohmann, and others think the new style is heralded by the ink drawing dated 1913 after "Small Pleasures" (see ill. 283), on which a circle has been drawn for the first time with a pair of compasses. But on the occasion of the large exhibition devoted to "The Russian Period and the Bauhaus Years," Clark Poling surmised almost entirely without any supporting evidence that Kandinsky was under the influence of the young Russian Constructivists and Suprematists, especially Alexander Rodchenko.[393]

Grohmann writes:

I share Lindsay's opinion (*The Art Bulletin*, 1953) that the drawing actually dates from 1913, and that Kandinsky here had a presentiment of things to come in his own development. [...] It is a curious case of prophetic vision. The painting and drawing were executed before his departure for Moscow, so that influence by Russian painters is out of the question.[394]

However, Kandinsky is known to have frequently remembered the date of an original work, and associated it with later works on the same theme. It is perhaps easier for an artist to understand that he could be vague about dating his own pictures, than for an art historian. Surely artists have better things to do than to be pedantic about cataloguing

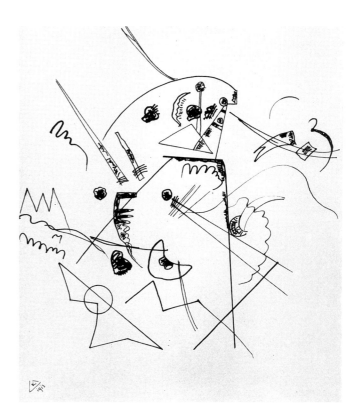

283 *Drawing after* Small Pleasures, *ca 1924*
India ink
Musée national d'art moderne
Centre Georges Pompidou, Paris

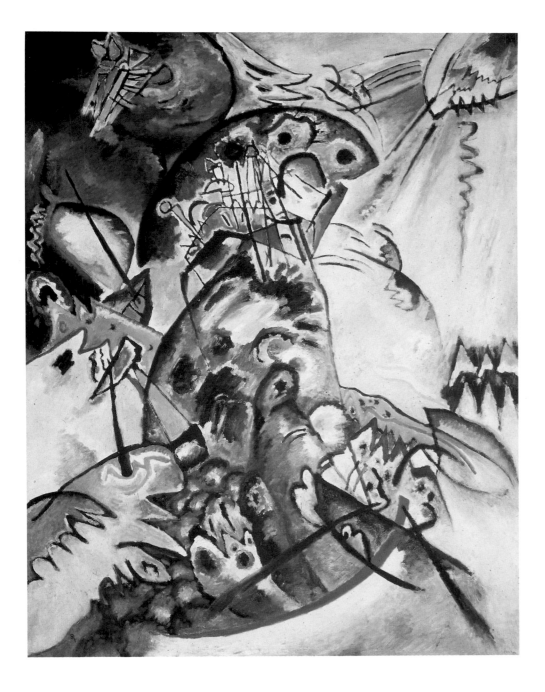

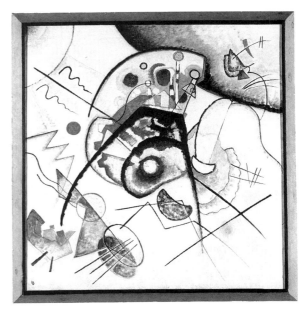

284 Blue Arch (Ridge), *1917*
Oil on canvas, 52⅜ x 40¹⁵/₁₆ in
State Russian Museum, St. Petersburg

285 Backward Glance, *1924*
Oil on canvas, 39⁹/₁₆ x 37⅜ in
Kunstmuseum, Bern

their own work? In the following letter, written at the time he was painting *Small Pleasures* (ill. 238), Kandinsky comments: "I know that I have painted *Small Pleasures* before – they were in the 'Sonderbund' [i.e. exhibited in Cologne]. But painted completely differently."[395]

This had been a little under two years previously, and he had then called the picture *Improvisation 21a* (ill. 166). When he took up the subject again in 1924 in *Backward Glance* (ill. 285), having meanwhile used it for *Blue Arch* in 1917 (ill. 284), he was to retain the most important elements of the original sketch, as illustrated so convincingly by Hideho Nishida in a purely stylistic way.[396] Roethel also thought the picture dated from 1923 and claims that Kandinsky's date was wrong.[397] Why should it be wrong? The 1924 picture looks back after all to the

period of 1913 (to give an impression of this time to his wife, Nina), so it would have been logical for the artist to record the sketch of a memory as going back to 1913, but understandably put the year it was actually painted, 1924, on the canvas. Why does an artist date an insignificant preliminary sketch anyway? Surely more for himself than for the world to come. Posterity is far from his thoughts, although once he is famous it is eager to attach some artistic value to his every last doodle.

In the painting Kandinsky has stuck fairly closely to the initial sketch. He has filled in the two corners bottom and top left, which were empty in the sketch, by adding a few figures, for example, the two oar motifs bottom left. This makes it seem unlikely that the drawing discussed dates from *after* the completed picture (in this case he would

have dated it 1924). For a work painted in 1924 the picture is quite clearly a "backward glance." Even the rigid geometry of the sketch is softened in keeping with the artist's earlier, "dramatic" style, and the colors are applied in the "busy" manner typical of that period.

Important information, as yet undiscussed in criticism, on Kandinsky's growing interest in more precise forms from 1914 onward is given in a letter he wrote to Münter as he was beginning his new life in Moscow:

> At last I've started to work. At the moment I'm making little sketches for a large picture, that began to take shape in my mind in Goldach. It's gradually becoming clearer. But I still have a lot of preparatory work to do, since I want to be *even more exact, even pedantic* in this picture, than ever before. I won't get down to the actual painting until I'm in my own house, which won't really be until June. I can only do small things here. I'm quite pleased about that, actually; any attempt to tackle something that is not yet ready is quite out of the question for me.[398]

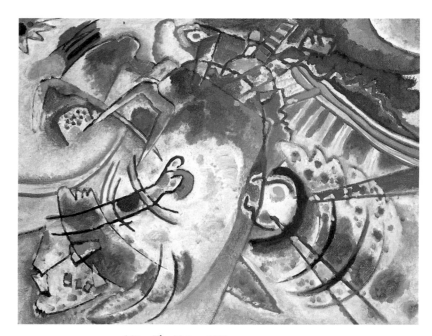

286 The Naive, *1916*
Oil on canvas, 19 11/16 x 23 5/8 in
State Lunacharsky Museum of Fine Arts, Krasnodar, Russia

A typical comment, but Kandinsky mentions the need to cogitate and mature his work more frequently than ever during the war years, and after the momentous social, political, and personal changes of his enforced return to Russia.

> It's dire that my thoughts are still at sixes and sevens. You know I'm usually in a dream, as far as "real" life is concerned. But it's worse than ever at the moment. I'm desperately craving work. I'd love to move into my studio, shake off all my practical worries, and plunge head first into my proper work! Oh yes! Be patient! When did I last hold my palette? It was months ago. I hope all those experiences weren't in vain and that everything will be reflected in rich spiritual form in future work. My watercolors, paintbrush and pencil are lying ready on the little cabinet. I keep trying to draw a couple of lines or put a few specks on the paper. But, lack of time aside, I haven't really got the nerve. These lines must reflect something; they'll have to be *more precise*, more substantial than before! What if quite suddenly that ceases to be the case? I'd rather wait a little longer, until these brushstrokes are provoked, not merely tolerated, by my inner mood. [. . .] Don't worry too much about the future. We are led by Fate, and a little trust is a good thing.[399]

Kandinsky may have been inspired to some extent by the geometrical pictures of one or two younger colleagues, but he is known to have taken a long time to assimilate new ideas, always needing to "listen to his inner voice." For that reason there has been plenty of attention paid by scholars to his independent progress toward geometry.[400] He had used geometrical forms earlier, but mainly in sketches for his compositions and in color charts that had nothing – at least from his point of view – to do with "art" and his later geometric style of painting. John Bowlt and Rose-Carol Washton Long make an interesting suggestion. They point out that the artist attached so much importance to his "Table 4" that it was the only thing reproduced in color in the 1914 Russian edition of *On the Spiritual in Art* (how else could he have illustrated the effect of primary colors on black and white?!).[401] This table may have been extremely useful to the young, Russian Cubo-Futurists if not to Kandinsky himself. Malevich in particular was on the point of founding Suprematism. He may well have found an unexpected source of inspiration in Kandinsky's table. This theory is supported by the following, previously undiscovered letter from Kandinsky to the New York gallery owner J. B. Neumann, referring to a book by Alfred Barr on Cubism:

> Barr also derives Suprematism from Cubism. That may be true, but it leaves things unsaid. When the founder of Sup[rematism] heard about my book *On the Spiritual in Art*, he asked for a translation of the whole thing, as he is unable to read German. At the time he was painting Expressionist Russian peasants, maybe Cubist ones as well (ill. 288). Immediately he got hold of the translation, he founded his Suprematism. Of course Barr didn't know about this. [. . .] The influence of the Russian (Pole) Malevich, for example, is greatly exaggerated; he's even supposed to have influenced me.[402]

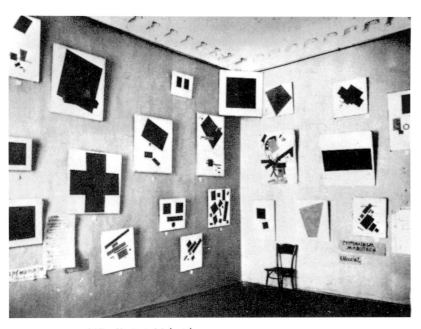

287 *Kasimir Malevich,*
Exhibition Room, Moscow, end of 1915

One more step, and the object represented becomes superfluous, an obstacle to the artistic revelation of pure painterly elements. The physicalness of painted elements now becomes crucial, this is where abstract art begins. Kandinsky is its ideologist and practitioner. In all truth, Kandinsky is on the threshold of Suprematism. He's not yet said the last word, he's not yet dotted his "i's." His pictures still contain faint echoes of forms from real life. [...] Others take this further, like Malevich, who uses forms from three-dimensional geometry to disclose the "painterly element." This is pure abstraction. It castrates painting and kills creativity.[404]

Disregarding the completely ill-founded final sentence, the insight shown by these two judgments deriving from different points of view is surprisingly profound. Even Kandinsky never began to grasp what this meant. Although he had gladly accepted Malevich's Cubo-Futurist work for his Munich collective exhibitions and had exchanged gifts with him (ill. 288), he was strangely unable to see anything attractive in his new, "abstract" works. He wrongly categorized this art form, which transcended subject-matter, as a kind of Constructivism (as many people did initially). By the thirties, he had at least corrected his terminology, but his opinion of Constructivism remained as negative as his opinion of Suprematism. He had reached the limits of his comprehension. Could these few geometric forms, that he had used for lessons and experiments, really be art? At the same time, Kandinsky's own richness of forms and motifs was attacked by a counter-movement as excessive. His error of judgment

After a very pronounced Cubo-Futurist phase, Malevich exhibited his *Black Square* and other purely geometrical Suprematist works (see ill. 287) for the first time at the end of 1915. He had banned everyone from his studio prior to this sensational event. Nothing of this kind had ever been seen before December 1915. Malevich's stage set ideas of 1913 may have anticipated *Black Square*: a diagonally split curtain in black and white that was supposed to be torn apart at the beginning of the "first Futuristic opera," *Victory over the Sun.* The seed of Suprematism may have been sown as early as 1913, but it was no more than a seed. Kandinsky was adamant about this; if there was any influence at work, it was his influence on the younger Malevich (even indirectly), rather than vice versa.

In 1920 the Russian scholar Konstantin Umansky viewed things as follows:

> The entire Russian art scene can be traced back to Kandinsky. If anyone deserves a nickname, Kandinsky does; he should be called the "Russian Messiah." [...] His work has cleared the way for the victory of absolute art, although contemporary abstract art is now moving in a different direction. [...] Kandinsky's art found its logical conclusion in Suprematism.[403]

Dmitri Melnikov made a similar observation in the same year, when he paid tribute to Kandinsky and Rodchenko as leaders of the left-wing movement, stating that it was not important *what* was represented, but *how* it was represented:

288 *Kasimir Malevich,*
Study of a Farmer's Head, *1911*
Gouache, 10 13/16 x 12 5/8 in
Musée national d'art moderne
Centre Georges Pompidou, Paris

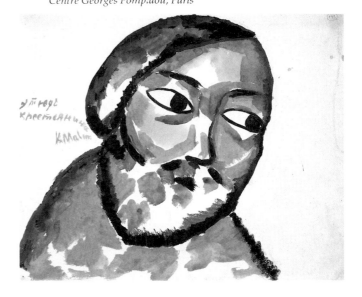

about one of the great artists of the younger generation, and by right his own successor, is regrettable to say the least. His failure to understand anything radically new must be explained by the generation gap.[405]

Not surprisingly, criticism was often directed at him and Malevich together, when their abstractions proved too baffling for the public's comprehension. In 1919, the following charge was levelled against the journal *Izobrazitelnoe iskusstvo* (Fine Art):

The journal is published by the so-called left-wing faction. We acknowledge their great importance in the world of contemporary art (which has sadly been a closed book to many Marxist comrades until now), but they are a group of individualistic, intellectuals, who really have no right to call themselves a group of proletarian artists [...]. The orientation of this pseudo-Marxist journal is revealed in the articles by Malevich ("On Poetry") and Kandinsky ("On Stage Syntheses"). [Malevich's defense of "alogical" poetry was called "illiterate drivel"...] These middle-class innovators must be shown that their innovations are middle-class and have nothing in common with Communism. "Art is entirely self-contained. Art is independence. It is a world sufficient unto itself," writes Kandinsky, a typical metaphysicist and individualist where art is concerned. Whatever did the editors see in "our artists?"[406]

Looking at Kandinsky's pictures in isolation, uncolored by knowledge of the rest of avant-garde art in Russia, one might think that he was entirely unaware of it and did not react to it until later during his "Bauhaus period." He makes his own way, step by careful step, toward geometry and a more rational language of forms. Outlines give more precision to the well-known forms; straight lines appear; irregular shapes at least have better defined edges, for example circles drawn with compasses. The wild turbulence of his earlier compositions has settled into a calm but still provocative clarity. Color is applied more thinly, losing some of its individuality or "surface structure," the "fattura" that was so highly valued in Russia at the time. The brushwork is not as obvious as it had been earlier, making the style seem less daring. This also reduces the impression of spontaneous, vivid expression.

X-rays and photographs of the surface structure of Kandinsky's oil paintings confirm this fundamental shift in technique for the first time in about 20 years. From 1914 and the cityscapes of 1916 (ills. 273, 274), one notices a thin, flat coloration, almost "alla prima." The forms are defined by thin black or dark outlines and excluded from any application of color. The artist is now using a more delicate brush than before. Dynamic momentum has been replaced by cautious delicacy.[407] The observer is no longer "swept off his feet," but nonetheless he is surely captivated by the new, subdued harmony.

What the artist himself and many of his successors referred to as "drama" was gradually losing popularity in favour of a more obvious type of "composition." Essays by Clark Poling and others in the "Russian Period and the Bauhaus Years" catalogue give good descriptions of pictures. However, Poling's reference to a "predisposition toward capital cities" seems to misrepresent the artist's well-known and very strong attachment to Moscow in particular. If Kandinsky's anthems to his native city appear to be rather turgid, his letters to Münter show that this is not a mere literary affectation. He wrote to her every time he stayed in Moscow, and without exception his letters contain the same enthusiastic, lyrical eulogies. Poling subsequently reiterated that the problem of the picture's border was now increasingly important to Kandinsky, as every scholar since Grohmann has pointed out.[408] The author would like to put forward a new observation in this connection.

Kandinsky paid increasing attention to the border of his pictures from the *Painting with White Border* of 1913 (ill. 246) and *In a Circle* onward. In these works, he created a sort of additional frame area in keeping with the composition of the picture, and separated the central image from the border, giving the impression that the painting was a view into a crater or a strange, distant world. Pictures that appear "rotational" (where the artist has obviously painted different parts of them from different perspectives; see ill. 297) are particularly strongly reminiscent of Kandinsky's very early experience in the brightly decorated peasants' huts in Vologda, where he had the impression that he himself was moving "within the picture." He had the same experience in Russian and south German churches (see pp. 34 ff.). Why should he not then feel the same way in natural surroundings? Let us switch location to the Alps for a moment, where Kandinsky went walking on a number of occasions, and take another look at his picture *Kochel Waterfall I* (ill. 66). We follow the course of the stream uphill. In the background, where the waterfall is located, the mountain is very steep. Often, where the water has washed away more and more earth and rocks over the centuries, we find that we are climbing up through a kind of narrow pass or even a "tunnel." At times the water has dried up, so all that is left is the steep tunnel leading upward. These are called "ravines" in the Alps, or "chimneys" if they are very narrow. (Many of Kandinsky's letters show how familiar he was with Alpine terminology.) If we look upward while climbing, we are overwhelmed by the view. A more or less circular section of sky shines through, brightly distinct from the surrounding, dark vegetation. Pine branches and strangely shaped rock formations jut in from the edge. Clouds sailing by alter the otherwise unreal blue of the sky. Silhouettes of birds add brief flashes of life to the scene.

This has never been taken into consideration by scholars as a further variation of Kandinsky's early experience of space. There are many such "ravine" formations in

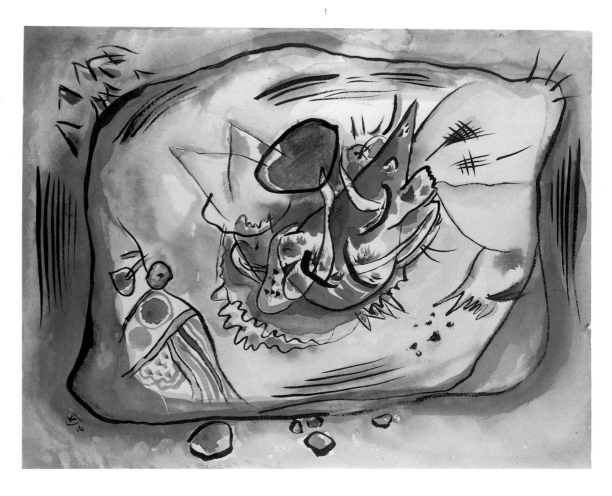

289 *Study for* Painting
with Orange Border, *1916*
Watercolor and India ink,
9 x 11⅜ in
Mr. and Mrs. Irving Mathews
Collection, San Antonio, Texas

the Alps, and they are a source of unforgettable wonder to numerous hikers. Kandinsky is known to have been a keen walker. In 1904, for example, he went to the Zugspitz massif and the "Hell's Valley" ravine (Höllentalklamm) with Gustav Freytag.[409] He went walking on several occasions with Münter and other friends. In 1914 Münter recorded another trip to the "Hell's Valley" ravine in her diary and linked this with his picture *Improvisation Klamm* (ill. 290). It was some time before these experiences gave rise to actual pictures; in *Klamm* of 1914 it is really too early to tell, but in numerous round and oval pictures of the artist's later Russian period (ill. 289) they can be seen clearly. *Improvisation Klamm* might be taken as a precursor, in so far as the tiny peasant couple in traditional costume in the center of the picture seems to lead the observer "into the picture" (that is, once you have identified the pair amidst all the chaotic action). Kandinsky himself called the picture "Sunset" (*zakat*) and described it as a further attempt to capture the essence of "his Moscow." For this reason we might compare it with the Moscow pictures (ills. 292, 293) produced two years later. In the first, a similar miniature couple more or less in the center of the picture can still be distinguished. It draws the observer toward it along an open, path-like route whose perspective "leads into" the picture; the city surrounds the two little people in a half circle on their hilltop, while the

sun is setting. The rainbow, symbolically the richest arc shape as well as the most beautiful, forms a smaller semicircle. Initially it was painted in pastel shades, but analysis by X-ray has revealed that a stronger blue and red were added later, lending it more substance.[410] Several of the artist's comments relating to *Moscow I* are of interest here:

I should like to paint a large landscape of Moscow, to take components from all over the place and bring them together in a painting. Weak elements and strong ones, I would mix them together just as the world is a mixture of different elements. It should be like an orchestra. [...] At 8 in the evening I went to the Kremlin to see churches in the way I need to see them for the picture. New riches unfolded themselves before my eyes ... [Four months later] It's developing gradually in my mind's eye. What was only a fancy is now taking physical shape. What this idea lacked was depth and sound, very serious, complex and yet simple at the same time ... [After two and a half months he claimed to have realized his old dream at last] You know that I had this dream of painting a large picture inspired by happiness, joy of life, or of the universe. Quite suddenly I am aware of the harmony of colors and forms, which come from this world of joy.[411]

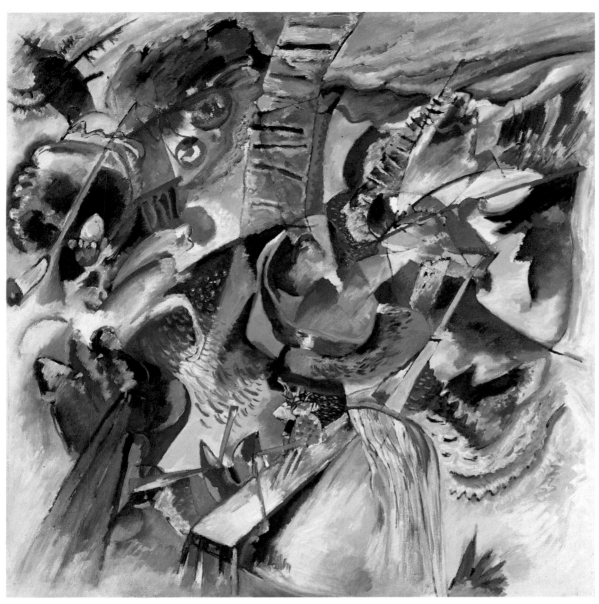

290 Improvisation Klamm, *1914*
Oil on canvas, 43 15/16 x 43 15/16 in
Städtische Galerie im Lenbachhaus, Munich

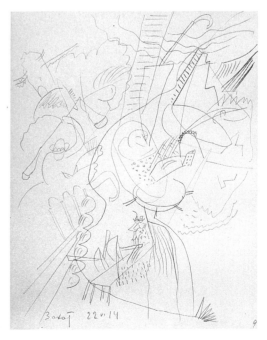

291 *Sketch for* Improvisation Klamm, *1914*
Pencil, 8 1/8 x 6 1/2 in
Städtische Galerie im Lenbachhaus, Munich

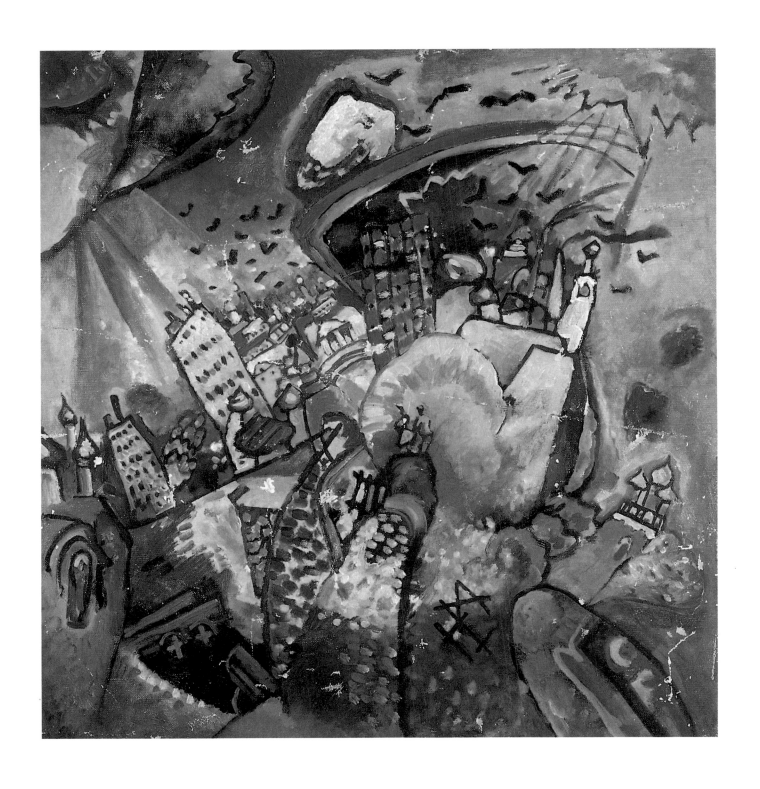

292 Moscow I, *1916*
 Oil on canvas, 20¼ x 19½ in
 State Tretiakov Gallery, Moscow
 (Gift of George Kostakis)

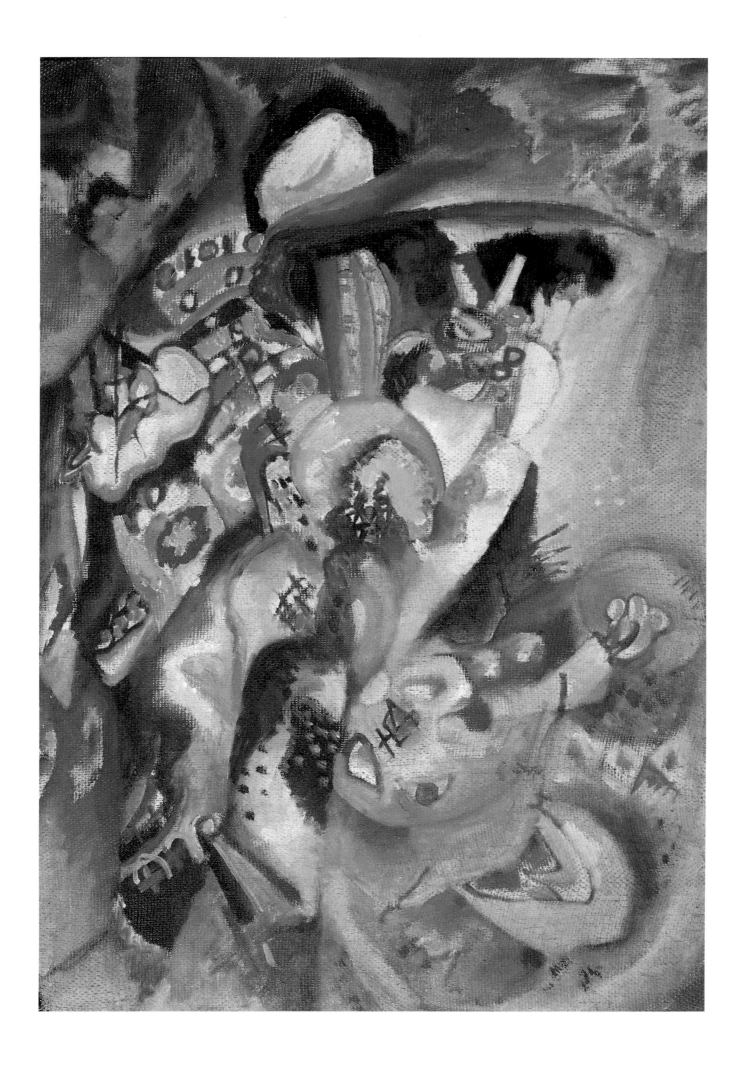

It was not long before Kandinsky dispensed with the help of a "couple leading into the picture," depicting his panorama from the center outward, always from three, and sometimes from all four sides, so that the picture became completely "rotational." If you turn the watercolor *Untitled* (ill. 297) upside down, it becomes clear that the artist painted the top of the picture *this* way up first, then turned it round. It is only his signature that indicates which way up he would like people to view his painting. The problem of the border is always serious, regardless of whether the picture is a centrifugal composition, like this and all the "Moscow" pictures, or a centripetal composition.

Of course, sections of sky opening up for the climber, or couples "leading into the picture," were not indispensable to Kandinsky's compositions. It is the artist himself who stresses the importance of his early spatial experiences. The literature on his later Paris works makes constant reference to a "view through a microscope." The present author's suggestion that Kandinsky's close observation of natural phenomena be regarded as supporting this idea is not unjustified (see p. 216).

Psychologists might read other things into Kandinsky's round and oval pictures. They might evoke the birth process, a child's view of the as yet incomprehensible variety of the world through the birth canal (border of the picture).[412] An obvious counter-argument is that children being born cannot yet see anything. However, what is being discussed here is not the reality, but the archetypal experience "known" to everyone, which can therefore form a legitimate part of our pictorial language.

Both Grohmann and Roethel record as "unknown" in their catalogues an *Improvisation 209* of 1917 (ill. 294). This was kept at the NARKOMPROS in Moscow until 1926, when it was taken into storage in the basement of the State Art Museum of Kransoiarsk. It had scarcely been released from there for the "First Soviet Retrospective" in 1989, when it was banished to the basement again in Frankfurt because its authenticity was doubted by the "Kandinsky Society." Will the small work with a similar motif in the Nina Kandinsky collection in the Centre Pompidou be exposed as doubtful as well (ill. 295)? The oil painting is admittedly a simple picture, not very refined; the round, red shape intersected by the sail, next to the yellow circle outlined in blue, looks awkward. Nevertheless, Russian researchers, as well as Grohmann, Roethel, and this author, do not doubt that the work is authentically Kandinsky's.

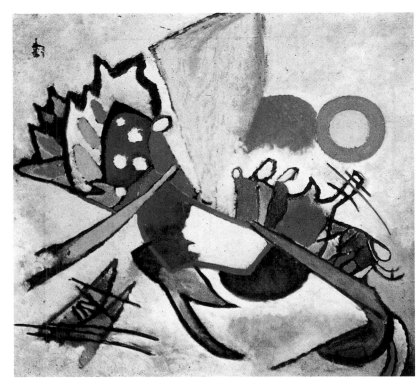

294 Improvisation 209, *1917*
Oil on canvas, 24⅞ x 26⅜ in
State Surikov Art Museum, Krasnoiarsk, Russia

295 *Drawing with Similar Motif as* Improvisation 209
India ink, 7⅛ x 8⁵⁄₁₆ in
Musée national d'art moderne
Centre Georges Pompidou, Paris

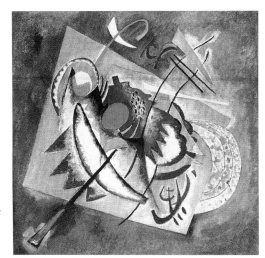

296 Red Oval, *1920*
Oil on canvas, 28⅛ x 28 in
The Solomon R. Guggenheim Museum, New York

293 Moscow II, *ca 1916*
Oil on canvas, 20½ x 14⅜ in
Private Collection

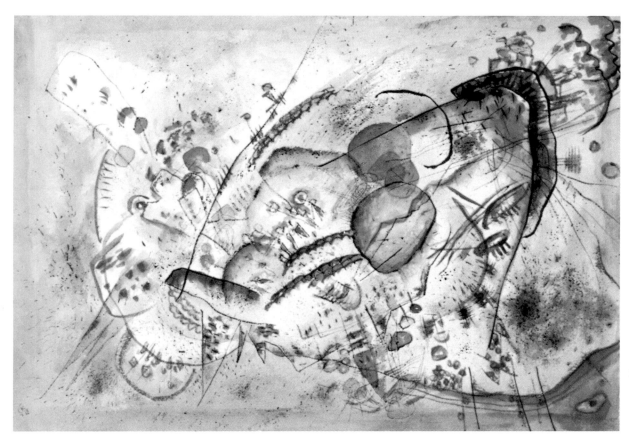

297 Untitled, *1918*
Watercolor, India ink, and pencil,
10¾ x 15 in
The Solomon R. Guggenheim
Museum, New York

298 Violet Wedge, *1919*
(Muzykal'naia overtiura. Violetovy klin)
Oil on canvas, 23⅝ x 26⅜ in
Museum of Fine Arts, Tula, Russia

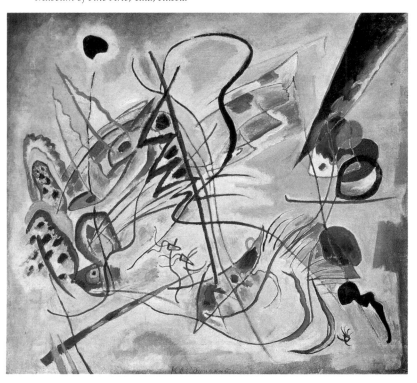

Violet Wedge is recorded in Roethel's catalogue as "unknown" and represented only by the artist's sketches made as a personal reminder after the work had been completed (entry no. 221 in the artist's "private catalogue," ill. 298). Thanks to the Tretiakov Gallery and the Russian Museum, it was discovered in the storeroom of the Tula museum, where it had been since 1922. Were it not for Kandinsky's own mention of it and indisputable documentary evidence, we might think that it could be a fake, especially as Kandinsky's name is written at the bottom in a foreign hand. The picture is a chaotic mixture of heterogeneous elements, scattered about on the canvas with no visible attempt at structure. The cheerful colors and the sloppy play of lines are "overshadowed" by the purple wedge at the top right, which is echoed by the zigzag form in the center. This is not the only weak picture of Kandinsky's from this period, as we have seen. Works produced during a time of transition are undoubtedly of historical value, even if they manifest clear signs of experimentation and ideas not fully brought to fruition.

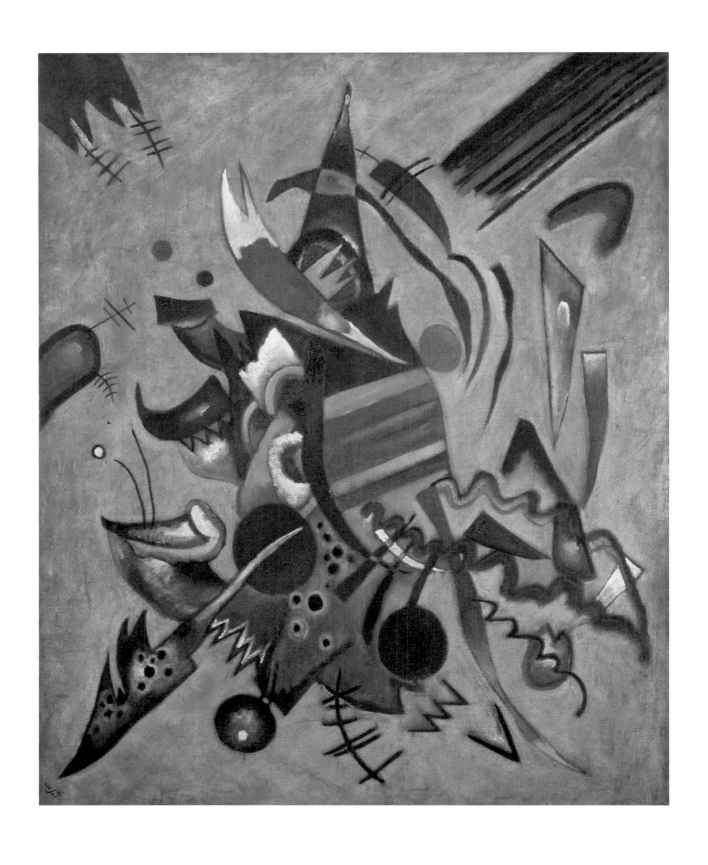

299 Points, *1920*
 Oil on canvas, 43 15/16 x 36 in
 Ohara Museum of Art, Kurashiki, Japan

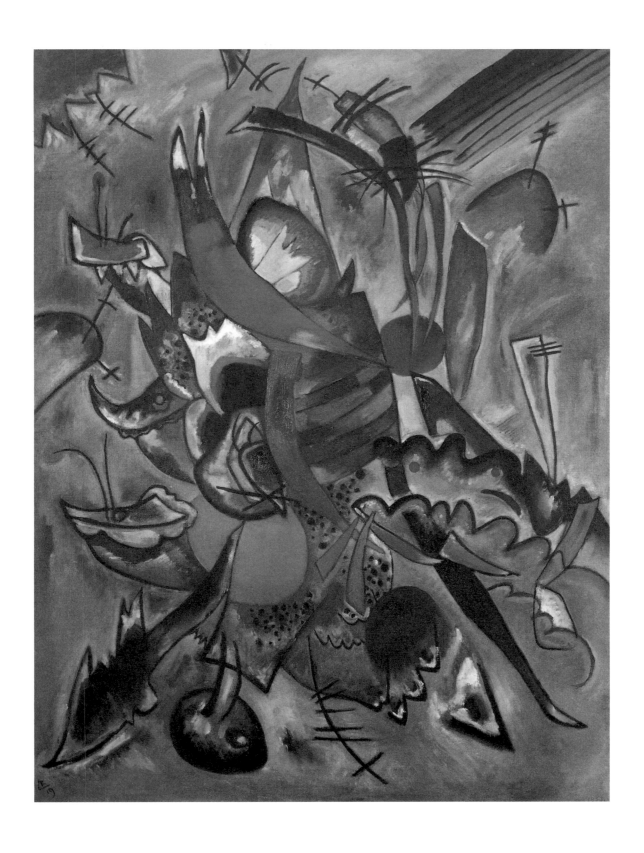

300 Painting with Points, *1919*
Oil on canvas, 49¼ x 37⅜ in
State Russian Museum, St. Petersburg

Echoes of landscape forms may still be recognizable in the 1919 *Painting with Points* (ill. 300) in St. Petersburg and the comparable *Points* (ill. 299) of 1920 in Japan (in the second, these are pine branches reaching into the picture as if into a crater, and spiky rock forms); but then, the very exact, geometrical shape in the center would jar our perception. The time has surely come to forget about such traces of landscapes and other motifs used in ever decreasingly recognizable forms. Yet this is difficult. They greet us like old friends – for example, the reclining couple from left to center in *The Naïve* (ill. 286), in the center and on the right of *Overcast* (ill. 301), and once more stretching from the left corner to the center in *Sketch* (ill. 308). They are still apparent as a dim outline in the center top of *On White I* (ill. 303), but unrecognizable to those who have not studied earlier pictures. When in fact did Kandinsky begin to introduce new, completely free visual elements bearing no resemblance to natural or any other type of familiar objects into his pictures? Are we supposed to make an effort not to think of a chessboard when confronted by the chessboard shape in *On White I* (ill. 303)? And this despite the title of another picture, *Chessboard*, of 1921?

After the "first abstract oil painting" (ill. 224) came a further sensation from the storeroom of the museum in Georgia's capital Tbilisi: *Black Line*. This 1920 painting is the only example known to date of such an exciting, highly refined color composition combining gray and variegated tones, formlessness and high definition (ill. 302). Instead of the precisely defined border of many other pictures from this year, here gray border-forms are more strongly involved in the dynamics of the picture. They press more forcefully into the picture plane, particularly on the right-hand side. This "ugly," dull gray acts as a contrasting base, out of which the small, colorful, precise, at times geometrical forms glow forth. The way they are distributed emphasizes the assertive movement of the composition from the bottom left to the top right, which even "crashes" uncharacteristically into the corner (thus releasing the tension, see Kandinsky's own explanation in *Point and Line*). Equilibrium is maintained by an equally assertive counter-movement of different shapes from bottom right to top left. This is another good example of how Kandinsky avoids the classical horizontal/vertical compositional grid.

Points was followed immediately by the very famous *White Line* (Ludwig Museum, Cologne). The solution to the problem of the border, the "cut-off" corners, is taken up in *Red Spot II* (ill. 306), with a more varied richness of color. It is another typical, unbalanced work of the transition from the Russian period (already with a high degree of geometrical content) to the Bauhaus period (with clearer execution of basic geometrical forms and colors). The variegated-gray corners are reminiscent of the color application of his earlier years. The white "picture within a picture" added diagonally contains almost exclusively geometrical forms, by way of contrast. Only the largest of these appear to have been colored with any particular

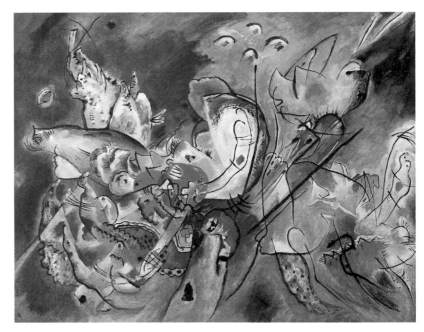

301 Overcast, *1917*
Oil on canvas, 41⅜ x 52¾ in
State Russian Museum, St. Petersburg

302 Black Line, *1920*
(Cherny strich)
Oil on canvas, 22⁷⁄₁₆ x 27⅞ in
State Museum of Fine Arts,
Tbilisi, Republic of Georgia

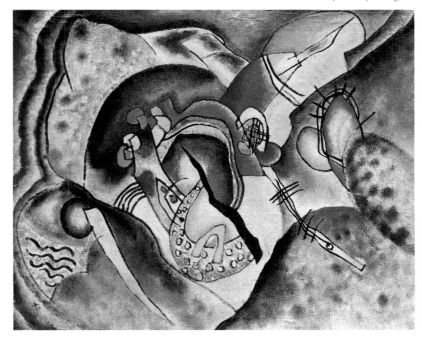

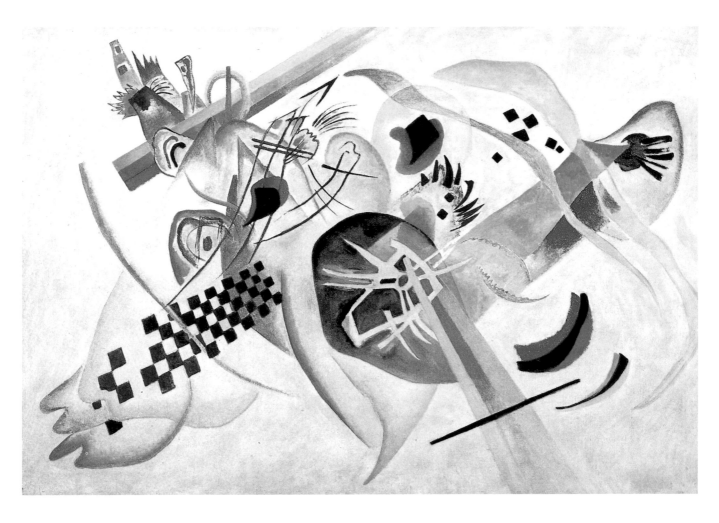

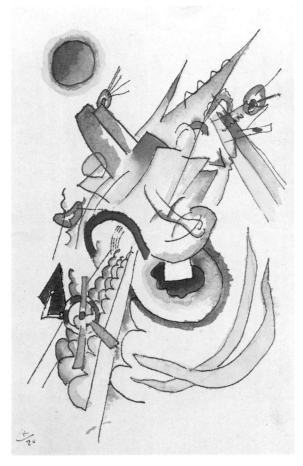

303 On White I, 1920
Oil on canvas, 37⅜ x 64⅜ in
State Russian Museum, St. Petersburg

304 Untitled, 1920
Watercolor and India ink,
6¹⁵⁄₁₆ x 4⁷⁄₁₆ in
Private Collection

305 *Exhibition Room Kandinsky,*
Moscow 1920
Gabriele Münter- und Johannes Eichner-Stiftung, Munich

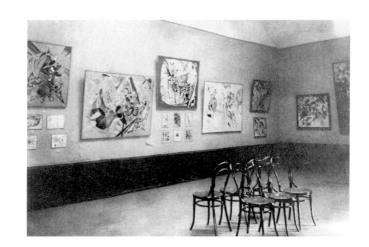

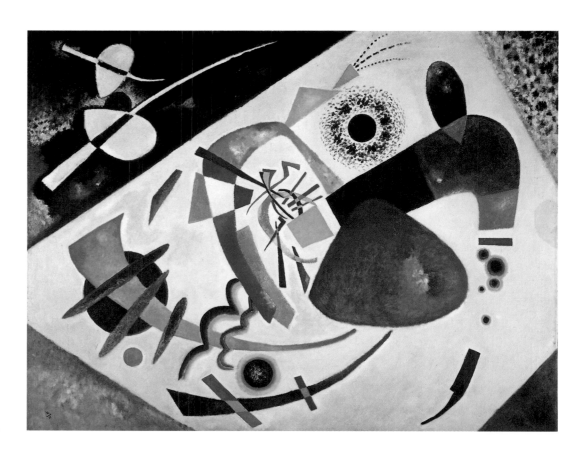

306 Red Spot II, *1921*
Oil on canvas, 53 15/16 x 71 5/8 in
Städtische Galerie im Lenbachhaus, Munich

caution. As yet, there are no clear, undifferentiated color areas as there were to be later on; instead they are grainy or transformed by other color tones.

Two large arch or yoke shapes give the picture definition: on the right the triangular arch split into different colored sections, and in the center the semicircular red arch shape, enclosing a few small, pointed forms, which might still be interpreted, if necessary, as the horse (or hobby horse), and the oar motif with two and three oars coming from a semicircular "boat." From the red spot that gives the work its title two long "trumpet forms" point to the left. One of these is even colored metallic yellow. Both lend the picture as a whole a harmonious border toward the left. Recognition is not important, but it might ward off misinterpretations. The trumpet form, as used by Kandinsky in many "angels of the Last Judgment," points clearly in a particular direction. Its shape can be just as easily interpreted in this picture as a "horn." But this might be a problematic interpretation, because it would invert the direction of movement, making the two "horns" point into the red spot instead of away from it. One art historian obviously less well-acquainted with Kandinsky's imagery interprets them as "horns" in one of those

volumes which happily can be bought by all young people (so that the next generation of scholars will accept the "horn-shape" as proven, because "it's there in black and white").[413]

But if there was any invasion by the content of Kandinsky's "figures," still derived from actual objects, into the content of his geometrical period, just how long and to what extent did this go on? There is still considerable doubt surrounding this interesting issue. The author would not like to suggest that the two "trumpets" here have anything to do with the "Last Judgment" and the loud "heralding of doom." But even if he was not aware of it himself, the artist always retained the inner logic of his motifs (see p. 208). Here, for instance, the direction is vital to the composition of the picture; the opening up of the forms toward the left is the exact opposite of the aggressive movement to the right which would result in a collision with the red spot. This is clear *solely* from the picture's composition. (Several colleagues and non-specialists share the author's point of view.) Research into motifs can be helpful at times; here an interpretation that, with the help of "horns," reads into the picture an aggressive element not put there by the artist would be a distortion of the facts.

CHAPTER THREE
ACTION

In 1915 Kandinsky recorded not one single oil painting in his "private catalogue!" And very few works are listed in the years following this until he left the country in 1921. He submitted older, as well as smaller, new works to the important exhibition "The Year 1915" with Malevich and Tatlin. The period after the October Revolution left him little time for painting; he and others were working with great hope and enthusiasm to advance liberal measures in official artistic policy. But he did not assume the position of authority or spokesman that his age and experience might have entitled him to. There has been a tendency to exaggerate this, for example by Will Grohmann, Nina Kandinsky, and French critics in general. Kandinsky remained something of an outsider; his underlying "romantic" tendencies were increasingly considered out-of-date. (He was to have the same problem in a milder form later at the Bauhaus, in the face of a predominantly "left-wing," younger majority.)

When the Minister for Culture, Lunacharsky, set up the "Department of Fine Arts" (IZO) under the "People's Commissariat for Enlightenment" (NARKOMPROS) in 1918, he gave Tatlin the task of recruiting Kandinsky as a member. On condition that he would not have to join the Party or have anything further to do with politics, Kandinsky agreed to join. He was made a professor at the VKHUTEMAS (Higher Technical-Artistic Studios) in the same year, and at Moscow University in 1920. A former friend of his, Dmitri Kardovsky, angrily protested that he could not even draw properly (see p. 40). On the other hand, Konstantin Umansky acknowledged him as the only teacher of any value at the VKHUTEMAS, one who did not use his authority to influence young painters, but qualified this by adding: "It's doubtful whether Kandinsky is able to exercize any attraction as an artist and teacher over those young Russian students whose sympathies lie with radical materialist manifestations or (more rarely) with pseudo-abstract movements (like Suprematism or abstract art)."[414]

Most importantly, however, Kandinsky was one of the founders of INKHUK (Institute of Artistic Culture) in 1920. He became director of the physico-psychological department of the Academy of Sciences in 1921, after serving as vice-president (according to Nina he was barred from the post of president for Party reasons).[415]

As part of one of the most important programs implementing the revolutionary cultural policies, Kandinsky founded the "Museum of Artistic Culture" in Moscow, together with 22 regional museums along the same lines in Vitebsk, Perm, Astrakhan, Barnaul, Ufa, etc. He furnished them with paintings from as many periods as possible, with representative examples illustrating every artistic innovation, regardless of his personal preferences. One of these is of course abstract painting, and he selected works by colleagues as well as by himself for the new

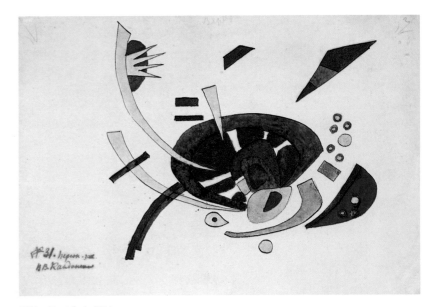

307 Untitled, *1921*
Watercolor and India ink, 7⅝ x 11⅛ in
Private Collection

museums. This is undoubtedly his most important contribution to early Soviet artistic policies. He perceived the new "a-historical" organization of museums as a sign of freedom and generosity: "In this respect, Russia offers an example of municipal museum organization such as has never been seen before. The exemplary achievement in the museum sector, realized by the IZO NARKOMPROS, comprises the principle of the 'Museum of Artistic Culture' and the complete liberty offered to each innovator in art to demand civil recognition, aid, and adequate support."[416]

Characteristically, he defended absolute art against "right-wing" as well as "left-wing radical" factions. From the end of 1918 onward, he strove to lead Russia out of the cultural isolation that had shrouded it since 1915 by making contacts with the German artistic scene (through the international committee of IZO).[417]

A year after his return to Russia he resurrected his old plans for the Russian edition of *Reminiscences* which Angert and Schor had failed to publish. The latter were musicians, unlike Piper who was a professional publisher, and Kandinsky praised this fact in his letters to Münter, Kubin, and Marc. But by the end of December 1915 nothing had come of this new plan either: "I've finally managed to get through to Angert by phone and in a few days we (he, myself, and Schor) are going to meet to discuss publication of my books."[418]

With the founding of the state publishing house (of IZO NARKOMPROS), the Russian edition of *Reminiscences* was finally published in 1918. Kandinsky called it *Steps*, selecting 25 reproductions starting with *Old Town II* of 1902 (ill. 73) and including *Composition VI* (in color, ill. 242), and his most recent watercolors, such as one he had

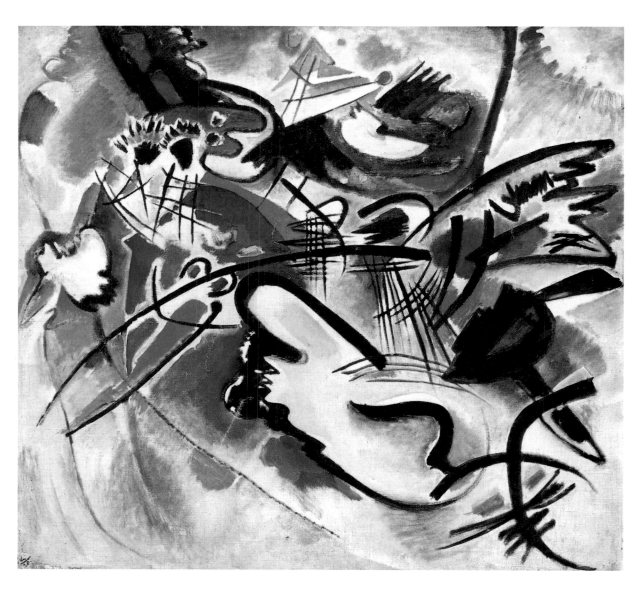

308 Sketch, *1920*
Oil on canvas, 38 3/16 x 42 1/2 in
Uzbekistan State Museum
of Fina Arts, Tashkent

painted in 1916 after a telephone conversation with Nina, calling it *To a Voice*. He revised the text slightly, emphasizing aspects more of interest to a Russian audience and deleting some details present in the German edition of 1913, including allusions to Christianity. One cannot accuse him of doing this as a concession to the new régime, since European thought in general from 1910 onward to the twenties had taken a turn toward functional criticism (comparable to the shift from Jugendstil to functional geometry in art). Furthermore, Kandinsky added two "non-conformist" statements in 1918, one on the positive role of country priests as "selfless creators of the future Russia," which compensate for several deletions.[419] At the end of the new edition, he added that, before the outbreak of the world war, he had become acquainted with young

representatives of the "unofficial" Germany, as well as of other countries, who were very strongly attracted to Russia. This must have been in connection with his peace initiative (see Part IV, Chapter 7). From this he drew hope that "the borders between nations are gradually disappearing. Soon 'Mankind' will no longer be an empty word."

Concurrently with these professional activities, Kandinsky enjoyed his new love. He married at the beginning of 1917, and became father of a son, Vsevolod, in the fall. His young wife Nina was in charge of finding food during the lean periods to supplement their pitifully inadequate "academic rations." She also acted as her husband's secretary. Their son died from gastro-enteritis before reaching his third birthday – surely a terrible blow to the parents, who kept their grief to themselves.[420]

309 Madonna and Child, *ca 1917*
Watercolor, gouache, and India ink
(Study for a Painting on Glass)
8⅜ x 7½ in
Private Collection

In 1920 Kandinsky painted a few "dreadful" pictures, for example *Sketch* (ill. 308), whose starkly contrasting colors, dominated by the black, have a coarse and jarring effect. Even the lyrical, pastel-like, "empty" bottom left corner, familiar from his earlier pictures, above which a couple has been painted reclining diagonally toward the centre, cannot mitigate the catastrophic atmosphere. Kandinsky exhibited this picture in October 1920 with 53 other pictures in Moscow before it was sent to the Tashkent museum. It then went "missing" until 1989; in Roethel's catalogue of works it is represented only by an old black-and-white photograph.

Despite his private grief, Kandinsky had to get on with his professional activities. In addition to his short essays on point and line and the abstract synthesis on the stage, he

wrote on the "Great Utopia" and a few treatises on art and politics. His statements from this period come across to Kandinsky experts as a fairly unattractive "legalese," weighted down with nominal phrases and pedantic detail, quite unlike his earlier German style. Kandinsky was after all a Russian lawyer and had mastered this style as a student, when he wrote his first legal essay in 1889 (see p. 31). His own translation of *Reminiscences* into Russian is linguistically far less original and lively than that of the first German edition.[421] The following lecture, given on June 2, 1920 and preserved in manuscript form in a private Moscow archive, seems to be the basis of all the theses he eventually put forward in 1926 in *Point and Line to Plane*. Compared with his earlier writings, one cannot miss the dry, factual tone here.

> Basic Elements of Painting. What They Are and What They Mean. (A Short Explanation of the Theory of Form in Painting.)
> The basic elements of expression in painting are the two elements of form in painting: 1. Volume, 2. Form. The volume of most relevance to painting is the plane, i.e., a two-dimensional form. Treating the plane in a certain way creates the illusion of volume. Thus one can call such volume illusionist. On the other hand, it is almost unavoidable in the colored form. The illusionist third dimension cannot be measured exactly and so has to be called an unreal dimension. These two aspects of space – plane and volume – determine the *graphic form* of painting.

Then Kandinsky goes into detail on the subject of points, lines, and geometrical forms, introducing the interesting question of the picture plane. Top and bottom are associated with heaven and earth, with the result that the top is always considered to be "lighter."

> Right and left are also fundamentally different, though without suggesting any particular associations. The movement from center to right is the tendency toward calm or homecoming. That from center to left is toward far-off places, or away from calm. In the first case, the mood is one of "being at home," being encircled, or behind locked doors. [. . .] On the left the doors are open, leading to the "unknown." Forms making their way toward the left are not impeded in any way, in fact their position seems to support their striving. But forms going toward the right encounter increasing resistance as they approach the right-hand side.

[Consider Elijah's "troika" mentioned above, heading toward the left "with no resistance" into "unknown territory."]

Then Kandinsky returns to the correlation between color and sound that he had discussed in *On the Spiritual*.

310 *Kandinsky with his Son Vsevolod, ca 1918*
Photo: State Tretiakov Gallery, Moscow

311 *Kandinsky with Colleagues*
of NARKOMPROS, Dept. of the Synthesis of the Arts:
From left: Shor (violonist), Robert Falk (painter),
Kandinsky, Alexander Shenshin (composer),
Pavlov (choreographer), Peter Uzbenski (physicist).
Photo: State Tretiakov Gallery, Moscow

Color	Instrument
Yellow	Trombone – high, clear tone
Mid-blue	Flute
Dark blue	Cello
Midnight blue	Double bass, organ – low notes
Mid-green	Violin – quiet, longer, and more middle of range
Yellow-green	Violin – quiet, higher notes
Blue-green	Alto violin with mute
Saturn red	Fanfare – strong, direct sound
Vermilion	Trombone, drum – strong beats
Cold red	Cello – mid- and low-range
Orange	Alto (voice and instrument), bell (mid-range)
Violet	Cor anglais
Indigo	Oboe, bassoon – low notes[422]

From today's perspective one might consider such ideas rather naïve. Surely by the twenties they had already been superseded? In fact, the whole issue was still unclear. Kandinsky was in charge of the department set up specially to investigate "monumental art" (i.e., to examine the synthesis of the arts). He wanted to be scientific in his study of creativity and intuition, and to produce explanations comprehensible to everyone. There were individual artistic areas and their interrelation with each other to be researched, as well as the principles of construction of various art forms. Kandinsky had committed himself to *construction* in art as early as 1911 (a fact which is often overlooked), in contrast, for example to Arnold Schönberg, who based his ideas principally on *intuition*.[423] He was convinced that his earlier dreams could at last be realized in Soviet Russia. To this end, he produced a comprehensive questionnaire:

1. Which art form do you find affects you the most? Which has the strongest appeal to your emotions?
2. What is it about this art form that affects you?
3. Have you ever asked yourself to what extent the means of expression of art as such might have an effect on the psyche (for example, color in painting, tone in music, etc.)?

 [There follow increasingly detailed questions on drawing, including technical drawing.]

 Do you think you could express any of your feelings graphically, for example using any kind of straight or curved line, any kind of geometric form, or any kind of surface sketch, or even a whole combination of lines, planes, and spots (black and white)?

 [Kandinsky goes on at length about the effect of geometric elements, then about colors with instructions on various (time-consuming) exercizes.]

9. Mix the primary colors together in order. Add blue to a yellow spot, for example, or yellow to a red, etc. Take note of what happens. Now paint splotches of an irregular shape, now more geometric forms, free but

precise. Try to describe the result with any means at your disposal, use all the parallels you can think of. [The entire questionnaire fills four pages; it ends with a reference to Kandinsky's well-known interest in the synthesis of the arts:] Since this questionnaire on painting will be followed by others on the other art forms, there may be the possibility of deducing some sort of connection between the rules of painting and those of music, sculpture, poetry, architecture, dance, etc.[424]

Besides the general effect of artistic means of expression on the human psyche, Kandinsky was clearly interested in comparing the effect of geometric forms with that of a picture's less rigid components. If they were different, he wanted to know in what way they were different. He wanted to collect empirical data through extensive field research, in order to deduce general laws for the effects of color and sound. He did not quite succeed, partly because he left Russia at the end of 1921, partly because the interest of his colleagues in the subject began to wane. The musicologist Leonid Sabaneev – the same "Sabaneiev" whose essay on Scriabin Kandinsky had included in the *Blaue Reiter* – continued to work from Kandinsky's initial research for a few years. Parallel to this research was the work being carried out in Leningrad at the time by the musician-painter Mikhail Matiushin, the composer of the "first Futurist opera," *Victory over the Sun*, in 1913, for which Malevich had designed the décor and costumes and Alexei Kruchenikh had written the libretto. Matiushin, as already mentioned, had worked on a theory of "further division of tones" immediately after Nikolai Kulbin between 1910 and 1915 and had invented a quarter-tone violin.

Kandinsky the painter was becoming "geometric," Kandinsky the theorist was becoming increasingly rational and down-to-earth. What was the fundamentally new content of his theory? From what we know about his theoretical work, it does not look as if he had developed many new ideas during the time that he was experimenting with his innovatory painting techniques. His essay "On the Artist" for the catalogue of his Swedish show in 1916 concentrates on the familiar theme of the "virtuoso" and "original" artist (which is really just a variation on the "content/form" theme). His 1919 essay "On Synthesis on the Stage" does not contain any substantially new material compared to his essay "On Stage Composition" of 1911. His lecture "On Practical Methods for Synthetic Art" at the Russian Academy of Artistic Sciences in the summer of 1921 begins with historical references: "By synthetic art we understand a work of art that has been produced with the help of various artistic media. The concept of 'monumental art' can be traced back to Richard Wagner. It means a work that, ideally, involves all the arts." This too is merely an elaboration of what Kandinsky had begun in 1900. Thus, rather surprisingly, there is an absence of any

basic, new theories or lines of thought in the published writings of the artist's Moscow period from 1915 to 1921.

Kandinsky's "students" at the VKHUTEMAS studios included Sergei Nikritin, Konstantin Vialov, and Kliment Redko.[425] Kandinsky left the INKHUK in 1921 with several like-minded colleagues, such as Alexander Shenshin. Two years later this was reported as:

a fundamental difference of opinion appeared between Kandinsky and some of the members of the Institute. Kandinsky's psychologizing deviated drastically from the opinions of those who advocated the material, self-sufficient "object" as the basis of creation. Kandinsky dropped out, and Rodchenko, Stepanova, Babichev, and Briusova took over leadership.[426]

It was the next generation's turn – Alexander Rodchenko and his wife (who had studied at Kandinsky's studio), the sculptor Babichev, and the musicologist Nadezhda Briusova.

But meanwhile Kandinsky had discovered another composer, Alexander Shenshin, who shared his ideas. In 1921, he wrote enthusiastically about Shenshin's "scientific" proof of the correspondence between art and music, claiming that it had been demonstrated by a mathematically calculated correlation between a Michelangelo sculpture and a composition on the same theme by Franz Liszt.[427] Kandinsky's life-long preoccupation with the "synthesis of the arts" and the "common denominator" of different art forms was characterized by his persistent quest for precision and measurability. He now threw himself into this empirical research. He had known since his "Lohengrin experience" (pp. 37 f.) that highly sensitive people like himself could unconsciously translate a musical impression into a visual one, but how could such subjective experiences be measured precisely? Presumably, if one was able to photograph a visual image produced by Wagner's music, thus capturing it in a *clearly defined* form, as Annie Besant and C. W. Leadbeater had done, in Kandinsky's view this could perhaps be well worth further investigation. Even reputable scientists testify that such experiments are well-founded, he wrote in *On the Spiritual in Art*.[428] Sixten Ringbom misinterprets Kandinsky when he dismisses his idea of precision. Kandinsky meant that a published photographic image is a more precise manifestation than a subjective impression. He wanted to present the Theosophist achievement briefly and *statistically* in the *Blaue Reiter*.

From the modern vantage point it is all too easy to forget that "non-scientists" in those days were not able to assess such "discoveries" in the light of scientific breakthroughs like X-rays. There was far more interest in radiography, which was given wide coverage in Russian journals at the turn of the century, than for example in the invention of cinematography. Making pictures move seems less of an achievement than shining something

through people to see through them.[429] Which seems more like voodoo: mental photographs, film, radiography, or the results of measuring the correlation between music and painting? Between 1910 and 1920, most people would have said it was radiography, which we now take for granted as a highly scientific, medical achievement.

Kandinsky probably continued work on his 1914 "pre-Dadaist" stage composition *Violet* during his last months in Moscow. Pencil comments in smaller writing have been added to the original manuscript, which is in ink.[430] They are in Russian, but of course this does not prove that they were written in Russia rather than later in Germany. Their content seems more in keeping with the artist's preoccupation during the "Bauhaus period" as well. We know at any rate that he resumed work on this theater project in 1926. The main subject matter is the interplay between abstract-geometrical forms. To supplement his new "geometrical" painting with a temporal dimension, he conceived the notion of projecting onto a screen and viewing it as a film sequence:

Entracte (before Scene III)

Darkness (5 [seconds]). A tiny red dot appears in the top right-hand corner. Slowly it begins to glow and grow. A white beam comes toward it from the bottom left corner. RED goes toward the center and becomes a large circle. WHITE takes refuge from it overhead. A light blue oval is seen lying at bottom right. A dented yellow circle appears in the middle of the red, disappears quickly upward and huddles in the right-hand corner. This happens three times. The pale blue oval turns green and revolves slowly around RED
WHITE falls down, dragging YELLOW with it. RED shrinks a little and its edge turns blue. Several colored patches in different shapes light up suddenly around the center. The blue border is framed by a bright yellow one. Sudden darkness (3 [seconds]).
The red patch in the top right-hand corner rushes to the center. The action with the white beam is repeated very fast. Darkness (3).
The red spot is in the center. It expands quickly and covers the whole surface.
Trumpets and drums: Tara-tara-tara! Boom! - Darkness.

Apotheosis [finale of the stage play *Violet*]

In the center of a BLUE background, roughly outlined in yellow, a small red spot appears. WHITE strands come reaching down toward it from the corners. A BRIGHT GREEN oval chases around in all directions on the blue backdrop, but cannot reach the red spot. The nearer to RED it gets, the harder it becomes; as soon as it comes close to it, it bounces off at top speed. Then it chases around again excitedly on the blue background.

The white strands quiver and retreat toward the corners. Once they have gathered more strength, they move gradually toward the red dot again. This is repeated several times. Each time the red dot quivers, expanding or contracting at random.
Then a VIOLET patch shaped like a lop-sided "8" emerges from the bottom right-hand corner. It moves cautiously along the edge of the blue backdrop, going along the bottom, sideways and upward, then across in an elliptical arc.
The smaller the oval is, the faster its movements. The "8" circles absent-mindedly around the red spot, faster and faster, coming closer and closer.
The green oval sits and waits in the top left corner.
The "8" bumps into the red spot. The blue backdrop is shattered by a tremendous crash and explosion.
The blue has disappeared. The backdrop glows red and vibrates.
The green oval has disappeared, and so have the white strands. (Backstage) MEN (in chorus): Look, look, look! Look at the rrrrr-e-e-e-ed (vowel sound drops glissando into lower register and fades away).
WOMEN (sostenuto): It is not caving into infi-i-nity (high-pitched) Blu-u-u-ue.
The center of the backdrop turns dull. Slowly a black triangle appears. Its top point gradually tips to the right. The tempo increases. The whole picture revolves like a wheel from right to left. The sound of increasingly rapid cracks of a whip. The turning motion gets faster and faster. (A shot [has been crossed out]). Darkness and silence. – Curtain.[431]

A few months before leaving Russia, Kandinsky expressed in an interview his disappointment over the change in the artistic climate since 1917: art was ultimately being reduced to a kind of "laboratory." He himself attached equal weight to the "what" and the "how," but artists in Moscow were only concerned with the "how" (i.e., the externals of painting). They were painting white on white and black on black. All the young painters considered artistic intuition to be unnecessary, even dangerous. They were pursuing the materialist point of view to the limits of absurdity, in the belief that art without a usefulness is bourgeois. Strangely enough, he himself had been the first to paint cups and saucers. The state was paying the same hourly wage to every painter; this system inevitably advantaged the mediocre.[432]

Kandinsky was officially invited to the Weimar Bauhaus. But first the artist wanted to complete a few important projects at the Academy of Sciences (RAKHN). The opening ceremony eventually took place in October after extensive preparations. Petr Kogan was named president and Kandinsky vice-president. Then, toward the end of 1921, Kandinsky accepted the Bauhaus offer, thinking it was to be for a few years only (otherwise he would never have left 22 pictures behind, when he had no trouble taking

others with him). He had no intention of leaving Russia permanently.[433] He received official acknowledgment for his services to the new Soviet art, but basically the new régime was glad to be rid of him: he did not fit into the new order. In the same year the "new economic policy" was announced, and art was drafted into the service of propaganda, state ideology, and the production process. In the following year, abstract art was officially banned.

DOCUMENT

Berlin, November 16, 1922.

My Dear Doctor, [...] I am most grateful for your invitation. I should enjoy discussing all kinds of interesting and important matters with you. I have devoted these last few months in Moscow wholly to founding and setting up an "Academy of Artistic Sciences." Representatives of the art world work together here with those of the so-called exact sciences. Collaboration with Germany and Sweden seems most desirable – I should at least like to sow some seeds in these countries and set up some kind of mutual relations between these countries and Russia. Would you be interested in this?

(Vasily Kandinsky, letter to Dr. Poul Bjerre, Sweden [extract published here for the first time]; Kungliga Biblioteket, Stockholm; for reference to Bjerre, see p. 226.)

VI.

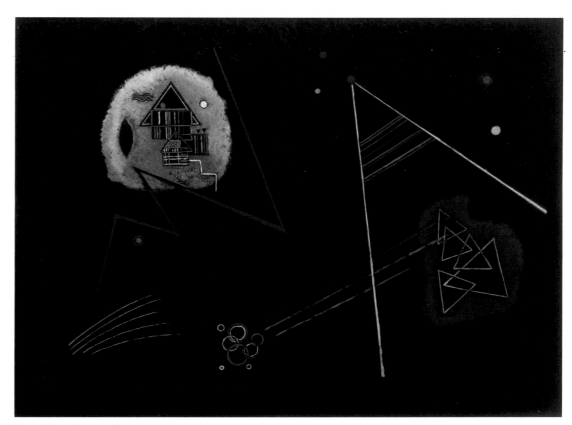

312 Three Places, *1928*
 Oil on canvas, 17 ½ x 23 ¼ in
 Private Collection
 (Location has been unknown for a long time)

VI THE BAUHAUS YEARS 1922–1933

CHAPTER ONE
THIRD FRESH START

Western scholars have always presented Kandinsky's departure from Moscow at the end of 1921 as a virtual flight from bondage. Russian art historians on the other hand state that Kandinsky was sent to Germany as an "ambassador" to continue his increasingly important policy of rapprochement between Russian and German artists (see p. 256). Both these versions are correct. Kandinsky went on receiving his salary from Moscow for three months after he left. However, the official chiefly involved in obtaining the mission to Germany for him was not Karl Radek, as Nina Kandinsky recalled, but the far-sighted critic and exceedingly well-educated bohemian from Vienna, Konstantin Umansky.[434]

A further, rather more personal reason for the artist's departure can be put forward now that Nina's death has removed any obstacle to mentioning their child who died in 1920; the couple probably wanted to escape from the scene of this memory.

Furthermore, the atmosphere in artistic circles in Russia had already begun to change by 1921. An artist known to have retained cultural attitudes from earlier bourgeois days had especially little room to manoeuvre in. As it happened, Kandinsky was branded a "formalist" and quickly all but forgotten.

Germany offered slightly more favorable conditions than Russia in the early twenties. There were no food shortages, as Nina was amazed to discover after moving to Berlin. On the other hand the economy was plagued with galloping inflation, thus Kandinsky's proceeds from the sale of almost 150 (!) pictures, realized by Herwarth Walden from 1914 onward, amounted to practically nothing. The artist probably approved of the fact that there had been a shift to the left in the political climate since he was last here, and that the tone of the cultural scene was set by the "November Group" and the "Workers' Art Counsel" (Arbeitsrat für Kunst).

In spring 1922 Kandinsky was given a one-man-show in Berlin, and another in Munich that summer. The artist took part in the first international exhibition after the war in Düsseldorf, even writing the foreword to the catalogue. The undiminished optimism of his words echoes the conclusion of the Russian edition of *Reminiscences*: "All the paths we have been taking alone up until now have become a single path, along which we are traveling together – whether we want to or not." He was able to exhibit in Stockholm again in October, and in the same month he participated (already as an "old leftie") one last time with the full circle of Russian artists in the large exhibition organized by NARKOMPROS at the Berlin Galerie van Diemen. In addition to Malevich (represented by his *White Square on a White Ground*), Constructivists like El Lissitzy, and the young "Production" painters, Chagall, Archipenko, the Gabo and Pevsner brothers, all recently

313 *ID-card of Bauhaus, Dessau*
Bauhaus Archives, Berlin

exiled, were also present. The show presented a comprehensive variety of movements. The young avant-garde painters unknown outside Russia aroused enormous interest.

In 1921, when Kandinsky was still living in Russia, events were beginning to take place in the still relatively provincial town of Weimar. Weimar's School of Arts and Crafts had flourished under the Belgian Jugendstil artist Henry van de Velde, who nominated as his successors August Endell, Hermann Obrist, and the architect Walter Gropius, the school's director after 1915. After the First World War the school was amalgamated with the School of Fine Arts and renamed the "State Bauhaus." An ambitious "school of form" was established on its premises. It was no art academy in the usual sense of that term, nor yet a school of painting. Gropius' first manifesto recalls some of Kandinsky's writings: it emphasizes the synthesis of the arts and attaches particular importance to architecture and the crafts as a solid foundation for every art field. It ends with the following appeal, which surpasses even Kandinsky's emotiveness: "Let us together desire, devise, and create the new construction of the future, molding everything in a single form. Architecture and sculpture and painting will one day tower up into heaven from the millions of hands of craftsmen as a crystal symbol of a new faith."[435]

Gropius shared Kandinsky's romantic belief in the future as well as a keen interest in synthesis. He appointed to the faculty Kandinsky's colleague from his Munich period, Paul Klee (along with Lyonel Feininger, Oskar Schlemmer, Georg Muche, Johannes Itten, Gerhard Marcks, and Lothar Schreyer), and, in the middle of 1922, Kandinsky. The latter found ideal conditions for work and development at the Bauhaus, where he was surrounded by gifted colleagues and interested, motivated students. His thoughts of returning to Moscow gradually faded and in 1927 he finally took German citizenship, thereby forfeiting his ownership rights to all the pictures he had left behind in Russia.[436]

His relationship with Paul Klee in particular deepened into a stimulating artistic friendship. The two artists gave each other pictures for their birthdays (ills. 314, 379). Their families got on well together; they even shared a semi-detached house later on in Dessau, and Klee's son Felix became Kandinsky's assistant (see p. 304). Kandinsky had already grown to like the artist thirteen years his junior in Munich and had included him in the Blaue Reiter. Now they were united by the common aim of systematizing artistic methods in theory and teaching, Klee in his *Pedagogical Sketchbook* of 1925 and Kandinsky in his *Point and Line to Plane* of 1926.

Both held the fundamental belief that a picture followed its own laws; both had long since ceased to regard a painting as a mere reproduction of something else. Both believed art to be inseparably linked with the higher laws of the cosmos. When Klee claims that art is cast "in the image of Creation,"[437] it could be Kandinsky speaking. The difference in their beginnings (Klee drew small-format, delicate pictures) makes it all the more interesting that their work came to be similar for a while during the Bauhaus period (ills. 315, 365, 366, 387). Since they were both highly individual artists and personalities in their own right, there was never any question of jealousy or competition between them, nor any fear of artistic dependency. Let us too forget about petty questions of influence and rejoice quite simply in the results of such a *mutually* fruitful relationship. Kandinsky and Klee have been exhibited together on numerous occasions, the first being an exemplary show organized by Magdalena Droste.[438] She stressed in particular the similarities of their theory of art and their views on life, such as their joint concern for overcoming the subjective "I" (the author believes this to be more relevant to Klee than to Kandinsky however). "I dissolve [...] into the cosmos and find myself then on the same brotherly level with the rest of the earthly community."[439]

This comment by Klee could also have been made by Kandinsky. However, the two artists' views about absolute abstraction did differ. Klee was more negative, and – as

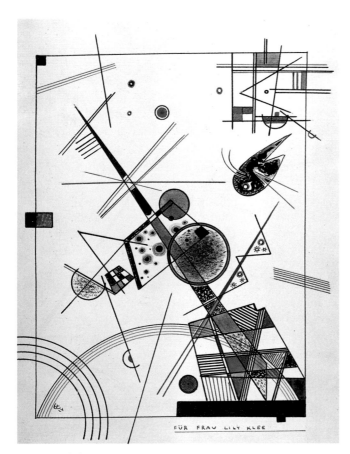

314 Untitled, *1924*
Watercolor, pen and ink, 9¹³⁄₁₆ x 7⅞ in
Private Collection

315 Glow, *1927*
Oil on canvas, 19⅞ x 13⅜ in
Courtesy Thomas Gallery, Munich

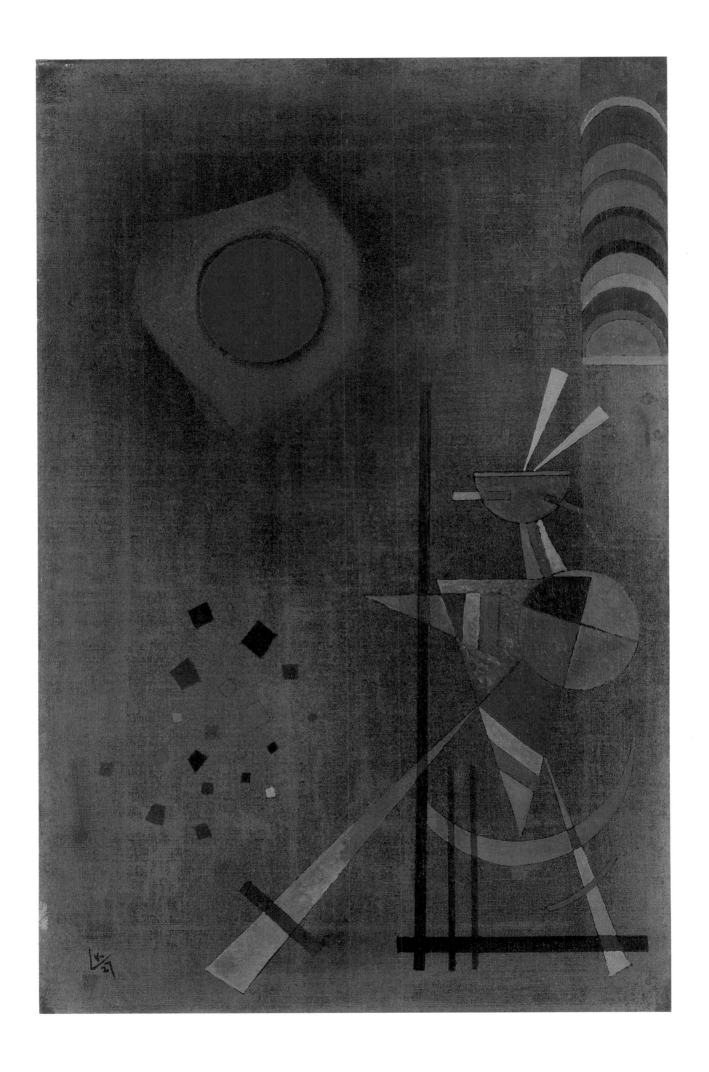

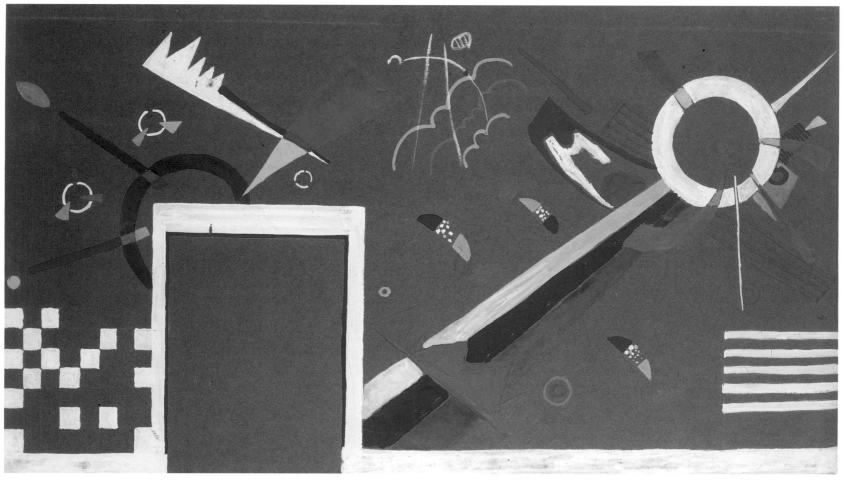

316 *Study for the* Mural Painting of the Juryfreie Kunstschau, *1922*
Gouache on black paper
Wall D, 13¾ x 23⅝ in
Musée national d'Art moderne
Centre Georges Pompidou, Paris

later developments in art history show – he may have been wrong: "The more horrible this world (as today, for instance), the more abstract our art, whereas a happy world brings forth an art of the here and now."[440]

One of Kandinsky's rare "here and now" pictures is *Glow* (ill. 315), with its clearly distinct figure. The title is not very informative, but in his private catalogues the entry "Galka Scheyer's Trip to America" suggests that he may have been inspired by Scheyer's mission to make him, Klee, Feininger, and Jawlensky famous in America (see p. 308). The merely suggested Indian headdress represents America; the decisive striding into the picture and the pilgrim's staff, the courageous project. The improbably bright sun does not just stand for its success, however, but lifts this small work above its strictly anecdotal dimension.

It is not unlikely that Kandinsky's naming of pictures was influenced by Klee's unusually rich imagination. Klee found the retrospective naming of pictures a happy science with a literary character of its own, whereas Kandinsky reiterated to Will Grohmann in 1928 what he had already said to Gabriele Münter in 1905:

People would rather I called "Veiled Green" something like "Primal Cosmic Energy," or "Several Circles" "Circles in Infinity!" My titles are supposed to make my pictures "trivial" and "boring." But I think pompous titles are ghastly. Normally every title is a necessary evil, because it limits instead of extending – just as the "object" does.[441]

In practice, though, his distaste for titles seems to have weakened somewhat during these years.

While his friendship with Klee was deepening, another of his friendships was breaking up. Scarcely had Kandinsky been accepted into the Bauhaus than he seemed to feel the absence of another friend, Arnold Schönberg, another creator interested in the synthesis of the arts – with whom he had shared a very stimulating exchange of ideas between 1911 and 1914. It must be remembered that at the beginning of 1911, during the "wild" period of dissolution of forms and "atonality," Kandinsky had insisted to his friend that artistic intuition alone was not sufficient; it had to be supplemented, he had declared, with an underlying

construction.[442] In the meantime the composer and the artist had embarked upon new paths: music on a twelve-note scale and calm, geometric painting. It was time for renewed discussion between them. Kandinsky did what he could to get Schönberg appointed to the Weimar School of Music. But his attempts failed, due in part to a terrible misunderstanding. The Jewish composer was alerted (by Gropius' wife Alma Mahler) to Kandinsky's supposed anti-Semitism. In fact the cosmopolitan Kandinsky, tolerant in all respects, had no such prejudices. His circle included a large number of Jewish friends. It must be admitted, however, that his letters show rather less sensitivity toward the problem of anti-Semitism, which was increasing dramatically in Germany during the twenties, than those of the composer who was more personally affected by it. After several inadequately formulated letters, the old friendship was broken off, to be renewed only years later.[443]

Another old friendship was becoming a source of trouble. Gabriele Münter refused to return the hundreds of pictures Kandinsky had left in Munich, as well as the rest of his possessions. He was obliged to enlist the help of a third party, and there ensued an ugly dispute that dragged on for years until Münter finally agreed in 1926 to relinquish his

personal effects (his books, his beloved racing bicycle, etc.) as well as a small number of his pictures. The others he never saw again. Long after his death, Münter bequeathed them to the Lenbach gallery in Munich. The artist thus remained cut off from this part of his lifework, as he was from the output he had left behind in Russia.

After building up his strength again for a few months in Berlin (and, as Nina reports, finally being able to buy himself a new pair of shoes),[444] Kandinsky moved to Weimar in the summer of 1922. He was assigned to teach the basic "theory of form" and the workshop on mural painting. Klee also taught the theory of form. Besides a compulsory course in the theory of the craft they were learning, students were supposed to be taught the basics of the theory of form and color, which were considered indispensable for future architects, designers, carpenters, and other artistic trades. Painting was introduced later as an optional subject. Kandinsky enjoyed mural painting with its obvious connection with architecture (see ill. 316 and manuscript – ill. 317). At last he had an opportunity to work on a project that would satisfy his old dream of letting the observer "stroll around within the picture!" He immediately set to work, together with his students, on a commission he had been given earlier in Berlin: a series of

317 *Exhibition Program of the Workshop for Mural Painting at the Bauhaus Exhibition, 1923 Kandinsky's Handwriting, 8 9/16 x 6 7/8 in Bauhaus-Archiv, Berlin*

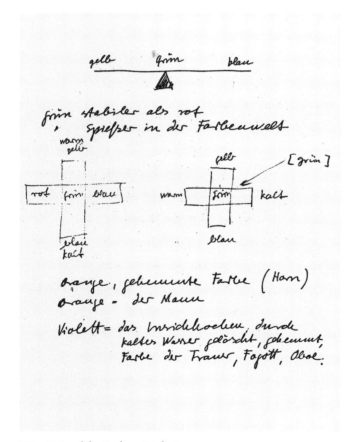

murals for the entrance hall of a museum being planned there (ill. 316). Their joint work was completed and exhibited, but no money was available to build the museum.

Times were hard, the faculty and students at the Bauhaus were poor as well – the former were only just able to make ends meet on their salary. But as during the early years immediately following the October Revolution in Russia, poverty was made bearable by the atmosphere of experimentation, enthusiasm for work, and friendly solidarity against the Weimar "petit bourgeois." Kandinsky rejected an offer to teach at the Tokyo Academy of Art. He was soon able to increase his earnings by giving paid lectures in various German cities. In 1925 the collector Otto Ralfs established the "Kandinsky Society," which earned the painter membership contributions of a couple of thousand Deutschmarks a year in return for an annual donation of one work. It was nonetheless a long time before he was able to travel extensively. In 1928 he went to Ostende to visit James Ensor; in 1930 he visited Ravenna, and the following year Egypt, Syria, and Turkey.

In Weimar Kandinsky was once more surrounded by young people, as he had been in the "Phalanx," the "New Artists' Association," the "Blaue Reiter," and in Moscow. This was how he liked things to be. His talent as a teacher was always much appreciated. His correspondence shows that students were constantly asking for advice and correction even outside his classes. He took his teaching at the Bauhaus very seriously; Nina records that he prepared his lessons every day. Teaching manuals did not exist. Notes (ill. 318) reveal what he taught, and how he taught it. We find variations on his old themes, reworked in a more sober fashion than fifteen years previously.

His students recall that he taught them not only to paint but also to *see* things. He showed them that every form in painting has a meaning. "I didn't find out what meaning they could have from Kandinsky, but by experimenting under his direction."[445] It is a particularly high tribute to him that such a variety of artists, some with a style utterly unlike his own, could study and develop under him. These include Josef Albers and Max Bill, who represent the opposite pole to Kandinsky in their painting technique as well as their politics. Another of his students, the great sculptor Hannes Neuner, states:

> Kandinsky could take criticism. He reacted to it like a mature person. He would reply patiently and impassively. He even answered dumb questions, and persisted until the questioner was happy. He didn't go as far as to let students correct him. Kandinsky wanted to talk with the students, whereas Klee was glad to get away to collect his thoughts. Kandinsky spread his work out in front of the students and discussed it with them. He explained why he had put red rather than green in a particular place."[446]

318 *Notes of the Bauhaus Student*
Söre Popitz: Color Experiments
Courtesy Eberhard Steneberg, Frankfurt

270

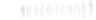

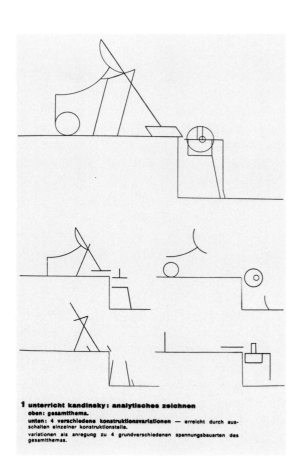

1 unterricht kandinsky: analytisches zeichnen
oben: gesamthema.
unten: 4 verschiedene konstruktionsvariationen — erreicht durch aus-
schalten einzelner konstruktionsteile.
variationen als anregung zu 4 grundverschiedenen spannungsbauarten des
gesamtthemas.

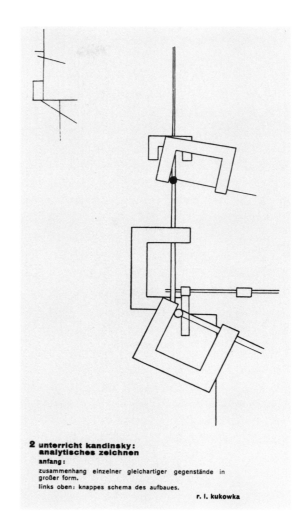

2 unterricht kandinsky:
analytisches zeichnen
anfang:
zusammenhang einzelner gleichartiger gegenstände in
großer form.
links oben: knappes schema des aufbaues.

r. i. kukowka

3 unterricht kandinsky:
analytisches zeichnen
dritte stufe:
gegenstände vollkommen in energiespannungen übersetzt,
komplizierte konstruktion mit verschiebungen in einzelnen
teilen. großer aufbau durch punktierte linien sichtbar.
links unten: schema.

fritz fiszmer

4 unterricht kandinsky:
analytisches zeichnen
zweite stufe:
gegenstände erkenntlich, hauptspannungen durch farbe,
wesentliche gewichte durch verstärkte linien bezeichnet,
ausgangspunkt des konstruktiven netzes.
links oben: knappes schema.

erich fritzsche

319 *Kandinsky's Teachings:*
Analytical Drawing (Variations of Constructions)
Bauhaus-Archiv, Berlin

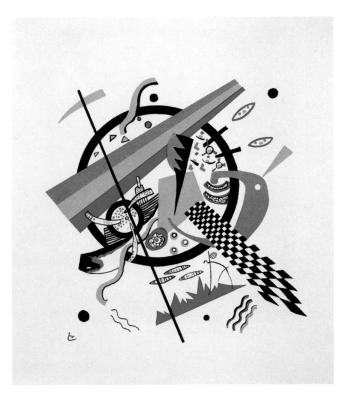

320 Small Worlds IV, *1922*
Color lithograph, 10½ x 10¹⁄₁₆ in
Städtische Galerie im Lenbachhaus, Munich

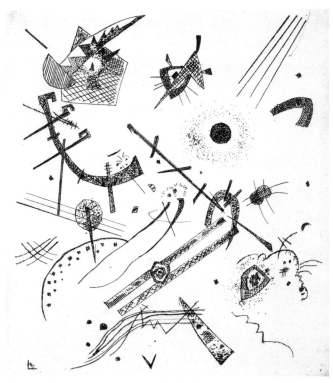

321 Small Worlds XI, *1922*
Etching, 9⅜ x 7⅞ in
Städtische Galerie im Lenbachhaus, Munich

Kandinsky disliked affected feelings, as his reaction to a "Japanese"-style screen, done by one of his students, shows: "Are you a Japanese, then?"[447] It was not by chance that Kandinsky's looks belied his age all through his life; ever youthful in spirit, he was always looking toward the future. He was more interested in creating new things and fighting against convention, than in staying in touch with longstanding old colleagues or "mentors."

The monumental mural commission was followed by a "tiny" one: to produce a small folder, *Small Worlds*. Kandinsky's poetic, precise introduction to the booklet is terse and factual. The booklet itself is a professionally executed work of art, hand-printed and compositionally self-contained.[448] The individual, extremely diverse graphics suggest rich dialogues with each other (ills. 320–322).

The "Small Worlds" sound forth from 12 pages.
4 of these pages were created with the aid of a stone,
4 – with that of wood,
4 – with that of copper.
$4 \times 3 = 12$
Three groups, three techniques.
Each technique was chosen for its appropriate character. The character of each technique plays an external role in helping to create 4 different "Small Worlds."
In 6 cases, the "Small Worlds" content themselves with black lines or black patches.
The remaining 6 require the sound of other colors as well.
$6 + 6 = 12$
In all 12 cases, each of the "Small Worlds" adopts, in line or patch, its own necessary language.
12.

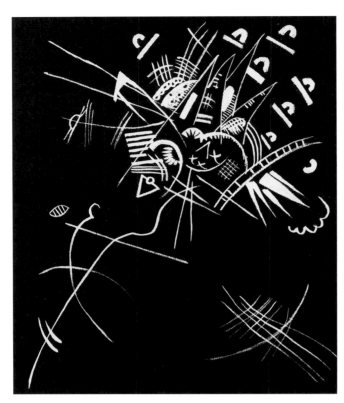

322　*Sketch for* Small Worlds VII, *1921*
Gouache on black paper,
12¹/₁₆ x 9¹³/₁₆ in
Private Collection

323　*Poster of a Bauhaus Exhibition, 1923*
Bauhaus-Archiv, Berlin

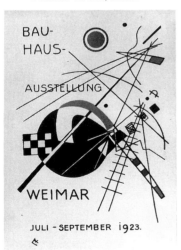

Small Worlds IV contains the chessboard motif from Kandinsky's Russian period, but this time unfolding to the right rather than to the left (lithographs are produced in reverse, like other printed works; ill. 320). The forms on *Small Worlds VII* resemble those of the mural paintings the artist was working on at the time. There are two "rider"-figures bottom left (the semi-circle of the line of their heads and backs; ill. 322). *Small Worlds XI* contains an echo of the well-known lovers, stretching from bottom left to the center (ill. 321). The most remarkable thing about the work is the exciting, abstract interplay of lines and forms, in keeping with the fundamental characteristics of graphic techniques Kandinsky had worked out in Russia and given definitive shape to in *Point and Line to Plane*:

> It is the nature of etching that the tiniest black point can be obtained with playful ease. A large, white point can, on the other hand, only come about as a result of considerable effort and various ruses. With woodcut, matters are quite the reverse: the tiniest white point needs but a prick, whereas a large black one demands effort and care. With lithograph, the path is equally smooth in both these cases. [...] Etching is certainly aristocratic by nature; it only gives a few good prints, which in any case turn out differently each time, so that every print is unique. Woodcut is more economical and evenly matched, however, it is only suitable for use with color under special circumstances. Lithograph, on the other hand, is capable of producing almost limitless numbers of prints at top speed in a purely mechanical way. Its ever more sophisticated use of color makes it almost as good as a hand-painted picture, or at least a reasonable substitute. Thus we can prove the truly democratic nature of the lithograph.[449]

Kandinsky's fundamental work *Point and Line to Plane* has captivated every artist and art historian since 1926. It is more factual and serious than *On the Spiritual in Art*, and he demands long hours of painstaking, "tedious" research from artists, in the fields of physics and chemistry as well: "Only by a process of microscopic analysis will the science of art lead to an all-embracing synthesis, which will ultimately extend beyond the boundaries of art into the realm of 'union' of the 'human' and the 'divine.'"[450]

The author begins by presenting detailed material in graphs, charts, and even equations, using natural phenomena such as lightning to illustrate lines, clusters of stars to illustrate collections of points, and "plants swimming by means of their 'tails' (flagella)." He then characteristically goes beyond the "material realm:" "To draw final conclusions from this material is the task of philosophy, and is synthetic work. This work will lead to revelations in the highest sense, in the internal – insofar as that is given to any age."[451]

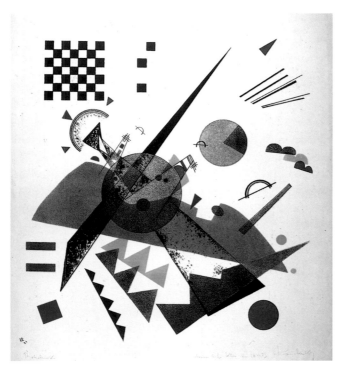

324 Orange, *1923*
·*Lithograph, 15 15⁄16 x 15 1⁄16 in*
Private Collection

The French philosopher and writer Professor Michel Henry has accomplished much the same in our day and age (see his essay p. 375). His book, which is based mainly on *Point and Line to Plane*, can be read by anyone who wishes to find out more concerning this subject.[452]

Kandinsky did not feel politically at home in Germany for very long. In 1924 he was falsely accused of being a Communist (see Documents below). He was not alone. The whole Bauhaus came under increasing attack from right-wing conservatives and was no longer welcome in Weimar. In December 1924 it transferred successfully to Dessau. However, internal disagreements began to appear as the Communists gained a majority among the students (and began to accuse their teachers, and Kandinsky among them, of "formalism"). Once more Kandinsky was forced to defend himself from both left and right. This of course does not mean that he can simply be dismissed as a "fence-sitter."

325 Drawing No. 11, *1923*
India ink, 8 11⁄16 x 9 13⁄16 in
Private Collection

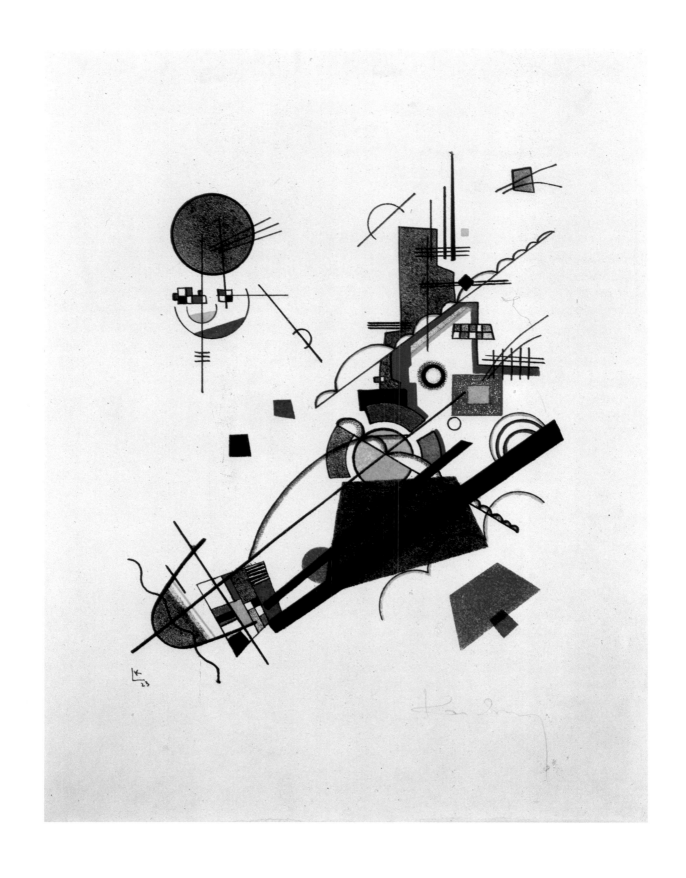

326 Happy Ascension, *1923*
Lithograph (artist's proof), 9 3/8 x 7 5/8 in
Private Collection

DOCUMENTS

Letters to Will Grohmann

August 11, 1924:

*If it were still possible, I should be delighted if you could
include the following, emphatic comment in your text: I
have absolutely no interest in politics, I am completely
apolitical and have never been involved in political
activities (I never read papers). This is important,
because I have been coming under the most scandalous
attacks here recently. Please get hold of issue 260 of the
Braunschweigische Landeszeitung (regional news-
paper). For once I have reacted. There I am, portrayed as
a dangerous Russian Communist, who "has been proven
to be an agitator" in charge of the Russian political
exhibition of art in Germany [reference to 1922 Galerie
van Diemen in Berlin, where he had exhibited work with
others]. Even in artistic matters I have never been
biased; the Blaue Reiter and the exhibitions of its
editorial team show this quite plainly. People shouldn't
be allowed to write such lies about me.*

(*Künstler schreiben an Will Grohmann*, Cologne 1968)

November 21, 1925:

*As a matter of fact, I should like people to see what is
behind my painting (for this is really the only thing I
care about; the so-called question of form has always
played a subordinate part with me, see the Bl.R.!!!) and
not content themselves with saying that I use triangles or
circles. I know that the future belongs to abstract art, and
I am distressed when other abstract artists fail to go
beyond questions of form. [...] By now, it should be clear
that for me form is only a means to an end, and that I
spend so much time on the theory of form because I want
to capture the inner secrets of form. [...] Once you
referred to "Romanticism" and I am glad you did. It is no
part of my program to paint with tears or to make people
cry, and I really don't care for sweets, but Romanticism
goes far, far, very far beyond tears. Today there is Neue
Sachlichkeit; why should there not be a (or the) New
Romanticism? I once set out to write about it ... [Kan-
dinsky contemplated writing a book on this "new"
Romanticism at some stage.]*

(Grohmann, *op. cit.*, 1958, p. 179.)

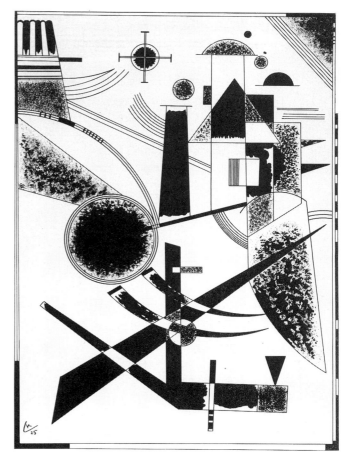

327 Lithograph No. III, *1925*
18 ¹³⁄₁₆ x 13 ⁵⁄₁₆ in
Bauhaus-Archiv, Berlin

328 Drawing No. 7, *1925*
India ink, 7 ⁷⁄₈ x 5 ¹⁵⁄₁₆ in
Private Collection

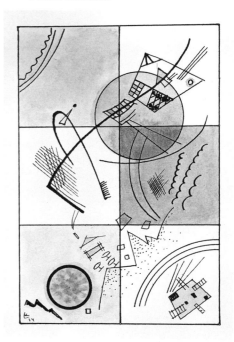

276

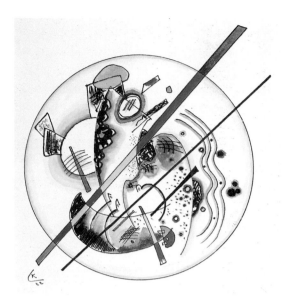

329　*In the Galston Guest Book, 1922*
Watercolor, 10⅞ x 7¼ in
Bauhaus-Archiv, Berlin

330　In the Happy Harbor, *1923*
Watercolor and India ink, 11⅛ x 8⁹⁄₁₆ in
Gmurzynska Gallery, Cologne

CHAPTER TWO
THE GEOMETRY OF FORMS

From the end of 1922 until January 1923 Kandinsky worked on the large square composition *Accented Corners* (ill. 331). Many different forms overlap each other in this work, and all the primary colors and shades join in the game, bold in the center and pastel toward the top left. The artist has paid particular attention to the picture's corners. As in the smaller picture he painted next, called *Diagonal*, the sweeping movement from bottom left to top right leads right into the corner with a long pointed shape (ill. 332). In the second picture, a rider can still be distinguished bottom left on the "street;" behind him there are two wheel shapes. What is more, the black rectangular form above the wheels could be said to be a coach. The most surprising feature of this picture, however, is its dynamism. The artist has created movement through his construction and the directions of the geometrical forms. Movement is just as apparent as in the Munich pictures, where it had been created with the aid of brushstrokes and the orientation of the color streaks. He is clearly more adept at expressing movement than the Italian Futurists, despite the fact that they made a virtual science of it.

In *Black Form* (ill. 333), not a well-known picture, the diagonal movement encounters decisive opposition from the truncated, almost empty corners. In addition to the form from which it gets its name, the picture is dominated by the large, – and uncharacteristic – green circle ("Green = the bourgeois of the color world," wrote Söre Popitz, one of his students, during one of his lectures; see ill. 318).

Kandinsky produced several variations of the same basic composition in 1922 and the following years. He also used watercolor, which had become increasingly important in his work after 1915, and was no longer used merely in studies for oil paintings, as in the artist's Munich days. Grohmann states that Kandinsky never simply transposed a composition from a watercolor to a larger oil painting as a merely mechanical enlargement.[453] Consider the faintly romantic watercolor that he painted in a guest book in 1922, composed as a circle (ill. 329). It is a bright, "personal" piece of work. At bottom left a row boat echoes the roundness of the circle; one can make out three people in it. The motif of the yellow-red oar is taken up again by the large slash cutting through the circle. Other small "personal" watercolors seem just as cheerful, and contain many more traces of objects, such as boats, a bird, or the well-known reclining couple, usually positioned in the left of the picture (ills. 330, 348). Nevertheless, it is obvious even here that Kandinsky was using a compass and ruler.

A year later Kandinsky enlarged his diagonal composition dramatically. *Through-going Line* (ill. 334) is a two-meter wide, purely geometrical composition, full of tension and harmony, complex and yet utterly clear. In contrast to his earlier pictures, even those produced in Russia before 1920, he daringly uses a very pale back-

277

331 Accented Corners *1923*
Oil on canvas, 51³⁄₁₆ x 51³⁄₁₆ in
Private Collection, Boston

332 Diagonal, *1923*
Oil on canvas, 27⁹⁄₁₆ x 22⁷⁄₈ in
Landesgalerie, Hanover

333 Black Form, *1923*
Oil on canvas, 43 5/16 x 38 3/16 in
Mr. and Mrs. Joseph Lauder, New York

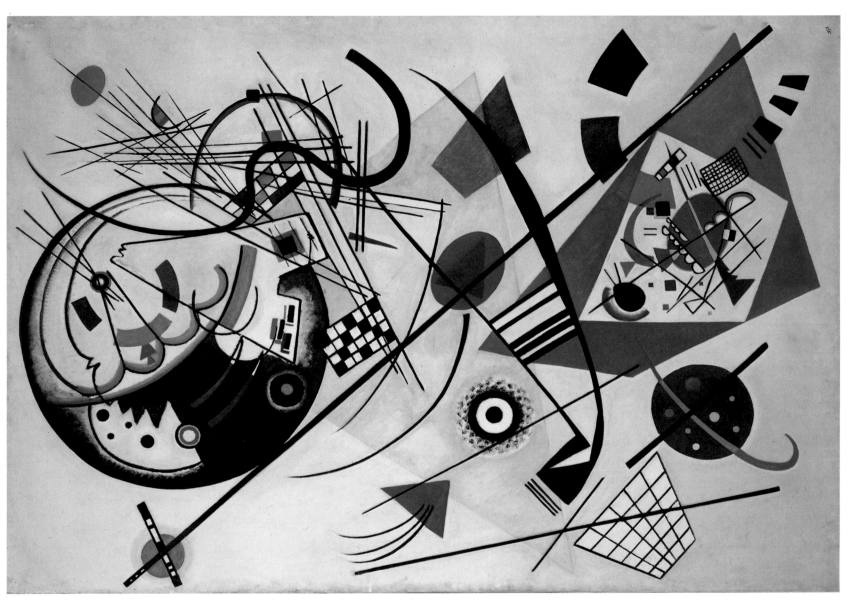

334 Through-going Line, *1923*
Oil on canvas, 45¼ x 78¾ in
Art Collection Nordrhein-Westfalen, Düsseldorf

ground with hardly any color differentiation, thus giving the picture a flat quality. This extensive renunciation of "space," particularly when large areas of the monochrome background are left untouched, was to become characteristic of his work from now on.

After Kandinsky painted *Compositions VI* and *VII* in 1913, ten years went by before he awarded this title of honor to another piece of work. According to Grohmann, he rated the enormous *Composition VIII* (ill. 335) as the highpoint of his post-war achievement.[454] This painting is distinguished by circles and angles drawn in fine, black lines on a light, delicate background color. The double circle top left comes as quite a surprise.

Such an emphasizing of the top left corner is typical of the compositional devices that Kandinsky often used in strong diagonal movements from bottom left to top right. In cases where he did not introduce a strong opposite motion, he filled the top left corner with calm, self-contained pictorial elements. However, he had never before used such an isolated form as here, dominating the picture from the depths of the corner in which it lurks. He thus increases the composition's tension almost to the point of disharmony. Without the circle, the nearly contrapuntal composition would be a harmonious balance of sharply pointed and round forms, triangles and circles, spiky forms and soft ones.

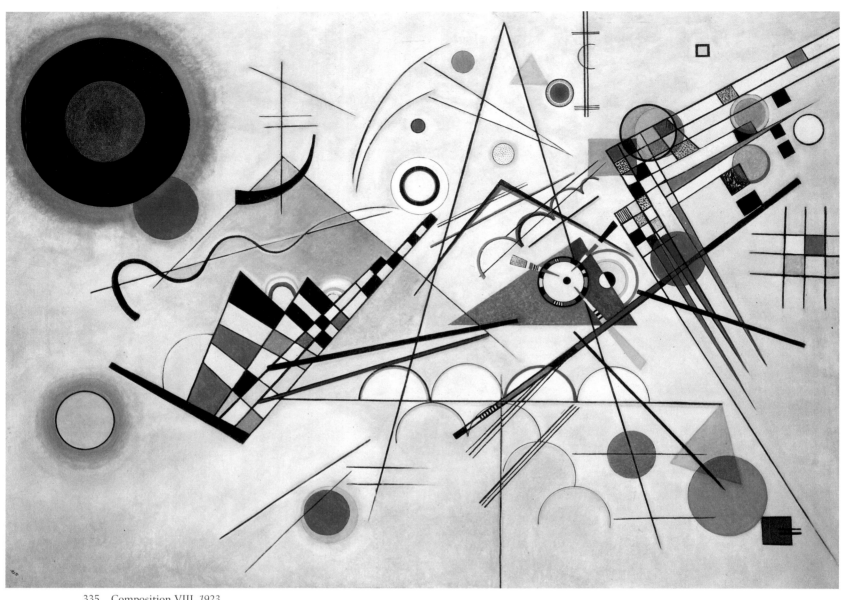

335 Composition VIII, *1923*
Oil on canvas, 55⅛ x 79⅛ in
The Solomon R. Guggenheim Museum, New York

336 Untitled, *1923*
Pencil, India ink, 10¹⁵/₁₆ x 14⅞ in
Musée national d'art moderne
Centre Georges Pompidou, Paris
Nina Kandinsky Bequest

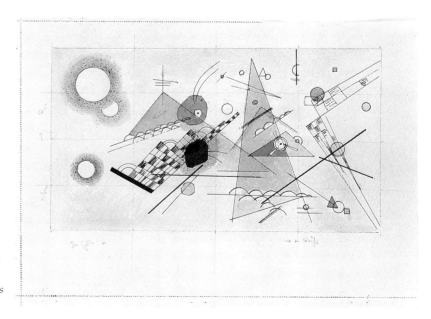

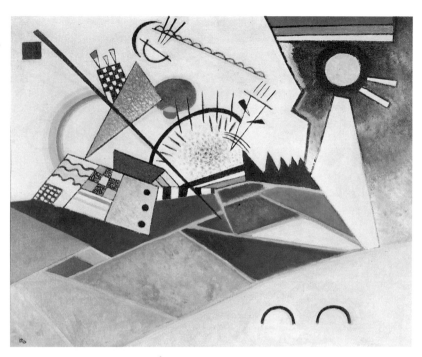

337 Animated Repose, 1923
Oil on canvas, 23⅛ x 27¾ in
Private Collection

338 In the Black Circle, 1923
Oil on canvas, 51³/₁₆ x 51³/₁₆ in
Adrien Maeght Collection, Paris

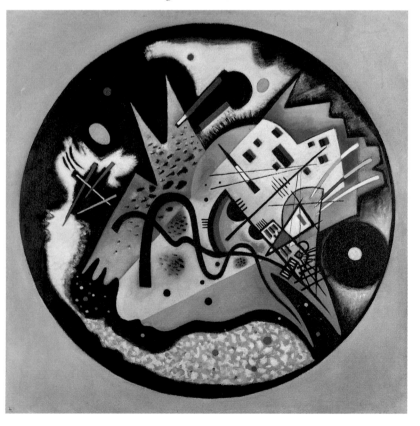

Several years later Kandinsky returned to the same problem in his treatise *Point and Line to Plane*. In the pencil sketch for *Composition VIII*, the circle dominates simply because of its size, while the dominant color is placed as an irregular dark patch left of center (ill. 336). Another irregular patch above this similarly disturbs the composition which otherwise consists solely of geometrical forms. He dispensed with these patches in the final version.[455]

From this point on, throughout his Bauhaus years, the artist favored small- to middle-sized formats. The small oil painting *Animated Repose* (ill. 337) is characterized by a sophisticated distribution of planes in the bottom right section of the composition (this is more often a feature of Paul Klee's work), creating an atmosphere of tranquility in spite of all the diagonals. The smaller individual forms concurrently create a joyful motion. Might it be significant, in view of the field-like arrangement in earth brown, to know if the artist had ever looked at the earth through the window of an aeroplane? Not really in Kandinsky's case, since he had plenty of imagination. More of interest is his innate sense of color, which he developed throughout his life. His daring juxtaposition of brown and violet in the large planes of this picture shows courage and creates additional tension.

In 1923 Kandinsky painted his first circle composition, *In the Black Circle* (ill. 338), which is thus of historical interest. One might have expected this to occur earlier, after all his rounded or "off the edge" compositions, or after his special treatment of the border since *Painting with White Border* of 1913. *In the Black Circle* is really three pictures in one. The active, colored forms are placed inside the black circle, which is in turn set inside the square, white picture. The black border, more strongly pronounced on the left side, counteracts any tendency toward the decorative, a danger that seems to threaten circle compositions in particular. *Composition VIII* was followed one year later by the purely geometrical *Circles within a Circle*. It was not until 1925 and 1926 that the artist started using oval-shaped frames for works of a more private nature: *Easter Eggs for Nina*, *Intimate Message*, *Whispered*, and so on.

Pink and Gray (ill. 339) is perhaps the most interesting, though least known, work of 1924. After Kandinsky himself selected it for his large touring exhibition, which began in Dresden in 1924 and traveled to Wiesbaden, Barmen, Bochum, and Düsseldorf, it was never shown again. He eventually gave it to his best friend, Thomas van Hartmann. The most remarkable thing about this picture is its borders: the wave-shaped incision top right, and the large dark shapes jutting in from the left and below. The delicate red point balancing on the cube at the bottom easily carries the whole "floating" diagonal composition of the other forms directed toward the center top. Their balanced harmony is set off against an extremely unusual color combination, as in the earlier picture. Here, the dominant pink of the large circle clashes not only with the red of the smaller shapes, but with the entire background.

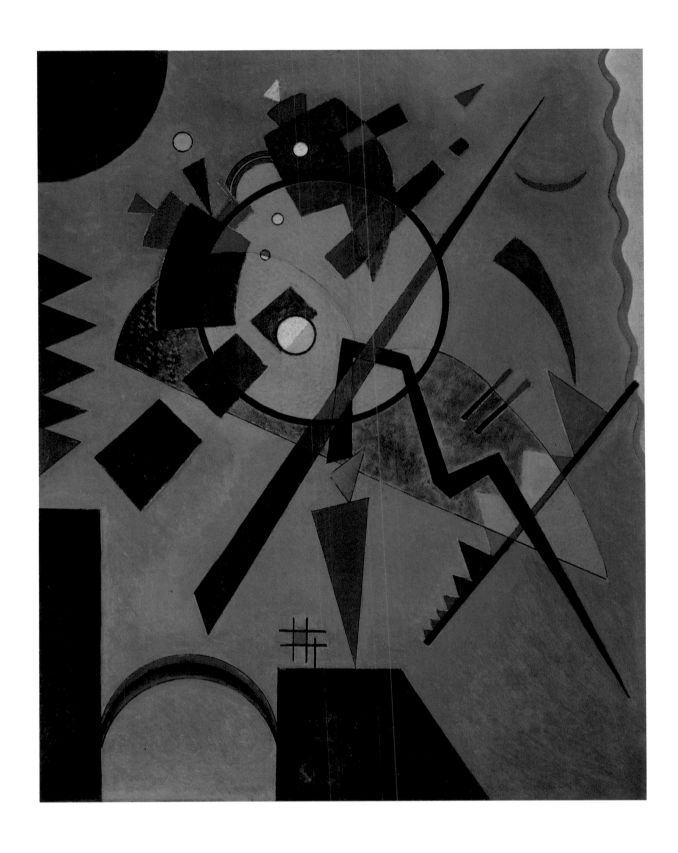

339 Pink and Gray *1924*
Oil on cardboard, 23⅜ x 19 1/16 in
Atkins Museum, Kansas City

Kandinsky was devoting more and more attention to the circle; it became his favorite form during his Bauhaus period. In *Several Circles* (ill. 342) he achieved his most significant, profound, and beautiful work, from the point of view of harmony. He was aware of this himself. Particularly worthy of note are the square format and the deep black, faintly modulated background. Kandinsky's comment on the latter was that he was "annihilating" the background so that it would look as if it had been pulled open, looking not only onto infinity, but also out to the observer. He wanted the forms to appear as if they were floating in space. *Several Circles* was the first of his Bauhaus pictures to be bought by a museum, the State Art Collection of Dresden (which nevertheless dismissed it as "degenerate" a few years later, in the same way that the Berlin National Gallery and other German museums all ended up storing or selling off their Kandinsky works).

There is a strong association with planets and stars in this and all the pictures of circles, especially those painted on dark backgrounds. The links between artistic creation and the "creation of the world," bound by the laws of nature, come easily to mind. Now it has been proven that

Kandinsky did indeed have an interest in astronomy, as was long suspected. One of his first extant pictures, *The Comet* of 1900 (ill. 89), is less important in this connection than the letters the artist sent to Münter from Odessa in September 1905. At that time, at Kandinsky's request, his family invited an astronomer to give regular demonstrations every evening at their home. The Kandinskys took turns looking through his telescope every fine evening, while the astronomer explained about the Pleiades, Saturn, the moon, and the constellations. On nights when the sky was overcast he lectured. Kandinsky learned a great deal from him, and his interest in astronomy never waned. He even planned at one time to set up a small private observatory in a tower of his six-story house in Moscow.

Conclusion (ill. 345), painted the same year as *Several Circles* and the less evocative *Closely Surrounded* (ill. 344), has a deeply meditative effect in the spirit of the East.

The artist's own comment on the circle as a compositional element was that it is: "1. the most modest form, but asserts itself unconditionally, 2. a precise but inexhaustible variable, 3. simultaneously stable and unstable, 4. simultaneously loud and soft, 5. a single tension that carries

340 Blue, *1927*
 Oil on cardboard, 19¹¹⁄₁₆ x 14⁹⁄₁₆ in
 Museum of Modern Art, New York
 Katharine S. Dreier Bequest

341 Yellow Circle, *1926*
 Oil on cardboard, 27⁹⁄₁₆ x 19¹¹⁄₁₆ in
 Photo: Beyeler Gallery, Basel
 Private Collection

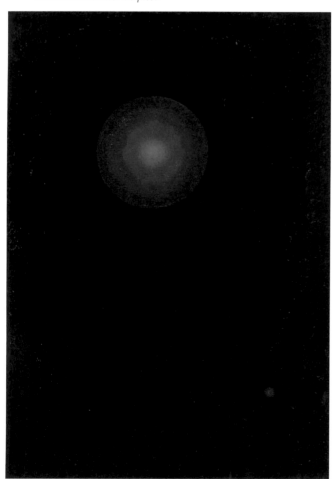

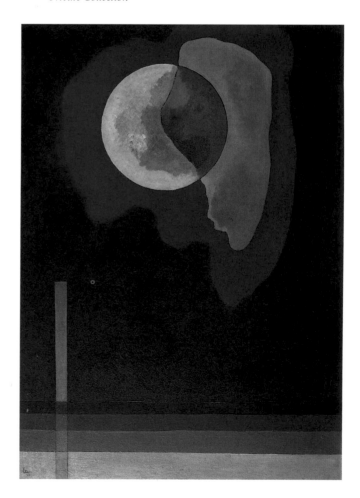

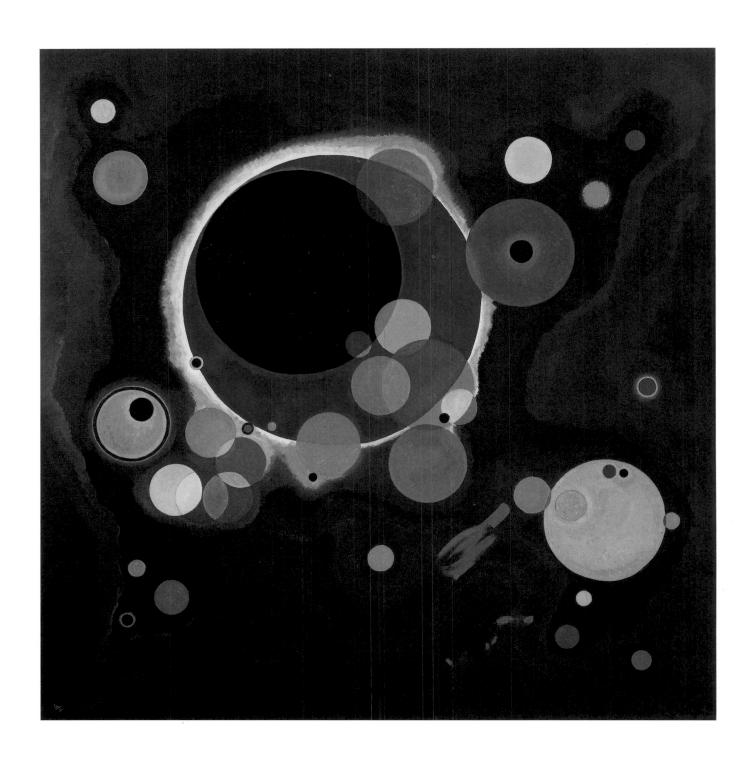

342 Several Circles, *1926*
Oil on canvas, 55¼ x 55⅜ in
The Solomon R. Guggenheim Museum, New York

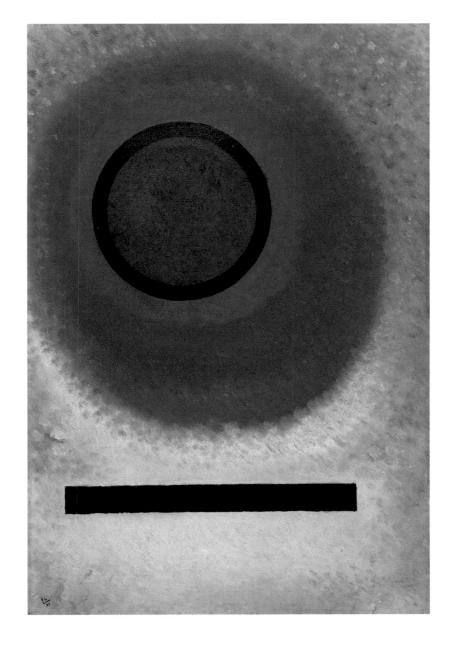

343 Blue Circle no. 2 *1925*
Oil on canvas, 24 x 16�5/16 in
Galerie Maeght, Paris

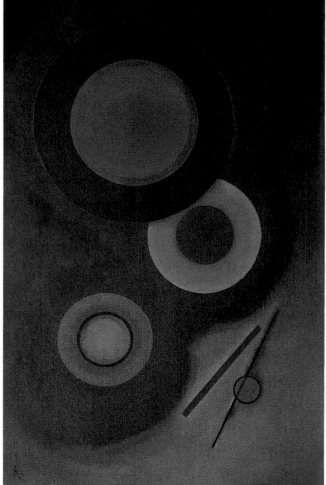

344 Closely Surrounded, *1926*
Oil on canvas, 39⅜ x 25³/16 in
Adrien Maeght Collection, Paris

286

345 Conclusion, *1926*
Oil on cardboard, 23 ⅝ x 15 in
Adrien Maeght Collection, Paris

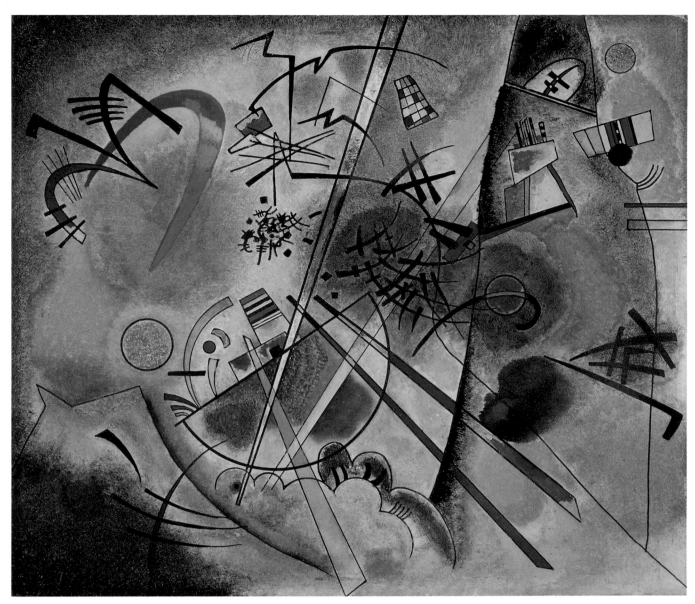

346 Small Dream in Red, *1925*
 Oil on cardboard, 13¾ x 16⅛ in
 Kunstmuseum Bern

347 *Analytical Drawing after*
 Small Dream in Red, *1925*
 in: Point and Line to Plane, *1926*

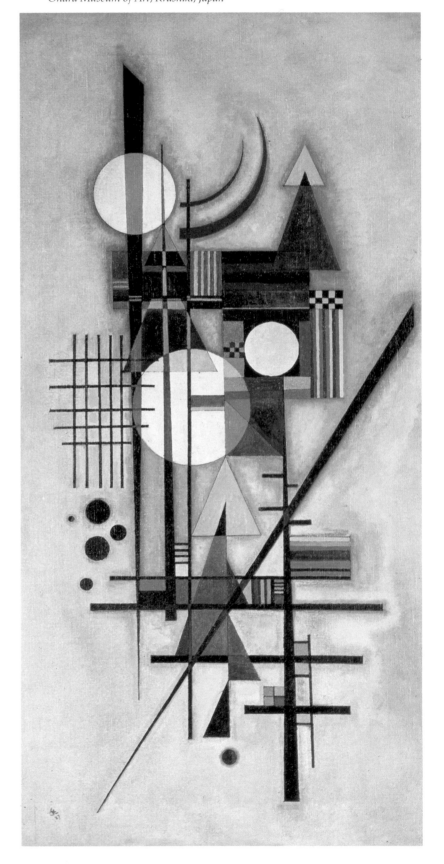

348 *In the Guest Book of
 Alfred and Thekla Hess*, 1925
 *Watercolor, 11 x 8⁷⁄₁₆ in
 Bauhaus-Archiv, Berlin*

349 Hard in Soft, 1927
 *Oil on canvas, 39³⁄₈ x 19¹¹⁄₁₆ in
 Ohara Museum of Art, Krashiki, Japan*

countless tensions within it. The circle is the synthesis of the greatest oppositions."[456] No wonder, then, that the artist attached so much value to a form so ideally suited to his personality.

One of Nina's favorite pictures was the *Small Dream in Red* (ill. 346) of 1925. It is a plainly retrospective work, with its less rigidly geometrical shapes, although not as much so as *Backward Glance* (ill. 285) of the previous year. It too contains a recognizable rowing boat with three long oars. In *Point and Line to Plane* Kandinsky appended the "linear structure" of this picture (ill. 347) to many simpler examples of "line." It was not intended to be a straightforward reproduction: the top left-hand corner departs from the original, as does the left-hand side with its extended parallel slash. These "linear structures" show the complexity of such harmonious, "decorative" pictures.

Kandinsky's artistic range is evident during this same year in works of gentle, pure, harmonious poetry, from *Pink on Gray* to *Loose – Firm* (ill. 359), in which the dream-like structure has been executed in a more interesting way. The bottom section of the picture represents a circle, which looks very like a clock, and a strange little rectangle that creates the impression that one is looking through a window (with a view of a factory chimney and a comet?). It is rare that one of Kandinsky's compositions should bear such a marked resemblance to Dadaist or Surrealist works. The principle, dragon-shaped form was reworked the following year in a simpler, but no less evocative composition, *Supported* (ill. 358). Here too the application of color is

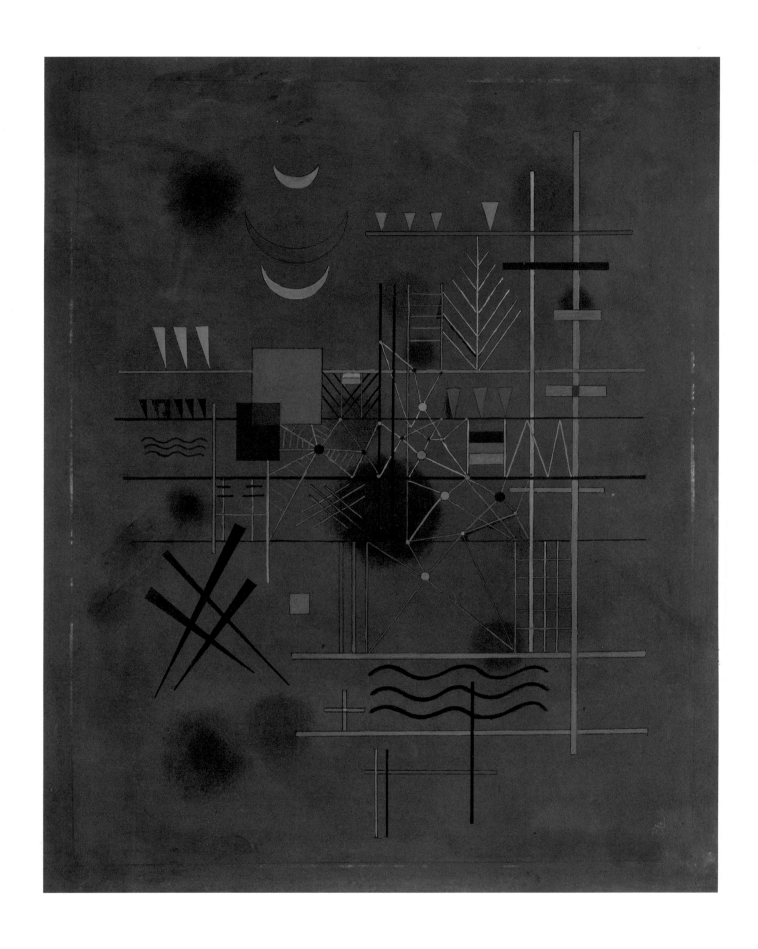

350　Red in the Net, *1927*
Oil on canvas, 24⁷⁄₁₆ x 19¼ in
Yokohama Museum, Japan

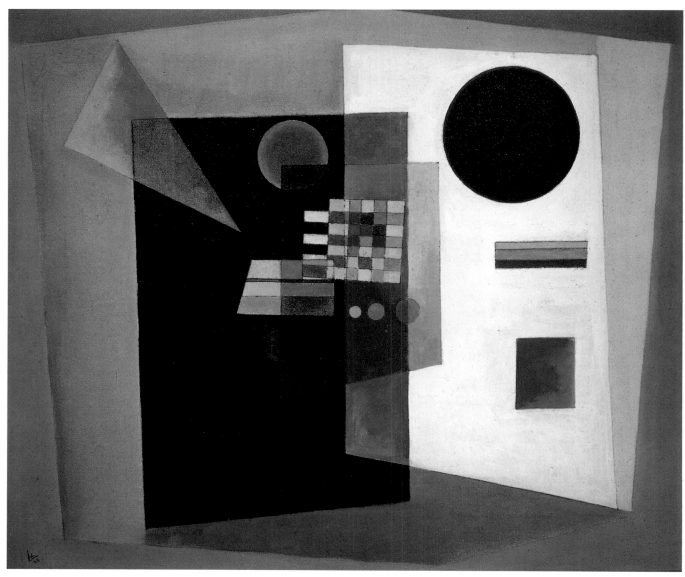

351 Asserting, *1926*
Oil on canvas, 17¾ x 20⅞ in
Private Collection

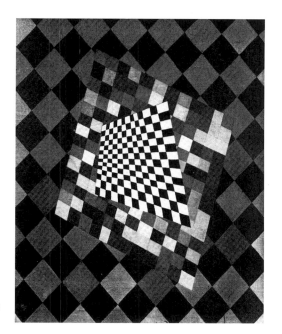

352 Square, *1927*
Oil on canvas, 28¾ x 23⅝ in
Location unknown

353 Red Circle, *1927*
Oil on canvas, 13 x 16⅛ in
Private Collection

354 Several Cool, *1927*
Oil on canvas, 11 x 12⁹⁄₁₆ in
Private Collection

smooth and outlined on the one hand, contrasted with smudged patches and a rich, self-modulating "inner structure." The same can be said of the smaller, "personal" picture *Homage to Grohmann*, though less so of the comparable, larger picture from later on, *Hard in Soft* (ill. 349). This latter gives the impression that the composition was almost mathematically calculated; the diagonal slash is a decidedly disruptive element. Yet no more than any other Kandinsky painting could it be mistaken for a Constructivist composition (see p. 299).

Two recent discoveries demonstrate that there are still surprises to be found in the extensively researched Bauhaus period. *Red in the Net* (ill. 350) disappeared after the 1942 exhibition at the Nierendorf Gallery in New York. Its whereabouts was still "unknown" at the time Roethel brought out the second volume of his *Catalogue raisonné* in 1984. The picture attracted enthusiastic buyers in Japan, like many of the artist's other works. This is understandable since an extremely delicate and complex equilibrium lends the picture a particular charm: the balance between horizontal/vertical and smaller, diagonal forms; between glowing, accurate, geometrical squares and blurred circles in a subdued hue, in the background, as well as between colored and black lines.

The second discovery is *Red Circle*, which was also listed in Roethel's catalogue "whereabouts unknown" and represented only through Kandinsky's pencil sketches of it (ill. 353). Typical "Bauhaus forms," which predominate in the otherwise similar *Several Cool* (ill. 354), are supplemented here with a leaf-like, vegetable form, very much in the style of Klee. The tapering of the two vertical stripes in the center of the picture in inverse directions upsets any illusion of a regular, fixed space between the two and illustrates Kandinsky's fascination with such ambivalence.

The director of the Bauhaus after Gropius, Hannes Meyer, invited not only painters like Marcel Duchamp and Albert Gleizes to lecture them, but also composers such as Stravinsky, and Gestalt psychologists such as Wilhelm Ostwald and Hans Prinzhorn. They encouraged a more scientific study of visual phenomena. Klee, Kandinsky, and other colleagues began to include ambiguous and reverse-image figures, optical illusions and ambivalent shapes in their paintings (ills. 365, 366). The result was to engage the active participation of the viewer, who experienced the laws of optics at first hand.

In 1927, while still at the Bauhaus, and several years after Klee, Kandinsky learned a completely new technique – spraying with watercolor. He combines this with the usual watercolor technique, or uses it on its own with a variety of templates. He was soon producing satisfactory results, such as the picture he gave to Klee, *Too Green* (ill. 355), and the small, fantastically beautiful picture (ill. 356) published here for the first time. Its misty, pastel colors flowing into each other make it look as though it is about to dissolve. It was in Nina's possession and was a particular favorite of hers.

355 Too Green, *1928*
Watercolor, 19⅝ x 9¾ in
(given to Paul Klee on his 50th birthday)
Private Collection

356 Blue Smoke, *1928*
Watercolor, 11¹³⁄₁₆ x 7⅛ in
Private Collection

CHAPTER THREE
THE DEBATE ON ABSTRACTION

Many years had gone by since Kandinsky had begun working with the idea of abstract painting, and since he had found his geometric-abstract style in Moscow. One might think that there could be no further discussion about the fundamental principles of his art, not among those familiar with the much clearer, more simplified, totally "cool" pictures of his Bauhaus period. Not so. He was being attacked on the same points as before, with new arguments being put forward all the time. His geometric pictures were said to show his fossilization and intellectual frigidity.[457] Kandinsky's response to this was characteristic: "Sometimes there is boiling water flowing beneath ice – nature 'works' with opposites; it would be flat and dead without them. Art is the same."[458]

German critics had begun to reappraise his pre-war painting and were starting to accept it (during his Moscow years he had not been forgotten in Germany, where his writings and pictures had had a profound effect), when suddenly he was producing geometrical pictures! They mocked his mural painting at the Juryfreie exhibition of 1922 (ill. 316) charging that it consisted of wallpaper patterns, and that he had surrendered his real talents to "interior decorating."[459] Geometric patterns had until then only been seen on architect's plans and wallpaper, and only a very open mind could conceive that they might be art.

For his sixtieth birthday in 1926, Kandinsky was honored with a touring exhibition and published tributes, but he also received a slap in the face. Carl Einstein, the critic, dealt him a sore blow in his book on the art of the twentieth century. Apart from accusing him of inadequately mastering space (see p. 186), Einstein added the charge of solipsistic arrogance, claiming that Kandinsky considered painting to be a means of spiritual isolation, and was an artist who created things solely from within himself and was incapable of communication.[460] This was a disastrous misunderstanding and had potentially dire consequences for an artist who depended on selling his pictures and on being exhibited to supplement the meagre salary he got from the Bauhaus.

However, Kandinsky was not one to let negative criticism crush his spirits:

> The waves of attack against abstract art, which had died down a little recently, but are now almost desperately towering up again, are, as far as I'm concerned, 1. particularly illuminating proof of the inner strength of this art, its inner tension, and the implications bound up with it in particular as concerns "life," and 2. a clear picture of an acute crisis, which will not last for long.[461]

He wrote this to Will Grohmann, with whom he shared his thoughts, impressed by his sensitivity and ability as an art

357 A Circle (B), 1928
Oil on canvas, 13¾ x 9⅞ in
Private Collection

358 Supported, 1927
Oil on canvas, 31⅛ x 20⁷⁄₁₆ in
Dr. and Mrs. Israel Rosen Collection, Baltimore
Photo Courtesy Gmurzynska Gallery, Cologne

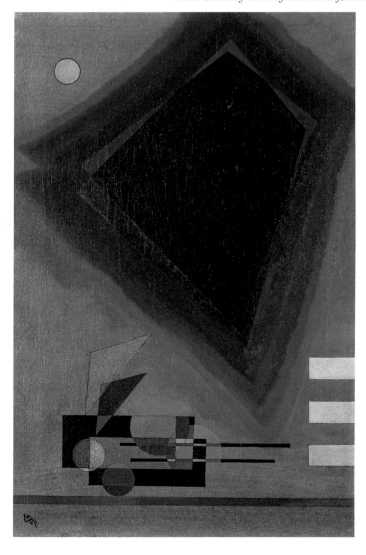

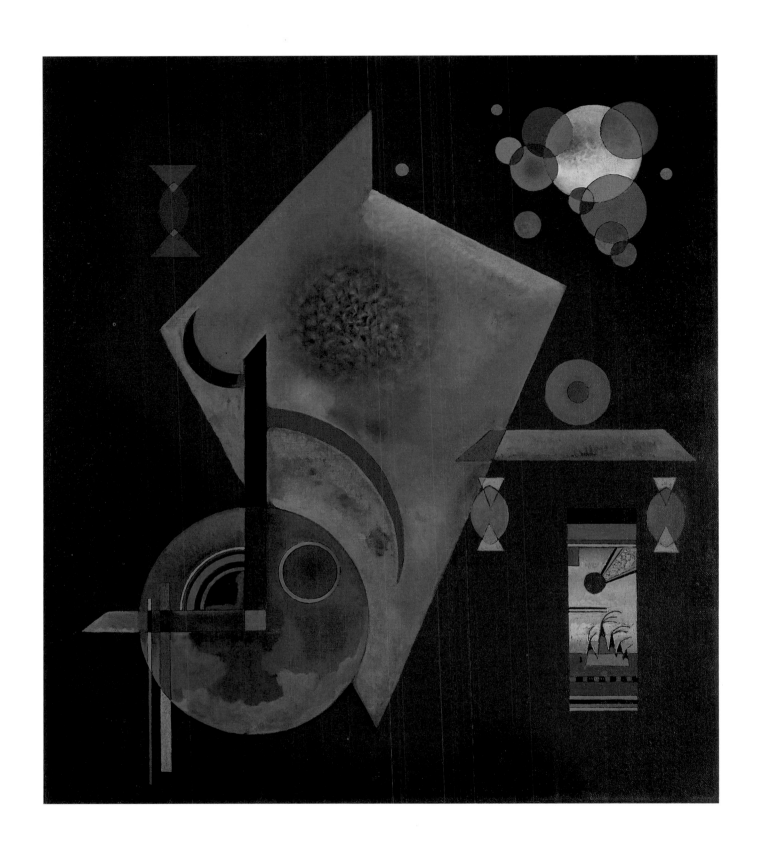

359 Loose – Firm, *1926*
Oil on canvas, 43 11/16 x 41 3/8 in
Private Collection, Stuttgart

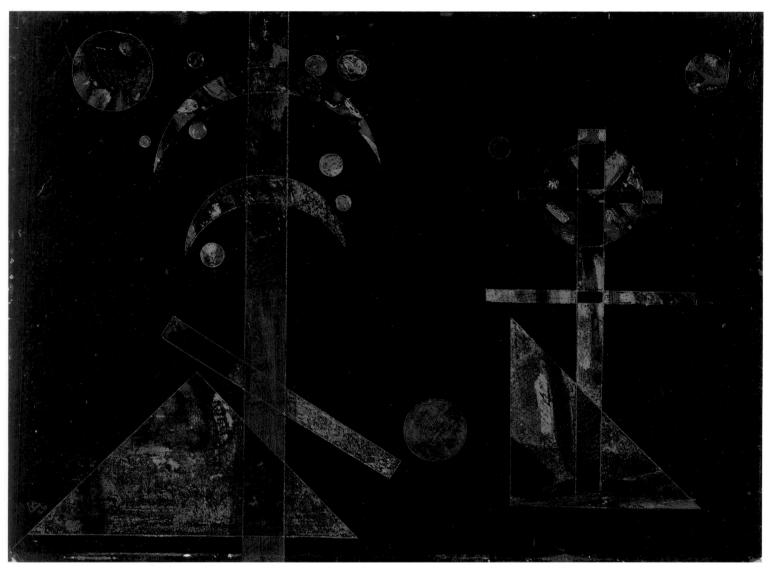

360 For Nina for Christmas, *1926*
 Oil on cardboard,
 13 x 17¾ in
 Musée national d'art moderne
 Centre Georges Pompidou, Paris
 Nina Kandinsky Bequest

historian. Grohmann, who had already written illuminatingly on Klee and Kirchner, defended Kandinsky's position scrupulously, helping the artist gain understanding in Germany and France. In 1928 Kandinsky told Grohmann that he was surprised that critics were still intent on attacking him:

> In spite of my dramatic "exit" from the Association [New Artists' Association, Munich] I still look back fondly on this period. It held the initial excitement; the first bombs were tossed, flung right out of Schwabing into the rest of the world, horrifying it, goading it, and ultimately enriching it. Then I would sometimes think, what will it all be like in 20 years? Surely we'll all be professors, i.e. spiritually buried people, who fight against anything new and hate the

young? I thought to myself, every artist eventually becomes a "professor," even if he doesn't hold the title, and what can happen that I shall not be able to understand and shall reject? I never dreamed that I myself would be attacked and sometimes reviled in 20 years' time. All I was frightened of was some reaction that would bang down the lid on art again and give poor old mankind "a bit of peace." I knew that there is still an ugly battle to be fought with superficial materialism, a battle that is unavoidable and that will yield no easy victory. I felt great excitement at this, and I trusted in its strength. I'm no less convinced today that the long battle will lead to a conclusive victory, even if it has to last for centuries (or millennia).[462]

In fact Kandinsky's categorical and unshakeable beliefs earned him the respect of even the most malicious of his critics, without their understanding the reason behind his supreme artistic conviction. The author believes that the critical blindness to his achievement during the Bauhaus years had the same roots as it did in his expressive period: critics and other observers still tried to detect some kind of universally comprehensible content – which exists, Kandinsky claimed – on a *materialistic* level. Yet it was not to be found there. As Kandinsky wrote in *Content and Form* in 1911, natural forms can be dispensed with, because their forms and colors are accidental. But critics held the opposite viewpoint; they considered Kandinsky's invented forms to be accidental and subjective. This proved, they claimed, that the object was after all indispensable. Critics in the twenties were still trapped in this crippling logic. Kandinsky's bid for freedom in art singled him out as someone years ahead of his time. As recently as 1979 Michel Lacoste, the author of a monograph on Kandinsky, considered a defence of abstract art and a lengthy justification of its existence so essential that he devoted almost a quarter of his book to this subject.

As in earlier days, Kandinsky's strangeness was blamed on his Russian origins. We have already seen that he was hardly any better understood by his own countrymen, whether in 1900, 1910, or later.[463]

361 Thin, *1929*
Oil on cardboard, 14 3/16 x 10 5/8 in
Private Collection

362 *Nina and Vasily Kandinsky, ca 1926*
Photo: Lucia Moholy

363 Leftward, *1927*
 Oil on cardboard, 16⅛ x 13 in
 Adrien Maeght Collection, Paris

A further source of misunderstanding was Kandinsky's enormous breadth of artistic vision and personality. Any kind of limitation was alien to him; he could not understand, much less value, either the Suprematism of Malevich or the Purism of Mondrian and the Constructivists. They for their part raised objections to his work. Mondrian thought that Kandinsky's pictures contained too many recognizable shapes, that they were too close to "life." Kandinsky's comment on Mondrian was: "Avoiding every kind of constructive basis apart from the horizontal/vertical condemns 'pure' art to death."[464] Their vastly different views on life and nature were of course the fundamental reason for their different artistic methods. In *Point and Line to Plane* Kandinsky predicts: "The separate and individual laws of those two great realms, nature and art, will ultimately shed light on the general laws of the world and its makeup [...] and reveal the independent operation of both within a higher, synthetic sequence of external and internal."[465]

Other artists found Kandinsky's paintings too heavy, and their construction too obviously derived from individual intuition, rather than objective laws. This is something Kandinsky criticized in the Constructivists: "They are trying to create 'calculated construction' and want to suppress feeling not only in themselves but in onlookers, to liberate them from middle-class ideas, and make 'matter-of-fact people' out of them. Artists like this are in truth mechanics."[466]

What is the difference between these "mechanics," including also the Suprematists, and Kandinsky's Bauhaus student Josef Albers, for example, whom he admired and encouraged? Kandinsky himself had carried out precise scientific research, analysis, and schematization with his students at the Bauhaus, producing tables with them for their use. But like Leonardo da Vinci with his formulae for powdered pigment, when a student asked him how he used it himself, his reply was "I don't." However great an interest he had in calculable construction, Kandinsky's lifelong priority was artistic intuition – "inner necessity" – without which he believed the most perfectly constructed picture to be a dead canvas.

Today the Russian avant-garde painters are gaining popularity, especially the Constructivists. Despite their limitations, they are sometimes rated higher than Kandinsky. Take the specific example of the latter's highly minimalist pictures, which contain few forms, such as *Conclusion* (ill. 345), *Leftward* (ill. 363), *Square Lyrical*, or *Two Squares*. Does the privilege of originality that Malevich has as founder of this idea constitute the only difference between the two artists? Or is it that Kandinsky was still painting "too beautifully," unable to give up an element of decorativeness even at that late stage? Can we perceive the different philosophies of the two painters behind even their most similar pictures?

If we study in detail such perfectly constructed works as *Thin* (ill. 361), *Erect* (ill. 364), or one of the pictures in

364 Erect, *1930*
Oil on canvas, 19 5⁄16 x 31 1⁄4 in
Private Collection

Chapter Five (pp. 308 ff.), we always see a difference compared to the works of Constructivists like Laszlo Moholy-Nagy, a colleague from the Bauhaus, or Lissitzky. Notice the uneven band of color meandering on the left side in *Leftward*. What is the point of this? Does this noticeably freehand "artist's touch" give the picture life and individuality? It is characteristic of Kandinsky's personal style to include this element that runs counter to the geometry of the whole. And what about the "more mechanical" technique of spray painting (ills. 355, 356)? Surely Kandinsky had mixed feelings about this technique? He did not use it for very long at any rate. Nor did he ever use the even more impersonal technique of collage, despite his lively curiosity about different techniques.

Naturally, even the Constructivists did not suppress their intuition completely: it is evident in their magnificent work, far more clearly than in their over-rigid theories. There are purely or principally "constructed" works among Kandinsky's weakest pictures, as there are among those of his pre-geometric period. During his Bauhaus years, however, Kandinsky produced exceptional, seemingly "constructed" works, which partially satisfied his search for expression, particularly where form was concerned. However, he once said: "Form without content is not a hand, but an empty glove filled with air."[467]

Criticism of the great Russian master has not kept artists in Germany or anywhere else from admiring him; they continue to study his artistic development and writings with great respect. In Germany, he and Klee were considered to be the most influential pioneers of modern art. The comparative scarcity of obvious followers is even more to his credit. It is hardly possible to overestimate his contribution to a new understanding of art.

365　*Paul Klee,*
　　Hanging, 1930
　　Oil on canvas, 33 1/16 x 33 1/16 in
　　Kunstmuseum Bern

366 *Watercolor Nº 497, Study for* All the More, *1932*
 Watercolor and India ink
 Private Collection

DOCUMENTS

Letter to Will Grohmann

February 25, 1929.

I was particularly pleased to notice at my exhibition in Brussels that the French attach more importance to quality = achievement than to any underlying theory, something I rarely come across in Germany, hence my despairing foreword at Möller's [On the Berlin Exhibition, October 1928]. This issue of theory has been under discussion for almost 20 years – is it possible in principle to paint in the abstract style? To what extent? For how long? ("He's still painting abstract pictures!") Which countries should be allowed to do this? Will it destroy painting proper, even art itself? Where does painting stop and ornamentalism begin? What's the difference between a picture and wallpaper? Or ties? Or socks?... All this comes under the heading of the German inclination for philosophizing.

Please excuse my agitation; after 20 years even the most patient of men would be riled.

(Künstler schreiben an Will Grohmann, Cologne, 1986.)

Letter to Galka Scheyer

December 11, 1925.

I'm so pleased to hear that your feeling for my work is getting stronger. [...] It isn't actually easy to get "behind" my work and sense whatever it is that lies beneath an often rather reticent form. I've emerged from my "dramatic" and "expressive" periods, in which the narrative of painting lay more on the surface. You may have read what I wrote in my album (Publisher, Der Sturm) 14 years ago about cigarette butts in ashtrays and trouser buttons glinting out of puddles [see p. 79]. That essentially was when I started to hear this "language" in silence. As I have developed since, the sound of "dry" or "cold" form has become louder and clearer. I know that these "dry" phases have alienated even good friends, not to mention those more superficial ones who "worshipped" me one minute and were quick to be disappointed in my new work the next.

Destiny dictates such changes in attitude toward my work. Every step I take forward, I experience the same thing: a chorus of disappointed friends saying: "Why aren't you painting as you did before?" Sometimes this leaves me feeling very lonely.

(Vasily Kandinsky, letter to the representative of the *"Blaue Vier"* (Blue Four), Galka Scheyer, by kind permission of Hella Hammid and Peg Weiss.)

August 7, 1929.
"To Think or Not to Think"

I have long since discovered the answer to this question. In Russian schools drawing was not compulsory. The lessons took place after the compulsory ones had finished. Thus, few of the boys attended these lessons. And still fewer took them seriously. More than 50 years ago, I belonged to those very few.

[...] At that time I admired him [our drawing teacher] greatly, for not only could he draw and paint mere heads or landscapes, but he also possessed a little table he had painted himself, on which banknotes, a silver coin, and a fly had been so realistically painted that to my eyes they surpassed "nature."

This teacher used to say: "Boys, drawing is a difficult thing. It's not like Latin or Greek – here, you have to think!"

Some 20 years afterward I studied drawing in the then famous Ažbè school in Munich. I already had a full beard, and many of my colleagues were under twenty. Anton Ažbè was a very small man with a big moustache combed upward, a large, broad-brimmed hat, and a long Virginia [cigarette] in his mouth (which often went out, and which he sometimes used for correcting the drawings). Outwardly he was tiny; inwardly he was immense – gifted, clever, strict, and kindly beyond all bounds.

I didn't like anatomy, and I asked Ažbè whether I absolutely had to learn it.

"Yes, my friend, you've got to know anatomy properly. But woe betide you if you think about anatomy in front of the easel! When he's working, the artist shouldn't think!"

I have followed these two suggestions to this day and have remained true to them to the end.

(Vasily Kandinsky, "Two Suggestions", CW, p. 735)
[Written on August 7, 1929 in Hendaye-Plage, where Kandinsky was on vacation with the Klee family.]

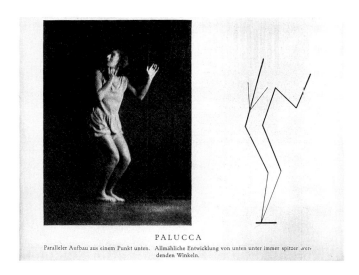

PALUCCA

Paralleler Aufbau aus einem Punkt unten. Allmähliche Entwicklung von unten unter immer spitzer werdenden Winkeln.

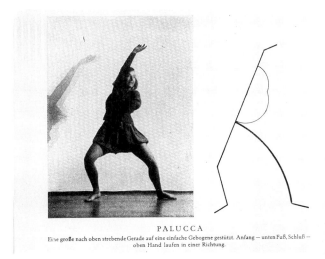

PALUCCA

Eine große nach oben strebende Gerade auf eine einfache Gebogene gestützt. Anfang — unten Fuß, Schluß — oben Hand laufen in einer Richtung.

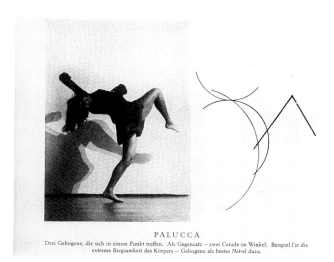

PALUCCA

Drei Gebogene, die sich in einem Punkt treffen. Als Gegensatz — zwei Gerade im Winkel. Beispiel für die extreme Biegsamkeit des Körpers — Gebogene als bestes Mittel dazu.

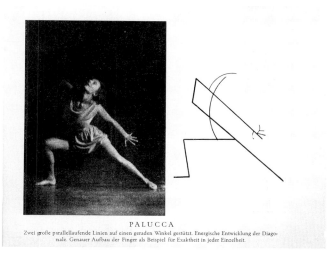

PALUCCA

Zwei große parallellaufende Linien auf einen geraden Winkel gestützt. Energische Entwicklung der Diagonale. Genauer Aufbau der Finger als Beispiel für Exaktheit in jeder Einzelheit.

367 *Diagrams of the Dance of Palucca*
in: Das Kunstblatt, *10/1926, p. 117–121*
Bauhaus-Archiv, Berlin

CHAPTER FOUR
A THEATER PROJECT

A long break occurred before Kandinsky took up his theater work again. In the interval his interest in dance and the principles of movement (see p. 156 on his experiments with Alexander Sakharov in Munich) manifested itself in a series of remarkable diagrams inspired by the "modern" dancer, Palucca (ill. 367), which he drew from photographs of her. Similar diagrams exist for his compositions. Movement, tension, and the main axes of the body are "explained" with various bold lines. One of these analytical drawings was published in *Point and Line to Plane* and four others in *Art Journal* (*Kunstblatt*) in 1926.

In 1928 finally Kandinsky was able to realize the only theater project staged during his life, for Modeste Mussorgsky's piano pieces *Pictures at an Exhibition* at the Friedrich Theater in Dessau.

Mussorgsky had written the cycle in 1874, spurred by the early death of his friend, the painter Viktor Hartmann, whose pictures he had seen one last time at a posthumous exhibition. We know Hartmann as the architect of the artists' colony at Abramtsevo (ill. 48).[468] The music consists of ten movements, named after individual pictures whose effect Mussorgsky was trying to translate into musical terms. The intermezzos called "Promenades" evoke the composer's own walk as he went from picture to picture at the exhibition. Kandinsky commented:

The music, however, turned out to be anything but "program music." If it does "depict" anything, it is not the painted pictures but Mussorgsky's own experiences, which went far beyond the content of the paintings to find a purely musical form. That was why I was delighted to accept the offer of staging the composition, made to me by the then director of the Friedrich Theater in Dessau, Dr. Hartmann.[469]

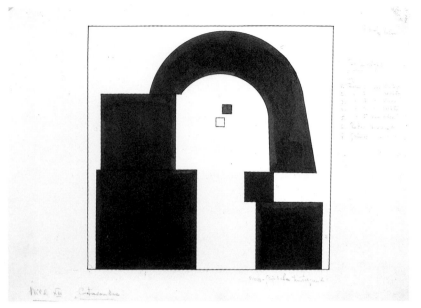

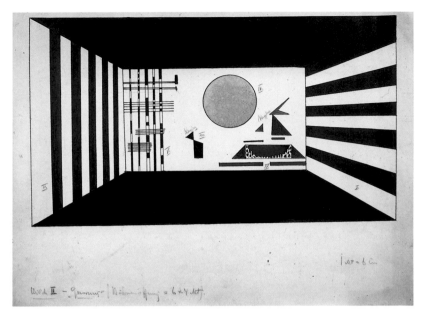

368 *Stage Design for* Pictures at an Exhibition, *1928*
Catacombs,
India ink and watercolor
11⅞ x 15¾ in
Musée national d'art moderne
Centre Georges Pompidou, Paris
Nina Kandinsky Bequest

369 *Stage Design for* Pictures at an Exhibition, *1928*
Gnome,
India ink and watercolor
8⅛ x 14³⁄₁₆ in
Musée national d'art moderne
Centre Georges Pompidou, Paris
Nina Kandinsky Bequest

Kandinsky was apparently not familiar with Mussorgsky's "models." He speculates in the same text that they were merely the watercolors and drawings of an insignificant artist. Thus, he assumes, there were no limits to the composer's imagination. Nor did Kandinsky attempt to reproduce the musical impression in his stage décors. He produced something even more individual than Mussorgsky; an abstract dramatic action with changing geometrical, colored forms in the spirit of his old dream of a synthetic "total drama." Every now and then he used forms that were evoked by the music, as he states in the same article. But his principal resources were:

1. form itself,
2. color and form, to which
3. the color of the lighting was added as a kind of more profound painting,
4. the independent play of the colored lights and
5. the structure of each scene, which was bound up with the music, and of course the necessity of dismantling it.[470]

Kandinsky's estate includes his stage designs (ills. 368–372) and eight type-written pages describing the sequence of the action in *Pictures at an Exhibition*, as well as the complete piano score with handwritten comments by Felix Klee, Paul Klee's son and Kandinsky's assistant on this project. To accompany each of his markings on the score, Felix Klee had sketched out in note and diagram form on the back of each page of music the relevant action on stage, according to Kandinsky's instructions. He recalls

that the director wanted to give the rather conservative Dessau public a taste of the modern musical theater at least in matinée performances. *Pictures* was thus performed following Kurt Weill's *The Emperor's New Clothes* on April 4, 1928. There was a single repeat performance on April 11. Klee and two other assistants moved the geometrical forms around the stage. The décors were evidently quite stunning.[471]

In *Pictures*, Kandinsky apparently repeated on a larger scale the stage settings he had been experimenting with in Munich since 1908. The stimulus of one work of art (Mussorgsky's music) through a series of works from another artistic genre (Viktor Hartmann's pictures) acted in turn as a stimulus for Kandinsky's kinetic stage "pictures." In effect this was a continuation of the abstract play between light, forms, and color in the entractes in *Violet* (see pp. 261 f.). But Kandinsky used geometric forms even more pointedly here, in the spirit of his Bauhaus compositions. The circle in particular played an important role in the latter, and the theater piece began and ended with one too. A new three-dimensional feature was the space of the stage, which replaced the flat screen of the entractes in *Violet*. The action on stage was developed into complete abstraction. In *Yellow Sound* and *Violet* the action had already gained a great deal from the abstract interplay of colors and light. Instead of people and simplified landscapes, Kandinsky used colored forms in *Pictures*, even for the figures in the two scenes whose protagonists are supposed to be actual "people" (ill. 371). Each individual tableau is an "authentic Kandinsky," closely related to the

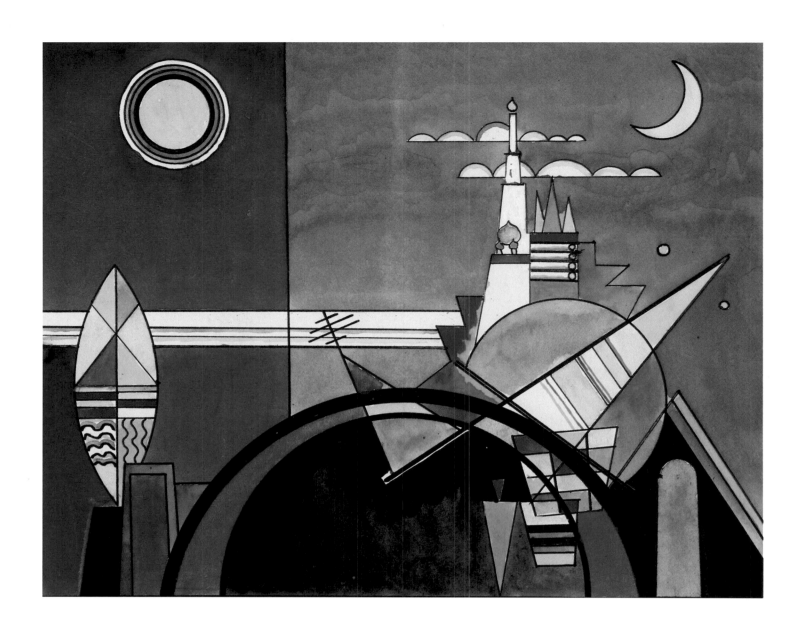

370 *Stage Design for* Pictures at an Exhibition, *1928*
The Great Gate of Kiev,
India ink and watercolor, 8⅜ x 10⅝ in
Musée national d'art moderne
Centre Georges Pompidou, Paris
Nina Kandinsky Bequest

371 *Stage Design for* Pictures at an Exhibition, *1928*
 Women at the Market in Limoges,
 India ink and watercolor, 11¾ x 8⅞ in
 Musée national d'art moderne
 Centre Georges Pompidou, Paris
 Nina Kandinsky Bequest

372 *Stage Design for* Pictures at an Exhibition, *1928*
 Market Square at Limoges,
 India ink and watercolor
 11¾ x 15¾ in
 Musée national d'art moderne
 Centre Georges Pompidou, Paris
 Nina Kandinsky Bequest

artist's other pictures of this period. He himself makes this clear:

> For each picture [...] there will be a black velvet curtain hanging at the back of the stage, which will give the effect of intangible depth.

Picture One – Promenade

The front curtain rises at the first sounds of music. The stage is a borderless, deep black hole. A circle (2 m diameter) made of transparent red material is hanging rather close to the front; as yet it is unlit. There are a few red lights behind the material (the red is more vermilion) which start gradually to glow in the second bar (p. 5, l. 2 [in score]), reaching maximum illumination by the first bar (l. 4). The light fades in the second bar (l. 5).

In the third bar (l. 6) the red light goes out and the circle is raised [...].

The main point of the staging is the development of *pictures in time*, i.e. the gradual assembling and dissolving of colored forms, as the music unfolds. [...] The *colors* in the sketches are only meant to be suggestions. The color should not look at all solid; it should emerge from the *initial touch*, its solidity dissipated by *colored lighting*.[472]

It is entertaining to compare Kandinsky's stage pictures with some of the pictures by Viktor Hartmann, which Mussorgsky used as models, especially *The Great Gate of Kiev* (ill. 370). Stasov described the latter as follows:

> Hartmann's drawings include the plan for a city gate for Kiev in an old Russian, monumental style with a cupola shaped like a Slavic warrior's helmet [...].[473]

Unlike *Yellow Sound*, for which only fragments of a piano score survive, it is possible in this instance to make a comparison with the music. The score was orchestrated, Felix Klee has suggested, by Ravel, whereas Nina Kandinsky maintained that it was unfortunately not Ravel's pleasant orchestration, but one by a lesser known composer whose name she could never remember.[474] Mussorgsky, himself an accomplished pianist, was able to evoke many of the effects of other instruments in his piano piece, so that the orchestral version – whichever one is used – adds little to the original. It is therefore enough to base a comparison on the original version. There is not much obvious correspondence between Kandinsky's stage action and the music, and certainly no support or embellishment of it. The movement and changes of color and form in his settings obey their own rules. In the second part of the ninth picture, *Ballet of the Chicks*, the music and the action actually appear to be contradicting each other. The play of color toward the end of the twelfth picture, *Limoges*, has no equivalent in the music.

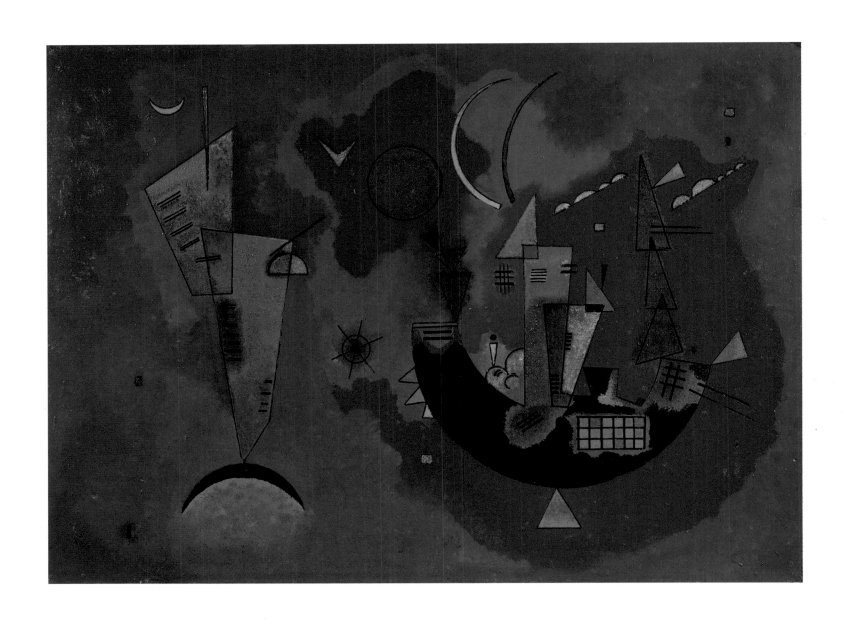

373 For and Against, 1929
*Oil on canvas, 13¾ x 19¼ in
Courtesy Thomas Gallery, Munich
(The first painting bought by
Solomon R. Guggenheim)*

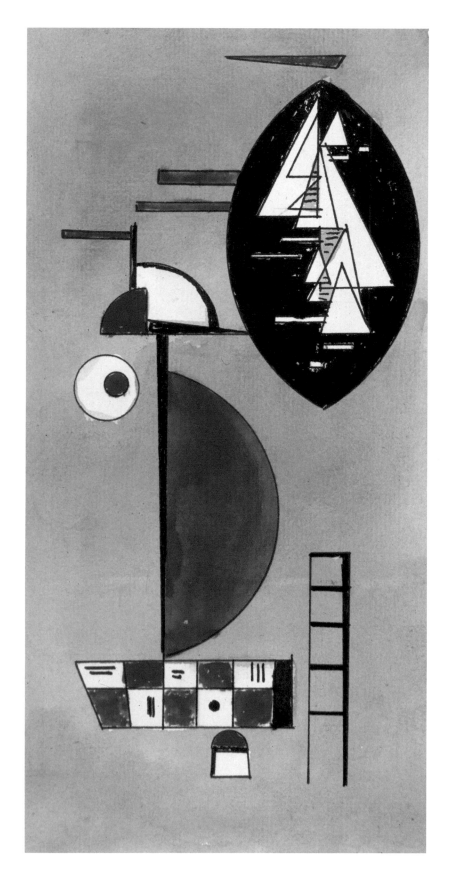

In May 1924, Emmy (Galka) Scheyer, who came from a wealthy Jewish industrialist family in Brunswick, emigrated to the United States (see p. 268). A painter herself, she had given up her art studies, begun in Brussels and interrupted by the First World War, after becoming acquainted with Jawlensky's work. She showed herself to be a perfect, sensitive companion to that artist. She championed his art in infectiously enthusiastic lectures in Germany from 1920 onward. She then formed a plan to win fame in America for Jawlensky and other important artists in his circle. These included Paul Klee, whom she got to know in 1920, Kandinsky, and the native New Yorker Lyonel Feininger, a former teacher at the Bauhaus, who had been exhibiting with the Munich circle since 1913. Galka Scheyer invented the group's name "The Blue Four" in memory of the Blaue Reiter. She lectured and eventually managed to organize a handful of exhibitions and actual sales, for example to the collector Arensberg. Once she settled in Los Angeles, she applied herself, with limited success, to converting Hollywood to the new art. She was more successful in arousing the enthusiasm of the young, who did not however have much purchasing power. On one occasion, an impoverished music student set his heart on buying one of Jawlensky's small *Heads*, and Galka let herself be persuaded to sell the picture for $25, with a $1 commission to... John Cage.[475] Scheyer managed the group's first exhibition in New York in October 1925 and one at Stanford University near San Francisco. Two other shows followed a year later, in Los Angeles and New York.

375 *Kandinsky with Students
 at the Bauhaus, 1931
 Bauhaus-Archiv, Berlin*

374 *Watercolor for a Color Woodcut*
 Cahiers d'Art 1930, 8⅝ x 4⁵⁄₁₆ in
 Thomas Gallery, Munich

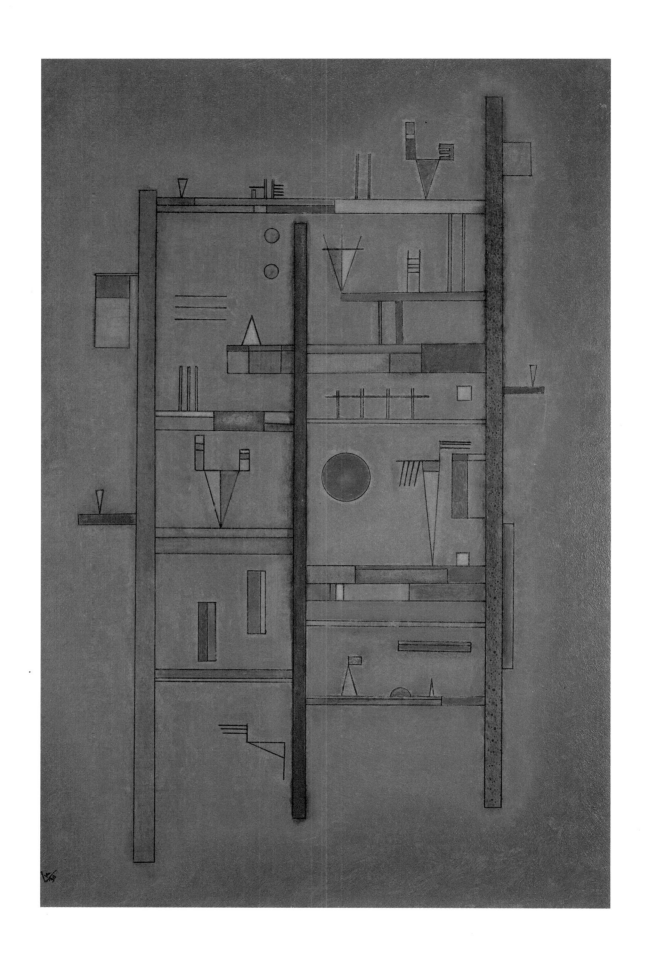

376 Intimate Division, *1930*
Oil on canvas, 27¼ x 19¼ in
Adrien Maeght Collection, Paris

377 Peaceful, *1930*
Watercolor and India ink, 18 11/16 x 13 in
Private Collection
Photo· Thomas Gallery, Munich

By 1923, Kandinsky had had his first one-man show in New York, organized by Marcel Duchamp's *Société Anonyme*, which even elected him honorary vice-president.

There were exhibitions, besides the many in Germany, in Amsterdam, The Hague, and New York (Brooklyn Museum) in 1927; in Brussels in 1928; and in 1929, an important exhibition of The Blue Four at Ferdinand Möller's gallery in Berlin. Kandinsky had his first one-man show in Paris at the Zak Gallery that same year. This was an important prelude to his and Grohmann's connection with *Cahiers d'Art*. The question whether this connection helped to pave the way for his forthcoming emigration or not will be explored in the next chapter.

Kandinsky had comparatively little contact with the English and American art scenes, mainly because he spoke no English. For this reason teaching activities or emigration to the USA were out of the question. But unquestionably Kandinsky was interested in the Americans, as is clear from the following letter he wrote to Galka Scheyer:

> I get the impression that Americans have on the whole an emotional appreciation of art; they really know how to experience it. The mind isn't excluded, but woe betide if it's allowed to take over. It should reflect behind the scenes without getting in the way of the emotions. In Germany in particular people reflect so much that emotion is eventually killed. The consequence is dreadful, incurable blindness. Only the other day I heard from an art dealer that the modern public can't really relate to abstract art, because it makes them think too much... Poor thinkers, gradually losing their soul! In abstract art it's precisely thought that impedes experience. In abstract art you don't need to think if you know how to experience things. If you don't know how, all the thought in the world won't help you. These clever people, in getting more and more clever, are going to end up being very stupid. That's why today's world looks dumber and dumber. [...] It probably won't be long before people realize what a dead-end all this "deep thought" has led them to.[476]

Two years later Kandinsky and other contemporary artists were being branded "degenerate" in Germany and their work was being removed from German museums. Later still, in 1937, Kandinsky wrote to Galka Scheyer:

> Recently the Führer said "All modern artists are either conmen (money!), in which case they should be in gaol, or dedicated fanatics (ideals!), in which case they should be in an asylum. It is up to us to decide which." You've read about the Munich exhibition of "Degenerate Art," I suppose? Poor, dear Munich! It was more successful than anyone thought, with an enormous turnout; there were over 1 million people

378 Green Empty, *1930*
Oil on cardboard, 13¹³/₁₆ x 19¼ in.
Musée national d'art moderne
Centre Georges Pompidou, Paris
Nina Kandinsky Bequest

there, and the population of Munich is only 1 million! It was teeming with art dealers, although I heard that they weren't made very welcome there. One of my old students told me that interest in modern art in Germany has never been keener and livelier than it is at the moment – in Germany of all places![477]

Nevertheless Kandinsky stayed on in Germany until the inevitable closure of the Bauhaus by the Nazi authorities in 1933. Besides his teaching and time-consuming administrative duties there, he was able to produce an amazing amount of very diverse, high-quality work, including such harmonious "compositions" as *Peaceful* (ill. 377), and such ingeniously reductive works as *Green Empty* (ill. 378) and

the small, almost monochrome *Cool Condensation* (ill. 379), given to Klee as a birthday present (December 1930). The title seems ironical, since the predominant color is red, but unlike Klee, Kandinsky eschewed irony, preferring his titles to draw the viewer's attention to oppositions and contrasts. The irregular, overlapping circles are not meant to be seen as expansion, but on the contrary as condensation. Their striking contrast to the two defined forms below them gives the composition an unusual tension. In another picture given to Klee, the watercolor *Weak Support* (ill. 380), Kandinsky's title refers to the construction balancing on a thin point, something he had tried out earlier in *Pink and Gray* (ill. 339).

379 Cool Condensation, *1930*
Oil on cardboard, 15¾ x 14⁹⁄₁₆ in
Private Collection

380 Weak Support, *1930*
 Watercolor and colored pencil, 12 5/16 x 9 3/8 in
 Private Collection

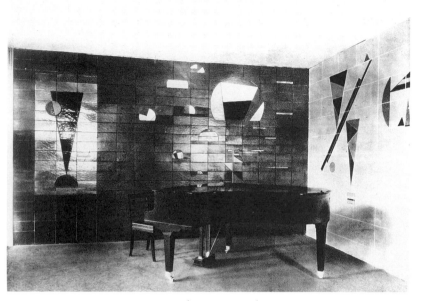

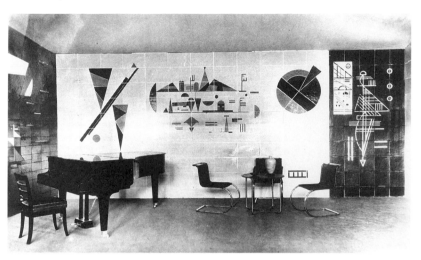

381　*Music Room at the German Architecture*
　　　Exhibition, Berlin 1931
　　　Photo Bauhaus-Archiv, Berlin

382　*Music Room at the German Architecture*
　　　Exhibition, Berlin 1931
　　　Photo Bauhaus-Archiv, Berlin

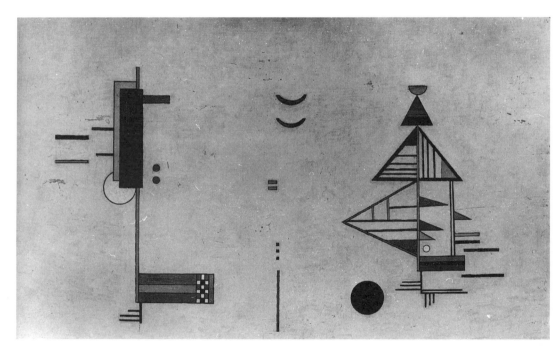

383　*Tile Design for the Entrance*
　　　to the Music Room, No. 3,
　　　at the German Architecture
　　　Exhibition, Berlin 1931
　　　Oil on cardboard, 17¹⁵/₁₆ x 29¼ in
　　　Artcurial Gallery, Paris

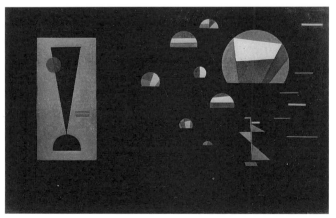

384　*Tile Design for the Exit*
　　　of the Music Room, No. 1,
　　　at the German Architecture
　　　Exhibition, Berlin 1931
　　　Oil on cardboard, 17¹⁵/₁₆ x 29¼ in
　　　Artcurial Gallery, Paris

During the following year Kandinsky was busy creating a music room. Rather surprisingly his murals were supposed to be executed in tiles, as it was felt that this would improve the room's acoustics. But in spite of their unusual format, they reveal nothing unexpected in comparison with his other pictures of the same period (ills. 381–384). His comment to Galka Scheyer was: "The great 'German Architecture Exhibition, Berlin 1931' opened today; there's an international section, including exhibits from America. We didn't get back from there until yesterday, because I've made a music room for it – a ceramic painting. Two 5 m. side walls, one 7 m. and a fourth which is all entrance area and glass. It was very exciting, but 'all's well that ends well'! It looks really good. That's the kind work I'd like more of."[478]

By 1932, Kandinsky produced among other things some highly "constructed" works, with ink pen as well as in oil or as etchings (ills. 378, 387), some of which were intended as his annual donation to the Kandinsky Society. *Fixed Flight* (ill. 388), with its hovering shapes spread over the whole picture plane, already points forward to his later development – to *Sky Blue*, which he produced in Paris eight years later (ill. 421).

In 1932, the Nazis shut down the Bauhaus in Dessau. An attempt to carry on giving lessons in an empty factory in Berlin was soon quashed. Kandinsky in particular came under attack; in July 1933 the Gestapo produced a secret document ordering that Kandinsky and his colleague Hilbersheimer be replaced by their own people.[479] In a letter he wrote to Galka Scheyer the same year Kandinsky summed up his "weak points:" in spite of his German citizenship he was a Russian, in other words a foreigner who could never be above suspicion of being a Communist. Besides which, he was also an abstract painter and, worst of all, a teacher at the Bauhaus.[480]

385 Untitled, 1932
India ink, 14⁵⁄₁₆ x 6⅛ in
Musée national d'art moderne
Centre Georges Pompidou, Paris

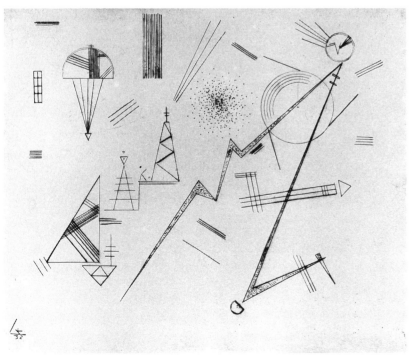

386 Moderate, 1931
Watercolor, 20 x 14½ in
Private Collection

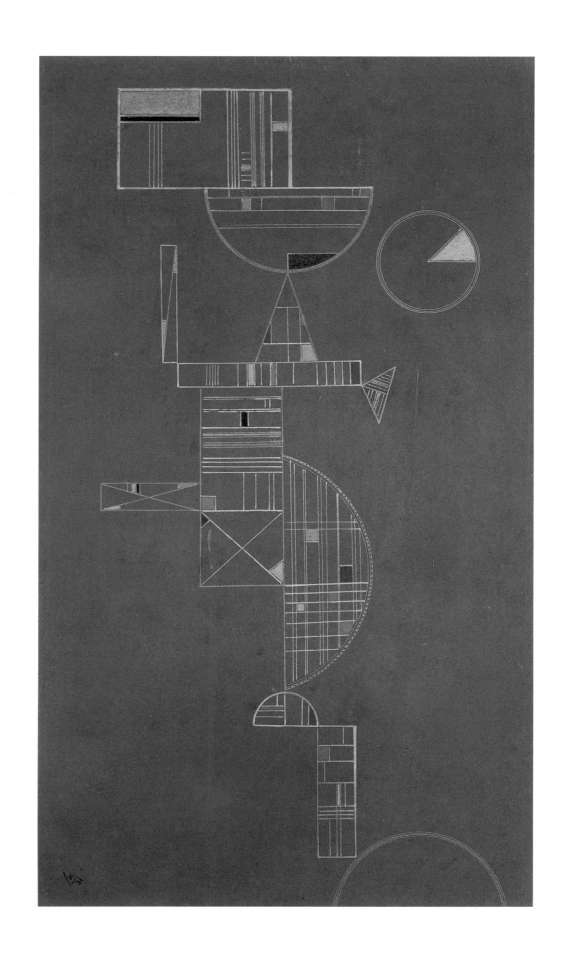

387 Rising from the Half Circle, *1931*
Mixed media on canvas, 29¼ x 17¾ in
Maeght Gallery, Paris

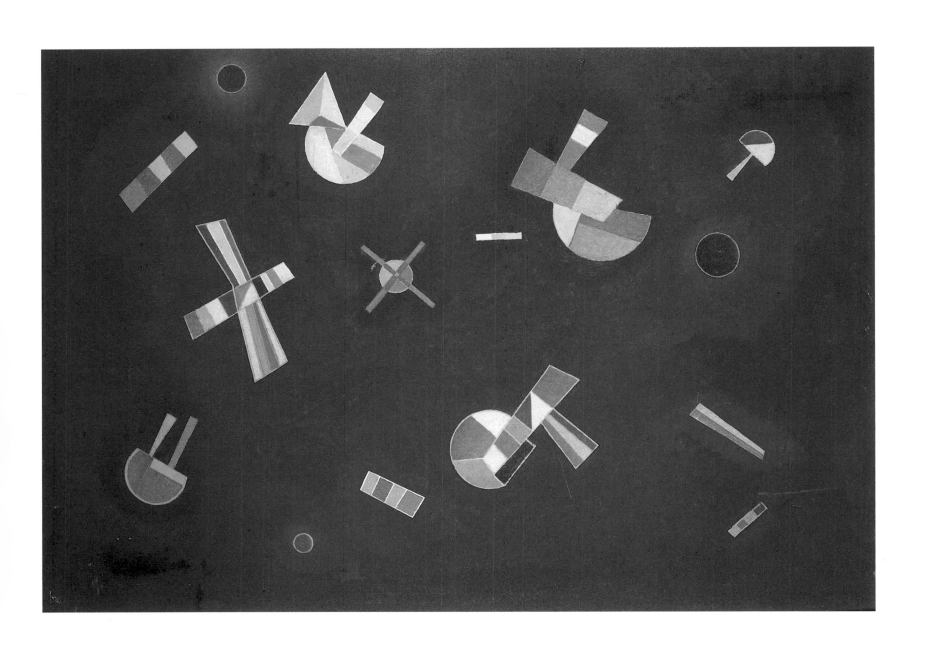

388 Fixed Flight, *1932*
Oil on cardboard, 19¼ x 15¾ in
Adrien Maeght Collection, Paris

DOCUMENTS

Letters to Alexei Jawlensky

January 5, 1928 from Dessau.

Generally I enjoy teaching, but there are times when all I really want to do is paint.

March 10, 1932.

There are hardly any opportunities for selling anything, and our income is getting lower and lower. [...] Neither Feininger, Klee, nor myself got an invitation to the Venice Exhibition, we have had no information about it at all. I mean, if not one of our foursome has been invited, the exhibition has nothing to do with us. We are, after all, the "Blue Four," or rather "multi-colored," for different tastes. From this, logically, we cannot have anything to offer one taste in particular. I therefore believe that the overriding taste there is a strictly official, "academic" one.

September 1, 1932.

Dear Alexei Georgievich! I just got your letter and have already taken some steps. I spoke to Klee, who entirely shares my opinion of your significance as an artist. Without a moment's hesitation, I have written the following to the "Sélection":
"Among the names of the artists taking part, there appears to me to be one missing, that of Jawlensky, who in my opinion is one of the most significant modern artists of our time.
[...] I take the liberty of hoping that this omission will soon be rectified, and enclose the necessary address for your information. [...] Do not forget how important "nationalist" attitudes are at the moment. We both of us find "-sky" to be a most disagreeable suffix, even if you were one hundred percent "Prussian" and I a true-born "Saxon." It is too late now to cut off our little tails; we should have had to become Mr. Javlens and Mr. Kandin (both with a nasal "n") thirty years ago, then we would have been decently appreciated long ago.

[July 3, 1934.]

Did you get an invitation to the German Exhibition in Zürich? An influential Swiss chap was at my place, and I gave him your address. They wanted to invite you. I made sure to tell them you were – a Prussian.

January 25, 1933.

I am applying to you on behalf of the Bauhaus to request a favor. In order to plug up a few financial holes, the Bauhaus plans to put on a Bauhaus festival on February 18 at which works of art – painting and sculpture – will be raffled. To this end we are contacting the BEST artists in Germany and France ("canons") and asking them to donate a small picture (no graphics or watercolors) for the lottery.

(Vasily Kandinsky, letters to Alexei Jawlensky, unpublished, by kind permission of Maria Jawlensky Archive, Locarno.

August 8, 1936.

[In 1933 a whole selection of pictures had been consigned to the store room] to continue their ghostly existence in half-darkness, where their shrill dissonance might hurl reproach at the ruined world from which they had come. [...] From this collection the Folkwang Museum has sold the large oil painting, "Improvisation," executed in 1912 by the Russian Vasily Kandinsky (b. 1866 in Moscow) to the Ferdinand Möller Gallery in Berlin for 9000 Reichsmark. [...] It cannot be mere coincidence that it is an uprooted man, an exile from his own fatherland, who gave birth to this idea, which is now no more than a kind of incomprehensible game for the mind which conceived it; a mind which considers itself the ultimate intellect, but which is actually a half-educated, undisciplined intellect, opposed to life and suicidal. [...] Only a Russian mind could have dreamed such a thing up. [...] The fact that such a strongly interested party has come forward for this picture, prepared to pay out such a handsome sum for it, should not cause displeasure. It is known that synagogues number among the places of worship here. They are built with no expense spared. The people who enter them are those who belong in them. We, however, do not. A good photographic reproduction more than suffices as a reminder of this attempt to Russify German art.

(Count Klaus von Baudissin, Director, "Das Essener Folkwang Museum stösst einen Fremdkörper ab," in *Essener Nationalzeitung*, August 8, 1936.)

VII.

389 *Kandinsky, 1935*
 Photo: Hannes Beckmann
 Musée national d'art moderne
 Centre Georges Pompidou, Paris

VII PARIS

CHAPTER ONE
THE LAST MOVE

By the end of 1933 Kandinsky realized that he had no desire to remain in Hitler's Germany. According to Nina he also considered emigrating to Switzerland and Italy.[481] However, it seemed more logical to settle in Paris, where his recent successes at the 1929 and 1930 shows seemed to have paved the way. The first had been a solo watercolor exhibition at the Zak Gallery, the second a show at the France Gallery. He had sold pictures at both (among others, two watercolors to André Breton). Moreover, *Cahiers d'Art* had recently published several of his theoretical essays as well as a short monograph by Will Grohmann.

After his early successful appearance in *Les Tendances Nouvelles* in 1904 and his virtually unbroken participation in the Salon d'Automne and elsewhere since then (see Chronology), it was only during his Moscow years that Kandinsky's contact with French art had been interrupted. It had been especially vigorous at the time of the Blaue Reiter, with Henri Le Fauconnier acting as middleman between him and Delaunay, Girieud, even Matisse and Picasso (see pp. 132 f.). Kandinsky was thus no stranger to Paris. In 1906 he had almost sought refuge there from his complicated personal situation in Munich, and he had been offered a teaching post there in 1907 (see p. 103). But when Gabriele Münter had taken lodgings in Paris, Kandinsky had spent a year in the suburb of Sèvres to get away from the busy life of the metropolis. His own artistic vision had not yet become strong enough to withstand the din of Paris.

This all changed when he made a name for himself internationally. The cosmopolitan Kandinsky considered a city in which Spanish (Picasso and Miró), Czech (Frantishek Kupka), Dutch (Piet Mondrian), and many other international artists had made their home to be the ideal choice for him. His familiarity with that city since his first visit in 1889, the language and the fact that all Russians of education were attracted to France in general were enough to make him feel perfectly at home there.

To his astonishment, however, his welcome was far from warm. The art capital of the world was overrun with artists; competition had replaced comradeship; the only art that attracted any attention was that linked with scandal, such as Surrealism.

Paris was blasé. The arrival of one more political refugee made little impact there. Kandinsky complained bitterly:

> It's incredible that no effort is being spared to support the academics who were obliged to leave Germany; they get a warm welcome everywhere, while we artists, who've also had a raw deal, are left out in the cold. People are even trying to make the most out of our situation by making ludicrously low offers and then complaining that we're stubborn. This is no

more and no less than to actively support the National Socialists' art policies.[482]

Kandinsky was undoubtedly right, though most art dealers were probably unaware of the consequences of their attitude. Abstract artists were the least welcome in Paris. There had been hardly any tendency toward abstraction since Cézanne, the Fauves, and the Cubists. The full potential of this art had not been realized in France. Mondrian, Kupka, and Arp were experiencing difficulties too. The economic situation was such that art once again seemed a deplorable way to earn a living. The following letters to Jawlensky, published here for the first time, are a vivid reflection of Kandinsky's first months in Paris:

On January 23, 1934, one month after moving to Neuilly, he wrote:

We don't want to leave Germany permanently (we've got deep roots there!), but we'd like to stay in Paris for a couple of years. [...] Our flat's on the sixth floor, with a great view of the Seine, the hills behind it, and a huge expanse of sky. The Bois de Boulogne is a couple of minutes away. [...] The Paris art market is on its last legs. You can't sell a thing, and the few exhibitions that are still being organized hardly attract any visitors.

Then on February 20, 1934:

As far as exhibitions are concerned, apart from the USA and recently England, you're wasting your time. I heard that in Belgium nearly all the galleries of modern art have shut down. At any rate, the only art that's selling there is Belgian. In addition, the galleries are now charging for hanging space! If you can exhibit for free in Belgium, it's worth it, because interest in modern art is still keen there in spite of everything. [...] Marcel Duchamp was here the other day, he's just got back from New York. Life's a lot brighter over there. [...] Prices here have crashed, partly because they'd been artificially pumped up. That doesn't bother the Paris dealers who have already made their packet, but the artists are in real trouble – no exceptions. We met Chagall too, he's very nice. He's got fat and bald. His wife is really sweet too.

July 3, 1934:

Recently we went to a concert of [Thomas] Hartmann and thoroughly enjoyed it. [...] It was a great success. They've both stayed as sweet and uncomplicated and sincere as they were in Ainmillerstrasse. They came round yesterday and send you their fondest love.

August 9, 1934:

Yesterday we were at the Arps' [Hans/Jean and Sophie Arp], very nice people, we get on well with them.

April 3, 1935:

You ask whether there might be a chance for you to exhibit your work in Paris. Believe me, I mention you here a lot. Exhibiting in Paris is both easy and difficult. It's easy because nearly all the art dealers (including the bigwigs) are letting artists have their space ... for a fee. Not much (from about 2000 FF), but you have to pay for transportation costs and publicity! Nearly all the critics charge for their articles. Besides that, gallery owners only exhibit those artists with whom they have a contract.

December 23, 1935:

There's a *marvellous* exhibition of Dutch painting running at the moment – mainly Van Eyck, Brueghel, and Bosch.

May 14, 1936:

Yes, hackney-cabs and artists certainly haven't got it easy. They're being squeezed out by taxis. We're being squeezed out by everything that bows to Mammon instead of to things of the spirit. People are convincing themselves that art is a luxury, but jewels, expensive furs, cars, 500 FF lunches, even private planes are "life's essentials." Well, you can't wear a picture on your finger, or wind it round your neck, you can't drive around in it, and you certainly can't eat it. And who needs to be able to fly high in a spiritual way?

July 26, 1936:

Nothing other than "dead old masters" is selling here now. That's how an art dealer put it. We've got fresh competition from abroad, the Surrealists. They're chic, cheap, and have snob-appeal. They had a big exhibition in London recently, and the "shattering" number of visitors covered all their costs and more. [...] Now the Museum of Modern Art in New York is planning an even bigger exhibition of Surrealist art. In America, where "sex-appeal" counts for a lot, they'll probably score an even bigger hit. Long live Freud and his followers! [The last sentence was in German; it was followed by a description of a Surrealist picture and an eccentric lecture by Salvador Dali.] Dadaism in the West and the "Donkey's Tail" in Eastern Europe [Mikhail Larionov's *Oslinny khvost* in Moscow] caused no less of a stir, but that was 20 years ago.

On March 24, 1937 Kandinsky mentioned the Surrealists again: "However, we out-moded dodos are still looking for purity of expression."

September 20, 1937:

> I'm working, "a stupid habit," as I like to say. But without this "habit" life would be rather dismal. However many difficulties an artist has – in every respect – I would still ask to be an artist all over again, if I had a second life. [...] Benois is living here, writing for the Latest News. We've met a couple of times, he's nice, but unfortunately can't identify with new art at all.[483] Every now and then we see the Chagalls, apparently they're grandparents now. Between you and me, we are a little afraid of artists, they are over-sensitive about things that don't really matter. We move in a small circle of friends, of which artists make up less than half.

March 27, 1939:

> There's a good Cézanne show here at the moment. Fifteen years after his death he's all the rage in Paris. Smart cars are driving a smart crowd up to visit the exhibition rooms. Belated Success![484]

There is sarcasm in these letters, but no bitterness. But the artist's difficulties in Paris were not over yet. Narrow-minded nationalism, which Kandinsky had not expected to find, isolated foreigners who had not yet found their niche. When invitations failed to come, Kandinsky went out and made his own contacts. But he remained a rather lonely figure, as his letters show. Apart from Duchamp, he mentioned only other foreigners to Jawlensky. These were his old friends the Hartmanns, Lisa Epstein, who lived on the other side of town, the Russian writer Alexei Remisov, and the sculptor Anton (Antoine) Pevsner. Kandinsky certainly had no desire to belong to the patriotic and often bitterly divided circle of Russian emigrés. It was bad enough that the French press had almost confused him with Chagall when he arrived; bad enough that, like the German press, it had dismissed him as a proponent of exotic Russian "folklore."

Kandinsky was not able to identify with the artistic philosophy of the Surrealists, though the latter at least recognized his work; they seemed to him too restrictive, clannish, and complicated. Nevertheless, he may have shared their interest in psychoanalysis (see his descriptions of dreams, his prose poems of 1913, his theater piece *Violet*, and a few of his later poems), though he never studied the theory of psychoanalysis in any great detail. His own creative processes had no use for the "automatism" that characterized the early phase of Surrealism in particular. In the face of the continuing incomprehension of abstract art, Kandinsky clarified his earlier statements concerning the artist's "inner necessity" as "artistic honesty."[485] How-

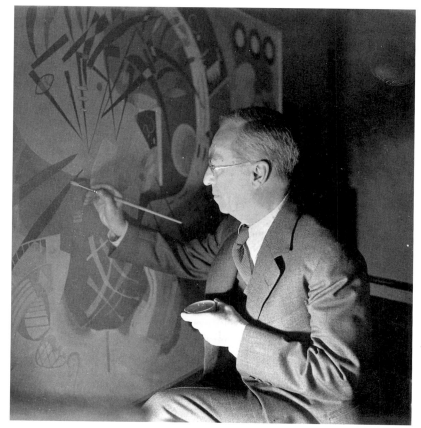

390 *Kandinsky Painting* Dominant Curve, *1936*
Photo: H. Roger Viollet
Musée rational d'art moderne
Centre Georges Pompidou, Paris

ever, he did not immediately ask what kind of unconscious forces were driving the hand of the artist engaged in "automatic" painting or writing, or what the origin of so-called chance might be, to which the Surrealists attributed such importance in the creative process. Might it not be traceable to the same source as his "inner necessity?" It is interesting that the apparently irrational Kandinsky should have dismissed out of hand the idea of chance, used widely by the Surrealists and many other artists. He went as far as to reject "ready-made" materials, such as those used in collage, preferring to stay in absolute control while yet following his intuition. If this wavered, he would simply set down tools and wait for it to pick up strength. Conscious calculation and the ability to "construct" were just as essential as the skills he acquired in craft work. He had no secrets; his abstract art was no special "language" that had to be learnt to be understood:

> People shouldn't complicate this issue unnecessarily. My "secret" is purely and simply that I have over the years acquired (perhaps even won) the happy ability to rid myself (and therefore my painting) of "background noise," because I considered *every* form to be alive and full of sound and therefore expression.[486]

by lamplight; in the evenings he sometimes sketched or worked on his essays. During these years he published a dozen essays. Nina also reveals the following important point. Kandinsky did not begin a piece of work until all the details, all the colors were ready "in his mind's eye." She says that, "his ideas for pictures came to him like a photograph."[504] He sometimes – though not always – could dispense with preliminary sketches altogether. This is fully consistent with his methods in Munich, as shown by Gabriele Münter in the four photographs she took over the three and a half days in which he completed *Composition VII* (see pp. 212f.). Nina goes on to describe how her husband invariably concentrated on one work at a time, in contrast to Klee who worked on several paintings simultaneously. This is corroborated by a letter from the artist to Freundlich in which he excuses himself for not coming to his opening, as he had just finished one picture and had felt obliged to begin the next one straight away: it had been in his head for six months and he simply had to free himself of it.[505] Nina continued:

> Kandinsky, who hardly ever used pure colors [i.e. ready-mixed paints], used to mix his palette himself from various tones. With powder colors he used a mortar. Because his palette was made up of such sophisticated colors, it was hard for forgers and imitators to copy his pictures ... The colors differ from picture to picture, at times even within the same picture.[506]

It is significant that Kandinsky never allowed anything to distract him. When concentrating on his work, he turned down visits to exhibitions and other events. Nina respected his wishes and never disturbed him in his studio, shielding him from visitors and trivial problems. Her role became increasingly important after twenty years of happy marriage. Although she was not an artistic "equal" like Gabriele Münter, but "just" a loving wife, she does not deserve the dismissive treatment she has received at the hands of some critics.

395–396 *Sketch for* Composition IX *and its Frame, 1936*
Musée national d'art moderne
Centre Georges Pompidou, Paris

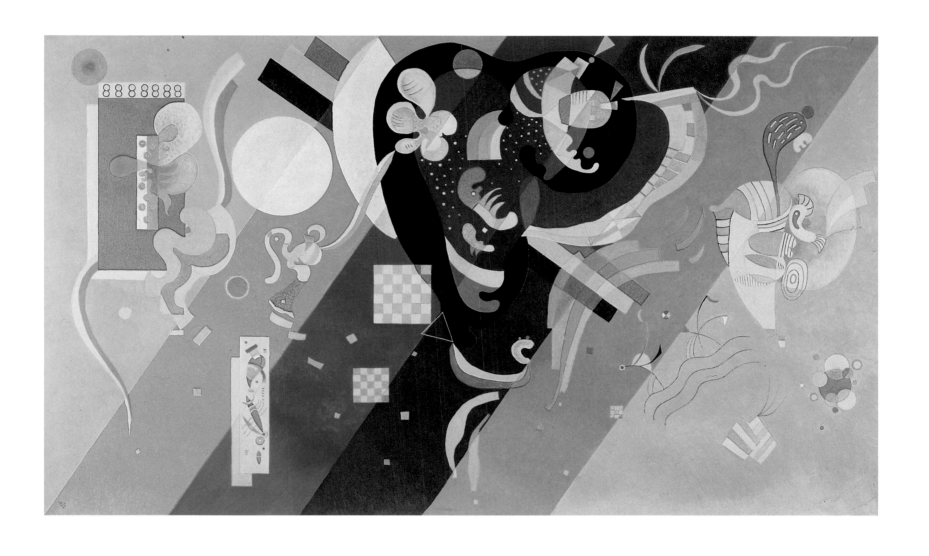

397 Composition IX, *1936*
Oil on canvas, 44 ⅞ x 76 ¾ in
Musée national d'art moderne
Centre Georges Pompidou, Paris

DOCUMENTS

Letters to Galka Scheyer

July 3, 1934.

*Serious things take a long time to mature. [...] Typical
sign of moral-cultural decay. Typical organic, necessary
consequences of pure materialism. "Spirit! Morality!"
God, how old-fashioned! "Objective!" – Hell, how
childish! If you want to be "up-to-date" you have to be
spiritless, amoral, and over-subjective. I'm not given to
hating things; I hardly ever do. But what I absolutely do
hate is Modernism. [...]*
*What I'm particularly pleased about is the enthusiastic
welcome my work gets from young people – I have
many young admirers. Nothing could be worse than to
be dismissed by young people as an "old wreck." Even
the Surrealists, who otherwise reject "abstract" art
outright, take a positive view of my painting. [...] In any
case, young artists have it easier than we did; we paved
the way nicely for them, sanding it so they won't slip. An
art historian said of me once that I could have enjoyed
greater public success, that I had earned it, but that the
law of nature dictates that "the pioneer smooths and
indicates the way, but never gets anywhere himself."*

January 5, 1936.

*I often use color combinations that are "forbidden" in
Paris, and young people are pleased at my "cheek."[507] In
general, the old "harmonies" and the same old themes
are still in vogue here – still life, figures, landscapes.
When the "pretentious" paint that way, their drawing is
"correct." When the avant-garde paint that way, their
drawing is "incorrect." Paris still has many small-town
elements, not only in that respect. In spite of everything,
though, Paris is unique.*

March 23, 1936.

*I call people who don't think only of their own interests
and who are capable of loving something other than
themselves "abnormities." The "normal" person of
today is worse than terrible, and to call those rare
exceptions "eccentrics" would leave things unsaid. With
my somewhat tattered but nevertheless incorrigible
"optimism" I know that the future belongs to the
"abnormals." We won't see it, but it will happen.
Definitely.*

May 29, 1936.

[On the early picture Crusaders *with the two knights,
cf. ills. 93, 94.] From the outset I was interested in*

*"contrasts," which I later used in a less literary way until
I arrived at purely "painterly" contrasts. I said to my
Bauhaus students, "there is only one eternal law in art –
the law of contrasts."*

June 29, 1937.

*As a historian Barr suffers from discovering influences
that at times appear rather odd. For example, the
comparison of my* Landscape with Two Poplars *(ill.
217) with a picture by Gauguin! Or my old watercolor
with Malevich, not bad either. What capped it all was the
claim that my Parisian painting was influenced by Arp
and Miró. Barr might just as well have mentioned Corot
instead of Arp and Velazquez instead of Miró. You learn
all over the place – even from weaker talent (you're not
supposed to!). Miró once said to me he would be
eternally grateful to me for his "liberation." I often hear
things like that from younger people who have no reason
to curry favour with me. In any case "influences" on
form aren't significant, but historians are rarely aware
of this. They often call such external connections
"schools." In my opinion, school is the spiritual stimula-
tion of the next generation. The passing on of form is
epigonism. I'm grateful to Barr, because he didn't say
my painting was derived from Cubism, as is often the
case in Paris, but from Cézanne, which I agree with. I
had the initial shock from Claude Monet's* Haystack
*when I was still in Moscow. At that time I understood
darkly, that is "unconsciously," that the object does not
exist as such. With Cézanne I understood that the
painter has to paint. [...]*

June 29, 1937.

*It's nice to see that the few remaining Bavarian land-
scapes that I did in 1908–09 are going down very well
here. But what I'm really proud of is that the colors are
just as vivid today as they were when they were still
damp! I've not been wrestling so much with technical
problems for nothing. Self-praise! What a lot of
illiterates the great painters here are these days as far as
technique is concerned, you'd hardly credit it. In actual
fact you have to know your craft. What good is the finest
shoe, if the leather splits after a couple of days?
Strangely, there's been a lot of importance being
attached to "brio" and "primitive savagery in painting"
here up to now. These qualities are supposed to indicate
"temperament!" No, temperament doesn't only consist
of noise, but more importantly of mastering and direct-
ing inner tension.*
*You, my beloved wallet, how great your power is in
"Parisian Art." People used to say "cherchez la femme."
Where are you now, poor femme? You've been usurped
by the wallet.*

December 23, 1937.

You have to have an eye for true art. But the eye alone cannot manage the task, it has to lead into the "depths" that I call "soul" following old customs. An eye AND a soul! Rare...

August 13, 1938.

[I know] that my pictures contain a calm confirmation of LIFE, not of life. It is a great relief for me to have achieved this. This was my dream (although I was unaware of it at first). Earlier on I wanted more "noise," and in 1914, i.e., before war and revolution broke out, a "great calm" began to hover before me. I started with the most strictly limited means of expression, which did me a lot of good. Nowadays, this calm "Yes" holds its own even in the most complicated pictures. Quite right too! [...] When we emigrated to Paris, I was unable to work for three months. It was a shock. I thought I was no longer a painter. It was really unpleasant. I never work during holidays, I just absorb everything, unconsciously, but all the time. When I get back, I am unable to work for a while. It is always a shock – for heavens' sake, it'll be the same old thing when I get back from the Riviera. But it always comes along later like an explosion.
[...] So I've not done nearly enough for some time. Nowhere near enough! I'd like to do something BIG – the sort of size of the lightning we had here a couple of days ago which ripped through half the sky and seemed to be fixed "for ever" in the heavens.

April 21, 1940.

All the really awful things that people of today are experiencing will lead eventually to a spiritual awakening. When exactly this will finally come about, I've no idea. Maybe by the year 2000.

(Vasily Kandinsky, letters to Galka Scheyer, unpublished with a few exceptions, by kind permission of the owners Hella Hammid and Peg Weiss.)

398 Sketch N° 24, *1933*
India ink, 12¾ x 17⅞ in
Private Collection

399 Sketch, *1933*
India ink, 9⅞ x 13¾ in
Private Collection

CHAPTER TWO
BIOMORPHOUS STYLE

In 1933, shortly before his emigration, Kandinsky produced several large-format drawings using a variety of different forms. These include *Sketch No. 24* (ill 398), a geometrically linear, apparently Constructivist work, and *Sketch* (ill. 399), the very delicate, horizontal composition partly drawn free hand. There is a pronounced emphasis on the right side of this picture, rarely found in Kandinsky's work. In the watercolor *Above – Below* (ill. 391), which was a gift to Klee and very closely associated with his pictorial language, Kandinsky continued to develop what he had worked on at the Bauhaus since 1927. This is also true of the two magical, "constructively reduced" temperas on black paper (ills. 403, 404), in which delicate lines readily bring to mind the pen-and-ink drawings that the artist was to produce in Paris later on.

Although Kandinsky had not confined his efforts purely to geometric pictures in the previous years, a definite change of style can be detected after the usual few months' "post-upheaval rest" following his emigration. His last German picture, *Development in Brown* is a heavy, sombre, constructional work (although the title does not necessarily refer to the Nazi regime). In contrast, his first Paris picture, *Montée Gracieuse* of March 1934, seems like the arrival of a personal springtime. It is light, vibrant, and executed in cheerful pastel colors, evoking Kandinsky's optimism and readiness to absorb new ideas from the Paris he loved. This change is not as abrupt as that of 1915, however; rounded shapes predominate slightly over geometric ones, although for the most part Kandindsky seems to have tried to combine the two types of form in a balanced manner.

Woven (ill. 406) was a new departure for the artist. The double figure stretching upward looks as if it has been crudely knitted together, in stark contrast to the treatment of the geometric form on which it rests. The playful work *Pointed Oval with Loop* (ill. 405) is reminiscent of Paul Klee in both form and title. It is interesting that Kandinsky called the thick line detached from any other shape "loop;" it is applied here much more decoratively than in his earlier works, where the same motif tended to have a more whip-like appearance, as in *Composition V* (ill. 214).

In *Division – Unity* (ill. 400) Kandinsky once again explores the regular distribution of forms over the entire picture plane. He emphasizes his favorite compositional element, the diagonal, through a regular grid. The main thrust of the movement is toward the top left corner, which unbalances the picture and offsets its flat and static elements. The grid separates the small, wilful, brightly-colored "toy" figures from each other. A preparatory sketch for this painting contains the note, written in Russian: "White and violet background, surrounding pink and gray tones."[508]

A variation on this theme appeared six months later in

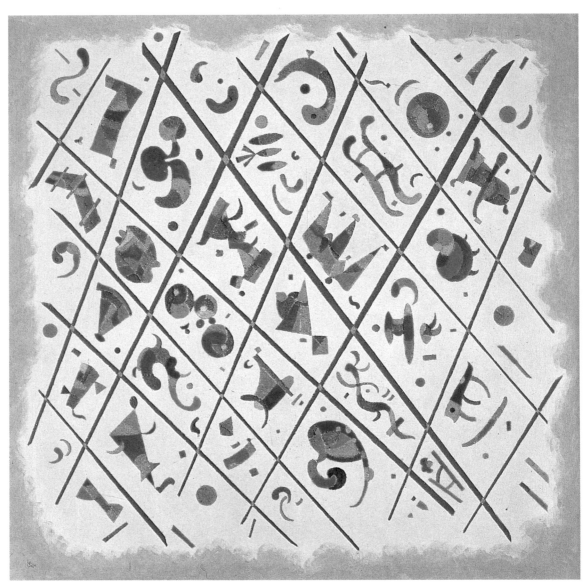

400 Division – Unity, *1934*
Mixed media on canvas, 27¼ x 27¼ in
Seibu Museum of Art, Tokyo

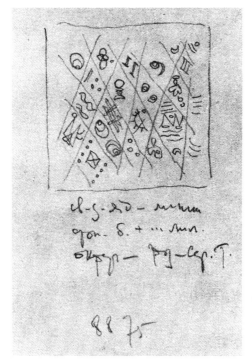

401 *Sketch for* Division – Unity, *1934*
Pencil, 6 x 6 ¹¹/₁₆ in (sheet)
Musée national d'art moderne
Centre Georges Pompidou, Paris
Nina Kandinsky Bequest

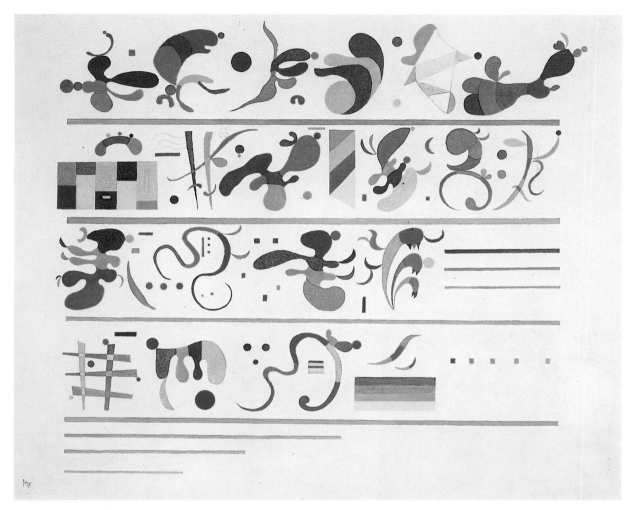

402 Succession, *1935*
Oil on canvas, 31⅞ x 39⅜ in
The Philipps Collection, Washington, D.C.

larger format. *Succession* (ill. 402) is a balanced, cheerful masterpiece. The figures are mainly rounded and have a more mobile, plant-like appearance. Their effervescence is only slightly diminished by the marked horizontal grid. The effect of these even stripes is enhanced by the absence of any diagonal or vertical lines to split the "little beasts" up. How is one to view these works? One option is to let the imagination run riot and conjure up amoebae, jellyfish, insects, worms, or strings of cells. Another is to approach things scientifically and go through all the biological diagrams in Kandinsky's encyclopaedias, demonstrating which embryonic shapes have been copied and discovering

the names of the worms, etc. the artist must have used as a model. Vivian Barnett has done precisely this in staggering detail.[509] Kandinsky himself included examples from the world of nature in *Point and Line to Plane* (see p. 273), but is the study of the origin of such shapes in books, or the works of Klee or Miró, really relevant, assuming that Kandinsky has *transformed* such elements into his own art? The origins of Max Ernst's collages have been traced quite clearly to clippings from specific newspapers, which have been lent artistic qualities exclusively by his own arrangement and composition, but such an exercise seems fairly pointless.

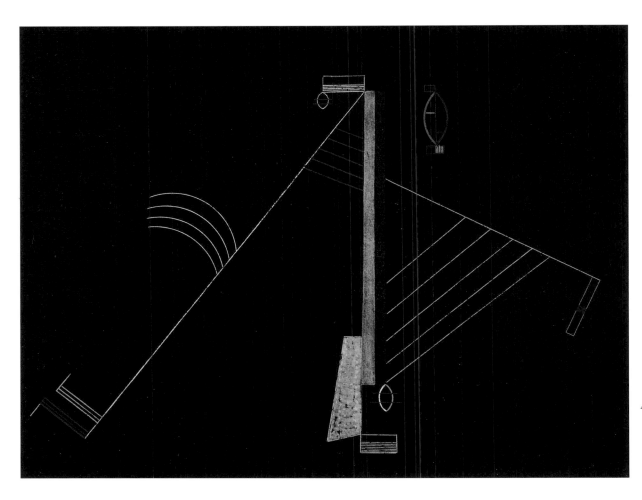

403 Stretched on Two Sides,
 1934
 Tempera Nº 591,
 on black cardboard,
 16½ x 23³⁄₁₆ in
 Private Collection

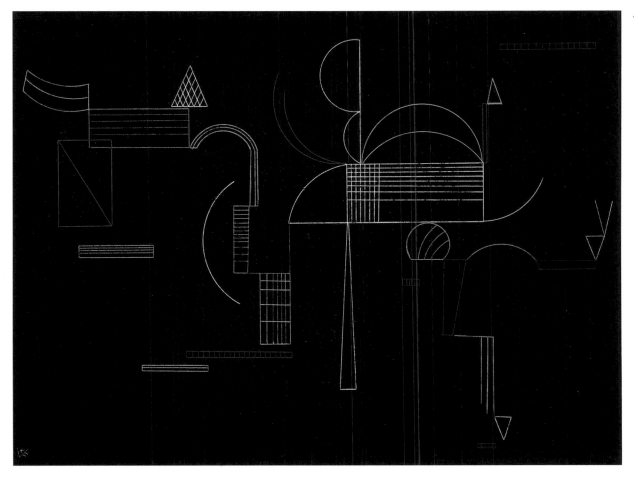

404 From Here to There,
 1933
 Tempera on black
 cardboard,
 16½ x 23³⁄₁₆ in
 Private Collection

335

405 Pointed Oval with Loop, *1934*
Pen and India ink, 13 5/16 x 9 1/16 in
Graphische Sammlung
der Staatsgalerie, Stuttgart

406 Woven, *1934*
Pen and brush with gouache on dark brown paper,
18 3/8 x 12 13/16 in
Graphische Sammlung
der Staatsgalerie Stuttgart

Artists' sources often include printed material, other works of art (for example the Mona Lisa *minus* her Duchampian mustache), nature, whether viewed through a telescope or a microscope, and subjective optical illusions, such as those seen when looking at the sun for a moment and then closing the eyes. The important thing, though, is what the artist *makes* out of these elements. It might help some viewers to have a better understanding of Kandinsky's pictures if they knew about their "origins," but it might well hinder others to be reminded constantly of insects or embryos or placentae. Better to try and forget any prior knowledge while looking at works of art, as Kandinsky himself made a practice of doing. During the twenties he supported research and analysis, because he was interested in laws of color, form, and composition in painting as outlined in *Point and Line to Plane*, rather than as some kind of detective work to discover the sources of iconographic components.

It is of course always possible to make such extra-pictorial identifications in Kandinsky's oeuvre, for example "Origin of Life in Primeval Shapes," "New Beginning from the Very Basics," or "Formation and Structure of Pure Vitality;" this is fine, as long as one does not overlook the play of color and movement, the emphases, tensions, and overall composition and the way these show a refinement and enriching after the Bauhaus years.

In the very large major work *Dominant Violet* (ill. 407) the artist resolves the tension between a few enlarged, round shapes and a subtle, horizontal-vertical pictorial structure in a highly complex manner. The playfulness of the round shapes is anchored by the geometrical stripes, but almost threatened – or stimulated? – by the zestful, domineering violet form. Even the surface texture is varied; Kandinsky mixed in finely ground sand to produce a coarse, matt texture which accentuates the soft pastel colors. The forms worked in this way seem very flat, almost solid and tangible. This particular technical innovation was the most important to occur during the artist's Paris years, and one that he was to repeat in most of his large pictures thereafter.

In *Subdued Circles* (ill. 408) Kandinsky resurrected a theme from ten years previously. The delicate, precisely outlined, intersecting circles of different sizes executed in very subtle color washes appear almost transparent, like bubbles, and their association with the night sky is faint, despite the dark background.

It took Kandinsky two years after settling down in Paris to begin his next monumental painting. This was *Composition IX* (ill. 397) following on from his compositions of thirteen years ago. This composition is characterized mainly by the division of the background into wide diagonal stripes, by the new plant and microbe shapes, the small rectangles on the left (which evoke a picture within a picture), and by the two chess-boards near the center. The only thing intersecting the diagonals is the vibrant composite figure outlined in black, which cuts in just above the center to create a surprisingly high central focus. When this picture was bought by the Jeu de Paume in 1939, Kandinsky's suggestion to the museum director for a frame to complement it was, as usual, highly unconventional (ill. 396).

Kandinsky's "archive sketch" of *Composition IX* in his private catalogue is interesting as well (ill. 395); every detail is included, despite its tiny scale. Such drawings helped the artist to remember each picture he painted and the forms he had used in each case. For example, in the sketch of *Thirty* (ills. 411, 412) he included thirty basic forms, instead of being satisfied with a photograph or a larger sketch. An illustration cannot show that the picture is a meter-wide oil painting. Most areas seem like delicate ink-pen drawings, others like woodcuts. The work is strikingly imaginative in both its treatment of details and its overall composition, where alternating black and white squares evoke a chess-board.

Shortly after completing *Composition IX*, Kandinsky used his new motifs in the smaller *Red Knot* (ill. 414), enlarging them to fill the picture and thus giving them added "vitality." Two dense central focal elements are split up by an elegant, thin red line. Positioned quite high above this, the picture has another smaller central focal point.

Kandinsky reworked the delicate aspects of *Composition IX* into the larger masterpiece, *Center with Accompaniment* (ill. 409). The heaviest, most concentrated form again dominates the upper part of the picture, while the smaller, sophisticated figures are scattered playfully over the bright, hardly noticeably modulated background. These are balanced by the forceful horizontal-vertical structure of fine lines and pastel-colored rectangles. The striking effect of lightness also comes from the empty bottom-left corner, out of which a thin black line wiggles its way upward. There is a similar empty corner with four wavy lines emerging from it in *Mouvement I* (ill. 410). Kandinsky described such thin, wiggly lines in *Point and Line to Plane*, calling them *"flagella"* i.e., sperm. Although he may have been unconscious of the fact, it can hardly be pure chance that these "sperm" cells sally forth mainly from the bottom-left corner, in which the reclining couple is located in earlier pictures, or in which the word "Origin" (*zarozhdenie*) is written in earlier sketches (preparatory work for *Composition VII*, see ill. 255). If asked to indicate the "point of departure" for most of Kandinsky's pictures, artists and lay-observers alike would point to the bottom-left corner.

A characteristic of all Kandinsky's great works of this period is the "neutralization of gravity," the practice of positioning heavy elements in the upper part of the canvas, thus making the motion of the picture appear to be straining upward, as in the first abstract oil painting of 1911. In spite of the horizontal format, the "earthly" or calm elements are neutralized by an upward movement. Using formats so much larger than those of his Bauhaus days, the artist was purely indulging his own pleasure, since he was hardly likely to sell any of these over-sized pictures.

407 Dominant Violet, *1934*
 Mixed media on canvas, 51³/₁₆ x 63¹³/₁₆ in
 Adrien Maeght Collection, Paris

408 Subdued Circles, *1936*
Gouache on black paper, 19⅝ x 10 1/16 in
Thomas Gallery, Munich

409 Center with Accompaniment, *1937*
 Oil on canvas, 44⅞ x 57½ in
 Adrien Maeght Collection, Paris

410 Mouvement I, *1935*
 Mixed media, 45 ¹¹/₁₆ x 35 ⅛ in (detail)
 Musée national d'art moderne
 Centre Georges Pompidou, Paris

411/412 Thirty, *1937*
 Oil on canvas, 31⅞ x 39⅜ in
 (with pencil sketch)
 Musée national d'art moderne
 Centre Georges Pompidou, Paris

413 Red Form, *1938*
 Oil on canvas, 32⁵⁄₁₆ x 23⅝ in
 Adrien Maeght Collection, Paris

414 Red Knot, *1936*
 Oil on canvas, 35⅛ x 45¹¹⁄₁₆ in
 Maeght Foundation, Saint-Paul-de-Vence

341

But let us look at what Kandinsky himself says about his work of the mid-thirties. Here is an excerpt from his final "supplementary analysis," concerning *Animated Stability* of 1935 (see ill. 416 and Kandinsky's sketch after it, ill. 415), a forceful and particularly impenetrable work:

Stiff, schematic structure: two stressed verticals. At the upper right a circle – a form that is simultaneously hard and soft, stiff and loose, displaying concentric and eccentric tensions. In this case, the concentric tension is emphasized by the deep-violet color of the circle, and the neighboring area of green. This somewhat poisonous green intensifies the depth of the violet, and with it the concentric element.
The combination of these two colors and the combination of rounded and angular [forms] create at this point the strongest *accent* in the picture.
"Distortion" is used sparingly: a few crookedly placed rectangular and oval forms. Below them, the large red rectangle at the lower left.
The combination of white, black and red within the red rectangle creates the second *accent*, to which the "crooked" position of the rectangle contributes most. These two accents manifest an invisible *tension* between them (see the dotted line in the sketch). This main tension goes in a diagonal direction, loosening the larger and smaller horizontal-vertical tensions.
The three long rectangular forms (from left to right: white, black, and green), being lesser contrasts, are given for the most part thin horizontal lines with very few diagonals. In this way, a number of gentler tensions are created.
A few "independent" forms and finally the lower acute angle intensify this "loosening," "enrich" the stiff structure, and accelerate its "pulse."
In this way what is hard and stable becomes "animated".[510]

415 *Sketch after* Animated Stability, *1937*
India ink and pencil, 7 x 4⅝ in
Musée national d'art moderne
Centre Georges Pompidou, Paris
Nina Kandinsky Bequest

416　Animated Stability, *1937*
Mixed media on canvas, 45 11/16 x 35 1/8 in
Miyagi Museum of Art, Sendai, Japan

417 Many-colored Ensemble, *1938*
Mixed media on canvas, 45 $^{11}/_{16}$ x 35 $^{1}/_{8}$ in
Musée national d'art moderne
Centre Georges Pompidou, Paris

418 Animated Oval, *1935*
Gouache and watercolor, 18 ⅞ x 14 ⅜ in
Thomas Gallery, Munich

419 Variegated Black, *1935*
Mixed media on canvas, 45 ¹¹⁄₁₆ x 35 ⅛ in
Adrien Maeght Collection, Paris

Soon after this, the artist produced a completely different picture, Nina's favorite, *Many-colored Ensemble* (ill. 417). He also called this *Ordered Arrangement*, which describes it rather better. It is one of the few pictures that cannot be properly reproduced. Kandinsky's allusion to "goldsmith's work" in 1915 can certainly be applied to this work too. Its precise, highly lustrous, multi-colored circles are closely clustered together on the black background, producing a joyful, festive riot of color. It is reminiscent of such early decorative works as *Riding Couple* and *Motley Life* (ills. 101, 104), which ended his short phase of brightly colored tempera and oil paintings on a black background – for thirty years.

Like many pictures of this period, *Many-colored Ensemble* has a remarkable border. As if he did not trust the frame, Kandinsky has painted an outward-spreading oval-

heart-shaped outer zone in which the actual picture seems to float. The small *Animated Oval* of 1935 (ill. 418) was a cheeky experiment with the idea of a picture within a picture within a picture . . . In fact the oval is surrounded no fewer than five times, notwithstanding the signature interrupting the center space instead of being in the corner. The artist evidently had mixed feelings about borders. In his glass paintings and in several oil paintings of 1911, he had painted borders to "go with" the picture. In Moscow he had also experimented with round and oval internal "border zones." Now he was playing with borders, causing them to intrude into his compositions. The festive, almost two-dimensional and symmetrical *Many-colored Ensemble*, brings to mind the wide, irregular metal borders of icons, from which only the very center of the picture (the saint or his face) appeared as the focus.

420 Various Parts, *1940*
 Oil on canvas, 35 ⅛ x 45 ¹¹/₁₆ in
 Städtische Galerie im Lenbachhaus, Munich

421 Sky Blue, *1940*
 Oil on canvas, 34 ⅜ x 28 ¾ in
 Musée national d'art moderne
 Centre Georges Pompidou, Paris
 Nina Kandinsky Bequest

Russian icons were usually fitted with a gold or silver frame, which covered all but the precious, central part of the image (it was only in museums that such frames were removed). Kandinsky in his later period may well have wanted to give an icon-like aspect to certain of his pictures, by adding protective borders of color to his composition as internal "frames." In the case of such pictures as *Sky Blue* (ill. 421), with its faintly modulated, shadowy surrounding color wash, this is doubtful, however. He did it for purely optical reasons; transforming the flat dimension of the canvas, or making the shapes "hover" more clearly in the space created. Such conscious annihilation of actual space reflects Kandinsky's experience of Russian steam baths, in which figures seem to "hover" at some indeterminate point, neither near nor far away (see p. 204).

Psychological research into introvert and extrovert behaviour might suggest that whoever finds the relation between picture and frame problematic also has problems identifying with his own surroundings and the people around him. However, such experiments as the suggested frame for *Composition IX* (ill. 396) are also legitimate attempts to break away from the traditionally hide-bound "easel pictures."

Will Grohmann was also reminded of icons by Kandinsky's Paris pictures, but for different reasons: "the divisions of the paintings are related to the contrast between the large and the small forms."[511] The unusual division of large pictures into individual fields, as in *Various Parts* (ill. 420), is like many Western and Eastern religious pictures, in which scenes from the life of a saint are arranged in little self-contained episodes around a large-scale central portrait of the saint himself. In folk art in particular, the difference in size between the figures is indicative of their relative importance (see also Kandinsky's glass paintings, pp. 126ff.). But Kandinsky's biomorphous, at times almost anthropomorphous figures are certainly governed by their visual relevance to the picture, rather than the laws of perspective.

A different explanation of Kandinsky's predilection for compartmentalizing his pictures might also be his long-standing love of the Russian "red corner" where collections of icons, folk pictures, and other personal treasures were hung close together. The arrangement of his own flat (see ill. 30) would seem to suggest this. In museums and exhibitions, where spatial limitations result in pictures being hung close together, he was often in favour of hanging highly diverse pictures on the same area of wall, so that their *combined effect* created a picture."[512]

CHAPTER THREE
THEORY AND PRACTICE

The artist acknowledged universally (or at least in expert circles) as the founder of abstract painting had been living in the artistic capital of the world for several years. Kandinsky was referred to as "*Patron*" or "*Master*" by younger artists, and, less appropriately, as "Father of Surrealism." Surely by now he was no longer troubled by the kind of critical blindness and misinterpretations to which his work had been subjected in his earlier years? Was it not sufficient that all his pictures had been removed from public collections in Germany? We shall see nonetheless that his difficulties were not confined to Germany alone.

At the age of seventy, Kandinsky received yet another slap in the face from an art historian, albeit not quite so painful a one as that delivered by Carl Einstein on his sixtieth birthday. When the director of the New York Museum of Modern Art, Alfred Barr, published his study of Cubism and Abstract Art in 1936, Kandinsky was given a copy straight away. The painter immediately shared his impressions of it with many of his correspondents (see pp. 330, 354). On the whole he was pleased by the sensible book; but he was justifiably angry that Barr had claimed he was influenced not only by Malevich (see p. 330), but also by Miró and Arp. Miró had expressed his gratitude to Kandinsky for his artistic "liberation" (see Documents, p. 354). The two artists' pictures are comparable in certain respects, as are Kandinsky's and Arp's. The three artists got on well with each other. Kandinsky wrote to Grohmann in 1935: "This small man [Miró], who always paints enormous canvases, is actually a real volcano in miniature, spewing forth pictures. He's got quite incredible reserves of energy and strength."[513]

In the years since Barr's book, people's knowledge of the forms used by Kandinsky, which remind us in part of Miró and Arp, has deepened, as has their knowledge of the gouaches and temperas on a black background that he painted from the twenties on (ills. 403, 404, 408). There is a glaring generation gap; Kandinsky never attempted the sorts of indecorousness with which Arp and, especially, Miró experimented. Moreover, it is a general rule that younger artists learn from older ones, not only because that is a "law of nature," but also because older artists, who tend to have become more set in their ways, do not always understand younger ones as well as vice versa. Obviously there are exceptions, such as Kandinsky's younger colleague, Paul Klee, with whom he had a *mutually beneficial* relationship, but such exceptions are rare. Miró, twenty-six years Kandinsky's junior, and Arp, from whom Kandinsky may have borrowed one or two forms, never considered themselves to have influenced their esteemed friend in any way. Thus Rose-Carol Washton Long's claim that it would have been easy for Kandinsky to see Miró's pictures in Paris and be inspired by their biomorphic abstraction is rather surprising.[514] Miró might just as well

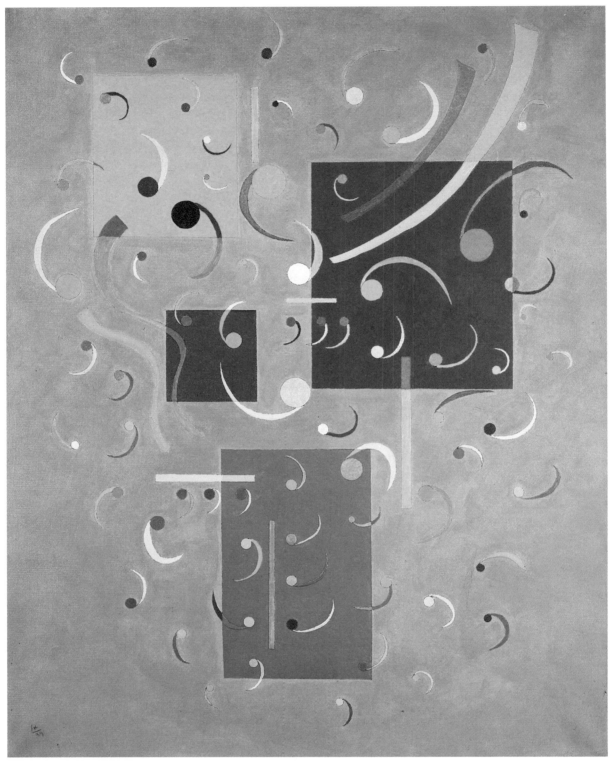

422 Circuit, *1939*
Oil on canvas, 36¼ x 28¾ in
Adrien Maeght Collection, Paris

have been influenced in 1935 by Kandinsky's gouaches on a black background, which were exhibited along with some of his watercolors in the Zak Gallery in 1929.

Be that as it may, the mature Kandinsky, respected by his fellow artists, was once again compelled to explain his art and theory. He did this more succinctly and wittily than previously, as the following extracts from the dozen or so essays he wrote during this period will show.

Two times two herring = four herring, and seems to be an everlasting law that remains absolutely firm. Two times yellow and two times yellow is? Often = zero.

In art, enlargement is often reached through diminution. What happened to calculation? Logic smiles, embarrassed. Mathematics scratches its head.

Is there anyone who still wants to calculate a work of art? (And who still wants to calculate it?)

The artist "hears" how something or other tells him: "Hold it! Where? The line is too long. It has to be shortened, but only a little bit! Just a little bit, I tell you." Or: "Do you want the red to stand out more? Good! Then add some green. Now they will 'clash' a little, take off a little. But only a little, I tell you." What Henri Rousseau considered to be his "dead wife's" dictate.

The "dead wife" is the inexhaustible source of the "wonders of art." The road that disappears into infinity. One must have the perception to "listen" when the voice sounds. Otherwise, no art.

In such a way does the artist "create" and "measure" the forms, and in such a way arises "proportion, balance". "Construction!" [...]

Life does not consist only of "realities." What then will happen to the "unreal?" Where would we be able to find room for the dream? Not the dream about the "Seven-League Boots," which has already come true, but the unreal – which together with the real world creates the world.

The spiritual individual has been "castrated;" only half a man has been put into the place of the whole one.

When people in the good old days (before the World War, which is still not "paid for") made fun of our dreams, then they were still alive because they spat out of indignation. [See p.132.] They spat because they apparently had their own dreams, which were offended by ours. They spat because they had experienced the work of art, even if in reverse. When today they have lost this negative connection with art, then the "propeller" is more than a little guilty. [i.e., speed, technology etc.]

No, it is not megalomania to dare to state that the art of today does not "say" less than was the case hundreds of years ago. Rather, more.

Twenty-five years ago painting discovered, and so did sculpture quite soon afterward, a new "language" – a "speech" with exclusively artistic means – without a single "addition." This language is the so-called "abstract," or whatever one wants to call it. Isn't it remarkable how this "pure," unmixed language (without "stucco"), according to many people, completed the gap between art and life.

Art seemed unable to follow life. Or was it maybe life that was unable to follow art? I would like to answer "yes" to this question. A very energetic "Yes."

[...] I ask you to understand that my painting does not try to reveal "secrets" to you, that I (as many people think) have not found a "special language" that has to be "learned" and without which my painting cannot be "deciphered."

This should not be made more complicated than it really is. My "secret" consists solely of the fact that over the years I have obtained that fortunate skill (have maybe fought for it unconsciously) to liberate myself (and with that my painting) from "destructive secondary noise;" so that each form becomes alive and vibrant – and consequently expressive, too. Simultaneously, I have experienced the bliss of "hearing" the weakest language. And so I have fortunately been able to extract, with complete freedom and without restraint, whatever form from the endlessly great "treasure of form" that I need for a particular moment (work of art). Here, I do not need to worry about the "content," but solely about the right form. And the correctly extracted form expresses its thanks by providing the content all by itself.

Here lies the solution to the "abstract art" issue. Art remains silent only to those who are not able to "hear" the form. But! Not only the abstract, but each kind of art, however thoroughly "realistic" it may be.

The "content" of painting is painting. Nothing has to be deciphered. The content, filled with happiness, speaks to that person to whom each form is alive, i.e., has content. The person to whom the form "speaks" will not unconditionally look for "objects." I willingly admit that "objects" are a necessity of expression for many artists, but these objects remain something incidental to painting. Thus the conclusion follows that objects do not necessarily have to be regarded as something inevitable in painting; they can just as well have a disturbing effect, which is what I feel they have in my painting.

[...] The creation is free and must remain so, i.e., not becoming oppressed by anything except what is required by "the internal dictate": "the voice of the dead wife." Therefore, I do not become shocked when a form that resembles a "form in nature" insinuates itself secretively into my other forms. I just let it stay there and I will not erase it. Who knows, maybe all our "abstract" forms are all together "forms in nature" ...

(Vasily Kandinsky, *Assimilation of Art*, 1937, CW, pp. 799–803.)

Q: People often say abstract art no longer has any connection with nature. Do you think so too?

No! And no again! Abstract art leaves behind the "skin" of nature, but not its laws. Let me use the "big words" cosmic laws. Art can only be great if it relates directly to cosmic laws and is subordinated to them. One senses

these laws unconsciously if one approaches nature *not* outwardly, but – *inwardly*. One must be able not merely to *see* nature, but to *experience* it. As you see, this has nothing to do with using "objects." Absolutely nothing! [...]

Q: Equally, people quite often say "abstract painting" comes exclusively "from the head." Is that true?

It happens not infrequently that it is true. But...it is no less often true of "representational" and "realistic" painters. Man's "head" is a necessary and important "organ," but only if organically linked to the "heart," or to "feeling" – call it what you will. Without this link, one's "head" is the source of all kinds of dangers and disasters. In all realms. Hence in art too. In art even more so: there have been great artists "without heads." But never without "hearts." During great periods, and in the

case of great artists, there has always been this organic link between head and heart (feeling). It is only in times of great confusion such as we have today that one can possibly nurture the miserable thought that art can be arrived at by the head alone.

(Extracts from an interview with Kandinsky by the art dealer, Karl Nierendorf, 1937, CW, p. 807.)

[...] In every more or less naturalistic work a portion of the already existing world is taken (man, animal, flower, guitar, pipe...) and is transformed under the yoke of the various means of expression in the artistic sense.

[...] Abstract art renounces subjects and their reformulation. It creates forms in order to express itself.

[...] This can happen in various ways. As for me, I prefer not to "think" while working. It is not entirely unknown that I once did some work on the theory of art. But: woe to the artist whose reason interferes with his "inner dictates" while he is working.

Thus, next to the "real" world abstract art puts a new world that in its externals has nothing to do with "reality." Internally, however, it is subject to the general laws of the "cosmic world."

Thus, a new "world of art" is placed next to the "world of nature"... a world that is just as real, a concrete one. Personally, then, I prefer to term so-called "abstract" art concrete art.

(Vasily Kandinsky, *Abstract or Concrete?*, 1938, CW, p. 832.)

Letters to J. B. Neumann

May 25, 1935.

It's 25 years since my first "abstract" picture, painted in 1911. I must say that I have never lost heart and have stayed firmly on my "perch." What else could I have done, since in my work the only thing I obey without question is my driving force, or should I say, my calling... [...]

An "-ism" starts getting dangerous when it negates the fundamental law of art. This fundamental law is that every artist of every age draws his artistic "nourishment" from external nature. The difference is one of variety of "expression" or questions of "form." The other danger is not necessarily directed at art, but puts the artist himself at terrible risk. This danger consists of the construction of some "infallible principle" that the artist feels he has to follow at whatever cost. Set programs are always a "deadly risk," (I love that Bavarian word, "Mordsgefahr"), whether they be in politics, medicine, physics, or whatever. But the worst thing of all is the consequences they have for art, because

423 *Study for* Green and Red, *1939*
India ink, 8½ x 6⁵/₁₆ in
Adrien Maeght Collection , Paris

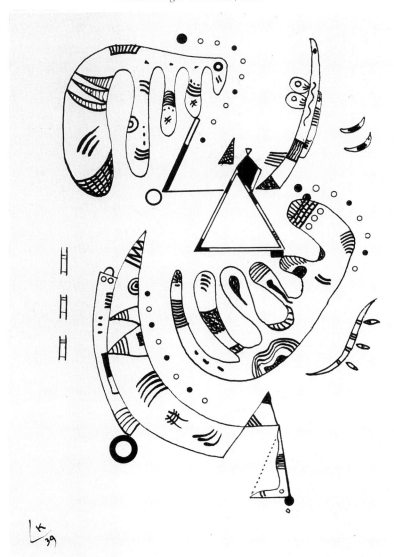

they lead to the death of art. Luckily, art has got an incredibly well-developed capacity to save its own life! But it can "feign death" for some time, as it is doing in some countries today, where art is supposed to be produced "in accordance with official dictates." I have already saved myself twice from such official dictates, because I am convinced that art can only develop in complete liberty.

[...] If the whole situation is ever fully understood and properly "digested," then true abstract art will come into its own. It will celebrate a great victory, because it will be in the position to reveal a hitherto undisclosed world of art. People will say "thanks!" to us over and over again. Perhaps this time is not so far off. In your native America, where people are not slaves to sickly traditions (to differentiate from the healthy ones) quite to the degree of Europeans, it may happen sooner than elsewhere (which is why I said "thanks" rather than "merci" or "Danke").

July 4, 1935.

[...] my Cahiers d'Art exhibition, for which I requested you to be sent an invitation. The exhibition looks very good and is enjoying a huge success here. Paintings from 1934 and '35, watercolors from the last four years, drawings since 1910.

October 21, 1935.

Naturally I also have phases, but the difference is that, within a phase, I never stick to the same theme or same mode of expression or same technique. This is one of my peculiarities, that makes my work difficult to "understand". [...] My "root" remains the same, but my "tuning fork" is constantly changing. [...] Corresponding with this difference in "tuning fork" I have selected a few watercolors for you too. These include "dramatic" and "lyrical" works, hot and cool and very cold, heavy and feather-light, but all of them having my own "equilibrium," which Zervos says is always an enigma. I know how to balance out, and I like doing it, but so that the object looks unbalanced from the outside. Talking of external appearances, balancing out is not only very easy but incredibly boring. But since I use (not all those possible, but nonetheless) various "means to an end," so the external equilibrium, as in Watercolor No. 369 Horizontal – Blue also manages to fight back against boredom, because of its effortless construction, its very limited means and the completely "insubstantial" blue. I have already written in On the Spiritual that "all means are holy, if they stem from inner necessity" (something like that). There are many people who travel far and wide, but eat their native cuisine whereever they go. It's due to this damned force of habit, which makes people deaf and blind. [...] Try to teach the people of New York that they

should be glad that I am not always the same, and that I am in a position to present a variety of worlds to them.

December 28, 1935.

Is it really necessary to put frames around the works for the exhibition? 200 dollars is a lot of money. At one time, I was putting on an exhibition of watercolors with Möller in Berlin, and we decided to experiment and hang the pictures unframed. It looked so good, we left them like that...

February 27, 1936.

It would be dangerous to make a writer out of me or to make me seem too much like a writer. What did Goethe say? "Poet, put down your pen!" In his day it was extremely dangerous for artists to write anything, because they were then suspected of being able to think. I told my students how terribly scared artists used to be of thinking. They sat there and waited for their Muse to come along. Normally they'd sit for hours in some café. Along would come the Muse and ask, "pale, medium, or dark?" [meaning beer, of course] Then the artist would make a grab at her.

March 21, 1936.

I've been working hard, and I've produced a few large pictures which aren't too bad. Of course, these days, large pictures are almost always a "self-indulgence."

May 4, 1936.

Over here I'm deliberately not included among the "abstract" artists, because people don't like the word. I don't give a damn about fear of words, and so I was glad to take part in an exhibition with several young, abstract artists.

May 10, 1936.
[Kandinsky is thanking Neumann for the book by Alfred Barr, *Cubism and Abstract Art*, New York, 1936.]

The book has many positive aspects. One is particularly rare. The average art historian (not without reason is the German word pronounced to mean "art hystericals") suffers from an inflated ego. He feels himself bound to "criticize," to allocate "value," to give magnanimous praise, or to wag an admonishing finger – just as a teacher might do to small children. Barr has avoided doing this and has actually written his book from a historian's point of view. Of course, he is rather prone to the Parisian disease of deriving everything from Cubism. But even in this case he is a refreshing exception, in that

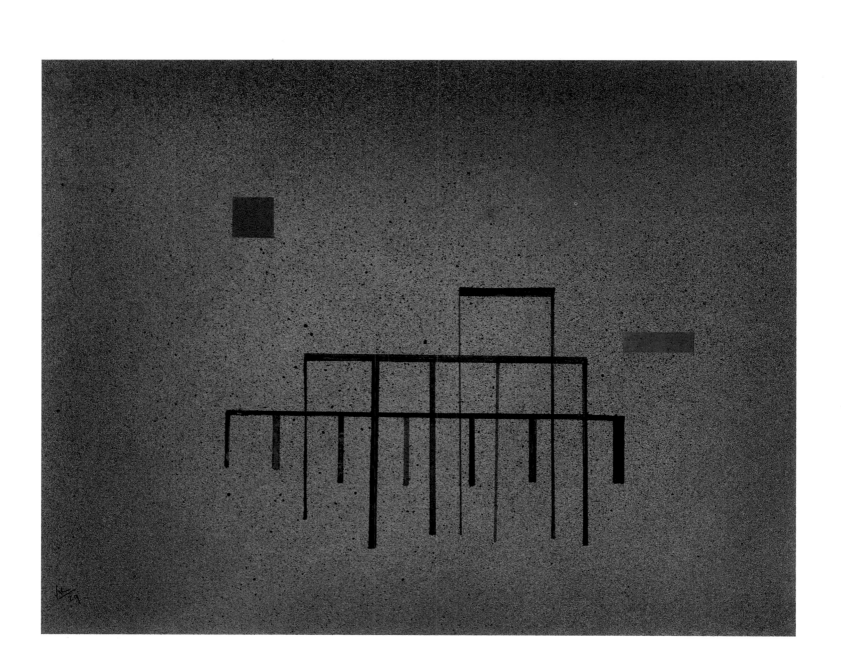

424 Horizontal – Blue, *1929*
Watercolor, gouache, and blue India ink,
9 1/2 x 12 1/16 in
The Solomon R. Guggenheim Museum, New York

he derives "Abstract" ("Expressionism") as an independent branch of "Synthetism," just as he does for Cubism.

May 10, 1936.

Over here I often have to explain to the hide-bound art historians that abstract art, in the way that I founded it and that I practice it, has nothing whatsoever to do with Cubism! And never has had! [...] I've heard many a young artist over here say that it was my art that "liberated" them and gave them "fresh heart." Miró, to name but one. I've also been dubbed the "father of Surrealism" on more than one occasion. An illegitimate one, as far as I'm concerned. [...] People are always trying to discover my "secret," that is to get some kind of explanation from me as to why my stuff is always so well "balanced out." I'll make no secret of the fact that this aspect (among others) of my work arouses great astonishment. And of course I am aware that such a precise "construction" can only be achieved through feeling, and I am the best-equipped for that. That's enough swanking for now!

May 14, 1936.

As far as influence on form is concerned, I've experienced one or two amusing things on occasions. For example, I gave a lecture in Plauen once, and a fine gentleman came up and thanked me afterwards ... for his millions! "I am the first lace manufacturer to use abstract shapes. At first I was laughed at by my colleagues, but now they admire me, because I have earned a fortune from this "abstract" lace. And do you know what gave me the idea? Your pictures. So I'm thanking you now." I said, "My pleasure! What about my commission?" He laughed his head off.

June 9, 1936.

[In France, people were worried that a dictatorship was about to be imposed.] I'm really not keen to see a third dictatorship come into being. So I'm prepared to take up the pilgrim's staff once again. God, if only it were just a staff! What about furniture? And more importantly, pictures? And more importantly still, the money needed to pay for the move and setting up in a new country?

July 23, 1936.

The Surrealists are a panoptic mirror, in which all the ills of our beautiful times are beautifully reflected, or rather magnified. So-called abstract art, on the other hand, is the reflection of the healthy roots of the future. The percentage of healthy people to sick ones is 1:100. But in spite of this I know that the future belongs to the healthy. In any case it's wonderful that people who are interested in art do exist, such as yourself, Galka Scheyer, Nierendorf, and more besides. But not that many.

February 10, 1937.

[Paris exhibition was a great success, it had even been prolonged. Even young people were attending it, which always pleased Kandinsky.]

(Vasily Kandinsky, letters to J. B. Neumann, Archives of the Getty Center for the History of Art and the Humanities, Los Angeles.)

[For the most part these have never been previously published. They are particularly interesting in that Kandinsky tells his new gallery owner some of his basic ideas about his art.]

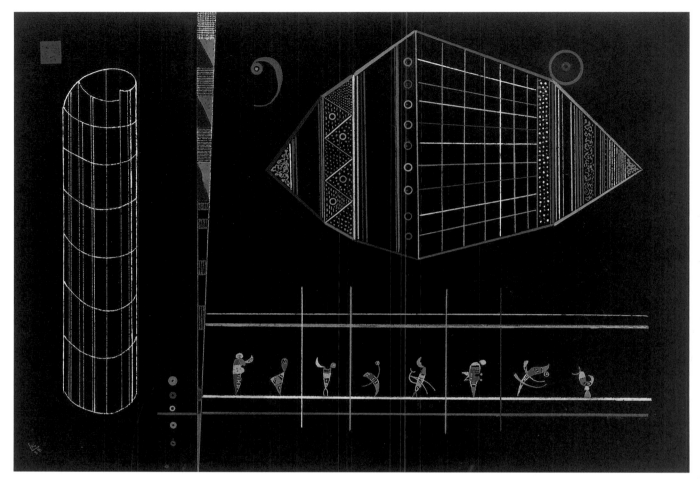

425 Over, *1938*
Gouache on black paper, 13⅜ x 19½ in
Private Collection

CHAPTER FOUR
NATURE AND ART ARE NOT TWO DISCRETE
REALMS

This chapter heading might appear to contradict the earlier chapter heading "Nature and Art are two discrete realms," an idea that had helped Kandinsky in his pre-abstract days to win through in a tough competition with nature and overcome the final obstacle to his own artistic development. His love of nature was profound, but so too was his need to view art as a world in its own right. Even as a young artist he had been aware that art cannot exist independently of cosmic laws. In the early days he simply concentrated more on the difference between art and nature. Summing up his opinion later in Paris, he stated that a work of art is not produced by putting together parts of nature, but "by following the laws of nature that govern the universe as a whole." Just as a musician might compose a sunrise piece, without physically reproducing the cock's crowing, so might the artist also paint the break of day using purely artistic means. "This morning, or rather the whole of nature, life, and the entire world surrounding the artist, plus the life of his soul, are the single source of his art."[515] Michel Henry was quick to pick up on this characteristic statement by Kandinsky (cf. p. 375).

In a letter to Galka Scheyer written on May 19, 1935, Kandinsky repeated this basic idea, with a significant addition:

What about my relationship with nature or the outside world? I love the whole of LIFE and therefore also the whole of nature; the experiences I have here are the fount of my creativity. [...] I'm noticing less myself, although it is constantly being brought to my attention, that my experiences with the natural world find their way immediately into my painting. I myself notice what is gained from my travels – the ocean, then Africa, Palestine, etc. The move to Paris totally altered my "palette."[516]

Some readers might be surprised to learn about the large number of detailed and almost poetic descriptions of different effects of light Kandinsky observed in Paris, central Germany, Moscow, and Bavaria, as if he were an Impressionist landscape painter. It is significant that, even in his "most abstract" period, he never felt himself to be cut off from nature, but remained keenly aware of it:

> Work is going wonderfully well here. The Paris light is very important to me, although it stopped me from working for two months when I first arrived, because it had such a shattering effect on me. The difference in light to central Germany is enormous – here it can be simultaneously bright and gentle. There are gray, overcast days also, with no rain, which is rare in Germany. The light on these gray days is incredibly rich, with a varied range of color and an endless degree of tones. Such a quality of light reminds me of the light conditions in and around Moscow. So I feel "at home" in this light. At the other extreme, I love the light in Bavaria, where it's like "thunderbolts," illuminating great chasms, and always "fortissimo." I learned a lot there.[517]

426 Around the Center, *1939*
Watercolor, 19 11/16 x 12 5/8 in
Private Collection
Photo: Beyeler Gallery, Basel

Kandinsky also learned a lot in Paris, where he was entirely devoted to his painting, alone but for Nina's supportive presence. Perhaps light was more important to him than social intercourse.

Around the time Kandinsky painted *Many-colored Ensemble*, he began work on his tenth and last *Composition* (ill. 427), which was completed in early 1939. This major work is his only large composition on a black background, which the artist modulated, creating a "black within black" around each shape, as he did more often with his paler background colors. In spite of its honorary title of "Composition," it does not come up to the standard of many other works of his later years as far as subtlety and originality are concerned.

Concurrently, Kandinsky produced a whole range of smaller gouaches on black paper, which are just as significant a part of his oeuvre as his drawings and watercolors, and not just in terms of quantity. *Over* (ill. 425) of 1938 is a tiny, captivating masterpiece, as is *Around the Center* (ill. 426) with its distinctive composition and rich, finely differentiated color application in the most diverse and imaginative forms. Many other gouaches followed, of which a few examples are given here: two very beautiful gouaches of 1940; a muted, watercolor spray picture showing only two forms; a tectonic, and a "Constructivist" work on gray paper (ills. 428–430, 432, 433). These testify not only to an amazing range of pictorial ideas, but also to the artist's complete mastery of both lyrical and subdued tones and of their combinations. Like the comparable works from his Bauhaus years, these gouaches appear to be "feather-light" (as Kandinsky himself describes them, see Documents, p. 352), almost like ink-pen drawings.

427 Composition X, 1939
 Oil on canvas, 51³/₁₆ x 76³/₄ in
 Kunstsammlung Nordrhein-Westfalen, Düsseldorf

428 Untitled, *1940*
Tempera, 19⅞ x 13 in
Private Collection
Photo: Beyeler Gallery, Basel

429 Untitled, (Pink and Blue), *1940*
Gouache, 12 x 18½ in
Private Collection
Photo: Beyeler Gallery, Basel

430 Untitled, *1940*
Watercolor, 19½ x 12⅜ in
Private Collection
Photo: Thomas Gallery, Munich

Kandinsky also produced a voluminous sketchbook over the course of 1941 (ill. 431). These small drawings are perfectly complete works of art (not only because they are signed, since Kandinsky sometimes only signed to indicate which way up the pictures go). Some served as studies for oil paintings or gouaches, with slight modifications (ills. 434, 436). *Balancing* of 1942 more or less follows the structure of the drawing. However its effect is completely different, because the central "bridge"-component is pale instead of dark, and the character of the picture is much softer due to the pastel colors and pale background. Naturally the impact of the delicately outlined forms is far weaker in an oil painting five times larger than the drawing. The main focal point is transferred to the left of the picture. All this goes to show what an infinite variety the artist was able to produce even when adhering closely to a preliminary sketch.

Two years later Kandinsky created *Dark Center* (ill. 436) from a very simple drawing, following the basic structure and adding considerably to the variety of forms. Such works are interesting because they transpose an ink-pen drawing onto a black background, which remains dominant amidst the forms, defined almost exclusively by lines and faint dots. Here too Kandinsky's lengthy artistic development bears fruit. To describe his later gouaches as "kitsch" (Derouet) is a gross misjudgment and failure to appreciate their quality.

431 *Four drawings in India ink*
Sketchbook of 1941,
11 3⁄16 x 7 5⁄16 and 7 5⁄16 x 11 3⁄16 in
Private Collection

432 Untitled, *1940*
Gouache and India ink
on brownish paper, 19¼ x 12⅝ in
Private Collection

433 Untitled, *1940*
Gouache and India ink, 18 ½ x 12 in
Adrien Maeght Collection, Paris

434 Balancing, *1942*
Mixed media on canvas, 35⅛ x 45¹¹⁄₁₆ in
Adrien Maeght Collection, Paris

435 Sketch, *1941*
India ink, 7¼ x 11³⁄₁₆ in
Sketchbook of 1941
Private Collection

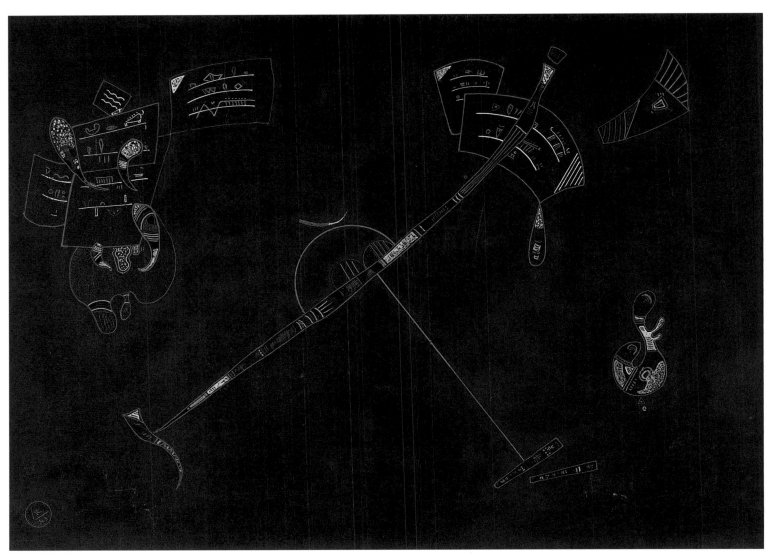

436 Dark Center, 1943
 Mixed media on cardboard, 16½ x 22 ¹³⁄₁₆ in
 Private Collection
 Courtesy Beyeler Gallery, Basel

437 Sketch, *1941*
 India ink, 7¼ x 11 ³⁄₁₆ in
 Sketchbook of 1941
 Private Collection

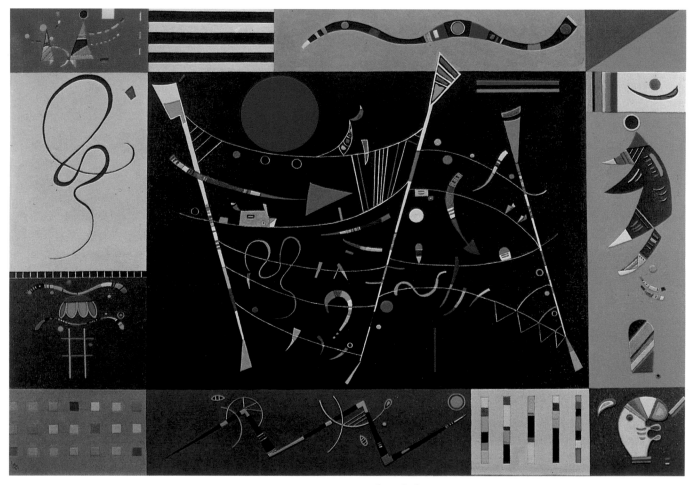

438 The Whole, *1940*
Oil on canvas, 32 x 45 ¹¹⁄₁₆ in
National Museum, Tokyo

439 *Sketch for* Little Accents, *1940*
India ink, 6 ¼ x 8 ⁹⁄₁₆ in
The Solomon R. Guggenheim Museum, New York

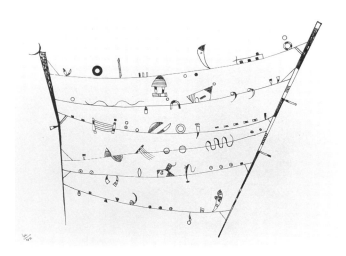

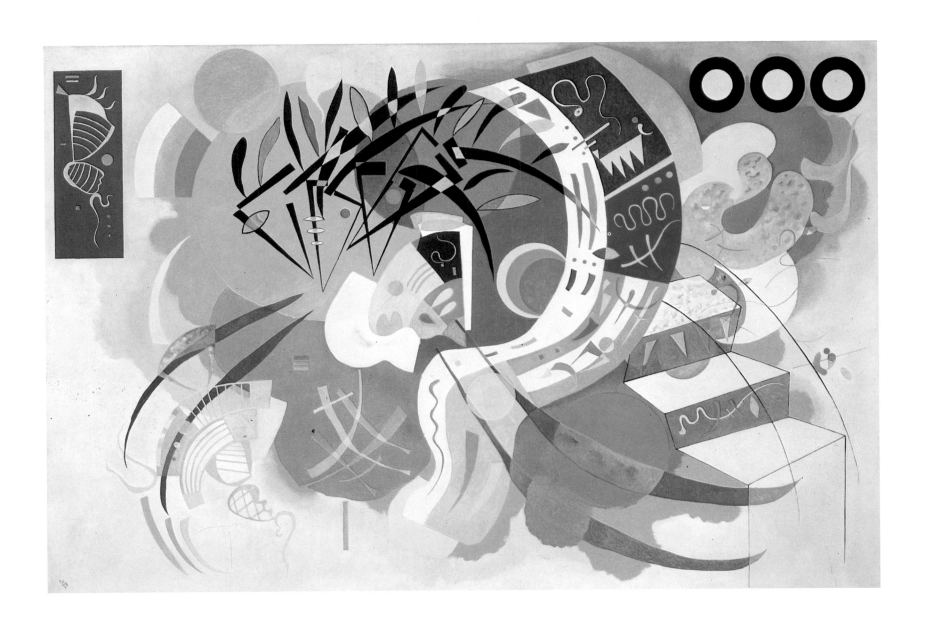

440 Dominant Curve, *1936*
Oil on canvas, 51 3/16 x 76 3/4 in
The Solomon R. Guggenheim Museum, New York

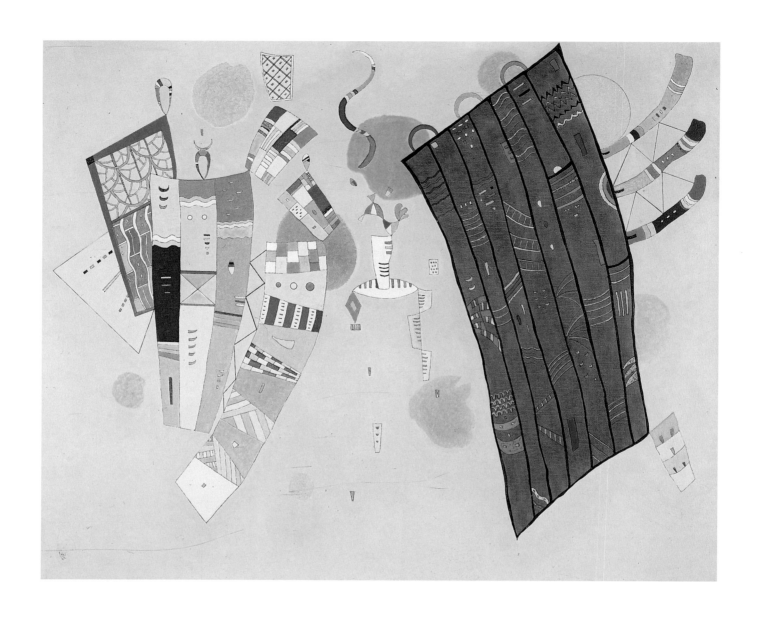

441 Delicate Tensions, *1942*
 Oil on canvas, 32 x 39⅜ in
 Adrien Maeght Collection, Paris

The small oil painting *Little Accents* in the Guggenheim Museum is based very closely on delicate, precise, "melodic" drawing, and the next work listed in Kandinsky's private catalogue, *The Whole* (ill. 438), shows some variation of the central composition. The works of Kandinsky's later years, as of his earlier periods, never suggest that he was short of inspiration, or that he confined himself to endless variations on the same theme. Nor do they show any signs of "routine" or superficial harmoniousness, although Kandinsky had come a long way from the violent images of his Munich days. His temperament had been channeled, but by no means stripped of its inspirational powers.

The works of Kandinsky's Paris years are substantially bigger than those of his Bauhaus period, but not as large as those he painted toward the end of his Munich period. Grohmann described them as "Baroque" because of their richness of form. Was Kandinsky trying to intensify the impact of his paintings on the viewer? Or was he compensating for the absence of commissions for wall paintings, such as he had in 1914, 1922, and 1931, commenting to Galka Scheyer that he was looking for "that kind of work;" (see p. 315)? Since he painted slowly and carefully in his mature period, the physical aspect of painting did not overly concern Kandinsky, as it did the abstract and Expressionist painters later on (how long a brushstroke can the arm execute without a break?).

1941 saw a sudden end to the large-format works. This puzzles some researchers, but those who are familiar with all Kandinsky's periods of creativity know that in Munich he always selected each canvas himself with a particular picture in mind. Once he had conceived the finished idea for the picture in detail, he would spend half an hour or more choosing the right size of canvas.[518] He invariably fitted canvas to idea, rather than vice versa. Consequently, he did not keep spare canvases in his studio. During the war, when he and Nina were again struggling with poverty and inadequate rations and fuel to heat their flat, canvases were simply not available. The artist appears to have been given a stack of German cardboard in 1943, on which he executed his last Paris pictures.

Two lilac and violet pictures of this period, *Light Ascent* and *Brown Impetus* (ills. 442 and 443), have a certain "oriental," sober beauty. It is not hard to recognize the figure of St. George armed with a lance on horseback. The dragon is reduced to a spiral snake, and – uncommon feature in Kandinsky's work – there is a letter between the two. Even if all this is not clear, the picture retains both its effect and its significance.

Isolation (ill. 444) includes a lance-bearing figure, a horse's head, and possibly a cart on the right-hand side. Although the lance is not pointing at anything, the isolated figure on a white background and composed of curious rectangular boxes seems threatening; perhaps it has taken the place of the dragon. Once again there is no limit to interpretation, but the artist himself warns us not to read

442 Light Ascent, *1943*
Mixed media on cardboard, 22 ⅞ x 16 ½ in
Adrien Maeght Collection, Paris

443 Brown Impetus, *1943*
Mixed media on cardboard, 16 ½ x 22 ¹³⁄₁₆ in
Adrien Maeght Collection, Paris

444 Isolation, *1944*
Mixed media on cardboard, 16½ x 22 ¹³⁄₁₆ in
Adrien Maeght Collection, Paris

him too literally, "the content of painting is painting" (see Documents p. 350).

Two Blacks (ill. 445) is a pared-down picture in the now less common vertical format. The two black rectangles are reminiscent of the boxes in the picture discussed above and lend this painting a very forbidding character. The precise, geometric internal structure contrasts with the other lighter, pastel-colored figures. There is a multitude of similar rectangular shapes in the smaller *Fanlike* of 1943 (ill. 446).

During Kandinsky's Paris years, the relationship between his sketches and paintings altered; even for his biggest pictures he now executed only a couple of preliminary studies. Christian Derouet speculates that the artist may have destroyed some of his preliminary works. However, a large number of insignificant sketches and mere doodles are preserved, even from his later period, some of them documented by Derouet himself,[519] and since there is no other evidence of the artist's "covering his tracks," this claim is probably unfounded. It is more probable that after forty years of professional creativity, Kandinsky, like Picasso, Braque, and Matisse, was able to produce original and high-quality mature work without much preparation. He had acquired a mastery of his craft

that made preparatory work redundant. The 1941 book and the small gouaches demonstrate the sureness of his strokes. His unique powers of imagination helped him to produce even large-format works by painting almost directly from his "inner vision."[520]

Typical of Kandinsky's final creative period is the lovely little work *Support* (ill. 447), its composition saved from being innocuous by the huge, offset red form. A similar effect is achieved in the larger, more intense *The Arrow* (ill. 448) with another bright red form paradoxically seeming to *hover* above three upright "figures."

In his final year, Kandinsky, already ill, used only small formats, executing watercolor compositions rather than gouaches. His *Last Watercolor* (ill. 449) is related to the Bauhaus picture *Fixed Flight* (ill. 388), with its parachute- or butterfly-like forms scattered over the canvas, forms that seem to drift aimlessly in space. Peg Weiss sees these as mushrooms and bases a whole theoretical argument on this. She claims that Kandinsky had connections with Shamanism, since "magicians" are known to use toxic mushrooms as drugs.[521] Unfortunately, her claim seems to be based on a misunderstanding of an explanatory comment in the translation of one of Kandinsky's early Russian texts, to which she thereafter attaches a disproportionate

445 Two Blacks, *1941*
Mixed media on canvas, 45 11/16 x 32 in
Adrien Maeght Collection, Paris

446 Fanlike, *1941*
Tempera and oil on cardboard, 22 5/8 x 16 1/2 in
Private Collection
Photo: Beyeler Gallery, Basel

447　Support, *1942*
Oil on mahogany panel, 7⅞ x 10¼ in
Private Collection

importance.[522] In fact Weiss has rather worryingly devoted an entire book as well as several essays to the subject, potentially encouraging future generations of critics to enshrine such opinions, as indeed has been the case with the previous generation. Thus scholarship has been bedeviled with such myths as: Kandinsky, a product of the Munich Jugendstil and Kandinsky, the portraitist of Stefan George.[523]

To return to Kandinsky and the facts: what Peg Weiss may in fact have meant, and what she, like everyone, is searching for, is the source of his obvious spirituality. For example, offering us his own interpretation of *Painting with White Border* (pp. 205 f.), he declares that he finds the conceptual definition of a picture "repulsive," because it is too restrictive. We may well imagine what his reaction would have been to "interpretations" based on Shamanism, cult objects, and simple superstition. Even Ringbom's and Washton Long's tendency to attribute the artist's spirituality to Theosophy and Anthroposophy is reductive; it angered Nina and Kandinsky's other friends. His belief cannot even be attributed to Russian Orthodoxy, though he was exposed to it for thirty years.

The artist himself explained it often enough: for him, art and religion were similar, and the content of painting was painting itself. Metaphysical concepts are not necessary to gain an understanding of Kandinsky's "secret," because, as he saw it, art followed a parallel path toward the same goal as religion. But it remained art. Obviously Kandinsky, like any great artist – even an atheistic one – was in his own way a priest, prophet, or magician, but this did not mean that he was inclined toward any particular "form of worship." Simply opening our eyes and looking at his pictures, with no preconceived ideas, tells us more about them than all the learned critical writings put together.

This can of course be applied to every artist's work. Art lovers and critics in Paris may have wondered why the Germans and Russians were making such a fuss about "seriousness," and why they – and Kandinsky – were accusing the Fauves, the Brücke group, and the Russian Cubo-Futurists of not being "serious" enough. Kandinsky never accused Paul Klee of a lack of seriousness, despite the latter's apparently juvenile "scribblings" (which philistines argued that a child of such-and-such age could have done just as well). He did not consider that playfulness, sensuousness, and liveliness could not be reconciled with seriousness. Kandinsky's graphic works and gouaches and his vigorous defence of such "playing around" make it clear that he did not reject decorativeness as such. His complaints about a "lack of seriousness" in other artists were no doubt caused by his impatience with the superficiality or

370

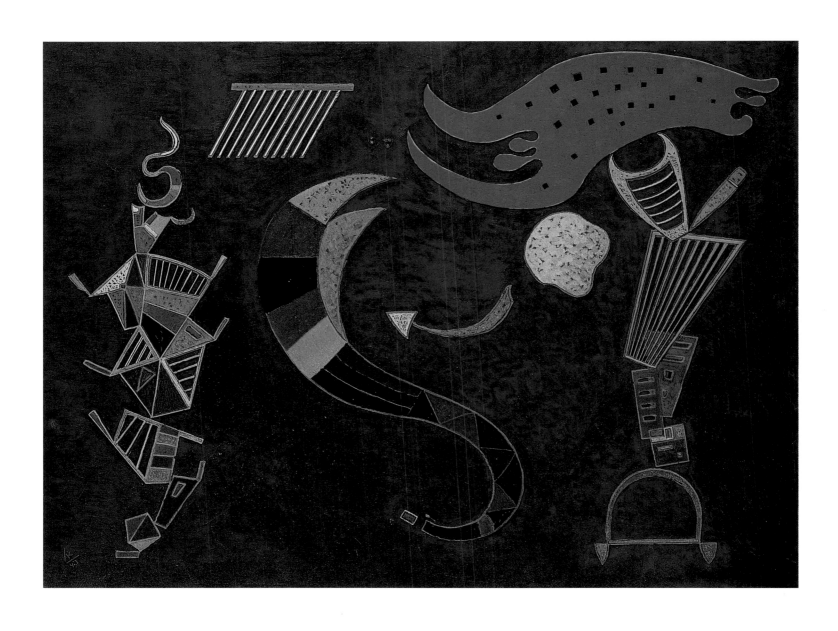

448 The Arrow, *1943*
 Oil on cardboard, 16 ½ x 22 ⅞ in
 Kunstmuseum, Basel

triviality of those whose spiritual and intellectual potential was not being developed to the full.

A particular characteristic of Kandinsky is his extraordinary thematic and emotional breadth. Whether he was able to reach the same depth in his versatility as, for example, Malevich and Mondrian did by consciously limiting themselves to a very few formal means, is open to question; and the answer for many experts is not always affirmative. Can one say that his less characteristic work is not always free from weakness? Perhaps it is simply the law of the market that decrees that Kandinsky's "untypical" pictures change hands more frequently, as if no one wanted to keep them. (For example, *The Elephant* struck the author as being a weaker work; then she found out that it was constantly being bought and resold).

It is also difficult to say in which pictures Kandinsky failed to meet his own exacting standards, since not every viewer can appreciate every one of his pictures. The diversity of approaches in Kandinsky's oeuvre calls for a corresponding diversity of approaches in those who judge it, from the most delicate and tender areas to the most savage, the most vigorous and harmonious, the most heart-rending, lyrical, and dramatic ones. When speaking of the "progress" of mankind in *On the Spiritual in Art* and elsewhere, Kandinsky meant principally its spiritual refinement, the opening of our minds to new, as yet unknown "sounds," tonal intervals, and nuances. He believed this could be achieved through painting as well as music and other art forms, especially those free of irrelevant detail, decoration, or subject matter. In short, those free of all "background noise" and, though Kandinsky rarely refers to this, free of the artist's ego as well. In this way a color composition full of tension can be experienced by viewers as a harmony; it can unlock their heart and make them more sensitive and receptive. Kandinsky claims: Christ did not overturn the laws of the Old Testament, but refined and added to them. Similarly the lyrical, tender aspects of painting can have an elevating spiritual effect on viewers.

Those minimal modifications in tone and color through the use of microtones, which are too subtle to be registered by the human brain and which therefore affect the subconscious directly, mentioned in Part III, Change of Instruments, seem to the author still to fall within the same subject-area. As far as the human voice is concerned, one might call to mind the chanting of Orthodox priests, who over centuries have mastered the art of modifying their vocal pitch by barely perceptible fractions of a tone during particularly dramatic passages. Kandinsky was interested in such techniques throughout his life and sought continuously for scientific explanations of such phenomena. Modern psychological research has shown that all areas of pure color, stripped of all external objects, are registered by the "lowest" level of the subconscious, whereas painting's up until now traditional language of color and tone, transfixed in forms, belongs to the next higher level of consciousness. So Kandinsky aimed to have an effect on the very lowest levels of consciousness, while at the same time, as a highly intelligent, broadly educated person, he concerned himself with the highest level of the language of thought, by writing his innumerable theoretical discourses.

The author finds the artist's examples of dissonance more difficult to follow, but they of course cannot be ignored. In particular dramatic elements are not limited to clashing contrasts and opposites, but are according to the artist himself the aspect of creation that reveals the deepest human and cosmic depths. The turbulent and cleansing strength of warring elements gives some of his pictures the cathartic force of Ancient Greek tragedy. Those who do not believe that a picture can do such a thing will never fully appreciate Kandinsky's oeuvre.

It has been said of Kandinsky's later works that they exude a cheerful peacefulness, and such a comment certainly seems justified. His artistic creativity remained original and uninterrupted; until the very end of his life he was planning not only paintings, but also, for example, an ambitious theater project with his old friend Thomas von Hartmann. Although death from arteriosclerosis, following an attack of influenza which had lasted several weeks, was somewhat unexpected, he had nonetheless naturally devoted some thought to it, especially to his will. Since his marriage to Nina, he had bequeathed to her not only those paintings she liked best, but also particularly representative works which he wanted to keep together as a collection and which he was probably also reluctant to part with. Since most major museums right up until his death did not exactly go to great lengths to obtain his pictures, Nina was left with a superb collection of about two hundred oil paintings and an even larger number of watercolors and sketches. What was to become of this? A proportion of it would ensure her an income. Kandinsky had no need of a will; it was enough for him to know that Nina was aware of his last wishes and would see that they were carried out to the best of her ability: he wanted to leave his entire legacy of pictures to the *Russian people*. This must come as a surprise to almost all Kandinsky experts, since it is well-known that his wishes were not in fact carried out – his legacy passed to the Centre Georges Pompidou in Paris – and this is certainly worth further reflection.[524]

It is hoped that this book has helped the reader to get to know many of Kandinsky's works, including several unknown ones, and to learn about some hitherto unexplored areas of his work. The author would like to leave the final word to the philosopher and poet, Professor Michel Henry, who has valuable comments to make concerning Kandinsky's mature work from a refreshingly original perspective.

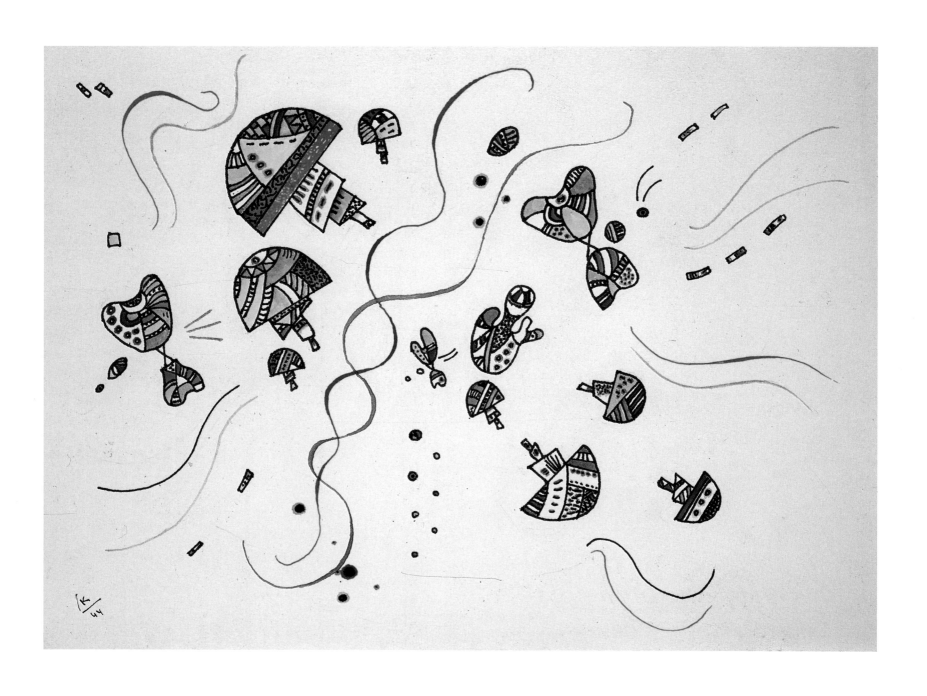

449 Last Watercolor, *1944*
 Watercolor. India ink over pencil, 10 x 13⅝ in
 Musée national d'art moderne
 Centre Georges Pompidou, Paris

MICHEL HENRY

THE MYSTERY
OF THE LAST WORKS

Translated by Pierre Adler

More than his other works, and certainly more than the pulsating works of "lyrical abstraction" that can so easily captivate the viewer, Kandinsky's last works present us with a mystery. But few people can feel their extraordinary fascination and to most they remain, to this day, a closed door.

We do, however, have the key to this mystery: it can be found in the painter's admirable corpus of theoretical writings. We are faced here with a unique occurrence in the history of art, with an artist who, while offering us the pictorial elements we see before us, also provides a rigorous explanation, one that never strays into the generalities of "culture" but adheres closely to those same pictorial elements. We now have analyses that reveal for the first time the true nature of color, of form, of the "original plane," and of the material, the "object." After learning from these analyses we can turn our attention to the pictorial elements used in their abstract purity and assembled in accordance with the laws of this abstraction, as seen in the series of Paris paintings from Kandinsky's last period. We should now be in a position to "understand;" we now expect finally to penetrate the enigma. Yet the mystery remains. I will tell you why.

The theory of abstract painting developed by Kandinsky in his three major works, *On the Spiritual in Art*, *Point and Line to Plane,* and *Reminiscences*, refers to a phenomenology that is original and profoundly different from the one Husserl was formulating just at the time when Kandinsky was discovering abstraction. Briefly, the phenomenology of Husserl, Heidegger, and their successors centers on perception: it is a phenomenology of the world, in which "all that which is" is situated in the light of the world and is therefore evident. According to this phenomenology, which in many respects is simply a continuation of traditional thought, a phenomenon is that which shows itself, which is seen in the light of day, *the visible*. Inasmuch as painting seems to deal with the visible and with it alone, this phenomenology naturally deems itself qualified to speak about art – and the plastic arts in particular.

Kandinsky, on the other hand, offers us a revelation that is far more essential than that of the visible world and that precedes it, the revelation of life unfolding within us, an invisible life which defines our true nature, our soul. If, as the greatest creative spirits have always held, art has a metaphysical import, if it is concerned with the ultimate essence of things, then it refers to life. Painting itself must break the pact it sealed with the visible world since its inception: it must *paint the invisible*. Kandinsky not only dared to set this new and astonishing goal for painting; he also had the genius to provide the means of attaining it.

These means are the "pictorial elements," primarily colors and forms. Are forms and colors not visible? Do we not find them in what we see before us, in the world? Even if the ordinary, real world gives way, in modern painting, to imaginary, flattened, impoverished, or enriched spaces,

450 Untitled *(Blue, Light-Blue), 1941*
Watercolor, gouache, and India ink
on gray paper, 12 3⁄16 x 18 7⁄8 in
Private Collection, Japan

whether two- or *n*-dimensional, does that mean that the colors and forms that make up a painting are no longer seen? It does not mean that because, in their true essence, they never have been and never will be seen: *invisible colors and forms, that is Kandinsky's abyssal and disconcerting insight*. This insight, expressed with unbelievable force, makes up part of the "mystery" of the Paris canvases.

In his analysis of the "elements" of painting, Kandinsky shows that they can all be experienced in two ways: "external" and "internal",[525] that they are visible and invisible. Each color is spread out before us on a part of the surface; it appears to us as an external area, a field of light over which the eye can glide, a "thing." But no "thing" is a color in itself, just as no stone is hot, or in pain, or in torment. Heat, pain, and color are sensations, impressions, and as such they are, as Descartes said, *modes of our soul*. Red is really a certain impression: it is therefore something invisible; the same applies to blue, green, yellow, etc. To paint red is to paint this specific impression, this sudden, more violent sense of life itself that makes us call red "the color of life."

To paint blue is to paint the peace we feel when something moves quietly away from us; whereas yellow is aggressive, menacing.

It should be noted that these feelings, to which Kandinsky devotes the same meticulous analyses as to the various colors, are certainly not linked to the colors by virtue of some contingent association, differing from one person to another or one country to another. Nor is Kandinsky forcibly imposing a literary description onto the pictorial material. What he is describing is the essence of color, its sensory effect, precisely because color is in itself an impression, a fragment of our subjective life, our pains and pleasures. Visible color is nothing but the external, worldly, "noematic" projection of this impression of color, which is subjective and pathetic,[526] which resides in our invisible life and exists only as a moment of that life.

What we have just said about color applies equally to forms, which also have two sides: they are *external* because our eyes can follow their outline on the paper or canvas, and *internal* because *every form is in reality a force* within our life, a motive force, an impulse, a desire, an invincible effort to turn all suffering into its opposite, to appease it with joy and happiness. All the formal combinations Kandinsky invented in such profusion merely translate the forces through which life is always seeking to create itself – they are the "vocabulary" or "formal grammar" of those forces.

Here again we must not interpret these dazzling graphic elements[527] as a sign or "expression" of our inner emotions. Instead we must repeat that they are the forces which wrest the point from the plane (the point, "the simplest of forms," is in itself a force, a concentric force that rejects space, reverts back to itself, and is invulnerable), create a straight line by moving the point in a single and continuous action, and create a curved line as a result of a new external force bending the straight line – for the curve is simply the result of these two forces acting in concert, the curvature is a measure of their respective strength, and so forth.

We do not normally perceive that each form and each color draws its dynamism and pathos from our innermost life because we tend to look toward external things, always seeking the utilitarian meanings with which we fill our daily lives. To grasp the forms and colors in their "pure pictoriality," to perceive them in and for themselves, implies a "reduction," discarding all the objective and utilitarian meanings that make up the external world, the so-called "real" world, and all the words by which we express that world. Many painters who wanted to rediscover "true" colors have spontaneously performed this reduction, *which is also Husserl's phenomenological reduction*. By putting all the objective, "transcendent" meanings that constitute our ordinary world "in brackets," this Husserlian reduction attempts to rediscover what we really know of this world, namely the appearances, the pure colors and forms which are really experienced and which painters seek in their own way to restore.

Kandinsky has given a better and more radical description than anyone else of this elimination of the object, this rejection of representation which refers painting back to its own particular "elements." He recounts how when he was a boy he was squeezing colors out of their tubes and to his amazement discovered true colors: they were no longer the colors of a particular object but the colors of nothing, restored to their simple being as colors. He showed how by separating a letter or sign from its linguistic meaning or any other context in which it usually occurs one could again experience its "pure form," its "purely pictorial" form.

But once the world and all its meanings have been set aside, once its *logos*, which has always been that which is spoken by men, has been silenced, what exactly is left? According to Husserl and those artists who gave up realism, we are left with the sensate appearances to which the true, given world is reduced, the pure experience of the world. But what, ultimately, "are" these pure appearances, what do they really show us, what can they mean to us, once any intentional reference to anything other than themselves, to the shape of a face or an object, to the meaning of a word, to any meaning at all, has been abolished?

What we see in Kandinsky's last, Paris canvases is pure forms and colors, pictorial elements taken to the extremes of their pictorial and abstract nature. And this leads us to ask: what do they show us, what do we see in them, what meaning do they still have for us? It is at this point that Kandinsky's genius sets him apart from any other painter or philosopher with whom one might be tempted to compare him, even those he preceded on the road to abstraction. Is it not remarkable that today, three quarters of a century after Kandinsky's extraordinary

377

discovery, a critic discussing Dubuffet's last painting, *Pulsions*, which "represents" nothing, in fact saw only "Nothingness" in it, i.e., the nihilism that, according to him, led Dubuffet to give up painting after this canvas because, having plumbed the depths of the abyss, there was nothing left to do?

In fact, if anyone were to ask whether these colors and forms indicate or mean anything beyond themselves, the answer would surely have to be: nothing. Here the "mystery" of Kandinsky's last works appears in its negative form. The viewer is baffled. This fabulous optical feast, these outgrowths of light, these configurations from nowhere floating in a weightless environment, expanding their inner space through the squares of an oneiric chessboard, these ironic appendices, these immaterial, metaphysical bodies, catch us so unawares that for a moment at least we are unable to avert our gaze. But our eye seeks in vain the secret of these mute forms, of these dazzling colors; it encounters no reality, no content other than expanses of color and forms that refer to nothing recognizable, to nothing of which they could be the colors and forms.

To look at something is to aim at it, to be oriented intentionally toward that thing, to expect to encounter it. To encounter that which one expects to see is to recognize it. But we recognize exactly nothing in these canvases. The intentionality of consciousness, the desire for cognition, is thwarted; there are only perspectives which the eye is unable to follow, spaces it cannot cross, colors of nothingness, forms and signs bereft of meaning, remaining for ever hieroglyphs. At the end of the journey of initiation into abstraction, as at the close of a mystical journey, the seeker finds nothing.

We "moderns" who belong to the world of science, of objective knowledge of the material universe, make the mistake of believing obstinately that such knowledge constitutes our only mode of knowing, our only means of access to the hidden essence of things. What if this essence of things were so well "hidden" that it could not be found through objective knowledge, in the light of the world and of objectivity, i.e. in the "Outside" into which intentionality throws itself, and where objects are situated, receiving their meaning from language? What if this essence of things were the invisible life which constantly floods us with the invincible experience of its suffering and its joy, the passage from one to the other which makes up the very flow of life, its pathetic power? Finally, what if colors and forms drew their essence from the essence of this life, what if they were originally impressions and forces, pathos and dynamism?

If that were so, then in the face of Kandinsky's last canvases, these hieratic "compositions" in which graphic elements and colors are linked by laws for which there is no visible model, *that which is essential would no longer be seeable since it never can be seen, and could only be experienced within ourselves. As we look, we are struck by another revelation*, that inner stirring which makes us feel our own life more intensely, more violently, and opens us up to never-experienced impressions, to unsuspected forces, to this greater life which the work of art takes on within us. These new impressions, these indomitable and stronger forces, are those of the colors and forms painted by Kandinsky, free of any reference to the clarity of a world or the intelligibility of a meaning, sent back into their Night, crushed into themselves, pure feeling, pure power, "internal resonance," "tonality," flesh of our flesh, "vibration of our soul."

We must resolutely divest ourselves of our reflexes as inhabitants of the world of science; we must stop believing that the mystery is merely transitory and that the task of knowledge is to dissolve it gradually. Art preserves the mystery; its sole task is to lead us to the mystery, to the only thing that matters, that is, to the essence of our invisible life. The fact that the abstract painting invented by Kandinsky became aware of this situation and of the mission this implied for art is something that concerns all forms of art, and primarily painting. *All painting is abstract.* All painting consists of colors and forms, but its goal is never the visible, even when it endeavors to represent it naively; nor is its substance the visible. The goal of painting is to enable us to feel what we are, this life with its passion, its anguish, its suffering, and its joy. The substance of painting, the substance of the colors and forms, are the fragments of that life, of its exalted dynamism.

The last, Paris canvases thus reveal to the spectator the essence of all painting and all art, because they disclose its true theme, the mystery of life, and because they define unequivocally the means of achieving that revelation, that is to say these colors and forms which, when the reality of their pure subjectivity is lived and experienced, are themselves a part of life. The enigmatic canvases move the viewer to see or rather experience himself or herself: hence the extraordinary emotion they arouse – emotion in the strict sense of the term, for now it is a question of nothing other than the eternal movement of the viewer's inner life, his or her innermost and endless being.

Colors and forms, however, are not only pictorial elements; they are also elements of the universe in which we live. If it is of the essence of all forms and colors to be two-fold, external and internal, does not this condition necessarily also apply to natural colors and forms? Aside from their outward aspect, must not they too reach down into the nocturnal life of our soul where, like any pictorial element, they must have their "resonance," their "inner sound," their "tonality?"

If that were so, the status of the universe would be akin to that of an abstract painting; it would be situated within us, there where every color is an impression that can touch us, and where every form is a force that can grow in us at the sight of the profusion of baffling graphic elements created by the master of the Bauhaus. The world would then not be what we are expected to believe, i.e., strictly speaking an *external world*, a pure and dead objectivity with

451 Three Ovals, *1942*
Mixed media, 19¼ x 19¼ in
Fuji Television, Japan

no internal dimension, an accumulation of material particles, of "things" that are reduced to their geometric extension and do indeed have no feelings. This world of science, inhabited by abstract idealities, is in fact built on the world of life, the sensate world, the world of cold and hunger, of anguish and beauty, of colors and forms. Like them, the world of science has its roots within ourselves. As Kandinsky put it so magnificently: *"the world sounds. It is a cosmos of spiritually affective beings. Thus, dead matter is living spirit."*[528]

We are dumbfounded. It was our understanding that abstract painting was the outcome of a long struggle, an intense reflection. It had defined its position against representation. It had needed to overcome not only the etiolated art of Naturalism and, more generally, Realism in all its varieties, but also the age-old belief that "reality" is what we see before us in the evidence of its light, what modern philosophers call "the object" ("ob-ject" means "that which is placed before or in the way of"). By setting the world aside, abstract painting assigned itself a new and paradoxical goal, the invisible. But after setting aside this world, which it implicitly depreciated, it recovered it at a new and unknown level of profundity. This is no longer a world reduced to objects, to the purely external, but one that once again moves and affects us, in which each thing is suffering or joy, each color is an impression of gaiety, of cheerfulness, or of uneasiness, each form is a moment of our will, its exaltation or its arrest. This is the true world, nature in its original, subjective, dynamic form, a world of impressions and pathos, of which we are the flesh and the blood. It is the cosmos where we live our life but whose substance is that very life: it is the *living cosmos*!

This discloses the second and most profound mystery of Kandinsky's last works: *the identity of abstract painting and the cosmos*. When we consider the enigmatic splendor of these canvases we seem to be seeing another world. This world differs from that of our everyday perception in that what we are marveling at relates to nothing we know. And the ordinary world arouses no emotion in us comparable to what we feel at the sight of these brilliant colors, evocative perhaps of an "Oriental bazaar," these sumptuous forms slowly revolving about themselves or coming to rest in a precarious equilibrium, these levitating metallic cones, these sadistic angles connected up in enigmatic fashion, these diagonals charging off to victory – in short, all these configurations that are armed with an invincible strength, self-assured, indifferent to the visible world, coming from elsewhere.

In the ordinary world and the world of representation, the resonance of the *elements common to both the universe and painting* is so muffled by habit that we have stopped hearing it within us and are reduced to feeling only boredom instead. By infinitely varying the range and relationships of colors, by inventing a proliferation of structures, of novel graphic elements, by discovering relations between forms and colors that are no longer founded

on those obtaining in the objective world but instead on the resonance peculiar to each element, the extraordinary experimental work Kandinsky carried out so tirelessly not only restored to these elements their original dynamism and pathos but also created in us forces, feelings, and emotions which no individual and no people had ever experienced before.

However, if each element of the world derives its true reality from a power or a pathos of our own life, then to discover or create within ourselves new forces and feelings, to awaken the hitherto hidden potentialities of our pure subjectivity – infinite potentialities, if this life is, as Kandinsky believed, a divine life – amounts by the same token to discovering or creating new worlds, in infinite number, like those graphic elements with which Kandinsky experimented. The last works offer us new worlds of this kind, captured in their nascent state, in the life that engenders them through its power to posit something other than what is, to trace out these unknown graphic elements and thus to engender these new worlds.

On several occasions Kandinsky amused himself by creating series of hitherto non-existent universes, for example the series of "Small Worlds." Each of these worlds was to be understood and was conceivable only as a "cosmos," as a universe whose reality lies in our emotion. Whether the result of a dominant geometry or of irreal colors, each of these worlds was, however, "abstract" and bore no relation to ours. We were becoming accustomed to this "otherworldliness," to this rift between art and reality. What strikes us in the last canvases, however, is the impression of being once again in the presence of a *world*, not ours to be sure, but nonetheless a dimension of being analogous to it, a milieu containing living beings, again not beings familiar to us but configurations that resemble organisms – animated entities of a kind – even if these organisms are reduced to a mere part of themselves, to mere appendages. Never having seen such things before, we do not really recognize them; yet we do seem to glimpse, in passing, bits of insects, semblances of infusorians, and in a sphere that is becoming distorted, stretched, and thickened, a fairy-like medusa with incandescent filaments sways in a transparent medium, traversed by invisible currents. What do these fleeting likenesses, these rudimentary plant-forms, these inverted pylons, these stalks and these ladders mean? Perhaps abstraction, having reached the end of its journey, felt nostalgic for firm land?

It is more likely that these last paintings indicate that at the end of a systematic exploration of the dynamic and pathetic potentialities of our living subjectivity, of the resonances governing forms and colors, Kandinsky could now play with them at his leisure. His mastery of the primordial powers of life had given him mastery of the pictorial elements that derive their invisible substance from those powers. He had reached the place preceding the world from which every world proceeds, and through his art he would always be able to create these new universes. The

452 The Red Point, *1943*
Mixed media on cardboard, 16 1/2 x 22 13/16 in
Adrien Maeght Collection, Paris

453 Two Rays, *1943*
Oil on canvas board, 16 1/2 x 22 13/16 in
Private Collection

precise knowledge Kandinsky acquired during his experimental work of the powers and effects of various pictorial elements enabled him to arrange these elements with incredible assurance. The look of truth, the apparent resemblance to the constituents of a real world which, in spite of their extravagance, characterizes the graphic elements and colors of the last works are the function of an immediate certainty, the certainty of the life that inhabits them. The overabundance of this life, its invincible joy, gives these unusual elements, which were already present in the works of the Bauhaus period, the ability to alter slightly, to curve under the breath of this life, to grow longer, to swell, and finally to look like animalcules, like those undulating and luminous shapes that begin slowly to move. Because life is the principle of the universe, this is indeed a living cosmos that is taking shape and beginning to move before our eyes.

Surely every creation bears some trace of the power from which it originates? However, Kandinsky's last works are conceivable only if we invert the traditional meaning of the concept of creation. By "creation" we normally mean the externalization of a content which the artist carries within him- or herself and wants to express. Expression thus consists in bringing to light that which previously lay unformulated. If abstract painting aims at painting this "abstract content," which is our invisible life, it must surely bestow a visible "form" on it? And is form not the coming to light of the content which was originally invisible? (It is worth noting that Kandinsky himself sometimes reasoned this way.)

Yet we cannot forget his categorical and very decisive assertion that *"form itself is 'abstract,'"*[529] namely, invisible. Abstract creation thus cannot consist of proceeding from the internal to the external, of bringing into the world something that would become "a work" only when exposed to the light of the visible. Far from being identical with this process of externalization, abstract creation consists in hearing the sounds of all that is visible resonate within us. Creation does not proceed from the internal to the external but, in a sense, from the external to the internal. It does not externalize our life, which on principle cannot be grasped objectively and cannot therefore be objectified. It arranges the elements of the world – whether the real world or an abstract universe – in such a way that the inner life of these elements, that is to say our own life, becomes "audible" to us, that we feel it more intensely. Our life, and it alone, is the means and the end of abstract creation.

It so happens that this life, which is the impression of every color, the force of every form, is also that of the universe, of all conceivable universes. Insofar as Kandinsky's last canvases enable us to feel, within our invisible Night, this life which is at the same time ours and that of the universe, they refer us back to the one, greatest Mystery of all: the mystery of life, which no one has ever seen or will ever see; the mystery of the universe or, as we have suggested, of the cosmos, which also exists only in and through that life; and, lastly, the mystery of what we ourselves are, borne aloft by this higher life that carries us along on its great swell and gives itself to us in such a way as to become our own life. Kandinsky's last paintings refer us to this unique, threefold mystery, and through it to the mystery of creation, to their own mystery.

For no great creation is ever limited to some imaginary projection, to constructing a space, forming a world, if every element of this world draws its life from the life of the power that produced it and refers back to it as though to its own essence. In all great creations, the created is never really separate from its source, the uncreated. *Every great creation is an inner creation*; it simply grants the life that flows through us without our consent the ability to experience itself within us, and in this pathos, to communicate its joy and its new spiritual adventures, a part of the infinite, eternal love with which it loves itself forever.

454 A Conglomerate, *1943*
Mixed media on cardboard, 22 ¹³⁄₁₆ x 16 ½ in
Musée national d'art moderne
Centre Georges Pompidou, Paris

455 Simplicity, *1943*
Mixed media on cardboard, 22¹³⁄₁₆ x 16½ in
Kunstmuseum, Bern

JELENA HAHL-KOCH

DEVELOPMENTS
IN RESEARCH

Research on Kandinsky began in Germany, where the artist made what is perhaps his most significant contribution to the history of art between the years 1896 and 1914, and where he was again resident from 1921 to 1933, working at the Bauhaus.

After one or two small studies, for example Hugo Zehder's monograph of 1920 and the American Kenneth Lindsay's thesis of 1951, Klaus Brisch wrote his excellent doctoral thesis in 1955, which was never published. Will Grohmann's substantial monograph followed in 1958; the major significance of this work was that the author had known Kandinsky personally from 1922 onward. Besides this, he was the only art historian whom Kandinsky himself judged to have "hit the nail right on the head" when it came to analyzing and understanding the artist's work. The dismissive claim by Rose-Carol Washton Long that the only value of Grohmann's book lies in his large illustrations section is unfounded.

There is increasing criticism nowadays of the "grand old men": besides Grohmann and Roethel in Germany, also Jacques Lassaigne and Michel Seuphor in France, among others. After saying no more than the bare minimum about Kandinsky's most difficult period, his years in Paris, they confined themselves to discussing his elevated artistic and personal ethos (cf. Christian Derouet for instance). But in so doing they also expressed some important ideas; besides which, since they were close to the artist and his set, they were able to pass on authentic information (even if they did not always give their sources in footnotes), and cannot be dismissed as out-of-date. Even if they strike us nowadays as venerable old statues preaching all-encompassing, brilliantly formulated words of wisdom down from their pedestals, the fact remains that their work laid a solid foundation for future, more structured and specialized research. Even Nina Kandinsky's memoirs offer more than just personal information; the editor who reworked her recorded cassettes into the book *Kandinsky und Ich* admittedly distorted her own narrative style, but not the substance of her narrative. Furthermore, his text at least adheres to the writings of the artist himself. Nina made no more errors of judgment in her accounts of Kandinsky's pictures than many experts do themselves, and she does not deserve the contempt that has been meted out to her, principally in Germany in the wake of her thirteen-year long lawsuit and Lothar Günter Buchheim's article on artists' widows, "Witwenverbrennung" (Suttee).

The next great researcher on Kandinsky after Grohmann must be Hans Konrad Roethel with his superb catalogues of the oil paintings and graphic works, some extremely clear essays, and other works. Of the complete writings he envisaged producing in German, only the first of seven volumes has appeared; the exemplary editorial principle of numbering lines was tailor-made for the third volume, *On the Spiritual in Art*, with its numerous notes, and proved to be so clear and practical, even for the first, autobiographical volume, that it was enthusiastically

exploited (for example by Peter Anselm Riedl in his paperback *Kandinsky*). Following the deaths of Roethel and Nina Kandinsky, the material for the first four volumes that Roethel and Hahl had drafted together and brought almost to the point of publication was set aside; however, the planned co-publication with the Centre Pompidou is shortly to be set in motion, starting with the extremely important volume on the "Theater."

In the meantime, two out of three volumes of the French work *Écrits Complets* were published; this is less systematic and comprehensive, and not always entirely reliable (see p. 261 and footnote). For instance, the translation from the Russian manuscript simply omits anything that proved to be illegible, with no indication of the omission.

Another book published in France is a rare model of over-zealousness: *Regards sur le Passé et autres Écrits sur l'Art* by Jean-Paul Bouillon. This is a real treasure trove, but unfortunately it renders Kandinsky's writings virtually unreadable by its constant interpolation of a complicated and intrusive clutter of parentheses and footnotes.

The best, most comprehensive catalogue yet to be published is that of the Centre Pompidou. However, while the co-editor Jessica Boissel seems to have included even the most unlikely of dates with no questions asked (see p. 181), the editor Christian Derouet appears to feel bound to mistrust Kandinsky's every statement and artistic objective. The consistently scornful tone he employs, and some of the inaccurate and often unjustified conclusions he reaches, are a source of some irritation (see pp. 74, 80, 181, 239, etc.).

The two-volume English edition of Kandinsky's writings by Kenneth Lindsay and Peter Vergo is thoroughly researched and offers English-speakers an excellent basis for further research.

While Sixten Ringbom was preparing his book *The Sounding Cosmos* during the sixties, the cataloguing of Kandinsky's Munich estate was only just getting under way. However, Roethel allowed Ringbom full access to the material, and Ringbom gave his word not to publish too precipitately. To Roethel's great disappointment, this promise was not honored. At the time it was not known for sure how many of Kandinsky's books had been returned by Münter. The assumption that the library of Theosophical, Anthroposophical, and occult texts belonged to Kandinsky rather than to Münter (see pp. 177f.) contributed largely to a heavy over-emphasis on this aspect of the artist's thought, which was discussed and indeed highly exaggerated over and over again by successive authors. Kandinsky's lifelong Christian and more importantly his "abstract" spiritual inclinations are set in confrontation with one or two pencilled-in scribbles he made while struggling to follow Rudolph Steiner's tortuous trains of thought. Because of these pages, which Ringbom used as the basis of a fundamental piece of research, Kandinsky and his paintings are ever more frequently and ever less

objectively judged from a Theosophical and Anthroposophical point of view, with many authors taking it for granted that he had Theosophical inclinations and condemning him for them.

Many doctoral theses and essays cast a welcome light on particular aspects of Kandinsky's work. It is regrettable that these works are generally not published due to lack of funding. Commendable examples include: Jonathan Fineberg on the Paris Period 1906–7; Susan Stein on *Yellow Sound*; Heribert Brinkmann, *Kandinsky als Dichter*; Eva Priebe, *Angst in Kandinskys Werk*.

Roethel's verdict on Peg Weiss' book of her expanded dissertation, *Kandinsky in Munich. The Formative Jugendstil Years*, was that Weiss reflects:

> the opinion that Kandinsky's development toward abstraction has its roots in his first art teacher in Munich, Anton Ažbè. The foundation of this bizarre hypothesis is a string of reasons put forward by the author, none of which adds up. In view of the boundless diligence and irreproachable thoroughness with which she has gathered her material, it is even more regrettable that the complete lack of any artistic or art-historical judgment and the inability of the author to examine the material she has gathered in an objective way have resulted in her coming to the most grotesquely distorted conclusions. Instead of basing her arguments on primary pictorial and written sources (for what she says about Ažbè as much as about Kandinsky), she combines facts with a skill bordering on acrobatics to concoct hypotheses, which she then puts forward with sham intellectual dexterity. [...] In order to prove her abstruse hypotheses, Peg Weiss not only disregards obvious artistic facts, but, what is even worse, she mutilates primary written sources for her own ends, or uses written sources at second or even third hand.
>
> [... Concerning the Russian sections] Weiss bases her assertions on a "synopsis" by John E. Bowlt, and also on a tertiary source in the form of an article by France Stele, which was translated for her by a Slav at the university of Syracuse. (For more details see GS, pp. 139f.)

Jonathan Fineberg's critique of the same work is discussed in footnote 523. Furthermore, when this author read the manuscript of Roethel's critique and asked if he might word it less strongly before publication, he replied that it was not strongly worded enough by half, and we should just wait and see the kind of pseudo-research to which it would give rise. He personally was even more deeply disappointed by Rose-Carol Washton Long's book, for which he had provided her with a great deal of material and advice. This is another, rather one-sided dissertation that has been expanded into a book: *Kandinsky. The Development of an Abstract Style*. Jonathan Fineberg criticized it as

follows: "Why is Kandinsky supposed to have 'disguised' objects, when he in fact retained them to a large extent, so that uninitiated viewers should discover something comprehensible? Her identification of 'disguised' objects with some kind of concealed iconography is a misunderstanding of Kandinsky's motivation, and her procedure leads her to an over-literal 'decoding' of his pictures." This author agrees with Fineberg's verdict. Apart from one or two interesting, thought-provoking ideas, Washton Long's judgment of Kandinsky's relationship with his public strikes the author as most misfounded. His understanding of art was far removed from a small-minded restriction of this kind. Consider how difficult he made life for himself and the degree of isolation in which he found himself in exchange for his attitude! Naturally he was delighted when other creative artists, such as Schönberg, von Hartmann, or Kubin, understood and valued his work, but he was not dependent even on this, let alone on the acclaim of the general public (indeed, he predicted that this would follow a couple of generations later). The very opposite is true of him: "How boring it is to read the idiocies of the 'professional theoreticians;' what a narrow-minded, unimaginative and impotent train of thought they have. Now on the other hand, as you know, what really pleases me is 'incomprehension;' if the thickheads did understand me right now, then my work would not actually be worth anything much at all."[530] Washton Long sees Kandinsky as a market stall-holder, afraid that his pictures might not win the comprehension of every viewer. As early on as in her preface she claims: "he feared he would not be able to communicate to a wide audience if he eliminated all recognizable content." (p. vi); or "Kandinsky was determined not to lose his audience" (p. xi). Things become somewhat absurd when, drawing on Ringbom's "auras" and "thought-forms" in Kandinsky's pictures, she takes it as read that: "The warnings of Leadbeater and Besant that not everyone could see the 'thought-forms' must have given him some pause about the ability of abstract art to communicate to others."[531] Washton Long's conceptual confusion here is symptomatic; for example, she describes the Symbolists as an "occult group" ("Symbolist, Theosophical, and other occult groups", p. ix). Her causal links are also unusual: "The process of stripping may have its primary roots in Kandinsky's own diagrammatic sketches for many of his works." Much of what she claims seems strange, for example: "By 1914 and 1915, however, Kandinsky and a few others were willing at times to experiment with what they considered 'pure abstraction'" (p. vii). What then had he been doing since 1911? Washton Long's later essays are less irritating, although they remain too narrow in scope and too "literal" in their interpretation.

The double biography of Münter's later partner, the art historian and researcher on Kant, Johannes Eichner, handles Kandinsky objectively and offers interesting explanations in a philosophical vein of the beginnings of abstract art (although some of his ideas are not entirely free of a National Socialist attitude). All Eichner's ideas have been "incorporated" in the next, much larger biography of 1990, although the author, Gisela Kleine, ridicules Eichner almost to the point of defamation. The welcome abundance of extracts of letters of a personal nature published here for the first time is unfortunately set against the tendentious commentary of the author, whose aim appears to be to enhance the image of Münter at Kandinsky's expense. The fact that in so doing she did little service to Münter will be illustrated in Reinhold Heller's forthcoming monograph on Münter. As far as Kleine's image of Kandinsky is concerned, any readers who manage to pass their own judgment on the cited material will recognize the unfoundedness of her conclusions. Those acquainted with much more original source material will be able to see how very biassed is the selection itself of material cited. From the hundred or so essentially positive works on Kandinsky, Kleine has chosen to cite from the only three negative ones (Carl Einstein, Arnold Gehlen, Armin Zweite), and these three alone, so as to present the artist from the outset in the light that best suits her argument. A selection of the factual errors in Kleine's biography is given in this author's review of it.[532]

Asking artists for their own opinion of their work is always exciting, in Kandinsky's case it is particularly rewarding. For this reason the title of the post-doctoral thesis written by Felix Thürlemann, *Kandinsky über Kandinsky* (Kandinsky on Kandinsky), is most promising. This work provides perhaps the most rigorously consistent attempt to achieve a specific language for the interpretation of abstract works of art, in order to go beyond the previous disparate and historically colored research. Furthermore, his thorough study of the analytical sketches is a significant contribution to research in this field. He makes important and completely logically founded corrections to the interpretations of Grohmann, Ringbom, and above all Washton Long. But one has to agree with the author's comment that "my investigations seem to have raised more new problems than they have solved old ones" (p. 180). In particular where Kandinsky's own very clear and concise "supplementary definitions" are described as not quite precise enough and elaborated twentyfold, even when formulae promise clarity of thought, this extravagance of detail is seldom of real value. However, his method is not only interesting, but points a way to the future (see p. 209).

In *Voir l'invisible* Michel Henry has been clear, concise, and to the point in his treatment of Kandinsky and abstraction. For example, he shows that apart from Kandinsky no one has really painted in the abstract, but that on the other hand every art is abstract in the widest sense of the term. His claim that, before Kandinsky, none of the great philosophers understood the slightest thing about art, neither Plato nor Aristoteles, nor Kant, Schelling, Hegel, Schopenhauer, or Heidegger, is perhaps an exaggeration. But he clearly accords a high rank both to Kandinsky the

artist and to Kandinsky the theorist. Kandinsky would have been delighted at this perceptive book by a poet and philosopher, without however being at all surprised, since he was never overly fond of "art experts."

This brief overview leaves unmentioned many worthy and well-executed research works; the author felt it behoved her more to mention several biassed, tendentious contributions which seem to reinforce each other with a momentum much like an avalanche (perhaps because extreme points of view attract more attention than balanced arguments?). Of course, the question now arises which slant the present book adopts, besides attempting to avoid any kind of biassed or over-literal interpretation and offer not only an art historian's approach but also (which is all too rare today) an artist's point of view. The author hopes to evoke Kandinsky's many-sidedness, his rich imagination, his sensitivity, yet also his persistent vitality and his capacity for intense emotions, without covering up the difficulties he experienced or the weaker pictures he produced. From this aim there arose unbidden an even more important one. In this book the artist is brought back into the twentieth century, where he belongs, while recent critical literature appears to have been trying to banish him to the nineteenth century by referring to his apparent bourgeois attitudes, his romanticism, his idealism, and his occasional criticism of "modern" movements. This is not justified; of course Kandinsky had his roots in the nineteenth century, but this did not prevent him from taking an enormous leap forward into the new age, which he, more than many others, actually *shaped with his own hands*.

Space does not permit much personal detail in this book, but the author has also developed this aspect in a biography due to be published soon. Any comparison with other artistic movements has also had to be cut down to leave more space for Kandinsky himself. There are many topics still left to be studied: questions on the "internal nature of painting;" comparison with Malevich (did the latter merely "construct" while Kandinsky "experienced?" is their path to abstraction fundamentally different?); comparison with Miró as an "intermediary" between abstraction and Surrealism; discussion of spiritualism, going far beyond the Theosophical and Anthroposophical movements; and abstraction itself, even if it does seem to be going out of date toward the end of the twentieth century. To ask oneself why this is so is in itself an interesting question. Why indeed does abstract art still arouse strong feelings, and why does it seem still to be incomprehensible to many viewers (and not only in the formerly Socialist Eastern European countries in which it was frowned upon for so many years)?

As far as Kandinsky's direct influence on later painters is concerned, the American "Abstract Expressionists" are just one example of a movement that would have been unthinkable without him. Thomas Messer has produced some excellent work on Kandinsky's successors in America.[533] However, bearing in mind Kandinsky's own distinction between formal "schools" and general spiritual influence on future generations (see p. 330), the many levels at which his art and his ideas had an effect become apparent, stretching far beyond the modest number of immediate successors, and also beyond his later influence on Abstract Expressionism, Tachisme, and other movements. Through abstraction, Kandinsky opened up a new dimension to the world, working it through theoretically to make it accessible. This produced the most diverse ramifications, even to the extreme case that arose in Germany (among other places), after the Second World War, when most art teachers dismissed as worthless all realistic and figurative art, except insofar as it formed a very primitive and fundamental basis for the *real* art, for *great* art, which of course could *only* be abstract. Even an almost amusing misunderstanding such as this – which utterly disregards Kandinsky's own tolerance – bears witness to the ever-increasing consequences of his ideas. Kandinsky is still absolutely up-to-date, have no doubt about it. At last, the prediction by Diego Rivero cited in the opening lines of this book is gradually beginning to be realized.

456 White Balancing Act, *1944*
 Mixed media, 22 ¹³/₁₆ x 16 ½ in
 Prof. Löffler, Zurich
 Photo: Walter Dräyer

BIOGRAPHICAL SUMMARY

1866

Vasily Kandinsky born in Moscow on December 4. Using the old Russian (Julian) calendar, this was November 22; the difference between the Russian and Western (Gregorian) calendars was 12 days until 1916, after which it was 13. Hence Kandinsky's birthday was originally celebrated on December 5, and on December 4 after 1916.

1869

Travels to Italy with his parents.

1871

Kandinsky family moves to Odessa. Parents divorce. Kandinsky lives with his father, but retains close contact with his mother and later on with his three step-brothers and step-sister. His mother's sister, Elizaveta Tikheeva, takes over his upbringing; he was later to dedicate his first book, *On the Spiritual in Art*, to her.

1876

Attends the grammar school in Odessa; first lessons in art, piano, and cello. From 1879 onward spends every summer in Moscow with his father.

1885

Begins university studies in Moscow: law under Professor Alexander Nikitich Filippov, economics under Alexander Ivanovich Chuprov, Professor of Statistics and Political Economy.

1889

Two-month research expedition to Vologda and the north of Moscow province, (1) to study punishment (including corporal punishment) in peasant courts, and (2) to track down the traces of pagan beliefs in a Finno-Hungarian tribe. Publishes his first essays on these subjects. Deeply affected by folk art, in particular by the colorfully painted and decorated farmhouse interiors.
Visits the Hermitage in St. Petersburg; learns about Russian art here and in Moscow, copies Vasily Polenov. First trip to Paris.

1892–93

Sits State examination to finish his studies; at Chuprov's suggestion continues to work on a dissertation on the legality of laborers' wages. Marries his second cousin Anna Fedorovna Shemiakina, with whom he lives until 1904; official separation in 1911.

1895

Becomes manager of the collotype department of the N. Kushnerev printing press in Moscow.

1896

At an exhibition of French art in Moscow is deeply impressed by Claude Monet's *Haystack*. Similarly affected

by a performance of Richard Wagner's *Lohengrin* later
that year. Turns down offer of a post at the University of
Dorpat (now Tartu, Estonia).
In December moves to Munich. Registers as student at
Anton Ažbè's private school of art and remains there
almost 2 years; gets to know Alexei Jawlensky, Marianne
Werefkin, Dmitri Kardovsky, Igor Grabar, Alexander von
Salzmann, and other painters.

1898
Fails the entrance examination to the Munich Academy of
Art; continues to work by himself. First participation in an
exhibition in Odessa.

1900
Accepted at the Academy of Art; studies under Franz
Stuck. In February, participates in an exhibition with the
"Moscow Artists' Association".

1901
Co-founder of the exhibition and artists' association, the
Phalanx; organizes 12 exhibitions between 1901 and 1904.
First travels from Munich to Wiesbaden, Krefeld, and
Barmen. Exhibitions in Odessa and St. Petersburg. First
essay on art, "Critique of Critics," published in Moscow
newspaper *Novosti dnia* (News of the Day).
Opening of Phalanx school of art, where teaches classes
in nude and still-life painting. Makes acquaintance of
Gabriele Münter.

1902
Writes a comprehensive report on artistic life in Munich
for the St. Petersburg art journal *Mir iskusstva* (World of
Art). Exhibits in St. Petersburg, with the Berlin Secession,
and with the Phalanx. Spends summer in Kochel, Upper
Bavaria, with his art class.

1903
Works in Kallmünz with his art class; school closed down at
end of year. Peter Behrens offers teaching post at school of
arts and crafts (Kunstgewerbeschule) in Düsseldorf, which
Kandinsky turns down. Exhibitions in Budapest, Prague,
Venice, again in Odessa, Moscow, and St. Petersburg.
Travels to Nuremberg, Regensburg, etc. Travels via Venice
to Odessa and Moscow, return trip via Berlin. Visits
museums there, including exhibitions of Egyptian, Greek,
Italian, and early German art.

1904
Begins writing a theory of colors; these are the preliminary
notes for *On the Spiritual in Art*. First exhibition with the
"Salon d'Automne" at the Petit Palais in Paris, to be
repeated every year from now until 1912. Further
exhibitions in the "Tendances Nouvelles" gallery, the
Galerie Sagot, with the "New Artists' Association" in
St. Petersburg and the "Moscow Artists' Association,"

the Berlin Secession, in the Krefeld Museum, in Warsaw, Crakow, and Vienna. His folder of woodcuts published in Moscow as *Stikhi bez slov* (Poems without words). In December the twelfth and final exhibition of the Phalanx, which travels on to Düsseldorf, Darmstadt, Frankfurt, Karlsruhe, and Königsberg.

1905
Travels to Tunisia with Gabriele Münter. Bicycle tours in Germany. Exhibitions with the "Moscow Artists' Association," in Rome, Odessa, at the "Salon d'Automne," where he is supposed to join the panels of judges but has to refuse invitation because of the distance involved. Joins German artists' association "Deutscher Künstlerverbund." In Odessa in the fall is caught up in the events of the Russian Revolution. Spends December in Italy with Münter.

1906
Moves to Paris at the end of May with Münter, where they stay for a year. Exhibitions at the "Salon d'Automne," where wins the Grand Prix, also at the "Musée du Peuple" in Angers (109 works). Exhibitions in Dresden (with the artists of the "Brücke" group), with the Berlin Secession in Berlin and Vienna, at the Krefeld Museum, and in Odessa and Moscow.

1907
Besides three exhibitions in Paris, his pictures on show in Rome, Moscow, Odessa, and Berlin. Spends period from fall of 1907 to early 1908 in Berlin with Gabriele Münter.

1908
Intensive "summer of painting" in Murnau with Münter, Jawlensky, and Werefkin. Makes acquaintance of composer Thomas von Hartmann, with whom works on his first pieces for the theater. Exhibitions with the "Salon des Indépendants" and the "Salon d'Automne" in Paris, with the Berlin Secession, and in Odessa, Moscow, and St. Petersburg at "salon" of editor of journal *Apollon*, Sergei Makovsky. Goes rambling and cycling with Münter. From September once more resident in Munich, rents a flat at 36 Ainmillerstrasse in Munich-Schwabing.

1909
In January founding of the "Neue Künstler-Vereinigung München" (New Artists' Association) of which becomes president. In December first exhibition at the Thannhauser Gallery, also elsewhere: Brno, Barmen, Hamburg, Düsseldorf, Wiesbaden, Schwerin, and Frankfurt. His volume of woodcuts *Xylographies* published in Paris, and recent woodcuts printed by *Tendances Nouvelles*. Exhibitions at the "Salon des Indépendants" and at the Royal Albert Hall in London. Writes several "Letters from Munich" for the St. Petersburg art journal *Apollon* (1909–10). Münter and Kandinsky buy a house on the

outskirts of the village of Murnau in Upper Bavaria. Second summer of painting with Münter, Jawlensky, and Werefkin. First glass paintings. In December participates in Vladimir Izdebsky's "International Salon" exhibition in Odessa, together with Russian, German, and French artists; this exhibition shown in Kiev, St. Petersburg, and Riga in 1910.

1910
Paints *Composition I*. Spring to beginning of the fall spent once more in Murnau. Second exhibition of the "Neue Künstler-Vereinigung München" leads to withering criticism; only Franz Marc offers a positive verdict and joins the association. Kandinsky strikes up contact with Russian artists: Nikolai Kulbin, Natalia Goncharova, Mikhail Larionov, the brothers David and Vladimir Burliuk, among others.
Exhibits with the "Sonderbund" in Düsseldorf and at the "Salon d'Automne" in Paris. From the fall onward stays in Moscow, brief visits to St. Petersburg and Odessa. Very active for Izdebsky's "International Salon II" 1910–11; exhibits 52 pictures there, writes article "Content and Form," adds a translation of part of Schönberg's "Theory of Harmony," and plays major part in designing the catalogue. Exhibitions with the "Art and Theater Society" in Ekaterinoslav and in December-January at the important exhibition of Russian avant-garde work, "Knave of Diamonds" (*Bubnovy valet*), organized by Larionov in Moscow.

1911
Strikes up contact with Arnold Schönberg. In February publishes "Whither the 'New' Art?" in the *Odessa News*. Exhibition at the "Salon des Indépendants," with the "New Secession" in Berlin, at the Wallraf-Richartz-Museum in Cologne, and at the Hagen Museum. Spends spring and summer in Murnau. Paints his first abstract oil painting. In December (dated 1912) *On the Spiritual in Art* is published by Piper in Munich. Also in December, leaves the "New Artists' Association" following disputes and founds the "Blaue Reiter" with Franz Marc; first exhibition in the same month, which travels on to Cologne, Berlin, Bremen, Hagen, and Frankfurt. Becomes friends with Paul Klee.

1912
Second exhibition of the "Blaue Reiter" from February until April; in May the almanac of the same name is published, edited by Kandinsky and Marc. Exhibitions in Cologne, Berlin, Bremen, Hagen, Zürich, and Frankfurt, at the "Salon des Indépendants," "Knave of Diamonds" in Moscow, in Ekaterinoslav, at the Kunsthaus in Zürich, in Amsterdam, etc. Hernia operation. In October first one-man exhibition at the "Sturm" Gallery in Berlin; this travels on to Rotterdam, Brussels, Aachen, Magdeburg, Stuttgart, and other cities. October to December in Odessa, Moscow, and St. Petersburg.

1913

Exhibition in the *Armory Show* in New York. His first American collector, Arthur Jerome Eddy, a Chicago lawyer, buys a small collection of pictures spanning all periods of his creativity. Travels via Berlin to Moscow. His "Album" with reproductions of his work is published by "Sturm", with his *Reminiscences* and three retrospective picture definitions. Exhibition in the "First German Autumn Salon" (Erster Deutscher Herbstsalon), in the "Sturm" Gallery in Berlin, at the Stedelijk Museum of Amsterdam, in Budapest, Vienna, Prague, Helsingfors, and other European cities. Prose poems *Sounds (Klänge)* published by Piper in Munich.

1914

One-man exhibition at the Thannhauser Gallery in Munich and at the "Kreis für Kunst" in Cologne; writes very informative explanations of his painting for Cologne, which are neither printed nor read in public, however.
Further exhibitions in Tokyo, Geneva, Malmö, at the Kestner Gesellschaft in Hanover, and elsewhere. Works with Dmitri Mitrinovich's and Erich Gutkind's peace initiative.
On the Spiritual translated into English. Works on 4 abstract paintings for Campbell's entrance hall in New York.
Plans to perform his theater pieces *Yellow Sound* and *Violet* with Hugo Ball in Munich are hindered by the outbreak of war, as is publication of his theater pieces with Ball, von Hartmann, and others.
On the outbreak of war Kandinsky flees with Münter to Switzerland; begins to develop further his theories of *On the Spiritual*, to be published in 1926 as *Point and Line to Plane*.
Travels to Odessa; settles in Moscow and becomes Russian citizen once more.

1915

Participates in the important exhibition *The Year 1915* in Moscow – together with Malevich, Tatlin, and others, as well as at Dobychina Gallery in St. Petersburg. Alexander Rodchenko and Varvara Stepanova move into his Moscow house (in Dolgy pereulok, now Burdenko Street). Spends the summer in the Crimea.
In December travels to Stockholm where Gabriele Münter is staying. Exhibition in the Gummeson Gallery; writes two articles for the exhibition.

1916

Final break-up with his partner Münter.
Hugo Ball reads Kandinsky's prose poems in the Cabaret Voltaire in Zürich and publishes them in the journal of this name; the "Dada" gallery in Zürich exhibits his pictures. Further exhibitions at Dobychina in St. Petersburg and in the West in the Hague, Christiania, Helsinki, and Berlin.

1917

Exhibitions in Berlin at the "Sturm," and again at the "Dada" in Zürich, also in Göteborg, Copenhagen, and Munich.
In February marries Nina Andreevskaia. In September, birth of their son Vsevolod, who dies in 1920.

1918

Becomes a member of the forerunner of IZO NARKOMPROS (the department of Fine Arts of the People's Commission for Enlightenment); defends abstract art against criticism from the "right" as well as from the Socialist orientated left-wing radicals.
The Russian version of his *Reminiscences* is published as *Stupeni* (Steps).
Revives contacts with artists in the West through the international committee of IZO.
Takes part in the fifth State Exhibition in Moscow.

1919

In February takes part in a museum conference in St. Petersburg, at which it is decided to found a "Museum of Artistic Culture" in various parts of the country; Kandinsky becomes director of the museum in Moscow (until January 1921). Elected president of the Russian Purchasing Commission for museums belonging to IZO NARKOMPROS (until March 1921). Is largely responsible for the distribution of pictures to 22 provincial museums. Teaches at VKHUTEMAS (free art studios); is honorary professor at the University of Moscow. Member of the Commission for the publication of the *Fine Arts Encyclopaedia*, for which writes short autobiography eventually published in *Kunstblatt* in Germany.
Publishes several short articles in the Moscow journal *Iskusstvo* (Art) and the article "On Stage Composition" in *Izobrazitel'noe iskusstvo* (Visual Arts).
Exhibitions in St. Petersburg, Vitebsk, also Dresden, Zürich, and at "Sturm" in Berlin.
In December his works are exhibited at the "Fifth State Exhibition" beside those of Chagall, Malevich, and Lissitzky.

1920

Participates in the "Painting Section" in Moscow, which gives rise to INKHUK (Institute of Artistic Culture). Draws up Institute's programme and directs the Department of Monumental Art.
Publishes articles "The Museum of the Culture of Painting," "The great Utopia," and "Steps taken by the Department of Fine Arts in the realm of International Art Politics" in *Khudozhestvennaia zhizn* (Artistic Life).
Conflict with Rodchenko and other artists deepens.
Exhibits 54 works at the 19th Exhibition by the Russian Central Exhibition Committee in Moscow; further exhibitions in Darmstadt, Amsterdam, Hanover, and New York.

1921

Leaves INKHUK. Works with RAKHN, the Russian Academy of Art, directing the physico-psychological section; elected vice-president.

With other opponents of Constructivism and its emphasis on production, Kandinsky takes part in the exhibition "The World of Art" in Moscow.

Two exhibitions in New York, two in Hanover, also exhibits in Berlin, Worcester, and Cologne.

In December leaves Russia for Berlin; invited to teach at the Bauhaus in Weimar; contacts with Russia maintained for a while.

1922

One-man exhibitions in Berlin, Munich, and Stockholm. Takes part in the First Exhibition of International Art in Düsseldorf and the First Exhibition of Russian Art in Berlin, also exhibits at the Art Institute, Chicago, in New York, Weimar, and Dresden.

In June moves from Berlin to Weimar, teaches "Theory of Form" in the foundation course and the workshop for mural painting. Executes a commission for a mural painting with his new students; the work is shown in Berlin in the fall.

His album of prints *Small Worlds* is published. Turns down the offer of a lectureship at the Tokyo Art Academy.

1923

One-man exhibitions in Berlin, at the Kestner-Gesellschaft in Hanover, and (for the first time) at the "Société Anonyme" in New York. Further exhibitions in Munich, Brooklyn, Jena, Detroit, and elsewhere.

Several essays published in the anthology *Bauhaus Weimar 1919–1923*.

1924

With Klee, Jawlensky, and Feininger becomes a member of the "Blue Four." Represented by Galka Scheyer in America.

Exhibitions include the Russian Art Exhibition and the Secession in Vienna, the Secession in Dresden, and one at the Brunswick Landesmuseum.

1925

One-man exhibitions in the museums of Erfurt and Wiesbaden, other exhibitions at the Zürich Kunsthaus, the Stedelijk Museum in Amsterdam, in Düsseldorf, and in New York.

Moves to Dessau with the Bauhaus. The Kandinsky Society is founded by eight art collectors.

1926

Publishes his second theoretical book, *Point and Line to Plane*, and an essay on "The Dances of Palucca."

Death of Kandinsky's father.

First edition of the journal *bauhaus* is dedicated to Kandinsky on his 60th birthday.

His Jubilee exhibition travels from Brunswick to Dresden, Berlin, Dessau, and Munich. Further exhibitions outside Europe in San Francisco, Oakland, San Diego, Los Angeles, New York, Philadelphia, and Portland.

1927

Takes an optional painting class at the Bauhaus. Holidays in Switzerland and Austria, where meets Schönberg. Makes acquaintance of Christian Zervos.

Adopts German nationality (according to Nina, literature has always given 1928 as the date for this).

Exhibitions in Oakland, New York, Los Angeles Museum, Mannheim, Zürich, Amsterdam, and The Hague, among others.

1928

Performance of his theater piece set to Modeste Mussorgsky's music, *Pictures at an Exhibition*, at the Friedrich Theater in Dessau. Several theoretical essays published in *bauhaus*. Makes acquaintance of César Domela and Rudolf Bauer.

Exhibitions in Brussels, the Nationalgalerie in Berlin, New York, Frankfurt, and at the Folkwang Museum in Essen, among others.

1929

One-man exhibition of watercolors at the Galerie Zak in Paris, then the Hague and Brussels; five exhibitions in Berlin, others in Basel, Chicago, Oakland, Antwerp, the Zürich Kunsthaus, and the Schlesisches Museum in Breslau.

Marcel Duchamp visits him at the Bauhaus; Kandinsky makes acquaintance of Hilla Rebay and Solomon R. Guggenheim, visits James Ensor in Ostend.

1930

One-man exhibition in the Galerie de France as well as exhibitions with "Cercle et Carré" (Michel Seuphor invites him to contribute to the journal of the same name); also in Stuttgart, Saarbrücken, Krefeld, Essen, Nationalgalerie Berlin, Venice Biennale, Bordeaux.

Meets Jean Hélion and Gualtieri di San Lazzaro in Paris.

His works are removed from the Weimar Museum (already under National Socialist influence). Holidays in Italy, visits Ravenna for the first time, where is impressed by the mosaics.

1931

Produces a ceramic wall decoration for a music room. Turns down the offer of a teaching post at the Art Students League in New York. Exhibitions in Belgrade, Brussels, the Städel in Frankfurt, the Zürich Kunsthaus, New York, San Francisco, Santa Barbara, and Mexico City.

Travels to Egypt, Palestine, Turkey, Greece, and Italy.

Writes on abstract art for Christian Zervos' *Cahiers d'Art*.

1932
One-man exhibition of drawings, watercolors, and graphics at Ferdinand Möller's in Berlin; other exhibitions in Essen, New York, Stockholm, Vienna, Amsterdam, Königsberg, and Gdansk.
The journal *Transition* publishes his poetry.
The National Socialists in Dessau close down the Bauhaus. Kandinsky moves to Berlin where the Bauhaus continues its activities for a short while. Holiday in Dubrovnik.

1933
The Bauhaus is closed down in Berlin as well. Kandinsky visits Paris, guest of honor at an exhibition of Surrealist works. Further exhibitions at the Museum of Modern Art in New York, in Chicago, at the Los Angeles Museum, in London, and elsewhere.
At the end of the year, moves to Neuilly near Paris.

1934
Reproductions of his work published in the journal *Abstraction-Création*. Exhibitions in the Palais des Beaux-Arts in Brussels, with *Cahiers d'Art* in Paris, in Milan, and again with Gummeson in Stockholm.
Makes acquaintance of Joan Miró, Piet Mondrian, and Alberto Magnelli, later also of Man Ray, Max Ernst, Robert and Sonya Delaunay, Fernand Léger, and Constantin Brancusi.

1935
Invited to become "artist in residence" at the Black Mountain College in North Carolina, but turns this and all subsequent offers from America down because does not speak enough English.
One-man exhibition at the gallery of *Cahiers d'Art*. Exhibitions in Lucerne, Paris, San Francisco, and in New York at Jerome B. Neumann's, who becomes his representative for the east coast states.

1936
One-man exhibition at Neumann's in New York; takes part in "Abstract and Concrete" in Oxford, at the Tate Gallery in London, at the Museum of Modern Art in New York in "Cubism and Abstract Art," then once again in "Fantastic Art, Dada, Surrealism," and for the first time with Jeanne Bucher in Paris.
Holidays in Genoa, Florence, Pisa, and Forte dei Marmi.

1937
One-man exhibition at Karl Nierendorf's in New York, others in Cleveland and Cambridge, at the Musée du Jeu de Paume in Paris, in Basel, Bern, and Copenhagen.
His pictures are also included in the exhibition of "Degenerate Art" in Munich, and shown until 1941 in Berlin, Leipzig, Düsseldorf, Hamburg, Frankfurt, Vienna, Salzburg, Stettin, and other cities. German museums are forced to remove his works.

Holiday in Brittany. In December visits exhibitions of work by Arp, Taeuber-Arp, and Miró.

1938
One-man exhibition at the Guggenheim Jeune Gallery in London; takes part in exhibitions in New York, Milan, at Bucher's in Paris, and in Oslo. Signs a petition in support of Jewish artist Otto Freundlich.

1939
Paints his tenth and last *Composition*. The French Government buys *Composition IX*. Exhibitions in London, in the Museum of Modern Art and the Guggenheim Museum in New York, in Seattle, and in San Francisco; one-man exhibition at Bucher's in Paris.
Plans multi-media ballet with Thomas von Hartmann and Leonide Massine.
Takes French nationality.

1940
During the German invasion of France Kandinsky lies low in the Pyrenees. *On the Spiritual* published by Edizioni di Religio in Rome. Exhibitions only in Mexico City and with Neumann in New York.

1942
One-man exhibition at Bucher's in Paris. December to February 1943, retrospective at Nierendorf's in New York.

1943
Three exhibitions in New York. Writes an obituary for Sophie Taeuber-Arp and a dedication for an album by Domela. Visits a Miró exhibition at Jeanne Bucher's.

1944
Yet more exhibitions: in Paris at Bucher's with Domela and de Staël, in New York, Basel, Bern, and a final one-man exhibition at the Galerie l'Esquisse in Paris.
Falls ill with influenza, but continues painting until July. Dies on December 13 at 78 years of age from a stroke.

WHAT KANDINSKY'S CONTEMPORARIES HAVE TO SAY

Wilhelm Michel, writer, to Kandinsky (extract from a letter dated November 19, 1909, published here for the first time, on Kandinsky's paintings in the "Neue Künstler-Vereinigung München" (New Artists' Association, GM/JE St.)

These are documents of the starkest, most high-flown idealism, a parallel manifestation of a philosophical radicalism that raises the strongest doubts about the possibility of objective recognition. You are right to say that every artist's picture of the world is predominantly subjective. You are also right to defend the freedom of abstraction. But you provide only the final results of this abstraction, whereas your task should have been to represent the *process* of abstraction. You and your fellow-fighters make purely subjective, unsubstantiated, and unverifiable assertions in your pictures. As a civilized person one has to say: I believe you, and that you were affected by this impression in this way, but I cannot *see* it myself. [...] If you paint an enormous teardrop on the canvas, does that give you the right then to say that you have painted your father's funeral?

[...] I consider the tendencies shown by you and a few younger French artists to be a delayed pursuit of naturalism, which has with truly Prussian rigor drawn the ultimate idealistic conclusions from naturalist premises. [...] Just one more sentence in conclusion: a relationship with the objective world is the link between the artist and the perception of a third person, although in so saying I use "objective world" in the broadest sense of the concept. Those who reject this are withdrawing *eo ipso* from the realm of art itself, either into arts and crafts or into snobbism – something I have experienced more than a few times in Munich. Please accept the length of this letter as the expression of my most sincere respect, with which I salute you!

Alfred Kubin to Kandinsky, May 5 1910 (GM/JE St.)

Your method is crazy and ecstatic and tempting [...]. I sense in your work primeval, long-forgotten objects married with the secret vibrations of future spiritual possibilities.

P.S. I am convinced that a language of forms *similar* (not the right word) to your own lies hidden as a treasure of immense value in many people. – Everybody has his own personal rhythm. It may well be that we will come to see in you later the beginning of a new era of art. [...] Such a thing must grow organically and mature over many years, and then one fine day appear before the inner eye as a magnificent sequence of visions. You already have all that, as you are well aware – this is why your work fascinates me

so much. – Redon, Munch, Ensor, myself, we're all still too heavily entangled in the material, and in part dependent on what has already been achieved. I know of a couple of successful solutions by Nolde. [...] Grossmann and Nolde are indeed painters, but not mystics in *our* sense of the word; the same is probably true of the French.

Paul Klee, 1911 (*Diaries*, pp. 273 f.)

Really remarkable pictures. This Kandinsky wants to call together a new society of artists. Through personal acquaintance I have built up a feeling of strong trust in him. He is Someone and has an exceptionally beautiful, clear mind.

August Macke to Franz Marc, September 1, 1911.

There is a constant stream of energy, which is wonderful, emanating from Kandinsky's pictures. A romantic, a dreamer, a visionary, a teller of fairy tales, he is all those things as well. But what he is in addition to all that is what is really important. He is full of boundless life. Those surfaces which set viewers dreaming effervesce without ever sleeping. His tumultuous cavaliers are the coat of arms which hangs in front of his house; but there are not only boulders, mountains, and oceans in tumult, there are also the infinitely tender and pastoral elements...

Franz Marc, 1913 (in *Der Sturm*, 1913).

When I imagine him to myself, I see him always on a broad street, in which grotesque, shrieking figures are pushing and shoving; in their midst a clever person goes calmly on his way, this is he. Kubin ought to paint him so. [...] When I consider these pictures and think of what Europeans have grown used to describing as "painting," I envisage in my mind's eye a picture of the "spirit" saluting painting, and saluting it really enthusiastically! Painting had been feeling fine without it, and now it is deeply shocked, striking out around itself despairingly in an attempt to prevent the "spirit" from forcing its way in. Paul Klee ought to draw that. He is the only one who could. – And there is something else that I feel when I look at Kandinsky's pictures; an unutterable thankfulness that there is once more among us a man who can level mountains. And he has done this in such a distinguished manner. It is an inexpressible relief to know this.

Wilhelm Hausenstein (in *Der Sturm*, 1913).

When I first met Kandinsky, the thing that struck me most strongly about him was his all-embracing tolerance. I had imagined some kind of radical, one who stands on his principles, someone forceful. The first thing he said to me was the simple comment that he considered his art to be something highly relative. [...]
There is a certain amount of didacticism in Kandinsky, I believe – possibly even a certain conviction of the rights of the academic, a certain predominance of the intellect. But his character is much too complex to be described thus. A wealth of the most irrational sensitivity is bound up with this rationalism – admittedly not a Corinthian sensitivity, but one which has been spiritualized. [...]
The whole storm over Kandinsky is doubly and triply absurd because Kandinsky did not have the slightest inclination to put himself on a pedestal. I have never met a more reserved artist. What is more, Kandinsky is convinced that his method is not the one and only new principle. He sees himself as a conservative, just as Signac considered himself to be the guardian of the formal tradition of Delacroix.

Hugo Ball, 1917.

Kandinsky is liberation, comfort, release, and reassurance. People should go on pilgrimages to see his pictures; they are an escape route from the confusion, defeats, and doubts of our times. They are liberation from a century on the point of collapse. Kandinsky is one of the very great innovators, a Reformer of Life. The vitality of his intent is staggering and as unheard of as that of Rubens in his time, and of Wagner in his a generation before our times. His vitality encompasses equally music, dance, drama, and poetry. His significance is founded upon a simultaneously practical and theoretical initiative. He is the critic of his own work and of his era. He is the poet of hitherto unequalled verse, the creator of a new style of theater, the author of some of the most spiritual books that recent German literature has to offer.

Carl Einstein, *Die Kunst des 20. Jahrhunderts* (Art of the Twentieth Century), 1926.

Kandinsky concerns himself all too much with the material of dye traders, which he transforms into a literary version; color in itself is nothing, only color which has been formally modified and brought into relation with the volume/form achieves artistic significance [...]. At the beginning of his work Kan-

dinsky may have been governed by color almost to the extent of hallucination, interpreting it associatively, rather than attributing some preconceived conception of form to it. But the usefulness of color and line lies in fact in the variety of potential arrangements of the two, which is determined ultimately by the artist. It is precisely this passive submission to color which may have barred the path toward creation of objects for Kandinsky. His doctrine narrows down the potential for composition all too strongly, so that, rather than penetrating to the subject of the picture, he was content to declare the color to be the driving force and purpose of the picture. [...] Kandinsky overlooked powerful forces, above all the arrangement of space. His teaching is too weak and nothing more than the generalization of his purely personal experience; he has turned the simplicity and all too personal source of this experience into a theoretical justification, to ease his own conscience.

Galka Scheyer to Kandinsky, September 5, 1938.

What you yourself write about your work – about "great calm" and "affirmation of life" – is precisely the reason I love your art so much and the reason it is so essential to me in the affirmation of my own life. I am not the only one, I know for sure that future generations will need this affirmation too, in order to further develop the spiritual in the world.

Will Grohmann (*Wassily Kandinsky, Life and Work*, New York, 1958, p. 9).

The Italian artist Prampolini calls him "the Giotto of our time," the painter who brought painting back to life. His closest friends, Paul Klee and Franz Marc, were already on record that during the crucial years of the rebirth of European art, Kandinsky was far in the vanguard and supplied them with courage to go on. His uncompromising attitude to life and art, his faith in the unconquerability of the human spirit, came with him from Russia. He remained Russian to the last, although both by blood and spirit he was related to western Europe as well as to Asia. [...]
Kandinsky the man has remained for most people as great a mystery as Kandinsky the artist. Although he was [...] frank and informal in manner, most people know little about him beyond the fact that he was aristocratic in appearance, and possessed both integrity and amiability. He struck his contemporaries as more like a diplomat or a widely traveled scholar than as an artist. Only his closest friends and pupils knew how kind he was, let alone the full range of his spiritual and creative gifts. Even they sensed a solitary greatness in this man who remained a foreigner despite all the attraction he felt toward Europe, its problems and achievements, and regardless of the friendship and respect it showed to him. He clung to the Greek-Orthodox Church and to a faith in his native land. He read the Russian classics, loved Russian music [...]. If Kandinsky, for all his cheerfulness, struck many of his friends as cold and aloof, it was because he had remained different. Moreover, he wanted to keep the secret of his inner being, as well as that of his work.

ABBREVIATIONS

UG = W. Kandinsky, *Uber das Geistige in der Kunst, insbesondere in der Malerei*, 1912, (8th edition, Bern, 1965).

PLF = W. Kandinsky, *Punkt und Linie zu Fläche, Beitrag zur Analyse der malerischen Elemente*, 1926, (7th edition, Bern, 1973).

GS = W. Kandinsky, *Gesammelte Schriften*, ed. Hans Konrad Roethel und Jelena Hahl-Koch, vol I, Bern, 1980.

CW = W. Kandinsky, *Complete Writings on Art*, ed. Kenneth Lindsay and Peter Vergo, 2 vols, Faber & Faber, 1982.

GM/JE St. = Gabriele Münter- und Johannes Eichner-Stiftung, Munich.

Cat. Paris 1984 = *Œuvres de Vassili Kandinsky*, Catalogue établi par Christian Derouet et Jessica Boissel, Collections du Musée National d'Art Moderne, Centre Georges Pompidou, Paris, 1984.

Cat. Frankfurt 1989 = Exhibition catalogue, *Wassily Kandinsky. Die erste sowjetische Retrospektive. Gemälde, Zeichnungen und Graphik aus sowjetischen und westlichen Museen*, Frankfurt, 1989.

After the initial reference, major critical works are referred to only by the author's name and year of publication, for example: Grohmann 1958. The full title and details can be found in the Bibliography.

INTRODUCTION
AND ACKNOWLEDGMENTS

1 In Russia Kandinsky research is beginning to flourish now, but the pictures in the museum store rooms were in fact accessible earlier on to those experts who did not want to be deprived of their fellow-countryman. (See Dmitri Sarabianov: "Wassily Kandinsky – Künstler und Bürger Europas," in: Exhibition Catalogue Frankfurt 1989, p. 25). – When H. K. Roethel and I visited the store rooms of all four major museums in Moscow and Leningrad in the seventies, we saw that the curators guarded their treasure lovingly and kept it in very good condition.

2 Letter of May 5, 1910, (GM/JE St, Munich).

3 Lecture held at the opening of a Kandinsky exhibition in 1931 in San Francisco.

4 Inquiries to G. Freudenthal, Städt. Galerie, Luisenstraße 33, Munich.

PART I
CHAPTER 1

1 "Concerning Sentences Passed by Peasant Courts in the Moscow District," 1889, GS, p. 75.

2 Letter of June 8, 1935, in *Künstler schreiben an Will Grohmann*, Karl Gutbrod (ed.), Cologne, 1968, p. 66.

3 Will Grohmann, *Wassily Kandinsky, Life and Work*, New York, 1958, p. 30.

4 Preface to the catalogue of the Kandinsky 1902–1912 retrospective, GS, p. 22.

5 CW, p. 363.

6 *Zwischen Ost und West. Russische Geistesgeschichte.* Hamburg, 1961, vol. II, pp. 62–105. Tschižewskij's merit in comparison with most historians is to be both a Russian and a cosmopolitan who is able to acknowledge his universal culture as a Slavist, connoisseur, historian, and philosopher (he was a student of Husserl). His broad knowledge and intellectual background allow him to see beyond mere historical facts.

7 D. Tschižewskij. See note 6, pp. 89 ff.

8 CW, p. 130.

9 G. Chulkov, *Gody stranstviy*, Moscow, 1930, p. 61.

10 "K chitateljam", in *Vesy*, 1909, No. 12, p. 188.

11 Preface to *Russkie simvolisty*, Moscow, 1910.

12 Dmitri Merezhkovsky, *O prichinakh upadka i o novykh techeniyakh sovremennoy russkoy literatury*, 1892. in *Poln. sobr. soch. D.M.* 17 tt. SPb/M., 1911–1913, vol. XV, p. 247.

13 CW, p. 128.

14 "Otvet g. Andreevskomu" in *Mir iskusstva*, 1901, p. 241.
Briusov is referring to Soloviev's "Tale of the Antichrist."

15 CW, p. 135.

16 CW, p. 140.

17 Diaries, *Lettres à un inconnu III*, MS p. 80, Museo Municipale, Ascona.

18 in *Odesskie novosti* (Odessa News), No. 8339, Feb. 9, 1911.

19 D. Tschižewskij. See note 6, p. 91.

20 N. Chernyshevsky, *Esteticheskie otnosheniya iskusstva k deistevitelnosti*, in N. J. Pervoe *poln. sobr.*, I, Vevey, 1868, p. 152.

21 CW, p. 135.

22 *Reminiscences*, in CW, p. 363.

23 Cat. Frankfurt 1989, p. 50.

24 "Whither the 'New' Art?" in *Odesskie novosti* (Odessa News), No. 8339, Feb. 9, 1911. CW, p. 99.

25 Quoted from A. I. Zotov and O. I.

Sopocinsky, *Russkoe iskusstvo, Istoricheskiy ocherk*, Moscow, 1963, p. 202.

26 CW, p. 119.

27 CW, p. 99.

28 *Sbornik postanovleny po ministerstvu narodnogo prosveshcheniya*, pp. 980–1050, 1.9. *Carstvovanie Imperatora Aleksandra II 1884 goda*, St. Petersburg, 1893.

29 CW, p. 361.

CHAPTER 2

30 Grohmann 1958, p. 13. A registration form, filled out when he visited Munich with his son in 1898, says: "Born in Moscow, 1840" (G. Kleine, "Vasilij Sil'vestrovič Kandinsky, ein Maler?" in *Kunstchronik* No. 3., March 1990, p. 93). On the other hand, N. Avtonomova wrote to the present author on May 7, 1990, that Kandinsky's father, according to all known documents, seems to have been born in Siberia before 1840. The puzzle may never be solved.

31 Letter from N. Avtonomova, Chief Curator at the Tretiakov Gallery in Moscow, June 25, 1990.

32 In a letter to Gabriele Münter, Kandinsky says that he is as jealous as an Asian, "and I am a bit Asian" he adds (GM/JE St, Munich). See also W. Grohmann 1958, p. 13, and Nina Kandinsky, *Kandinsky und ich*, Munich, 1976, p. 22.

33 Letter to the author from Alexei Kandinsky, Moscow, June 1990.

34 Cat. Paris 1984, p. 18.

35 Vassily Kandinsky, *Tekst khudozhnika*, Moscow, 1ZO NKP, 1918, pp. 170–171. A Munich police form concerning Kandinsky's father prompted Gisela Kleine to raise the question, as late as 1990, whether Vasily senior may not have been a painter himself. ("Vasilij Sil'vestrovič Kandinsky – ein Maler?" in *Kunstchronik*, No. 3, March 1990, p. 93.) There is no evidence to suggest that Vasily senior was a professional painter, nor is there even any explanation why the police form gives his birth date as 1840 and his birthplace as Moscow (all the Russian documents state that he was born in Siberia). The Bavarian officials who questioned the artist's father may have been unable to decipher his Russian passport, and as the elder Kandinsky spoke no German his son, whose grasp of the language was still somewhat shaky and in any case did not extend to the Bavarian dialect, may have translated for him. Vasily junior may have thought that the officials were asking him his own profession, and not his father's, when he replied "painter."

36 CW, p. 382.

37 CW, p. 365.

38 Nina Kandinsky, *Kandinsky und ich*, Munich 1976, p. 24.

39 GM/JE St, letter dated November 12, 1903.

40 J.-P. Bouillon, (ed), *Vassily Kandinsky. Regards sur le passé et autres textes 1912–1922*, Paris 1974, p. 65.

41 CW, p. 382.

42 M. Werenskiold's statement that Kandinsky's father took "him and the other children" to Odessa after his divorce in 1872 is incorrect. ("Kandinsky's Moscow," in *Art in America*, March 1989, p. 97). A "single child" may have meant something different in the nineteenth century. If the child's nanny was considered part of the family and had children of her own, which was sometimes the case, or if any other domestics in the household had children, his "singleness" would not have

been a solitude. Moreover families were more extended in those days than they are now, and ties between cousins, etc., tended to be closer – especially in Russia. Absolutely nothing indicates that Kandinsky lacked playmates, as Gisela Kleine speculates (*Gabriele Münter und Wassily Kandinsky*, Frankfurt, 1990, pp. 130 & 132).

43 GM/JE St, letter from Odessa, dated October 2, 1912.

44 GM/JE St, letter of September 15, 1903.

45 Letter of December 28, 1906. Cat. Paris 1984, p. 26.

46 "Hommage à Kandinsky," in *XXième siècle*, 1966.

47 GM/JE St. This seems excessive by today's standards, but we have reason to think that the artist's parents remained on exceptionally good terms after their divorce. Lidia Tikheeva had servants who took care of her household and had plenty of time to visit her first son. Besides, she may have been particularly solicitous of him out of guilt at having left him with his father. Gisela Kleine speculates that, on the other hand, young Kandinsky may have had a guilt complex based on an unconscious belief that he had driven her away (a fact that is true for many children of divorced parents, but does not seem to apply in this case). Kleine's biography *(Gabriele Münter und Wassily Kandinsky, op. cit.)* creates an impression that does not really fit the documentary evidence. If one accepts Münter's viewpoint, it appears incomprehensible that Kandinsky should once again postpone his return to Munich simply in order to attend a name day celebration for one of his relatives (and spend time making a toy airplane for one of the children). One wonders why, for that matter, he chose to "protect" his mother by holding back the news of his planned divorce from Ania and remarriage with Gabriele Münter? He reports on October 5, 1905, that his mother's grief over the death of one of her sons had reduced her to a skeleton; but only a week later he decides to tell the news anyway.

48 *Tekst khudozhnika*, GS, p. 28 and p. 148. In a letter dated September 15, 1903, Kandinsky expresses deep sorrow at the death of his aunt, and recalls how her restless, kindly old hands had caressed him when he was a child (GM/JE St). His half-sister Lisa was named after this aunt.

49 Cat. Frankfurt 1989, p. 49.

50 GM/JE St, letters of October 10, 1905 (relatives' nicknames), December 8, 1910 (Kandinsky was "idolized" as a child), and 27 March, 1903.

51 CW, p. 358.

52 Ibid.

53 *Tekst khudozhnika*, GS, p. 34 and p. 154. Kandinsky used dark blue instead of black, even in his preliminary sketches for oil paintings (see Chapter 5).

54 "Supplement," 1913, Catalogue of the Kandinsky 1902–1912 retrospective, GS, p. 24.

55 *Die Kunst des 20. Jahrhunderts*, 1922–1926, new edition, Leipzig, 1988.

56 CW, pp. 371f.

57 GS, p. 166.

58 CW, p. 371.

59 According to Nina Kandinsky, he took music lessons starting in 1874. *Kandinsky und Ich*, 1976, p. 26.

60 GM/JE St, letter of September 23, 1903.

61 CW, p. 364.

62 GM/JE St, letter of October 11, 1903.

63 In the Russian edition of *Reminiscences*, Kandinsky elaborates on his father's attachment

to the churches of Moscow: ". . . when, for example, he recites, with a special fondness, the ancient, redolent names of the forty times forty churches of Moscow." (GS, p. 170). The latter expression comes from an old Moscow chronicle and is universally known in Russia.

64 Letter of July 31, 1937, to André Dezarrois. Cat. Paris 1984, p. 13.

65 CW, p. 372.

66 GM/JE St, letter of September 9, 1903. According to Münter, Kandinsky was "never at all religious-minded" (interview with Edouard Roditi, 1958. *Dialogues on Art*, London, 1960, p. 145). However Nina Kandinsky told Paul Overy that her husband prayed every night before going to bed (P. Overy, *Kandinsky. The Language of the Eye*, New York / Washington, 1969, p. 29). In the course of the numerous conversations I had with her between 1968 and 1980, she gave me the impression that although Kandinsky had been a very pious man, his religious sentiments were not restricted to any one denomination or nation. She knew that I would correctly interpret her memories of regularly attending Easter Mass with her husband, and that I would not attach too much importance to them. (Only the most fanatically atheist of Russians would miss those splendid midnight celebrations.) She declared that otherwise they did not attend church. Grohmann confirms her first statement, but not the second: ". . . when he [Kandinsky] was living in Western Europe he never missed attending the Resurrection Mass in a Russian church; during his Bauhaus years, he regularly came to Dresden, where there was a Russian church, for Easter" (Grohmann, 1958, pp. 13–14).

67 For more about Benia, see Part II, Chapter 7, and the "testimon" by Grohmann at the end of this book.

68 *Kandinsky und Ich*, 1976, pp. 233f.

CHAPTER 3

69 CW, p. 381.

70 Mentioned for the first time in extenso in J. Langner. "Gegensätze und Widersprüche – das ist unsere Harmonie," in *Kandinsky und München. Begegnungen und Wandlungen 1896–1914* (catalogue), Munich, 1982, pp. 106–132.

71 CW, p. 382.

72 CW, p. 360.

73 CW, p. 364.

74 First noticed by Hideho Nishida and his student Hiroko Ouchi: "On the Origins of Kandinsky's Remarkable Themes," in *Art History*, No. 8, Tohoku University, Japan, 1986, p. 117.

75 After several attempts in this direction by S. Ringbom and R. C. Washton-Long, a Japanese study was published about the typically Orthodox "moments" of Kandinsky's religious themes (see n. 74). See also the detailed research on "Kandinsky's Moscow" by the Norwegian art historian Marit Werenskiold (n. 42).

76 D. Merezhkovsky, "La Question religieuse: enquête internationale," in *Mercure de France*, vol. 67, May 1, 1907, pp. 68–71. Ringbom, *The Sounding Cosmos*. Abo 1970, p. 175. Werenskiold, *op.cit.*, p. 108.

77 Kandinsky's correspondence with D. Mitrinovich makes it clear that the artist was personally acquainted with Merezhkovsky (GM/JE St. – Mitrinovich's letter of June 19, 1914). Marianne Werefkin also knew Merezhkovsky personally and thought highly of him, according to her student and nephew

Alexander Werefkin. She discussed his ideas in her "salon" (oral information, 1964).

78 O prichinakh upadka i o novykh techeniyakh sovremennoy russkoy literatury, 1892, in *Poln. sobr. soch. D. S. Merezhkovskogo*, 17 vols., SPb/M, 1911–1913, vol. 15, p. 303.

79 See n. 42, pp. 98 ff.

80 Alexander Ivanovich Chuprov (1842–1908), economist, statistician, and liberal writer. From 1879 on, he taught at Moscow University. His *History of Political Economy* was published in 1892.

81 Cesare Lombroso (1835–1909). Pathologist and psychiatrist at the University of Turin. Mainly known for his book *L'Uomo delinquente*, which argues the theory that criminals ought to be viewed and treated as patients. In *On the Spiritual in Art* Kandinsky refers to him as the "inventor of the anthropological method in criminology" (CW, p. 143). No doubt the artist's interest in Lombroso sprang from the latter's attempt to view criminality from the standpoint of the human psyche – in other words, that "inner motivation" which had already fascinated Kandinsky in connection with Russian peasant law.

82 CW, p. 362.

83 *Tekst khudozhnika*, GS, p. 150.

84 *Ibid.*, p. 32.

85 *Vasilij Kandinskij 1866–1944. Zhivopis, grafika, prekladnoe iskusstvo* (catalogue), St. Petersburg, 1989, p. 10.

86 From Grohmann (pp. 31 ff.) on, almost all catalogues, monographs, etc., up to P. A. Riedl (ed.), *Wassily Kandinsky*. Hamburg, 1989, p. 15.

87 V. Kandinsky, "Iz materialov po etnografii sysolskich i vechegodskikh zyrjan, Nacionalnye boshestva (po sovremennym verovaniyam)," in *Etnografitcheskoe obozrenie*, Moscow, 1889, vol. III, pp. 102–110. "O nakazaniyakh po resheniyam volostnych sudov Moskovskoj gubernii," in *Trudy obshchestva lyubiteley estestvoznaniya antropologii i etnografii*, Moscow, 1889, vol. IX, pp. 13–19. Both articles have been published, with annotations, in German translation in GS, pp. 68–87, notes 194–198.

88 GS, p. 75.

89 GS, pp. 86 f.

90 GS, p. 81.

91 GS, p. 85.

92 CW, pp. 379 f.

93 *Tekst khudozhnika*, GS, p. 47 and pp. 168 f.

94 Epifaniy Premudry, *Zhitie Stefana episkopa permskogo*. It is thanks to Dmitrij Tschiżewskij that this work was reprinted by s'Gravenhage in 1959. Tschiżewskij was instrumental, too, in my being able to study, for an entire university term, this old Russian biography with its remarkable stylistic ornamentation.

95 "Kandinsky and 'Old Russia.' An Ethnographic Exploration," in *The Documented Image*, Syracuse University Press, N.Y., 1987, pp. 187–222.

96 GS, pp. 68–74. Commentary on pp. 194–197. Peg Weiss' objection that "errors and omissions render this version unreliable" is unfounded. The translation is complete, accurate, and adequately annotated (considering the fact that Kandinsky the artist is of more interest than Kandinsky the ethnographer).

97 GS, p. 32.

98 It is another of Pierre Volboudt's poetic fantasies that Kandinsky's travels in northern Russia took him all the way to the Arctic Sea *(Kandinsky*, Paris, 1984, p. 17). This error has to be pointed out. The reader who is told that

Kandinsky traveled to the Arctic might wonder why the artist never mentions that experience.

99 "Folk pictures." Kandinsky probably means the *lubki*, inexpensive, unframed and often colored prints that were run off in large quantities and were much appreciated by the rural population of Russia from the early 17th century well into the 20th century. The *lubki* technique was rudimentary, the composition straightforward and simple, the renderings easy to grasp and often naive, at once original and realistic. The subjects included religious, historical, and traditional motifs, as well as political satire and crude visual jokes. An explanatory or humorous text usually accompanied the prints.

100 He may have based this motif on a popular postcard of the time. At all events, the angle is the same. See Cat. Paris 1984, pp. 32 ff.

101 Grohmann 1958, p. 30.

102 CW, p. 369.

103 A copy of this rare catalogue is at the Tretiakov Gallery in Moscow.

104 CW, p. 363.

CHAPTER 4

105 Grohmann 1958, pp. 46 and 257.

106 K. Brisch, *Wassily Kandinsky (1866–1944). Untersuchung zur Entstehung der gegenstandslosen Malerei an seinem Werk von 1900 bis 1921*, thesis, Bonn 1955, p. 92.

107 J. Hahl-Koch, "Kandinsky und Kardovskij. Zum Porträt der Maria Krustschoff," in *Pantheon*, No. IV, 1974, pp. 382–390.

108 Dmitri Kardovsky, *Ob iskusstve*, Moscow, 1960, p. 191.

109 *L'Art abstrait*, Paris, 1980.

110 It is listed as No. 41 in the catalogue of the Exhibition of the Association of Southern Russian Artists in Odessa. It was again shown, together with Kandinsky's studies for it, in Moscow in 1901. The Tretiakov Gallery has acquired it. The picture's original owner was an Odessa lawyer.

111 Cat. Frankfurt 1989, p. 49.

112 CW, pp. 366 f.

113 Cat. Paris 1984, p. 22.

114 GS, p. 152, No. 27. In spite of his thorough research, Jean-Paul Bouillon was unable to locate this painting by Polenov; he concludes that Kandinsky may either have been referring to N. N. Ge rather than to Polenov, or else to Polenov's historical painting *Christ and the Sinner* – despite the fact that Kandinsky was notoriously uninterested in historical painting. (J.-P. Bouillon (ed.), *Vassily Kandinsky: Regards sur le passé et autres textes, 1912–1922*. Paris, 1974, p. 250).

115 Moscow catalogue, 1989 (see note 85), p. 34. Discussed at length in J. Hahl-Koch, "Kandinskys erstes Ölbild" in: *Kunstchronik*, 1989, vol. 4.

116 Cat. Frankfurt 1989, pp. 35 ff.

117 GM/JE St.

118 GM/JE St. for all the Kandinsky-Münter correspondence.

119 A landscape by this painter, dated 1900, was found in Kandinsky's estate (Cat. Paris 1984, p. 465).

120 Max Nordau (1849–1923): Hungarian author and physician whose dogmatic writings on degeneration and the psycho-physiology of creativity (*Entartung*, 1895) caused a considerable stir in the last years of the nineteenth century.

PART II
CHAPTER 1

121 Foreword to the 1902–1912 Kandinsky "Collective Exhibition" catalogue. CW, p. 343.

122 Ibid.

123 CW, p. 364.

124 For a detailed commentary, see GS, p. 153.

125 CW, p. 142.

126 MS at GM/JE St, Munich.

127 GM/JE St, letter of November 16, 1904.

128 GM/JE St, letter dated Berlin, October 31, 1903.

129 P. Weiss, *Kandinsky in Munich. op. cit.*, p. 33. Münter states that Obrist's art was always more decorative in intention than Kandinsky's abstractions, and was less of an influence on the latter than might be assumed (E. Roditi, interview with Gabriele Münter in *Arts*, 34, No. 4, Jan. 1960, p. 38). For more about Kandinsky's views on ornamental and decorative art, see document on p. 58, and *On the Spiritual in Art*, CW, pp. 197 ff.

130 First hypothesis in *Um die Schönheit, eine Paraphrase über die Münchner Kunstausstellungen*, Munich, 1896, p. 13. Second hypothesis in "Formenschönheit und dekorative Kunst," in *Dekorative Kunst*, No. 1, Nov. 1897, p. 75.

131 M. Gassner, E. Gillen, ed., *München um 1900*, Bern/Stuttgart 1977, pp. 6 and 114.

132 See note 523.

133 *Abramtsevo. Khudozhestvenny kruzhok, zhivopis, grafika, skulptura, teatr, masterskie*, St. Petersburg, 1988.

134 See K. Stanislavsky, "Vospominaniya o S. I. Mamontove," in *Abramtsevo, op. cit.*, p. 261.

CHAPTER 2

135 D. Kardovsky, *Ob iskusstve*, Moscow, 1960, p. 65. A. Jawlensky, "Lebenserinnerungen," in C. Weiler, *A. Jawlensky. Köpfe, Gesichte, Meditationen*, Hanau, 1970, p. 107. I. Grabar, *Moia zhizn*, Moscow & St. Petersburg 1937, p. 127 Jawlensky, Grabar, and Kardovsky all say they worked hard, daily from 8 am to 8 pm.

136 Siegfried Mollier (not Moillet, as Kandinsky mistakenly writes) was a professor of medicine at the univerity and taught special anatomy classes for artists.

137 CW, p. 375.

138 Letter of March 23, 1934, in Russian. Quoted by kind permission of Maria Jawlensky, Locarno.

139 I. Grabar, *Moia zhizn, op. cit.*, p. 257.

140 CW, p. 374.

141 P. Weiss, *Kandinsky in Munich. The Formative Jugendstil Years*, Princeton 1979, pp. 13–19.

142 CW, p. 375.

143 Ibid., p. 376.

144 P. Weiss, 1979, pp. 48–53.

145 CW, p. 376.

146 GS, p. 132. See also Kandinsky's "Letters from Munich," *Apollon*, 1909–1910, *passim*.

147 CW, p. 376.

CHAPTER 3

148 Ibid. p. 374.

149 K. Brisch, 1955, p. 92.

150 CW, p. 368.

151 Quoted in Grohmann, 1958, p. 33.

152 M. F. Vikturina, "Zur Frage von Kandinskys Maltechnik," in Cat. Frankfurt 1989, p. 46. Formulas for colors and varnishes are also to be found in Notebook No. 346 in the Städ-

tische Galerie im Lenbachhaus archives (Munich).

153 Vikturina, Cat. Frankfurt 1989, p. 37.

154 Grohmann 1958, p. 41.

155 Vikturina, Cat. Frankfurt 1989, p. 56.

156 Ibid, *op. cit.*, p. 46.

157 The author is grateful to the restorer, Dr. Rudolf Wackernagel, for this interesting information.

158 A study of 1902 shows Ania with Daisy. Another study, dated 1904, depicts the same dog with a child (Roethel, Benjamin, *Kandinsky: Catalogue raisonné I, Nos 57 and 114*).

159 K. Brisch, 1955, p. 93.

160 Ibid., pp. 93 ff. See also Paul Overy, *The Language of the Eye*, New York/Washington, 1969, pp. 35 ff.

161 CW, pp. 359 f.

162 For the evidence from X-ray analysis, see Vikturina, Cat. Frankfurt 1989, p. 37.

163 R. Gollek's observation that the long spatula stroke predominates in the Kallmünz studies cannot be confirmed throughout. (*Der Blaue Reiter im Lenbachhaus München*, Munich, 1982, p. 318).

164 Cat. Paris 1984, p. 22: "... les petites esquisses à l'huile ... les lieux qu'il choisit sont toujours chargés de la symbolique et la mythologie du Modern style ..."

165 W. Kandinsky, "Mein Werdegang" (1914), in GS, p. 54. The fact that Kandinsky disliked anatomical distorsions is confirmed in a letter to Kardovsky, in which he inquires anxiously whether the latter has not given too long a bust to one of his figures, as would seem to appear from a photograph of the work (Cat. Frankfurt 1989, p. 51).

166 Quoted from Gören Söderström, "Strindbergs Malerei," in A. Gundlach, ed., *Der andere Strindberg*, Frankfurt, 1981, p. 237 (my italics). See also p. 102 of the same for more about "skogsnuvism," the new painting pioneered by Strindberg.

167 CW, pp. 129, 185 n., etc.

168 New edition: Paris, 1978. Kandinsky also mentions Signac in "Analyse des éléments premiers de la peinture," in *Cahiers de Belgique*, Brussels, 1928 (translated in CW, p. 852). It is almost certain that Kandinsky also mentioned Signac in private conversations: it is probably no accident that Hausenstein compares Kandinsky with Signac, who saw himself as continuing the Delacroix tradition (GS, p. 183).

169 Signac, *D'Eugène Delacroix au néo-impressionisme*, Paris 1899, new ed. 1978, p. 85.

170 Ibid., p. 109 (on Monet), pp. 53, 124.

171 Ibid., pp. 107, 60, 144.

172 Ibid., pp. 54, 149 (about the "thinking artist"), pp. 57, 150, 75 f.

173 CW, p. 392.

174 *Sturm*, March 1913, No. 150/1, p. 277.

175 H. K. Roethel, *Kandinsky, op. cit.*, p. 19.

CHAPTER 4

176 N. Avtonomova, "Die Briefe W. Kandinskys an D. Kardivskij," in Cat. Frankfurt 1989, p. 49.

177 Archives of the Städtische Galerie im Lenbachhaus, Munich. Partly published in H. K. Roethel, *Kandinsky: Das graphische Werk*, Cologne 1970, pp. 429 ff.

178 Archives of the Städtische Galerie im Lenbachhaus, Munich.

179 Freytag's MS is also in the archives of the Städtische Galerie im Lenbachhaus, Munich.

180 Peg Weiss, 1979, p. 58.

181 Alexander von Salzmann (1870–1914), like Kandinsky, studied with Franz Stuck and

joined the Phalanx; he was known mainly as a stage artist. He was fond of "shocking the bourgeois," particularly in his student days. I owe this information to his son, Michael von Salzmann (in a conversation in March 1991 in Paris).

182 This particular passage from Freytag's memoirs is quoted extensively in Roethel's book on Kandinsky's graphic œuvre. C. Derouet is mistaken about Kandinsky being the Phalanx's sole financial backer (Cat. Paris 1984, p. 20).

183 MS in the archives of the Städtische Galerie im Lenbachhaus, Munich.

184 *Konstens Karyatider*, Stockholm, 1950, p. 54.

185 Ibid., p. 56.

186 GM/JE St, letter of April 20, 1905.

187 V. Kandinsky "Letters from Munich [III]," in *Apollon 7*, April 1910, p. 12 (translation in CW, p. 64).

188 GM/JE St, letter of May 4, 1904.

189 GM/JE St, letter of October 2, 1903.

CHAPTER 5

190 Kandinsky included the first "Song" in a letter to Münter dated September 2, 1903 (not February 9, as indicated in CW. On September 15, he answers: "I am not offended because of my little song." On November 26, 1903, he again sent Münter some rhyming verses. They are published here for the first time.

"THE WIND XI. 26

Listen to me what I say
and come closer, my dear child,
screams and tempests, damnation, sorrow
in the forest the mean wind.

Do you fear me? No? Oh say it
Or does worry you the wind?
Do you hear old pines that mourn
And a birch weeps like a child.

Was it you? I heard a mourning:
Could it only be the wind?
Don't be silent! Do say something!
Do come closer my dear child.
etc.
In the forest the mean wind.

Do you fear me? No? Oh say it.
Or does worry you the wind?
Do you hear old pines that mourn
And a birch weeps like a child.

Was it you? I heard a mourning:
Could it only be the wind?
Don't be silent! Do say something!
Do come closer my dear child.
etc.
this procedure can be applied ad infinitum if one feels like it! –"

191 GM/JE St, letter April 3, 1904.

192 Quoted by J. Eichner, *Kandinsky und Gabriele Münter. Von Ursprüngen moderner Kunst*, Munich 1957, p. 128.

193 GM/JE St, for both letters (as well as the following ones).

194 *Kandinsky in Paris, op. cit.*

195 K. Brisch, *op. cit.*, p. 117.

196 CW, p. 185.

197 GS, p. 156.

198 GM/JE St, letter of January 31, 1904.

199 Letter to J. B. Neumann, dated October 2, 1935, Archives of the Getty Center for the

History of Art and the Humanities, Los Angeles. A similar letter, dated December 8, 1937, is addressed to Kandinsky's former Bauhaus student Hans Thiemann.

200 GS, p. 54.

201 Hans K. Roethel in collaboration with Jean K. Benjamin, *Kandinsky*, New York, 1979. See also *Kandinsky*, Paris 1977, p. 7. See also Johannes Eichner's remarkable double biography, *Kandinsky und Gabriele Münter, Von Ursprüngen moderner Kunst*, Munich, 1957, *passim*.

202 GM/JE St. The first letter is dated June 23, 1907; the second, sent by messenger, about April 5, 1909.

CHAPTER 6

203 GM/JE St. letter of August 10, 1904.

204 *Kandinsky. Das graphische Werk*, Cologne, 1970.

205 Ibid, p. XX, with precise illustrations of Kandinsky's method of working with several blocks. See also K. Lindsay's research on the role of black and white in *Prints 12*, 1962, p. 235.

206 Peg Weiss, *Kandinsky in Munich. The Formative Jugendstil Years*, Princeton, 1979. *Kandinsky in Munich 1896–1914*, exhibition catalogue, The Solomon R. Guggenheim Museum, New York, 1982. "Kandinsky: Symbolist Poetics and Theater in Munich," in *Pantheon III*, 1977, p. 209.

207 "Leere Leinwand undsoweiter," in *Cahiers d'Art*, No. 5, 1935.

208 GM/JE St. Manuscript concerning literature, dance, etc., probably material for *On the Spiritual…*

209 GM/JE St, letter from Odessa, dated October 31, 1904.

CHAPTER 7

210 Diary. GM/JE St.

211 R. Gollek, ed., *G. Münter*, exhibition catalogue, Munich, 1977, p. 11.

212 Ibid. p. 24.

213 GM/JE St, letter of December 8, 1910. A similar letter is dated March 27, 1903. The Kandinsky-Münter letters quoted here are in the GM/JE St in Munich. They were partly published in J. Eichner, 1957; H. K. Roethel, *Graphik*, Cologne 1970, and more extensively in Gisela Kleine, *G. Münter und W. Kandinsky*, Frankfurt, 1990.

214 GM/JE St, letter of October 11, 1903.

215 GM/JE St. The first letter is undated (probably end of March 1904), the second is dated November 8, 1902.

216 Olga von Hartmann, the widow of Kandinsky's composer-friend, told me that Münter had often isolated herself. She had gone to Murnau alone, for example, when Kandinsky had been obliged to stay in Munich. She had been the more difficult of the two (conversations in Paris/Garches, August 1972). Nina, Kandinsky's second wife, was under the impression that Kandinsky had had to spend some time in a sanatorium because of his stormy relationship with Münter during their stay in France in 1907. *(Kandinsky und ich*, Munich, 1976, p. 45).

217 I have shown in a review of G. Kleine's book that the facts simply contradict her picture of Kandinsky and Münter's relationship. (*Kunstchronik*, January 1993). R. Heller shows that Kleine's partial treatment does not render Münter any service either: *Gabriele Münter*, forthcoming.

218 GM/JE St, letters of December 17 and November 20, 1910.

219 GM/JE St, letters of November 8, 1902, and March 13, 1903.

220 Petr Mikhailovich Bogaevsky, "Ocherk byta Saranul'skikh votyakov," Moscow, 1888. We owe this find to Annette Evrard.

221 Benia's letters are at the GM/JE St.

222 Conversation between Ksenia Bogaevskaya and Natalia Avtonomova, the Chief Curator of the Tretiakov Gallery in Moscow, November 1991.

CHAPTER 8

223 GM/JE St, letter of July 7, 1907.

224 In J. Eichner, 1957, pp. 90–102.

225 He made a sketch of this important painting and decided it should be sent to the Knave of Diamonds exhibition in Moscow (he says this in a letter to Münter, dated Oct. 20/Nov. 3, 1910, GM/JE St).

226 Grohmann 1958, p. 56.

227 J. Eichner 1957, p. 90. H. K. Roethel states also: "A direct dependence is out of the question" ("Kandinsky in Deutschland," in *Wassily Kandinsky 1866–1944*, exhibition catalogue, Kunsthalle Basel, 1963, p. 22).

228 B. Fäthke, exhibition catalogue, *Marianne Werefkin. Leben und Werk*. Munich 1988, pp. 107–114.

229 J. Fineberg, *Kandinsky in Paris 1906–1907*. Thesis, Harvard 1975.

230 Peg Weiss, "Kandinsky und München. Begegnungen u. Wandlungen," in *Kandinsky und München*, exhibition catalogue, Munich, 1982, pp. 60 & 65.

231 Among many others, see M. Lacoste, *Kandinsky*, Paris, 1979, p. 32.

232 "Letter From Munich III," in *Apollon* No. 7, April 1910.

233 Werner Hofmann has demonstrated this filiation with great clarity, as well as the one leading back to Maurice Denis, but he mentions Gauguin instead of Cézanne. *Von der Nachahmung zur Erfindung der Wirklichkeit. Die schöpferische Befreiung der Kunst, 1890–1917*, Cologne, 1970, p. 69.

234 R. Gollek, *Das Münter-Haus in Murnau*, Munich, undated, p. 15.

235 Ibid, p. 28.

CHAPTER 9

236 G. Pauli, *Erinnerungen aus sieben Jahrzehnten*, Tübingen, 1936, pp. 264 f.

237 The argument Jawlensky's German would have been too poor to make him a co-author of the introduction (B. Fäthke, *op. cit.*, p. 116) is absurd, since half of the group spoke Russian and could therefore have communicated with him. Fäthke's idea that Werefkin could have been the sole, or co-author of the text cannot be invalidated, but it seems unlikelier than K.'s authorship.

238 "Letters From Munich II," in *Apollon* No. 4, January 1910. CW, p. 63.

239 November 3, 1910 in a letter to Münter. On December 2, 1910 he wrote to her that a true relationship with Erbslöh did not seem possible anymore. GM/JE St, Munich.

240 Special edition for the exhibition of the "Neue Künstlervereinigung" by Thannhauser, Munich, 1910.

241 Ukrainian painter from Kharkov (1882–1967), studied in Odessa, then in Munich with Ažbè, leading member of Russia's "Fauves." Brother of the painter Vladimir Burliuk. (1886–1917).

242 GM/JE St, letters of October 26 and November 8, 1910.

243 The first to research this context were T. Andersen, then J. Hahl-Koch and J. Bowlt. The following letters are all in GM/JE St.

244 MS in GM/JE St, Munich.

245 GM/JE St, letter dated December 4 (November 21 on the Russian calendar).

246 (Kandinsky's letters to Nikolai Kulbin are in the Russian Museum in St. Petersburg and are so far unpublished in the West; Kulbin's letters in the Gabriele Münter- und Johannes Eichner-Stiftung in Munich are so far unpublished). Nikolai Nikolaevich Kulbin (1868–1917), St. Petersburg artist, music theoretician, physician, founder of the artist's association "Triangle" (Treugolnik) of 1909, important organiser and patron of the Russian Cubo-Futurists. He gave a reading of Kandinsky's "On the Spiritual in Art" during the Pan-Russian Artists' Congress in St. Petersburg in December 1911.

PART III
CHAPTER 1

247 Letter of May 25, 1935, Archives of the Getty Center for the History of Art and the Humanities, Los Angeles.

248 GM/JE St, letter to Münter, November 1, 1912.

249 GM/JE St, October 27, 1910.

250 Städtische Galerie, Munich.

251 GM/JE St, December 8, 1910.

252 We shall not anticipate the 5th volume of GS, which will include all the poems, plus variants and Kandinsky's own translations. There is some literature about the German edition of *Sounds*, notably the thorough essay by H. Brinkmann: *Wassily Kandinsky als Dichter*, dissertation, Cologne, 1980.

CHAPTER 2

253 In the Munich estate, GM/JE St. The connection through Münter's sister was discovered by G. Kleine, 1990, p. 288. For more about Kandinsky and Craig see: J. Hahl-Koch, "Kandinsky und Schönberg. Zu den Dokumenten einer Künstlerfreundschaft," in *Arnold Schönberg-Wassily Kandinsky, Briefe*, pp. 201 & 203.

254 V. Briusov, "Nenuzhnaya pravda. Po povodu Moskovskogo khudozhestvennogo teatra," in *Mir iskusstva*, Nos 1–6, pp. 67–74. Kindermann's *Theatergeschichte Europas*, vol. IX, Salzburg, 1970, p. 321, erroneously gives Meyerhold as the author of this article.

255 V. Briusov (pseud. Avreli), "Vekhi. Iskaniya novoy sceny," in *Vesy*, No. 1, January 1906, pp. 72–75.

256 In V. Meyerhold, *Stati, pisma, rechi, besedy*, vol. I, 1891–1917, Moscow, 1968, pp. 105–143.

257 Ibid.

258 Thomas von Hartmann (1885, Khoruzhevka, Ukraine – 1956, Princeton, USA) had half Russian-half German origins and was related to the philosopher Eduard von Hartmann. He studied music with Taneev and Arenski at the Moscow conservatory and became famous at the Court Theater of St. Petersburg in 1907 as the composer of the ballet *The Purple Flower*. From 1908 on, he pursued his studies in Munich with Felix Mottl. His life was decisively influenced (and his career as a composer probably hampered) by his adhesion to the Sufi community headed by Gurdjieff (see Thomas von Hartmann, *Our Life with Mr.*

Gurdjieff, New York, 1964). Hartmann used a pseudonym to write film music, thus contributing to the financial needs of that small, closely knit community. In 1919 Hartmann became the director of the Tiflis conservatory. From 1922 he lived near Paris with his community and remained on close terms with Kandinsky all his life. Olga von Hartmann, his widow, remembers that they worked until the very end on a bacchanalian ballet. Hartmann acquired moderate fame as a composer of chamber music, symphonies, operas, and ballets, as well as music for meditation (in collaboration with Gurdjieff).

259 Lecture held in New York around 1950. English manuscript in the Yale University Music Library, New Haven.

260 GM/JE St.

261 G. Münter, *Tagebuch-Rückblick*, 1911: "Nothing came of this project, though Kandinsky devoted much time to it and had a little theatre (ca. 60 cm.) made for rehearsals, and though he designed all the scenery himself..." (GM/JE St).

262 Manuscript of lecture, see note 259. Alexander Sakharov (1886, Marinpol – 1963, Siena), studied painting from 1903 to 1905 with Bouguereau in Paris. Deeply impressed by Sarah Bernhardt's acting he then decided to become a dancer. He moved to Munich and gravitated into the Jawlensky-Werefkin circle, where he met Kandinsky. They were kindred spirits and it may have been Kandinsky's influence that prompted him to eliminate all decorative and secondary elements and to seek to express the (religious) origin of dance. He saw no possibility for this in ballet from the very start and as a result developed his own style of expressive dancing. He reinterpreted the role of Daphnis as conceived by Kandinsky for his first stage appearance in 1910 at the Odeon in Munich. There were plans for him to dance in Kandinsky's *Yellow Sound*. From 1913 on, he shared his stage appearances with Clotilde von Derp, whom he married in 1919. The couple soon became world famous. Sakharov devoted himself to teaching dancing from 1950 on.

263 Städt. Galerie im Lenbachhaus, Munich. I again have to correct an old reading error, mine this time: in the first edition of E. Hanfstaengl's catalogue of Kandinsky's Munich watercolors and drawings, I mistakenly read *burya* (tempest) for *zarya* (dawn). Here the context suffices to make everything clear, as does the word "picture," which Kandinsky used for "act." This sheet should therefore be dated 1908, and not 1907 (E. Hanfstaengl, [ed.] *Wassily Kandinsky, Zeichnungen und Aquarelle im Lenbachhaus München*. Munich 1974, p. 49).

264 Kandinsky's collaborator Thomas von Hartmann states in an article in *Apollon* (No. 7, April, 1910, p. 15) that *Pelleas* and Strauss' *Elektra*, which were performed in the 1908/09 season. were the most important opera events in years. It is safe to assume that Kandinsky saw these performances too.

265 Manuscript of lecture (see note 259).

266 GM/JE St, Journal.

267 GM/JE St, letters to G. Münter of October 3 and November 17, 1910.

268 Hugo Ball, letter of May 27, 1914, to his sister Maria, in Hugo Ball, *Briefe 1911–1927*, Einsiedeln, 1957. Kandinsky reports to the art historian Hans Hildebrandt about Hartmann and other plans in *Werk*, October, 1955, No. 10, pp. 327 ff.

269 The fourth volume of Kandinsky's collected writings will be devoted to his theater crea-

tions. It is being edited by J. Boissel and J. Hahl-Koch.

270 *Kandinsky in Munich, op. cit.*, p. 98 ("mentioning in particular the Russian stage, but perhaps thinking of the much closer Munich Artists' Theater"). Peg Weiss' assumptions led P. A. Riedl of the University of Heidelberg to conclude: "It may be considered as proven that the work *[Yellow Sound]* was conceived for the special and, for the time, quite advanced technical potential of the Künstlertheater directed since its foundation in 1908 by Georg Fuchs." (*Kandinsky*, Reinbek bei Hamburg, 1983, p. 60). And more recent scholars have assumed that Kandinsky was influenced by Fuchs from the statements of these two serious art historians.

271 Letter to Münter, June 19, 1913: "I have to translate Tomik (his article is generally good)." Concerning the familiar address, see Nina Kandinsky, *Kandinsky und ich*, Munich 1976, p. 196.

272 Manuscript, GM/JE St.

273 Manuscript copy book in the Städt. Galerie, Munich.

274 Manuscript, GM/JE St.

275 e.g. H. Brinkmann, Schreyer, Shepperd, and Stein. See Bibliography.

CHAPTER 3

276 R. Wagner, *Das Kunstwerk der Zukunft*, 1850, particularly section 3.

277 Letter of April 9, 1911. in *A. Schönberg–W. Kandinsky, Briefe, Bilder und Dokumente einer aussergewöhnlichen Begegnung*, Salzburg, 1980, p. 25. This book, as well as the essay mentioned further on deals in depth with the synthesis of the arts: J. Hahl-Koch, "Kandinsky, Schönberg und Der Blaue Reiter" in catalogue *Vom Klang der Bilder. Die Musik in der Kunst des 20. Jahrhunderts*, Staatsgalerie Stuttgart, Munich, 1985.

278 CW, p. 180.

279 Kandinsky's letters to Kulbin of June 24 and October 18, 1910. Reproduction with the permission of the Russian Museum, St. Petersburg. Kandinsky also wrote several times to Münter from Moscow that he might visit the musician, but it seems that they never met in person. Gisela Kleine's statement that Kandinsky met her in Munich in 1908 already is invalidated by the above quoted letter of Kandinsky and lacks all foundation.

280 GM/JE St, letter of October 23, 1910.

281 Kulbin's letters at the GM/JE St. Kandinsky's letter of July 19, 1911, in the Russian Museum of St. Petersburg. See also the documents on p. 135.

282 "Les lois d'harmonie de la peinture et de la musique sont les mêmes," in *Tendances Nouvelles*, No. 35, p. 721. "Garmoniya v zhivopisi i v musyke" (Harmony in painting and music), in V. A. Izdebsky (ed.), *Salon 2*, Odessa, 1910–1911, pp. 19–26.

283 GM/JE St, letter of November 8, 1910.

284 GM/JE St, letter of October 26, 1910.

285 "Paralleli v oktavakh i kvintakh," in *Salon 2*, *op. cit.*, pp. 16–18.

PART IV
CHAPTER 1

286 *Reminiscences*, CW, pp. 369 f.

287 Letters of December 18, 1909 and May 5, 1910. Kubin Archive, Städtische Galerie im Lenbachhaus, Munich.

288 This is not intended to suggest that one must look for phallic symbols, without which – as Gisela Kleine would have it – the concept collapses: "Painting as an act of violence! Colors as a battle corps." (G. Kleine, 1990, esp. p. 137). Might it not also be interpreted as a richness of life, rather than being turned into a reproach?

289 Letter to Münter of November 5, 1910 (GM/JE St): "my paysage (= Comp. II)." Description in: *Cologne Lecture*, CW, pp. 395 ff.

290 *Schönberg/Kandinsky. Letters, Pictures and Documents*, ed. J. Hahl-Koch, London/Boston 1984, pp. 38 f. and 41 f.. See letter of December 14, 1911, and Kandinsky's reply of January 13, 1912.

291 *The Language of the Eye*, op. cit.

292 *Cologne Lecture*, 1914, CW, p. 396.

293 *Reminiscences*, CW, p. 373.

CHAPTER 2

294 Volume 3 of the *Gesammelte Schriften* including an edition of *Uber das Geistige* with an academic (but nonetheless readable) critique has been on the point of publication since 1980, as have volumes 2 (Essays) and 4 (Stage Compositions). The deaths of Nina Kandinsky and Hans Konrad Roethel, compounded by a lack of funds, have delayed publication. Since the unknown Stage Compositions take precedence, and some of these were included in Nina's legacy to the Centre Pompidou in Paris, it was necessary to wait until the Centre Pompidou had made arrangements for co-publication with the Lenbachhaus in Munich. This seems at last to have been done, so that all the long-awaited volumes can now appear. It is a good thing that the *Complete Writings* of K. Lindsay and P. Vergo have been issued in the meantime. They have corrected the "yesterday's" dictation error mentioned above, and on the whole theirs is an excellent, reliable publication. The *Scritti* were also a real prize for Italian readers, as were the *Ecrits Complets* for the French.

295 Complete Correspondence with Münter, GM/JE St.

296 This and all other letters to Münter, GM/JE St. For reference to Natalia Briusova and Boleslav Javorsky, see Part III. For reference to Benia, see Part II, Ch. 7.

297 Letter from Kubin to Kandinsky, June 9, 1909 (GM/JE St)

298 The author would be interested to hear the point of view of philosophers, historians (of art), and Slavic specialists who are bilingual (like herself). For now she is grateful to Dr. Natalie Reber for the exchange of views.

299 Letter to Münter, November 16, 1910, GM/JE St. Many other letters also show clearly that Kandinsky was only reluctantly "business-minded" about his own affairs. Thus other assumptions relating to this are unjustified, such as those put forward by Armin Zweite ("Kandinsky zwischen Moskau und München," in *Kandinsky und München*, pp. 9 ff. Also *Der Blaue Reiter im Lenbachhaus, Munich*, Munich, 1989, p. 52) and Gisela Kleine, who makes constant reference to Kandinsky's "tireless cultivation of contacts" (*Gabriele Münter und Wassily Kandinsky, op.cit.*, pp. 354, 366, etc.).

300 Comment by among others Ady Erbslöh, widow of Kandinsky's opponent in the New Artists' Association, Adolf Erbslöh. For reference to the reading in St. Petersburg and the publication of the Russian version, see J. Hahl-Koch, "Kandinsky's Rôle in the Russian Avant-Garde," in *The Avant-Garde in Russia 1910–1930*, Los Angeles/Washington, 1980, p. 84. Also J. Bowlt, "The Russian Connection," in *The Life of Vasilii Kandinsky in Russian Art. A Study on the Spiritual in Art*, ed. J. Bowlt, R.-C. Washton Long, Newtonville, 1980.

301 Letters of November 8 and December 3, 1910. GM/JE St.

302 Letter to Münter of November 25, 1910. GM/JE St. (Elisabeth, Lisa, or Elizaveta Ivanovna Epstein, née Hefter, born in Poland in 1879. Jewish. She lived in Russia, Munich, and later on Paris. She studied painting under Kandinsky at the "Phalanx." The correspondence between them reveals a mutual friendship. She once enclosed a single poem about death (Russian, no date). The painter is distinguished by great sensibility and self-critical intelligence. It is very probable that she was immortalized as "Lisaveta Ivanova" by Thomas Mann in his novel *Tonio Kröger*, as G. Kleine suspects. On November 15, 1910 she recommended the Czech painter Eugen Kahler to Kandinsky, and he was subsequently accepted into their circle. She most probably also arranged the initial contact between Kandinsky and the journal *Tendances Nouvelles* in Paris.) Emy Dresler (1880–1962) joined Steiner's Anthroposophic group and undertook production of the stage sets for their *Mystery Plays* in Munich in 1910.

303 *Memoirs*. Undated manuscript quoted in the catalogue *Maria Strakosch-Giesler (1877–1970)*. Exhibition at the Anthroposophic Society, Munich, 1988, p. 16. It is typical that even in Kandinsky's nude classes students did not "daub on the paint superficially after the style used until now." Instead they "awoke the inner energy of the spiritual life of color. [. . .] A new sense was aroused and nurtured in us. [. . .] The very essence of the person was revealed."

304 A. Strakosch, *Lebenswege mit Rudolf Steiner*, Strasburg/Zürich, 1947, p. 16.

305 Letters from Moscow of November 8 and 27, 1910, to Gabriele Münter (GM/JE St). Kandinsky's cousin three times removed, Elena Ivanovna Tokmakova (1868–1945), was married to Sergei Nikolaievich Bulgakov (1871–1944); for details of his activities, see V. Baraev, *Drevo Dekabristy i semeistvo Kandinskikh*, Moscow, 1991, pp. 249, 133, 176. It seems quite possible in this connection, which has only just been suggested, that Kandinsky like many of his colleagues was also a Marxist during his student years. This interesting question can only be solved in Moscow, and Baraev is already carrying out research in all the archives.

306 "Khristianstvo i mifologya" in *Russkaia mysl*, 1911, No. 8, pp. 115–133.

307 S. Ringbom, *The Sounding Cosmos*, Abo, 1970 and further essays. R-C Washton Long, *Kandinsky. The Development of an Abstract Style*, Oxford, 1980.

308 See the catalogue *On the Spiritual in Art*, Los Angeles, 1988. After Los Angeles the exhibition was transferred to The Hague, and the artist was immediately acclaimed by the occult faction as one of their own.

309 J. Eichner, 1957, p. 19.

310 *Kandinsky und Ich*, Munich, 1979, p. 196. An account of this ceremonious agreement to be on such intimate terms is contained in the letter to Münter from Moscow of November 27, 1910 (GM/JE St).

311 In 1972 at Garches near Paris, when the author was staying with Olga von Hartmann while studying Kandinsky's stage compositions. Despite some disagreement on this one point, the author holds Olga's discernment, neutrality, and powers of recollection in the greatest of respect. So her firm conviction that Kandinsky had learned something of Sufism from Hartmann is substantiated and would be worth a detailed investigation.

312 For example, to the "Giselists" shortly before the rift in the New Artists' Association, see p. 134.

313 Letter of October 2, 1912 to Münter. His text continues, and the "sun" he mentions is illustrated in a line drawing. GM/JE St.

314 Letter to Münter of October 3, 1910. GM/JE St.

CHAPTER 3

315 W. Kandinsky, "Der Blaue Reiter (Rückblick)", in *Das Kunstblatt XIV*, 1930; "Abstrakte Malerei", in *Kronick van Hedendaagsche Kunst en Kultur VI*, Amsterdam, 1936; in letters to Merle Armitage, Ferdinand Möller, Hilla von Rebay, Alois Schardt, Galka Scheyer, J. J. Sweeney, and also an interview with Karl Nierendorf in 1937, in which Kandinsky certainly mentions a watercolor from 1910 (see M. Bill, ed., *Kandinsky's Essays on Art and Artists*, Bern, 1955, second edition 1963, p. 212).

316 Letter of June 15, 1913. GM/JE St.

317 For the opinion of Nina Kandinsky and other scholars, see CW, Vol. II, Note 9, p. 864.

318 H. Nishida, "Génèse de la 'Première aquarelle abstraite,'" in *Art History*, No. 1, 1978, p. 1–19. Paris, 1984, p. 100.

319 K. Lindsay and H. Nishida discuss it in particular detail. M. C. Lacoste, *Kandinsky*, Paris, 1979, p. 33.

320 In "Kandinsky 1901–13," *Der Sturm*, Berlin, 1913. See also CW, p. 385.

321 "A New Light on Kandinsky's First Abstract Painting," in *The Burlington Magazine*, November 1977.

322 Ibid., p. 772.

323 Archives of the Getty Center for the History of Art and the Humanities, Los Angeles.

324 In the "Sturm Album: Kandinsky 1901–13," *Der Sturm*, Berlin, 1913. See also CW, p. 391.

325 *Cologne Lecture*, CW, p. 398.

326 G. de Marchis, "The Fourth Dimension," in *Space in European Art*, Tokyo, 1987, p. 268.

327 Reprint of the book written in 1926, *Die Kunst des 20. Jahrhunderts*, Leipzig, 1988. His negative opinions on a lack of ability to manage space, for example in the work of the Impressionists, can be found on pp. 10, 14, 15, 16, 18, 84; in Van Gogh on pp. 28, 30; in Matisse pp. 41, 59 ff.; in Derain p. 57; in Fauves and German Expressionists p. 83; in Russian Constructivists p. 273.

328 Kandinsky himself plainly did not take Einstein's criticism seriously. When Einstein asked for photographic material and excused his negative comments with his *"Ernst"* (honest intentions), Kandinsky wrote this word very large with several exclamation marks near the date of his reply (Archives of the Getty Center for the History of Art and the Humanities, Los Angeles). He also wrote about Einstein to Galka Scheyer on July 3, 1934: "[. . .] an art historian with such profoundly gloomy depths, that you can no longer see anything." By kind permission of Hella Hammid, Los Angeles, and her successor, Peg Weiss. The letters Kandinsky wrote

to his representative in the USA, Emmy (Galka) Scheyer, of importance to the history of art, are to be found in the Norton Simon Museum in Pasadena, and the publishing rights (is there such a thing as a *duty* to publish?) were awarded to Peg Weiss before 1980. Everyone has been waiting impatiently for her book ever since...

329 *Cologne Lecture*, 1914, CW, p. 397.

330 Cat. Paris 1984, p. 100, footnote 2; and Cat. Frankfurt 1989, p. 261.

331 W. Grohmann 1958, p. 118.

332 E. Hanfstaengl 1974, No. 156. A. Zweite studied these motifs, in particular that of the boat, in detail in *Kandinsky und München*, Munich 1982, pp. 134 ff..

CHAPTER 4

333 This is true of almost the whole of Kandinsky literature; see Bibliography for the main areas of interest. Of course much interesting information is obvious from today's vantage point, of which Kandinsky would not have been aware. One might justifiably devote the rest of the book to such theoretical issues, but a few pages will have to suffice, or else there will be no room to show and discuss any more pictures.

334 Letters to Münter of June 26, 1907 and (about Gorky) November 6, 1905. GM/JE St.

335 Letter to Franz Marc of March 8, 1913 (ed. K. Lankheit, *Kandinsky/Marc Briefwechsel*, Munich/Zurich, 1983, pp. 211 f.).

336 Most importantly among the books owned jointly by Kandinsky and Münter the Munich library contains some articles by Rudolf Steiner, annotated by Kandinsky. One can only assume, but not prove, that the other books were owned *jointly*, including a large number of works in a "spiritual" vein. The year of publication of some books shows, however, that they did not enter the library until after Kandinsky and Münter separated (Helena Blavatsky, *The Esoteric Doctrine*, 1932; Maria Strakosch-Giesler, *Die erlöste Sphinx*, 1955). The first of these, a major work by the founder of Theosophy, served as an important proof for Ringbom of Kandinsky's interest in these doctrines, and it is generally assumed that he was familiar with this book.
The Munich library is accessible and there has been a complete list of titles at the disposal of any researcher since 1968. This will certainly soon be the case in Paris too. There has been only sporadic information on the book collection there until now. In Cat. Paris 1984, p. 454, the works of the Russian Futurists are selected and presented, but hardly anything else. After this library was awarded to the Centre Pompidou on the death of Nina Kandinsky, it was not open to researchers for some time. The author was able to collect information on it during Nina's lifetime. She had opportunities to ask the artist's widow about the background of some of the books and other matters, and was able to look through each book for underlinings and marginal comments.

337 Cubo-Futurist literature is listed in Cat. Paris 1984, p. 454, see preceding note.

338 V. Baraev, *Drevo. Dekabristy i semeistvo Kandinskikh*, Moscow, 1991, p. 246.

339 P. Vergo, "Kandinsky and the 'Blue Rider Idea,'" in *Nya perspektiv på Kandinskich*, Malmö, 1990, p. 49. Schopenhauer, *Farbenlehre*, Leipzig, 1895, in Munich library.

340 Evelin Priebe's thesis *Angst und Abstraktion*, Frankfurt/Bern/New York, 1986, offers an excellent, comprehensive study of all the philosophical movements of importance to Kandinsky, especially in Germany. But why is it that every time Kandinsky uses the word "cosmic," he is immediately associated with the "Cosmic Circle" of Schuler, Klages, and George?

341 J. Hahl-Koch, *Marianne Werefkin und der russische Symbolismus. Studien zur Aesthetik und Kunsttheorie*, Munich, 1967.

342 This is discussed extensively in the literature on Jawlensky, among others in J. Hahl-Koch, "Jawlensky's Studien- und Geniezeit," in *Alexeij Jawlensky*, Emden, 1989, p. 74. The Munich circle probably knew Maurice Denis' *Nouveau Traditionalisme* of 1890 in which he pleads the case for anti-naturalistic art as a means of transforming "vulgar sense impressions" into "sacred, hermetic, reliable pictures."

343 K. Brisch 1955, p. 22; on Worringer in general see D. Vallier, *L'art abstrait*, Paris, 1980, pp. 21 f. as well as her commentary in the French edition of Worringer's writings.

344 L. Sabaneev, "Moi vstreci" (My Encounters), in *Novoe russkoe slovo*, New York, July 19, 1953, p. 2.

345 L. Sabaneev, "Iz oblasti sovremennykh nastroeny" (From the Realm of Contemporary Opinions), in *Vesy*, 6, 1905, pp. 35 f.

346 CW, pp. 218 f.

347 W. Winkler, *Psychologie der Modernen Kunst* (The Psychology of Modern Art). Tübingen, 1949. Understandably, Kretschmar's and Klages' doctrine of types has been totally discredited in Germany following the erroneous simplification and perversion of it by National Socialism. Of course one cannot generalize that all schizoid people are introvert, and that they are for that reason more predisposed toward abstraction. It will be interesting to see if a rational new approach to this psychological slant will be taken outside Germany in a few decades, which would be worth considering in relation to art.

348 R. Volp, "Kunst als Sprache von Religion," in *Kunst und Kirche*, 4, 1988, p. 234. The Bible passage referred to is Ex. 20:4.

349 "There is nothing in art I hate more than a translation into trivial kindliness." Letter to Marc of April 25, 1912 (*Kandinsky/Marc Briefwechsel*, 1983, p. 163).

CHAPTER 5

350 Letter of September 22, 1911, Kubin Archive, Städtische Galerie im Lenbachhaus, Munich.

351 Kandinsky was related to Sergei Bulgakov through a cousin. He mentions both several times in letters to Münter. This citation is from a letter to Marc on September 1, 1911, in *Der Blaue Reiter*, new edition by K. Lankheit, Munich, 1967, p. 261.

352 Ibid., pp. 24 and 31.

353 For example Susan Stein in her admirably thorough work on *Yellow Sound*. In fact Kandinsky had mentioned in a letter of January 7, 1912 to Marc that he wanted to borrow six plates from Piper for his stage composition. By this he meant Wilhelm Worringer's *Die altdeutsche Buchillustration*, from which four illustrations were included in *Yellow Sound*. (ed. K. Lankheit, *W. Kandinsky/F. Marc Briefwechsel*, Munich/Zurich, 1983, p. 120).

354 Ibid., p. 69.

355 Letter to Marc of January 14, 1912, ibid., p. 113.

356 Letter to Marc of April 25, 1912, ibid., p. 163.

357 Described in detail by J. Hahl-Koch, "Kandinsky's Rôle in the Russian Avant-Garde," in *The Avant-Garde in Russia 1910–1930*, Los Angeles, 1980, p. 84.

CHAPTER 6

358 A new addition to the dozens of misinterpretations we know of: during an exhibition in Brussels in 1913 Kandinsky's painting was called "Orphistic" [sic] simply because Delaunay was making a name for himself at the time. Kandinsky defended himself vigorously in writing, as he had done on many previous occasions (see Raphael de Smedt, "Kandinsky à Bruxelles en 1913," in *Gazette des Beaux-Arts*, vol. CXIII, No. 131, May–June 1989, p. 237).

359 CW, p. 400. Even these days some art historians fail to understand that neither Kandinsky nor any other artist worth his salt is bothered about critical or public acclaim.

360 In the album *Kandinsky 1902–12*, Berlin, 1913 (CW, pp. 385–388 and 389–391).

361 N. Lee, "Some Russian sources of Kandinsky's Imagery," in *Transactions of the Association of Russian-American Scholars in USA*, 15/1982, pp. 185 ff. Based on R. C. Washton Long 1980.

362 F. Thürlemann, *Kandinsky über Kandinsky. Der Künstler als Interpret eigener Werke* (Kandinsky on Kandinsky. The Artist as Interpreter of his own Work) (post-doctoral thesis), Berne, 1986, pp. 184 and 196. Thürlemann devotes six pages to the troika motif alone. It is certainly true in semiotic terminology that this motif "is merely formal, rather than symbolic, thus part of a level of expression that can be assumed to have a corresponding level of content," but since the author's "perspective is a-chronic rather than diachronic," and one which he researches with precision and thoroughness, one might have expected him to mention the "yoke" instead of the "trumpet." His misreading of "collision" (*Zusammenstoss*) as "amalgamation" (*Zusammenschluss*) in Kandinsky's analytical drawing (p. 295) has serious consequences for large sections of his thesis. This is a pity, as his method on the whole represents a promising fresh approach to interpreting abstract art. His criticism of Washton Long's methodological inexactitude is well justified. But the trumpet motif is mentioned by her only with reference to the *Painting with White Border* and not to the many other troika pictures in Kandinsky's oeuvre (Washton Long 1980, pp. 127 f.).

363 To the Museum of Modern Art, New York. See H. K. Roethel 1979.

364 Letter of 5 June 1913 to F. Marc. Cited by K. Lankheit in *Der Blaue Reiter*, Reprint, Munich, 1967, p. 179.

CHAPTER 7

365 This letter of 1904 and all subsequent letters to Münter are to be found in GM/JE St, Munich.

366 Yule F. Heibel, "They danced on Volcanos, Kandinsky's Breakthrough to Abstraction, the German Avant-Garde and the Eve of the First World War," in *Art History*, vol. XII, No. 3, September 1989. Why should the supposed "auras" be proof of anything, however? It seems that since the publications of Ringbom and Washton Long the world sees only "thought-forms" instead of Kandinsky's pictures themselves.

367 V. Baraev, *Drevo. Dekabristy i semeistvo Kandinskikh* (Family tree. The Dekabristys and the Kandinsky family), Moscow, 1991. G. Kleine's Münter/Kandinsky biography (1990), also cites letters from the artist to Münter illustrating his political commitment.

368 Letter of February 17, 1914 (*Kandinsky/Marc Briefwechsel*, 1983, p. 250).

369 This project's full title was *Das Arische Europa. Internationales Jahrbuch für Kultur-philosophie und Kulturpolitik. Herausgegeben von der Bewegung "Zur Menschheit der Voll-kultur durch ein Gesamteuropa"* (Aryan Europe. International Almanac for Cultural Philosophy and Politics. Published by the movement "for the proper civilization of mankind through a united Europe.") This is disclosed by the family of the Munich art historian and lecturer Dr. Fritz Burger, who lent his wholehearted support to the new art. Mitrinovich had told him in detail about the project. This subject has been researched by Klaus Lankheit, see *Kandinsky/Marc Brief-wechsel*, 1983, p. 254.

370 Letter of June 19, 1914. For all letters from Mitrinovich to Kandinsky, see GM/JE St. On June 16 Mitrinovich had reported that he had written to (Houston Stewart) Chamberlain and Bernard Shaw.

371 Kandinsky's draft letter, GM/JE St.

372 For example Jean-Paul Bouillon (1974, p. 230) makes no comment on the "Mitriz." reference in Kandinsky's letter of September 10, 1914, to Klee, despite going into exhaustive detail on every other name that features in it.

373 The parallels in thought between Mitrinovich and Kandinsky can only be touched on very briefly in this book, however they would be a fascinating subject for Slavonic Kandinsky fans. The only work that has appeared on Mitrinovich to date – Andrew Rigby, *Initia-tion and Initiative. An Exploration of the Life and Ideas of Dimitrij Mitrinovic*, Boulder, 1984 – is not well known, but in fact excellent. There are further details: after the outbreak of the world war, he was in danger of being called up, being a Serb with an Austrian passport, which would have meant fighting against his own people. So he fled to England, where he remained until his death in 1953. He continued his political activities there, first for the creation of a Yugoslavian state, then later on wider-ranging issues. He wrote for *The New Age* under the pseudonym M. M. Cosmoi. The editor at the time, A. R. Orage, left both the journal and England shortly afterwards, in order to join Gurdjieff's community in Fontainebleau near Paris, where Kandinsky's friend, Thomas von Hartmann, was already living. In 1926 Mitrinovich made the acquaint-ance of Alfred Adler and founded the English branch of the International Society for Indi-vidual Psychology. He was an active member of the "New Europe Group," which promoted the idea of a federal Europe. The "New Bri-tain" movement grew from this, with the aim of completely restructuring the whole of soci-ety following Mitrinovich's motto "Self change for world change." This collapsed from financial difficulties in 1935, however. Mit-rinovich spent his entire life working with unshakable enthusiasm for the promotion of international understanding and peace. His vision certainly seems to have been based more on an idealistic world view than concrete real-ity. However, the impression formed of him by Gisela Kleine is not very accurate, arising as it does probably from incomplete information,

since her short commentary on him contains several factual errors (*Münter/Kandinsky-Biographie*, 1990, pp. 449 and 749).

374 See Lucie B. Gutkind/Henry Le Roy Finch (eds), *The Body of God. First Steps towards an Anti-Theology. The Collected Papers of Erich Gutkind*, New York, 1969.

375 *Schönberg/Kandinsky Briefwechsel*, pp. 70 f.

376 Thus A. Rigby 1984, (see note 373), p. 32.

377 GM/JE St.

378 V. Barnett, *Kandinsky and Sweden*, Malmö, 1989, p. 44.

379 Vivian Endicott Barnett has documented these contacts of 1915–16 in comprehensive detail in her book *Kandinsky and Sweden* (see note 378 above).

380 "Den abstrakta konstens pionjär," in P. Bjerre, *Gestalter och Gärningar, Elva person-liga porträtt*, Stockholm 1958, pp. 125–138.

PART V
CHAPTER 1

381 Letter of December 31, 1914 from Moscow. On December 25, 1914 Kandinsky told Münter that she was *welcome* to take 2000 of the 3000 he had received from Müller. "My conscience is weighing me down. So is my awareness that much of what I ought to be doing is beyond my capabilities. I cannot help my own nature. But time brings counsel. This long separation neither of us wants is bound to shed light on a few things." A year later on November 20, 1915 he wrote, "If you sell any of my pictures, please keep the money for yourself. I worry all the time that you don't have much money." GM/JE St.

382 He mentions medical duty several times in letters to Münter. Suggestions that this is Kandinsky's attempt to make excuses (in V. Barnett, *Kandinsky and Sweden*, Malmö, 1991, p. 86, for example) are of dubious value, since even in World War I any healthy man not called up for military service was liable to be involved in medical service in emergencies. The absence of any call-up papers in Kan-dinsky's belongings implies either that he did not think them worth keeping over the course of three emigrations, or that he did not receive an individual notification to report for medical service. In the end, he was not called up.

383 By J. Eichner in 1957, by Nina Kandinsky in 1976, by V. Barnett in 1990 (see previous note), by G. Kleine in 1990.

384 Letter of December 31, 1914 from Moscow, GM/JE St.

385 January 24, 1915, GM/JE St.

386 From Roethel (1979) to Derouet (Cat. Paris 1984).

387 Letter of January 15, 1915 to Münter. Author's emphases. GM/JE St.

388 Letter of November 16, 1915 to Münter. Originally written in French in order to cir-cumvent censorship. GM/JE St.

389 Grohmann 1958, p. 165, to Derouet (Cat. Paris 1984, p. 146). The scorn with which some authors seek, without proof, to find Kandinsky "guilty" of "conformity" and commercialism would be unjustifiable even in those cases where he, like so many others, was driven by hunger to paint one or two "sale-able" pictures. All those who have experi-enced war and deprivation safely in front of a television screen should be reminded that the death of Kandinsky's son was due to malnut-rition.

390 Extensively documented in V. Barnett 1990, p. 94. The little-known period Kandinsky

spent in Sweden is thoroughly and objectively researched in Barnett's excellent book. How-ever, the citations selected from his letters suggest that Kandinsky accepted money from Münter, whereas the money in question came from the sale of his pictures. Furthermore, there are far more letters in which he exhorts Münter to keep as much as she needs (which she in fact did not do). The author has already referred to some errors made in the reading of his German letters in "Kandinskys erstes abstraktes Ölbild," *Kunstchronik 3*, March 1990, pp. 102 f.

391 Historians are gradually coming round to what Kandinsky knew all along. On May 10, 1936 he explained to J. B. Neumann: "Here [in Paris] I often have to explain to the merry old art experts that abstract art as I practice it has nothing to do with Cubism. And never did! It's the Constructivists who have their root in Cubism, and I applaud them for it, since it's probably true. Maybe that'll make people get off my back with all this Cubist stuff." (Archives of the Getty Center for the History of Art and the Humanities, Los Angeles.)

392 Letters to Münter of December 24, 1912 (January 6, 1915 in the Western calendar) and February 20, 1915.

CHAPTER 2

393 C. Poling, "Kandinsky in Russland und am Bauhaus 1915–1933," in exhibition catalogue *Kandinsky. Russische Zeit und Bauhausjahre 1915–1933*, Berlin, 1988. See p. 25 for refer-ence to Rodchenko. Alexander Rodchenko has only recently won the acclaim he deserves. At the time in question he was still a young art student who had arrived in Moscow from the provinces. Kandinsky gave him lodging, let him use his studio, and observed the begin-nings of his development, which must have been as alien to him as the Suprematism of Malevich. Ideological differences of opinion were soon to cause a rift between the father-like "Romantic" and the Soviet production artist. Wassily Rakitin showed that the flow of ideas went from the older to the younger man and not vice versa (W. Rakitin, "Zwi-schen Himmel und Erde, oder wie befreit man das Rationale vom trockenen Rationalis-mus," in Cat. Frankfurt 1989, p. 79).

394 W. Grohmann 1958, p. 130.

395 Letter to Münter of July 4, 1913, GM/JE St.

396 "Concerning the Attribution of the Date of the First Geometric Sketch of Kandinsky," in *Art History*, Tohoku University, No. 3, 1980, pp. 1–16.

397 Catalogue of Oil Paintings, vol. II, p. 667.

398 January 14, 1915 to Münter from Moscow. GM/JE St. On his return to Moscow there were no vacancies in his large apartment house, and he wasn't able to move in until later.

399 Letter of December 18 (or December 31 on the Western calendar), 1914.

400 Lindsay, Grohmann, Nishida, Thürlemann (see Bibliography).

401 pp. 76–77 in *Vserossiski siezd Khudozhnikov*, St. Petersburg, 1914. See J. E. Bowlt, *The Life of Kandinsky in Russian Art*, 1980, cover picture and interesting texts by him and Washton Long.

402 Letter of May 10, 1936 to J.B. Neumann, Archives of the Getty Center for the History of Art and the Humanities, Los Angeles.

403 K. Umansky, "Kandinskys Rolle im russi-schen Kunstleben," in *Ararat*, second special

issue, 1920, p. 29. Second citation in *Neue Kunst in Russland*, Potsdam/Munich, 1920, pp. 20 ff.

404 D. Melnikov, "Po povodu levoi zhivopisi na 19 gosudarstvennoi vystavke," in *Tvorchestvo*, Moscow, No. 7–10, 1920, p. 42–44.

405 Nina, highly emotional and intuitive, found Malevich's fanatical expression, suggesting an equally fanatical nature, very off-putting (*Kandinsky und Ich*, Munich 1976, p. 76). It is not certain whether her husband shared this point of view. Even their writing is worlds apart; Malevich wrote long-winded, ponderous, tortuous, highly theoretical passages with occasional highlights. His handwriting was regular and well-formed, almost like that of a child. It had no emphasized upward or downward strokes and was often underlined or annotated in different colors, which made his manuscript look like a mini work of art itself.

406 Boris Arvatov, "Izobrazitelnoe iskusstvo No. 1," in *Pechat' i revolucia*, 1921, No. 2, pp. 215–17. Also appeared in German in the excellent volume, ed. H. Gassner/E. Gillen, *Zwischen Revolutionskunst und sozialistischem Realismus*, Cologne 1979, pp. 58 f.

407 M. P. Vikturina, *Zur Frage von Kandinskys Maltechnik*, in Cat. Frankfurt 1989, pp. 39 ff.

408 C. Poling, "Kandinsky in Russland und am Bauhaus 1915–1933," in Cat. *Kandinsky. Russische Zeit und Bauhausjahre*, Berlin, 1984, pp. 9 ff. Grohmann 1958, pp. 163, 166.

409 Both Freytag's manuscript (Städtische Galerie im Lenbachhaus, Munich) and Kandinsky's letters to Münter (GM/JE St) describe this at length. Freytag admits he did not have the courage to go up to the glacier, so Kandinsky climbed on alone.

410 M. P. Vikturina, in Cat. Frankfurt 1989, p. 40.

411 Letters to Münter of June 4, September 4, and November 26, 1916. GM/JE St.

412 There has been no discussion of this in the literature on Kandinsky. The author puts forward this idea after consultation with several psychologists corroborated it. The only danger might be that it will now be developed into a further (fifth? sixth?) hypothesis on the origin of Kandinsky's later favorite component, the circle.

413 H. Düchting, *Wassily Kandinsky 1866–1944. Revolution der Malerei*, Cologne, 1990, p. 94. It is precisely this sort of popular publication that ought to be written with closer attention to fact and detail, because of its enormous influence. Yet in this case the author has been fairly successful when basing himself on Kandinsky's own words and other critical literature (but without giving sources).

CHAPTER 3

414 K. Umansky, "Kandinskys Rolle im russischen Kunstleben," in *Ararat*, second special edition, 1920, p. 28.

415 *Kandinsky und Ich*, Munich 1976, p. 86.

416 W. Kandinsky [V. V. Kandinskij], "Museum für Malkultur," in *Khudozhestvennaia zhizn*, 1920, No. 2. All the details of the founding of the museums are described in full in N. Avtonomova, "Kandinsky in sowjetischen Sammlungen," in Cat. Frankfurt 1989, p. 32. Nina also remembers that the conditions for artists were out of this world until the death of Lenin (*Kandinsky und Ich*, pp. 86 f.).

417 Two of his articles provide further information about this: "Shagi otdela izobrazitelnykh iskusstv v mezhdunarodnoi khudozhestvennoi politike," (Steps taken by the IZO in International Artistic Policy) in *Khudozhestvennaia zhizn*, Moscow, 1919, No. 3, pp. 16–18; "O velikoi utopii" (On the Great Utopia), ibid., 1920, No. 3, pp. 2–4.

418 Letter to Münter of December 24, 1915, GM/JE St.

419 GS, p. 158. For a comprehensive comparison of *Reminiscences* of 1913 with those of 1918, Roethel and the author counted the deletions of "Christian allusions," and Roethel referred in his introduction to Kandinsky's "diplomatic foresight" (GS, p. 16). Since Kandinsky neither joined the Communist Party nor compromised himself in any other way, the author would like to speak out against those researchers (in particular Jean-Paul Bouillon, Paris, 1974) who count up every last change made in relation to the German text, yet pay no attention to the insertions on Christian matters. They wrongly claim that Kandinsky deleted from the Russian version the phrase that the word "composition" affected him like a prayer (p. 105). Finally, having failed to compare the changes in his writing in any way with that of thousands of other writers throughout Europe of his day, they attempt to accuse Kandinsky of adaptation. The most regrettable result of Bouillon's overzealous philological work is that he has made Kandinsky's *Reminiscences* unreadable for French readers by breaking up the text with an incredibly complicated system of notes, in which double brackets, numbers, letters, and asterisks abound (for criticism of concrete examples see GS p. 147). Christian Derouet states that Kandinsky in the German edition "wanted to reassure the German bourgeoisie that his discovery was well-founded by giving guarantees in the form of references to his good origins and the level of education he had attained during his study of the 'Humanities.'" (Cat. Paris 1984, p. 152). This also seems a rather narrow view; was Kandinsky supposed to conceal his respectable origins and play the Bohemian in Munich and the proletarian in Moscow?

420 People took offence at Nina's refusal to talk about their child, suspecting her of vanity rather than distress. Her close circle of friends knew about it through a friend in whom she had confided, but of course never spoke of it during her lifetime. Nina was as discreet about her private life as her husband was about his and kept private matters separate from "artistic business," though she never failed to give generous assistance to scholars in this domain.

421 Nina confirmed to the author that it was Kandinsky's own translation on November 8, 1970. Concerning the linguistic differences between the German and the Russian editions the German edition is certainly the more "poetic and original," even if Kandinsky's German is not perfect, as his Russian is; perfection is after all quite different from originality.

422 Private archive, Moscow, Cited from S. O. Chan-Magomedov, "V. V. Kandinsky v sektsii monumentalnogo iskusstva INKHUKA (1920)," in exhibition catalogue *V. V. Kandinsky. Zhivopis, grafika, prikladnoe iskusstvo*, St. Petersburg, 1989, p. 53. Kandinsky's work in the then newly-founded "Academy of Artistic Sciences," aka RAKhN, is currently being researched and published by Nicoletta Misler and John Bowlt, Los Angeles.

423 This is particularly evident from Kandinsky's letters (*Schönberg/Kandinsky Briefwechsel*, 1980, p. 19).

424 Leaflet, in some Russian private archives, e.g., that of S. O. Chan-Magomedov. Cited from his article (see note 422 above), pp. 46 ff.

425 The consensus is that Kandinsky failed to establish any kind of "school" or influence any "students" in Russia. This new field of research can only be tapped with cooperation between Russia and the West. Lack of such cooperation would produce a very fragmented picture, because Eastern and Western material is hopelessly intermeshed. In fact it is an ideal opportunity for a cooperative project wholly in line with the artist's philosophy. Such a project has just been set up between Moscow, Munich, and Los Angeles.

426 "Ochet o deiatelnosti INKhUKa" in *Russkoe iskusstvo*, 1923, No. 2/3, pp. 85–88. Also in H. Gassner, E. Gillen (eds.), 1979, p. 100.

427 In "Lecture by the artist Kandinsky," in *Vestnik rabotnikov iskusstv*, No. 4–5, Moscow 1921, p.73. Alexander Shenshin (1890–1944) Russian composer, conductor, and music teacher, taught from 1919 to 1922 at the Music High School in Moscow. See V. Beliaev, *A. Shenshin*, Moscow, 1929.

428 CW, p. 142 – Illustration in S. Ringbom, *The Sounding Cosmos*, Abo 1970, No. 50.

429 When the director of the film museum in Riga, Juri Tsivian, looked systematically through all the Russian newspapers and journals from the years just before and after the turn of the century, to see what had been said about the discovery of film, he was amazed to find that there were many more stories concerning radiography (Lecture at the conference "Malevich and the Russian Avantgarde," Los Angeles, 1990).

430 This Russian manuscript was in the possession of Nina Kandinsky and was translated by A. Nakov for the *Ecrits Complets* and by the author for the *Gesammelte Schriften* (presently missing, photocopy in the author's possession).

431 Russian manuscript, formerly in the possession of Nina Kandinsky (see earlier note). In the *Ecrits Complets* (vol. 3, Paris, 1975) several things which obviously could not be decoded have been left out without a mention; a whole sentence from the entracte, several sentences from the apotheosis and finale. The colors have not been emphasized as they were in the original (pp. 95 and 113). The apotheosis has been printed as an independent play with its own heading. It was not kept in the best order among Nina's papers. Its content and the handwriting both suggest that it belongs to the finale of the play.

432 Interview with C. A. Julien, July 10, 1921. Printed in *La Revue d'Art*, 1969, No. 5, p. 71.

433 Nina Kandinsky, 1976, p. 89.

PART VI
CHAPTER 1

434 See Nina Kandinsky 1976, pp. 93 and 89. The painter Eberhard Steneberg, Frankfurt, drew Nina's attention to the fact that it was Umansky, and she immediately acknowledged that she had mixed the two up.

435 Cited from H. M. Wingler, *The Bauhaus. Weimar, Dessau, Berlin, Chicago*, Cambridge, Mass. and London, 1982, p. 39.

436 Nina Kandinsky, 1976, p. 125. Grohmann 1958, p. 201 (although here the date given is 1928).

437 F. Klee, *Paul Klee*, Zurich, 1960, p. 28.

438 Cat. *Klee und Kandinsky. Erinnerung an eine Künstlerfreundschaft*, Stuttgart, 1979.

439 Ibid. p. 14 (cited from F. Klee, 1960, p. 28).

440 *The Diaries of Paul Klee. 1898–1918*, ed. F. Klee, London, 1965, entry No. 951.

441 November 10, 1928. (*Künstler schreiben an Will Grohmann*, ed. K. Gutbrod, Cologne, 1968, p. 54). Kandinsky had already written the same to Münter on September 24, 1905, as she was preparing his pictures for an exhibition: "Titles mean nothing to me . . . you know that. Call them whatever you like. What do I think about this subject in general? Well, calling them anything usually does them no good. It will make much better sense when we no longer do this." GM/JE St.

442 See their letters of January 18, 1911 onward in *Schönberg/Kandinsky Briefwechsel*, 1980, p. 19, and commentary in J. Hahl-Koch, "Kandinsky und Schönberg. Zu den Dokumenten einer Künstlerfreundschaft," ibid. p. 138.

443 Letters of 1923 and commentary in *Schönberg/Kandinsky Briefwechsel*, 1980, pp. 91 ff., 138 ff. There is always the possibility that Alma Mahler jumped to the wrong conclusion on hearing comments made by Kandinsky privately and in jest. This was still *before* the Nazi atrocities. Kandinsky had lived in Odessa until he was eighteen. This city was renowned for its anti-Semitism, and the fact is that even tolerant citizens reflected such attitudes unconsciously in their jokes and conversation. A single example of this appears in a personal letter from Kandinsky to Münter, when he was convalescing at Bad Reichenhall, recovering after his traumatic stay with her in Paris. The first thing he hears is the hated Odessa dialect. Swanky, "nouveau riche" Jews, able to afford the long journey, disturb him with their uncultivated manners (he refers to their spitting and telling dirty jokes) and their noisy behaviour, singing along and clapping in time during concerts. On June 16, 1907 (GM/JE St) Kandinsky's light-hearted comment, "What an annoying folk!," was provoked by his need for peace and quiet more than anything else. He contradicts this over-generalization himself, by observing that among the guests at the spa the German Jews were quieter, those from Poland, Austria, and the rest of Russia less flashy. Although this private comment, made unthinkingly in a daily letter to his closest friend, cannot be held against him, it nevertheless illustrates how misunderstandings might have arisen.

444 N. Kandinsky, 1976, p. 93. Such poverty and hunger, so unimaginable to us today, does, of course, to some extent also influence working conditions.

445 Reported by Jean Leppien. His wife, Susanne Markos-Ney, expresses herself rather more critically. Cited in Nina Kandinsky 1976, pp. 133 f.

446 Cited in Nina Kandinsky 1976, p. 175. The sculptor also spoke in glowing terms of his teacher to the author, both professionally and personally. This was why he carried on visiting him whenever possible in Paris after the Bauhaus time.

447 Recorded by Nina Kandinsky, 1976, p. 110, as well as in the words of the student Mr Adams (see P. A. Riedl, *Kandinsky*, Reinbek/Hamburg, 1983, p. 104; see also H. M. Wingler, *Das Bauhaus*, Bramsche and Cologne, 1962; Cat. Berlin 1983. The Bauhaus period, and chiefly Kandinsky's classes, have been so extensively documented that the author need not go into much detail here.

448 W. Kandinsky, *Kleine Welten* (twelve pages of original graphics), Berlin, 1922. Further information in H. K. Roethel, *Graphik*, 1970, p. 542.

449 W. Kandinsky, *Punkt und Linie zur Fläche*, 1926, 7th edition, Bernem 1955, pp. 47 f. and 127 f. (here after, PLF). See also CW, pp. 527 ff.

450 PLF, p. 19. CW, p. 537.

451 Ibid. p. 168. CW, p. 672.

452 *Voir l'Invisible*, Paris, 1988. It is hoped that there will soon be translations of this into languages other than Japanese.

CHAPTER 2

453 Grohmann 1958, p. 190.

454 Ibid. p. 188.

455 The numerous earlier descriptions and interpretations of *Composition VIII* and other pictures from the Bauhaus period are reviewed efficiently by C. V. Poling, "Kandinsky in Russland und am Bauhaus 1915–1933," in Cat. Berlin 1984, pp. 35 f.

456 Reported in Grohmann 1958, p. 188. Kandinsky's reply to a questionnaire by Paul Plaut in 1929 is that he liked the circle less for its geometric form than for its inner force and variations.

CHAPTER 3

457 The influential, progressive critic Paul Westheim was happy to print Kandinsky's essays in *Das Kunstblatt* (Art Journal), but criticizes him constantly without really understanding him, beginning in *Das Kunstblatt*, year 6, 1922, p. 269.

458 "Leere Leinwand undsoweiter," in *Cahiers d'Art*, 1935, p. 169.

459 W. Wolfradt, "Ausstellungen: Berlin. Juryfreie Kunstschau," in *Das Kunstblatt*, year 6, issue 12, Dec. 1922, p. 543 – all the criticisms of the Munich and Bauhaus periods are clearly presented and discussed in an excellent essay by Charles W. Haxthausen ("Der Künstler ohne Gemeinschaft," in Cat. Berlin 1984, pp. 72–89).

460 *Die Kunst des 20. Jahrhunderts*, Berlin, 1926, p. 136.

461 Kandinsky to Grohmann on November 23, 1924, in *Künstler schreiben an Will Grohmann*, ed. K. Gutbrod, Cologne, 1968, p. 47.

462 Ibid, p. 53. Kandinsky had already written to Galka Scheyer that he was encountering as much resistance as he had 10–12 years earlier. (Unpublished correspondence, cited with kind permission of the owner Helle Hammid and her successor Peg Weiss).

463 Perhaps after 1917 it was due (largely) to political circumstances that he failed to find greater understanding in his homeland, since in theory his countrymen were closer to him than West Europeans.

464 PLF, p. 151, CW, p. 658. There is not enough space to discuss the meetings with Mondrian reported by Nina (see p. 326). Interestingly, she perhaps gives her husband's personal point of view in portraying Mondrian and Malevich as bigoted and egocentric (which is rather an exaggeration). Nina Kandinsky, 1976, pp. 176–178.

465 PLF, p. 117.

466 "Die Kunst von heute ist lebendiger denn je," in *Cahiers d'Art*, 1935, (*Kandinsky, Essays über Kunst und Künstler*, ed. M. Bill, Berne, 1955, p. 170).

467 "Leere Leinwand undsoweiter," in *Cahiers d'Art*, 1935, p. 169.

CHAPTER 4

468 See Stasov's review of the exhibition in *Peterburgksie vedomosti* (Petersburg News) of March 12, 1874. Viktor Alexandrovich Gartman (Hartmann), 1834–1873, painter and architect. Like Mussorgsky and Repin, he belonged to the circle of Slavophiles around the famous historian and critic Stasov. They all shared an interest in Russian popular traditions, as shown by Hartmann's pictures and buildings in Moscow, St. Petersburg, and the artists' colony at Abramtsevo. Stasov organized the posthumous exhibition, and Mussorgsky dedicated his piano piece to him. Hartmann was soon forgotten as a painter. One source of information is Stasov's *Complete Works*, St. Petersburg, 1894. A few pictures were exhibited in the Public Library of St. Petersburg in 1931, following Mussorgsky's death. The watercolors and drawings are executed skillfully, including not particularly original sketches of historical monuments in the Russian style (see also A. Frankenstein, "Viktor Hartmann and Modeste Mussorgsky," in *The Musical Quarterly XXV*, 1939, pp. 268 ff.).

469 W. Kandinsky, "Modeste Mussorgsky, 'Pictures at an Exhibition,'" in *Das Kunstblatt* (Art Journal), year 14, August 1930, p. 246. See also CW, pp. 749 f.

470 Ibid.

471 Several conversations with the author between 1969 and 1982.

472 Translated from the Russian manuscript of *Violet* into German by the author, Centre Pompidou, Paris.

473 Coll. Works, St. Petersburg, 1894, p. 45.

474 Conversations with the author between 1968 and 1979. "Muralli" and a question mark have been added to Kandinsky's score: this may have referred to the musical director of the Friedrich Theater in Dessau, Alfons Mourot, in which case the question mark denoted doubt as to the spelling of his name. Ravel's orchestral version was premièred in Paris in 1922, although the the score appears not to have been published until 1929, as the copyright for the "Edition Russe de Musique" dates from that year.

CHAPTER 5

475 Reported by Peg Weiss in "Introduction," *The Blue Four*, Cat. Hutton Galleries, New York, 1984, p. 10.

476 Letter of July 18, 1931 (Galka Scheyer Blue Four Archive, Norton Simon Museum of Art, Pasadena). By kind permission of Hella Hammid, the owner of the letters, and Peg Weiss.

477 Letter of October 19, 1937 (see note 476 above).

478 Letter of May 9, 1931, ibid.

479 Joseph Albers Archive, Yale University, New Haven.

480 Cited from C. Derouet, "La fermeture du Bauhaus," Cat. Paris 1984, p. 236.

PART VII
CHAPTER 1

481 Nina Kandinsky 1976, p. 160.

482 Letter of March 21, 1936, Archives of the Getty Center for the History of Art and the Humanities, Los Angeles.

483 Alexander Benois, Jugendstil painter from St. Petersburg who belonged to the *Mir iskusstva*

(World of Art) group. Kandinsky's comment is borne out by a letter by Benois on December 8, 1936, after a visit to his fellow artist's show, "I looked at everything very closely but didn't understand a thing [...] I must be missing the right organ. Theoretically, I'm ready to admit that such an art could exist [...]. I'm even ready to admit that your art has a great future, I wouldn't be at all surprised [...]. But it would make me sad." (letter in Russian, Centre Pompidou, Paris).

484 Letters in Russian, Jawlensky Archive, Locarno. First publication by kind permission of Maria Jawlensky.

485 "Die Kunst von heute ist lebendiger denn je," in Cahiers d'Art, 1935; reprinted in Essays über Kunst und Künstler, ed Max Bill, Berne, 1955, pp. 162 f.

486 For the notion of "setting down tools," see "Die Kunst von heute ist lebendiger denn je," op. cit., p 169. On "special language," see "Zugang zur Kunst", 1937, publ. in Essays (see previous note), p. 207.

487 M. P. Vikturina, "K voprosu o zhivopisnoi tekhnike V V Kandinskogo," in Kandinsky 1866–1944 Zhivopis, grafika, prikladnoe iskusstvo, St. Petersburg, 1989, pp. 191 f. and Cat. Frankfurt 1989, p. 35. Such citations are often repeated unverified. However, in this case, the author insisted on discovering the source, and found out (as she expected to) that the quote was a paraphrase of a citation based on a citation of equally dubious source, with the result that Kandinsky's ideas appear to be the opposite of what they really were. (This is not only true of Russian research, of course, though the Russians have a particularly large amount of catching up to do in the area of abstraction.)

488 Letter to Will Grohmann, January 28, 1936 in Künstler schreiben an Will Grohmann, Cologne, 1968, pp. 65 f.

489 Cat. Paris 1984, pp. 356 and 364. Wherever Derouet cites documents that must allay his suspicions, for example when Kandinsky mentioned to Grohmann his joy at the official recognition of Lipschitz's memorial to the Jewish dead, he asks himself whether Kandinsky was in fact being sarcastic. "Kandinsky in Paris 1934–1944," in Cat. Kandinsky in Paris 1934–1944, New York, 1985, p. 21. Let's just hope that Derouet's unjustified assertions were meant ironically.

490 Cited in Nina Kandinsky, 1976, p. 187.

491 This is very well documented in the comprehensive exhibition by Stephanie Barron, "Degenerate Art." The Fate of the Avant-Garde in Germany (catalogue, Los Angeles County Museum of Art, 1992), which was also shown in Chicago and Berlin.

492 The books in question are: René Char, Le marteau sans maître, Paris 1934, and Tristan Tzara, La main passe, Paris 1935. – Documentation on Kandinsky's support of Otto Freundlich (petition, help in buying a picture, participation in the "Hommage" exhibition in Paris, photograph with Freundlich) is to be found in the Centre Pompidou, published by Derouet in the catalogue Kandinsky in Paris, 1985, pp. 20 f., and mentioned briefly in Cat. Paris 1984, p. 364, with the biased comment, "[Kandinsky] did not get involved. Nevertheless, he came to the opening in Paris ... of work by the Jewish artist Otto Freundlich."

493 Cat. Paris 1984, p. 364, "a wait-and-see attitude vis-à-vis the Nazis" is surely an exaggeration. Derouet also states that Kandinsky was "...somewhat short on analysis and comprehension, he lumped together

Communists and Fascists, the criticism of the Moscow trials and the Führer's auto da fés." "Kandinsky in Paris 1934–1944," in Cat. Kandinsky in Paris 1934–1944, New York, 1985, p. 19. Derouet, who speaks neither Russian nor German, is evidently concentrating on the (small) proportion of Kandinsky material written in or translated into French. Of course, it would be too much to ask that he sit for two years in the relevant archives (with a German translator on his right and a Russian on his left). But it would be in his own interests to have a more positive attitude toward the necessity of (1) the translation and (2) the publication of unknown texts.

494 Interview with Edoardo Westerdal, editor of Gaceta de Arte, Tenerife, publ. in Essays, Berne, 1955, p. 155. CW, p. 790.

495 Letter of January 28, 1936 to Will Grohmann, in Künstler schreiben an Will Grohmann, op. cit., p. 65.

496 Letter to G. Scheyer, cited in Nina Kandinsky 1976, p. 169.

497 Letter of April 24, 1931 to Christian Zervos, in Cat. Paris 1984, p. 356.

498 Nina Kandinsky 1976, pp. 177 f.

499 Letter of January 28, 1936 to Will Grohmann, in Künstler schreiben an Will Grohmann, op. cit., pp. 65 f. For reference to Josef Albers, see Part VI.

500 Cited in Nina Kandinsky 1976, p 186.

501 Letter of August 18, 1932, to Will Grohmann, in Künstler schreiben an Will Grohmann, op. cit., p. 59.

502 Letter to J. B. Neumann, gallery owner in New York, February 10, 1937, Archives of the Getty Center for the History of Art and the Humanities, Los Angeles.

503 Letter to Grohmann, August 6, 1935, in Künstler schreiben an Will Grohmann, op. cit., p. 64.

504 Nina Kandinsky 1976, p. 168. Nina has spoken to the author with the greatest of respect of this amazing eidetic capacity of her husband's.

505 Cited from C. Derouet, "Kandinsky in Paris 1934–1944," in Cat. Kandinsky in Paris 1934–1944, op. cit., p. 27.

506 Nina Kandinsky 1976, p. 168.

507 Kandinsky's words are supported by Magnelli: "His color scale is wonderfully varied. He uses every possible combination, without shrinking away even from the most hazardous dissonances." ("Kandinsky le peintre" in Max Bill (ed), Wassily Kandinsky, Paris, 1951, p. 17).

CHAPTER 2

508 Cat. Paris 1984, p. 374 (Russian abbreviations, but very clear: "fon b. + lil./okrug – ros – ser. t.").

509 "Kandinsky and Science. The Introduction of Biological Images in the Paris Period," in: Kandinsky in Paris 1934–1944. New York, 1985, p. 61. The author is not so sure about Barnett's interpretation of the star-shaped object as the female sex organ, which Kandinsky is supposed to have borrowed from Miró. There were already variations on this star during the Bauhaus years, which do not give rise to such an interpretation. Most of the lengthy detail about the embryonic shapes leave the author similarly unconvinced, except in a few cases such as ill. 419. Why should Kandinsky begin painting embryos at this date, when he lost his child back in 1920?

510 Short supplementary analysis, 1938, written for Max Bill, not published until 1955, CW, pp. 834 f.

511 Grohmann 1958, p. 228. This comparison, especially the question of the borders, is rich enough to merit a thesis in itself.

512 He liked a group of pictures to be combined "orchestrally." CW, p. 369.

CHAPTER 3

513 Grohmann 1958, p. 222.

514 Untitled essay in catalogue Kandinsky: Parisian Period 1934–1944, M. Knoedler, New York, 1969, p. 16.

CHAPTER 4

515 "Die Kunst von heute ist lebendiger denn je," in Cahiers d'Art, 1935.

516 Letter of June 27, 1937, cited by kind permission of Hella Hammid and Peg Weiss.

517 Cited by kind permission of Hella Hammid and Peg Weiss.

518 Kandinsky's correspondence with Münter in particular gives examples of this (GM/JE St).

519 Thoroughly documented in Cat. Paris 1984, pp. 369 ff.

520 Nina explained this personally to the author much more clearly than in her memoirs.

521 P. Weiss, "Kandinsky and 'Old Russia,'" in The Documented Image. Visions in Art History, Syracuse, n. d., pp. 187–222.

522 In 1889, Kandinsky wrote an essay on surviving pagan beliefs among the Syryenian tribes of northern Russia. In fact he found little to report. However, Weiss argues the opposite in her article on "Kandinsky and 'Old Russia.'" She claims that the Syryenians referred to their ancestors derogatively as "poganyi," a word related to "poganka" or "poisonous mushroom" [Ibid. pp. 193 f. and 213]. She cites no source for this. Since Weiss (knowing no Russian) used this author's own German translation and commentary (GS, pp. 69 and 195), she may have based her erroneous claim on a misunderstanding. To explain Kandinsky's claim that "the pagan forebears were given the insulting name 'Paganye,'" readers should know that several centuries after the birth of Christianity, this word (pagan) underwent a change in meaning. It began to connote everything offensive or ugly, or simply eerie, foul weather, criminals, etc. The noun "poganka" was used for "slut" or "whore," or for any inedible fungus, including (but not exclusively) poisonous mushrooms.
Syryenians in fact have nothing whatsoever to do with poisonous mushrooms. There are no hints of any particular interest in mushrooms in any of Kandinsky's work. But Peg Weiss claims, in The Green Band of 1944, that the mushroom-shaped object which was present in the artist's preliminary sketch has been omitted by Kandinsky. Perhaps he feared that it would be interpreted as a Shaman symbol. It was not until several months later that he finally plucked up the courage to include mushroom-shaped objects in his Last Watercolor (ill. 449), almost to saturation point. This is hardly sufficient evidence of an artistic identification with Shamanism! Weiss also describes Kandinsky's trip to northern Russia as a "return to his roots," referring to his father's origins in Kyakhta southeast of the Baikal Sea (and ignoring the distance of several thousand kilometers between the two). Her indiscriminate jumbling together of Russian and Syryenian cultural traditions (Saint Vladimir etc.) is responsible for many errors, her comments on

"dukhovnom" (failing to register that *"-om"* is merely an ending and *"dukhovny"* the adjective of the noun *"dukh"* or "spirit") are all difficult to subscribe to.

523 It should now be clear that it is not merely a question of missing "proof" as to whether Kandinsky really did paint Stefan George, but that to do so would have been entirely contrary to Kandinsky's nature even in his early years. The knight is *the embodiment* of knighthood. Jonathan Fineberg made the following judgment of Weiss' "Jugendstil" book, which is just as relevant as her Shaman theme:
"Peg Weiss is the only writer on Kandinsky who thinks that Jugendstil provided the stylistic vocabulary to Kandinsky's breakthrough to abstraction. In her book Weiss piles up quotations and specific detail, but she never shows their importance for Kandinsky or proves that Jugendstil as a whole had the impact on him which she claims it did. Her notion of irrefutable evidence is to find two pictures that have something in common visually or two passages of text that sound somewhat alike and to presume in such cases the existence of a causal relation. For example, she claims that the use of the phrases 'purely artistic means' and 'uninhibited use of color' by the Jugendstil critic Schultze-Naumburg reveal 'startling insights into Kandinsky's later thought, the direction of his development, and even his use of language as found in his earliest writings.' Not only is Weiss apparently ignorant of the wide currency of such language [. . .] the quality of analytical thinking in Weiss' book is weak throughout. Even her citation of evidence is unreliable because she misreads the primary sources." ("Kandinsky: Through the Scholar's Glass," in *Art in America*, Dec. 1982. Special issue: *Expressionism*, pp. 11 f.).

524 On making the acquaintance of the author in 1968, Nina immediately confided her overriding concern to her (hoping possibly for some help from a young compatriot): how was she to execute her husband's last wishes during the "cold war" that was still being waged? The only contact that the author could think of at the time was the Soviet ambassador, with whom Nina was already in touch. In general the author, as yet quite unaware of the full significance of a last will and testament, reacted in as narrow-minded a way as the rest of Nina's circle of friends. Instead of realizing that noone has the right to criticize the last wishes of another, the author expressed her surprise and her belief that it would be more advisable to keep the paintings in the West, asking if Kandinsky had been aware of the fact that in Russia his paintings would in any case have been banned and locked away from the public eye. "Oh yes, he realised this, but this was still his wish. What is more, I am determined to carry it out, in spite of all the efforts people make to try and stop me or make me change my mind." Nina was doubtless disappointed in the author's lack of understanding or interest (and with hindsight the author could kick herself for it!). She would tell of her latest progress with this or that contact in the Soviet Government, or about her trip to Moscow; however, in the years preceding her murder, she spoke less and less on the subject. Although the author has no doubt whatsoever about Nina's original determination to carry out Kandinsky's final wishes, she knows too little about the last months of her life to be able to judge whether and to what extent Nina's friends were responsible for her change

of heart. Unlike her husband, she made a will, bequeathing all the paintings from his legacy to her to the new center for contemporary art that had just opened in Paris. Her choice of the Centre Georges Pompidou, instead of the Musée d'Orsay, with its emphasis on the art of the nineteenth century, was at least sound. In this way her collection of about four hundred paintings has ended up in a suitable setting, where they belong as the foundation of the art of our century. However, this does not alter the fact that Kandinsky's own final request has never been honored.

The mystery of the last works

525 CW p. 532. For this, see my commentary in my book *Voir l'invisible* (Paris, Editions François Bourin, 1988), pp. 14 ff.
526 Translator's note. Throughout the text, "pathetic" is to be taken in its etymological sense.
527 Translator's note. "Graphic elements" renders the French term *"graphisme"* throughout. Instead of "graphic elements", the translation of *Complete Writings* uses the less felicitous term "graphics," e.g., pp. 536, 537, and 547.
528 "On the Question of Form," CW p. 250.
529 *Point and Line to Plane*, CW p. 548, my emphasis.

Developments in research

530 Letter to Münter of October 22, 1912. (GM/JE St.).
531 R. C. Washton Long, *Kandinsky. The Development of an Abstract Style*, p. 34; see also pp. 3, 12, 41, 48 f., 66, 137 etc., also her chapter "Involving the Viewer."
532 *Kunstchronik I*, January 1993.
533 T. Messer, "Kandinsky en Amérique," in *XXᵉ siècle*, special issue, Paris, 1974, p. 116.

BIBLIOGRAPHY

Russian titles are transliterated according to the International Scientific Transcription System which renders every Cyrillic letter exactly (š = sh; č = ch; ž = zh). Translations of Kandinsky's works into languages other than English, French, German, and Italian are not listed.

I. CATALOGUES RAISONNÉS/ WERKVERZEICHNISSE

Roethel, Hans Konrad. *Kandinsky: Das graphische Werk*. Köln 1970.

Roethel, Hans K.; Benjamin, Jean K. *Kandinsky: Catalogue Raisonné of the Oil Paintings*. Vol. 1: 1900–1915. London 1982. Vol. 2: 1916–1944. London 1984. (Fr.: *Catalogue Raisonné de l'œuvre peint*. Vol. 1: 1900–1915. Paris 1982. Vol. 2: 1916–1944. Paris 1984.)

Barnett, Vivian Endicott. *Kandinsky Watercolours: Catalogue Raisonné*. Vol. 1: 1900–1921. London 1992. (Dt.: *Kandinsky: Werkverzeichnis der Aquarelle*. Bd. 1: 1900–1921. München 1992. Fr.: *Kandinsky Aquarelles: Catalogue Raisonné*. Vol. 1: 1900–1921. Paris 1992).

KANDINSKY'S WRITINGS/ ÉCRITS/SCHRIFTEN

Kandinsky: Essays über Kunst und Künstler. Ed.: Max Bill. Stuttgart 1955.

Kandinsky, Wassily. *Écrits complets*. Ed.: Philippe Sers. Vol. 2, Paris 1970. Vol. 3, Paris 1975.

Kandinsky: Die Gesammelten Schriften. Ed.: Hans K. Roethel; Jelena Hahl-Koch. Bd. 1: Autobiographische, ethnographische und juristische Schriften. Bern 1980.

Kandinsky: Complete Writings on Art. Ed.: Kenneth C. Lindsay; Peter Vergo. Vol. 1: 1901–1921. Vol. 2: 1922–1943. London 1982.

Kandinsky: Tutti gli scritti. 2 vol. Transl. by L. Sosio, Milano 1974.

Über das Geistige in der Kunst. Insbesondere in der Malerei. 1. Aufl., München 1912 [Print: 1911; dat.: 1912]. 2. Aufl., München, April 1912. 3. Aufl., München, Herbst 1912. 4.–6. Aufl., Bern 1952–1959. [Introd.:] Max Bill.

The Art of Spiritual Harmony. Transl. by Michael T. H. Sadler. London 1914. Boston 1914.

On the Spiritual in Art. Ed.: Hilla Rebay. New York 1946.

Concerning the Spiritual in Art and Painting in Particular. New York 1947. (With the essays: Kandinsky, Nina. »Some Notes on the Developments of Kandinsky's Painting«, pp. 9–11. Feininger, Julia and Lyonel. »Wassily Kandinsky«, pp. 12–14. Hayter, Stanley William. »The Language of Kandinsky«).

Du spirituel dans l'art et dans la peinture en particulier. Transl. by M. et Mme. DeMan. Paris 1949.

Du spirituel dans l'art et dans la peinture en particulier. Text: Charles Estienne. Paris 1951. 1954. 3. ed. 1963. Republ. by P. Sers 1971.

Du spirituel dans l'art et dans la peinture en particulier. Transl. by Pierre Volboudt. Paris 1969.

Du spirituel dans l'art et dans la peinture en particulier. Preface: Philippe Sers. Paris 1989.

Della Spiritualità nell'arte, particolamente nella pittura. Transl. by G. A. Colonna di Cesarò. Roma 1940. Republ. in: *Wassily Kandinsky. Tutti gli scritti*. Milano 1974.

Rückblicke: 1901–1913. Berlin 1913. *Rückblicke*. [Introd.:] Ludwig Grote. Baden-Baden 1955. *Kandinsky: Rückblicke*. Bern 1977.

Stupeni. Tekst Chudožnika. Moskva 1918.

Kandinsky. Ed.: Hilla Rebay. New York 1945.

Regard sur le passé. Transl. by Gabrielle Buffet-Picabia. Paris 1946.

Regards sur le passé et autres textes, 1912–1922. Ed.: J.-P. Bouillon. Paris 1974.

Sguardi sul Passato. Transl. by M. Milena [after the French transl. by G. Buffet-Picabia]. Venezia 1962. *Sguardi al Passato*. Transl. by L. Sosio, in: *Wassily Kandinsky. Tutti gli scritti*. Milano 1974.

Klänge. München 1913.

Sounds. Transl. and introd.: Elizabeth R. Napier. New Haven; London 1981.

Klänge. Transl. into French by Inge Hanneforth and Jean-Christoph Bailly. Paris 1987.

Om Konstnären. Stockholm 1916.

Punkt und Linie zu Fläche: Beitrag zur Analyse der malerischen Elemente. Ed.: Walter Gropius; László Moholy-Nagy. München 1926 (Bauhausbücher 9). 2. Aufl. 1928. [Introd.:] Max Bill. 3. – 4. Aufl. Bern 1955–1959.

Point and Line to Plane: Contribution to the Analysis of the Pictorial Elements. Ed.: Hilla Rebay. New York 1947.

Point, Ligne, Plan: contribution à l'analyse des éléments picturaux. Transl. by Christine Boumeester. Paris 1963.

Point, Ligne, Plan: contribution à l'analyse des éléments picturaux. Transl. by Suzanne et Jean Leppien. Paris 1970.

Point et Ligne sur Plan. Paris 1972.

Point et Ligne sur Plan. Ed.: Philippe Sers. Transl. by Suzanne and Jean Leppien. Paris 1991.

Punto, linea, superficie. Transl. by M. Calasso. Milano 1968. *Punto e linea nel piano*. Transl. by L. Sosio, in: *Wassily Kandinsky. Tutti gli scritti*. Milano 1974.

ARTICLES

»O nakazanijach po rešenijam volostnych sudov Moskovskoj Gubernii«. In: *Trudy obščestva ljubitelej estestvoznanija, antropologii i etnografii*. Moskva, 51 (1889) 9, pp. 13–19.

»Iz materialov po etnografii sysol'skich i vyčegodskich zyrian«. In: *Etnografičeskoe obozrenie*. Moskva, (1889) 3, pp. 102–110.

»Kritika kritikov«. In: *Novosti dnja*. Moskva, Nr. 6407, 6409; 17., 19. Apr. 1901.

»Korrespondencija iz Mjunchena«. In: *Mir Iskusstva*. St. Petersburg, (1902) 5–6, pp. 96–98.

»Vorwort«. In: *Neue Künstler-Vereinigung München e.V.* Cat. München, Neue Künstler-Vereinigung, Turnus 1909–1910, pp. 52–53.

»Pis'mo iz Mjunchena«. In: *Apollon (Chronika)*. St. Petersburg, (1909) 1, pp. 17–20; (1910) 4, pp. 28–30; 7, pp. 12–15; 8, pp. 4–7; 11, pp. 13–17.

»[Ohne Titel]«. In: *Neue Künstler-Vereinigung München e.V.* Cat. München, Neue Künstler-Vereinigung, 2. Ausstellung, Turnus 1910–1911, p. 7.

»Soderžanie i forma«. In: *Salon 2, meždunarodnaja chudožestvennaja vystavka […]*. Odessa, (1910–1911), pp. 14–16.

»Paralleli v oktavach i kvintach – Notes on Arnold Schönberg«. In: *Salon 2, meždunarodnaja chudožestvennaja vystavka […]*. Odessa, (1910–1911), pp. 16–18.

»Kuda idet ›novoe‹ iskusstvo?«. In: *Odesskie novosti*. Odessa, Nr. 8339, 9. Febr. 1911.

»[Ohne Titel]«. In: *Im Kampf um die Kunst: Die Antwort auf den ›Protest Deutscher Künstler‹*. München 1911, pp. 73–75.

»[Ohne Titel]«. (2 Beiträge). In: *Die erste Ausstellung der Redaktion ›Der Blaue Reiter‹*. 2. Aufl., München 1911–1912.

»Über das Geistige in der Kunst« (Auszüge). In: *Der Sturm*. Berlin, 3 (1912) 106, April, pp. 11–13.

»Die Bilder«. In: *Arnold Schönberg*. Mit Beiträgen von Alban Berg [. . .] Wassily Kandinsky. München 1912, pp. 59–64.

»[Ohne Titel]«. In: *Die zweite Ausstellung der Redaktion ›Der Blaue Reiter‹*. München 1912, pp. 3–4.

»Eugen Kahler«. In: *Almanach Der Blaue Reiter*. Ed.: Wassily Kandinsky; Franz Marc. München 1912, pp. 53–55.

»Über die Formfrage«. In: *Almanach Der Blaue Reiter*. Ed.: Wassily Kandinsky; Franz Marc. München 1912, pp. 74–100.

»Über Bühnenkomposition«. In: *Almanach Der Blaue Reiter*. Ed.: Wassily Kandinsky; Franz Marc. München 1912, pp. 103–113.

»Der Gelbe Klang«. In: *Almanach der Blaue Reiter*. Ed.: Wassily Kandinsky; Franz Marc. München 1912, pp. 115–131.

»[Ohne Titel]« (Autobiographische Notiz). In: *Kandinsky: Kollektiv-Ausstellung 1902–1912*. München 1912, pp. 1–2.

»Über Kunstverstehen«. In: *Der Sturm*. Berlin, 3 (1912) 129, Okt., pp. 157–158.

»Ergänzung«. In: *Kandinsky: Kollektiv-Ausstellung 1902–1912*. 2. Aufl., München 1913, pp. 3–6.

»Pis'mo izdatelju«. In: *Russkoe Slovo*. Moskva, Nr. 102, 4. May 1913.

»Briefe an Karl Wolfskehl: 31. Dezember 1911; 22. Januar 1913; 15. August 1913 (Postkarte); 12. September 1913«. In: *Karl Wolfskehl, 1869–1969: Leben und Werk in Dokumenten*. Darmstadt 1969, pp. 334–337.

»Malerei als reine Kunst«. In: *Der Sturm*. Berlin, 4 (1913) 178/179, Sept., pp. 98–99.

»Rückblicke«; »Komposition 4«; »Komposition 6«; »Das Bild mit weißem Rand«. In: *Kandinsky 1901–1913*. Berlin 1913, pp. III–XXIX; XXXIII–XXXIV; XXXV–XXXVIII; XXXIX–XLI.

»O duchovnom v iskusstve«. In: *Trudy vserossijskago s'ezda chudožnikov, dekabr' 1911 – janvar' 1912*. T. 1, Petrograd 1914, pp. 47–75.

»Letters to A. J. Eddy«. In: Eddy, Arthur Jerome. *Cubists and Post-Impressionism*. Chicago 1914, pp. 125–126; 130–131; 135–137.

»Konsten utan ämne«. In: *Tidskriften Konst*. Stockholm, (1916) 1/2, p. 9.

»Kunstneren«. In: *Klingen* 1 (1918) 7, o. p. (pp. 12–15).

»Malen'kie statejki po bol'šim voprosam. 1: O točke. 2: O linii«. In: *Iskusstvo: Vestnik otdela izobrazitelnych iskusstv Narodnago Kommissariata po prosveščeniju*. Moskva, (1919) 3, 1. Febr., p. 2; 4, 22. Febr., p. 2.

»Kunstfrühling in Russland«. In: *Die Freiheit, Abendausgabe*. Berlin, 9. April 1919.

»Selbstcharakteristik«. In: *Das Kunstblatt*. Potsdam, 3 (1919) 6, Juni, pp. 172–174.

»Muzej živopisnoj kul'tury«; »O velikoj utopii«; »Šagi otdela izobrazitelnych iskusstv v meždunarodnoj chudožestvennoj politike«. In: *Chudožestvennaja Žizn'*. Moskva, (1920) 2, pp. 18–20; 3, pp. 2–4, 16–18.

»Otčet chudožnika Kandinskogo«. In: *Vestnik rabotnikov iskusstv*. Moskva, (1921) 4/5, pp. 74–75.

»Vorwort«. In: *Katalog der Ersten Internationalen Kunstausstellung Düsseldorf 1922 […]*. Düsseldorf 1922.

»Antwort auf ein Interview: ›Ein neuer Naturalismus?‹«. In: *Das Kunstblatt*. Potsdam, 9 (1922) 9, Sept., pp. 384–387.

»[Untitled]«. In: Cat. Gummeson, Stockholm 1922.

»Einleitung«. In: *Kleine Welten*. Berlin 1922.

»K reforme chudožestvennoj školy«. In: *Iskusstvo*. Moskva, (1923) 1, pp. 399–406.

»Die Grundelemente der Form«; »Farbkurs und Seminar«; »Über die abstrakte Bühnensynthese«. In: *Staatliches Bauhaus Weimar, 1919–1923*. Weimar; München 1923, pp. 26; 27–28; 142–144.

»[Ohne Titel]« (Color Questionnaire). In: *bauhaus*, 1923.

»Gestern – Heute – Morgen«. In: *Künstlerbekenntnisse*. Ed.: Paul Westheim. Berlin 1925, pp. 164–165.

»Zwielicht«. In: *Europa-Almanach*. Ed.: Carl Einstein; Paul Westheim. Potsdam 1925, p. 65.

»Abstrakte Kunst«. In: *Der Cicerone*. Leipzig, 17 (1925), pp. 639–647.

»Tanzkurven: Zu den Tänzen der Palucca«. In: *Das Kunstblatt*. Potsdam, 10 (1926) 3, pp. 117–120.

»der wert des theoretischen unterrichts in der malerei«. In: *bauhaus*. Dessau, 1 (1926) 1, Dez., p. 4.

»Und. Einiges über synthetische Kunst«; »Ohne Titel« (Diskussion von Ernst Kallais ›Malerei und Photographie‹). In: *i10*. Amsterdam, 1 (1927) 1, Jan., pp. 4–10; 6, June, pp. 230–231.

»aus ›violett‹, romantisches bühnenstück von Kandinsky«. In: *bauhaus*. Dessau, 2 (1927) 3, Juli, p. 6.

»Über die abstrakte Malerei«. In: Cat. Frankfurt, Kunstverein, Febr. 1928.

»kunstpädagogik«; »unterricht kandinsky, analytisches zeichnen«. In: *bauhaus*. Dessau, 2 (1928) 2/3, pp. 8; 10–11.

»Analyse des éléments premiers de la peinture.« In: *Cahiers de Belgique*. Brussels, May 1928.

»Kunstpädagogik«. In: *bauhaus*. Dessau, No. 2–3, 1928.

»[Ohne Titel]«. In: *Oktober-Ausstellung in der Galerie Ferdinand Möller*. Berlin 1928.

»Die kahle Wand«. In: *Der Kunstnarr*. Dessau, 1. April 1929, pp. 20–22.

»Zwei Ratschläge«. In: *Berliner Tageblatt*, Nr. 412, 1. Sept. 1929.

»Antwort auf ein Interview«. In: Plaut, Paul. *Die Psychologie der produktiven Persönlichkeit*. Stuttgart 1929, pp. 306–308.

»[. . .] Interview: Enquête 1830–1930«. In: *L'Intransigeant*. Paris, 2. Dec. 1929.

»Unterricht Kandinsky«. In: *bauhaus*. Dessau, Prospectus, 1929.

»Der Blaue Reiter (Rückblick; Brief an Paul Westheim)«. In: *Das Kunstblatt*. Potsdam, 14 (1930) 2, Febr., pp. 57–60.

»Modest Mussorgsky: ›Bilder einer Ausstellung‹«. In: *Das Kunstblatt*. Potsdam, 14 (1930) 8, Aug., p. 246.

»Reflexions sur l'art abstrait«. In: *Cahiers d'Art*. Paris, 1 (1931) 7/8, pp. 351–353. (Dt.: »Betrachtungen über die abstrakte Kunst«. In: *Essays über Kunst und Künstler*. Ed.: Max Bill. Bern 1963).

»[Ohne Titel]« (Für Paul Klee). In: *bauhaus*. Dessau, 3 (1931).

»Interview: ›Pouvez-vous dire quelle a été la rencontre capitale de votre vie‹?«. In: *Minotaure*. Paris, 1 (1933) 3/4, Dec., p. 110.

»Interview: ›L'art d'aujourd'hui est plus vivant que jamais‹«. In: *Cahiers d'Art*. Paris, 10 (1935) 1–4, pp. 53–56.

»[Ohne Titel]«. In: *Thèse – antithèse – synthèse*. Cat. Luzern, Kunstmuseum, Frühjahr 1935, pp. 15–16.

»Line and Fish«. In: *Axis*. London, 2 (1935) 6, April.

»[Ommagio a Baumeister]«. In: *Il Milione: Bolletino della Galleria del Milione*. Milano, 41 (1935) V/VI.

»To retninger«. In: *Konkretion*. Kobenhavn, 15. Sept. 1935, pp. 7–10.

»Toile vide, etc«. In: *Cahiers d'Art*. Paris, 10 (1935) 5/6, p. 117.

»Abstrakte Malerei«. In: *Kroniek van hedendaagsche Kunst en Kultuur*. Amsterdam, 1 (1936) 6, April, pp. 224–226.

»Interview: ›respuestas . . . al cuestionario de gaceta de arte‹«. In: *Gaceta de Arte, Revista internacional de cultura*. Teneriffa, (1936) 38, VI, pp. 85–87.

»Franz Marc«. In: *Cahiers d'Art*. Paris, (1936) 8–10, pp. 273–275.

»Tilegnelse af Kunst«. In: *Linien*. København, (1937), pp. 2–4.

»Ergo«; »S«; »Erinnerungen«; »Immer Zusammen«. In: *Transition*. Paris, (1938) 27, April/Mai, pp. 104–109.

»L'art concret«. In: *XXe Siècle*. Paris, 1 (1938) I.

»Abstract of concreet?«. In: *Tentoonstelling abstracte kunst*. Cat. Amsterdam, Stedelijk Museum, 1938, pp. 8–10. (– In: *Kroniek van hedendaagsche Kunst en Kultuur*, Amsterdam, 3 (1938) 6, April, pp. 168–170.)

»L'esprit poétique«. In: *Cahiers du Journal des Poètes: mensuel de création et d'information poétiques*. Bruxelles, 10 (1938). (Reprint in: *Art d'Aujourd'hui* 6 (1950) 5).

»Mes gravures sur bois«. In: *XXe Siècle*. Paris, 1 (1938) 3.

»La valeur d'une œuvre concrète«. In: *XXe Siècle*. Paris, 1 (1938/39) 5/6, pp. 48–50.

»Salongespräch«; »Testimonium Paupertatis«; »Weiss-Horn«. In: *Plastique*. Paris; New York, 4 (1939), pp. 14–16.

»Abstract and Concrete Art«. In: *London Bulletin*, (1939) 14, May, p. 2.

»[Ohne Titel]. ›Toute époque spirituelle . . . ‹ (Vorwort)«. In: Portfolio mit 10 Originalen. Ed.: Max Bill. Zürich 1942.

»Préface«. In: *Doméla, six réproductions en couleurs d'après quelques œuvres récentes*. Paris, Galerie Jeanne Bucher, 1943.

»Tekst Artista«. In: *In Memory of Wassily Kandinsky*. Cat. New York, The Solomon R. Guggenheim Foundation, Museum of Non-Objective Paintings, 1945.

»Les reliefs colorés de Sophie Taeuber-Arp«. In: *Sophie Taeuber-Arp*. Ed.: G. Schmidt. Basel 1948.

»Kleine Welten«. In: *Mizue*. Tokyo, (1963) 697, pp. 55–59.

»Briefe an Hermann Rupf 1931–1943«. Ed.: Sandor Kuthy. In: *Berner Kunstmitteilungen* (1974) 150/151, pp. 1–13; 152/153, pp. 5–19.

II. LITERATURE ON KANDINSKY PUBL. / CATALOGUES

Anton Ažbè in Njegova Šola. Cat. Ljubljana, Narodna Galerija, 1962.

Arnold Schönberg, Wassily Kandinsky: Briefe, Bilder und Dokumente einer außergewöhnlichen Begegnung. Ed.: Jelena Hahl-Koch. Salzburg; Wien 1980.

Aust, Günter. *Kandinsky*. Berlin 1960.

Bader-Griessmeyer. Gabriele. *Münchner Jugendstil-Textilien: Stickereien und Wirkereien von und nach Hermann Obrist, August Endell, Wassily Kandinsky und Margarete von Brauchitsch*. München 1985.

Ball, Hugo. *Die Flucht aus der Zeit: Fuga saeculi*. München; Leipzig 1927. Luzern 1946.

Ball, Hugo. *Kandinsky*. [Lecture manuscript, Galerie Dada.] Zürich 1916/17.

Bamberg, Juliann Leila. *Kandinsky as Poet: The ›Klang‹*. Tallahassee, Fla.; Ann Arbor. Mich., 1983. – Tallahassee, Florida State University, Ph. D. Diss., 1981.

Baraev. *Drevo: Dekabristy i semejstvo Kandinskich.* Moskva 1991.

Barnett, Vivian Endicott. *Handbook: The Guggenheim Museum Collection 1900–1980*. New York 1980.

Barnett, Vivian Endicott. *Kandinsky and Sweden*. Cat. Malmö, Konsthall, 1989.

Bayer, Herbert. *Bauhaus 1919–1928*. Boston 1952.

Beljaev, A. *Šenšin*. Moskva 1929.

Bellido, Ramon Tio. *Kandinsky*. Paris 1987.

Der Blaue Reiter, München, und die Kunst des 20. Jahrhunderts 1908–1914. Cat. München, Haus der Kunst, 1949.

Der Blaue Reiter: Wegbereiter und Zeitgenossen. Cat. Basel, Kunsthalle, 1950.

Der Blaue Reiter und sein Kreis. Cat. Winterthur, Kunstverein, 1961.

Der Blaue Reiter. Cat. München, Städtische Galerie im Lenbachhaus, 1963.

Der Blaue Reiter. Cat. München, Städtische Galerie im Lenbachhaus, 1970.

Der Blaue Reiter, Städtische Galerie München. Cat. Wien, Neue Secession, 1971.

Der Blaue Reiter: Dokumente einer geistigen Bewegung. Ed.: Andreas Hüneke. Leipzig 1986.

The Body of God: First Steps towards an Anti-Theology. The Collected Papers of Eric Gutkind. Ed.: Lucie B. Gutkind; Henry Le Roy Finch. New York 1969.

Bouillon, Jean-Paul. *Kandinsky: ›Regards sur le passé‹ et autres textes 1912–1922*. Paris 1974.

Bovi, Arturo. *Kandinsky*. New York 1970. London 1971. Luzern 1972.

Bowlt, John E. *Russian Art of the Avant-Garde: Theory and Criticism 1902–1934*. New York 1976.

Brinkmann, Heribert. *Wassily Kandinski als Dichter*. Köln, Diss., 1980.

Brion, Marcel. *Geschichte der abstrakten Malerei*. Köln 1960.

Brion, Marcel. *Kandinsky*. Paris; Hamburg 1960. London 1961.

Brisch, Klaus. *Wassily Kandinsky (1866–1944): Untersuchungen zur Entstehung der gegenstandslosen Malerei an seinem Werk von 1900–1921*. Bonn, Diss., 1955.

Buchheim, Lothar-Günther. *Der ›Blaue Reiter‹ und die ›Neue Künstlervereinigung München‹*. Feldafing 1959.

Burger, Fritz. *Cézanne und Hodler: Einführung in die Probleme der Malerei der Gegenwart*. München 1912.

Cassou, Jean. *Interférences: Aquarelles et dessins de Wassily Kandinsky*. Paris 1960.

Cassou, Jean. *The Sources of Modern Art*. London 1962.

Il Cavaliere Azzurro. Cat. Torino, Galleria Civica d'Arte Moderna 1971.

Černyševskij, N. G. *Sočinenija N. Černyševskogo. Pervoe poln. izd. t. 1: Naučnaja i literaturnaja kritika*. Vervey 1868.

Conil Lacoste, Michel. *Kandinsky*. Paris; New York 1979. München 1979.

Craig, Edward Gordon. *Die Kunst des Theaters*. Leipzig 1905.

Craig, Edward Gordon. *On the Art of the theatre*. London 1911. New ed. 1968.

Čulkov, G. *Gody stranstvij*. Moskva 1930.

Denkler, Horst. *Drama des Expressionismus: Programm, Spieltext, Theater*. München 1967.

Derkatsch, Ingrid. *Wassily Kandinsky's Theory of the Identity of Realism and Abstraction in his Essay ›Über die Formfrage‹*. Berkeley, University of California, Ph. D. Diss., 1967.

Derouet, Christian; Boissel, Jessica. *Kandinsky: Œuvres de Vassily Kandinsky (1866–1944). Collections du Musée National d'Art Moderne, Centre Georges Pompidou*. Paris 1984.

Doelman, Cornelis. *Wassily Kandinsky*. New York 1964. Berlin; München 1964.

Dube, Wolf-Dieter. *Die Expressionisten*. Frankfurt am Main 1973.

Düchting, Hajo. *Wassily Kandinsky (1866–1944): Revolution der Malerei*. Köln 1990.

Eberlein, Dorothee. *Russische Musikanschauung um 1900: Von 9 russischen Komponisten dargestellt aus Briefen, Selbstzeugnissen, Erinnerungen und Kritiken*. Regensburg 1978.

Eddy, Arthur Jerome. *Cubists and Post-Impressionism*. Chicago; London 1914.

Edgington, Ann K. *Abstraction as a Concept in the Criticism of Gertrude Stein and Wassily Kandinsky*. The American University, Ph. D. Diss., 1976.

Eichner, Johannes. *Kandinsky und Gabriele Münter: Von Ursprüngen moderner Kunst.* München 1957.

Einstein, Carl. *Die Kunst des 20. Jahrhunderts.* Berlin 1926 (Propyläen Kunstgeschichte 16).

Eller-Rüter, Ulrika-Maria. *Kandinsky: Bühnenkomposition und Dichtung als Realisation seines Synthese-Konzepts.* Hildesheim 1990 (Studien zur Kunstgeschichte 57).

Endell, August. *Um die Schönheit: eine Paraphrase über die Münchner Kunstausstellungen bis 1896.* München 1896.

Entartete Kunst. Cat. München, Staatsgalerie moderner Kunst im Haus der Kunst, 1987.

Erenburg, Il'ja. *A vse-taki ona vertitsja* (Und sie dreht sich doch). Moskva; Berlin 1922.

Estienne, Charles. *Kandinsky.* Paris 1950.

Europa-Almanach. Ed.: Carl Einstein; Paul Westheim. Potsdam 1925.

Farner, Konrad *Der Aufstand der Abstrakt – Konkreten oder die ›Heilung durch den Geist‹: Zur Ideologie der spätbürgerlichen Kunst.* Neuwied; Berlin 1970.

Fechter, Paul. *Der Expressionismus.* München 1914.

Fineberg, Jonathan David. *Kandinsky in Paris 1906–07.* Ann Arbor, Mich., 1984 (Studies in the Fine Arts: The Avant Garde 44). – Cambridge, Mass., Harvard University, Ph. D. Diss., 1975.

Fischer, Otto. *Das neue Bild.* [Publ.: ›Neue Künstlervereinigung‹.] München, 1912.

Fuchs, Georg. *Die Revolution des Theaters: Ergebnisse aus dem Münchener Künstlertheater.* München; Leipzig 1909 (Engl.: *Revolution in the Theatre: Conclusions Concerning the Munich Artist's Theatre.* Transl. by Constance Connor Kuhn. Ithaca 1959; Russ.: *Revoliutsiia teatra.* St. Petersburg 1911).

Fuhr, James Robert. *›Klänge‹: The Poems of Wassily Kandinsky.* Ann Arbor, Mich., 1982.

Gehlen, Arnold. *Zeit-Bilder.* Frankfurt 1986.

Glatzel, Ursula. *Zur Bedeutung der Volkskunst beim ›Blauen Reiter‹.* München, Diss., 1975.

Gollek, Rosel. *Der ›Blaue Reiter‹ im Lenbachhaus München: Katalog der Sammlung in der Städtischen Galerie.* München 1974. 2., erw. und korr. Aufl., München 1982.

Gollek, Rosel. *Das Münter-Haus in Murnau.* München 1984.

Gollek, Rosel. *Wassily Kandinsky: Frühe Landschaften.* München; Zürich, 1978.

Gordon, Donald E. *Modern Art Exhibitions 1900–1916.* Vol. 1.2. München 1974 (Materialien zur Kunst des 19. Jahrhunderts 14/1.2).

Gordon, Donald E. *Expressionism: Art and Idea.* New Haven; London 1987.

Grabar', Igor'. *Moja žizn'.* Moskva; Leningrad 1937.

Gray, Camilla. *The Great Experiment: Russian Art 1863–1922.* New York; London 1962.

Gray, Camilla. *Die russische Avantgarde der modernen Kunst 1863–1922.* Köln 1963.

Grohmann, Will. *Wassily Kandinsky.* Leipzig 1924 (Junge Kunst 42).

Grohmann, Will. *Wassily Kandinsky.* Paris 1930.

Grohmann, Will. *Wassily Kandinsky: Farben und Klänge.* Folge 1: *Aquarelle.* Baden-Baden 1955. Folge 2: *Gemälde.* Baden-Baden 1956.

Grohmann, Will. *Wassily Kandinsky: Leben und Werk.* Köln 1958. 2. ed. 1961. (Engl.: *Wassily Kandinsky: Life and Work.* New York, 1958. 2. ed. 1963).

Grohmann, Will. *Wassily Kandinsky: Eine Begegnung aus dem Jahre 1924. Zum hundertsten Geburtstag am 4. Dezember 1966.* Berlin 1966.

Grohmann, Will. *Wassily Kandinsky zum 100. Geburtstag.* Festvortrag, gehalten anläßlich der Tagung zum 100. Geburtstag von Wassily Kandinsky in der Akademie der Künste am 4. Dezember 1966. Berlin 1967 (Anmerkungen zur Zeit 13).

Haftmann, Werner. *Malerei im 20. Jahrhundert.* Bd 1.2. München 1954. 1955. (Engl.: *Painting in the Twentieth Century.* London, 1960).

Hahl-Koch, Jelena. *Marianne Werefkin und der russische Symbolismus: Studien zur Ästhetik und Kunsttheorie.* München 1967 (Slavistische Beiträge 24). – Heidelberg, Diss., 1965).

Hanfstaengl, Erika. *Wassily Kandinsky. Zeichnungen und Aquarelle: Katalog der Sammlung in der Städtischen Galerie im Lenbachhaus München.* München 1974. 2. ed. 1981.

Harbison, Robert. *Deliberate Regression. The disastrous history of Romantic individualism in thought and art, from Jean-Jacques Rousseau to twentieth-century fascism* (n. d. [London 1970]).

Hausenstein, Wilhelm. *Die bildende Kunst der Gegenwart.* Stuttgart; Berlin 1914.

Hausenstein, Wilhelm. *München – Gestern, Heute, Morgen.* München 1947.

Henry, Michel. *Voir l'invisible: Sur Kandinsky.* Paris 1988.

Herbert, Barry. *German Expressionism, Die Brücke and Der Blaue Reiter.* London 1983.

Hommage à Schönberg: Der Blaue Reiter und das Musikalische in der Malerei der Zeit. Cat. Berlin, Nationalgalerie, 1974.

Hommage à Wassily Kandinsky. Ed.: Giorgio di San Lazzaro. In: *XXe siècle (1974).* Special issue. (Dt.: Wiesbaden; Luxemburg 1976).

Hommage de Paris à Kandinsky. Paris 1972.

Huysmans, Joris-Karl. *Là-bas.* 4. ed. Paris 1896.

Im Kampf um die Kunst: Die Antwort auf den ›Protest deutscher Künstler‹. München 1911.

In Memory of Wassily Kandinsky. Ed.: Hilla Rebay. Cat. New York, Museum of Non-Objective Painting, 1945.

Jelavich, Peter. *Munich and Theatrical Modernism: Politics, Playwriting, and Performance, 1890–1914.* Cambridge, Mass., 1985.

Jelavich, Peter. *Theater in Munich, 1890–1914: A Study in the Social Origins of Modernist Culture.* Princeton University, Ph. D. Diss., 1982.

Kandinsky. Antwerpen 1933. (Sélection: Chronique de la vie artistique 14).

Kandinsky. [Introd.:] Carola Giedion-Welcker. Cat. Zürich, Galerie Maeght, 1972.

Kandinsky. Text: Carlo A. Quintavalle. Barcelona 1973 (Maestros de la Pintura 63).

Kandinsky: Album de l'exposition. Cat. Paris, Musée national d'art moderne, Centre Georges Pompidou, 1984.

Kandinsky: Aquarelle und Zeichnungen. Cat. Basel, Galerie Beyeler, 1972.

Kandinsky: Gouaches, aquarelles, dessins. Text: Marcel Arland. Paris 1947.

Kandinsky: Russian and Bauhaus Years, 1915–1933. Cat. New York, Guggenheim Museum, 1983. (Dt.: *Kandinsky: Russische Zeit und Bauhausjahre 1915–1933.* Ed.: Peter Hahn. Cat. Berlin, Bauhaus-Archiv, Museum für Gestaltung, 1984).

Kandinsky et l'expressionisme. Ed.: Toshio Nishimura. Tokyo, 1973 (Les Grands Maîtres de la Peinture moderne 14).

Kandinsky, Franz Marc, August Macke: Drawings and Watercolors. Cat. New York, Hutton-Hutschnecker Gallery, 1969.

Kandinsky in Paris, 1934–1944. [Contrib.:] Thomas M. Messer; Christian Derouet; Vivian Endicott Barnett. Cat. New York, The Solomon R. Guggenheim Museum, 1985.

Kandinsky und Gabriele Münter: Werke aus fünf Jahrzehnten. Cat. München, Städtische Galerie im Lenbachhaus, 1957.

Kandinsky und München: Begegnungen und Wandlungen 1896–1914. Ed.: Armin Zweite. Cat. München, Städtische Galerie im Lenbachhaus, 1982. (Engl.: *Kandinsky in Munich: 1896–1914.* Cat. New York, The Solomon R. Guggenheim Museum, 1982; Cat. San Francisco, Museum of Modern Art, 1982).

Kandinsky Watercolors: A Selection from The Solomon R. Guggenheim Museum and the Hilla von Rebay Foundation. Cat. New York, The Solomon R. Guggenheim Museum, 1981.

Kandinsky, Nina. *Kandinsky und ich.* München 1976. (Fr.: Paris 1978).

Kandinsuki-ten = Kandinsky. Cat. Tokyo, The National Museum of Modern Art, 1987; Kyoto, The National Museum of Modern Art, 1987.

Kardovskij, D. *Ob iskusstve.* Moskva 1960.

Klee, Paul. *Tagebücher von Paul Klee, 1898–1918.* Köln; Zürich 1957. New ed. Ed.: Wolfgang Kersten, Stuttgart, 1988. (Engl.: *The Diaries of Paul Klee, 1898–1918.* Berkeley; Los Angeles 1964).

Klee und Kandinsky: Erinnerungen an eine Künstlerfreundschaft anläßlich Klees 100. Geburtstag. Cat. Stuttgart 1979.

Kleine, Gisela. *Gabriele Münter und Wassily Kandinsky: Biographie eines Paares.* Frankfurt am Main 1990.

Klumpp, Hermann. *Abstraktion in der Malerei: Kandinsky, Feininger, Klee.* Berlin 1932 (Kunstwissenschaftliche Studien 12).

Köllner, Sigrid. *›Der Blaue Reiter‹ und die vergleichende Kunstgeschichte.* Karlsruhe, Diss., 1984.

Korn, Rudolf. *Kandinsky und die Theorie der abstrakten Malerei.* Berlin 1960.

Lankheit, Klaus. *Der ›Blaue Reiter‹: Dokumentarische Neuausgabe.* München 1965.

Lassaigne, Jacques. *Kandinsky: Biographisch-kritische Studie.* Genève 1964 (Der Geschmack unserer Zeit 41). (Fr.: *Kandinsky: étude biographique et critique.* Paris 1964. Engl.: *Kandinsky: Biographical and Critical Study* (The Taste of our Time 41)).

Lemaître, Maurice. *Kandinsky est-il vraiment celui qu'on dit?* Paris 1979.

LeTargat, François. *Kandinsky.* Paris 1986. Barcelona 1986.

Lieber Freund... Künstler schreiben an Will Grohmann: Eine Sammlung von Briefen aus fünf Jahrzehnten. Ed.: Karl Gutbrod. Köln 1968.

The Life of Vasilii Kandinsky in Russian Art: A Study of ›On the Spiritual in Art‹. Ed.: John E. Bowlt; Rose-Carol Washton Long. Newtonville, Mass., 1980. 2. ed. 1984 (Russian Biography Series 4).

Lindsay, Kenneth Clement Eriksen. *An Examination of the Fundamental Theories of Wassily Kandinsky.* Madison, University of Wisconsin, Ph. D. Diss., 1951.

Lipsey, Roger. *An Art of Our Own: The Spiritual in Twentieth-Century Art.* Boston 1988.

Lodder, Christina. *Russian Constructivism.* New Haven; London 1983.

Lombroso, Cesare. *Der geniale Mensch.* Hamburg 1890.

Lorenz, Marianne; Levin, Gail. *Theme and Improvisation: Vassily Kandinsky and the American Avant-Garde, 1912–1950.* Boston 1992.

Lukšin, I. P. *Govorit' o misterii na jazyke misterii. Estetičeskaja koncepcija i tvorčestvo V. Kandinskogo.* Moskva 1991.

Maeterlinck, Maurice. *Der Schatz der Armen.* Aus dem Franz. übersetzt von Friedrich von Oppeln-Bronikowski. Illustrationen von Melchior Lechter. Florenz; Leipzig 1898.

Die Maler am Bauhaus. Cat. München, Haus der Kunst, 1950.

Marcadé, Jean-Claude. *Le futurisme russe.* Paris 1989.

Marcadé, Valentine. *Le renouveau de l'art pictural Russe.* Lausanne 1971.

Modern Artists on Art: 10 Unabridged Essays. Ed.: Robert L. Herbert. Englewood Cliffs 1964.

Moeller, Magdalena M. *Der ›Blaue Reiter‹.* Köln 1987.

München um 1900. Ed.: M. Gasser. Bern; Stuttgart 1977.

Myers, Bernard S. *Malerei des Expressionismus.* Köln 1957.

Nakov, Andrei. *Abstrait / Concret, art non objectif.* Paris 1981.

New Perspectives on Kandinsky. Symposium, Malmö, 1990.

Nishida, Hideho. *Kandinsky.* Tokyo 1993.

On the Spiritual in Art: Abstract Painting 1890–1985. Cat. Los Angeles, County Museum of Art, 1986; Chicago, Museum of Contemporary Art, 1987; Den Haag, Gemeentemuseum, 1987.

Overy, Paul. *Kandinsky: The Language of the Eye.* New York; Washington 1969. London 1969. (Dt.: *Kandinsky: Die Sprache des Auges.* Köln 1970).

Palme, Carl. *Konstens Karyatider.* Halmsted 1950.

Paris – Paris 1937–1957. Cat. Paris, Musée national d'art moderne, Centre Georges Pompidou, 1981.

Pevitts, Robert Richard. *Wassily Kandinsky's ›The Yellow Sound‹: A Synthesis of the Arts for the Stage.* Carbondale, Southern Illinois Univ., Ph. D. Diss., 1980.

Pisarev, D. *Sočinenija v četyrech tomach.* Moskva 1955. 1956.

Plaut, Paul. *Die Psychologie der produktiven Persönlichkeit.* Stuttgart 1929.

Pobedonoscev, K. P. *Istoričeskie izsledovanija i stat'i.* St. Petersburg 1876.

Poling, Clark V. *Kandinsky-Unterricht am Bauhaus: Farbenseminar und analytisches Zeichnen, dargestellt am Beispiel der Sammlung des Bauhaus-Archivs Berlin.* Weingarten 1982. (Engl.: *Kandinsky's Teaching at the Bauhaus: Color Theory and Analytical Drawing.* New York 1986).

Priebe, Evelin. *Angst und Abstraktion: Die Funktion der Kunst in der Kunsttheorie Kandinskys.* Frankfurt am Main 1986 (Europäische Hochschulschriften: Reihe 28. 53). – Tübingen, Diss., 1984.

Read, Herbert. *Wassily Kandinsky 1866–1944.* London; Berlin 1959.

Riedl, Peter Anselm. [Introd.:] *Wassily Kandinsky: Kleine Welten.* Stuttgart 1962 (Werkmonographien zur Bildenden Kunst 78).

Riedl, Peter Anselm. *Wassily Kandinsky.* Milano 1964 (I maestri del colore; 43).

Riedl, Peter Anselm. *Wassily Kandinsky in Selbstzeugnissen und Bilddokumenten.* Reinbek bei Hamburg 1983 (Rowohlts Bildmonographien 313).

Rigby, Andrew. *Initiation and Initiative: An Exploration of the Life and Ideas of Dimitrij Mitrinović.* Boulder 1984.

Ringbom, Sixten. *The Sounding Cosmos: A Study in the Spiritualism of Kandinsky and the Genesis of Abstract Painting.* Åbo 1970 (Acta Academia Aboensis: Ser. A. 38,2).

Roditi, Edouard. *Dialogues on Art.* London 1960. (Dt.: *Dialoge über Kunst.* Wiesbaden 1960. Frankfurt am Main 1973).

Roethel, Hans Konrad. [Introd.:] *Kandinsky: The Road to Abstraction.* London 1961.

Roethel, Hans Konrad. *Kandinsky and his Friends.* Cat. London 1968.

Roethel, Hans Konrad. *Kandinsky: Das graphische Werk.* Köln 1970.

Roethel, Hans Konrad. *Der Blaue Reiter.* München 1970.

Roethel, Hans Konrad. *The ›Blue Rider‹.* New York 1971.

Roethel, Hans Konrad; Benjamin, Jean K. *Kandinsky.* Paris 1977. (Engl.: Oxford; New York 1979. Dt.: München; Zürich 1982).

Roskill, Mark. *Klee, Kandinsky, and the Thought of Their Time: A Critical Perspective.* Urbana; Chicago, Ill., 1992.

Rovinskij, D. *Russkie narodnye kartinki.* 5 vols. St. Petersburg 1881.

Rudenstine, Angelica Zander. *The Guggenheim Museum Collection: Paintings 1880–1945.* New York 1976.

Rüden, Egon von. *Van de Velde, Kandinsky, Hölzel: Typologische Studien zur Entstehung der ungegenständlichen Malerei.* Ratingen; Wuppertal; Kastellaun 1971.

Le Salon de réception conçu en 1922 par Kandinsky. [Reconstruction of Kandinsky's murals at the Juryfreie Kunstausstellung 1922.] Paris, Musée national d'art moderne, Centre Georges Pompidou, 1977.

Schönberg, Arnold. *Harmonielehre.* Wien 1911.

Schreyer, Lothar. *Erinnerungen an Sturm und Bauhaus.* München 1956.

Selz, Peter. *German Expressionist Painting.* Berkeley; Los Angeles 1957.

Seuphor, Michel. *L'art abstrait: Ses origines, ses premiers maîtres.* Paris 1949. (Engl.: *Abstract Painting.* New York 1964. Dt.: *Ein halbes Jahrhundert abstrakte Malerei: Abstract Art von Kandinsky bis zur Gegenwart.* München; Zürich 1962).

Sihare, Laxmi Prasad. *Oriental Influences on Wassily Kandinsky and Piet Mondrian, 1909–1917.* New York, Ph. D. Diss., 1967.

Sinn, Anneliese. *Kandinsky's Theory of Inner Necessity.* Chicago, Ph. D. Diss., 1966.

Solowjow, W. S. *Sobranie sočinenij Vl. Serg. Solov'eva. t. 1–10.* St. Petersburg, t. 1: 1911; t. 3–7: 1911–1913; t. 9: 1914.

Solowjow, W. S. *Kurze Erzählung vom Antichrist.* Bonn 1946.

Solowjow, W. S. *Übermensch und Antichrist und das Ende der Weltgeschichte.* Ed.: L. Müller. Freiburg 1958.

Sounds. Ed.: Elizabeth R. Napier. New Haven; London 1981.

Space and Dream. [Introd.:] Robert Goldwater. New York 1967. – New York, Knoedler and Co., 1967.

The Spiritual in Art: Abstract Painting 1890–1985. Cat. Los Angeles, County Museum of Art. New York 1986.

Stelzer, O. *Die Vorgeschichte der abstrakten Kunst: Denkmodelle und Vor-Bilder.* München 1964.

Strakosch, Alexander von. *Lebenswege mit Rudolf Steiner.* Strassburg/Zürich 1947.

Strakosch-Giesler, Maria. *Vom Frühwerk des Malers Wassily Kandinsky.* [Manuscript] 1945. [Publ. partly in: *Wir entdecken Kandinsky.* Ed.: Hugo Debrunner. Zürich 1946.]

Der Sturm: Ein Erinnerungsbuch an Herwarth Walden und die Künstler aus dem Sturmkreis. Ed.: Nell Walden; Lothar Schreyer. Baden-Baden 1954.

Thiemann, Eugen. *Wassily Kandinsky.* Dortmund 1963.

Thürlemann, Felix. *Kandinsky über Kandinsky: Der Künstler als Interpret eigener Werke.* Bern 1986 (Schriftenreihe der Stiftung von Schnyder von Wartensee 54).

Tower, Beeke Sell. *Klee and Kandinsky in Munich and the Bauhaus.* Ann Arbor, Mich., 1981.

Trost, Detlef. *Wassily Kandinsky: Seine Bühnenkomposition ›Der gelbe Klang‹.* [Unpubl. paper.] München 1969/70.

Tschižewskij, Dmitrij. *Russland zwischen Ost und West: Russische Geistesgeschichte II: 18.–20. Jahrhundert.* Reinbek bei Hamburg 1961.

Umanskij, Konstantin. *Neue Kunst in Russland: 1914–1919.* Potsdam; München 1920.

Vallier, Dora. *L'Art abstrait.* Paris 1967. 1980.

Vasily Kandinsky, 1866–1944: A Retrospective Exhibition. Cat. New York, Solomon R. Guggenheim Foundation, 1963.

Vasily Kandinsky: Painting on Glass (Hinterglasmalerei). Anniversary Exhibition. [Introd.:] Hans Konrad Roethel. Cat. New York, The Solomon R. Guggenheim Museum, 1966.

Vassily Kandinsky. [Contrib.:] Jean-Paul Bouillon; Pierre Vaisse; Felix Thürlemann; Karl Flinker; Annie Perez. Cat. Paris, Musée national d'art moderne, Centre Georges Pompidou, 1984 (Collection Les Grandes Expositions 5).

Vergo, Peter. *The ›Blue Rider‹.* New York 1977.

Vergo, Peter. *Kandinsky Cossacks.* London 1986.

Vezin, Annette. *Kandinsky et le Cavalier bleu.* Paris 1991.

Vogt, Paul. *Geschichte der deutschen Malerei im 20. Jahrhundert.* Köln 1976.

Vogt, Paul. *Der ›Blaue Reiter‹.* Köln 1977.

Vogt, Paul. *Expressionismus: Deutsche Malerei zwischen 1905 und 1970.* Köln 1978.

Volboudt, Pierre. *Kandinsky: 1896–1921. Kandinsky: 1922–1944.* Paris 1963. (Dt.: Gütersloh 1963).

Volboudt, Pierre. *Les dessins de Kandinsky.* Paris 1963. (Dt.: *Die Zeichnungen Wassily Kandinskys.* Köln 1974).

Volpi Orlandini, Marisa. *Kandinsky: Dall'Art Nouveau alla psicologia della forma.* Roma 1968.

Volpi Orlandini, Marisa. *Kandinsky e il ›Blaue Reiter‹.* Milano 1967.

Washton, Rose-Carol. *Vasily Kandinsky, 1909–1913: Painting and Theory.* New Haven, Yale Univ., Ph. D. Diss., 1968.

Washton Long, Rose-Carol. *Kandinsky: The Development of an Abstract Style.* Oxford; New York 1980.

Wassili Kandinski: 43 opere dai musei sovietici. Ed.: Claudia Terenzi. Cat. Roma, Musei Capitolini, 1980/81; Venezia, Museo Correr, 1981.

Wassily Kandinsky. Ed.: André de Ridder. Antwerpen 1933.

Wassily Kandinsky. Ed.: Max Bill. [Contrib.:] Jean Arp; Charles Estienne; Carola Giedion-Welcker; Will Grohmann; Ludwig Grote; Nina Kandinsky; Alberto Magnelli. Boston; Paris 1951.

Wassily Kandinsky 1866–1944. Ed.: Giorgio di San Lazzaro. In: *XXe Siècle* 40 (1966) 27. Special issue ›Centenaire de Kandinsky‹. (Engl.: New York 1975).

Wassily Kandinsky: Die erste sowjetische Retrospektive. Gemälde, Zeichnungen und Graphik aus sowjetischen und westlichen Museen. Cat. Frankfurt am Main, Schirn Kunsthalle, 1989.

Wassily Kandinsky: Gegenklänge. Aquarelle und Zeichnungen. Cat. Köln 1960.

Wassily Kandinsky: Zehn Farblichtdrucke nach Aquarellen und Gouachen. Ed.: Max Bill. Basel 1949.

Wassily Kandinsky, Franz Marc: Briefwechsel. Mit Briefen von und an Gabriele Münter und Maria Marc. Ed.: Klaus Lankheit. München; Zürich 1983.

Weiss, Peg. *Kandinsky and the Munich Academy.* College Art Assoc. of America, Annual Meeting, Detroit, Mich., January 1974.

Weiss, Peg. *Kandinsky in Munich: The Formative Jugendstil Years.* Princeton, N.J., 1979.

Werefkin, Marianne. *Briefe an einen Unbekannten 1901–1905.* Ed.: Clemens Weiler. Köln 1960.

West, James. *Russian Symbolism: A Study of Vyacheslav Ivanov and the Russian Symbolist Aesthetic.* London 1970.

Whitford, Frank. *Kandinsky.* London 1967.

Windecker, Sabine. *Gabriele Münter, eine Künstlerin aus dem Kreis des ›Blauen Reiters‹.* Berlin 1991. – Kiel, Diss., 1990.

Wingler, Hans Maria. *Das Bauhaus 1919–1933: Weimar, Dessau, Berlin.* Bramsche; Köln 1962. 2. corr. ed. 1968. 3. ed. *Das Bauhaus […] Berlin und die Nachfolge in Chicago seit 1937.* Köln 1975. (Engl.: *The Bauhaus.* Cambridge, Mass.; London 1969).

Wingler, Hans Maria. *Der Blaue Reiter: Zeichnungen und Graphik.* Feldafing 1954.

Wir entdecken Kandinsky. Ed.: Hugo Debrunner et al. Zürich 1946.

Karl Wolfskehl (1869–1969): Leben und Werk in Dokumenten. Darmstadt 1969.

Worringer, Wilhelm. *Abstraktion und Einfühlung: Ein Beitrag zur Stilpsychologie.* Neuwied 1907. München 1981. (Engl.: *Abstraction and Empathy.* Cleveland 1967; Fr.: *Abstraction et Einfühlung: contribution à la psychologie du style.* Paris 1978).

Zehder, Hugo. *Wassily Kandinsky.* Dresden 1920 (Künstler der Gegenwart 1).

Die Zeichnungen Wassily Kandinskys. Ed.: Pierre Volboudt. Köln 1974.

Zen'kovskij, V. V. *Aus der Geschichte der ästhetischen Ideen in Rußland im 19. und 20. Jahrhundert.* s'-Gravenhage 1958.

ARTICLES

Albers, Josef. »La pensée + le sentiment«. In: *XXe Siècle* 40 (1966) 27. Special issue ›Centenaire de Kandinsky‹, p. 99.

Anders, Ursula. »Im Zeichen des Geistes: Wassily Kandinsky zum hundertsten Geburtstag«. In: *Gegenwart* 28 (1966) 8/9, pp. 337–343.

Andersen, Troels. »Some Unpublished Letters by Kandinsky«. In: *Artes* 2 (1966) October, pp. 90–110.

Argan, Giulio Carlo. »La libération du mythe«. In: *XXe Siècle* 40 (1966) 27. Special issue ›Centenaire de Kandinsky‹, pp. 96–97.

Arp, Jean. »Dompteur des étoiles. [Poem.] In: *XXe Siècle* 40 (1966) 27. Special issue ›Centenaire de Kandinsky‹, p. 91.

Arvatov, Boris. »Izobrazitel'noe iskusstvo No. 1«. In: *Pečat'i revolucija* (1921) 2, pp. 215–217. (Dt. in: *Zwischen Revolutionskunst und sozialistischem Realismus*. Ed.: H. Gassner; E. Gillen. Köln 1979, pp. 58 ff.).

Ashmore, Jerome. »Sound in Kandinsky's Painting«. In: *Journal of Aesthetics and Art Criticism* 35 (1977) 3, pp. 329–336.

Ashton, Dore. »La grande rétrospective de Kandinsky«. In: *XXe Siècle* (1963) 21, pp. 116–123.

Avtonomova, Natalia B. »Die Briefe Wassily Kandinskys an Dmitrij Kardovskij«. In: *Wassily Kandinsky: Die erste sowjetische Retrospektive. Gemälde, Zeichnungen und Graphik aus sowjetischen und westlichen Museen*. Cat. Frankfurt am Main, Schirn Kunsthalle, 1989, pp. 47–54.

Avtonomova, Natalia B. »Kandinsky in sowjetischen Sammlungen«. In: *Wassily Kandinsky: Die erste sowjetische Retrospektive. Gemälde, Zeichnungen und Graphik aus sowjetischen und westlichen Museen*. Cat. Frankfurt am Main, Schirn Kunsthalle, 1989, pp. 32–34.

Avtonomova, Natalia B. »Očiščenie«. In: *Sovetskaja kul'tura*. 11.05.1989.

Bachrach, Susan P. »A Comparison of the Early Landscapes of Münter and Kandinsky, 1902–1910«. In: *Woman's Art Journal*, [n. d.].

Baker, Rob. »Hearing the Sound of Color: ›Der gelbe Klang‹ by V. Kandinsky«. In: *Parabola* 7 (1982) 2, May.

Ball, Hugo. »Brief an Wassily Kandinsky«. Ed.: Richard W. Sheppard. In: *Hugo-Ball-Almanach* (1978), pp. 66–70.

Ball, Hugo. »Das Münchner Künstlertheater«. In: *Phoebus* (1914) May, pp. 68–74.

Barnett, Vivian Endicott. »Kandinsky: From Drawing and Watercolor to Oil«. In: *Drawing* 3 (1981) 2, pp. 30–34.

Barnett, Vivian Endicott. »Kandinsky Watercolors«. In: *Kandinsky Watercolors: A Selection from The Solomon R. Guggenheim Museum and The Hilla Rebay Foundation*. Cat. New York, The Solomon R. Guggenheim Museum, 1981, pp. 8–18.

Barnett, Vivian Endicott. »Kandinsky and Science: The Introduction of Biological Images in the Paris Period«. In: *Kandinsky in Paris: 1934–1944*. Cat. New York, The Solomon R. Guggenheim Museum, 1985, pp. 61–87.

Barnett, Vivian Endicott. »Kandinsky in den großen Sammlungen des Westens«. In: *Wassily Kandinsky: Die erste sowjetische Retrospektive. Gemälde, Zeichnungen und Graphik aus sowjetischen und westlichen Museen*. Cat. Frankfurt am Main, Schirn Kunsthalle, 1989, pp. 55–58.

Barnett, Vivian Endicott; Barnett, Peter H. »The Originality of Kandinsky's Compositions«. In: *The Visual Computer* 5 (1989) 4, pp. 203–213.

Barnett, Vivian Endicott. »Fairy Tales and Abstraction: Stylistic Conflicts in Kandinsky's Art 1915–1921«. In: *New Perspectives on Kandinsky*. Symposium, Malmö 1990, pp. 99–109.

Batrakova, S. P. »Romantičeskaja utopija u istokov abstraktnogo iskusstva«. In: S. P. Batrakova. *Iskusstvo i utopija. Iz istorii zapadnoj živopisi i architektury*. Moskva 1990, pp. 118–145.

Bauer, Hermann. »Kandinsky: Ein Russe in Bayern«. In: *Pan* (1985) 8, pp. 6–25.

Baumer, Franz. »Wassily Kandinsky: Der Weg zur Abstraktion. Aus der Geschichte des blauen Reiter«. In: *Alfa* 1 (1962) 5/6, pp. 36–40.

Belli, Carlo. »Kandinsky«. In: *Kn 13* (1935) pp. 99–115.

Benjamin, Jean K.; Roethel, Hans Konrad. »A New Light on Kandinsky's First Abstract Painting«. In: *The Burlington Magazine* 119 (1977) 896, p. 772.

Beutler, Christian. »Zwölf Briefe von Wassily Kandinsky an Hans Thiemann 1933–1939«. In: *Wallraf-Richartz-Jahrbuch: Westdeutsches Jahrbuch für Kunstgeschichte* 38 (1976), pp. 155–166.

Bjerre, Poul. »Den abstrakta konstens pionjär«. In: Bjerre, Poul. *Gestalter och Gärningar, Elva personliga porträtt*. Stockholm 1958, pp. 125–138.

Boissel, Jessica. »Solche Dinge haben eigene Geschicke: Wassily Kandinsky und das Experiment ›Theater‹«. In: *Der Blaue Reiter*. Ed.: Hans Christoph von Tavel. Cat. Bern, Kunstmuseum, 1986, pp. 240–251.

Boulez, Pierre. »Parallèles«. In: *XXe Siècle* 40 (1966) 27. Special issue ›Centenaire de Kandinsky‹, p. 98.

Bowlt, John E. »Wassily Kandinsky: Verbindungen zu Russland«. In: *Wassily Kandinsky: Die erste sowjetische Retrospektive. Gemälde, Zeichnungen und Graphik aus sowjetischen und westlichen Museen*. Cat. Frankfurt am Main, Schirn Kunsthalle, 1989, pp. 59–78.

Breton, André; Eluard, Paul. »Enquête«. In: *Minotaure* (1933) 3/4, Decembre, pp. 101–116. Reply by Kandinsky, p. 110.

Breton, André. »Genèse et perspective artistique du surréalisme«. In: *Labyrinthe* (1945) 5, pp. 10–11, 49–50.

Brion, Marcel. »Le tournant spirituel«. In: *I 4 soli* 2 (1955) 6, pp. 4–11.

Bucarelli, Palma. »Kandinskij«. In: *Accademia* 36 (1958) 5.

Bucarelli, Palma. »Une nouvelle poétique«. In: *XXe Siècle* 40 (1966) 27. Special issue ›Centenaire de Kandinsky‹, p. 97.

Bucarelli, Palma. »Presenza di Kandinskij«. In: *Galleria Nazionale d'Arte Moderna*. Cat. Roma, 1958.

Cassou, Jean. »Kandinsky et la vie spirituelle«. In: *XXe Siècle* 40 (1966) 27. Special issue ›Centenaire de Kandinsky‹, pp. 53–54.

Cassou, Jean. »Wassily Kandinsky – Der Mensch und das Werk«. In: *Wassily Kandinsky: Gegenklänge. Aquarelle und Zeichnungen*. Cat. Köln, 1960, pp. 13–23.

Černyševskij, N. G. »Estetičeskie otnošenija iskusstva k dejstvitel'nosti«. In: *Soč. N. Černyševskogo. Pervoe poln. izd. t. 1*. Vervey, 1868.

Chan-Magomedov, S. O. »V. V. Kandinskij o vosprijatii i vozdejstvii sredstv chudožestvennoj vyrazitel'nosti«. In: *Trudy VNIITE*. Serija ›Techničeskaja estetika‹. Moskva 1978, vyp. 17, pp. 77–95.

Chan-Magomedov, S. O. »V. V. Kandinskij v sekcii monumental'nogo iskusstva INCHUKA (1920)«. In: *V. V. Kandinskij 1866–1944: Živopis', grafika, prikladnoe iskusstvo*. Cat. Leningrad 1989, p. 53 ff.

Chastel, André. »Kandinsky ou le Vœu intérieur, 1921–1927«. In: *Derrière le Miroir*. 1960.

Chevalier, Denys. »Wassily Kandinsky ou la conquête de la paix intérieure«. In: *Aujourd'hui* 41 (1963) 7, pp. 4–9.

Courthion, Pierre. »Kandinsky et la Peinture abstraite«. In: *Le Centaure* (1930) 9, 10.

Craig, Edward Gordon. »The Actor and the Übermarionette«. In: *On the Art of the Theatre*. London 1911 (New ed. 1968).

Craig, Edward Gordon. »Etwas über den Regisseur und die Bühnenausstattung«. In: *Deutsche Kunst und Denkmalpflege* 16 (1905) April – September, pp. 595–605.

Damus, Martin. »Ideologiekritische Anmerkungen zur abstrakten Kunst und ihrer Interpretation – Beispiel Kandinsky«. In: *Das Kunstwerk zwischen Wissenschaft und Weltanschauung*. Ed.: M. Warnke. Gütersloh 1970, pp. 48–73.

Derouet, Christian. »Kandinsky, ›Triumvir‹ de l'exposition du Jeu de Paume en 1937«. In: *Paris – Paris 1937–1957*. Cat. Paris, Musée national d'art moderne, Centre Georges Pompidou, 1981, pp. 64–67.

Derouet, Christian. »Vassily Kandinsky: Notes et documents sur les dernières années du peintre«. In: *Cahiers du Musée National d'Art Moderne* (1982) 9, pp. 84–107.

Derouet, Christian. »Kandinsky in Paris: 1934–1944«. In: *Kandinsky in Paris: 1934–1944*. Cat. New York, The Solomon R. Guggenheim Museum, 1985, pp. 12–60.

Derouet, Christian. »On the Importance of the Small Oil Sketches of Kandinsky«. In: *Wassily Kandinsky (1866–1944)*. Cat. Tokyo, The National Museum of Modern Art, 1987, pp. 20–24.

Deutsch, Max. »La recontre avec Schoenberg«. In: *XXe Siècle* 40 (1966) 27. Special issue ›Centenaire de Kandinsky‹, pp. 29–30.

Dmitriev, M. »Chudožnik mirozdanija: O tvorčestve V. V. Kandinskogo«. In: *Naše nasledie* (1990) 3, pp. 120–133.

Dorazio, Piero. »Le créateur du XXe siècle«. In: *XXe Siècle* 40 (1966) 27. Special issue ›Centenaire de Kandinsky‹, p. 103.

Dorival, Bernard. »Jeunesse de Kandinsky«. In: *XXe Siècle* 40 (1966) 27. Special issue ›Centenaire de Kandinsky‹, pp. 5–6.

Droste, Magdalena. »Klee und Kandinsky«. In:*Klee und Kandinsky: Erinnerungen an eine Künstlerfreundschaft anläßlich Klees 100. Geburtstag.* Cat. Stuttgart 1979, pp. 9–22.

Droste, Magdalena. »›. . . oh, du liebe kunstpolitik‹: Kandinskys Ausstellungen und seine Verkäufe während der zwanziger Jahre in Deutschland«. In: *Kandinsky: Russische Zeit und Bauhausjahre 1915–1933*. Cat. Berlin, Bauhaus Archiv, Museum für Gestaltung, 1984, pp. 66–71.

Dube, Wolf-Dieter. »Zur ›Träumerischen Improvisation‹ von Kandinsky«. In: *Pantheon* 27 (1969) 6, pp. 486–488.

Dubenskaja, L. »Svetlo-zelenyj, belyj, krasnyj, černyj (o živopisi V. V. Kandinskogo)«. In: *Teatr* (1992) 1, pp. 94–100.

Dupin, Jacques. »L'univers plastique de Kandinsky«. In: *XXe Siècle* 40 (1966) 27. Special issue ›Centenaire de Kandinsky‹, pp. 67–71.

Eitner, Lorenz. »Kandinsky in Munich«. In: *The Burlington Magazine* 99 (1957) 651, pp. 193–199.

Elderfield, John. »Geometric Abstract Painting and Paris in the Thirties. Part 2«. In: *Artforum* 8 (1970) June, pp. 70–75.

Estienne, Charles. »Kandinsky ou la liberté de l'Esprit«. In: *Les Arts plastiques* (1952) 4.

Estienne, Charles. »Situation de Kandinsky«. In: *Art d'aujourd'hui* (1949) Octobre.

Estienne, Charles. »Le voyageur«. In: *XXe Siècle* 40 (1966) 27. Special issue ›Centenaire de Kandinsky‹, pp. 75–77.

Ettlinger, Leopold D. »Kandinsky«. In: *L'Oeil* (1964) 114, pp. 10–17, 50.

Ettlinger, Leopold D. »Kandinsky's ›At Rest‹«. In: *Charlton Lectures on Art at King's College*. London 1961, pp. 3–21.

Evans, E. P. »Artists and Art Life in Munich«. In: *The Cosmopolitan* 9 (1890) May, pp. 3–14.

Evans, Myfanwy. »Kandinsky's Vision«. In: *Axis* (1935) 2, p. 7.

Feininger, Julia; Feininger, Lyonel. »Wassily Kandinsky«. In: *Magazine of Art* 38 (1945) 5, pp. 174–175.

Fineberg, Jonathan D. »Kandinsky: Through the Scholar's Glass«. In: *Art in America* 70 (1982) December. Special issue ›Expressionism‹, pp. 11–13, 153–155.

Fineberg, Jonathan D. »Kandinsky's Relation with ›Les Tendances Nouvelles‹ and Its Effect on his Art Theory«. In: *Les Tendances Nouvelles*. Vol. 1, reprinted New York 1980, pp. XVIII-XXVIII.

Fineberg, Jonathan D. »›Les Tendances Nouvelles‹, The ›Union Internationale des Beaux-Arts, des Lettres, des Sciences et de l'Industrie‹ and Kandinsky«. In: *Art History* 2 (1977), pp. 221–246.

Fingesten, Peter. »Spirituality, Mysticism and Non-objective Art«. In: *The Art Journal* 21 (1961) 1, pp. 2–6.

Flemming, Hanns Th. »Kandinsky's Entwicklungsstufen«. In: *Die Kunst und das Schöne Heim* 54 (1956) 4, pp. 128–131.

Floch, Jean-Marie. »Kandinsky: sémiotique d'un discours plastique non figuratif«. In: *Communications* 34 (1981), pp. 135–157.

Freudenberg, Franz. »Über Spaltung der Persönlichkeit und verwandte psychische Fragen«. In: *Die übersinnliche Welt: Monatsschrift für okkultistische Forschung* 16 (1908), pp. 18–22, 51–67, 101–111.

Fuchs, Georg. »Das Münchener Künstler-Theater«. In: *Dekorative Kunst* 14 (1910) 3, pp. 138–142.

»Für Kandinsky«. In: *Der Sturm* 3 (1913) 150/51, pp. 277–279; 152/53, p. 288; 4 (1913) 154/55, pp. 3, 5–6.

Gage, John. »The Psychological Background to Early Modern Colour: Kandinsky, Delaunay and Mondrian«. In: *Towards a New Art: Essays on the Background to Abstract Art 1910–20*. London 1980, pp. 22–40.

Garte, E. J. »Kandinsky's Ideas on Changes in Modern Physics and their Implications for his Development«. In: *Gazette des Beaux-Arts* (1987) Octobre, pp. 137–144.

Gartman, F. (= Hartmann, Thomas von). »Kandinsky: Über das Geistige in der Kunst«, München 1912 [Review]. In: *Muzyka* (1912) 64, p. 207.

Gaudnek, Walter. »The Religious Archetype in Ontomorphic and Polymorphic Art«. In: *Union Seminary Quarterly Review* 25 (1970) 3, pp. 311–326.

Gennadiev, V. »›Želtoe zvučanie‹ V. Kandiskogo«. In: *Sovetskaja muzyka* (1982) 11, p. 127.

Gérôme-Maesse. »Kandinsky, La Gravure sur bois, l'Illustration«. In: *Les Tendances Nouvelles* 3 (1906) 26, pp. 436–438. (Reprint in: Roethel, Konrad: *Kandinsky. Das graphische Werk*. Köln 1970, pp. 427–428).

Gérôme-Maesse. »Le Musée du Peuple«. In: *Les Tendances Nouvelles* (1907) 30, pp. 560–561.

Giedion-Welcker, Carola. »Ansprache [. . .] zur Eröffnung der Ausstellung ›Wassily Kandinsky, Aquarelle und Gouachen‹ im Kunstmuseum am Mittwoch, den 26. Mai 1971«. In: *Berner Kunstmitteilungen* (1971) 126/127, pp. 2–6.

Giedion-Welcker, Carola. »L'élan vers le monumental«. In: *XXe Siècle* 40 (1966) 27. Special issue ›Centenaire de Kandinsky‹, pp. 41–44.

Giedion-Welcker, Carola. »Kandinsky als Theoretiker: 1951«. In: *Schriften 1926–1971: Stationen zu einem Zeitbild*. Köln 1973, pp. 310–318.

Giedion-Welcker, Carola. »Kandinskys Malerei als Ausdruck eines geistigen Universalismus«. In: *Das Werk* 37 (1950) 4, pp. 117–123.

Giedion-Welcker, Carola. »La peinture de Kandinsky: Expression de l'universalité spirituelle«. In: *L'Art d'aujourd'hui* (1950) 6.

Giedion-Welcker, Carola. »Wassily Kandinsky und die Synthese der Künste«. In: *Universitas* 22 (1967) 12, pp. 1253–1258.

Giedion-Welcker, Carola. »Wassily Kandinsky und seine universelle Kunst«. In: *Universitas* 28 (1973) 4, pp. 355–362.

Gindertael, R. V. »Quelques documents pour aider à mieux comprendre ›Le passage de la ligne‹«. In: *L'Art d'aujourd'hui* 3 (1952) 5, pp. 18–19.

Gollek, Rosel. »Der Blaue Reiter und die Neue Künstlervereinigung München«. In: *Der Blaue Reiter im Lenbachhaus München*. Cat., ed. by Rosel Gollek. München 1982, pp. 9–11.

Gollek, Rosel. »Murnau im Voralpenland«. In: Wietek, Gerhard. *Deutsche Künstlerkolonien und Künstlerorte*. München 1976, pp. 178–187.

Grabska, Elzbieta. »Wczesny obraz Kandinsky'ego w Muzeum Slaskim«. In: *Roczniki sztuki slaskiej* 7 (1970), pp. 152–157; Résumé: »Un tableau de Kandinsky au Musée de la Silésie«, p. 158.

Greenberg, Clement. »Kandinsky«. In: *Art and Culture*. Boston 1961, pp. 11–114.

Grohmann, Will. »Ansprache [. . .] am 10. September 1963 anläßlich der Eröffnung der Ausstellung Wassily Kandinsky in der Kunsthalle Basel«. In: *Basler Kunstverein. Jahresbericht* (1963), pp. 17–30.

Grohmann, Will. »Art into Architecture: The Bauhaus Ethos«. In: *Apollo* (1962) 76, pp. 37–41.

Grohmann, Will. »Catalogue des oeuvres graphiques«. In: *Sélection* (1933) 14, pp. 28–32.

Grohmann, Will. »Le Cavalier Bleu«. In: *L'Œil* (1955) 9, pp. 4–13.

Grohmann, Will. »Festvortrag zum 100. Geburtstag von Wassily Kandinsky«. In: Hanfstaengl, Erika: *Wassily Kandinsky, Zeichnungen und Aquarelle*. Cat. Sammlung in der Städtischen Galerie im Lenbachhaus München. München 1974, pp. 3–11.

Grohmann, Will. »La grande Retrospettiva di Kandinsky alla XXV Biennale«. In: *La Biennale* (1951) 3.

Grohmann, Will. »La grande unité d'une grande œuvre«. In: *XXe Siècle* 40 (1966) 27. Special issue ›Centenaire de Kandinsky‹, pp. 7–16.

Grohmann, Will. »Kandinsky et Klee retrouvent l'Orient«. In: *XXe Siècle* 35 (1961) 23, pp. 49–56.

Grohmann, Will. »Wassily Kandinsky«. In: *Cahiers d'Art* 4 (1929) 7, pp. 322–329.

Grohmann, Will. »Wassily Kandinsky«. In: *Der Cicerone* 16 (1924) 19, pp. 887–898.

Grote, Ludwig. »Bühnenkompositionen von Kandinsky«: In: *i10 Internationale Revue* 2 (1928) 13, pp. 4–5.

Güse, Ernst-Gerhard. »Postkarten aus dem Künstlerkreis des ›Blauen Reiter‹«. In: *Expressionistische Grüße: Künstlerpostkarten der ›Brücke‹ und des ›Blauen Reiter‹.* Ed.: Magdalena M. Moeller. Cat. Berlin, Brücke Museum, 1991; München, Städtische Galerie im Lenbachhaus, 1991; Saarbrücken, Saarland Museum, 1991, pp. 21–31.

Haftmann, Werner. »Kandinsky (1927–1933)«. In: *Derrière le miroir* (1965) 154, pp. 1–18.

Hahl, Jelena. »Abstraction et musique atonale: Kandinsky et Schönberg«. In: *L'Oeil* (1976) 250, pp. 24–27, 64.

Hahl, Jelena. »Neuere Beiträge zu Kandinsky und Münter« (Vivian Endicott Barnett: Wassily Kandinsky, Werkverzeichnis der Aquarelle, Bd. 1, 1900–1921. München 1992; Gisela Kleine: Gabriele Münter und Wassily Kandinsky. Frankfurt am Main 1990. Reviews). In: *Kunstchronik* 46 (1993) 1, pp. 31–39.

Hahl-Koch, Jelena. »Kandinsky und Kardovskij: Zum Porträt der Maria Krustschoff«. In: *Pantheon* 32 (1974) 4, pp. 382–390.

Hahl-Koch, Jelena. »Kandinskys erstes abstraktes Ölbild, 1989 wiedergefunden«. In: *Kunstchronik* 43 (1990) 3, pp. 95–103.

Hahl-Koch, Jelena. »Kandinsky's Role in the Russian Avant-Garde«. In: *The Avant-Garde in Russia, 1910–1930: New Perspectives.* Los Angeles 1980, pp. 84–91.

Hahl-Koch, Jelena. »Wassily Kandinsky: Die erste sowjetische Retrospektive. Gemälde, Zeichnungen und Grafik aus sowjetischen und westlichen Museen.« In: *Kunstchronik* 42 (1989) 8, pp. 408–422.

Harms, Ernest. »My Association with Kandinsky«. In: *American Artist* 27 (1963) 6, pp. 36–41, 90–91.

Hartmann, Georg. »Eine Inszenierung Kandinsky's«. In: *Der Querschnitt* 8 (1928) pp. 666–667.

Hausmann, Raoul. »Note sur le poème phonétique: Kandinsky et Ball«. In: *German Life & Letters.* N. S. 21 (1967) 1, pp. 58 ff.

Haxthausen, Charles Werner. »Klees künstlerisches Verhältnis zu Kandinsky während der Münchner Jahre«. In: *Paul Klee – Das Frühwerk 1883–1922.* Ed.: Armin Zweite. Cat. München, Städtische Galerie im Lenbachhaus, 1979, pp. 98–130.

Haxthausen, Charles Werner. »›Der Künstler ohne Gemeinschaft‹: Kandinsky und die deutsche Kunstkritik«. In: *Kandinsky: Russische Zeit und Bauhausjahre 1915–1933.* Cat. Berlin 1984, pp. 72–89.

Hayter, Stanley W. »The Language of Kandinsky‹. In: *Magazine of Art* 38 (1945) 5, pp. 176–179.

Heibel, Yule F. »›They Danced on Volcanos‹: Kandinsky's Breakthrough to Abstraction, the German Avant-Garde and the Eve of the First World War«. In: *Art History* 12 (1989) 3, pp. 342–361.

Heller, Reinhold. »Kandinsky and Apocalyptic Traditions‹. In: *Art Journal* 43 (1983) 1, pp. 19–26.

Henniger, Gerd. »Die Auflösung des Gegenständlichen und der Funktionswandel der malerischen Elemente im Werk Kandinskys 1908–1914«. In: *Edwin Redslob zum 70. Geburtstage, eine Festgabe.* Berlin 1955, pp. 347–355.

Henry, Michel. »La peinture abstraite et le Cosmos (Kandinsky)«. In: *Le Nouveau Commerce* 65 (1989), pp. 37–52.

Heron, Patrick. »London: The Riddle of Kandinsky's Influence as propounded by the Tate's Display of a Guggenheim Selection«. In: *Arts* 31 (1957) September, p. 12.

Hess, Walter. »Die große Abstraktion und die große Realistik: Zwei von Kandinsky definierte Möglichkeiten moderner Bildstruktur«. In: *Jahrbuch für Ästhetik und allgemeine Kunstwissenschaft* 54 (1960), pp. 7–32.

Hildebrandt, Hans. »Drei Briefe von Kandinsky«. In: *Das Werk* 42 (1955) 10, pp. 327–331.

Hofmann, Werner. »Kandinsky und Mondrian. ›Gekritzel‹ und ›Schema‹ als graphische Sprachmittel«. In: *1. Internationale der Zeichnung.* Darmstadt 1964, pp. 13–27.

Hofmann, Werner. »Studien zur Kunsttheorie des 20. Jahrhunderts«. In: *Zeitschrift für Kunstgeschichte* 19 (1956) Januar, pp. 136–150.

Holtzmann, Harry. »Liberating Kandinsky«. In: *Art News* 51 (1952) May.

»L'inchuk secondo il piano di Kandinsky«. In: *Rassegna sovietica* 16 (1965) 1, pp. 80–81.

Jaffé, Michael. »Een schilderij uit Kandinsky beginperiode«. In: *Bulletin Museum Boymans-van-Beuningen* 7 (1955) 1, pp. 2–5.

Jakovsky, Anatole. »Wassily Kandinsky«. In: *Axis* (1935) 2, pp. 9–12.

Jamabi, Paul. »Kandinsky«. In: *L'Arche* (1946), p. 15.

Jelavich, Peter. »München als Kulturzentrum: Politik und die Künste«. In: *Kandinsky und München: Begegnungen und Wandlungen 1896–1914.* Ed.: Armin Zweite. Cat. München, Städtische Galerie im Lenbachhaus, 1982, pp. 17–26. (Engl.: »Munich as a Cultural Center: Politics and the Arts«. In: *Kandinsky in Munich: 1896–1914.* Cat. New York, The Solomon R. Guggenheim Museum, 1982; San Francisco, Museum of Modern Art, 1982).

Johansson, Ejner. »Gabriele Münter i Danmark: Kandinskys hustru der sammen med ›Der Sturm‹-gruppen blev skoeldt ud i Kobenhavn«. In: *Berlinske Tidens Kronik,* 15. 2. 1965.

Judd, Donald. »Kandinsky in His Citadel«. In: *Arts* 37 (1963) 62, pp. 22–25.

Kandinsky, Nina; Grohmann, Will; Rannit, A. »Čiurlonis et Kandinsky«. In: *La Biennale di Venezia* 26 (1953) Februario.

Kandinsky, Nina. »Kandinsky, mio marito«. In: *La Biennale di Venezia* (1951) 3, pp. 8–10.

Kandinsky, Nina. »Kandinsky vivant«. In: *XXe Siècle* 40 (1966) 27. Special issue ›Centenaire de Kandinsky‹, pp. 83–88.

Kimball, Maulsby. »Kandinsky and Rudolf Steiner«. In: *Arts* 34 (1960) March, p. 7.

Kirby, John B. »Vasily Kandinsky 1866–1944: A retrospective exhibition«. In: *Worcester Art Museum News Bulletin and Calendar* 29 (1964) 6, pp. 2–3.

Kleine, Gisela. »Vasilij Sil'vestrovič Kandinskij – ein Maler?« In: *Kunstchronik* 43 (1990) 3, pp. 93–95.

Kojève, Alexandre. »Pourquoi concret«. In: *XXe Siècle* 40 (1966) 27. Special issue ›Centenaire de Kandinsky‹, pp. 63–65.

Kojève, Alexandre. »Deux lettres inédites d'Alexandre Kojève à Vassily Kandinsky (3. 2. 1929 und 20. 9. 1931)«. In: *Kandinsky: album de l'exposition 1er novembre 1984–28 janvier 1985.* Cat. Paris, Musée national d'art moderne, 1984, pp. 64–74.

Koročancev, V. »Poslednjaja pesnja Vasilija Kandinskogo«. In: Koročancev, V.: *Čtob rodiny veličie postič.* Moskva 1986, pp. 29–40.

Kramer, Hilton. »Towards an Art of Mysticism, the Life and Work of Kandinsky«. In: *Arts* 33 (1958) December, pp. 34–37.

Kroll, Jack. »Kandinsky, Last of the Heresiarchs«. In: *Art News* 62 (1963) 10.

Kropfinger, Klaus. »Schönberg und Kandinsky«. In: *Bericht über den 1. Kongreß der Internationalen Schönberg-Gesellschaft, Wien 1974.* Wien 1978, pp. 110 ff.

Kuchling, Heimo. »Das Frühwerk Kandinskys«. In: *Kontur* (1967) 34, pp. 1–11.

Kudrjašov, Ju. »Filosofija iskusstva Kandinskogo v svete estetiki nemeckogo romantizma«. In: *Problemy muzykal'nogo romantizma.* Leningrad, pp. 76–108.

Kühn, Rolf. »Ästhetik und absolute Subjektivität bei Kandinsky: Zur Phänomenologie abstrakter Kunst nach Michel Henry«. In: *Zeitschrift für Ästhetik und allgemeine Kunstwissenschaft* 34 (1989) 1, pp. 103–122.

Küppers, P. E. »Rußland: Eine Ausstellung russischer Kunst in Hannover«. In: *Der Ararat* 2 (1921) 4, pp. 135–139.

Kuhn, Herbert. »Kandinsky: 1. Für«. In: *Das Kunstblatt* 3 (1919) 6, p. 178 (T. 2 cf.: Wolfradt, Willi).

Kurtz, Stephen A. »In the Beginning Was Kandinsky«. In: *Art News* (1970), pp. 38–41, 62–63.

Kuspit, Donald B. »Utopian Protest in Early Abstract Art«. In: *Art Journal* 29 (1970) 4, pp. 430–437.

Kuspit, Donald B. »The Illusion of the Absolute in Abstract Art«. In: *Art Journal* 31 (1971) 1, pp. 26–31.

Kuthy, Sandor. »Wassily Kandinsky im Kunstmuseum Bern«. In: *Berner Kunstmitteilungen* (1971) 126/127, pp. 6–17.

Langner, Johannes. »Gegensätze und Widersprüche – das ist unsere Harmonie: Zu Kandinskys expressionistischer Abstraktion«. In: *Kandinsky und München: Begegnungen und Wandlungen 1896–1914*. Ed.: Armin Zweite. Cat. München, Städtische Galerie im Lenbachhaus, 1982, pp. 106–132.

Langner, Johannes. »›Impression V‹: Observations sur un thème chez Kandinsky«. In: *Revue de l'Art* 45 (1979), pp. 53–65.

Langner, Johannes. »›Improvisation 13‹: Zur Funktion des Gegenstandes in Kandinskys Abstraktion«. In: *Jahrbuch der Staatlichen Kunstsammlungen in Baden-Württemberg* 14 (1977), pp. 115–146.

Langner, Julius. »Kandinsky at Pasadena«. In: *Arts* (1963) 62, May.

Lankheit, Klaus. »Die Frühromantik und die Grundlagen der ›gegenstandslosen‹ Malerei«. In: *Neue Heidelberger Jahrbücher* (1951), pp. 55–90.

Lankheit, Klaus. »Kandinsky et Franz Marc«. In: *XXe Siècle* 40 (1966) 27. Special issue ›Centenaire de Kandinsky‹, pp. 31–32.

Lankheit, Klaus. »Zur Geschichte des Blauen Reiters«. In: *Der Cicerone* (1949) 3, pp. 110–114.

Lassaigne, Jacques. »Kandinsky, le premier«. In: *XXe Siècle* (1974). Special issue ›Hommage à Kandinsky‹, p. 3.

Laude, Jean. »Naissances des abstractions«. In: *Cahiers du Musée National d'Art Moderne* (1985) 26.

Lee, Natalie. »Some Russian Sources of Kandinsky's Imagery«. In: *Transactions of the Association of Russian-American Scholars in USA* 15 (1982), pp. 185–226.

Leonhard, Rudolf. »Kandinsky«. In: *Der Sturm* 3 (1912) 134/135, pp. 204–205.

Leppien, Jean. »La leçon de Kandinsky«. In: *XXe Siècle* 40 (1966) 27. Special issue ›Centenaire de Kandinsky‹, p. 100.

Libermann, Alexander. »Kandinsky«. In: *Vogue* 126 (1955) Novembre, pp. 134–137, 172.

Lindsay, Kenneth C. »Gabriele Münter and Wassily Kandinsky: What they Meant to Each Other«. In: *Arts Magazine* (1981) December, pp. 56–62.

Lindsay, Kenneth C. »The Genesis and Meaning of the Cover Design for the First Blaue Reiter Exhibition Catalogue«. In: *The Art Bulletin* 35 (1953) 1, pp. 47–52.

Lindsay, Kenneth C. »Graphic Art in Kandinsky's Oeuvre«. In: *Prints* (1962), pp. 235–252.

Lindsay, Kenneth C. »Kandinsky in 1914 New York: Solving a riddle«. In: *Art News* 55 (1956) 3, pp. 32–33, 58–60.

Lindsay, Kenneth C. »Kandinsky in Russia«. In: *Vasily Kandinsky 1866–1944: A Retrospective Exhibition*. Cat. New York, The Solomon R. Guggenheim Foundation, 1962.

Lindsay, Kenneth C. »Kandinsky's method and contemporary criticism«. In: *Magazine of Art* 45 (1952) 8, pp. 355–361.

Lindsay, Kenneth C. »Les thèmes de l'inconscient«. In: *XXe Siècle* 40 (1966) 27. Special issue ›Centenaire de Kandinsky‹, pp. 46–52.

Lindsay, Kenneth C. »Will Grohmann: Kandinsky«. [Review.] In: *The Art Bulletin* 41 (1959) 4, pp. 348–350.

Lindsay, Kenneth C. »Will Russia unfreeze her first modern master?« In: *Art News* (1959) 58, September, pp. 28–31, 52.

Lipps, Theodor. »Aesthetische Einfühlung«. In: *Zeitschrift für Psychologie und Physiologie der Sinnesorgane* 22 (1900), pp. 415–450.

Ludwig, Horst. »Kandinsky und Klee bei Stuck«. In: *Franz von Stuck und seine Schüler*. Cat. München, Villa Stuck, 1986, pp. 26–66.

Lundholm, Helge. »Kandinsky: Analyse des Théories de ce Peintre«. In: *Flammen* (1917) 2.

McCullagh, Janice. »Disappearances; Appearances: The First Exhibition of the ›Blaue Reiter‹«. In: *Arts* (1987) 9, pp. 46–53.

Maeterlinck, Maurice. »Das moderne Drama«. In: *Die Insel* 2 (1900) Januar-März, pp. 48–60.

Magnelli. »Une foi profonde«. In: *XXe Siècle* 40 (1966) 27. Special issue ›Centenaire de Kandinsky‹, pp. 91–92.

Maltese, Corrado. »Kandinsky e il Concetto dell'Arte astratta«. In: *Arti figurative* 3 (1943).

Marc, Franz. »Kandinsky«. In: *Der Sturm* 4 (1913) 186/87, pp. 129–131.

Marchiori, Giuseppe. »Mondo di Kandinsky«. In: *Ulisse* 4 (1945) 12.

Marchiori, Giuseppe. »Kandinsky en Italie«. In: *XXe Siècle* 40 (1966) 27. Special issue ›Centenaire de Kandinsky‹, pp. 104–106.

Marcus, Hugo. »Zur Ästhetik der Abstraktion«. In: *Zeitschrift für Ästhetik und allgemeine Kunstwissenschaft* 7 (1912), pp. 129 ff.

Martens, Kurt (K.T.M.S.). »Primitive, Expressionisten, Kubisten, Futuristen und Genossen«. In: *Der Zwiebelfisch* 4 (1912), pp. 125–132.

Martensen-Larsen, Britta. »Folkekunsten betydning for Kandinsky: med henblik pa hans mobler i bonde stil«. In: *Cras* 35 (1983), pp. 81–94.

Mel'nikov, D. »Po povodu levoj živopisi na 19 gosudarstvennoj vystavke«. In: *Tvorčestvo*, Moskva, (1920) 7–10, pp. 42–44.

Merežkovskij, D. »O pričinach upadka i o novych tečenijach sovremenoj russkoj literatury«. In: *Poln. sobr. soč. D. M.* 17 tt. St. Petersburg; Moskva 1911–1913, t. 15, p. 247.

Merežkovskij, D. »La question religieuse: enquête internationale«. In: *Mercure de France* 67 (1907) 237, pp. 68–71.

Messer, Thomas M. »Kandinsky en Amérique«. In: *XXe Siècle* 40 (1966) 27. Special issue ›Centenaire de Kandinsky‹, pp. 111–117.

Meyer, Franz. »Le Kandinsky du centenaire«. In: *XXe Siècle* 40 (1966) 27. Special issue ›Centenaire de Kandinsky‹, p. 94.

Michel, Wilhelm. »Wassily Kandinsky: ›Über das Geistige in der Kunst‹«. [Review.] In: *Die Kunst für Alle* 27 (1912) 15. September, p. 580.

Migunov, A.; Perceva, T. M. »Na rubeže iskusstva i nauki: K tvorčeskoj biografii V. V. Kandinskogo«. In: *Iskusstvo* (1989) 1, pp. 30–36.

Miró, Joan. »Un grand prince de l'esprit«. In: *XXe Siècle* 40 (1966) 27. Special issue ›Centenaire de Kandinsky‹, pp. 89–90.

Mösser, Andeheinz. »Hugo Balls Vortrag über Kandinsky in der Galerie Dada in Zürich am 7. 4. 1917«. In: *Deutsche Vierteljahresschrift für Literaturwissenschaft und Geistesgeschichte* 51 (1977) 4, pp. 676–704.

Moleva, Nina M.; Beljutin, Elij M. »Metoda Antona Ažbèta«. In: *Anton Ažbè in Njegova Šola*. Cat. Ljubljana, Narodna Galerija, 1962.

Monachova, L. P. »Kandinskij: Model' iskusstva«. In: *Tvorčestvo* (1990) 2, pp. 1–5.

Monachova, L. P. »Kandinskij v Bauchause, 1922–1933«. In: *V. V. Kandiskij 1866–1944: Živopis', grafika, prikladnoe iskusstvo*. Cat. Leningrad 1989.

Muche, Georg. »L'année 1913 à Munich«. In: *XXe Siècle* 40 (1966) 27. Special issue ›Centenaire de Kandinsky‹, p. 33.

Neugass, Fritz. »Kandinsky-Retrospective«. In: *Weltkunst* 33 (1963).

Niemeyer, Wilhelm. »Malerische Impression und koloristischer Rhythmus«. In: *Denkschrift des Sonderbundes auf die Ausstellung 1910*. Düsseldorf 1911, pp. 66 ff.

Nishida, Hideho. »Concerning the attribution of the date of the first geometric sketch of Kandinsky«. In: *Art History* (1980) 3, pp. 1–16.

Nishida, Hideho. »La couverture du ›Cavalier bleu‹: sur le rôle du sentiment religieux dans la peinture non figurative de Kandinsky«. In: *Annual Reports of the Faculty of Arts and Letters*, Université du Tohoku 16 (1965).

Nishida, Hideho. »Genèse de ›la Première aquarelle abstraite‹ de Kandinsky«. In: *Art History* (1978) 1, pp. 1–20.

Nishida, Hideho. »Genèse du Cavalier bleu«. In: *XXe Siècle* 40 (1966) 27. Special issue ›Centenaire de Kandinsky‹, pp. 18–24.

Nishida, Hideho. »Kandinsky: Establishment of Abstract Painting; Process of Development and its Significance«. In: *Mizue* 12 (1974) 837, pp. 5–37.

Nishida, Hideho. »On the Themes of the So-called ›Four Seasons‹ Paintings (1914) by Wassily Kandinsky«. In: *Wassily Kandinsky*. Cat. Tokyo, Museum of Modern Art, 1987, pp. 25–39.

Nishida, Hideho. »Le Pays du Cavalier bleu«. In: *Culture* (1963) 4, Université de Tohoku.

Nishida, Hideho. »Sur le rôle du sentiment religieux dans la peinture abstraite«. In: *Bigaku = Aesthetics* (1965) 4.

Ouchi, Hiroko. »On the Origins of Kandinsky's Remarkable Themes«. In: *Art History* (1986) 8, p. 117.

Overy, Paul. »Colour and Sound«. In: *Apollo* 29 (1964) 27.

Overy, Paul. »The Later Painting of Wassily Kandinsky«. In: *Apollo* 28 (1963) 18, pp. 117–123.

Perceva, T. M. »V. Kandinsky v GACHN«. In: *V. V. Kandinsky 1866–1944: Živopis', grafika, prikladnoe iskusstvo*. Cat. Leningrad 1989.

Perceva, T. M. »Problema sintezii v tvorčestve Kandinskogo«. In: *Sovremennyj Laokoon: Estetičeskie problemy sintezii*. Moskva 1992.

Petsch, Joachim. »George Grosz ›Im Schatten‹ 1921; Wassily Kandinsky ›Kleine Welten‹, 1922: Anmerkungen zur ›abstrakt-konkreten‹ und zur ›sozialen‹ Kunst«. In: *Kleine und grosze Welten*. Ed.: W. Kemp; J. Petsch. Bonn 1972, pp. 27–49.

Picon, Gaetan. »Grandeur de Kandinsky: La Féerie du premier jour«. In: *XXe Siècle* 40 (1966) 27. Special issue ›Centenaire de Kandinsky‹, p. 93.

Poling, Clark V. »Kandinsky: Russian and Bauhaus Years 1915–1933«. In: *Kandinsky: Russian and Bauhaus Years 1915–1933*. Cat. New York, The Solomon R. Guggenheim Museum, 1983, pp. 12–83.

Poling, Clark V. »Kandinsky au Bauhaus: Théorie de la couleur et grammaire picturale«. In: *Change* 26/27 (1976). Special issue ›La Peinture‹, pp. 194–208.

Ponente, Nello. »Kandinskij«. In: *Saggi e Profili*. Roma 1958.

Rakitin, Wassily. »Zwischen Himmel und Erde oder wie befreit man das Rationale vom trockenen Rationalismus«. In: *Wassily Kandinsky: Die erste sowjetische Retrospektive. Gemälde, Zeichnungen und Graphik aus sowjetischen und westlichen Museen*. Cat. Frankfurt am Main, Schirn Kunsthalle, 1989, pp. 79–88.

Raoul, Rosine. »The Complexities of Expressionism«. In: *Apollo* 76 (1962) March, pp. 37–41.

Ratcliff, Carter. »Kandinsky's Book of Revelation«. In: *Art in America* 70 (1982) December. Special issue ›Expressionism‹, pp. 105–109, 157–159.

Rathbun, Mary Chalmers. »›Stabilité animée‹«. In: *Hitchcock, H. R.: Painting Toward Architecture – The Miller Company Collection of Abstract Art*. New York 1948, p. 76.

Read, Herbert. »An Art of Internal Necessity«. In: *Quadrum* (1956) 1, pp. 7–22.

Read, Herbert. »Magie et raison«. In: *XXe Siècle* 40 (1966) 27. Special issue ›Centenaire de Kandinsky‹, p. 95.

Repin, I. E. »Mysli ob isskustve«. In: *Novyj Put'* (1903) 1, pp. 28–36.

Repin, I. E. »Pis'mo v redakciju«. In: *Apollon* (1910) 6, Chronika, pp. 50–51.

Riedl, Peter Anselm. »Abstrakte Kunst und der Traum von der rezeptiven Gesellschaft«. In: *Festschrift für Klaus Lankheit*. Köln 1973, pp. 67 ff.

Riedl, Peter Anselm. »Kandinsky und die Tradition«. In: *Neue Heidelberger Jahrbücher* 22 (1978), pp. 3–17.

Ringbom, Sixten. »Art in ›The Epoch of the Great Spiritual‹: Occult Elements in the Early Theory of Abstract Painting«. In: *Journal of the Warburg and Courtauld Institutes* 29 (1966), pp. 386–418.

Ringbom, Sixten. »Kandinsky und das Okkulte« In: *Kandinsky und München: Begegnungen und Wandlungen 1896–1914*. Ed.: Armin Zweite. Cat. München, Städtische Galerie im Lenbachhaus, 1982, pp. 85–101.

Ringbom, Sixten. »Mystik und gegenstandslose Malerei«. In: *Mysticism*. Ed.: Sven S. Hartman. Uppsala 1970 (Scripta Instituti Donneriani Aboensis 4).

Ringbom, Sixten. »Die Steiner-Annotationen Kandinskys«. In: *Kandinsky und München: Begegnungen und Wandlungen 1896–1914*. Ed.: Armin Zweite. Cat. München, Städtische Galerie im Lenbachhaus, 1982, pp. 102–105.

Ringbom, Sixten. »Transcending the Visible: The Generation of the Abstract Pioneers«. In: *The Spiritual in Art: Abstract Painting 1890–1985*. Cat. Los Angeles, County Museum of Art. New York 1986, pp. 131–153.

Robbins, Daniel. »Vasily Kandinsky: Abstraction and Image«. In: *The Art Journal* 22 (1963) 3, pp. 145–147.

Roditi, Edouard. »Interview with Gabriele Münter«. In: *Arts, incorp. Arts Digest* 34 (1959/60) 4, pp. 36–41. (Dt.: »Dialog mit Gabriele Münter«. In: *Deutsche Rundschau* 86 (1960), pp. 895–910).

Roethel, Hans Konrad; Benjamin, Jean K. »A New Light on Kandinsky's First Abstract Painting«. In: *The Burlington Magazine* 119 (1977) 896, pp. 772–773.

Roethel, Hans Konrad. »Die Gabriele-Münter-Stiftung der Städtischen Galerie München«. In: *Kunstchronik* 10 (1957) 8, pp. 213–215.

Roethel, Hans Konrad. »Kandinsky ›Improvisation Klamm‹: Vorstufen einer Deutung«. In: *Eberhard Hanfstaengl zum 75. Geburtstag*. München 1961, pp. 186–192. (Reprinted with some corrections in: *Wassily Kandinsky à Munich: Collection Städtische Galerie im Lenbachhaus*. Cat. Bordeaux, Galerie des Beaux-Arts, 1976, p. 49).

Roethel, Hans Konrad. »Wassily Kandinsky (1866–1944): Reitendes Paar«. O. O., [n. d.], pp. 153–154.

Roethel, Hans Konrad. »Wassily Kandinsky und die Revolution der modernen Malerei«. In: *Universitas* 12 (1957) 7, pp. 701–708.

Roh, Juliane. »Kandinsky und Gabriele Münter in der Münchener Städtischen Galerie«. In: *Das Kunstwerk* 10 (1956/57) 5, p. 52.

Roosval, Johnny (J. R.). »Kandinsky«. In: *Saisonen: Magasin för konst, nyheter och moder* (1916) 1, pp. 4–5.

Rossi, G. B. »Arte e Artisti: Kandinsky, E. Serra, C. P. Ripamonte, H. Cullen, F. Vitalini«. In: *L'Italia Industriale Artistica* 3 (1905) 5, pp. 3–7.

Roters, Eberhard. »Wassily Kandinsky und die Gestalt des Blauen Reiters«. In: *Jahrbuch der Berliner Museen* 5 (1963) 2, pp. 201–226.

Rovel, Henri. »Les Lois d'harmonie de la Peinture et de la Musique sont les mêmes«. In: *Les Tendances Nouvelles* (1908) 35, pp. 721–728; (1908) 36, pp. 753–757 (Facsimile in: Fineberg, Jonathan D. *Kandinsky in Paris, 1906–7*).

Rufer, Josef. »Schönberg – Kandinsky: Zur Funktion der Farbe in Musik und Malerei«. In: *Hommage à Schönberg*. Cat. Berlin 1974, pp. 69–75.

Russell, John. »Kandinsky hits England«. In: *Art News* (1967) February, p. 58.

Russell, John. »A Manifold Moses: Some Notes on Schönberg and Kandinsky«. In: *Apollo* 84 (1966) 57, pp. 388–389.

Sarab'janov, Dmitri V. »Effekt Kandiskogo«. In: *Pravda*, 3. 7. 1989.

Sarab'janov, Dmitri V. »Wassily Kandinsky: Künstler und Bürger Europas«. In: *Wassily Kandinsky: Die erste sowjetische Retrospektive. Gemälde, Zeichnungen und Graphik aus sowjetischen und westlichen Museen*. Cat. Frankfurt am Main, Schirn Kunsthalle, 1989, pp. 25–31.

Sarajas-Korte, Salme. »Kandinsky ja Suomi. I: 1906–1914. = Kandinsky och Finland. I: 1906–1914«. In: *Ateneumin Taidemuseo Museojulkaisu* 15 (1970) pp. 2–14; Resumé: Kandinsky et la Finlande, pp. 42–45.

Schapiro, Meyer. »Nature of Abstract Art«. In: *Marxist Quarterly* 1 (1937) January – March, pp. 77–98.

Scherstjanoi, Valeri. »Wassili Kandinsky und die russischen Futuristen«. In: *Bildende Kunst* (1988) 11, p. 502.

Schneider, A. »Hommage à Schönberg: Der Blaue Reiter und das Musikalische in der Malerei der Zeit«. In: *Pantheon* 35 (1977) 1, pp. 56–58.

Schneider, G. »Le premier lyrique de l'abstraction«. In: *XXe Siècle* 40 (1966) 27. Special issue ›Centenaire de Kandinsky‹, pp. 101–102.

Schneider, Theo. »Die Kunstlehre Kandinsky's«. In: *Kunstblatt* 11 (1927) 5, pp. 198–200.

Schorske, Carl E. »Die Retrospektive im kulturgeschichtlichen Zusammenhang: eine neue Tendenz«. In: *Kandinsky und München: Begegnungen und Wandlungen 1896–1914*. Ed.: Armin Zweite. Cat. München, Städtische Galerie im Lenbachhaus, 1982, pp. 13–16.

Segui, Shinichi. »Kandinsky et l'Orient«. In: *XXe Siècle* 40 (1966) 27. Special issue ›Centenaire de Kandinsky‹, pp. 107–110.

Selz, Peter. »The Aesthetic Theories of Wassily Kandinsky and Their Relationship to the Origin of Non-objective Painting«. In: *The Art Bulletin* 39 (1957) 2, pp. 127–136.

Selz, Peter. »The Influence of Cubism and Orphism on the ›Blue Rider‹«. In: *Festschrift Ulrich Middeldorf*. Ed.: A. Kosegarten; P. Tigler. Berlin 1968, pp. 582–590.

Sepp, Hans Rainer. »Kandinsky, Husserl, Zen«. In: *Art et phénoménologie: revue annuelle* 7 (1991), pp. 205–211.

Sepp, Hans Rainer. »Phänomenologische Reduktion und konkrete Kunst: Zur Affinität von Phänomenologie und moderner Malerei am Beispiel von Husserl und Kandinsky«. In: *La fenomenologia e le arti*. Ed.: Gabriele Scaramuzza. Milano 1991, pp. 113–135.

Sheppard, Richard. »Kandinsky's Abstract Drama ›Der Gelbe Klang‹: an Interpretation«. In: *Forum for Modern Language Studies* 11 (1975) 2, pp. 165–176.

Sheppard, Richard. »Kandinsky's Early Aesthetic Theory: Some Examples of Its Influence and Some Implications for the Theory and Practice of Abstract Poetry«. In: *Journal of European Studies* 5 (1975) March, pp. 19–40.

Sheppard, Richard. »Kandinsky's Oeuvre 1900–1914: The ›Avant-Garde‹ as Rearguard«. In: *Word and Image* 6 (1990) 1, pp. 41–67.

Signac, Paul. »Französische Kunst: Neoimpressionismus«. In: *Pan* 4 (1988), pp. 55–62.

Sinisi, Silvana. »Kandinski et la synthese scenique abstraite«. Transl. by Giorgio Perego. In: *Wassili Kandinsky: Quadri di un' esposizione*. Macerata 1984.

Smedt, Raphael de. »Kandinsky à Bruxelles en 1913«. In: *Gazette des Beaux-Arts* Ser. 6, 131 (1989) 113 mai/juin, pp. 237–248.

Soupault, Ré. »Quand j'étais l'élève de Kandinsky«. In: *Jardin des Arts* (1963) juin.

Soupault-Niemeyer, Ré. »Du cheval au cercle«. In: *XXe Siècle* 40 (1966) 27. Special issue ›Centenaire de Kandinsky‹, pp. 34–40.

Spira, Roberto. »Kandinskys Weg zur abstrakten Malerei«. In: *Weltkunst* 31 (1961) 10.

Staber, Margit. »Die Anfänge der Konkreten Kunst«. In: *Das Werk* 47 (1960) 2, pp. 367–374.

Stein, Susan Alyson. »Kandinsky and Abstract Stage Composition: Practice and Theory 1909–1912«. In: *Art Journal* 43 (1983) 1, pp. 61–66.

Strakosch-Giesler, Maria. »Vom Frühwerk des Malers Wassily Kandinsky«. [Manuscript.] [Publ. partly in: *Wir entdecken Kandinsky*. Ed.: Hugo Debrunner et al. Zürich 1946].

Strasfogel, I. »A Radical Vision: Vassili Kandinsky's Fusion of the Arts«. In: *Opera News* 46 (1982) 11, pp. 8–11.

Strauss, Monica. »Kandinsky and ›Der Sturm‹«. In: *Art Journal* 43 (1983) 1, pp. 31–35.

Stuckenschmidt, H. H. »Kandinsky et la musique«. In: *XXe Siècle* 40 (1966) 27. Special issue ›Centenaire de Kandinsky‹, pp. 25–28.

Tériade, E. »Kandinsky«. In: *Le Centaure* 3 (1929) 8, pp. 220–223.

Thomas, Vincent. »Kandinsky's Theory of Painting«. In: *The British Journal of Aesthetics* 9 (1969), pp. 19–38.

Thürlemann, Felix. »Analisi di una autointerpretazione di Kandinsky: il modo di significazione sinestetico – fisiognomico«. In: *Semiotica: attualità e promesse della ricerca*. Ed.: Paolo Fabbri et al. Bellinzona 1985, pp. 53–64.

Thürlemann, Felix. »H. K. Roethel; J. K. Benjamin: Kandinsky ›Werkverzeichnis der Ölgemälde‹, Bd 1.2.«. [Review.] In: *Zeitschrift für Kunstgeschichte* 46 (1983) 2, pp. 223–227; 47 (1984) 1, pp. 126–129; 48 (1985).

Thürlemann, Felix. »Kandinskys Analyse-Zeichnungen«. In: *Zeitschrift für Kunstgeschichte* 48 (1985) 1, pp. 364–378.

Tietze, Hans. »Der Blaue Reiter«. In: *Die Kunst für Alle* 27 (1912), pp. 543–550.

Tietze, Hans. »Kandinsky ›Klänge‹«. [Review.] In: *Die Graphischen Künste* 37 (1914), Beilage, pp. 15–16.

Turcin, V. »V. Kandinskij: duch, stil', romatika«. In: *Iskusstvo* (1989) 2, pp. 44–50.

Tschiżewskij, Dmitrij. »Wassily Kandinsky und die russische Literatur«. In: *Die Welt der Slaven* 2 (1957) 3, pp. 293–301.

Umanskij, Konstantin. »Rußland. IV: Kandinskijs Rolle im russischen Kunstleben«. In: *Der Ararat* (1920) Mai/Juni. 2. Sonderheft ›Paul Klee‹, pp. 28–30.

Vallier, Dora. »Kandinsky et l'aquarelle«. In: *L'Œil* (1977) 263, pp. 26–29.

Vallier, Dora. »Lire Worringer«. In: *Worringer, Wilhelm: Abstraction et Einfühlung: contribution à la psychologie du style*. Paris 1978, pp. 5–32.

Vallier, Dora. »Son fil d'Ariane, la couleur«. In: *XXe Siècle* 40 (1966) 27. Special issue ›Centenaire de Kandinsky‹, pp. 72–74.

Vanečkina, I. L. »Kuda skačet ›Goluboj vsadnik‹?« In: *Svetomuzyka v teatre i na estrade*. Kazan' 1992, pp. 13–15.

Vanečkina, I. L. »Sud'ba sceničeskoj kompozicii V. Kandinskogo ›Żeltyj zvuk‹«. In: *Svetomuzyka v teatre i na estrade*. Kazan' 1992, pp. 15–18.

Velde, Henry van de. »Allgemeine Bemerkungen zu einer Synthese der Künste«. In: *Pan* 5 (1899), pp. 261–270.

Vergo, Peter. »Kandinsky: Art Nouveau to Abstraction«. In: *Kandinsky: The Munich Years 1910–1914*. Edinburgh; München 1979, p. 4.

Vergo, Peter »Painting in Munich«. In: *Abstraction: Towards a New Art. Painting 1910–20*. London 1980, p. 63.

Vergo, Peter. »Music and Abstract Painting: Kandinsky, Goethe and Schoenberg«. In: *Towards a New Art: Essays on the background to abstract art 1910–20*. Cat. London, Tate Gallery, 1980, pp. 41–63.

Vergo, Peter. »Kandinsky and the ›Blue Rider Idea‹«. In: *Nya perspektiv pa Kandinsky*. Malmö 1990, pp. 49ff.

Veronesi, Giulia. »La casa di Kandinsky«. In: *Zodiac* (1962) 10, pp. 162–167.

Verwey, Albert. »Der Maler: An Kandinsky«. [Poem.] In: *Der Sturm* (1913) 148/149, p. 269.

Vieillard, Roger. »L'imagier des steppes«. In: *XXe Siècle* 40 (1966) 27. Special issue ›Centenaire de Kandinsky‹, p. 102.

Vikturina, M. P. »Zur Frage von Kandinskys Maltechnik«. In: *Wassily Kandinsky: Die erste sowjetische Retrospektive. Gemälde, Zeichnungen und Graphik aus sowjetischen und westlichen Museen*. Cat. Frankfurt am Main, Schirn Kunsthalle, 1989, pp. 35–46.

Volbehr, Th. »Von Herder zu Kandinsky«. In: *Die Kunst* 53 (1926), pp. 297–298 (Die Kunst für Alle 41).

Volboudt, Pierre. »Les aquarelles de Kandinsky«. In: *Exposition des aquarelles de 1910 à 1944*. Cat. Tokyo, Galerie Tokoro, 1979, pp. 35–38.

Volboudt, Pierre. »Kandinsky entre les deux Réalités«. In: *XXe Siècle* 24 (1962) Juin, pp. 13–16.

Volboudt, Pierre. »Kandinsky tel qu'en lui-même«. In: *XXe Siècle* 43 (1969) 33, pp. 104–112.

Volboudt, Pierre. »Philosophie de Kandinsky«. In: *XXe Siècle* 40 (1966) 27. Special issue ›Centenaire de Kandinsky‹, pp. 55–62.

Volboudt, Pierre. »Wassily Kandinsky«. In: *Cahiers d'Art* 31/32 (1956/57), pp. 177–215.

Volpi, Marisa. »Kandinskij«. In: *La Biennale* (1963) 50/51.

Volpi, Marisa. »Mostra alla Galleria d'arte moderna, Pollock e Kandinskij«. In: *Bolletino d'Arte* 43 (1958).

Volpi, Marisa. »Tre Momenti della Cultura di Kandinskij«. In: *Maratre* (1966) 23–25.

»Von Ausstellungen und Sammlungen: Köln. Bei Schulte . . . Bilder, Skizzen und Entwürfe von W. Kandinsky«. In: *Die Kunst für Alle* (1905) Dezember, p. 117.

»Von Ausstellungen und Sammlungen: München. Wassily Kandinsky und Ernst Treumann«. [Review of a Munich exhibition.] In: *Die Kunst für Alle* (1904) September, p. 554.

Wadsworth, Edward. »›Inner necessity‹: review of Kandinsky's book«. In: *Blast* (1914) 1, pp. 119–125.

Wangermee, R. »Kandinsky et Schoenberg: Sur quelques conjonctions peinture – musique«. In: *Bulletin de la classe des beaux-arts* 69 (1987) 3–5, pp. 113–137.

Washton, Rose-Carol. »Kandinsky's Paintings on Glass«. In: *Art Forum* (1967) February.

Washton Long, Rose-Carol. »Expressionism, Abstraction and the Search for Utopia in Germany«. In: *The Spiritual in Art: Abstract Painting 1890–1985*. Cat. Los Angeles, County Museum of Art; Chicago, Museum of Contemporary Art; Den Haag, Gemeente Museum. New York 1986, pp. 201–218.

Washton Long, Rose-Carol. »Kandinsky ›The Language of the Eye‹ by Paul Overy«. [Review.] In: *The Art Bulletin* 53 (1971) June, p. 273.

Washton Long, Rose-Carol. »Kandinsky and Abstraction: The Role of the Hidden Image«. In: *Artforum* 10 (1972) 10, pp. 42–49.

Washton Long, Rose-Carol. »Kandinsky's Abstract Style: The Veiling of Apocalyptic Folk Imagery«. In: *Art Journal* 34 (1975) 3, pp. 217–228.

Washton Long, Rose-Carol. »Kandinsky's Vision of Utopia as a Garden of Love«. In: *Art Journal* 43 (1983) 1, pp. 50–60.

Washton Long, Rose-Carol. »Occultism, Anarchism, and Abstraction: Kandinsky's Art of the Future«. In: *Art Journal* 46 (1987) 1, pp. 38–45.

»Wassily Kandinsky«: Essays by Charles Estienne, Carola Giedion-Welcker, R. V. Ginderstael. In: *Art d'aujourd'hui* (1950) 6.

Weiss, Peg. »The Graphic Art of Kandinsky: ›Lyric, intensely personal epigrams‹«. In: *Art News* 73 (1974) March, pp. 42–44.

Weiss, Peg. »Kandinsky: Symbolist Poetics and Theater in Munich«. In: *Pantheon* 35 (1977) 3, pp. 209–218.

Weiss, Peg. »Kandinsky and ›Old Russia‹: An Ethnographic Exploration«. In: *The Documented Image: Visions in Art History*. Ed.: Gabriel P. Weisberg et al. Syracuse, N.Y., 1987, pp. 187–222.

Weiss, Peg. ›Kandinsky and the ›Jugendstil‹ Art and Crafts Movement«. In: *The Burlington Magazine* 117 (1975) 866, pp. 270–279.

Weiss, Peg. ›Kandinsky und München: Begegnungen und Wandlungen«. In: *Kandinsky und München: Begegnungen und Wandlungen 1896–1914*. Ed.: Armin Zweite. Cat. München, Städtische Galerie im Lenbachhaus, 1982, pp. 29–84. (Engl.: ›Kandinsky in Munich: Encounters and Transformations«. In: *Kandinsky in Munich: 1896–1914*. Cat. New York, The Solomon R. Guggenheim Museum, 1982, pp. 28–82).

Weiss, Peg. ›Kandinsky, Wolfskehl und Stefan George«. In: *Castrum Peregrini* 138 (1979), pp. 26–51.

Weiss, Peg. ›Kandinsky's Lady in Moscow: ›Occult Patchwork‹ or Chekhov's Dog?« In: *Album amicorum Kenneth C. Lindsay*. Ed.: Susan Stein; George D. McKee. State University of New York, Binghamton, 1990, pp. 313–325.

Weiss, Peg. »Wassily Kandinsky, the Utopian Focus: Jugendstil, Art Deco and the Centre Pompidou«. In: *Arts Magazine* 51 (1977) 8, pp. 102–107.

Welsh, Robert. »Abstraction and the Bauhaus«. In: *Artforum* 8 (1970) March, pp. 46–51.

Werckmeister, Otto K. »From the Sounding Cosmos to the Fireworks of War«. [Review.] In: *Art History* 5 (1982) 2, pp. 231–236.

Werenskiold, Marit. »Kandinsky's Moscow«. In: *Art in America* (1989), March, p. 97.

Whitford, Frank. »Some Notes about Kandinsky's Development Towards Non-figurative Art«. In: *Studio international* 173 (1967) 885.

Winkel, Erich. »Das Horoskop Wassilli Kandinskys«. In: *Astrologische Blätter* 8 (1926) 6, pp. 178–184.

Winkler, Walter. »Wassily Kandinsky«. In: Winkler, Walter: *Psychologie der modernen Kunst*. Tübingen 1949, pp. 201–216.

Wolf, Georg Jakob. »2. Ausstellung der ›Neuen Künstlervereinigung München‹«. In: *Die Kunst für Alle* 26 (1910) 1. November, pp. 68–69.

Wolfradt, Willi. »Ausstellungen: Berlin. Juryfreie Kunstschau«. In: *Das Kunstblatt* 6 (1922) 12, p 543.

Wolfradt, Willi. »Kandinsky: 2. Wider (Die Kunst und das Absolute)«. In: *Das Kunstblatt* 3 (1919) 6, pp 180–183 (T. 1 cf.: Kuhn, Herbert).

Zahn, Leopold. »Bücher: Picasso und Kandinsky«. In: *Der Ararat* 2 (1921). pp. 171–173.

Zernov, B. ›Princip vnutrennej neobchodimosti: Zametki o tvorčestve V. Kandinskogo«. In: *Iskusstvo Leningrada* (1990) 2, pp. 55–63.

Zervos, Christian. »Notes sur Kandinsky«. In: *Cahiers d'Art* 9 (1934) 5–8, pp. 149–157.

Zervos, Christian. »Wassily Kandinsky, 1866–1944«. In: *Cahiers d'Art* 20/21 (1945/46), pp. 114–127.

Zweite, Armin. »Kandinsky zwischen Moskau und München«. In: *Kandinsky und München: Begegnungen und Wandlungen 1896–1914*. Ed.: Armin Zweite. Cat. München, Städtische Galerie im Lenbachhaus, 1982, pp. 5–12.

Zweite, Armin. »Kandinsky zwischen Tradition und Innovation«. In: *Kandinsky und München: Begegnungen und Wandlungen 1896–1914*. Ed.: Armin Zweite. Cat. München, Städtische Galerie im Lenbachhaus, 1982, pp. 134–177.

Zweite, Armin. »Hans Konrad Röthel und die Sammlung ›Der Blaue Reiter‹ im Lenbachhaus«. In: *Der Blaue Reiter im Lenbachhaus München*. Cat. ed. by Rosel Gollek. München 1982, pp. 5–7.

INDEX OF NAMES

(page numbers in *italics* refer to the captions)

PHOTO CREDITS

(references are to illustration numbers)

V. Baraev, Moscow, 7
Hannes Beckmann, Paris, 389
Walter Dräyer, Basel, 455
Jean Dubout, Paris, 432, 435, 437
Ali Elai, New York, 262
Simone Gänsheimer, Städtische Galerie, Munich, 71
David Heald, New York, 246, 424, 440
Hans Hinz, Basel, 448
H.H. Hoffmann, Munich, 187
Lipnitzki and Roger Viollet, Paris, 390
Robert E. Mates, New York, 439
Lucia Moholy, London, 362
Otto E. Nelson, New York, 136
Malcolm Varon, New York, 141, 265, 386
H. Roger Viollet, Paris, 390, 394

We also thank the Bauhaus-Archiv, Berlin, and the Galerie Maeght, Paris, for their warm support, together with all those who have provided us with photographs to which they own the rights.